A HISTORY OF VISUAL CULTURE

A HISTORY

OF VISUAL CULTURE

Western Civilization from the 18th to the 21st Century

**EDITED BY JANE KROMM
AND SUSAN BENFORADO BAKEWELL**

Oxford • New York

English edition

First published in 2010 by

Berg

Editorial offices:
First Floor, Angel Court, 81 St Clements Street, Oxford OX4 1AW, UK
175 Fifth Avenue, New York, NY 10010, USA

Berg is the imprint of Oxford International Publishers Ltd.

Library of Congress Cataloging-in-Publication Data

A catalogue record for this book is available from the Library of Congress.

British Library Cataloguing-in-Publication Data

A catalogue record for this book is available from the British Library.

ISBN 978 1 84520 493 8 (Cloth)
ISBN 978 1 84520 492 1 (Paper)

Typeset by Apex Covantage, LLC, Madison, WI, USA

Printed in Great Britain by the MPG Books Group, Bodmin and King's Lynn

www.bergpublishers.com

CONTENTS

PART SEVEN: MEDIA AND VISUAL TECHNOLOGIES

GENERAL INTRODUCTION

Jane Kromm

Walking along Leiden's small Pastoorsteeg street in the early years of the seventeenth century, a passerby, looking up, would see a painted copper plaque surmounting the doorway of a building (fig. 0.1).[1] Formerly the entryway to the cloister of St. Caecilia, this was now the main entrance for what had since become St. Caecilia's hospital. Even with just a cursory look, any passerby would easily grasp the new purpose and communal role of the institution by scanning the particulars of the plaque's imagery.[2] Offering a view into the hospital's interior spaces, the painting shows in the foreground an elderly, ailing man being carried with great care into a reception area, beyond which are a row of comfortable recessed and curtained beds. There are several homely details, such as the small tables and tankard, and the ailing inmates are being carefully attended to by family members or other caregivers.

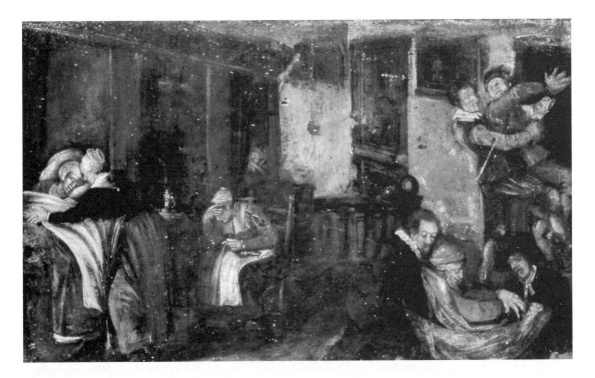

Fig. 0.1 Anonymous, *Scene in a Gasthuis,* plaque from St. Caecilia's Hospital, seventeenth century.

Along the rear wall are the doors and cell window hatches that are the accommodations for the disturbed and agitated. One such afflicted man is being forcibly carried into one of these small rooms, in a clear demonstration of the institution's ability to contain disorder. The man's disheveled appearance and flailing arms provide visual confirmation that this practice is an unfortunate necessity, and one that allows the hospital to maintain order by offering some distance between the quiet, ailing inmates and the more noisome. The scene is informative, making it clear that St. Caecilia's is able to provide a range of services for different kinds of patients and does so in an easily accessed, well-organized, but homelike setting. It is also evident that these services are offered in a transparent rather than a secretive manner, and this openness is underscored by the very position of the painting on the building's exterior, a proudly demonstrative act on the part of the hospital's managers that encouraged spectators on the street to consider what went on within the walls of the institution.

The plaque's public architectural location obviously ensured its high visibility, but it also called attention to the difference of this type of work from traditional forms of exterior decoration. It is a far cry, for example, from the sculptural embellishments of important civic buildings, which were often sedate and inspired by classical exemplars. Against this traditional practice, the plaque is rather casual and ad hoc in nature, qualities that also distance it from the typically Dutch practice of decorated façade gablestones steeped in the world of emblems, proverbs, and everyday life. Judged by these standards, St. Caecilia's plaque is clearly a hybrid variation on existing visual practices of public architectural embellishment. The work is also anonymous, although it contains motifs that resemble the institution's fundraising lottery poster of 1595–1596, designed by Isaac van Swanenburgh and engraved by Jacques de Gheyn.[3] Swanenburgh was one of Leiden's leading artists, as well as a hospital official. His lottery poster, like the plaque itself, is a good example of the kind of temporary, less exalted forms of art undertaken by professional artists at this time. Like the lottery poster, the plaque may also have been undertaken as a temporary device aligned with fund-raising or other seasonal projects. Around 1614, the plaque was removed and replaced by a rectangular sandstone gable bordered in strapwork and bearing simply the name of the institution. The short exposure period for this modest but nevertheless visually and socially significant image reminds us that many such similar visual objects can be easy to overlook in standard art historical, historical, or social historical studies.

That these ephemeral, hybrid forms like the hospital plaque existed in relation to more familiar and sophisticated art work rather than in some kind of oddball isolation can also be confirmed by their presence within more traditional formats. There are several examples of this integrative approach in a painting by Adriaen van Nieulandt that depicts a procession of lepers in Amsterdam in celebration of a religious holiday in 1604 (fig. 0.2).[4] Such processions were suppressed after that year, and the image is a recollection produced in 1633 at the request of the leper-house governors. In the lower right corner, a lottery poster for the city's asylum can be seen mounted on wooden brackets similar to those then used to display maps in the home, and carried on a tricolor pole by town functionaries in matching livery.

The poster is divided into three horizontal zones, beginning at the lowest level with lottery rules and regulations. The middle section displays rows of the prizes to be awarded at the lottery drawing, and finally, in the uppermost section, there is a scene of five asylum inmates shown within the institution in varying degrees of distraction and physical disarray—the intended recipients of the charitable benefits afforded by this fundraising system. Just beyond the men carrying the poster is a group observing a quack doctor's presentation in which several kinds of visual aids form part of his demonstration.

Fig. 0.2 Adriaen van Nieulandt, *The Annual Procession of Lepers on Banqueting Monday,* 1633, detail.

In a work like van Nieulandt's, it is evident that the separation of different kinds or levels of images belies the fact that actual visual practices in history were by contrast integrated, interrelated, and conceived in more dynamic, mutually engaging, and interactive ways. These two examples from the seventeenth century in the Netherlands demonstrate that ephemeral or hybrid or marginal visual forms coexisted alongside the more traditional visual arts in a manner that was both culturally and conceptually significant.

The resulting, more integrated visual field was not unique to the Dutch Republic or to seventeenth-century northern Europe, although claims for the primacy of visual experience in the Dutch Golden Age have been convincingly proposed, notably by Svetlana Alpers.[5] Rather, there is ample evidence that similar degrees of visual command and conceptualization can be found in other historical periods and geographical locations, albeit in different, perhaps more intermittent and episodic ways. A *toile de Jouy* fabric from late eighteenth-century France, for example, can also serve to demonstrate that the inclination to develop visually structured cultural phenomena was more widespread and apt to be found in any number of historical periods and circumstances.

This particular fabric pattern was designed by J. B. Huet and produced by the Oberkampf factory in 1790–1791 during the more optimistic early years of the French Revolution (fig. 0.3).[6] It commemorates a festive political event, the Fête de la Fédération, which was held on the first anniversary of the fall of the Bastille on July 14, 1790. Dispersed across the fabric in a disjunctive, episodic manner are scenes taken from the multiple aspects of the celebration, which took place simultaneously

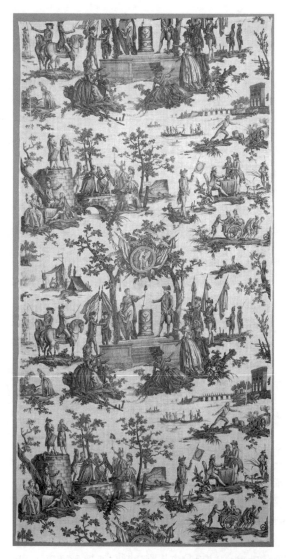

Fig. 0.3 Jean-Baptiste Huet, *La fête de la fédération*, 1790–1791; printed by engraved plate on cotton plain weave.

all over France. At the same time, many traveled by cart and boat to Paris to partake in the festive events there. The numerous figures represent a range of social classes, in particular peasants, workers, royalty, and aristocrats. Grouped together on small islands of spatial settings, these figures variously dance around a liberty tree or on miniature Bastille ruins; others are shown in transit, and many strike seemingly coordinated, perhaps even orchestrated or stage-managed poses of allegiance and oath-swearing. Significant principal characters include the female symbol of Liberty, General Lafayette on horseback, and a hopeful Louis XVI at Liberty's side. These separate glimpses of the festival provide multiple references to many of its aspects, and their loose, spatially noncommittal organization conveys the fraternal, unifying connotations that the planners of this political celebration wanted to project. Several of the visual devices used in the fabric's design were familiar, ornamental ones, such as the abbreviated perspectives of the individual units and the undefined open areas between

the separate scenes. These condensed yet visually diffuse elements were drawn from the traditional forms of a relatively purposeless decorative sensibility, but they are used here in a way that expresses a contemporary political orientation. As a length of fabric, the toile was clearly intended for private, personal use (typically on walls and beds and surrounding windows), yet at the same time it functioned as public, visible evidence of its owner's political affiliation, which might on one day be viewed as laudable and on the next treasonable, as the volatile revolutionary decade proceeded.

All three of these very different items—the anonymous painting on copper from St. Caecilia's hospital in Leiden, the lottery poster glimpsed from the corner of van Nieulandt's genre painting, and the politically calibrated *toile de Jouy* fabric—exemplify different aspects of what can be called "visual culture." Each work, in diverse ways and in varying degrees, fails to fit neatly into the traditional categories of the "high" visual arts. As a result, their marginal or hybrid status calls into question many of the longstanding assumptions about the so-called fine arts and calls attention to those spaces of visual experience that more traditional approaches have tended to overlook. The fact that these objects are on the margins of traditional art production makes them well-suited to studying the function of images and to probing the conceptual processes that informed them. These investigative tactics offer substantial alternatives to previous objectives of study, such as the defining qualities of a masterpiece or the stylistic sequences of a particular period. As new approaches, at variance with but not entirely foreign to the more familiar methods of studying art, they create not only an expanded, inclusive visual field, but also illuminate past practices of looking and of visual thinking, or those conceptual processes that are structured to a significant degree around visual concerns. In this way, visual culture can be gauged in terms of the objects it examines, the methods of interpretation or investigation it undertakes, and the subjects or viewers who engage with the objects.

VISUAL CULTURE: DEFINITIONS AND HISTORY OF THE FIELD

Visual culture has existed as a field of study since the 1980s. Throughout the last decades of the twentieth century, there have been numerous attempts to define its domain and methodology. The result is a fascinating plurality of approaches rather than a narrowly defined area of study to which all practitioners unanimously subscribe. Variations among these approaches concentrate around whether visual culture is defined by its objects, or its subjects, or whether the focus lies within the details of the method of approach itself. Many scholars of course attempt in their formulations to address all three of these different concentrations. Some proponents use the terms *visual culture* and *visual studies* interchangeably, while others take issue with this basic distinction in terms.[7] For example, W.J.T. Mitchell, among others, prefers the phrase *visual culture* for its contextual emphasis and because "it is learned and cultivated, not simply given by nature."[8] One major subject of debate concerns whether visual culture is a unique aspect of our contemporary era and intimately related to the proliferation of visual technologies, or whether it can also be said to have a significant historical dimension in relation to visual preferences and developments.[9] A further controversial issue relates to the inclusiveness of the visual cultural field, extending this range to embrace additional sensory modes on the one hand, and the textual and verbal on the other.[10]

There is, however, widespread agreement that visual culture is interdisciplinary or cross-disciplinary, and that its ability to question or strain existing disciplinary boundaries and traditional cultural

hierarchies is one of its most laudable characteristics. A significant number of proponents also agree that the inclusion of objects and experiences previously considered marginal in the study of visual art is likewise a promising intellectual development, provided that this broader focus nevertheless primarily considers "images for which distinguished cultural value has been or is being proposed."[11] This position voices a concern that the visual significance of what is being studied in the visual culture approach must not be taken for granted but is itself an important component requiring analysis and examination. For many scholars, this vigilant approach to visual acuity is balanced by claims that the circumstantial and contextual embeddedness of visual culture's objects are equally critical components within the field of study. Support for this position is found in claims that the proper focus of visual culture concerns the "social practices of looking," or, in a slightly more complex formulation, that it consists of the "visual construction of the social, not just the social construction of vision."[12]

A pronounced emphasis on the social aspect of visuality resulted in part from the fact that visual culture appeared as an academic approach in the 1970s just as the social history of art gained currency, endorsed by many for its capacity to test or push the borders of a more traditional art history.[13] In this decade, the reevaluation of academic disciplines and their purview was catalyzed not only by social historical approaches, but also by cultural studies, anthropology, and the Frankfurt School, among others. Feminist scholars in particular were active in demonstrating shortcomings and inaccuracies in the standard practices of art-historical and other area studies. One outcome of these developments was the so-called new art history of the 1980s, in which familiar disciplinary strategies were extended beyond their traditional limits, broadened by the methods of these new approaches as well as by a greater self-consciousness concerning the nature of their own revisionist premises and assumptions. The addition of new visual technologies was also a natural outcome of a socially expanded field for the study of visual culture, and one of the first works to acknowledge the role of media in this way was Caleb Gattegno's 1969 *Towards a Visual Culture: Educating through Television*.[14] By the 1990s, numerous introductory readers specifically addressing the field of visual culture became available, each with varying degrees of focus on new media in their more inclusive approach to understanding visual experience. Prominent contributions among this group include *Visual Culture* (1994), edited by Norman Bryson, Michael Ann Holly, and Keith Moxey, as well as Chris Jenks's *Visual Culture* of 1995 and Nicholas Mirzoeff's 1998 edition of *The Visual Culture Reader*. In several essays also published at this time, W.J.T Mitchell presented the syllabus used in his visual culture course, whose goal he claimed was "not to 'cover' the field of visual culture, but to introduce its central debates and dialectics—its various boundaries both internal and external."[15]

Then in the summer of 1996, the radical journal *October* published a visual culture questionnaire. This posed four questions its editorial staff considered crucial to an understanding of the new field, and these were made from a clearly antagonistic position.[16] It was suggested that, on the one hand, the interdisciplinary premises of the field were problematic, the result of institutional and financial pressures, and, on the other hand, that it was an undesirable development created by endorsing anthropological methods at the expense of the historical. Visual culture as a novel approach was undermined by one question that suggested that its methods were in fact recycled from the work of such major art-historical figures of the early twentieth century as Alois Riegl and Aby Warburg. The proper objects of study in visual culture were denigrated as well by suggesting that the new field would concentrate on virtual images rather than material objects. These points were followed by the

responses of the scholars canvassed. A very wide net was cast by the journal's editors, and this group included experts from the fields of art history, history, literature, film studies, anthropology, comparative literature, and cultural studies. While the results of the questionnaire were quite mixed, there is now a consensus that it served the field of visual culture well, by giving adherents of the approach an opportunity to consolidate and clarify their positions.[17] In the questionnaire's wake, there has been a steady rate of publication for readers, anthologies, and specialist studies with a focus on a visual culture approach. This process of sharing ideas and practices among proponents of visual culture, catalyzed by the *October* questionnaire, has continued through such groups as the visual culture caucus, which meets annually at the College Art Association national conference, and through several electronic forums.[18]

CRITICAL INFLUENTIAL FIGURES

Working in Hamburg in the late nineteenth and early twentieth centuries, Aby Warburg (1866–1929) pioneered an extraordinarily expansive interdisciplinary approach to art and intellectual history that encompassed the classical, the nonclassical European, and many non-European traditions.[19] His library, now at the University of London, was organized around an integrative, conceptual framework rather than along familiar disciplinary guidelines, and this novel arrangement was emblematic of Warburg's insistence on "diversity and heterogeneity in scholarship."[20] He is widely acknowledged to have founded the iconological approach to the study of art, in which images are studied within a broad social, cultural, and philosophical context, rather than in stylistic or biographical isolation. Unlike many of his contemporaries, who sought authoritative, linear overviews of the past, Warburg was drawn to study the tensions and discontinuities, the disruptions and transitions, within the historical tradition. He nevertheless approached these discontinuous moments with a scrupulous "historical familiarity" and with an attentiveness to the precise function of the images studied.[21] Warburg's unusually broad conception of interdisciplinary scholarship, and his insistence on sharp, close-up analysis of images in all their visual and contextual specificity, make his scholarly legacy an important contributing strain to the development of visual cultural studies.

Most contemporary visual culture anthologies and readers acknowledge the importance of the work of Walter Benjamin (1892–1940) in the formation of the field's basic premises, and in this role his essay "The Work of Art in the Age of Mechanical Reproduction" of 1936 is typically singled out. Benjamin's approach in this essay consists in analyzing the essential nature and functional impact of the modern era's new art forms. His particular focus is on those forms made possible by advances in modern technology and mechanical reproductive techniques. Benjamin's main interest is in the new pictorial and visual modes created by the sequential development of lithography, photography, and film. In studying these new forms, Benjamin was sensitive to their revolutionary effect on traditional art-historical concepts such as originality and authenticity, and how they vastly altered the circumstances of reception by being able to connect with "contemporary mass movements" and the collective spaces of exhibition and display.[22] On the basis of his close study of these new forms, Benjamin was able to offer radical new formulations concerning the nature of art and of visual experience in such claims as "during long periods of history, the mode of human sense perception changes with humanity's entire mode of existence" and that there are in the history of art "critical epochs in which a certain art

form aspires to effects which could be fully obtained only with a changed technical standard, that is to say, in a new art form."[23] Whenever the principal concerns in visual culture are on the impact of new visual technologies and mass media forms in tandem with a very close reading of individual objects and the circumstances in which they might be viewed, it is evident that Benjamin's work continues to be an influential operating model for the field.

In contributions from the late twentieth century, it is the work of Michael Baxandall and Svetlana Alpers that has offered some of the most valuable methodological models for the study of visual culture. Baxandall's *Painting and Experience in Fifteenth-Century Italy* of 1972 is grounded in notions of socio-visual variability: "some of the mental equipment a man orders his visual experience with is variable, and much of this variable equipment is culturally relative in the sense of being determined by the society which has influenced his experience."[24] He identifies a sequence in which "social facts" encourage the development of "visual skills and habits," which then will be taken into account by artists in the formation of their style.[25] The result is what Baxandall calls the "period eye," in which "vernacular visual skills" mold the artistic proclivities and visual preferences of a particular time and place.[26] In fifteenth-century Italy, for example, Baxandall found that the new prominence of a mercantile geometry was an operative force in the creative emphasis on the edgy clarity of complex objective forms typically cast among elaborate measurable perspectival spaces. Italian art of this period in Baxandall's schema thus developed in tandem with the visual habits and preferences of the culture, concluding that for the artist, "his public's visual capacity must be his medium."[27]

A decade later in *The Art of Describing* (1983), Svetlana Alpers made explicit reference to the term *visual culture* and credited her use of the term to Michael Baxandall.[28] In this study, Alpers examined Dutch visual culture rather than undertaking a history of Dutch art, because in the Netherlands "the visual culture was central to the life of society" and "visual experience [was] a central mode of self-consciousness."[29] The northern European penchant for the visually descriptive she saw as distinct from the more narrative-based arts of Italy.[30] Alpers's emphasis was thus placed more on the circumstances of art and on "gain[ing] access to images through a consideration of their place, role, and presence in a broader culture."[31] The pertinence of this conceptual model to an understanding of image-making and image use in the seventeenth-century Netherlands was also borne out in the discussion of the first two visual examples with which our chapter began. Alpers distinguished her understanding of visual culture from Baxandall's, arguing that each was working in very different time periods, and so the objects studied, the extensiveness claimed for the approach's application, and the results obtained were quite different. In fact it is this very claim for distinctiveness that argues for the historical validity of the visual culture model. Baxandall and Alpers deployed methods of visual culture in adaptations that varied according to the particularities of place and time studied. These adaptations were calibrated by the demands of historical specificity. The work of both scholars, although different, contradicts the position held by some academics that a visual culture approach is valid only for the modern and contemporary eras.

ORGANIZATION AND STRUCTURE

A History of Visual Culture traces the roots of much of the visually sensitive phenomena of the modern and contemporary periods to developments in the late eighteenth and the nineteenth centuries,

a strategy that counters the still widely held misconception that visual media acquired a position of cultural preeminence only as recently as the postmodern era. In this way, *A History of Visual Culture* investigates previously overlooked but intellectually critical revisions that have helped to shape the visual field for modern and postmodern societies.

In its pluralistic approach, *A History of Visual Culture* differs from the average visual culture readers currently available. Many of these readers presume a linear development that starts with a core group of theorists and proceeds through a familiar cohort of texts and objects. This arrangement typically traces an ur-trajectory in which canonical philosophers of the nineteenth and twentieth centuries are the source for a supposedly unique, visually rich, vision-monopolized postmodern era of film, television, and video. A number of presumptions behind this practice are highly problematic and include a tendency to position visual material along lines established by a preexisting intellectual, but primarily verbal culture, and a failure to distinguish between visually imperative and visually inarticulate phenomena. The concept of a "visual turn," which describes a notable preference for visuality, was introduced by W.J.T. Mitchell, but he did not intend it to designate a unique or singular historical development, but rather a possibility available potentially at any number of historical and contemporary moments, and this volume adheres to Mitchell's distinction here.[32]

The emphasis of *A History of Visual Culture* is for these reasons not limited to an explication of postmodern theory or the high literary culture of the nineteenth and twentieth centuries. Although the collection follows a similar chronological range from the late eighteenth century to the present, it parses a wider set of visual phenomena and is historically specific in its approach. The collection begins with the Enlightenment, when a confluence of factors gave new substance and urgency to claims for the value and power of visual thinking. New or more technically efficient forms of visual culture were created and refined, so that the impulse to ground knowledge more systematically in observation and display might be more easily satisfied. In these essays, the visual culture model is conceived as an investigative method in which visual thinking dominates, and for which there are multiple historical and geographical applications.

The collection's strengths are a greater historical sensitivity, a critical approach toward models and degrees of visuality, and an expanded field of material sources as objects of investigation. Most visual cultural texts limit their engagement with historical context to a few nineteenth-century figures. In so doing they fail to convey to students that a retrospective vantage is both a necessary and a critical position, one that enables rather than impedes an understanding of the dynamic forces underlying the formation of cultural values and artifacts. Our volume takes seriously recent revisionist calls for a greater historical awareness and deeper historiographical interest in approaching the study of visual culture.[33] Our text is also more sensitive to visual thinking in general, and it distinguishes between visibilities that are crucial to intellectual and cultural concerns from those that are passive, illustrative, or merely nonarticulating phenomena. This methodological approach is more investigative, and it extends and refines the models by which visual culture has been studied or assessed. Rather than continuing to survey a relatively circumscribed field as is the case with most other texts, our approach widens the context of investigation and opens up the field of visual culture to multiple future applications and studies.

The collection's structure is based on seven thematic sections that define critical areas of knowledge in which a significant degree of visuality served as major articulating and clarifying processes

for the modern period. Each section is prefaced with a brief introduction and followed by four "case study" chapters. These thematic sections are: Revolt and Revolution; Science and Empiricism; Gaze and Spectacle; Acquisition, Display, and Desire; Conquest, Colonialism, and Globalization; Image and Reality; and Media and Visual Technologies. The rationale behind the collection's structure is that its component parts offer a serious investigation into the roots of visual culture. Topics and themes address the visual basis of intellectual activity, the technologies of visuality, the politics of invisibility, and the problematic relation of the visual to the real. The sections identify historical moments when visuality and ways of seeing began to energize political phenomena, scientific theory, social interaction, and technological invention in the modern period. Each section presents scopic events and experiences significant for the ways in which it illuminates aspects of modernity and engages in the major discourses of modernism. Individual chapters introduce critical exempla that demonstrate visual agency past and present through specific mediums, situations, and contexts.

The chronological framework for the entire collection is 1780 to 2008, or in period terms, from the Enlightenment and Age of Revolutions to the contemporary era. The sections are paced at chronological increments that overlap as they advance forward. Most sections begin in the late eighteenth century or the first half of the nineteenth century, emphasizing the historical impetus behind the collection. Each section has an internal chronology, beginning with substantive contributions from the beginning of the span covered and ending with more contemporary instances of parallel or related phenomena. In some cases, later chapters develop from innovations established in earlier sections, so there is some degree of sequence or progress, but the majority of chapters deal with continuities, or with charting an expanding range of visual cultural experimentation.

Each particular case study was chosen based on considerations of the following criteria: material for each case demonstrates (1) strong, visually innovative features; (2) a capacity for articulating intellectual concepts in visual terms; (3) a significant degree of historical impact and effect; and (4) a capacity for illuminating broader cultural developments. The section introductions provide an important guide for the reader by establishing the significant themes of the section and demonstrating their centrality to understanding visual culture in the modern and contemporary periods. The introductions provide the necessary history for the section's topics and perform the important task of contextualizing the contributors' essays. The chronological and thematic trajectories for each section are also explicitly addressed in each introductory chapter. Contributions to this collection acknowledge that a significant confluence of orientation and event are critical to any serious historical understanding of visual culture. The logic behind the seven critical categories—their historical significance to the formation and the primacy of visual thinking to these designations—demonstrates the effectiveness of a wide chronological and geographical range for the study of visual culture, just as each chapter maps out fluctuating allegiances to different visual forms and media, from popular prints and posters to fine art and architecture, photography, film, television, video, and the Internet.

The editors would like to thank all the people who helped with this very large project, either by joining us as contributors or by suggesting other potential participants. In particular, Susan Bakewell would like to thank the University of Texas-Arlington, for a research leave, and Southern Methodist University for the use of its library. Jane Kromm would like to thank the Purchase College Faculty Support Fund and the Dr. Noel S. and Richard B. Frackman Fund for assistance with research expenses. We both also would like to acknowledge the expert technical assistance provided by Jennifer E. Kniesch

in collating images and permissions. Kristen Lindberg also made the final manuscript preparation process go as smoothly as possible.

NOTES

1. This anonymous work is in the Lakenhal Museum, Leiden.

2. H. A. van Oerle, *Het Caecilia-Gasthuis een onder zoek naar de bouwgeschiedenis van het Caecilia-Gasthuis . . . ,* unpublished manuscript, Museum Boorhaave, Leiden. Parts of the St. Caecilia complex have been incorporated into the Boorhaave museum building.

3. Royal Library, Brussels. See Jane Kromm, "Domestic Spatial Economies and Dutch Charitable Institutions," in *Domestic and Institutional Interiors in Early Modern Europe,* ed. Sandra Cavallo and Silvia Evangelisti (Ashgate, forthcoming).

4. Adriaen van Nieulandt, *The Annual Procession of Lepers on "Banqueting" Monday 1633,* Amsterdam Historical Museum. See Jane Kromm, "Site and Vantage: Sculptural and Spatial Experience in Early Modern Dutch Asylums," in *Madness, Architecture and the Built Environment: Psychiatric Spaces in Historical Context,* ed. Leslie Topp, James E. Moran, and Jonathan Andrews (Routledge, 2007), 19–39.

5. Svetlana Alpers, *The Art of Describing* (University of Chicago, 1983). The impact of this work on the field of visual culture will be discussed below.

6. On the history of *toiles de Jouy,* see Henri Clouzot, *Histoire de la manufacture de Jouy et de la toile impreeé en France* (van Oest, 1928); *La toile de Jouy, dessins et cartons de Jean-Baptiste Huet 1745–1811* (Musée de l'impression sur étoffes, 1970); Melanie Riffel and Sophie Rouart, *Toile de Jouy: Printed Fabrics in the Classic French Style,* trans. Barbara Mellor (Thames and Hudson, 2003).

7. Margaret Dikovitskaya, *Visual Culture: The Study of the Visual after the Cultural Turn* (MIT Press, 2005), 1.

8. W.J.T. Mitchell, "Showing Seeing: A Critique of Visual Culture," in *The Visual Culture Reader,* ed. Nicholas Mirzoeff (Routledge, 2002), 87.

9. For the postmodern emphasis, see Mirzoeff, "The Subject of Visual Culture," in Mirzoeff, *Visual Culture Reader,* 3–23. For the broader historical application, see, for example, Vanessa R. Schwartz and Jeannene M. Przyblyski, "Visual Culture's History: Twenty-First Century Interdisciplinarity and Its Nineteenth-Century Objects," in *The Nineteenth-Century Visual Culture Reader,* ed. Vanessa R. Schwartz and Jeannene M. Przyblyski (Routledge, 2004), 3–14.

10. Thomas Gunning, interview with Margaret Dikovitskaya, in *Visual Culture,* 173–180; and Mitchell in Mirzoeff, *Visual Culture Reader,* 90.

11. Keith Moxey, cited in Dikovitskaya, *Visual Culture,* 14.

12. Marita Sturken and Lisa Cartwright, *Practices of Looking: An Introduction to Visual Culture* (Oxford University Press, 2001), 6; Mitchell in Mirzoeff, *Visual Culture Reader,* 91.

13. Dikovskaya, *Visual Culture,* 2–6; Schwartz and Pryzblyski, *Nineteenth-Century Visual Culture Reader,* 4–5; John Walker and Sarah Chaplin, *Visual Culture: An Introduction* (Manchester University Press, 1997), 35–37.

14. Dikovskaya, *Visual Culture,* 6.

15. W.J.T. Mitchell, "What is Visual Culture," in *Meaning in the Visual Arts: Views from the Outside,* ed. Irving Lavin (Princeton University Press, 1995), 214.

16. Dikovitskaya, *Visual Culture,* 17.

17. Dikovskaya, *Visual Culture,* 18.

18. Dikovskaya, *Visual Culture,* 45.

19. Donald Preziosi, ed., *The Art of Art History: A Critical Anthology* (Oxford University Press, 1998), 167.

20. Preziosi, *The Art of Art History,* 167.

21. Michael Podro, *The Critical Historians of Art* (Yale University Press, 1982), 158.

22. Walter Benjamin, "The Work of Art in the Age of Mechanical Reproduction," trans. Harry Zohn, in *Illuminations,* ed. Hannah Arendt (Schocken, 1968) 221.

23. Benjamin, "The Work of Art in the Age of Mechanical Reproduction," 222, 237.

24. Baxandall, *Painting and Experience in Fifteenth-Century Italy: A Primer in the Social History of Pictorial Style* (Oxford: Oxford University Press, 1972), 40.

25. Baxandall, *Painting and Experience,* i.

26. Baxandall, *Painting and Experience,* i.

27. Baxandall, *Painting and Experience,* 40.

28. Alpers, *The Art of Describing,* xxv.

29. Alpers, *The Art of Describing,* xxv.

30. Alpers, *The Art of Describing,* xx. This premise was the cause of much subsequent debate. See, for example, the essays and responses in *Simiolus* 16, nos. 2/3 (1986).

31. Alpers, *The Art of Describing,* xxiv.

32. Mitchell, in Mirzoeff, *Visual Culture Reader,* 92.

33. This has been argued by James Herbert, in an interview with Margaret Dikovitskaya in *Visual Culture,* 181–92; and David N. Rodowick, interview with Dikovskaya in *Visual Culture,* 258–67; and comments made by James Elkins in the Visual Culture panel held in 2003 at the College Art Association annual meeting.

PART ONE

REVOLT AND REVOLUTION

INTRODUCTION

Jane Kromm

Part one studies the role of visual elements in the coordination of rebellious causes or groups, and in the expression of political allegiances. Considered in the context of controversy and upheaval, visual markers were not at this time mere adjuncts to a more mainstream political process but were instead the critical formative means by which citizens were informed, their political participation registered, and their opinion molded. For many scholars, the visual practices introduced during the French Revolution of 1789 mark a significant stage in the development of visual cultures in the modern era.[1] Contributors to the section trace this development from the revolutionary decade of the 1790s in France through nineteenth-century conflicts across Europe, in which visual persuasion was a major strategic consideration that in turn required an expansion of visible formats for political communication and for emblems of allegiance. Some visual interventions would prove to be too incendiary, and certain practices, such as caricaturing leaders or political parties or certain citizen types, achieved such a pitch that they led to serious repercussions, from censorship to incarceration and even execution. A significant episode in the development of visual cultures of revolt and revolution was the rise of the political poster, a popular form associated especially with protest groups of all sorts and socialist movements in particular. Designed for instantaneous intelligibility and with an energetic persuasiveness, these bold public notices could be distributed widely and posted at street level, achieving a maximum effect with a minimum of means. This sociopolitical visual purposiveness inspired many other avant-garde art movements in the first half of the twentieth century, whose members went on to pursue the role of generating visual cultures of protest and challenge for the modern period.

THE POLITICS OF VISIBILITY IN REVOLUTIONARY FRANCE (1789–1800)

Soon after the 1789 Revolution's inception, revolutionary leaders and organizations pursued new and eminently visible signs of affiliation for all levels of French society through the introduction of badges, furnishings, and fashions. These were intended not only to make allegiances a public rather than a private matter, but also to dissolve traditional visual ties to the ancien régime and to reduce the public memory of these institutions. Traditional names or patronymic plates with their religious references and phrases were replaced by novel variations covered with new political symbols and mottoes. Conscious of the need to instruct future citizens properly, even children's furniture was conceived in the form of revolutionary emblems like the tricolor and the fasces. The artist and revolutionary Jacques-Louis David was charged with redesigning uniforms for government officials so that traditional robes of office might be quickly retired from use.[2] There were heated controversies over the design of new symbols for the nation, and some deliberation over what new wallpapers might

be appropriate for the Revolution's official spaces and meeting rooms. Elaborate designs for the new revolutionary festivals were scrutinized to insure that suitable degrees of loyalty and rank would be projected by them. Even the familiar public spectacle of execution was reconstituted by the guillotine's visual effects, and these extended from the event itself to portrayals of the heads of those recently decapitated. In fact, the practices associated with the visible carriers of revolutionary ideology mutated with ominous ease from primary and independent visual registers of enthusiasm and support into dangerous, criminal markers of treason and disloyalty.

Helen Weston's chapter, "The Politics of Visibility in Revolutionary France: Projecting on the Streets," explores these issues of political visibility by focusing on one form of visual spectacle—the magic lantern. This apparatus for the public display of images evolved during the revolutionary decade (1789–1800) from an art of privilege and limited access to an art of the street, affiliated with public patriotic causes. Famous practitioners of the medium such as Paul Philidor and Etienne-Gaspard Robertson became veritable impresarios and fantastic manipulators of this form. They eventually had to distance themselves from the increasingly dangerous topicality of presentations that were grounded in references to notorious political figures. Robertson in particular moved on to more mysterious effects, favoring ghostly, phantasmagoric light demonstrations akin to those found in contemporary Gothic novels. The political relevance and political effectiveness of the magic lantern's earlier performances were soon displaced by shows in which the spectatorial experience became an end in itself rather than a means of public patriotic communication for audiences that were increasingly dominated by women and children.

NINETEENTH-CENTURY REVOLUTIONS AND STRATEGIES OF VISUAL PERSUASION (1800–1889)

Subsequent revolutionary efforts across Europe in the nineteenth century, including those in England, France, Germany, Austria, and Italy, continued to develop visual materials as a primary means toward successful persuasion and recruitment. In this sense, they extended the French revolutionary tactic, but in a less extreme form that was both more open-ended and more protracted. New formats appeared on a regular basis that offered commentary on unsettled events accented by a more pointed use of visual elements. The introduction and proliferation of illustrated newspapers available at reliable intervals offered a sequence of interpretative templates based on the visual persuasiveness of narrated events and caricatures of their participants. Some newspapers relied on pictorial caricature to establish their political orientation and message. These depictions might take the more traditional form of exaggerated views of principal leaders, but they also extended to distorted portrayals of all partisan members of the political process. Even stereotypes of enemies with their depraved proclivities might be uncomfortably highlighted. Images relying more on narrative tended to focalize around the frightening specters of modern revolutions, the crowds, barricades, incendiaries, and traitors. By focusing on appeals to the spectator as a continuous process of persuasion rather than its endpoint, nineteenth-century revolutionary organizations explored the ways in which visual culture could be used to maintain the unsettled and unstable atmosphere deemed necessary for political maneuvers premised on upheaval.

Richard Taws's chapter, "Nineteenth-Century Revolutions and Strategies of Visual Persuasion," examines the different kinds of visual formats invoked during the subsequent revolutions in

nineteenth-century France (1830, 1848, 1871) and the ways in which they were influenced by conflicting kinds of pressures. These ranged from the need to recall the original Revolution of 1789 and so to be retrospective and historical, to the necessity of accommodating the new instruments and technologies of image-making, from stereoscopes to lithography and photography. Producers of these new formats had to decide where to focus: This might vary from personality and figurative symbol (Louis-Philippe as a pear or the various mutations of Marianne) to processes and events (revolutionary episodes transformed into "news" images for the pages of papers like the *Illustrated London News* and *L'Illustration*). Photographs of events taken during the Commune showing ruined Paris streets, barricades, casualties, or triumphant partisans, were fair game for multiple uses. They could be approached by viewers as reliable news, as political affirmations, or as incriminating evidence, thereby accentuating an enhanced variability that exacerbated rather than mollified the unsettled and unstable elements in revolution and its visual strategies.

SOCIALIST MOVEMENTS AND THE DEVELOPMENT
OF THE POLITICAL POSTER (1870–1930)

As a way of redistributing power in society and expanding the base of political participation, the socialist movements and revolutions of the late nineteenth and early twentieth centuries in Spain, Germany, Austria, Russia, and the United States relied heavily on the judicious use of comparatively ephemeral works on paper. Large, expendable, bold and colorful, posters extended the public access of political information beyond the constraints and programmatic limitations of the familiar forms of contemporary news media. These political posters occupied a central position especially in campaigns of social redirection and reconstitution that were waged with more egalitarian than hierarchical preoccupations. Such movements conceived the political poster as first defining and then transforming a public space of protest. With graphic effects that might be insinuating, gripping, or compellingly attractive, posters relied upon typographical experiments and clever word–image relations so as to galvanize public attention and to enable comprehension with ease and immediacy. Crisp and exhortatory, these novel graphic designs hastened the perception that the traditional cultural divide between high and low art forms was clearly a visual shortcoming that endangered social stability. Political climates often made relocation a common occurrence, and while some artists were able to remain in their countries of origin, others thought it advisable to leave, and many immigrated to the United States, congregating in the major urban centers of New York and Chicago. Artists who chose to associate with these protest efforts adjusted their visual interests to accommodate accessibility and inclusiveness, insisting that art as well as government benefited from a wider social involvement and an emphatic public presence.

Elizabeth Guffey's chapter, "Socialist Movements and the Development of the Political Poster," traces the rise of the crowd motif and its subsequent treatment in political posters and propaganda. Socialist posters in particular develop the image of the crowd as a persuasive and compelling form and exploit the liveliness of commercial posters then in circulation that advertised, among other things, the socially conscious novels of Honoré de Balzac and Emile Zola. While left-leaning theorists saw the positive value of the crowd image as emblematic of positive collective progress, conservatives tended to see the motif as an index for manipulation and folly. In some instances, designers would substitute

a single isolated, virile, and heroic male figure in lieu of the crowd with its increasingly problematic connotations. By the time Adolf Hitler and Benito Mussolini revisited the crowd phenomenon and iconography, they saw it as the strategy par excellence for exercising mass manipulation and control.

AVANT-GARDES AND THE CULTURE OF PROTEST (1900–1950)

An increasingly coherent visual culture of protest arose from the visual elements harnessed to the revolutions of the nineteenth century. This culture flourished on several levels, from the mundane world of the political cartoon, to the ephemeral realm of posters and processions, marches and cabaret performances. Even the more vaunted productions of avant-garde artists might be designed and regarded as icons of protest. Candidates for this kind of iconic status include images related to the trauma of war at home or on the front lines, as well as avant-garde works and performances designed to indict the follies of the modern world. Individual works might exploit any number of strategies readily assimilable to forms or concepts of protest. Photomontage and collage methods, for example, epitomize protest by recycling imagery as acts of critique and accusation, and by their disjunctive applications of this appropriated material. Museum-sized works, whose dimensions signaled their status as significant artists' statements, were devoted to giving accounts of the atrocities of conflict and were gauged to have a climactic protest effect when exhibited at international venues. In Germany, Belgium, the Netherlands, Switzerland, Spain, Russia, England, and the United States, artists created significant works that qualified for iconic status or that earned it through their subsequent treatment, as debates raged over the location and display of, or access to, these incendiary exemplars of visual culture, and these debates were at their most acute in major cultural centers on opposite sides of the political spectrum, from Berlin to New York City.

Jelena Stojanović's chapter, "Avant-Garde Art and the Culture of Protest: The Use-Value of Iconoclasm," examines the 1950s Paris art movement known as Lettrism as a contrast to earlier avant-garde movements, which embraced a radical visibility. Cold War–era movements like Lettrism tended to favor avoiding, even destroying images, and the group's adherents, especially Jean-Isidore Isou, Gil Wolman, and Guy Debord, gravitated toward the formats of concrete poetry, cinematic experimentation, and the kinds of outrageous public events later associated with happenings and some forms of performance art. Lettrism's visual strategies were extreme, admitting letters, but disallowing recognizable forms or figures, and avoiding narrative and cinematic coherence. Their work is difficult to approach, largely incomprehensible, and frequently stretches to the limits the requirement that the social usefulness of art in visual culture requires some degree of recognition and accessibility.

NOTES

1. Lynn Hunt, *Politics, Culture, and Class in the French Revolution* (University of California Press, 1984); Keith Michael Baker, *Inventing the French Revolution: Essays on French Political Culture in the Eighteenth Century* (Cambridge University Press, 1990); Richard Wrigley, *The Politics of Appearances: Representations of Dress in Revolutionary France* (Oxford University Press, 2002).
2. Warren E. Roberts, *Jacques-Louis David, Revolutionary Artist: Art, Politics and the French Revolution* (University of North Carolina Press, 1989).

THE POLITICS OF VISIBILITY IN REVOLUTIONARY FRANCE: PROJECTING ON THE STREETS

Helen Weston

During the course of the revolutionary decade in France (1789–1799) it became mandatory to make political allegiances visible and audible. All possible carriers were mobilized to support the different regimes that developed from Constituent Assembly and Constitutional Monarchy to National Convention and First Republic, to powerful committees under the Terror, and councils under the Directory and Consulate. These included the wearing of particular costumes and certain colors, the designing of furniture, letter headings, public spaces to be used for festivals and funerals, songs to be sung on certain occasions, ways of speaking and writing, eating, drinking, and smoking. Shoe buckles and hats, sword hilts and belts, inkwells and fans all carried the revolutionary message and all had to be adapted according to the dictates of the regimes that were in power at any one moment.

In 1793 the Salon (the annual exhibit of the Académie des Beaux-Arts in Paris) opened on August 10 to commemorate the storming of the Tuileries Palace by the people on August 10 of the previous year, when King Louis XVI was finally toppled from power. This had effectively marked the end of the monarchy, and France's first Republic had been declared in September 1792. The Louvre, known at the time as the Central Museum, also opened its doors to the public on August 10, 1793,

as part of the festivities and celebrations throughout Paris, which enabled the people to claim the streets and squares, and certain public spaces, such as the Louvre, from which they had formerly felt excluded.[1] On the same day the official festival of Unity/Fraternity was orchestrated by Jacques-Louis David, with the aim of taking art onto the streets in the form of the erection of temporary sculptures, distribution of propaganda prints, choreography of large-scale festivals, and designing of official costumes. Two days earlier David, in an impassioned and sentimental speech, had called for the final suppression of all academies, those "vile jealousies" of academicians, with their cruel teaching methods and sinister and pernicious hierarchical structures that so offended notions of equality. The National Convention decreed their abolition immediately, putting an end to a tradition that had existed for 150 years. This was to be the dawn of a new era of artistic freedom.

In some ways this point in the revolutionary process represented a culmination of the recent effort by the state to break down barriers and create interactions between polite and popular, private and public, official and unofficial art practices. A relationship of "mutual resonance and exchange…between quite different types of cultural artefacts," as Jonathan Crary has put it,[2] already existed. Different

art forms functioned quite independently, if simultaneously, in different arenas, but there was now more surveillance, more awareness of the potential of all art forms to carry the same revolutionary messages without valorizing academically trained artwork above that of the print-maker or signboard painter, for example.

This chapter takes as its focus a form of art projection that has received very little attention from art historians so far, that is the very visible and audible form of slide projection with magic lanterns that had once operated in the wealthier homes, or at court, but that now appeared on the streets of major cities of France during the revolutionary decade. There is clear evidence that operators of the magic lantern shared an interest in targeting political figures and religious beliefs. In addition, the magic lantern was used metaphorically in the production of prints and indeed in common parlance for projecting ideas of enlightenment and political awareness during this same decade of revolutionary fervor.

In the 1793 free-for-all Salon, a large allegorical work, *Truth Leading the Republic and Prosperity* by Nicolas Courteille, was exhibited (fig. 1.1). The central figure of the naked Truth unveiling herself, with a radiating, disembodied,

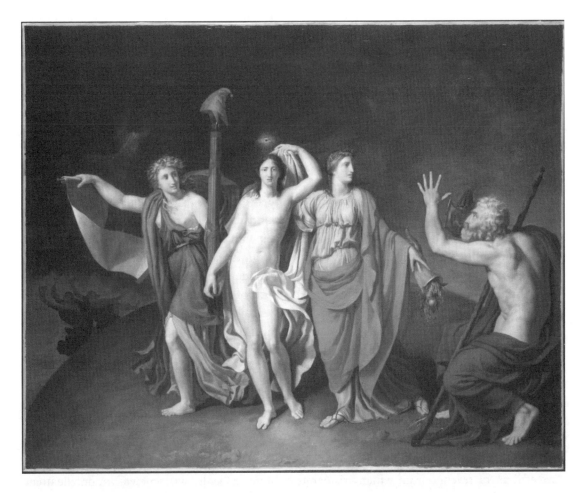

Fig. 1.1 Nicolas de Courteille, *Truth Bringing the Republic Abundance Forward,* 1790, oil on canvas.

all-seeing eye of Vigilance above her head, is flanked on one side by Abundance, and on the other by the Republic, who holds a bundle of fasces (symbol of law and fraternity) topped by the red bonnet (liberty) and a scroll with a proclamation to rid the world of royalism and fanaticism. The three main figures refer to current and recent events and to the official line of aspiration for the French people—to take liberty, equality, and fraternity to the rest of the world.[3] The most curious figure is the ancient philosopher, Diogenes, seated to the right. With his right hand he holds a lantern with which we are told he constantly sought a man of truth. With his left outstretched arm and hand he registers amazement that he has at last glimpsed truth and can blow out the candle.[4] Furthermore, he appears to see truth through the glass of his smoking lantern, which he raises to eye level. The allegorical figures, represented as almost floating on the rounded globe, are unaware of his presence, and indeed there is a sense in which he himself seems to have conjured them into being as a result of operating his lantern.

The presence of Diogenes in this scene should not be taken for granted. In the latter part of the eighteenth century the more usual configuration for this sort of allegory was Reason or Philosophy or Old Father Time unveiling truth. In the early years of the revolution Truth sometimes unveiled time. During the Terror (Autumn 1793–Summer 1794), the notion of the revealing of truth is to be found more readily in the speeches of, for example, Maximilien Robespierre, rather than in visual imagery, and in these speeches it was a case of truth revealing conspiracies and enemy plots against *la patrie*. The conjunction of the lighted candle of Diogenes, the "lanterne" or street light of revenge from which aristocrats would be hanged in the streets of Paris, the

magic lantern of enlightenment and phantasmagoria (gathering of ghosts) for propaganda, became almost commonplace in visual culture of the early years of the French Revolution. Diogenes was ubiquitous. He was represented as a hero of the people, embodying various civic virtues, often associated with "the friend of the people," Jean-Paul Marat,[5] living in very austere circumstances (in a barrel in Diogenes's case), and during the late 1790s in the phantasmagoria performed by Etienne-Gaspard Robertson, an apprentice dressed as Diogenes would walk around among the spectators flashing his lantern at people in search of a man of truth.[6] These were very popular shows and aroused interest among artists as well as among the curious and the gullible.

Philosophes, mountebanks, scientists, charlatans, Savoyards, and home amateurs all practiced the art of the lantern. By the second half of the eighteenth century, lantern shows had shifted from being a predominantly elitist form of education and entertainment to a pastime of the people, as itinerant showmen and their families toured far and wide to show their magical images and tell well-known stories. Nevertheless, the lantern did not sever its ties with its more serious uses in science and enlightenment, and it was still perceived as a modern, and for some, a highly desirable form of instruction in well-to-do households. We know that magic lanterns were used at court[7] by highly paid showmen, to instruct the dauphin—son of Louis XVI and Marie-Antoinette—for example. Louis Carrogis, famous for his writings of proverbs and *comédies* and for his exquisite watercolor portraits, and better known as Carmontelle, may also have used such devices in his role as tutor to the children of the Duc d'Orléans. According to Mme de Genlis, who knew Carmontelle over a period of fifteen years, both at Villers-Cotterets

and in Paris, he also had plans to turn his famous profile portraits and panoramas into transparencies for some sort of lantern show.[8]

On the other hand the lantern, and the phantasmagoria perhaps even more so, had reinforced prejudices of those who associated these new optical devices and arts of light and shadow and illusion with "false appearances," masquerade, deception, and who accused showmen of catering to the gapers and gawpers of society, for appealing to a lower, gullible order of the population. The new, exciting world of image projection and the mesmerizing apparitions of the phantasmagoria were seductive but deceptive and perturbed the logocentric critics, reinforcing prejudices against the image.[9] In revolutionary France, at a time of high rates of illiteracy, however, the visual image could keep a wider population informed and illiteracy could be compensated for through use of forceful visual material.

Evidence of the usefulness and validity of the magic lantern as an educational tool can be found in some unpublished correspondence between Brissot de Warville and Granville Sharp, both of them abolitionists, in which Brissot discussed an enclosed engraving of the *Brooks* slave ship, together with two related watercolors, produced for the London Society for the Abolition of Slavery. He explained that ministers who would have no time to read long pamphlets about the hideous conditions in which slaves were held on board could nevertheless be enlightened by a dramatic and powerful image, a sort of magic lantern slide that would make a strong impact on the mind.[10]

There are many representations of magic lantern shows as frontispieces for almanacs that flourished at this time and in propaganda prints from both sides of the English Channel. At the end of 1790 a small pamphlet was published in Berne, Switzerland, called *La Lanterne*

magique ou Fléaux des aristocrats: Etrennes d'un patriote (The Magic Lantern or Scourge of the Aristocrats: Almanac of a Patriot). It was dedicated to the liberated French and described itself as depicting all the most remarkable events of the previous two years, from the storming of the Bastille to the declaration of France as a constitutional monarchy. The frontispiece represents an impoverished *sans-culotte* lanternist, operating a magic lantern to enlighten the people (fig. 1.2). Onto a cloud of smoke

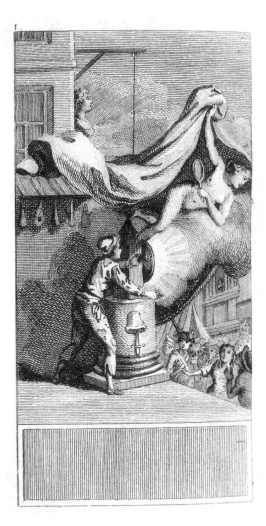

Fig. 1.2 Anonymous, Frontispiece illustration of almanac, *La lanterne magique ou Fléaux des aristocrats*, 1790.

he projects an image of the allegorical figure of the naked Truth. She holds the usual attribute of a mirror in one hand and with the other she unveils a magic lantern and its extraordinary beam of light projected onto the crowd, while the podium on which it stands has a liberty bonnet incised into it.[11]

During the Terror relatively few examples of magic lantern imagery appear to have been produced, and those that exist mostly target the British. *La Lanterne Magique Républicaine Montrée à Sire George Dandin et à Monsieur Pitt son féald Ministre* by Dupuis, dating from 1794, is a case in point (fig. 1.3). A republican *sans-culotte* in his tattered clothes and wooden shoes operates a lantern in a dark, bare room, in response to which King George and Pitt the Younger are terrified into realizing what is going on in France and what might indeed happen in Britain. The sight of the guillotine presented as the instrument of justice for traitors, the manufacture of weapons, the conquest by the French over the Spanish and Austrian forces, and the slogan "Virtue Is the Order of the Day" are sufficient to cause George's crown to be dislodged. Neither of the *sans-culottes* who operate the lantern and sing to the sound of the hurdy-gurdy is ridiculed. As with the almanac frontispiece, they are the voice of wisdom and of common sense, the voice of the people. This particular print was an officially commissioned anti-British propaganda piece. Indeed it was the prize-winning entry in a competition held in the Year II of the revolutionary calendar (1793–1794) and was ordered in a large print run so as to be distributed widely. It cost 25 sous, a relatively high price, in order to indicate the value attached to the print's educational and propaganda purpose. To attack the British in this way was very much in line with the official caricatures produced by Jacques-Louis David

during these months of the Terror, such as *The Army of Jugheads,* which likewise targeted both King George and William Pitt. Indeed, it was clearly dangerous to produce anything that might be construed as counterrevolutionary, as the following incident illustrates.

On March 22, 1793, a German journalist who had seen a performance of a phantasmagoria in Paris, described the extraordinary conjuring up, through the use of moveable magic lanterns on wheels and back-projection, of the ghosts of Marat, Robespierre, and Danton in the guise of the devil, with claws, horns, and a long tail.[12] At this point in time these men were still in power—Marat was not assassinated until July 1793, Robespierre not guillotined until July 1794. The phantasmagorist was taking a severe risk in projecting this negative and provocative representation of the men who were in control of the committees and corridors of power. The man in question who advertised his "apparitions" and "invocations" was Paul Philidor, also known as Paul de Philipstal.[13] He performed in Paris from December 1792 to April 1793, and his arena was the Hôtel de Chartres, 31 rue de Richelieu.

The cost of Philidor's show was three livres, an expensive outing, which would only be within reach for a relatively wealthy clientele. At this price Philidor would not expect a *sans-culotte* audience. On the other hand, the French monarchy had fallen in August 1792, and the king had been guillotined two months before the newspaper article in January 1793. Despite the official status and known political affiliations of those whom Philidor satirized, a wealthy royalist audience would be most unlikely. It would appear, therefore, that the audience that Philidor most probably expected was the reasonably well-to-do, moderate, Girondin sympathizers whose representatives

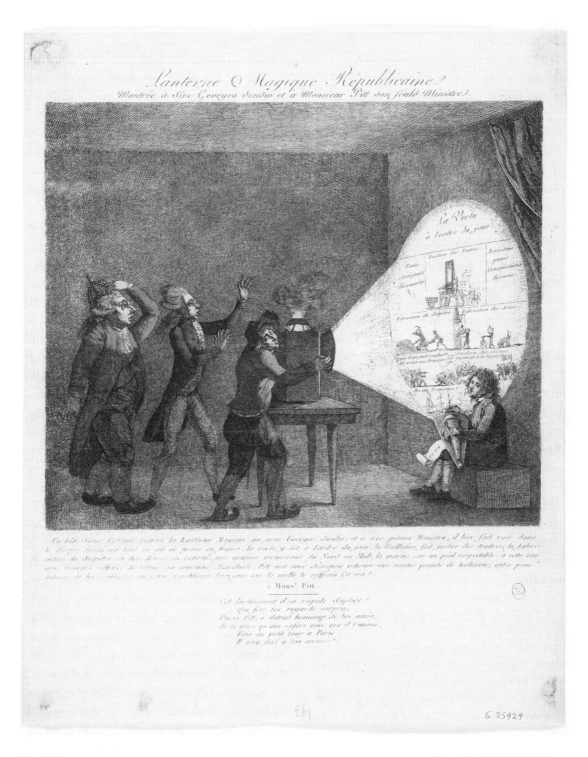

Fig. 1.3 Dupuis, *Republican Magic Lantern Shown to His Majesty George the Ninny and to Master Pitt His Faithful Minister*, 1794, colored engraving and etching.

had not yet been ousted by the Jacobins. In February 1793 he brought forth the phantom of Mirabeau, a prominent politician in 1789 and one of the principal heroes at the Oath of the Tennis Court at Versailles. Already by June 1792, however, Mirabeau was not only dead but had been disgraced as having worked closely with the king. Among the living whom Philidor also summoned in order to demonize them was the Abbé Jean-Siffrein Maury, a former ultra-royalist deputy in the National Assembly, well-known and already much satirized in prints for his proslavery stance in the early 1790s. Among the radical Jacobins, Philidor isolated the most extreme for ridicule. At the end of the show he would conjure up the recognizable features of Marat and Robespierre, as we have heard, and add fiery red devilish details—claws, tails, and horns.

It should not surprise us that Philidor disappeared from France shortly after the March 1793 newspaper article appeared, quite probably fleeing for his life. Philidor always claimed that the shows were suitable for men and women alike, that no one would come to physical harm. He also claimed that he was no charlatan, no quackish prestidigitator, no mere deluding conjuror, but was concerned to explain the art of optics, light, and image projection, and to debunk popular superstition.

> I will bring before you the illustrious dead, all those whose memory is dear to you and whose image is still present for you. I will not show you ghosts, for there are no such things, but I will produce before you enactments and images, which are imagined to be ghosts, in the dreams of the imagination or in the falsehoods of charlatans. I am neither priest nor magician; I do not wish to deceive you; but I will astonish you. It is not up to me to create illusions; I prefer to serve education.[14]

It was Philidor/Philpstal who brought the phantasmagoria to London and opened at the Lyceum Theatre in August 1801, performing there until 1803. There he was now able to conjure up the ghosts of Louis XVI, King Henry VIII, Lord Nelson, Bonaparte, and so on. Meanwhile, his inventions and methods were adopted by undoubtedly the most famous magic lantern operator and phantasmagorist at this time, "Citizen" Etienne-Gaspard Robertson. Much of his persona and material were apparently plagiarized from Philidor. Robertson too wished to be considered a scientist, an optician, an engineer and painter, debunking the delusions of a gullible public, not a magician or charlatan appealing to the irrational in man's nature. This did not work. His audience expected thrills and horrors, pyrotechnics and spectacular effects, and Robertson gave them what they wanted and indeed colluded with the need for mystification by attempting to keep secret his use of a wide range of magic lanterns. During the late 1790s, in new premises at the Couvent des Capucines (these had been closed down during the de-Christianization process), Robertson too summoned the ghost of Robespierre, making him rise from his tomb to the eerie sounds of the glass harmonica, only to fall back into it as thunder and lightning crashed around a petrified audience. Robertson's repertoire is interesting for the parallels to be drawn with subjects being explored by academically trained artists at the time. Apart from the ghosts of Benjamin Franklin, Beaumarchais, Rousseau, Condorcet, and Marmontel, he also conjured up, on May 11, 1799, the *Ghost of the Plenipotentiary Claude Roberjot.*

This referred to the assassination on April 28, just two weeks earlier, of one of the three peace negotiators sent by the Directory government to the Congress of Rastadt. It was a subject that

Anne-Louis Girodet de Trioson was commissioned to paint for a state-sponsored competition. In the end he never did paint it, possibly because by then he had hired three rooms in the Couvent des Capucines, where he eventually set up studio, on the same premises used by Robertson, and was already working toward one of the most extraordinary paintings to be produced at the turn of the century. This was *The Ghosts of French Heroes Who Died for Their Country, Led by Victory... Received by the Ghosts of Ossian and His Brave Warriors....* It was commissioned by the architects Percier and Fontaine for Bonaparte to have at Malmaison in the so-called *salon doré,* and it was a patriotic statement and tribute to the heroes of Bonaparte's armies. It was also a politically apposite compliment to Bonaparte, whose favorite literature was the *Tales of Ossian.* In this wild and chaotic painting, full of strange ethereal creatures and extraordinary lighting phenomena, Girodet insisted that he wished to create light effects for which neither nature nor art could provide him with precedent. Instead he spoke repeatedly, in his long descriptions of the painting of the "light of meteors" and of "fantastic beings." As Sarah Burns suggests, the likelihood is that he exploited lighting methods used at this time in the theater and phantasmagoria spectacles that were on his doorstep.[15]

Robertson was also interested in literary fashions, especially and not surprisingly, in Gothic novels such as *The Monk* by Matthew Gregory Lewis and the moralizing tales of virtue by Bernardin de Saint-Pierre in *Paul et Virginie* (1799), and in the *Night Thoughts on Life, Death and Immortality* of Edward Young (1742), especially in the poem of *Young Burying his Daughter.* Robertson performed this on May 11, 1802, activating skeletons opening and closing tombs and animating the characters with moving slides and lanterns on wheels. He described his phantoms in his *Mémoires* as follows:

> Sounds of the belfry, view of a cemetery illuminated by the moon. Young carrying the inanimate body of his daughter. He enters an underground passage where we discover a series of rich tombs. Young strikes on the first: a skeleton appears. He flees. He returns, works with a pickaxe: a second apparition and renewed terror. He beats on the third tomb; a ghost arises and asks him: What do you want from me? A tomb for my daughter, replies Young. The ghost recognizes him and gives up the place to him. Young places his daughter there. The cover is barely closed when we see the soul rising towards heaven: Young prostrates himself and remains in ecstasy.[16]

The former actual terror of guillotines and assassination on the streets of France is replaced now with the spectacle of fictive terror in spaces of entertainment. It would have been an experience for all the senses, and for many the illusion was complete. As one observer noted:

> Reason has told you well that these are mere phantoms, catoptic tricks devised with artistry, carried out with skill, presented with intelligence, your weakened brain can only believe what it is made to see, and we believe ourselves to be transported into another world and into other countries.[17]

Yet, among other things, Robertson claimed to be uncovering the artifice of priests, who, he believed, also used sleight-of-hand, ventriloquy, perfumes, and magical invocations, and also used *tableaux vivants* to dupe the gullible and grossly credulous public. In other words, he deployed his many extraordinary skills to produce effects for which he wanted admiration and that he wanted to keep secret from

those who might plagiarize him, but at the same time he perceived himself as being transparent and revealing, in true revolutionary spirit, as part of the dechristianizing and anti-superstition process, against the deceptions of the Catholic Church, which would have people believe in hell and damnation.

There is clear reference to this idea in a print by H. Strack (fig. 1.4), dated 1797 and entitled *La Lanterne Magique,* with a subtext *Venez voir La Religion de nos pères et nos mères pour 20 sols* (sous—very cheap). This ridicules the church and its possessions through the image projected onto a sheet. The showman is clearly represented as a deceiving charlatan, with his pointed ears and his grotesque parody

of a church bell. The lantern show here is used to mock the persuasive visual device used both by the church and by the lantern show-men. The monkey's inclusion is to critique the lanternist as no more than a mere showman, simply drawing attention to himself and using art as a commodity in the worst practices of persuasion. This in turn fed into the prejudices, already referred to, of those logocentric critics who believed that optical devices made meaning suspect, elusive, and untrustworthy, and that, on the art of the spectator and their education, the viewing process did not encourage any effort of intellectual analysis and understanding. Be that as it may, it is undeniable that the popularity of lantern show and

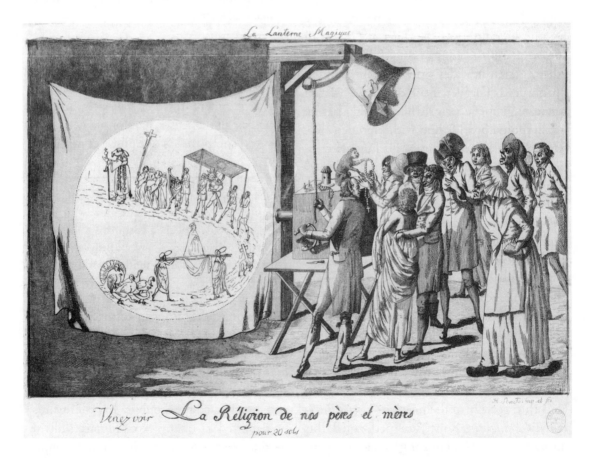

Fig. 1.4 H. Strack (attribution), *Venez voire la Religion de nos pères et mères, pour 20 sous,* 1797.

phantasmagoria increased and persisted right through to the early twentieth century. It was the television of the eighteenth and nineteenth centuries.

According to the evidence of the images, it would seem that, while the lantern operator was invariably a man, the targeted audiences for this form of visual culture were largely female, infantile, or senile. After a showing of *Paul and Virginie* a showman paused to look at the audience:

> Where the dim lantern shed its wavering fires
> On aunts and mothers, daughters and grandsires,
> And curly children, whose extreme surprise
> Clung to the shadowy form, (all mouth and eyes)[18]

The pamphlet *Lantern magique du Brabant* (1787) relates the activities of a "colporteur" by day and lanternist by night, "who, as soon as night falls, amuses our wives and children with the help of concave mirror and some glass slides."[19] It is important not to lose sight of the fact that the same gadgets and technical devices used by mountebanks, phantasmagorists, and traveling Savoyards were also being manipulated by serious educators for enlightenment and for making science accessible and pleasurable to nonprofessionals. That women and children are often represented in these situations suggests also that women were often the ones involved in the learning process for their children. In John Locke's *Some Thoughts Concerning Education* of 1693, much emphasis is placed on an active, hands-on approach for children, and this is exactly the notion represented in *The Magic Lantern* by Charles-Amédée Van Loo of 1764 or *L'Optique* by Louis-Léopold Boilly in 1793. The latter displayed the

second wife of the politician, Danton, shortly before he was guillotined, helping her stepson to understand the optical effects of using a zograscrope, which had convex lenses to create a three-dimensional effect from a two-dimensional image. In Van Loo's painting (actually a peep-show box, not a magic lantern), the mother supports a young child who touches and explores and looks and feels and wants to know how images appear in a peepshow or lantern projection. Thus the home became a teaching laboratory for upper-class families, while the fairs of Saint-Laurent and Saint-Germain became sites for inexpensive working-class entertainment and scaremongering morality lessons. As the century drew to a close, the interest in exploring political issues with magic lantern material became less evident, and issues of spectatorship became more pronounced, together with the questions of gender roles and matters of exclusion and inclusion already mentioned.

There was one artist at this time who had a passion for playing with optical devices and creating trompe-l'oeil and for observing audiences. This was Louis-Léopold Boilly. His son confirmed that he created dark rooms and devoted much time to working with zograscopes, pantographs (for copying) and producing little translucent watercolors/gouaches for optical viewers.[20] Boilly himself twice painted on glass, as if for magic lantern slides, one of which represented the Pont Royale, a sort of panorama, and the other, typically witty and playful, called *La Lanterne Magique,* where the only subject of the painting is now the audience. Mostly women and children and elderly folk, they are seen from behind looking at a fully illuminated space, presumably a wall or screen on which an image will presumably appear. Any political reference has now given way to the pure pleasure of examining the

audience looking and being seen to be looking at some imaginary projected image.[21]

Little of this material has been studied by art historians. Yet this area of visual culture was very visible, audible, tangible, and politically effective in revolutionary France. Thousands of hand-painted slides in their mahogany frames were produced, some of them exquisitely rendered with the precision of the miniaturist, and many still exist and can be magnified with the lanterns that date back to the early eighteenth century.[22] At that time audiences experienced lantern shows in the border zones between the private and the public, the polite and the vulgar, the family and the crowd, as they constituted a body of relatively cheap art, which, not unlike the impact of television and cinema, almost certainly reached a broader, larger audience of urban and rural communities than did the works of France's principal history, the work of portrait and landscape painters that were shown in official exhibition spaces or held privately in the home.

NOTES

1. "The appropriation of a certain space, that needs to be opened and forced, is the first climactic pleasure of revolutions." Mona Ozouf, *La Fête révolutionnaire*, (Gallimard, 1976), 149.
2. Jonathan Crary on Gilles Deleuze's *Negotiations* (Columbia University Press, 1995), in *Suspensions of Perception* (MIT Press, 1999), 9, n. 5.
3. For a discussion of this painting see Philippe Bordes, *Catalogue des peintures, sculptures et dessins*, Musée de la Révolution française (Réunion des Musée Nationaux, 1996), 58–60.
4. On Diogenes in visual imagery see Klaus Herding, "Diogène Héros Symbolique de la Révolution," in *L'Image de la Révolution Française*, ed. Michel Vovelle (Pergamon Press, 1989), 2259–71.

5. It should be remembered that in the 1780s Marat himself was a great enthusiast for solar microscopes, and experiments with fire, electricity, light, and optics generally. See Laurent Mannoni, *The Great Art of Light and Shadow: Archaeology of the Cinema* (University of Exeter Press, 2000), 130–33, 146.
6. On the phantasmagoria see Mervyn Heard, *Phantasmagoria: The Secret Life of the Magic Lantern* (The Projection Box, 2006).
7. See Mannoni, *Great Art of Light and Shadow*, 84–85. He cites the *Mémoires* of the Comte de Paroy, in which this magic lantern enthusiast recalls persuading Marie-Antoinette of its pedagogic use for teaching subjects "of sacred and secular history, the holy mysteries and mythology, the objects of natural history and even mathematics" to the dauphin.
8. Louis de Carmontelle, *Proverbes et Comédies Posthumes de Carmontelle, précédés d'une notice par Mme la Comtesse de Genlis* (De Fain, 1825), vol. 1, vj: "*il a eu depuis l'idée de faire sur du papier transparent une espèce de lanterne magique toute composée de jolies scènes d'invention, représentées dans les charmans paysages.*" In a footnote she goes on to mention that, toward the end of his life, Carmontelle showed her his magic lantern: "*si originale et de l'effet le plus agréable; il était alors en marché pour vendre avantageusement en Russie; j'ignore ce qu'elle est devenue.*"
9. See Barbara Maria Stafford, *Artful Science: Enlightenment, Entertainment and the Eclipse of Visual Education* (MIT Press, 1994) and *Body Criticism, Imagining the Unseen in Enlightenment Art and Criticism* (MIT Press, 1991), 362–63. On Mesmer and Mesmerism, see Robert Darnton, *Mesmerism and the End of the Enlightenment in France* (Harvard University Press, 1968).
10. I am grateful to the late Marcel Chatillon for sharing his knowledge and making available his collection of documents and artwork on slavery and France's colonies. Jacques-Pierre Brissot de Warville, letter to Granville Sharp,

1788, cited in Marcel Chatillon, "La Diffusion de la gravure du BROOKS par la Société des Amis des Noirs et son impact," *Actes du Collque International sur la Traite des Noirs,* vol. 2 (Centre de Recherche sur l'Histoire du Monde Atlantique, 1995), 138.

11. For further discussion of this and other pamphlets and prints of the revolutionary period, see Helen Weston, "The Light of Wisdom: Lanterns and Political Propaganda in Revolutionary France," in *Realms of Light: Uses and Perceptions of the Magic Lantern from the 17th to the 21st Century* (Magic Lantern Society, 2005), 97–104.

12. *Journal des Luxus und der Moden,* April 1793, 238.

13. For information on Philidor/Philipstal, see Heard; and David Robertson, Stephen Herbert, and Richard Crangle, eds., *The Encylopaedia of the Magic Lantern* (The Magic Lantern Society, 2001).

14. "La Phantasmagorie," *La Feuille Villageoise* 22 (Feb. 28, 1793): 506. See Jérôme Prieur, *Séance de Lanterne Magique* (Gallimard, 1985).

15. Sarah Burns, "Girodet-Trioson's *Ossian:* The Role of Theatrical Illusionism in a Pictorial Evocation of Otherworldly Beings," *Gazette des Beaux Arts* 95 (January 1980): 13–24.

16. Etienne Gaspard Robertson, *Mémoires récréatifs, scientifiques et anecdotiques,* vol. 1 (Robertson and Wurtz, 1831), 295.

17. *Courrier des Spectacles* 1092 (March 1800), 3.

18. M. N. Benisovitch, "Une Autobiographie du peintre Louis Boilly," in *Essays in Honour of Hans Tietze,* ed. Ernst Gombrich, Julius Held, and Otto Kurz (Gazette des Beaux Arts, 1958), 366.

19. Jean-Jacques Tatin-Gourier: *"qui, dès que la nuit est tombé amusent nos femmes et nos enfants à l'aide d'un miroir concave et de deux lentilles de verre."* "La lanterne magique: pluralité des imaginaires et des formes d'écriture," in *La Lanterne Magique, Pratiques et Mise en Écriture,* ed. Jean-Jacques Tatin-Gourier. *Cahiers d'Histoire Culturelle,* no. 2 (University of Tours, 1997), 5–16.

20. See Jean de la Monneraye, "Documents sur la vie du peintre Louis Boilly pendant la Révolution," *Bulletin de la Société de l'histoire de l'art français* (1929): 26.

21. For further discussion of this painting, see Susan Siegfried, *The Art of Louis-Léopold Boilly: Modern Life in Napoleonic France* (Yale University Press, 1995), 161.

22. Accounts of the history of the magic lantern, its uses and techniques, can be found in Robinson, Herbert, and Crangle, *Encylopaedia of the Magic Lantern,* and in Richard Crangle, Mervyn Heard, and Ine van Dooren, eds., *Realms of Light, Uses and Perceptions of the Magic Lantern from the 17th to the 21st Century* (The Magic Lantern Society, 2006).

NINETEENTH-CENTURY REVOLUTIONS AND STRATEGIES OF VISUAL PERSUASION

Richard Taws

REVOLUTIONARY ERA: Still going strong, since every new government promises to put an end to it.

—Gustave Flaubert,
Dictionary of Received Ideas, 1881

In the French Revolution of 1789–1799, revolutionaries, we are told, had to be "made."[1] With the disintegration of absolutist monarchy, and the sudden invalidation of its powerfully embedded and instantly recognizable symbolic codes, a new set of words, institutions, and images were brought into being to articulate the complex and at times abstract concepts that underlay the Revolution. Many of these were new inventions, while many more were appropriated and transformed from an eclectic range of classical, religious, and popular sources. In due course, they were joined by new methods of calibrating time, new names, new ways of dressing, and even new ways of eating, as successive revolutionary governments attempted to remake society from scratch, and to "regenerate" the revolutionary subject. Visual culture occupied a central role in this process, actively constituting revolutionary ideologies. History painting may have provided exemplary themes of moral judgment, sacrifice, and ideal virtue, but it was more ephemeral reproductive media that transmitted the message of the Revolution to a French audience who were only learning to think of themselves in national terms.

Money, letterheads, and stamps issued by the state, authorized revolutionary festivals, placards, and newspapers were important conduits for the transmission of condensed allegorical renderings of revolutionary ideas. Yet there were also those objects and images that operated outside of official culture, the numerous caricatures and prints whose production was regulated by market forces, images whose primary appeal was their representation of the Revolution in progress. Many of these, such as the battle scenes, images of *journées,* and portraits that formed series such as the long-running *Tableaux historiques de la Révolution française* (1789–1814) (fig. 2.1), were of a determinedly historical nature, reflecting on recent events and their main protagonists. Works such as these, which elide difference between representation *in* Revolution, and representation *of* Revolution, demonstrate too how flexible the boundaries between lived experience and its representation could be. Revolutionary behavior was learned, in part, through the consumption of a diverse and temporally fractured body of images, and it was images that replayed back the momentous events that, by shaping revolutionary systems of belief, they had helped bring into being.

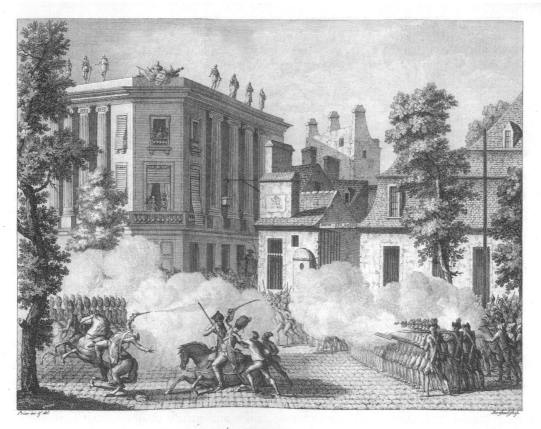

ACTION ENTRE ROYAL-ALLEMAND ET UN DÉTACHEMENT DES GARDES FRANÇAISES, EN FACE DU DÉPOT.
le 12 Juillet 1789.

Fig. 2.1 Jean-Louis Prieur (invenit and delineavit) and Jean Gabriel Berthault (sculpsit). *Action entre Royal-Allemand et un detachment des gardes françaises en face du depot, le 12 juillet 1789.* Engraving and etching, no. 8. Tableaux historiques de la Révolution française.

Repetition, as well as rupture, is ingrained conceptually, not to mention etymologically, in "Revolution." Certain conceptions of what it meant to be "revolutionary" could not be unlearned, erased from the national consciousness, despite the attempts of Napoleon and the Restoration to effect such an amnesia, or to remake the Revolution in their own image. The revolutions of the nineteenth century were, as Karl Marx recognized most eloquently, haunted by their political forerunners, which they echoed, sometimes unwittingly or unwillingly, but often with a full awareness of the contemporary possibilities of emulation or rejection.[2] Marx's statements on the inheritances of 1848 have acquired the status of cliché.[3] Nonetheless, it is clear that those who sought to determine the particular visual character of a revolutionary movement, or indeed to represent a particular revolutionary episode, in 1830, 1848, or 1871, consistently came up against the hard fact of 1789–1799, which invariably conditioned the meaning of an image. This is not to say that images produced during

the revolutions of the nineteenth century were stylistically dependent on previous models, or that historical precedents colored their meaning to the point that any contemporary relevance was lost—far from it. Rather, in the revolutions of the nineteenth century, image-makers were forced to engage not only with the conditions of the present, with revolution achieved under modern conditions and as a catalyst of modernity, but with the origins of that modernity too, in the past.

This dialectic was complicated by the nineteenth-century efflorescence of new media for the production of visual images, which brought about frequent shifts in the ways in which those images could be consumed.[4] As Walter Benjamin recognized, and Charles Baudelaire before him, technology determined the subjective experience of modernity.[5] New media, particularly lithography and later photography, and the cross-pollination of new photographic techniques with more traditional printmaking processes, radically altered the meaning of images, and their ability to adequately document the processes of revolution. Certainly, it became possible to produce and reproduce images in ever greater quantities, at less cost to the publisher, although this did not mean that access to the production of mass-reproducible images was democratized, for genuinely popular image making (if such a thing ever existed) increasingly fell into the hands of a select group of powerful interests who manufactured and resold a range of distinct "populars."[6]

Authenticity was at stake, with regards to both images and their consumers. In addition, problems of definition plague the historical field, for distinguishing the exact parameters of a particular revolution is fraught with ambiguity derived from a persistent blurring of difference between revolution as process, and

as event. At what point does a revolution cease and become an empire or a restoration? Are such sociopolitical periodizations not dependent on the presence of "revolution" as an overriding determinant? Teleology is a dangerous game, and periods of radical change more seductive to the historical imagination than periods of apparent stability, yet it is important to recognize that the lives of both individual subjects and the production of material objects do not always conform to narrowly prescribed time frames. Just as many artists of the French Revolution were involved in the production of art under an absolute monarchy, with many surviving to work under the Directoire, Consulate, and Empire, so the careers of artists later in the nineteenth century were responsive to frequent political change. At the same time, revolutions *do* bring about radical change in visual culture, as the very conditions for image making are transformed by an altered social system. Image-makers take sides and justify positions that may, through the positive reception of their work, move from the margins to the center-ground, or vice versa.

1830: MOCKERY AT THE BARRICADES

Insofar as it provided a representation of revolution based upon a renunciation of its *juste milieu* outcomes, the satires produced after the 1830 revolution by artists working for the Maison Aubert, of which Charles Philipon and Honoré Daumier are the best known, offer a concise statement of oppositional tactics in the field of reproductive image making.[7] These artists based their critiques of the July Monarchy on a distortion of the body of Louis-Philippe, the bourgeois "citizen king" whom the revolution had brought to power, mobilizing the polysemic form of "La Poire" to

critique both the ruling party and its antirevolutionary censorship measures. Invoking the ancien-régime crime of *lèse majesté,* the July Monarchy repeatedly prosecuted artists and publishers who confronted its reneging on revolutionary principles. A courtroom sketch by Philipon (fig. 2.2), a quartered sheet with four frontal portraits of Louis-Philippe, altered by degrees until his features metamorphosed into a large pear, an object whose multiple connotations of sexual perversity, decay, and wrongheadedness satirized the king without directly representing him, proved how slippery in the caricaturists' hands the line between direct criticism of the regime and "innocent" representation could be.[8] A happy coincidence of initials (La Poire—Louis-Philippe) aided this identification, and pears soon proliferated as the central motif of caricatures in the pages of the journals *La Caricature* and *Le Charivari,* hilarious and carnivalesque assaults on the

Fig. 2.2 Charles Philippon, *Métamorphose de Louis-Philippe en poire,* 1831, pen and bistre ink.

royal body politic whose dissemination was greatly aided by their lithographic production, which by 1830 had replaced etching as the dominant medium for the production of daily-use prints, from menus to sheet music to invoices, as well as the large folio caricatures in which these publications traded.[9]

Louis-Philippe too undoubtedly recognized the power of images in a revolutionary situation, stifling the potent republicanism of works such as Delacroix's *Liberty Leading the People* (Musée du Louvre, Paris, 1831), instituting his own iconographical projects in the Salle des Séances at the Chamber of Deputies, and controlling powerful Napoleonic interests in his propagandistic retelling of French history at Versailles.[10] These two radically divergent models of image making demonstrate how "revolutionary representation" resists fixity, for both Daumier and Philipon, and the artists hired to glorify Louis-Philippe, based their claims to authority, in part at least, on a legitimacy bestowed by revolution.[11] Whereas the artists of *La Caricature* and *Le Charivari* were actively oppositional, claiming to work in the interests of the principles of 1830, it was Louis-Philippe, brought to power in the revolution, who had active control over its official representation. Different versions of history were at stake between these two positions and modes of production, the relative hierarchical values of painting and lithography, which never really succeeded as a high-art medium, confirming a power relationship that the Maison Aubert artists acknowledged to transgressive ends.

It was characteristic that Louis-Philippe should attempt a restructuring of French history via a carefully chosen arrangement of historical paintings. Yet as Maurice Samuels suggests, it was the concurrent emergence of Romantic historiography and illustrated

histories in the 1830s and 1840s, particularly the visual or spectacular aspects of historical representation, that "helped the French cope with historical change by making it seem more 'real.'"[12] Aided by the integration of text and image brought about by advanced wood-engraving techniques, such visual histories were available to an increasingly wide public, one far more diverse than the audience for history painting. However, the content of the images inevitably ignited debate about the political agency and responsibility of history, with the representation of revolution and Napoleon in particular polarizing Left and Right. While legitimist writers sought the condemnation of all potentially revolutionary scenes, commentators on the Left also feared that the spectacular nature of these images would detract from the complexity of the historical account and would encourage viewers to over-identify with "the beautiful victims of Revolutionary violence."[13]

In Britain, a shift in audience brought about by increasing mechanization of the print-making process, and the emergence of a moral prurience absent in the so-called golden age of caricature at the turn of the century, had led to a decline in politically motivated caricature, which contrasted with the expansion of the form in France, particularly in the field of lithographic satire promoted by the Maison Aubert. Exchanging "the guffaw for the smile," as art historian David Kunzle has put it, British caricature in this period of transition was for the most part domesticated, conservative, and diluted for a "polite" audience.[14] There were, however, exceptions, artists such as C. J. Grant, whose Chartist sympathies set him in stark contrast to the gentle, socially dominant satires of an artist such as John Doyle, who worked under the pseudonym HB.[15] Grant's satires addressed a popular audience,

taking on controversial subjects such as the Reform Bill, and consistently drawing on a repertoire of anticlerical and antipolice subjects. Grant's work, beginning in 1833 for *The Political Drama,* and between 1837 and 1846 for *The Penny Satirist,* imparted a radical political message, bolstered by a self-consciously "popular" means of production referenced by a crude technical style, a style that, despite its apparently antitechnological form, was far from reactionary. Although the majority of Grant's output referred to British events and personalities, events in revolutionary France inevitably informed several images. In *The Citizen King Bamboozling Monsieur Crapaud* (fig. 2.3), Louis-Philippe, cast as a grotesque bonnet-rouge-clad "Citizen Thing," cynically forges chains for Thiers to constrain a violent, snaggle-toothed *sans-culotte,* straight out of the satirical tradition of Gillray, whose spluttered threats to "de Anglais" and "de Ros-Bif," and entreaties to "dam de plom-puddin" demonstrate the utility of such stereotypes to characterize, albeit in a knowing, ironic way, distant revolutionary situations.

1848: REVOLUTION AND REPETITION

The European revolutions of 1848 brought about a shift in the terms of revolutionary representation, partly motivated by the availability of new technologies. Certainly, the reflective, cyclical character of nineteenth-century revolutions was from this point on provided with a new template, for European politics after midcentury were no longer focused so single-mindedly on the schisms of 1789–1799, but they were now preoccupied with the divided legacies of 1848.[16] Nonetheless, despite a different context, many of the symbolic characteristics of the 1848 revolution, in France at least,

THE CITIZEN KING BAMBOOZLING MONSIEUR "CRAPAUD;"
OR, FORTIFYING PARIS.

Fig. 2.3 C. J. Grant, *The Citizen King Bamboozling Monsieur "Crapaud," or, Fortifying Paris.* Woodcut and letterpress, front page of *The Penny Satirist,* no. 181, Saturday, October 3, 1940.

were familiar in their basic incarnations from earlier revolutionary episodes. For instance, the mutable image of Marianne, first viewed in a revolutionary milieu from 1789, was used to a variety of ends during 1848, appearing in a range of contexts from the competition to design a female allegory representing the new republic to a range of popular manifestations and "live" allegories.[17] Such visualizations of revolution were divided according to political allegiance, as the image of Liberty in the form of a real woman was presumed to represent militant revolution and "Jacobin" interests, while more abstracted, allegorical versions were popular among moderates. It is no surprise that the competition of 1848 encouraged artists to represent an image of French Liberty as stolid, seated, and maternal, accompanied by profuse

allegorical clutter, rather than confrontational, working-class, or sporting everyday signs of popular militancy such as the *bonnet rouge.* In addition, the early events of 1848 brought about a transformation in the visual character of the city itself, illuminated for days at the end of February, following the resignation of Guizot and the toppling of the royal throne the following day.[18] The temporary aspect of these celebrations recalls a frequently remarked-upon characteristic of revolutionary France, its inability to contribute a permanent monument to itself. By the middle of 1848, with the revolutionary gains of February lost, and bourgeois power retrenched, such a lack might have appeared appropriate to the Parisian working classes, who were bitterly aware how fleeting freedom could be.

British responses to events in Germany, Czechoslovakia, Hungary, Poland, and especially France were predictably negative, especially following the battles of late June.[19] This response found visual expression in illustrations for newspapers such as the *Illustrated London News,* and in France, its nearest equivalent, *L'Illustration.* Yet the illustrations in these publications demanded a response to that most revolutionary thing, the *journée,* which was not always, in isolation, unequivocal. The images in these newspapers demanded a sophisticated viewership familiar with the codes of revolutionary behavior, and often expressed an ambivalence produced by the at times incompatible desires to reflect the political ambitions and class position of their readerships, and the will to present an impartial document of events. For many of course, revolutionary action in any form suggested treasonous criminality, and certainly, these images function in an inescapable dialectic with the text, which, if condemnatory, could alter perceptions of the image. Yet these illustrated newspapers demonstrate how the revolutionary episode had moved into the realm of everyday news, news whose transmission had in any case been revolutionized by increased access. For Pierre Nora, such a transition is indicative of modern conditions, and productive of modernity, for:

> Modernity oozes with events, whereas traditional societies tended to make events scarce. In peasant societies, the only events were those of religious routine, climatic calamity, or demographic disaster—a nonhistory. . . . All established societies seek to perpetuate themselves through a system of news whose ultimate purpose is to deny events, for an event is nothing other than a disruption of the equilibrium on which it is based. Events, like truth, are always revolutionary, grains of sand in the machine, accidents that come out of the blue to upset the status quo.[20]

Although it was the first newspaper published in Britain whose appeal lay primarily in images, the *Illustrated London News* avoided for the most part any motivated engagement with contemporary politics, especially in relation to the pressing social concerns of Victorian England. Publications such as the *Illustrated London News,* in common with an increasingly diverse range of illustrated weeklies catering to different clienteles, naturalized the imperialism and commercial interests brought to bear by the Industrial Revolution in Britain.[21] Although a certain truth in depiction was taken for granted, the choice of subject matter was fiercely edited so as not to offend the bourgeois sensibilities of its readers, and to satisfy dominant tastes. As Celina Fox has argued, "the *Illustrated London News* felt it had been bequeathed the honours reserved for history-painting in the academic hierarchy: a capacity to inform the minds of men, and to elevate them through art's permanent qualities."[22] This grand ambition exposes a deeper truth, for the realms of photography and printmaking were undoubtedly engaged in complicated reciprocal relationships with "high" art. Furthermore, the response of those working in different kinds of reproductive media to the standards set by academic painting was not necessarily a one-way process of emulation, for many painters were receptive to, and dependent on, the work of printmakers and photographers, destabilizing established hierarchies of medium and myths of the seamless ascendancy of photography.[23] What is more, conventional narratives of the manner in which photography came to "replace" painting do not take into account the complexity of photography itself, in both its "precious and commonplace forms," and the ways in which new taxonomies established by photography dramatized and exposed the fetishism of commodities.[24]

"The problem for a revolutionary artist in the nineteenth century," as outlined by T. J. Clark, "was how to use the conditions of artistic production without being defined by them. How to make an art-work that would not stay on an easel, in a studio, in the Salon for a month, and then on the wall of a sitting-room in the Faubourg Saint-Germain."[25] In 1848 several ambitious artists worked to simultaneously sidestep the conventions of the art world while operating inevitably from within its task, mobilizing the private realm of artistic creativity to reach a wide public. Yet such attempts to establish new forms of genuinely popular political art—Courbet's *Burial at Ornans* (Musée d'Orsay, Paris, 1849–1850) for instance, which "undermined the bourgeois sense of what was art and what was bourgeoisie"[26]—are only part of the picture, for 1848 also mobilized a range of *reactive,* and often *reactionary* representations, many of them appealing to the bourgeois audience critiqued by Courbet, yet who were nonetheless involved in the struggle over the political intersections of art and the social in a revolutionary context.

MONUMENT/RUIN

In 1889, the first centenary of the storming of the Bastille provoked a glut of commemorative schemes, marking the end of a century of attempts to neutralize revolutionary political schisms by reproducing them as historical mementoes. These attempts to memorialize revolution were begun as early as 1789, with the proliferation of schemes to construct a monument on the ruins of the Bastille, and had been enshrined in the 1880 decision to mark July 14 as a national holiday (other options, derived from revolutionary *journées* such as August 10 or January 23 were discarded as too politically loaded).[27] As a commemorative chromolithograph produced by Bognard (fig. 2.4) and sold as an advertising template to various confectioners demonstrates, the Revolution had been commodified, historicized, and drained of agency. This image, a forerunner of the twentieth-century cigarette or chocolate card, represents Robespierre, set against a highly detailed, oversized *assignat,* a state bond based on the value of nationalized church land, which became an official revolutionary currency, and is part of a series that includes other famous figures such as Desmoulins, Corday, Marat, and Barnave, represented in similar contexts against notes of other denominations. In London, the centenary was marked by theatrical productions set during the months after the storming of the Bastille, such as Watts Phillips's popular success *The Dead Heart,* performed at the Lyceum with a cast including Squire Bancroft and Ellen Terry, albeit with the play's republican themes significantly diluted.[28] The popularity of Dickens's *A Tale of Two Cities* thirty years previously, and Carlyle's two-volume *The French Revolution* in 1837, had set the tone for this revival of interest in the romantic possibilities of revolutionary France. Yet although the original Revolution had been repackaged and resold in a comfortably collectible format, the threat of insurgency and political faction was never too far away and certainly lingered in the memories of those who had been involved in the last large-scale revolution in France.

In comparison to the implied veracity and sense of presence developed by artists working for illustrated weeklies, or the immediate politicized response and precise exaggeration of the caricaturist, the most eloquent images of the 1871 Paris Commune made claims to truth by representing the traces, rather than presence, of revolution. The photographs by

Fig. 2.4 Bognard Company, Advertising card with Robespierre and ten sous assignat. Chromolithograph, about 1889.

artists such as Andrieu of a ruined, desolate Paris taken in the aftermath of the violent suppression of the Commune and the ravages of the Franco-Prussian War focused on an embodied yet depeopled urban fabric as the signifier of revolutionary failure.[29] Although defeat in the Franco-Prussian War became increasingly viewed as a victory, with the sponsoring of various commemorations and monuments in support of a "cult" of resistance to the invaders, representation of the Commune was inevitably shaped from the standpoint of the conservative reaction.[30] Nevertheless, the events of 1870–1871 had a profound effect on artists. Some, such as Courbet, responsible for his own act of staged iconoclasm, his orchestration of the destruction of the Vendôme Column, and directly involved in the day-to-day politics of the Commune, had been previously politicized by the events of 1848, carrying its inheritance into the revolutionary context of 1871.[31] As Jeannene M. Przyblyski notes, political reality was intricately linked to a transformed aesthetic, and even works as apparently innocuous as Courbet's still lifes could not fail but speak to the aftermath of the Commune, for "By 1871 there was little chance that Realist facture, however mediated by motifs borrowed from Chardin's household or the holy church, could register as anything but the unwelcome product of an unruly and immediately threatening working class."[32]

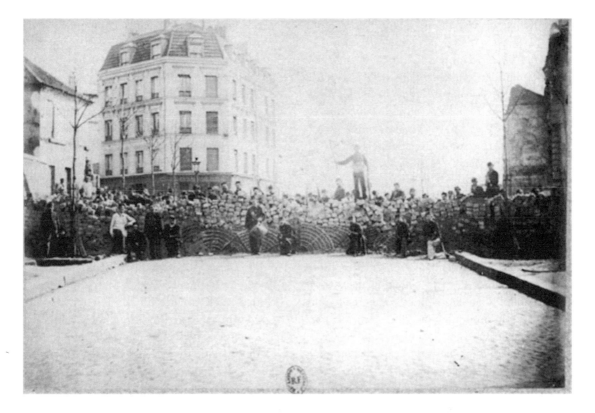

Fig. 2.5 Anonymous, *Barricades, Boulevard de Puebla (rue des Pyréneés),* 20th arrondissement, March 1871. Photograph.

In this context, the appearance and diversification of photography inevitably altered the experience of revolution, transforming the ways in which certain of its tropes, the barricade for instance, could operate as a language with which to articulate "politics," and attributing to it the value of the document. Spread throughout Paris in the months during and after the Commune, posed photographs of triumphant Communards in barricaded Haussmannized streets mixed the received visual language of revolutionary behavior with the signs of a transformed urban modernity (fig. 2.5). These expressive images swiftly acquired a second life as proofs of guilt, in the hands of the Parisian police, as the attempt by the Communards to memorialize their achievements was co-opted into an apparatus of surveillance, as authorities used them to identify participants in the revolution.[33] Looking back to previous revolutionary behavior, and forward, in their acknowledgement of the spectacular potential of the barricades, to the events of May 1968, the multiple uses of these photographs speak to the fluctuating significations of imagery in the revolutions of the nineteenth century, and to the power of images to themselves constitute a "barricade" on which the validity of political revolution was contested.

NOTES

Gustave Flaubert, *Bouvard and Pécuchet/ Dictionary of Received Ideas,* trans. A. J. Krailsheimer (Penguin, 1976 [1881]), 324.

1. Keith Michael Baker, *Inventing the French Revolution: Essays on French Political Culture in the Eighteenth Century* (Cambridge: Cambridge University Press, 1990); Timothy Tackett, *Becoming a Revolutionary: The Deputies of the French National Assembly and the Emergence of a Revolutionary Culture (1789–1790)* (Princeton University Press, 1996).

2. See Karl Marx, *The Eighteenth Brumaire of Louis Bonaparte* (Foreign Languages Press, 1978 [1852]), 9–21.

3. This point is made by James Livesey, who suggests that Marx's statements on the Revolution be reassessed as a rhetorical position produced in the context of the Revolution itself. James Livesey, "Speaking the Nation: Radical Republicans and the Failure of Political Communication in 1848," *French Historical Studies* 20, no. 3 (Summer 1997): 459.

4. For a study of the ways in which photomechanical technologies signified value toward the end of the nineteenth century, see Tom Gretton, "Signs for Labour-Value in Printed Pictures after the Photomechanical Revolution: Mainstream Changes and Extreme Cases around 1900," *Oxford Art Journal* 28, no. 3 (2005): 371–90.

5. The work of Jonathan Crary, in particular, has demonstrated how new or transformed means of encountering new visual media, such as stereoscopes, which "for decades defined a major mode of experiencing photographically produced images," were deeply implicated in the conceptualization of new frameworks of seeing. Jonathan Crary, *Techniques of the Observer* (MIT Press, 1990), 118.

6. For fascinating analyses of the ways in which a category of the "popular" might be fabricated, see Thomas Gretton, "Posada and the 'Popular': Commodities and Social Constructs in Mexico before the Revolution," *Oxford Art Journal* 17, no. 2 (1994): 32–47, and Stuart Hall, "Notes on Deconstructing 'The Popular,'" in *People's History and Socialist Theory,* ed. Raphael Samuel (Routledge and Kegan Paul, 1981), 227–40.

7. See James Cuno, "Charles Philipon, La Maison Aubert, and the Business of Caricature in Paris, 1829–1841," *Art Journal* 43, no. 4 (Winter 1983): 347–54.

8. For a discussion of Daumier's work in the context of the censorship of political opposition under the July Monarchy, see Elizabeth C. Childs, "The Body Impolitic: Censorship and the Caricature of Honoré Daumier," in *Suspended License: Censorship and the Visual Arts,* ed. Elizabeth C. Childs (University of Washington Press, 1997), 148–84.

9. Jeff Rosen, "The Political Economy of Graphic Art Production During the July Monarchy," *Art Journal* 48, no. 1 (Spring 1981): 40.

10. See the work of Michael Marrinan, in particular: "Resistance, Revolution and the July Monarchy: Images to Inspire the Chamber of Deputies," *Oxford Art Journal* 3, no. 2 (October 1980): 26–37, and *Painting Politics for Louis-Philippe: Art and Ideology in Orléanist France* (Yale University Press, 1988).

11. For an interesting discussion of the relationship between caricature and "official" art, see Aimée Brown Price, "Official Artists and Not-So-Official Art: Covert Caricaturists in Nineteenth-Century France," *Art Journal* 43, no. 4 (Winter 1983): 365–70.

12. Maurice Samuels, "The Illustrated History Book: History between Word and Image" reproduced in *The Nineteenth-Century Visual Culture Reader,* ed. Vanessa R. Schwartz and Jeannene M. Przyblyski (Routledge, 2004), 238.

13. Samuels, "Illustrated History Book," 246.

14. David Kunzle, "Between Broadsheet Caricature and 'Punch': Cheap Newspaper Cuts for the Lower Classes in the 1830s," *Art Journal* 43, no. 4 (Winter 1983): 339.

15. On the links between morality and reform in Britain and France, see Robert J. Bezucha, "The Moralization of Society: The Enemies of Popular Culture in the Nineteenth Century," in *The Wolf and the Lamb: Popular Culture in France from the Old Regime to the Twentieth*

Century, ed. Jacques Beauroy, Marc Bertrand, and Edward T. Gargan (Anma Libri, 1977), 175–87. On C. J. Grant, see Richard Pound, ed., *C. J. Grant's Political Drama: A Radical Satirist Rediscovered* (Strang Print Room, UCL, 1998).

16. Michael Rapport, *Nineteenth-Century Europe* (Palgrave, 2005), 158.

17. Maurice Agulhon, *Marianne into Battle: Republican Imagery and Symbolism in France, 1789–1880,* trans. Janet Lloyd (Cambridge University Press, 1981), 62–99.

18. Agulhon, *Marianne into Battle,* 65.

19. On British responses to the Revolution in France, see Fabrice Bensimon, *Les Britanniques face à la révolution française de 1848* (L'Harmattan, 2000).

20. Pierre Nora, "Le Retour de l'événement," in *Faire de l'histoire,* vol. 1, ed. Jacques Le Goff and Pierre Nora (Paris: Gallimard, 1974), reprinted as "The Return of the Event" trans. Arthur Goldhammer, in *Histories: French Constructions of the Past: Postwar French Thought,* vol. 1, ed. Lynn Hunt and Jacques Revel (The New Press, 1995), 430–31.

21. On the Imperialist ramifications of 1848, see Miles Taylor, "The 1848 Revolutions and the British Empire," *Past and Present,* no. 166 (February 2000): 146–80.

22. Celina Fox, "The Development of Social Reportage in English Periodical Illustration during the 1840s and Early 1850s," *Past and Present,* no. 74 (February 1977): 92.

23. See Stephen Bann, *Parallel Lines: Printmakers, Painters and Photographers in Nineteenth-Century France* (Yale University Press, 2001); and Tom Gretton, "Difference and Competition: The Imitation and Reproduction of Fine Art in a Nineteenth-Century Illustrated Weekly News Magazine," *Oxford Art Journal* 23, no. 2 (2000): 143–62.

24. Steve Edwards, "Photography, Allegory, and Labor," *Art Journal* 55, no. 2 (Summer 1996): 38.

25. T. J. Clark, *The Absolute Bourgeois: Artists and Politics in France, 1848–1851* (Thames and Hudson, 1973), 179.

26. Clark, *The Absolute Bourgeois,* 180.

27. See Mona Ozouf, "Le premier 14 juillet de la République," *l'Histoire* no. 25 (July–August 1980): 10–19.

28. Kristan Tetens, "Commemorating the French Revolution on the Victorian Stage: Henry Irving's *The Dead Heart,*" *Nineteenth-Century Theory and Film* 32, no. 2 (December 2005): 36–69.

29. Alisa Luxenberg, "Creating *Désastres:* Andrieu's Photographs of Urban Ruins in the Paris of 1871," *Art Bulletin* 80, no. 1 (March 1998): 113–37.

30. See Karine Varley, "Under the Shadow of Defeat: The State and the Commemoration of the Franco-Prussian War, 1871–1914," *French History* 16, no. 3 (September 2002): 323–44.

31. T. J. Clark, *Image of the People: Gustave Courbet and the 1848 Revolution* (Thames and Hudson, 1973). For an account that emphasizes the unexpected diversity of artistic practices under the siege of Paris, see Hollis Clayson, *Paris in Despair: Art and Everyday Life under Siege (1870–71)* (University of Chicago Press, 2002).

32. See Jeannene M. Przyblyski, "Courbet, the Commune and the Meanings of Still-Life in 1871," *Art Journal* 55, no. 2 (Summer 1996): 34.

33. For a fascinating analysis of these images, see Jeannene M. Przyblyski, "Revolution at a Standstill: Photography and the Paris Commune of 1871," *Yale French Studies,* no. 101 (2001): 55. On nineteenth-century police photography, particularly the development of *bertillonage,* and on the ways in which portrait photography combines both "honorific" and "repressive" aspects, see Allan Sekula, "The Body and the Archive," *October,* no. 39 (Winter 1986): 1–64.

SOCIALIST MOVEMENTS AND THE DEVELOPMENT OF THE POLITICAL POSTER

Elizabeth Guffey

With its plunging perspective and stark black and red graphics, Jules Grandjouan's 1906 poster promoting the antimilitarist daily *La Révolution* (fig. 3.1) depicts a surging mass of humanity overturning a flag-capped stone pedestal. This potent image visualizes socialist

Fig. 3.1 Jules Grandjouan, *La revolution,* 1906.

ideals of collective will and inevitable social change. But Grandjouan also masterfully deploys the poster, a communicative invention of the nineteenth century, to modern ends. Often identified as "the age of the masses,"[1] the late nineteenth and early twentieth centuries were also the era of the crowd. Grandjouan utilized the poster format to address anonymous crowds on the street; by imagining clusters of workers ascending a mighty mountain in rhythmic unity, he also indicates the power that such masses, when organized, could muster. Throughout the early twentieth century, artists like Grandjouan transcend simple epithets like "the age of the masses" with powerful images.

The cultural theorist Raymond Williams notes that "there are in fact no masses; there are only ways of seeing people as masses."[2] Grandjouan not only transforms individuals into a cohesive group, he also remakes the mob into a powerful and sympathetic new visual form, the crowd. In this way he translates the notion of the people's will, one of the key concepts to emerge from late eighteenth- and nineteenth-century liberalism,[3] into powerful visual imagery that pervaded European consciousness throughout the early twentieth century. Indeed, such socialist posters helped develop the concept of the masses as a persuasive and enduring visual form.

The international socialist movement was philosophically rooted in nineteenth-century developments. While earlier polemicists, including the medieval millenarians and Thomas More, advocated the dispersal of wealth, their long-term impact on preindustrial economies was limited.[4] But the Industrial Revolution created private wealth and social disparities on an unprecedented scale. Emerging industries, such as large-scale coal mining and textile production, employed millions of laborers, but these new working classes had little access to newly generated wealth and instead labored under remarkably harsh conditions.[5] In the early years of the nineteenth century, children as young as eight worked in mines and factories; even after child labor became more stringently regulated, men and women labored twelve-, fourteen-, and even eighteen-hour days. Among the age's vocal critics, Karl Marx announced the alienation of labor. But the socialists were more moderate, pushing for better wages, better working conditions, and workers' self-determination.[6] Their platform was largely expressed through newly minted workers' organizations that exercised increasing political and economic power.

The socialists' message further emerged in another phenomenon of the industrial period—the poster. Following the advent of Gutenberg's printing press some three hundred years earlier, handbills and broadsheets gradually became a common form of mass communication. Well into the nineteenth century, however, these remained largely composed of texts, including announcements issued by governments and early ads taking the form of trade cards for milliners, tobacconists, or grocers. While printers used a variety of large, bold, slab-serif, and ornamental typefaces to attract attention, posters remained largely text-based, appealing to growing numbers of literate urban dwellers. Only as paper production and printing processes themselves industrialized, lowering their costs significantly, did posters proliferate in public spaces during the early decades of the nineteenth century. With the development of chromolithography in the late nineteenth century, designers and artists began conceiving of posters as unique works, with hand-drawn lettering circumventing the constraints of traditional typesetting altogether. Printed in color by the thousands on cheap paper, posters with emphatic visual messages in a wide range of visual styles pervaded the late nineteenth-century urban environment.

Innovative and arresting poster designs promoted products ranging from bicycles to soap to cigarettes. In the commercial sphere, new advertising formulas emerged, not only introducing merchandise for sale, but presenting beautiful people in attractive surroundings consuming these products. Such images were augmented by practiced typography, innovative color schemes, and formal arrangements so compelling that they inspired contemporary fashions. Indeed, in some ways posters shaped social mores. Prior to the mid-nineteenth century, for instance, women were socially discouraged from drinking alcohol publicly. However, contemporary posters for wine and beer, for instance Alphonse Mucha's 1899 poster *Bières de la Meuse,* whose long-tressed beauty holds a mug while surrounded by green hops and barley stalks, enticed male attention by featuring images of attractive female drinkers. Although men remained the primary consumers of alcohol, such poster images ultimately helped create the conditions for more and more women to drink freely in public spaces.

Nevertheless, socialist organizers were slow in capitalizing on the poster's inherent visual

advantages, unhurriedly following the trail blazed by commercial advertisers. Conveying meeting information, employment updates, and calls to strike, union handbills and socialist party missives were not nearly as visually seductive as their commercial counterparts with whom they shared wall space and vied for attention; as late as the 1880s, socialist placards retained the densely worded formats reminiscent of commercial handbills produced some fifty years earlier.

The first socialists to follow the cues of commercial firms employed the vibrant imagery already familiar in advertising posters marketing products; rather than promoting political meetings or party elections, they advertised newspapers, magazines, or novels with politically radical themes. Commercial publishers had used images to promote various publications since the middle of the nineteenth century, when illustrated posters announced fiction by authors like Honoré Balzac or Emile Zola. But it was only around the turn of the twentieth century that socialist publishers began deploying compelling visual imagery to promote their own publications; as the political left began to imitate the advertising strategies of mainstream commercial firms, however, they also co-opted their vocabulary of consumption. Issued in 1900, Théophile Steinlen's spectacular advertisement for the socialist journal Le Petit Sou measures almost two meters in height and depicts a buxom Marianne exhorting workers. While idealized middle-class women populated late nineteenth-century posters for bicycles and toothpaste, socialist newspapers replaced them with images of virile men, often stripped to the waist.[7] Vorwärts, a newspaper founded in 1891 by the German Social Democratic Party, advertised early issues with the Belgian Jules Evarist van Biesbroeck's art nouveau-inflected drawings of a heroic man hoisting a furling flag, while the Italian Avanti, founded in 1896, embodied its claims to represent forceful visions of the future by regularly featuring drawings of robust, vigorous young men demonstrating their physical strength and virility by breaking chains or sailing boats.[8]

Many designers of socialist publications looked to classical precedents for inspiration. Avanti in particular specialized in posters of single male figures, often shown mounted on horseback or shouldering hammers in poses self-consciously evoking classical art. An 1899 poster soliciting subscriptions depicts a socialist leader in a pose that echoes the statue of the Emperor Marcus Aurelius on Rome's Capitoline Hill. Referring to the famous contrapposto pose of the Augustus Prima Porta, another Avanti poster from 1900 replaces the ancient emperor's imperial salute with a worker holding an orb of light aloft. As courageous and singular as these socialist heroes appeared, both posters also included looming crowds.

While these virile supermen replaced the feminine figures who dominated mainstream advertisements, the most imaginative socialist poster designers were increasingly drawn to the uniquely socialist conception of the masses. Their visual depictions of "the crowd" concretized contemporaries' theoretical conceptions of groups. Instead of remaining amorphous aggregates of individuals, artists like Grandjouan and Steinlen give literal shape to the crowd whose claims the socialists aimed to represent. In so doing, these artists altered the imagery of the public sphere, providing a visual vocabulary that combined social identity with protest.[9] Socialist organizers as varied as Jules Guesde and Jean Jaurès believed in the essential helplessness of the individual; the newly self-aware working classes

could take cohesive political action only by acting as a crowd.[10]

In the late nineteenth century, ideas of the crowd were still novel. Prior to the French Revolution, popular gatherings of individuals were described by educated commentators as a mob rabble or scum as often as they were dubbed a crowd. In the *Dictionnaire de l'Académie française* (1786) the crowd is identified as "in a hurry, a multitude of persons... [prone to] oppression, undue and violent vexation."[11] Officials might call on crowds to validate displays of power, as in royal processions, religious and civil celebrations, or government-sanctioned executions organized by central regimes. But monarchists also feared the dark potential of mob violence: crowds invited a disruption of public order and embodied the potential for revolutionary militancy. Using little more than barricades and chains, Parisians banded together to block city streets in both 1588 and 1648, barring royal troops from the urban core. By the eighteenth century, governments attempted other means to monitor crowd activities. Aside from regular soldiers, for instance, the Parisian police forces regularly paid informants and spies to infiltrate gathering crowds.[12]

During the French Revolution, such systems collapsed and crowds began to exert political power. Episodes like the storming and takeover of the Bastille demonstrated how loosely affiliated groups of individuals could gather together and decisively shape political events. Nevertheless, depictions of crowds from this period failed to invest their subjects with a sense of unified objectives. For instance, Pierre-Gabriel Berthault's print after Jean-Louis Prieur depicts *Camille Desmoulins Le 12 Juillet 1789* (c. 1789), showing the journalist and politician inciting Parisians to rise against the king. Although this plea resulted

in a unified action, the taking of the Bastille two days later, Prieur's scene represents not a crowd but rather numerous individuals slowly coalescing into a disjointed group. While men race to join the body of listeners in the background, an elegant family fleeing the scene occupies much of the foreground. Fenced in by a long row of elegantly trimmed trees, the assembly competes for the viewer's attention with the artist's detailed rendition of the neoclassical arcade of the Palais Royale.

Not until the middle of the nineteenth century, simultaneous with the rise of mass suffrage movements across Europe, did artists undertake concerted efforts to depict anonymous, plebian crowds acting in unison, as if of a single will. Honoré Daumier's *L'Émeute* (c. 1860), inspired by the Revolution of 1848, evokes such a crowd not by taking in its size but by focusing on a few of its members. The painting hinges on an otherwise unremarkable man emerging from a crowd while simultaneously acting as part of it. Lifting his right hand in defiance, this white-shirted figure cuts sharply across the composition, defining in turn his five or six shadowed compatriots whose faces are contorted with anger; his fist breaks the upper right corner of the canvas and their glances follow it, as all the bodies seem to pivot in unison. A vast crowd is only suggested through dark, irregular shapes visible between this man and his fellows: A protruding top hat and other rounded shapes imply hundreds of people, all of them jostling in the confines of a narrow Parisian street. Rather than Berthault's journalistic depiction of a historical event, Daumier evokes a spirit of communal frustration and release, and his unified crowd becomes both more powerful and more threatening in its anonymity.

If democratic movements in the nineteenth century invested the crowd with new and

tangible political power, such changes were also quickly acknowledged by governments themselves. In 1864 Napoleon III's government acknowledged a worker's right to strike; in 1884 the Third Republic ended a ban on French labor organizations. Organized individuals could band together in marches or as protest to express a united political will. By May Day, 1890, when workers in industrialized nations held the first international show of solidarity by striking for the eight-hour day, the power of the general strike was clear; organized masses could exert impressive political pressure.

By century's end, social theorists took note. Reflecting on developments during the Paris Commune, when citizens' militia rejected the central government and set up a provisional alternative government, the flamboyant and popularizing French sociologist Gustave Le Bon judged crowds to be essentially sinister. In his best selling *The Crowd: A Study of the Popular Mind* (1895), Le Bon argued that crowds are capricious, susceptible, easily manipulated, and likely to erupt into violence; above all, he believed that people engage in fundamentally irrational behavior when they act in groups.[13] Le Bon applied his precepts to apolitical congregations of women at department store sales as well as to workers assembled for a general strike. One of a growing number of practitioners in the emerging field of sociology writing on crowds at this time, including Gabriel Tarde and Scipio Sighele, Le Bon garnered considerable influence. Sigmund Freud formulated many of his theories on collective psychology based on Le Bon's writings. Conservatives in the contemporary French military, and later Mussolini and Hitler, studied his analyses. Le Bon called crowds inherently "feminine," arguing that they are suggestible and easily fooled.[14] Socialist claims

to represent these crowds made them, in Le Bon's view, suspect. Le Bon not only disdained crowds, but he believed that socialism could sap moral fiber, shaping a new religion that appealed to sentiment more than reason.[15]

The crowd, of course, appeared quite different to theorists on the political left. What cultural conservatives saw as disorganized and disruptive mob behavior was cast by leftists as positive collective action. By mid-century, political theorists like Karl Marx embraced the "masses," giving linguistic dignity to the large and increasingly self-confident working classes. Less radical socialists also welcomed the relatively new idea of organized group action. After the French government legalized union organization in 1884, carefully structured group protests replaced spontaneous demonstrations. Labor leaders encouraged disparate groups with diverse memberships to act in concert and focus both public and official attention on their collective demands. By the late nineteenth century, both European and North American labor organizers had developed a keen tactical sense in planning strikes; rather than deploying workers as an act of desperation, strikes were used as leverage or mounted as purely symbolic actions. The power of the crowd was recognized as a crucial political tool.

But the Left's most insistent rejoinder against theorists like Le Bon was the transformation of the crowd into a compelling visual icon; such images also inspired unity among the ranks. Jules Grandjouan's *La Révolution* (fig. 3.1) assembles a crowd into an improbable pile, its vertiginous angle resembling a steeply sloping mountain leaning in sharp ascent. In the lower foreground, several individuals gesticulate, exhorting with outstretched arms as well as raised hammers and sticks. But the massive upward thrust of this faceless

multitude, with occasional clusters of laborers sharply defining its roiling black form, dominates the poster; scattered constellations of anonymous but individual heads ascend the mighty summit in rhythmic unity. Grandjouan's composition makes concrete the growing power behind the mobilization of general strikes.[16] Moreover, its visual allusion to both mountains and waves recalls what contemporary commentators began referring to as "the rising tide of socialism."

Trained as a lawyer and from a middle-class background in provincial Nantes, Grandjouan was one of the French Left's earliest and most persuasive poster artists. Dedicating himself to socialist and anarchist causes, Grandjouan epitomized the ideal of a politically committed "artiste engagé." He made his name in *L'Assiette au Beurre*, France's leading satiric journal of social protest during the belle epoque. But Grandjouan's vision for social action reached far beyond the pages of a single journal; he idealized the notion of strikes and assembled crowds. *La Révolution* remains his most succinct visual statement; a visual symbol of a social movement, his crowd unites individuals in common bond. While a few raised arms and clenched fists emerge, individual gestures or attire hardly matter; instead, its tangible unity stretches to infinity, endowing the group with the brute force necessary to overturn governments, monuments, and even history itself.

Anonymous crowds appear in earlier advertising, but to different effect. In the posters of Henri Toulouse Lautrec and Jules Cheret, faceless clusters of onlookers frequent the darkened edges of crowded dance halls and cabarets. Toulouse Lautrec's *La Goulue* (1891) depicts the Moulin Rouge's star Louise Weber dancing the cancan against the sharp relief of silhouetted spectators. The shadowy crowd fringes the dance floor, their individual forms

articulated with fashionable top hats, broad collars, and the shapes of feathers curling from women's hats. Lautrec's crowd inhabits a mysterious place in its own right, forming a shadowy crescent around the dancer. It remains deliberately ambiguous. How are they reacting to the dance? Or are they even paying attention? Lautrec's assembly smacks of sophisticated ennui; Grandjoaun's crowd crackles with resolute purpose, marching purposefully across the surface.

Posters by Grandjouan and others concretize the abstract concept of the people's will, visually defining and shaping notions of the crowd. But they were also intended to be seen by the crowds that they pictured. Placed on walls, store windows, boarded up buildings, fences around empty lots, or on specially built kiosks, posters embellished public spaces in the teeming streets of London, Paris, and New York. Posters' impact was often achieved through saturation, by sheer repetition of hanging. Indeed, public postings so pervaded urban areas that some governments even taxed them. Political posters inevitably competed with the huge assortment of commercial bills, advertising vaudeville acts, soap, and beer; struggling for the attention of distracted passers-by, designers favored clear, easily legible compositions that relied on sharp contrasts in size and color coupled with clear, bold typography. Politically minded designers employed similar tactics, favoring simple, massive groups of figures deployed alongside graphic exhortations. Developing a visual vocabulary to express the concept of crowds, artists like Grandjoaun conceived the political poster as transforming a public space from a marketplace of desire to one of protest.

These political posters urged nothing less than social redirection and reconstitution. In posters like *Ne vote plus, prépare la révolte* (1910),

designed by Grandjouan and sponsored by the Comité Révolutionnaire Antiparlementaire, a dark, green-tinged crowd wielding batons gathers menacingly around a group of beribboned, top-hatted capitalists; oblivious, the bourgeoisie chatters and guffaws among themselves. His 1908 *Les victories de la IIIe République, Villeneuve-Saint-Georges,* a poster for l'Union des syndicates du département de la Seine, portrays a great black triangular wedge of helmeted cavalry slashing through a crowd of unarmed workers; pools of red blood gather underneath fallen elderly men. Another poster, *Cheminots syndiquez-vous* (1910) for the national railways union, contrasts a gray, haggard crowd of workers against a few gigantic golden-orange balloons, caricatures of industrialists and upper management figures. Both groups are tagged with job titles and descriptions of each worker's wages; the engineer-in-chief of the railway garners 44,000 francs per year, while a driver earns a mere 126 francs.

During World War I, many socialists joined the war effort. While Grandjouan remained silent during much of this period, Steinlen created posters that supported humanitarian causes. Nevertheless, beyond socialist circles, images of the crowd were increasingly deployed to reinforce the war effort. An anonymous recruitment poster for the British Armed Forces, *Come into the Ranks and Fight for your King and Country—Don't Stay in the Crowd and Stare* (1915), shows an orderly uniformed parade cutting a dark swath through the middle of the frame, while an assembly of men gazing at the line occupies the lower portion. No longer powerful or menacing, this crowd is passive, shamed by its inactivity; it is exhorted to "ENLIST TODAY." Meanwhile, a vast, modern French infantry brigade marches underneath the Arc de Triomphe in

a 1917 poster by Georges Goursat (Sem); the company is joined by a celestial column of Napoleon's Grand Army who descend from the monument on a curling cloud to join their corporeal counterparts.

With the rise of Bolshevism in the immediate aftermath of World War I, depictions of the crowd assumed new significance, as many socialists embraced the implications of the recent revolution in Russia. While this vision remained more promise than reality for most European leftists, the Hungarian Soviet Republic was declared in March 1919. The Hungarian artist János Tábor celebrated this upheaval while suggesting the inexorable progress of the new red armies in *Vörös Katonák Elöre* (1919) (fig. 3.2). Announcing the movement of "red soldiers forward," it deploys the crowd now as an advancing army marching to

Fig. 3.2 János Tábor, *Vörös Katonák Elöre,* 1919

revolutionary ends.[17] The poster is dominated by two muscular, grimacing figures who lunge before a massive red banner. Tábor suggests the site of their eventual triumph by depicting the pair towering over the smokestacks of a distant factory; a vast revolutionary army is implied by the tips of flags and bayonets that surge across the picture plane as if extending indefinitely.

Sharp and persuasive, Tábor's poster took pains to portray the socialist crowd as more than an armed mob; it was organized, dynamic, and increasingly threatening to political conservatives. For them, the crowd's power seemed to further endanger an already fragile social structure. By 1919, when Tábor's poster first appeared, revolutions had occurred in Hungary and Russia, and more leftist uprisings rocked Austria, Germany, and Spain in the immediate postwar years. Political conservatives responded in part by redeploying the powerful crowd imagery claimed by the Left. Bogdan Nowakowski's *Patrzcie Dokad Prowadza narod' Socjalisci!* (c. 1925) implored Poles to "look where the socialists are leading the people!" (fig. 3.3). This work upends the visual rhetoric that socialists had carefully crafted; rather than sneering, top-hatted capitalists, Nowakowski's antagonists are uniformed, whip-wielding leftists who herd a crowd of ethnic Poles off a precipice. As the column of innocent marchers falls into an abyss, a German, a Jew, and a Russian exult in the foreground. The Polish populace, depicted wearing distinctive garb such as the red striped pants and boots typical of Lowicz and the close-fitting velvet coats of the Polish nobility, march unwittingly to their demise. Their tormentors, bearing banners inscribed with the initials of political groups like the Polish Socialist Party, which opposed the nationalist regime then in power, are clearly in the pay of the caricatures of Poland's ethnic

Fig. 3.3 Bogdan Nowakowski, *Patrzcie Dokad Prowadza narod' Socjalisci!*

minorities: The German in a spiked helmet rubs his hands in obvious glee, while the Jew in a prayer shawl and the Russian in a bearskin hat hold aloft great bowls of coins; one of the whip-wielding persecutors greedily grabs a handful of money.[18] Nowakowski employs motifs similar to earlier socialist poster designers like Grandjouan, including visual tropes like the exaggerated foreshortening of the herded Poles. But this crowd more closely recalls Le Bon's admonitions a generation earlier; easily led, it is also easily duped.

Visualizations of the crowd were deeply ingrained in European socialist imagery. Indeed, they are often crucial to its burgeoning self-image. But the visualization of American socialism took different forms. Growing out

of important labor union activity in the late nineteenth century, as well as the actions of immigrants who brought Marxist doctrines from Europe, American socialism was an amalgam of foreign and nativist influences. After 1901, the year that the Socialist Party of America was founded, the group elected two members to Congress and numerous local mayors, state legislators, and city councilors. Its strongest support came from Jewish and German immigrants. But American-born coal miners, railway workers, and midwestern farmers also backed the group in large numbers. Like their contemporaries, American socialists adopted political imagery slowly, developing a visual vocabulary only in the wake of more vibrant commercial advertising. As in Europe, most American socialist posters and literature remained laden with text through the early years of the twentieth century. However, American socialist imagery never developed along the lines of European counterparts; critics like Le Bon aside, American socialists were less captivated by the power of the crowd.

The IWW, or Industrial Workers of the World, popularly known as the Wobblies, represented the most radical fringe of the American socialist movement. Although their rhetoric and actions echoed the goals of their European counterparts, emphasizing the need for unions based on direct action and militant solidarity, they recruited those overlooked by the trade- and skills-based unions like the American Federation of Labor. Seeking out unskilled workers, immigrants, nonwhites, women, and migrant workers, they also crafted a confrontational identity. Through Joe Hill and other charismatic leaders, inspiring songs like "Solidarity Forever" and "There'll Be Pie in the Sky When You Die (That's a Lie)," and specialized lingo, such as "muckamuck" to denote diffident authorities, the IWW

outstripped their less radical Socialist Party rivals by developing a distinct culture of protest. Wobbly songbooks, posters, and other printed ephemera suggest a dynamic subculture. But they avoided depictions of crowds. The IWW was instead widely associated with a distinctive graphic rendition of an arch-backed, defiantly hissing black cat. Another of its primary visual expressions was a rough line drawing of a bare-chested man poised to step out of a poster's frame (fig. 3.4). Emerging from an industrial complex of smokestacks and factory buildings, he gazes out with intensely focused eyes and raises his right hand in salute. This iconic figure was almost always matched with the portentous phrase "The IWW is coming."

Solitary, powerful male figures are similarly common in turn-of-the-century European socialist imagery. Socialist publications

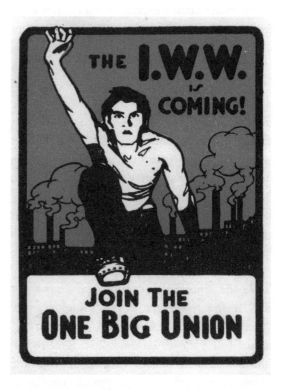

Fig. 3.4 Anonymous, I.W.W. Is Coming!

like *Avanti* and *Vorwarts* used a single figure to symbolize the entire workers' movement. But these figures remain virile and remote, in contrast to the lean, hungry, and personally aggressive Wobbly poised to pounce at any moment. In some ways the rhetoric and policies of the IWW may more closely be equated with European anarchists; certainly, the Wobblies deemphasized the concept of collectivity, so prized by European socialists. Wobbly strikes were incendiary affairs lacking leadership; at one such protest, management negotiators aiming to enter deliberations approached strikers demanding to know "Who is your leader?" They were bluntly told "We're all leaders!"[19] In practice, the IWW refused to negotiate contracts, arguing that signed documents were restrictive, and opting instead for the unconditional right to strike as needed. Such emphasis on anarchic individualism was perhaps better expressed by arching cats or lean, menacing young men as opposed to anonymous crowds who march in unison and share a unified will.

But the IWW was not alone in its rejection of crowd imagery; virtually all American socialist imagery avoided representations of organized groups. Socialist posters promoting the presidential runs of union leader and Socialist Party of America nominee Eugene Debs in 1904, 1908, and 1912 feature the candidate's face, not the assembled masses that he represented. Americans' pervasive acceptance of individualism and democracy also diluted the appeal of the crowd. Others, like the radical Wobblies, were hostile toward group organization, rejecting the very idea of collectivity.

Even in Europe, the promise of the crowd was greeted with skepticism. In 1895 Gustave Le Bon insisted that "the age we are about to enter will in truth be the ERA OF CROWDS."[20] Le Bon feared this new age

and intended his writing to be a diagnostic; warning against crowds' easy manipulation, he urged others to study crowd psychology. But a younger generation of politicians applied Le Bon's observations to different ends; ideas of propaganda and mob control obsessed politicians like Hitler and Mussolini in the first decades of the twentieth century. Hitler, for instance, read Le Bon avidly, paraphrasing Le Bon extensively in *Mein Kampf*.[21] Mesmerizing in their repetition of simple concepts, his speeches reinforced Le Bon's precepts on mass psychology; with their organized marches, spectacular night lighting, and compelling speeches, large Nazi rallies like the carefully choreographed assemblies held at Nuremberg applied Le Bon's concepts of crowd manipulation on a massive scale.

Where Grandjouan's *La Révolution* opened the century with a rousing depiction of the power of the crowd, an anonymous Nazi poster from 1934 pastes a photograph of Hitler over a photo of a large assembled group of Germans. The socialist promise of the crowd, as delineated by Grandjouan, is transformed in National Socialism into something different. A crowd enthusiastically raises their arms in a Nazi salute. The caption reads "Yes! Führer We Will Follow You!"

NOTES

1. Writers as diverse as Alexis de Toqueville in *Democracy in America* (1835) and Karl Marx in *The Communist Manifesto* (1848) used the term *masses* to describe the ordinary people as a unit, especially in political or economic contexts. The term *age of the masses* gained currency when Friedrich Nietzsche's *Jenseits von Gut und Böse* [Beyond Good and Evil] (Naumann, 1886) described contemporary European civilization as belonging to "the age of the masses, who prostrate themselves

before everything built on a massive scale."
For more on this topic see Michael D. Biddiss, *The Age of the Masses: Ideas and Society in Europe Since 1870* (Humanities Press, 1977).

2. Raymond Williams, *Culture and Society, 1780–1950* (Columbia University Press, 1958), 300.

3. With its roots in Enlightenment notions of individual liberty, nineteenth-century liberalism, and the idea of popular rule owes a debt to eighteenth-century thinkers like Charles Montesqieu, John Locke, Thomas Hobbes, and Jean-Jacques Rousseau. The concept of popular sovereignty, in which the populace is governed by the will of the people, motivated American revolutionaries like John Adams, Thomas Jefferson, and Thomas Paine, as well as such French revolutionaries as Maximilien Robespierre. For more on nineteenth-century European liberalism see Jan Goldstein and John W. Boyer, *Nineteenth-Century Europe: Liberalism and its Critics* (University of Chicago Press, 1988). For more on British liberalism, see Richard Bellamy, *Victorian Liberalism: Nineteenth-Century Political Thought and Practice* (Routledge, 1990).

4. Ultimately derived from Plato's image in *The Republic* of a perfectly run polis, More's vision was based on a preindustrial, agrarian economy dominated by farmers and craftspeople. Before the Industrial Revolution, other protosocialists include the Levellers, who in the 1640s advocated the equal distribution of private property during the English Civil War. More than a century later, the *sans-culottes* agitated for a system of property sharing. For more on socialism's roots, see Joshua Muravchik, *Heaven on Earth: The Rise and Fall of Socialism* (Encounter, 2002).

5. For these reasons, the first organized working-class movement took place in Great Britain. In the late 1830s and 1840s, organizers of the Chartist movement demanded equal rights, including universal suffrage and economic equality. Cotton workers and colliers were among the first to participate in the 1842 General Strike, stopping production across Great Britain. For more on the British labor movement, see James Hinton, *Labour and Socialism: A History of the British Labour Movement, 1867–1974* (University of Massachusetts Press, 1983).

6. In the nineteenth century, diverse British and French social critics, including the philosophers Pierre-Joseph Proudhon, Charles Fourier, Louis Blanc, Henri de Saint-Simon, and Robert Owen, attacked the excesses of poverty and inequality that characterized the Industrial Revolution. In *The Communist Manifesto* (1848), Karl Marx and Friedrich Engels argued for universal equality and the overthrow of capitalism. More moderate democratic socialists, often associated with trade unions, and socialist political parties emerged by the late nineteenth century, advocating the use of democracy and legally sanctioned means toward power.

7. Max Gallo, *The Poster in History* (Norton, 2000), 84.

8. For more on the richness of political rhetoric of these presses in one country, Germany, see Alex Hall, *Scandal, Sensation and Social Democracy: The SPD Press and Wilhelmine Germany, 1890–1914* (Cambridge University Press, 1977).

9. For further discussion of the representation of crowds in twentieth-century poster art, see Jeffrey T. Schnapp, *Revolutionary Tides: The Art of the Political Poster 1914–1989* (Skira, 2005).

10. See, for instance, Marcel van der Linden and Jürgen Rojahn, eds., *The Formation of Labour Movements, 1870–1914: An International Perspective,* 2 vols. (Brill, 1990). For more on the late nineteenth-century development of collective action across Europe, see Stefano Bartolini, *The Political Mobilization of the European Left, 1860–1980* (Cambridge University Press, 2000).

11. *Dictionnaire de l'Académie françoise,* vol. 1 (Beaume, 1786), 540.

12. Thomas Manley Luckett, "Hunting for Spies and Whores: A Parisian Riot on the Eve of the French Revolution," *Past and Present* 156 (August 1997): 125–27.

13. Gustave Le Bon, *The Crowd: A Study of the Popular Mind* (Macmillan, 1895; English edition, 1896), 12–13.

14. Le Bon, *The Crowd,* 21–23.

15. Gustave Le Bon, *Psychology of Socialism* (Macmillan, 1899).

16. Fabienne Dumont, "Jules Grandjouan, l'image de la révolte," in *Jules Grandjouan: Créateur de l'affiche politique illustrée en France.* Exhibit Catalog. (Masion du livre et de l'affiche, 2001), 25.

17. Schnapp, *Revolutionary Tides,* 126.

18. Schnapp, *Revolutionary Tides,* 123.

19. Franklin Rosemont, *Joe Hill: The IWW and the Making of a Revolutionary Working Class Counterculture* (Charles H. Kerr, 2003), 8.

20. Le Bon, *The Crowd,* xv.

21. Alfred Stein, "Adolf Hitler und Gustave le Bon," *Geschichte in Wissenschaft und Unterricht* 6 (1955): 362–68.

AVANT-GARDE ART AND THE CULTURE OF PROTEST: THE USE-VALUE OF ICONOCLASM

Jelena Stojanović

Originally a military phrase, the term *avant-garde* entered artistic and critical vocabulary in the nineteenth century from politics, where it was well established and in continuing use since the French Revolution, albeit connoting radically opposed political stances at times.[1] This metaphorical trajectory indicates the novel social and political role ascribed to art by industrial capitalism, which conceived of art both as a political force and a productive activity.[2] From the beginning, the rhetoric of contestation was integral to the avant-garde project and instrumental to its aim of subverting, among other things, the dominant aesthetic. Art thus moved from the realm of purely formal disputes into the public arena.

Since the early 1970s the rhetoric of contestation has been perceived mostly as underlining the avant-garde's ambivalence: "The avant-gardist protest, whose aim it is to reintegrate art into the praxis of life, reveals a nexus between autonomy and the absence of any consequences."[3] This verdict announced a renewed theoretical interest in the "avant-garde failure," that is, its rising institutionalization at a historically precarious moment.[4] The rhetoric of protest according to these interpretations identified avant-garde art as an ambivalent formation, constantly poised between a desire for a politically efficient role and a complete "lack of social impact."[5] This

same protest ultimately was seen to be a leveling measure dividing a true, authentic (historical, prewar) avant-garde from a formation known as neo-avant-garde: "Since the protest of the historical avant-garde against art as institution is now accepted as *art,* the gesture of protest of the neo-avant-garde becomes inauthentic. Having been shown to be irredeemable, the claim to be protest can no longer be maintained."[6]

This is how in the 1970s avant-garde practice and its rhetoric of contestation was appropriated and redefined. From an art called upon to lead and transform society by its destiny (*destinée*) as an unstoppable social utopian force,[7] with a strong belief in the political efficiency of the visual, the avant-garde became almost its opposite, characterized by a turn to "pure aesthetics."[8]

This chapter examines the reconfiguration of the visual and the way it informed and defined the logic of an avant-garde contestation recovering its materiality within a historically different context, when the nature of industrial capitalism was undergoing another successful transformation leading global economies into their spectacular phase.[9] Focusing on the practice of the Parisian Lettrists—founded by Jean-Isidore Isou in the late 1940s to counter Surrealist ideas by reviving certain aspects of Dada—in the early 1950s, at the beginning of

the Cold War, the chapter examines their use of iconoclasm (hatred of images, destruction of images) as a strategy conceived to recover the avant-garde's materiality. Their cinematic production is investigated as a case study, for cinema was at this historical juncture one of the foremost signs of upcoming global economic change. The chapter explores how the Lettrists' iconoclastic strategies both challenged and confirmed the neo-avant-garde project, perhaps complicating further the accepted and well-known sequence of a true avant-garde (authentic, prewar) followed by a neo-avant-garde (inauthentic, postwar).[10]

When Isou in his movie *Treatise on Slime and Eternity* (Traité de bave et de l'éternité, 1951) emphatically declared that he intended to destroy the image, was he merely radicalizing the avant-garde position? More importantly, how did the Lettrists' cinematic destruction of images complicate further the rhetoric of contestation, while revealing changes in the way visuality was to be lived in contemporary, spectacular society?

TO DESTROY THE IMAGE

Between 1951 and the 1952, the Lettrists produced an impressive number of films and in 1952 a special issue of the journal *Ion* entirely devoted to the cinema.[11] Cinema, cinematic representation, and debates regarding film's role in society occupied a prominent position in French postwar culture and politics. The tone was set early on. In 1944, before the liberation of Paris, Jean-Paul Sartre published "A Film for the Post-War," a manifesto-like text about the cinema and its role in society. For Sartre, cinematic representation was very different from theater or literature, since it had a unique power to represent fully the social.[12]

On the screen—and on the screen alone—is there a place for a crowd, maddened, furious or receptive. The novelist can evoke the masses; the theater, if it wants to represent them on stage must symbolize them in a half-dozen characters who take the name and function of the *chorus;* only cinema lets them be seen. And it is to the masses themselves that it shows them: to fifteen million, twenty million viewers.[13]

Only film has a capacity to speak "of the crowd to the crowd" (*de la foule à la foule*), and as such it is a privileged sociopolitical device. Hence, after the war film functioned as document, testimony, and catharsis after the national Calvary, enabling a national reconciliation. This new cinema for the postwar era would be liberated of all the ideological manipulations inflicted upon it during the Vichy regime. For Sartre the regime that resorts to ideological manipulation in cinema only exhibits its fear of cinematic power, which is a blatant display of a regime's lack of democracy and fear of the people. Hence, the liberation of cinema would follow the liberation of the country and be synonymous with a new political, democratic order in which the cinema could finally, freely, show to the masses "the masses themselves."[14]

This Sartrean cinematic utopia, in which the cinema and cinematic representation performs a role of political or democratic authentication, is not distant from early nineteenth-century avant-garde ideas about the role of visual representation in society. Both share a strong belief in the political efficiency of the visual, and its capacity to show unmediated truth to the masses while leading them to a new more democratic social order. However, only two years later the cinema and cinematic representation became engulfed in a very different debate, which only confirmed that the economical and political situation in France

had changed, or at least was about to change, dramatically. This further complicated the social and political implications of cinematic representation, while making it a top priority on the national agenda.[15]

In 1946, within a larger financial postwar settlement with the United States, France signed an agreement regarding cinematic production.[16] The Blum-Byrnes Accord, as this agreement became recorded in history, imposed a different kind of liberation than the one Sartre advocated. As a precursor of the Marshall Plan and its much more obliging economic "gift,"[17] the agreement imposed the liberation of the French cinematic market through a series of stipulations, forcing it almost unconditionally to open to the American film industry.[18] American competition quickly threatened to extinguish French movie production altogether.[19] Public protest was loud, people took to the streets, and national pride was invoked. The overwhelming feeling was that the American presence could be easily compared to that of the Germans, the difference being that the former imposed commercial pressure, the latter, military.[20] Fear of the long-term, systematic flooding of culture with purely commercial products without aesthetic value was pervasive. A member of the French film industry dramatically compared the long-lasting effects of such a transaction to the effects of an atomic bomb.

> There is no doubt that a film is a commodity; however what does the economic value of this commodity represent compared to the human value which it stands for?
> There are other arms than the atomic bomb.[21]

More important, and more disturbing to French audiences, this economic transaction, perceived to sound the death-knell of the already lethally wounded French film industry, came in a heavily ideological coating. It is almost as if the Cold War rhetoric offered a happy respite for the American film industry and its commercial interests. The overwhelming presence of Hollywood movies in France and Europe (and in the world by the same token) is needed, the explanation was offered, because only Hollywood movies can perform efficiently and satisfactorily in a decisive ideological battle. Or as an American administrator explained it bluntly:

> American cinema is and should always be an arm against Communism....American movies bring palpable evidence about the lies of totalitarian propaganda. The old legend about the decadence of capitalism in the USA falls apart as soon as the public has an opportunity to see our films and draw the conclusion for themselves.[22]

The Blum-Byrnes Accords, although somewhat amended in 1948, easing the French position, earned the infamous label of a *légende noire* (black legend).[23] They confirmed not only the socially, economically, and politically changed status of the film industry in postwar France, but more importantly, a social change in the understanding and interpretation of cinematic representation. Moreover, this historical episode pushed France into increasing institutionalization and state protection of the film industry.[24]

Film became an exemplary instance of a political economy in which cinematic representation serves as an ideological battleground while the correlation between economy and politics is skillfully blurred. The overwhelming and continuing (global) presence of Hollywood "*navets*,"[25] crass, commercial movies devoid of any but exchange value, signaled a new historical turn, one in which a new

generation of consumers eagerly threw themselves wholeheartedly into the bureaucratic society of controlled consumption, the society of spectacle.

CHISELING THE CINEMA

Lettrists saw film as central to their project. *Le cinéma ciselé,*[26] or "chiseled" cinema, was an early and radical Lettrist response to changes in the French film industry and society. The film manifesto that effectively introduced the Lettrist response was *Treatise on Slime and Eternity* (Traité de bave et de l'éternité), produced in 1951 by Isou. The manifesto is, of course, an avant-garde genre in itself, confirming both the political commitment of avant-garde art and, more importantly, a desire for change.[27]

For the first public screening of his still-unfinished production, Isou chose the Cannes Film Festival. Though only starting to build the reputation it has today, when the festival opened its doors to the public in 1946 it already represented an important artistic and cinematic venue in Europe. Isou's screening created a public scandal, due to in part perhaps to the film's unfinished state, although it seems that the youth of the director, combined with his novel filmic approach, contributed to the audience's shock. Isou was barely twenty-six years old at the time, and the film seemed to be organized around his alter ego Daniel, with his wide-ranging speculations and provocations ranging from cinema and politics through love, economics, philosophy, poetry, and literature. In this Isou was joined by Lettrist colleagues and an imaginary audience, which responds to Daniel's provocations and challenges him further by asking questions, whistling, and interrupting.

At the beginning of the film Daniel/Isou declares:

> I believe firstly that the cinema is overloaded. It is obese. It has reached its limits, its maximum....Under the blow...this greased pig will tear into a thousand pieces. I announce the destruction of the cinema, the first apocalyptic sign of disjunction, of rupture, of this corpulent and bloated organism which calls itself film.[28]

Destroying cinema meant destroying the way cinematic images were formed to undo the seamless, phantasmagoric quality abundantly available in mass-produced productions. This was a task for "chiseled" cinema. The chiseling or metaphorical destruction operates on several levels: narrative, filmic, and most importantly, iconic (see fig. 4.1.)

As Isou explained a year later, film is an art of reproduction.[29] In the past it referenced different artistic genres, predominantly literature. To free film from this narrative prison and to achieve purity in the medium, "chiseling" the cinema should consist of carving the image (*la ciselure d'image*), in which the filmmaker deliberately scratches or paints onto the actual film stock itself, and discrepant editing (*le montage discrépant*), in which the soundtrack and the images would be separated. Traditional montage according to Isou created an illusion of continuity that imprisoned the audience, not allowing them to think and see clearly. Moreover, the existing form of montage "detaches us [the viewers] from the image and its reality, makes us [the viewer] indifferent to it."[30] Hence, *chiseling* the cinema combined with the *discrepant* editing could destroy viewers' identification, the spell that the traditionally edited image creates.

In practice this means that while Isou's film consists of three parts, or three chapters, as Isou called them, the Principle, the Development,

Fig. 4.1 Isidore Isou, *Traité de bave et d'éternité,* 1951. Film still.

and the Proof, they are unrelated to each other. In a parody of classical rhetorical form, announced in the title of the film, Isou's film exhibits no narrative links or coherence. The three filmic parts function as autonomous circles, each without beginning or end. Sound and image are rendered autonomous, each part acting as a self-reflexive exploit.

In the first part, *Principle,* the audience follows Daniel/Isou down the Boulevard St. Germain-des-Près, the heart of bohemian postwar Paris, a move imitated by many subsequent directors.[31] The accompanying monotone litany pronounced by Isou/Daniel, attacking conventional cinema and announcing the Lettrist

project, is completely detached from the image. The scribbling and scratching over of reused film footage (French military newsreels) visible in the second part of the film, *Development,* again is independent from the soundtrack, in which one can hear members of the group reciting Lettrist poetry as a background noise. Finally, documentary footage presenting members of the group is incorporated to form with the reused footage the *Proof,* what Isou also called palimpsest cinema (*cinéma palimpseste*). This cinematographic work, "one of the most powerful films,"[32] thrives on incongruence, literally and metaphorically destroying the image in order to free film. "Isou turns

pictures upside down, scratches on them arbitrarily and does everything he can think of to spit upon and destroy the film image."[33]

The film succeeds in creating an almost sadistic attack on the senses (the name of the Divine Marquis, the Marquis de Sade, is mentioned throughout) with the credits intervening three times during the film, disrupting and mocking the convention of beginnings and endings. The movie, originally four and a half hours long, was pared to barely two hours,[34] thus playing with spectatorial expectation while denying the viewer any form of identification. All of these—the ways Isou manipulated expectations, mixing "found" film with new footage, and doing hand intervention in editing—were quickly recognized as a powerful experiment in the Parisian cinematic milieu.[35] The film's iconoclasm was recognized as a desire to return to cinema "as it is," a bold gesture that freed cinematic form from its subservience to narrative and photography, and more importantly from commercial, mass-produced entertainment. As Isou later claimed, the goal was to reintroduce in cinema a human, authorial presence, by the young.[36]

ION, OR HOW TO REIMAGINE THE (YOUNG AND ALERT) SPECTATOR

A few years before, Isou had published an eight-page manifesto. It addressed the *Youth Uprising* (Soulèvement de la Jeunesse) and attacked what the author believed was merciless exploitation of youth. He explained that revolutions thus far had failed because their focus was misplaced. The real antagonism lay between two different populations, the young and the old. There was a need for youth to take their destinies in charge and to formulate their political and economical demands,

freeing themselves from the old social control. To do so, they had to become cognizant of their social role, as a revolutionary body leading a modern revolution. The manifesto and the journal of the same name published between 1952 and 1955 were to raise consciousness and rally youth around a just cause. Not unlike the great social utopians who originated the avant-garde idea, Isou conceived of himself and his art in the service of a great social transformation.

For Isou the social transformation was to free a traditionally subjugated, excluded, and marginalized slice of population, youth, with the help of art as the purest form of creativity. Freeing youth and its creative potential, he believed, would form the basis of a better and more just society. To this end Isou developed a theory, the Créatique, expressed in a letter consisting of thousands of handwritten pages explaining in minute detail his ideas about the complete reversal (*bouleversement*) and renewal of human sciences and the arts.[37] "Chiseling" cinema was part of his overall program, which included all aspects of creativity.[38] The manifesto also functioned as a rallying cry; initially Lettrism consisted only of Isou and Gabriel Pomerand, gradually increasing its visibility by creating public scandals, thereby attracting quickly a number of young artists.[39]

The first big public occasion to both popularize Lettrist ideas and attract new followers was the Cannes festival of 1952. Concurrently, the only issue of the journal *Ion* was published, the sole collective Lettrist publication on cinema, with contributions by all the young members of the group at that time. (The average age of participants was twenty-one.) Soon after the journal's publication and the film screenings, these young members abandoned Isou, the exception being Gabriel

Fig. 4.2 Marc-Gilbert Guillaumin (Marc'O), *Ion*, 1952. Magazine cover, recto.

Fig. 4.3 Marc-Gilbert Guillaumin (Marc'O), *Ion*, 1952. Magazine cover, verso.

Pomerand. Thus *Ion* is the only document that attests to the incredible energy of the group at that time (figs. 4.2 and 4.3).

An edition of 100 copies of the journal was printed, plus 26 *hors commerce* (not intended for sale) copies signed by the authors. The issue had 290 pages and included Isou's text on the aesthetics of cinema, a conceptual and theoretical explanation of his iconoclastic strategies to which all members subscribed. Isou's essay on film aesthetics offered a theoretical elaboration of Lettrist iconoclastic strategies. In his peculiar rhetorical, and often prophetic, mode, Isou elaborated his idea that critical thinking about the medium mattered most, emphasizing the necessity to work for the destruction of cinema. In addition to the elements he had already tested in his own movie a year earlier, including discrepant editing

(*le montage discrepant*) and chiseled reproduction (*la réproduction ciselée*), Isou introduced a number of new and different terms relevant for a cinematic production, such as meca-cinematography (*la meca-cinématographie*), dealing with the cinema mechanics, and eco-cinematography (*l'eco-cinématographie*), dealing with reception of cinema and its economics.[40] He concluded by stating his conviction that the cinema as it now existed would disappear, leaving only debates about film of the past: "le film, en tant que tel disparaîtra, faisant place au simple débat sur le cinéma passé."[41]

The essay was followed by complete soundtracks and scenarios for Gabriel Pomerand's *La Légende Cruelle*, Guy-Ernst Debord's *Hurlements en faveur de Sade*, Francois Dufrene's *Tambours du Jugement Premier*, Gil J. Wolman's *L'Anticoncept (Argument Cinématochrone*

pour une Phase Physique des Arts) and *Ion's* editor Marc'O's *Le Cinéma Nucléaire.*[42] The entire issue operated under the ironic proclamation of the end of French cinema. ("Fini le Cinéma Francais," a pamphlet, was distributed at the same time at the festival.) Isou himself made no more films.

The ideal cinema advocated in *Ion* would be open to large audiences. It is important to remember that Lettrist films were shown in small cine-clubs in Paris. The cine-clubs offered small audiences of true cinema lovers a low-cost cinematic experience, albeit in a disorganized and marginal manner.[43] The tradition was that each screening be concluded by a discussion, that is, when the screening was not interrupted as it had been with Debord's *Hurlements en faveur de Sade.* For Isou the cine-club offered a unique reception of film through a film-debate, dissolving the passive spectator and transforming him/her into an active participant.[44] The Lettrists' goal was to form a new public, young and alert, which would employ film as a tool of social change.

ICONOCLASM REVISITED

Gil J. Wolman's *The Anticoncept (L'Anticoncept)* offered a new take on iconoclasm. Wolman finished the film late in 1951; it was first presented to the public February 11, 1952 at the Cine-Club d'Avant-Gardes at the Musée de l'Homme in Paris. The film consisted of a one-hour black-and-white projection of non-images, flashes of different duration, on a spheric screen (fig. 4.4). In its conception, the film was more radical than Isou's film-manifesto and completely imageless. It was divided into two sections: a nonnarrative soundtrack, an interior monologue including physiological noises exemplary of Wolman's poetic experimentation, and a visual section built on the irregular

Fig. 4.4 Guy Ernst Debord, *L'Anti concept,* 1952. Poster for Gil J. Wolman's film.

alternation of black and white circles screened onto a meteorological balloon, "a fluctuating ball of light, projected onto a large balloon."[45] The film staged the cinematic, both reducing it and literally converting into it into an actual presence/absence of light. Wolman's ambition was to radicalize further the Lettrist protest of "chiseled" reproduction and discrepant editing by dispensing with all unfilmic elements, to create cinema-time (*le cinématochrone*), destroying any fictionality, something not completely resolved in Isou's cinema-manifesto.

Not surprisingly, Wolman's film was perceived by Lettrists as a radical iconoclastic response. First to respond was Guy-Ernst Debord, who dedicated *Howls for Sade* (Hurlements en faveur de Sade) to Wolman, and who pushed Isou's iconoclastic project further. Isou had clearly explained the goal of his

iconoclastic project: "Chiseling the photograph and lettrism (givens) are here an expression of revolt."[46] Debord's final version of his film, unlike the version published in *Ion,* rejected images completely.[47] The projection alternated a blank white screen when there was speech in the soundtrack, and a black screen accompanying ever-increasing periods of total silence (the longest being twenty-four minutes). This alternation was the only visual event. Even the hint or suggestion of shapes, still residual in Wolman's film, was avoided, as was anything that would create an illusion or distract the observer's attention from reality. The soundtrack consisted largely of Debord and Lettrist friends reading from the French Penal Code, interspersed with random comments on daily events or sentences taken out of their context, a strategy that would be defined a few years later as *détournement.*

The spectator, even against his or her wish, was becoming a participant, chasing every possible sign or clue of an expected and long-awaited cinematic event. At the beginning of the film, after having recited a short history of cinema, Debord famously declares, "There is no film. Cinema is dead. No more films are possible. If you wish we can move on to a discussion," thus "détourning" Isou's own words.[48] On June 30, *Hurlements* premiered, echoing Wolman, at the Parisian Musée de l'Homme Ciné-Club d'Avant-Gardes.

CONCLUSION: (NEO)-AVANT-GARDE CINEMA AND THE COLD WAR SPECTACLE, OR *GO HOME MISTER CHAPLIN!*

Toward the end of 1952, a "brilliant year"[49] for Lettrist cinema, another filmic event brought about a schism in the Lettrist group. The occasion was Charlie Chaplin's press conference at the Ritz Hotel in Paris, part of his promotional tour for *Limelight,* his last movie, considered by Lettrists and others, a *navet,* a gross example of commercial film. A group of Lettrists led by Debord and Wolman with the help of Jean-Louis Brau and Serge Berna staged the event. The event's format and the group's youthful derision and impertinence made this pure Lettrism. The four young men bypassed security, entered the conference room, and distributed a tract, "Finis les pieds plats" (Done with—or down with—flat feet).[50]

The flat feet of the title referred to Chaplin himself (referring to an earlier signature role), in Europe to promote his movie when the Cold War was in a full swing. Chaplin was one of the industry's first stars, a mix of ordinary people's hero and shrewd businessman (who owned his own production studio). In the early 1950s, he earned a reputation as a politically persecuted artist for his alleged Communist leanings. This is precisely the point that the Lettrists found contentious and attacked mercilessly. "We don't believe in 'absurd persecutions,' which make you a victim, you flat-footed Max du Veuzit" (a sentimental novelist who had died in 1952). For young artists and future members of the International Lettrists, Chaplin's alleged political difficulties were nothing but another successful marketing trick: "'The Immigration Service' is in French yet another name for 'the Advertising Agency.'" Chaplin, a "sub-Mack-Sennett director" and "emotional blackmailer," was working only for his own financial interests. The tract finished in English: "Go home Mister Chaplin."[51]

The event prompted a swift response from Isou and the remaining Lettrist members, Lemaitre and Pomerand. They were quick to disapprove the action by publishing their response in a Parisian daily, *Combat.*[52] Isou explained

that members of the Lettrist movement came together on the basis and principles of a "new knowledge." Lettrism had nothing to do with the event, called the "accident," which he felt was due to participants' "youthfulness." He was right: the young artists had no time for Isou's elaborated and often over-sophisticated tirades. They felt that the Lettrists were out of touch with what was happening in everyday society and culture.[53] The movement seemed to them to have become megalomanical and to have slid into neo-artificiality.[54] The future members of the International Lettrists didn't want to talk about the revolutionary potential of youth: instead, they were poised to make a revolution.

NOTES

1. For a collection of 500 political publications, dating to the French Revolution and later, and featuring "avant-garde" in their titles, see Robert Estivals, Jean-Charles Gaudy, and Gabrielle Vergez, *L'avant-garde* (Bibliothèque National, 1968).

2. Marc Le Bot, "Idéologies de l'avant-garde," *Peinture et machinisme* (Klincksieck, 1973), 130.

3. Peter Buerger, *Theory of the Avant-Garde,* trans. Michael Shaw (University of Minnesota Press, 1984), 22.

4. The events of 1968 provoked a first systematic series of speculations on avant-garde art. In addition to the works discussed in this chapter, there is the work of Renato Poggioli, Hans-Magnus Enzensberger, and Harold Rosenberg.

5. Buerger, *Theory of the Avant-Garde,* 52.

6. Buerger, *Theory of the Avant-Garde,* 53.

7. Nicos Hadjinicolau, "Sur l'idéologie de l'avant-gardisme," *Histoire et critique des arts,* no. 6 (July 1978): 66.

8. Roland Barthes, "Whose Theater? Whose Avant-Garde?," in *Critical Essays,* trans. Richard Howard (Northwestern University Press, 1972), 69.

9. Eric Hobsbawm, *The Age of Extremes, A History of the World, 1914–1991* (New York: Vintage, 1996), 225–372; Serge Berstein and Pierre Milza, eds., *L'année 1947* (Presses de Sciences Po, 2000).

10. François Albera, *L'Avant-garde au cinéma* (Armand Colin, 2005), 11.

11. *Ion,* no. 1 (April 1952), Centre de Création; reprint: (Jean-Paul Rocher, 1999).

12. Jean-Paul Sartre, "Un film pour l'après-guerre," *L'écran français* (April 1944), republished in *Les lettres françaises clandestines,* ed. Morgan Claude (1944), 3–4.

13. Sartre, "Un film pour l'après-guerre," 3.

14. Two years later Sartre undertook the same argument: "In my opinion, Orson Welles's oeuvre well illustrates the drama of the American intelligentsia which is rootless and totally cut off from the masses." Jean-Paul Sartre, "Citizen Kane," trans. Dana Polan, *L'écran français* (August 1, 1946), republished in *Post Script* 7, no. 1 (Fall 1987): 64.

15. Serge Guilbaut, *How New York Stole the Idea of Modern Art, Abstract Expressionism, Freedom, and the Cold War,* trans. Arthur Goldhammer (University of Chicago Press, 1983), 138.

16. Annie Lacroix-Riz, "Négociation et signature des accords Blum-Byrnes (Octobre 1945–Mai 1946) d'après les archives du ministère des affaires étrangères," *Revue d'histoire moderne et contemporaine* 31 (July–September 1984): 417–47.

17. Georges Bataille, "The Marshall Plan," in *The Accursed Share,* trans. Robert Hurley (Zone Books, 1991), 169–90. (Published in 1949 as *La Part maudite*).

18. On this, see Patricia Hubert-Lacombe, *Le cinéma français dans la guerre froide 1946–1956* (Editions L'Harmattan, 1996).

19. Susan Hayward, *French National Cinema* (Routledge, 2005), 25. See also Patricia M. Goff, "Invisible Borders: Economic Liberalization and National Identity," *International*

Studies Quarterly 44, no. 4 (December 2000): 533–62.

20. Laurent Le Forestier, "L'accueil en France des films américains de réalisateurs français à l'époque des accords Blum-Byrnes," *Revue d'histoire moderne et contemporaine* 51, no. 4 (2004): 86.

21. Louis Daquin, as reported in Hubert-Lacombe, *Le cinéma français,* 26.

22. Eric Johnston, the "czar of the American cinema," as the contemporary press called him, was the president of the MPAA (Motion Pictures Association of America). See Hubert-Lacombe, *Le cinéma français,* 84.

23. Jacques Portes, "Les origines de la légende noire des accords Blum-Byrnes sur le cinéma," *Revue d'histoire moderne et contemporaine* 33 (April–June 1986): 314–29.

24. See Hubert-Lacombe, *Le cinéma français.*

25. A French popular term for purely commercial, mass-produced movies.

26. Chiseled cinema is part of an overall Lettrist project, as explained later. See Isidore Isou, "Esthétique du cinéma," *Ion,* no. 1 (April 1952): 58–63.

27. Martin Puchner, *Poetry of Revolution, Marx, Manifestos, and the Avant-Gardes* (Princeton University Press, 2006) offers a detailed analysis of "a poetics of manifesto"; however, the seminal text remains Marjorie Perloff, *The Futurist Moment: Avant-Garde, Avant Guerre, and the Language of Rupture* (University of Chicago Press, 1986).

28. Isidore Isou, "Traité de bave et d'éternité," in *Œuvres de spectacle* (Gallimard, 1964), 15. Unless specified otherwise, all translations are the author's.

29. Isou, *Esthétique du cinéma* (Ur, 1951), 51.

30. Isou, *Esthétique du cinéma,* 86.

31. Michel Marie, "Les déambulations Parisiennes de la nouvelle vague," in *Paris vu par le Cinéma d'Avant-Garde 1923–1983* (Editions Paris Expérimental, 1985), 52.

32. Stan Brakhage, *Film at Wit's End, Eight Avant-Garde Filmmakers* (Documentext, 1989), 115.

33. Brakhage, *Film at Wit's End.*

34. The publicly available version is only 111 minutes long. The movie was produced and in part filmed by Marc-Gilbert Guilaumin, a.k.a. Marc'O, and finished by Maurice Lemaitre.

35. Maurice Scherer (alias Eric Rohmer), "Isou ou les choses telles qu'elles sont," *Cahiers du Cinema* 2, no. 10 (March 1952): 30.

36. Isou, *Esthétique du Cinéma.*

37. Mirella Bandini, *Pour une histoire du lettrisme,* trans. Anne-Catherine Caron (Jean-Paul Rocher Editeur, 2003), 13.

38. According to their doctrine as explained in a number of writings including Kladologie, or Creatique (Novatique), modern art develops in two successive phases, amplifying (*amplique*), a period of accumulation and expansion, and chiseling (*ciselante*), a self-critical, reductive, or rather destructive moment where all unnecessary elements are discarded to realize the purity of the medium, necessarily different for each artistic discipline.

39. Jean-Paul Curtay, *La Poésie Lettriste* (Seghers, 1974), 13.

40. Isou elaborates his ideas about the cinema in *Esthétique du cinéma.*

41. Isou, *Ion,* 190.

42. In addition, the following Lettrist films were realized in 1952: *La Barque de la vie courante* by Jean-Louis Brau, and *Le film est déjà commencé?* by Maurice Lemaitre. See Dominique Noguez, *Eloge du cinéma experimental* (Paris Expérimental, 1999), 189. Noguez is one of the critics who calls 1952 "a brilliant year" for the Lettrist cinema.

43. Noguez, *Eloge du cinéma experimental,* 180.

44. Frédérique Devaux, quoting from Isou's preface for *Le film est déjà commencé?,* the screenplay published in 1952 in Frédérique Devaux, *Le cinéma lettriste (1951–1991)* (Editions Paris Expérimental, 1992), 93.

45. Devaux, *Le cinéma lettriste,* 116.

46. Guy-Ernest Debord, "Prolégomènes a tout cinéma futur," *Ion,* 217.

47. The screenplay had several versions. See Guy-Ernest Debord, *Contre le Cinéma,* (L'Institut Scandinave de Vandalisme Comparé, 1964).

48. Guy Debord, *Œuvres cinématographiques complètes, 1952–1978* (Gallimard, 1994), 9–19.

49. Noguez, *Eloge du cinéma experimental,* 189.

50. The tract was reprinted in the first issue of the journal the newly founded group published, *Internationale Lettriste,* no. 1 (December 1952).

51. See the tract referenced in the previous note.

52. "Les lettristes désavouent les insulteurs de Chaplin," signed by Jean-Isidore Isou, Maurice Lemaitre, and Gabriel Pomerand, *Combat* (November 1, 1952); reprinted in *Internationale Lettriste* no. 1.

53. Jean-Louis Brau, *Cours, camarade* (Albin Michel, 1968), 13.

54. Robert Estivals, *La Philosophie de l'Histoire de la Culture dans l'Avant-Garde Culturelle Parisienne depuis 1945* (Guy Leprat, 1962), 160.

PART TWO

SCIENCE AND EMPIRICISM

INTRODUCTION

Jane Kromm

Part two examines the role of visual experience as a critical organizing principle in the development of modern science and the scientific method. A closer study of the ways in which visual models have actively shaped scientific processes forms the substance of this section, which also focuses on how important accountability and certainty, understood in visual terms, were for the empirical strain of the sciences from the late eighteenth century through the present. Contributions begin by establishing the pertinence of the visible to processes of conceptualization and discovery in the modern sciences and go on to examine the collections and specimen groupings that accentuate systemization in observable terms, and to consider the social and prescriptive uses to which such visual evidence has been dedicated. Visual protocols highlighted include the explanatory models called upon to clarify a range of phenomena, as well as those systems of classification dependent upon standard traits that were visibly discernible and whose patterns of variation could be readily tracked or even cultivated. Newly minted instruments and the public demonstration of scientific apparatuses and experiments similarly engaged the visual thinking of experts and audiences alike. Of particular concern here are the ways in which such evidence could be manipulated in order to accommodate issues of rank and status as implicit factors in scientific assessment and classification. In a similarly hierarchical vein, limitations have traditionally been placed on accessing and interpreting visual material in the sciences, resulting in the somewhat paradoxical double standard of visibility for all viewers, but a legibility for only a restricted group of initiated experts.

TO COLLECT IS TO QUANTIFY AND DESCRIBE: VISUAL PRACTICES IN THE DEVELOPMENT OF MODERN SCIENCE (1790–1850)

Visual practices were central to the scientific tasks of collecting representative specimens and of organizing them into appropriate units and structures. Shells, fossils, and many other items drawn from the various branches of the natural world, including the mineral, the botanical, and the entomological, were avidly sought by amateur and learned collectors. These activities clarify the pivotal position that visual recognition and arrangement held in the development of scientific systems of classification. Preexisting expert opinion, but also considerations of color, size, markings, shape, texture, and substrata influenced the ways in which specimens could be coordinated and tabulated, and how they might fit into a larger framework of scientific knowledge. Discovering new specimens developed into a competitive challenge that was also predicated on the ability to discern subtle variations in a species' visual markings. Establishing quantifiable standards and organizational principles for qualities, exemplars, and specimens was a goal pursued on an extensive and egalitarian scale, as many individuals sought

to acquire their own collections for private study, consultation, and experimentation. A multiplicity of collections with varying typologies was the initial result of this enthusiasm for specimens. But collecting as a more scientific procedure, in which visible quantification and tabulation were the principal objects, eventually encouraged a movement toward greater coherence and standardization.

In "To Collect Is to Quantify and Describe: Visual Practices in the Development of Modern Science," Jane Kromm investigates the impact of Linnaeus's classification system on botanical observation and studies the extension of this system's visual habits into other fields of natural history and design. The penchant for proceeding first by observation and analysis, and then by analogy to other phenomena, allowed the orderly clarifying strategies of natural history to develop into what became the expansive, enriched perceptual schemas of the Romantic era.

EVOLUTIONARY THEORY AND THE TRANSPARENCY OF INHERITANCE (1830–1900)

Visual identification and recognition played a major part in the development and support of various models for evolutionary processes as they were introduced over the course of the nineteenth century, leading up to and including the major breakthrough represented by the work of Charles Darwin. These models relied on the inheritance of attributes, and in most cases this was a process that registered which visible traits were to be ranked as dominant or which might be considered recessive. Even at the next theoretical level, visual characteristics provided the evidence that could prove whether or not evolutionary processes had in fact been occurring. As traits were deemed superior or inferior, there developed a hierarchy of primarily visible attributes that might then be used to establish the progress or decline of a species. Height and weight, skull size and brain capacity, digits and dexterity are some of the visible criteria called forth in judgments regarding the status of a human or animal species, and whether or not it was headed for extinction unless the processes of adaptation intervened. Visual analogies between human and ape in this context came to occupy a heightened role of comparativist notoriety, as the proponents and critics of evolutionary theories sought to bolster the position of human development within a larger hierarchy of the natural world. With botanical specimens, breeding experiments over an extended period might be required in order to ascertain which traits were the dominant ones. Models for evolutionary processes thus might be gradual and only slowly visibly manifested, while others might occur through more sudden leaps of identifiable changes. Assumptions about what constituted advance or decline were to a considerable extent buttressed by transparent effects, and by the causes and potential outcomes of this transparency.

Fae Brauer's chapter, "The Transparent Body: Biocultures of Evolution, Eugenics, and Scientific Racism," examines the reciprocal, transparent relations between the exterior and interior of the body. This premise has a long tradition in Western thinking, and it flourished as the basis of increasingly deterministic biocultural theories from the nineteenth through the twentieth centuries. Efforts to measure and map the visible contours and coordinates of the face, skull, and body preoccupied theorists reliant on visual demonstrations and proofs. As they argued for a more scientific basis for their conclusions about comparative anatomical standards, they also sought to support a moral hierarchy with white male Europeans as the ideal type. The natural history museum established by the Comte de Buffon in Paris in 1794 offered the public displays that guided them through the stages and standards

of comparative anatomy, with exhibits showcasing a variety of species. Photographic methods were quickly annexed to this comparative project, with a reliance on grids and timed exposures used to measure all aspects of bodies and their movements. Responses to Darwin's *On the Origin of Species* (1859) were highly varied, but some saw in evolutionary theory the prospect of a kind of hierarchical anatomical thinking that received its most intrusive application in the work of his nephew, Francis Galton. Galton favored influencing evolution through interventions in breeding, and his work inspired the formation of societies for eugenics and racial hygiene that flourished worldwide. These organizations sponsored international exhibitions of comparative anatomy on an unprecedented scale, which were all largely premised on the visual manipulation of a degree of biodeterminism that was in the end never scientifically supportable.

BIOLOGY AND CRIME (1850–1920)

Debates about biological weakness and inferiority expanded in the wake of controversies spawned by evolutionary theories. Gradually the visible traces of organic limitations were increasingly regarded as signs of disease and degeneracy, or as indices for an inevitable, eventual occurrence of illness or debility. These signs were treated systematically, charting and tallying the features of degeneracy for purposes of diagnosis or treatment. Illustrated treatises were published to clarify just what these features looked like, and soon similar guidebooks were available for a wider public, advertising, for example, their usefulness in hiring reliable workers and servants. First presented with line drawings and engravings of facial types aligned with a panoply of traits, soon these books were printed with photographs of specific, so-called degenerate people. This diagnostic visual approach quickly became a reductive one, resulting in an overconfidence in simple visible indicators for character and behavior. Eventually, composite images of people with similar deviations were collaged into a single view to "enhance" their claims of accuracy. As visual protocols for deviant traits were matched increasingly with negative behavioral propensities, what had been merely a prescriptive system soon became a preventive one. Social mechanisms to deal with those bearing such traits, and especially to anticipate behavioral outcomes and to prevent them, were developed out of what was principally a visible calculus of deviant traits.

In "Biology and Crime: Degeneracy and the Visual Trace," Heather McPherson examines the convergence of art, medicine, and evolutionary theory in the late nineteenth-century obsession with visually documenting pathological conditions such as hysteria and other forms of mental and physical degeneration. From B.-A. Morel's treatise of 1857 to Emile Zola's Rougon-Macquart novels and Max Nordau's study of 1892, scholars, writers, and physicians described the impact of modern life on bodies and nerves. They took an acute interest in identifying pathologies through tell-tale visual markers that might often be quite elusive and intermittent, qualities suggesting something like traces, or, in religious terminology, stigmata. At hospitals and clinics, such as the Salpêtrière in Paris, where hysterics were studied and treated, and at jails and prisons, photography became the favored means whereby visual trace could be matched with pathological state, resulting in images regarded as truthful, scientific, and valuable in a documentary way. Subtle traces of disability and disease were sought out in these images by medical and criminal investigators, who also used other visual formats to supplement photography. These formats, including schematic and dotted-line drawings and composite images

condensing multiple movements, relied on graphic techniques that were judged to be essentially objective and scientific, despite evidence to the contrary. In the area of identifying individuals for a variety of purposes, photographs and schematic renderings focused on isolated parts of the body, such as ears or fingerprints. These renderings or photographs became the objects of analysis, resulting in a moral ranking of abstract visual criteria based on shape, pattern, and ornament, such that the better person would have the better-structured fingerprint, the latter a visual trace from which substantial conclusions about character and destiny were apt to be drawn.

VISUAL MODELS AND SCIENTIFIC BREAKTHROUGHS (1940–1970)

While exterior visible attributes preoccupied certain sciences, such as biology and botany, others, like physics, chemistry, and genetics, relied on implicit or underlying visual models or paradigms to facilitate problem solving and discovery. Uncommon or unfamiliar configurations—especially geometric ones—assumed the position of a major standard or framework for a number of newly discovered processes and operations. In many cases, a visual model crystallized in the course of study and experimentation, while in others, visual models enabled and facilitated further advances. The discovery of these new models might be gradual and subject to much resistance, as had been the case for establishing the elliptical, rather than circular, model for planetary movements. In chemistry, underlying templates were understood as constituting the necessary arrangement of molecules that gave substances their identity. Fundamental characteristics might be isolated by new techniques, like the introduction of X-ray crystallography. Sometimes the discovery of these underlying structures could be quite dramatic, as was the case with finding the double helix configuration for DNA, which propelled future genetic investigations. Many of these developments, which have in certain quarters acquired the status of a "paradigm shift," were accomplished by envisioning a drastic alteration to what was already an essentially visual model. In the later twentieth century, scientific communities had an increasingly international and global reach, and many discoveries were the work of teams of researchers in or from several countries, who benefited from the financial support of universities and research groups in nearly all the developed countries, but especially in the United States, England, France, and Germany.

Nancy Anderson's chapter, "Visual Models and Scientific Breakthroughs: The Virus and the Geodesic Dome: Pattern, Production, Abstraction, and the Ready-Made Model," investigates the use of scientific models in the period after World War II and traces the stages through which a structural pattern derived from a specific work of architecture was discovered to parallel that of the protective casings of viruses. In the 1950s and 1960s, scientists turned increasingly to the notion that models were a critical aspect of scientific process and discovery. Norbert Wiener in particular saw models as simplified structures that could be formal or material, with the latter often made from simple, readily available objects. Such models could be combined to produce patterns, and Wiener argued that pattern determined the order and meaning of the natural world. At the same time that models began to dominate the scientific world, artists and architects were following similar lines of visual reasoning. Gyorgy Kepes saw pattern as the underlying commonality uniting art, architecture, and science. The conferences he organized and the studies he published demonstrated the links that necessitated bringing together artists and scientists. Images of patterns drawn from disparate areas were essential

in establishing Kepes's claims, and these might include such varied phenomena as photographs of magnified raindrops, a painting by Wassily Kandinsky, or a geodesic dome by Buckminster Fuller. Fuller's domes were structures based on triangular forms that could be built up into geometrical solids, and for his geodesic design he favored the icosahedron. Several scientists in the 1950s, including Aaron Klug, and Francis Crick and John Watson, noticed the visual similarity of this dome pattern to that of virus coverings, with the result that eventually it became the preferred laboratory model for research into the structure of viruses. Experimenting with these models was an integral element in scientific research and in the discovery process. Scientists built templates of wood or metal, while others manipulated cut and folded papers, all with the goal of finding the correct structural blueprint or schematic configuration—both abstract visual models in their own right—that would reveal the significant patterns that make up the natural world.

TO COLLECT IS TO QUANTIFY AND DESCRIBE: VISUAL PRACTICES IN THE DEVELOPMENT OF MODERN SCIENCE

Jane Kromm

It were therefore, much to be wisht for and indeavoured that there might be made and kept in some Repository as full and compleat a Collection of all varities of Natural Bodies as could be obtain'd, where an Inquirer might be able to have recourse, where he might peruse, and turn over, and spell, and read the Book of Nature.... The Use of such a Collection is not for Divertisement, and Wonder, and Gazing, as 'tis for the most part thought and esteemed... but for the most serious and diligent study of the most able Proficient in Natural History.

—Robert Hooke

[The naturalist] distinguishes the parts of natural bodies with his eyes, describes them appropriately according to their number, form, position, proposition, and he names them.

—Carolus Linnaeus

I had often put my imagination to the stretch to find out what there is in nature which could furnish [the Etruscans] with such a variety of ideas and forms, when called on to see a collection of shells and other testaceous productions both marine and fossil,... when I thought I had perceived in these works of nature all the forms... which I had seen on the Etruscan vases.

—G. B. Piranesi

THE LURE OF NATURAL HISTORY

The widespread interest in natural history grounded in the visual strategies of collecting and describing specimens increased steadily over the course of the 1600s.[1] Toward the end of that century, Robert Hooke characterized the method of an "able proficient" in natural history in a manner that refined the earlier experience-based approach. It was not enough to acquire a collection of specimens just to gaze at its contents in wonder. What was crucial now was the serious study of a collection's objects: to handle every item, to examine all sides, to be able to "read" and "spell" every specimen. Such acts were preambles to ascertaining the order and organizing principles of the natural world. Hooke famously introduced into his own work carefully composed depictions of specimens informed by the use of the microscope, bringing a novel degree of visual scrutiny to his own observations.[2]

The practice of visually "reading" specimens was adapted by Carolus Linnaeus, the

great botanist of the eighteenth century, who emphasized the prominent role of sight in the naturalist's project. He described a kind of analytic gaze that could discern the quantifiable specifics of an object, and provided a clear prospectus of what to notice—the "number, form, position"—in order to ensure that the identification of a species would be accurate for users of the system at all levels of proficiency. In his design treatise of 1769, the architect Giovanni Battista Piranesi demonstrated that he was familiar with specimen collections and classification systems. His quoted comment relates the natural sciences to the history of Etruscan design. This is a bold example of the kind of analogical thinking advocated in eighteenth-century natural science, in which a link based on visible similarities was the preferred method for systematically connecting properties between groups of objects. Such practices created the potential for infinitely extending knowledge in a seemingly logical way, a method with great appeal for Enlightenment thinkers. The sense of historical development that Piranesi's comment reveals is grounded in a loosely evolutionary model much like that found in the work of several eighteenth-century naturalists. To the extent that the architect's comparison between shells and vases is one based on an imaginative leap, the connection also represents a considerable degree of Romantic sensibility. This chapter will trace the visual trajectory exemplified by the comments of Hooke, Linnaeus, and Piranesi, a trajectory from articulation and classification to the enhanced perceptual practices that developed in the Romantic era and became a significant feature of natural history by the end of the century.

The emphasis on experimental processes advocated by Isaac Newton and reinforced by John Locke in his *Essay Concerning Human Understanding* (1690) provided the philosophical platform for much eighteenth-century thinking.[3] Most intellectual endeavor hereafter would advocate sensation and observation as the bases of true knowledge.[4] Locke, who was trained in both botany and medicine, primarily stressed the value of individual experience in his method. Since the Renaissance, the botanical task had tended to be an expansive and unwieldy one, accommodating the culinary, the mythic, and the medicinal.[5] The new method helped to clarify and streamline botanical pursuits, which soon were distinguished from pharmaceutical preoccupations. An experimental approach mandated that prior textual information be set aside, and individual plant specimens were to be studied mainly through the observation of external features and parts. These observations would then be carefully described, and the descriptions would become the basis for a system of classification. The kind of looking encouraged by this approach was selective, favoring a sensitivity to the discernment of types, patterns, breaks, and recurrences. These results could then be organized, even tabulated, a project akin to that undertaken by the compilers of dictionaries and encyclopedias whose work was synonymous with enlightened intellectual activity.

Processes of observation were also tied to collecting specimens, a practice that was an essential one for naturalists, but which by the 1700s was something that carried social prestige. Many sought to extend the natural specimens in their collections, avidly pursuing both local and exotic examples.[6] These collections, unlike their Renaissance "cabinet of curiosities" ancestors, tended to be more carefully ordered and organized, with a thoughtful juxtaposition of specimens. Fossils, shells, dried plants, and preserved insects were more

"archived" than they were put on show, and it was not unusual for afficionados to warn against the "vague glance" of the unserious in favor of the "expert gaze of amateurs."[7]

Two such "expert gazes" can be seen in a portrait-caricature by John Kay of the Edinburgh botanist Dr. John Hope and his gardener from 1786 (fig. 5.1).[8] Kay's witty portrayals represented the city's notable characters, both high and low, professional and menial. While some decried Kay's lack of pictorial sophistication, others appreciated the humorous edge of his pencil. His caricatural abilities were judged to be acute, as Kay "drew the man as he walked the street everyday; his gait, his costume, every peculiarity of his

appearance done to a point...."[9] The portraits toyed lightly with truisms about the intimate relation between character and appearance and made much of the enlightened fashion for being aware of one's look and deportment.[10] In a similar vein, botanical guides that advocated sharp observation also suggested that readers consider parallels and analogies to human behavior.

The principal subject of the print, Dr. Hope, had been appointed professor of medicine and botany at the University of Edinburgh in 1760, following the death of the incumbent, the staunch anti-Linnaean Dr. Charles Alston.[11] Hope, however, was a supporter of Linnaeus's ideas, and after relocating the university's botanical garden in 1763, he was keen to introduce a new layout for the plants based on Linnaean principles. Published in the year of Hope's death, the print recollects the important moment of the garden's relocation and redesign some twenty years earlier. The professor is depicted in a sloping meadow flanked by a line of trees, next to his gardener, who has arranged six plant specimens in a neat row for Hope's inspection. The pair present parallel stern visages, emphasizing an eye-to-eye, keen purposefulness of looking. Dr. Hope's more assertive bodily pitch contrasts with the gardener's respectful salute. The skewed perspective of the specimen pots looks like the kind of awkwardness sometimes decried in Kay's work, but it serves the useful botanical purpose of emphasizing the "observability" of the entire plant. A highly schematized composition, the design offers two figures, three trees, and six samples. This, along with the repetition of creatively warped shadows, calls attention to order and alignment as the principal structural characteristics of the scientific visual field. As such, the print's composition underscores the redesign

Fig. 5.1 John Kay, *Dr. John Hope and His Gardener,* 1796.

of the botanic garden and reinforces the status that observational strategies held for the new natural historians. These features comprise the foundational principles behind eighteenth-century botanical researches that culminated in Linnaeus's work.

THE INNOVATIONS OF LINNAEUS

By the early eighteenth century, a large number of a specimen's parts were used to establish its place within classification systems. But such designations were cumbersome and difficult to use. There were mistakes and repetitions encouraged by unwieldy lists of significant features, and these were often matched by a plant's lengthy, compound names. Several naturalists set about the task of simplifying the situation by limiting the parts required to establish a class or order. John Ray in England developed a natural system that followed the likenesses found among a smaller number of parts, including the root, flower, seed, and seed vessel.[12] In France, Joseph Pitton de Tournefort similarly advanced a system based on limited parts, and here he looked primarily at floral characteristics. The resulting simpler template became quite popular and was followed by many even before Linnaeus's innovations became well-known.

Most naturalists were divided over findings published in the 1690s by Camerarius that argued for the presence of sexuality in plants. Many, including Tournefort, never conceded that plants had reproductive organs. But in Leiden, Hermann Boerhaave embraced this position almost immediately and incorporated it into his natural history lectures.[13] Boerhaave's advocacy greatly facilitated the wide acceptance of plant sexuality, reinforcing a theory that established one of the most important botanical analogies by making

a connection between the plant world and the animal kingdom based on a shared law of generation.[14] The discovery of plant sexuality not only upheld the basic validity of such analogies, it also focused study on the flowers and floral parts. This made the floral characteristics of species, now understood as sexual organs, the principal object of botanical observation.

Like Boerhaave, Linnaeus was an enthusiastic supporter of the theory of plant sexuality. In Holland from 1735 to 1738, Linnaeus was encouraged by Boerhaave, who also helped the botanist publish his manuscripts. One of these, the *Systema naturae* (1736), offered a succinct explanation of Linnaeus's ideas about botanical classification.[15] Not satisfied with Tournefort's system, Linnaeus instead devised a classification procedure based on the sexuality of plants, dividing species into 24 classes defined by the number, form, and position of the stamens.[16] The system accommodated the full range of fructification elements, including the four floral parts of calyx, corolla, stamen, and pistil, and the three fruit components of ovary, receptacle, and seed. Linnaeus defended his focus on fructification: "It is a temporary part dedicated to generation marking the end of the old plant and the beginning of the new."[17] In keeping with the plant–animal parallel, Linnaeus typically referred to the stamens in his writings as "husbands" and the pistils as "wives," analogies that later became controversial on moral grounds.

The sexual scheme of classification was also the basis for a new system of naming specimens. Linnaeus developed a binary form of nomenclature, combining the generic name with a trivial one. Both aspects of Linnaeus's system were lauded for making natural history more accessible and for laying out a clear procedure that could be followed by scholars,

amateurs, and students. His concentration on the flower and fruit parts of plants did much to advance the centrality of descriptive botany. Linnaeus's instructions guided the visual concentration of would-be botanists, advising them to observe in particular certain elements, and only those elements. These included the number of stamens and pistils, their particular form, their distribution construed as a basic geometric shape, and their relative size.[18] By setting aside the more variable or temporary visual aspects of plants, this template was able to yield consistent results across a range of observers, thereby supporting the botanical necessity of a reliable, ordered account of plant species. The visible attributes that Linnaeus isolated were the result of studying his own extensive collection. Yet the template he developed also owed something to earlier visual practices of botanical illustration, practices that his own researches subsequently influenced.

BOTANICAL ILLUSTRATION

The study of plants and herbs has always had a considerable visual component. Some of the very earliest texts, such as Dioscorides's *De material medica* (77 C.E.), were amply illustrated, and although his original manuscript is missing, numerous surviving copies demonstrate that the treatise was visually rich from its inception.[19] While many of these depictions are schematic, and, as a result of frequent copying, often inaccurate or misidentified, the habit of making some reference to plant appearance gradually led to greater visual sensitivity and less dependence upon confused or erroneous textual precedents.[20] Around 1500, the naturalism and empiricism fostered by Renaissance ideals led to the practice of depicting specimens

"from life." Treatises such as Otto Brunfels' *Herbarium vivae icons* (1530), with illustrations by Hans Weiditz, exemplify this trend.[21] Influenced by the finely detailed natural studies of Albrecht Durer, Weiditz's images typically showed the plant with its bulb attached and the root system visible. As the publication of such herbals flourished, other pictorial practices became standard, including the expanse of root to bud, the cutting of stems and tubers to show their inner structure, and the plants often shown in flowering as well as fruit-bearing forms.[22] Occasionally specimens might be depicted on the page configured in a way similar to that found in the arrangement patterns favored for dried herbs. The invention of the microscope influenced illustration in the direction of finer detail and specificity, and by the 1700s, the practice of depicting from life continued but with increasing botanical awareness evident in the concentration on morphologically significant structures and in the relationship of specimen to environment.[23] These developments helped to fuel a lively market for botanical prints as well as illuminated books, both remaining very popular throughout the eighteenth and early nineteenth centuries.

In many of these works, certain visual tendencies became standard. Along with the now familiar view from root to bud and the inclusion of one or more cuts in the stems, it was not unusual to see the leaves shown with both upper- and undersides revealed, their order and distribution along the stem clearly indicated. Flowers tended to be depicted both in profile as well as with an interior view made visible. Detail and clarity remained significant characteristics, but greater botanical awareness encouraged a certain degree of visual and intellectual manipulation that went well beyond the casual appearance of a plant.

BOTANICAL ILLUSTRATION AND THE LINNAEAN SYSTEM

Many naturalists were often skilled draftsmen and able to record the specifics of their growing specimen collections, but Linnaeus himself was not. The illustrations accompanying his publications were of necessity provided by others. One of these was Georg Dionysius Ehret, a German botanical draftsman who became the principal illustrator of plants in the first half of the eighteenth century.[24] Ehret traveled to Holland to meet Linnaeus and George Clifford, the new director of the Dutch East India Company and cultivator of an extensive garden. Clifford was impressed with Ehret's drawings and purchased several, and Linnaeus shared details about his new system. Ehret later recalled that "Linnaeus explained to me his new method of examining stamens . . . and I resolved privately to bring out a tabella of it."[25] He published such a table, *The Linnaei Methodus Plantarum Sexualis* in 1736 (fig. 5.2).[26] An extremely popular print, the table was avidly sought out by botanists, and its clear expository rendering of Linnaeus's system added further support to the sexual theory of plants.[27] Ehret's table presented the twenty-four classes in six rows of four specimens, each and all in a precise horizontal and vertical alignment. Each type displays the significant floral and fruit parts that had determined its placement in that class through a clear, schematic rendering. Ehret's drawing here is in a concise linear style that highlights the essential parts and their distribution in a streamlined, abstracted way, without any descriptive details about a plant's actual appearance. Despite the success of this table, no collaboration between Ehret and Linnaeus was ever attempted, and in fact the latter subsequently used this print in a publication without crediting the artist.

Fig. 5.2 Georg Ehret, *Linnaei Methodus Plantarum Sexualis,* 1736.

But Ehret's career as a botanical illustrator flourished, and he produced a number of texts and collections of engravings. In many of these he was able to combine a Linnaean-influenced schematized sexual focus along with other, more complex characterizations. A good example of this mixture is the *Plantaes et Papiliones Rariores,* which was intended for a general audience and issued in groups of hand-colored engravings between 1748 and 1762.[28] One of the plates depicts four different specimens, the convulus, the alsine, the iris, and the abutilon or glade mallow (fig. 5.3).[29] The overall composition of this engraving evinces

Fig. 5.3 Georg Ehret, *Plantaes et Papiliones Rariores*, pl. VIII, 1748.

the characteristics of a scientific table in the clear, orderly subdivision and rows of dissected parts all tagged with their Latin names and descriptions. Other observation-based or experiment-derived scientific qualities can be seen in the inclusion of cross-sections as well as in the isolated parts of the flower and fruit. In contrast to Ehret's earlier work on the Linnaean table, here some petals and leaves are sufficiently described so that the plant might be readily identifiable.

The plate also bears the marks of a private journal, highlighting the role of the individual in collecting and studying specimens. It projects the personal aspect of botanical explorations, with addenda inserted to suggest the cumulative effects of study and the whole treated as a kind of scrapbook. Its fourth specimen, the abutilon, is shown in a way that heightens these characteristics. The ad hoc, casually angled presentation of this separate, interleaved sheet is accompanied by the trompe l'oeil features of curving parchment and cast shadows. Centered on the page is a carefully articulated view—advanced from the visual practices of traditional botanical illustration—of the specimen in its entirety, from root system to bud, with leaves shown from both sides, and with the distribution pattern of parts and their natural graceful inclinations accentuated. Positioned in a subsidiary role, the schematic dissected parts and Latin labels are shown along the page's lower left margin. There is a separate smaller scrap of paper angled underneath the abutilon sheet. It contains the only vernacular writing on the entire plate and recounts the collector's path (here presumably Ehret himself) to the personal discovery of the plant:

> Of this plant there is a male and female plant, the male I observed several years in the Physick Garden at Chelsea. The female plant I met

by chance in an other garden in Chelsea, and saw likewise several at the Oxford Garden, both plants resemble one another when in bloom and grow to the height of 8 feet. The seeds were sent from Virginia.

Going well beyond the succinct presentation of the bare bones of Linnaeus's system, Ehret here presents a practical model for the individual pursuits of amateur naturalists. The plate's design also combines multiple views of different visual approaches to the presentation of specimens, providing a useful exemplar for those aspiring to become botanical illustrators. Finally, the image summarizes the various contributing factors or sectors influencing the current practices in the study of botany, by contrasting the learned with the amateur, the Latin with the vernacular, and distinguishing the cultivation of local plants from the exotic or colonial origins of others.

LATE-CENTURY BOTANICAL ILLUSTRATIONS AND THE LINNAEAN SYSTEM

Ehret was hardly alone among admirers of Linnaeus's work who were attentive to its visual implications for botanical studies. Two of the most enthusiastic followers of the naturalist's classification system were medically trained men active in a number of scientific areas at the end of the eighteenth century. Erasmus Darwin and Robert John Thornton devoted themselves to Linnaean-inspired projects aimed at clarifying the botanist's ideas and making them more accessible to amateurs, to young people, and especially to women.[30] And although both Darwin and Thornton were aware of and sometimes used the linear diagrammatic mode of technical treatises, neither fully embraced an abstract, quantifying

template for the visual expression of scientific ideas.[31] In fact they both enhanced their model with the addition of literary and poetic amplifications.

At a time when many experimenters were trying to sift the scientific from the nonscientific, Darwin did not, aiming instead for a synthesis of multiple, sometime seemingly conflicted, areas of knowledge.[32] In "The Loves of the Plants," the second section of his master work, *The Botanic Garden* (1791), Darwin presented Linnaeus's system in heroic couplets with vernacular terms substituted for the original Latin. Popular for almost a decade, the poem extended the botanical habit of analogical thinking and continued to link plants to people. Darwin's penchant for more spousal and courtship language in discussing the sexual life of flowers was part of an effort to aim the poem specifically at women readers, for whom botany was regarded as a suitable scientific area of study.[33]

Images in *The Botanic Garden* are as mixed as Darwin's textual references, and often not strictly speaking botanical.[34] Several are allegorical subjects by Henry Fuseli and others, while there are six botanical illustrations of the more traditional type showing a single specimen. Two charts relay the specifics of the Linnaean system, with twelve of the twenty-four classes shown on each page. These are some of the most diagrammatic images in the treatise, and they represent dissected fructification elements in horizontal rows, but with irregular spacings and partitions, resulting in an image that is both scientific and quirky, a kind of visual hybrid that aptly matches Darwin's own approach.[35] But most of the images are figurative narrative works on the linked theme of flowers, women, and sexuality. In the end, the sexual explicitness of Darwin's popularizing of Linnaeus in human terms for young women

readers was decried for having accentuated the carnal possibilities of floral study.

By contrast, Dr. Robert John Thornton's *A New Illustration of the Sexual System of Linnaeus* (1797–1807) is a more socially conservative synthesis of the scientific, the poetic, and the visual. Thornton avoided any appearance of impropriety in the discussion of Linnaeus's system by substituting floral vitality for the sexuality of individual plants. Each specimen receives a sermon-like exposition that adds moral and poetic overtones to the bare bones of the classificatory exercise. The sexual characteristics of a species were thus embedded within a much larger moralizing framework.[36] The specimens are shown against extensive landscape backgrounds, and this was Thornton's major innovation: "The images will not only express the different gradations of the flowers, but will generally have, what has not been before attempted. Backgrounds expressive of the situation in which each naturally belongs."[37]

Thornton's project marked an important development in botanical visual culture for the way it aligned Linnaean classification and the practices of scientific illustration with late eighteenth-century notions of the sublime, the picturesque, and the beautiful.[38] As we have seen, the longstanding tradition for representation in natural history tended toward favoring clarity and simplification with little perspective or modeling. Focusing on a single specimen in its entirety alongside some of its dissected parts had become the favored pictorial equivalent to a scientific, empirical orientation. One of Ehret's important adjustments to this standard was his heightening of the implicit human dimension in collecting and specimen gathering. Thornton's plans for his illustrations continued along this track of heightening the personal and emotional engagement of the spectator with the natural

object. Several artists provided images for his books, and he seems to have encouraged them to dramatize the temperament or character of the plants they were to illustrate. The greatest contrast to prior natural history depictions are Thornton's extensive landscape settings.[39] And while his prospectus suggested that these landscapes were the original, natural setting of each specimen, this in fact was not the case. Thornton's landscapes do not resemble the actual environments of the particular plant but are instead imaginative constructions. This union of scientific observation and imaginative projection was not unique to Thornton: Alexander von Humboldt's geological collaboration with German Romantic landscape painters is another contemporary example of this combination of approaches.[40]

Thornton's images show monumental examples of ideal specimens with their significant scientific parts visible. The emphatic contours and flat colors underscore that clarity, and these features are evident in Peter Henderson's illustration of the winged passion flower (fig. 5.4),[41] a plant native to South America and available to English gardeners from around 1773 onward. The flower's diagonal stem stands out clearly before a classical column and tree-filled landscape, with three bell-shaped flowers shown in different stages of development and from different vantages, its floral parts and leaves clearly indicated. Blooming in a complex setting, this lively plant slants away from a sharp, contrasting diagonal shadow and is set off against clear vertical striations that are the shaded flutings of a huge classical column. On either side of the column, generalized fronds of trees are visible, and to the left there is a circular, domed classical building or tholos.

In Thornton's system, these landscape features ought to instruct us about the temperament of the specimen, but they certainly do not do this clearly or with South American references. In fact the text invokes traditional religious symbolism, likening the specimen's various parts to elements in Christ's passion, and thus reads the plant in a missionary context like that presumed to surround its discovery. The pillar recalls the cross, the leaves resemble the spear that pierced Christ's side, the stamens and styles are the hammer and nails, and so forth. Thornton's setting thus presents the plant's original situation from a European vantage of a missionary/explorer in its moment of discovery, rather than portraying its native environment.

Many of Thornton's plates include references to classical architecture gauged to elevate the enterprise and to shift it to connect it with current aesthetic theory. However, these classical details are so abridged that their ability to evoke the picturesque or the beautiful is quite enfeebled. In the image of the winged passion flower, both column and temple have been rendered with a degree of simplification that is abstract, even diagrammatic. In its cropped and flattened condition, the column functions more like a set of vertical rows for measuring, a kind of graph or grid backdrop for the rounded, curving forms of the specimen before it. In other words, the column, while it might be glossed as a reference to Christ's passion or to classical aesthetics, is here delineated in a way that accentuates its role as a calibrating device. Against regular intervals, the flower's striations and its bell shape seem to repeat the contours of the column as well as the domed structure nearby. These calibrated parallels in plant and architectural structure heighten the sense of a relation between natural shapes and manmade classical forms, a relation that might even be construed as a kind of metaphorical kinship, a basis for a measurable comparison.

Fig. 5.4 Peter Henderson, *Winged Passion Flower,* 1802.

BEYOND BOTANY: SHELLS AND VASES UNDER SCRUTINY

Thornton's attractive alignment between quite different but visually similar objects united the natural with the manmade world. It presented a case in which specimen collecting and observation went beyond the aim of systematically ordering classes and species and attempted instead something more provocative, something more like a creative, association-based design process. Other scientifically engaged scholars and artists were attracted to this prospect at the end of the eighteenth century. A trajectory of innovative rather than merely passive description and observation was also characteristic of Piranesi's treatise, *Diverse Manners of Ornamenting Chimneys and all other Parts of Houses taken from Egyptian, Etruscan, and Grecian Architecture with an Apologetical Essay* (1769). This pattern book on decorative design is an unusual work for the engraver, architect, designer, and theorist, who enjoyed a wide reputation for his engraved and etched views of Rome, his capricci and imaginary prison interiors, and illustrated works on archaeology.[42]

From the 1750s onward, Piranesi joined the heightening controversy over the relative superiority of Greek versus Roman design, coming out squarely on the side of the latter. He particularly emphasized the role of the Etruscans as the principal source for Roman ideas, and other scholars embraced this position, founding Etruscan academies and museums.[43] The excavations of Pompeii and Herculaneum added to the enthusiasm for the discovery of ancient artifacts. Perhaps more surprisingly, interest in geology and mining for the purposes of improving the manufacture of pottery led to a connection between science, vases, and antiquity, producing a kind of "vase mania."[44] Josiah Wedgwood figured importantly in this

development, and his own pottery production was influenced by the Etruscan vase collection assembled by Sir William Hamilton, the English ambassador to Naples.

Piranesi's *Diverse Manners* begins with a lengthy essay arguing for the superiority of Etruscan and Egyptian design, and for a design process that would bring together nature and antiquity. This essay, printed in Italian, French, and English, was accompanied by three plates that are tabular presentations of objects relevant to the argument. They demonstrate Piranesi's argument that everything diverse and vivacious in Roman design was derived from the abstracted natural forms found in Egyptian and Etruscan objects and architecture. The ultimate agenda of his essay was to lay down a system for modern design, one that would reflect this ancestry and embrace a historical view of the natural embedded within prior works of architecture and ornament.

Two of the three tables make the case that Etruscan design was derived from the vitality of natural forms. For Piranesi, the creative variety of these designs had a precise parallel in the variation of species in nature. He claimed that shells in particular were the sources of this vital diversity and did not hesitate to contradict the venerable theory proposed by Vitruvius that Etruscan design reflected archaic architectural practices.[45] Piranesi called attention to the moment when he recognized a connection between Etruscan vases and shells, a moment much like the celebrated encounter with a new species as described in botanical writings. The idea came to him while visiting the collection of Monsignor Baldini, and then:

after my return home I had taken up with the collection of shells published by Nicolas Gualtieri, philosopher and Physician of the Faculty of Florence, I compared them with the forms, the

manner, and the Ornaments of the Vases: and behold! That is, I say to myself, the mine from whence the Tuscans drew so many different forms of vases: this is the secret which they formed so great and surprising a variety of them.[46]

The book to which he refers is Gualtieri's *Index Testarum Conchigliorum,* published in 1742 and considered the century's major work on shells. It was well illustrated, showcasing the contents of Gualtieri's collection in detailed renderings of specimens from various vantages, and underscoring the aptness of current classification systems such as Tournefort's.[47] The shells depicted by Piranesi in *Diverse Manners* reflect this familiarity, emphasizing the morphological properties of a range of specimens. Such excitement and enthusiasm about shells was actually widespread. While investigating some caves, Erasmus Darwin had accidentally come upon the fossils of shells and corals. This prompted him to alter the family crest on his coach by adding a scallop shell and the motto "*E conchis omnia*" (everything from shells), a claim giving shells a dominant position within an evolutionary scheme still only vaguely understood.[48]

Closer to Pranesi's own inclination was a theory linking shells to vases, put forward in a publication about Hamilton's collection of antiquities. Here the idea was proffered that certain vessels resemble shells because originally shells had served as actual containers.[49] But for Piranesi, this relationship was not one of literal imitation, but of an adaptive design intervention made by the creative imagination. It is this principle of design intervention that Piranesi set out to demonstrate in a second plate comparing shell specimens in multiple views with different types of Etruscan vases (fig. 5.5).[50] In ascending order, different views of shells in varying positions are aligned in rows, with some shells placed as interfaces between one

Fig. 5.5 Giovanni Battista Piranesi, *Diverse Manners of Ornamenting Chimneys and All Other Parts of Houses....* pl. 2, 1769.

group and the next above. Gradually the shells are integrated into ranks of different kinds of vases, and the page terminates at the top in the row of smaller vessels in frontal view. These are shown alongside the schematic outlines of vase contours that are primarily attentive to the relation of lip to base and the close study of angles, curves, and transitions. There are seven vases of various shapes drawn with continuous curves that emphasize the overall form, along with handles and lids. Designs on the vase bodies are principally figurative and narrative, but there are also repeated, purely abstracted motifs of patterns and swirls that are clearly indebted to the smaller features of the shells assembled beneath. These shells range from

long spirals adorned with striated markings and their apertures turned toward the spectator, to the rounded spirals of nautilus shells and the concentric structure of a bivalve. In content and layout, the engraving subtly accentuates the abstract values inhering in these natural forms, just as it elaborates on the contours and segments by which these forms were recollected in the shapes and component parts of the adjacent Etruscan vases. Piranesi's appreciation for the intricate details of different shell types and their relationship to vase forms is clearly explicated:

> In the monotomes, the spirals and the tubous are varied to infinity: in the diotomes and polytomes we have the umbilical, the cylindrical, the fluted, the pointed, the curve with orifices or a kind of lips, the beaked insomuch they may serve to teach us…the manner of giving the proper position, turn, and grace to the handles of vases.[51]

Such passages demonstrate Piranesi's sensitivity to formal patterns and his delight in the parallels he was confident that he had observed between the natural and the designed world. He has clearly mastered the visual strategies proposed by eighteenth-century naturalists, isolating the position, number, and relationships in specimens, and he has related these strategies by analogy to a wider framework. In following the human analogies to the natural world suggested by Linnaeus, Ehret, Darwin, and Thornton, and extending them to the realms of art and design, Piranesi brings us to a concluding point on the trajectory traced by this chapter. From the observation of specimens for the purpose of classifying orders, to the expansion of these systems into numerous byways supported by the descriptive accounting of observed traits, the qualities found in Piranesi's treatise exemplify the kinds of enhanced perceptual acts and sensibilities characteristic of late eighteenth-century scientific endeavor.

NOTES

The Posthumous Works of Robert Hooke (1705), 338; Carolus Linnaeus, *Systema naturae* (1753), 215; G. B. Piranesi, *Divers Manners of Ornamenting Chimneys* (Salomoni, 1769), 18.

1. Harold Cook, *Matters of Exchange* (Yale University Press, 2007); Lorraine Daston and Katherine Park, *Wonders and the Order of Nature* (Zone Books, 1998).

2. Janice Neri, "Between Observation and Image: Representations of Insects in Robert Hooke's *Micrographia*," in *The Art of Natural History,* ed. Therese O'Malley and Amy Meyers (Yale University Press, 2008), 83–107.

3. A. G. Morton, *A History of Botanical Science* (Academic Press, 1981), 234; Jenny Uglow, *The Lunar Men* (Farrar, Straus, Giroux, 2002), 9.

4. Morton, *A History of Botanical Science,* 235; see also Paul Farber, *Finding Order in Nature* (Johns Hopkins University Press, 2000); Philip Ritterbush, *Overtures to Biology* (Yale University Press, 1964); Jacques Roger, "The Living World," in *The Ferment of Knowledge,* ed. G. S. Rousseau and Roy Porter (Cambridge University Press, 1980); William R. Shea, *Science and the Visual Image in the Enlightenment* (Science History Publications, 2000).

5. Roger, "The Living World," 264; Michel Foucault, *The Order of Things* (Pantheon, 1970), chap. 5, "Classifying," 125–65.

6. For the economic argument, see especially Cook, *Matters of Exchange,* and Paula de Vos, "Natural History and the Pursuit of Empire in Eighteenth-Century Spain," *Eighteenth-Century Studies* 40, no. 2 (2007): 209–39.

7. E. C. Spary, "The 'Nature' of Enlightenment," in *The Sciences in Enlightened Europe,* ed. William Clark, Jan Golinski, and Simon Schaeffer (University of Chicago Press, 1999),

293, citing a shell guide of 1775 by Abbé Favart d'Herbigny.

8. John Kay, *Series of Original Portraits and Caricature Etchings,* 2 vols. (Hugh Paton, 1842); Hilary Evans and Mary Evans, *John Kay of Edinburgh, Barber, Miniaturist, and Social Commentator* (Impulse, 1973); Nick Prior, "Urban Portraits: Space/Body/City in Late Georgian Edinburgh," *New Formations* 47 (2002): 194–215.

9. Evans, *John Kay,* 25, citing Robert Chambers, *Biographical Dictionary of Eminent Scotsmen.*

10. Prior, "Urban Portraits," 201; 205–7.

11. Kay, *Series of Original Portraits,* vol. 2, 2, 415–17.

12. Uglow, *The Lunar Men,* 266.

13. Morton, *A History of Botanical Science,* 236–39.

14. Ritterbush, *Overtures to Biology,* 8; Morton, *A History of Botanical Science,* 238.

15. Tore Frangsmyr, ed., *Linnaeus: The Man and His Voice* (University of California Press, 1983); Wilfrid Blunt, *The Compleat Naturalist: A Life of Linnaeus* (Viking, 1971); James L. Larson, *Reason and Experience* (University of California Press, 1971).

16. Morton, *A History of Botanical Science,* 263–34. A system based on such a limited number of features is considered an artificial system.

17. Morton, *A History of Botanical Science,* 264.

18. On the visually limited nature of this method, see Foucault, *The Order of Things,* 134.

19. Alain Touwaide, "Botany and Humanism in the Renaissance: Background, Interaction, Contradictions," in O'Malley and Meyers, *Art of Natural History,* 34–35.

20. Larson, *Reason and Experience,* 14.

21. Lucia Tongiorgi Tomasi, "Naturalistic Illustrations and Collections in Tuscany in the Eighteenth Century," in Shea, *Science and the Visual Image in the Enlightenment,* 112; James S. Ackerman, "Early Renaissance 'Naturalism' and Scientific Illustration," in his *Distance Points* (MIT Press, 1991), 199.

22. Claudia Swan, "The Uses of Botanical Treatises in the Netherlands, c. 1600," in O'Malley and Meyers, *Art of Natural History,* 68, 75.

23. Tomasi, "Naturalistic Illustrations and Collections," 112. This development was preceded by a period after 1600 when copying the "from life" images led to some losses of detail and accuracy. See Ackerman, "Early Renaissance," 187; David Topper, "Towards an Epistemology of Scientific Illustration," in *Picturing Knowledge,* ed. Brian Baigrie (University of Toronto Press, 1996), 226, 234.

24. Gerta Calmann, *Ehret: Flower Painter Extraordinary* (Little, Brown, 1977).

25. Calmann, *Ehret,* 49.

26. Only the original drawing and one print have survived.

27. Calmann, *Ehret,* 33, 127; Tomasi, "Naturalistic Illustrations and Collections," 115; William Stearn, "Linnaean Classification, Nomenclature, and Method," in Blunt, *The Compleat Naturalist,* 244.

28. Calmann, *Ehret,* 93.

29. This is plate VIII, which is dated 1748.

30. Clive Bush, "Erasmus Darwin, Robert John Thornton, and Linnaeus' Sexual System," *Eighteenth-Century Studies* 7, no. 3 (1974): 295–320; Asia Haut, "Reading Flora: Erasmus Darwin's *The Botanic Garden,*" *Word and Image* 20 (2004): 240–56; Desmond King-Hele, *Erasmus Darwin* (DelaMare, 1999).

31. Bush, "Erasmus Darwin, Robert John Thornton, and Linnaeus," 298; Martin Kemp, "The 'Temple of Flora' Robert Thornton, Plant Sexuality, and Romantic Science," in *Natura-Cultura,* ed. G. Olmi, Lucia Tongiori Tomasi, and A. Zanca (Olschki, 2000), 15.

32. Bush, "Erasmus Darwin, Robert John Thornton, and Linnaeus," 297–99.

33. Ann B. Shteir, "Botany in the Breakfast Room: Women and Early Nineteenth-Century British Plant Study," in *Uneasy Careers and Intimate Lives,* ed. Pnina Abir-am and Dorinda Outram (Rutgers University Press, 1987), 31–43; 288–92.

34. This analysis is based on the 1791 edition.

35. These plates were engraved by E. Stringer. The layout is indebted to the plates in Bulliard's *Dictionnaire botanique* (1783).

36. Kemp, 23, 24; Kemp also discusses Thornton's emphasis on marriage and constancy rather than on promiscuity.

37. Charlotte Klonk, *Science and the Perception of Nature* (Yale University Press, 1996), 37.

38. Klonk, 37–38; Barbara Maria Stafford, *Voyage into Substance* (MIT Press, 1984), 3. The principal contemporary works were Edmund Burke and William Gilpin. See Klonk, 37–38; 48–52.

39. On the novelty of this idea, see Bush, 313–15; Kemp, "'Implanted in Our Natures': Humans, Plants, and the Stories of Art," in *Visions of Empire,* ed. David Miller and Peter Reill (Cambridge University Press, 1996), 200; and Klonk, chap. 2.

40. Kemp, "Implanted in Our Natures," 217. Kemp also emphasizes that Thornton's scientific publications include diagrams and abstract renderings of natural objects, suggesting that he was capable of adhering to several seemingly contradictory visual systems.

41. This is a stipple and line engraving with aquatint that dates from 1802.

42. Susan Dixon, "Giovanni Battista Piranesi's *Diverse Maniere d'adorne i Cammini* and the Chimneypiece as a Vehicle for Polemic," *Studies in the Decorative Arts* 1, no. 1 (1993): 76–98; Sarah E. Lawrence, "Piranesi's Aesthetic of Eclecticism," in *Piranesi as Designer,* ed. Sarah Lawrence (Smithsonian Institution Press, 2007), 93–121; John Wilton-Ely, *G. B. Piranesi: The Complete Etchings,* 2 vols. (Alan Wofsey, 1994); John Wilton-Ely, "Nature and Antiquity: Reflections on Piranesi as a Furniture Designer," *Furniture History* 26 (1990): 191–97; Rudolf Wittkower, "Piranesi's 'Parere su L'Architettura,'" *Journal of the Warburg and Courtauld Institutes* 2, no. 2 (1938): 147–58.

43. Wittkower, "Piranesi's 'Parere su L'Architettura,'" 149.

44. Uglow, *The Lunar Men,* chap. 17; Ian Jenkins and Kim Sloan, *Vases and Volcanoes* (British Museum, 1996).

45. Dixon, "Giovanni Battista Piranesi's *Diverse Maniere,*" 84.

46. Giovanni Battista Piranesi, *Diverse Manners of Ornamenting Chimneys and All Other Parts of Houses Taken from Egyptian, Etruscan, and Grecian Architecture with an Apologetical Essay* (Salomoni, 1769), 18–19.

47. Tomasi, "Naturalistic Illustrations and Collections," 128.

48. Uglow, *The Lunar Men,* 152.

49. Jenkins and Sloan, *Vases and Volcanoes,* 235.

50. Piranesi, *Diverse Manners,* pl. 2.

51. Piranesi, *Diverse Manners,* 19.

THE TRANSPARENT BODY: BIOCULTURES OF EVOLUTION, EUGENICS, AND SCIENTIFIC RACISM

Fae Brauer

The concept of the body as transparent is rooted in Western philosophy, theology, the medical gaze, and biocultures. The discursive formation of the external body as a mirror of the internal is traceable to Aristotle and the classical antique notion that seeing the face was equivalent to viewing the soul. With the Aristotelian revival during the Renaissance, an anagogic epistemology in modes of Christian thinking ensued, whereby the interconnectedness of being was predicated analogically. In this "order of things," as Michel Foucault called it, the world was linked together like a chain where "at each point of contact there begins and ends a link that resembles the one before it and the one after it; and from circle to circle, these similitudes continue."[1] Just as nature seemed to mirror heaven, man emulate God and microcosm mime macrocosm, so the external body seemed to reflect its physiology, psychology, morality, and the soul. Within this semantic web of resemblances, "man," not woman, was "the mode and the measure of all things."[2] Just as the microcosm seemed knowable through observations of nature, so the inner workings of the body appeared fathomable by its façade.

Once health became the new salvation during the medico-scientific era of biopower, far from this biological determinism abating, it was elaborated. This chapter will reveal how, far from being abandoned by the new intellectual disciples of anthropology, anthropometry, biometry, comparative anatomy, craniometry, criminology, palaeontology, physiognomy, phrenology, evolution, and eugenics, these reconceptions of the body were grafted upon it. The chapter will demonstrate that from the 1770s drawings of Dutch naturalist and artist-anatomist Pieter (Petrus) Camper to the 1930s eugenic exhibitions of "Transparent Man," anatomy and physiognomy were assumed to mirror physiology, psychology, morality, and the soul. Despite microscopes and X-rays exposing the invisibility of illness, particularly cellular and organic erosion and corrosion by cancers and tuberculosis, the concept of corporeal transparency endured. The biocultures of evolution, eugenics, and scientific racism were presumed to reflect stages of evolution, health, heredity, "civilization," and, most of all, race. In mediating this reflectionism, these biocultures were able to mold models of normality, beauty, and human perfectibility, while facilitating corporeal discrimination, the ranking of race and what Stephen Jay Gould called "the mismeasure of man."[3]

"THE MISMEASURE OF MAN": COMPARATIVE ANATOMY, PHYSIOGNOMY, AND CLASSICAL SCULPTURE

In the early nation-state the issue that perplexed so many anatomists, scientists, and naturalists was whether humans were separate from nature and the realm of animals as contended by the Christian "great chain of being" or whether they were integrated. This conundrum had become compounded by discovery of anthropoid apes, particularly the orangutan, and analogies drawn between their bodies and brains and those of humans.[4] "The Orang-Outang," observed the French naturalist Comte de Buffon in 1749, "which does not speak, nor think, nevertheless has a body, members, senses, a brain, and a tongue entirely similar to those of man, for it can initiate or imitate all human behaviours."[5] Not only were orangutans given the same genus of *homo,* but when the Swiss naturalist Charles Bonnet redrew the "great chain of being" in 1779 as a ladder of progress rather than a permanent hierarchy, the orangutan was also ranked immediately below *homo sapiens.*[6]

To illustrate the similarity between all vertebrates, especially between apes and humans,

Camper began to draw comparative anatomy early in the 1770s. His illustrations were designed to demonstrate how the measurement of anatomy, especially facial angles, made it possible to assess how humans—specifically males as the paradigm of humanity—had progressed from apes to anatomical perfection as embodied by antique sculpture.[7] Into a four-sided open frame with cross-wires to measure angles, Camper inserted skulls. By drawing two lines, one horizontally from nostril to ear, the other perpendicularly from jawbone to forehead, he was able to measure facial angle, as illustrated by figure 6.1. Since his drawings showed that Europeans were closest to the 90-degree angle formed by antique sculpture, while people of color were closest to the 58-degree angle of apes, he concluded that Europeans were the most evolved and civilized humans while people of color were the least.[8] Camper's conclusions were unwittingly reinforced by the new science of physiognomy developed in Zurich by Johann Caspar Lavater.

In 1668, when Charles Le Brun delivered his lectures on painting at the Académie de Peinture in Paris, he had emphasized, following René Descartes, that facial expressions were a product of mind and therefore the key to unlocking the soul. While systematizing the

Fig. 6.1 Petrus Camper, *On the Points of Similarity between the Human Species,* 1778, pen and ink.

representation of expressive states, Le Brun did not take Lavater's step of trying to prove scientifically the connection between physiognomy and the soul. In his *Essays on Physiognomy,* first published in 1772, Lavater explained how the reading of physiognomy could function as a science. "Physiognomy is the science of the correspondence between the external and internal man," he wrote, "the visible superficies and the invisible contents."[9] This pseudoscience was essentially semiotic: It entailed decoding internal life from external signs on the body, particularly the face. Since the face was the least covered part of the body, Lavater reasoned that it could bare what was concealed by clothing and distorted by such status symbols as jewelry.[10]

Drawing on theological notions as well as physiological ideas of the body and nature, Lavater linked physical beauty to inner goodness and intelligence, and, conversely, physical deformity to moral turpitude and stupidity. "The better the morals, the more beautiful; the worse the morals, the uglier," he explained.[11] This was purportedly demonstrated by the 22,000 portraits Lavater assembled in his archive, the Kunstkabinett, including Hans Holbein's engraving of Judas Iscariot's face as hideously gnarled, illustrating, according to Lavater, incorrigible evil. In keeping with the Enlightenment's progressive model of the "great chain of being," Lavater also sought to prove through some eight hundred illustrations in his *Essays on Physiognomy designed to promote the knowledge and the love of Mankind,* how humans were the most beautiful and moral of all creatures. In the twenty-four frames, illustrated in figure 6.2, he endeavored to show how humans may have progressively evolved not from the ape but from the lowliest of creatures: the frog.[12] However, the first human male to have done so was not portrayed

as European. Instead, this Swiss pastor pictured this figure as Semitic, with the same acute facial angle as Camper's negro, who he said had evolved from the ape. At Lavater's pinnacle of beauty and morality was not the portrait of a living person, but the same antique sculpture posited by Camper as the culminating point in human development. This was the marble copy of the Classical Greek bronze figure of the sun god sculpted by Leochares, which was rediscovered in 1489 and placed by Pope Julius II in 1511 in the Vatican Belvedere sculpture court: *Apollo Belvedere.*

Some twenty years before Lavater's *Essays,* the *Apollo Belvedere* had been measured and its Classical Greek origin appraised by the German antiquarian working in Rome, Johann Winckelmann. Appearing to encapsulate the cultural pinnacle of Western civilization, *Apollo Belvedere* was, in his words, "the consummation of the best that nature, art, and the human mind can produce."[13] In terms of human progress, it appeared to manifest the ideal male body. "No idea can soar above the more than human proportions of a deity in this Apollo," waxed Winckelmann, "which is a compound of the united force of nature, genius and a lofty ideal of a body elevated above nature."[14] Not only did Winckelmann's writings lead to the *Apollo Belvedere* becoming the gold standard in art. Its circulation in white plaster casts, alongside other copies of Classical Greek sculpture throughout America, Britain, Europe, and their colonies also ensured that the body idealized in biomedical cultures was white, European, muscular, and healthy. This racial criterion of human beauty and intellect disseminated by Winckelmann and demonstrated by Camper and Lavater were openly acknowledged. "Must it be madness to say," Lavater rhetorically asked, "that one forehead announces more capacity than the other, that

Fig. 6.2 Christian von Mechel, after Johann Caspar Lavater, *Twelve Stages in the Sequence from the Head of a "Primitive" Man Modeled on a Frog to the Head of Apollo Belvedere*, 1797, colored etching.

Gradation de la Tête de Grenouille jusqu'au profil d'Apollon.

Executé et publié à Basle par Chr: de Mechel en 1797 d'après les Idées du célèbre Lavater.

Fig. 6.2 *(Continued)*

the forehead of the Apollo indicates more wisdom, reflection, spirit, energy and sentiment than the flat nose of a Negro?"[15] Their corporeal model of transparency and ranking of race appeared ratified by palaeontology, craniometry, phrenology, and anthropometry.

MAPPING THE BODY: CRANIOMETRY, PHRENOLOGY, ANTHROPOMETRY, AND DARWINISM

After the first French Republic was formed, the French Museum of Natural History opened in 1794 under the directorship of Buffon. Immediately he appointed zoologist and theorist of evolutionary transformism Jean-Baptiste Lamarck as chair of invertebrate zoology and mineralogist, and Etienne Geoffroy Saint-Hilaire as chair of vertebrate zoology and director of the menagerie at the Jardin des Plantes. While Lamarck endeavored to display the transmutation of life from such simple forms as insects and worms, Saint-Hilaire exhibited the homologous structures of cetaceans, birds, reptiles, and fish. For the first time it became possible for the public to see and compare the anatomy of animals, mollusks (shells), insects, and fish. When Saint-Hilaire appointed Georges Cuvier as assistant professor of comparative anatomy, the menagerie was conceived as a living museum curated according to Saint-Hilaire's model of the universal "unity of type." Once Georges Cuvier became its director in 1826, a special hall of comparative anatomy was opened, in which skeletons of these four anatomical types could be compared with human skulls, embryos, and fossil vertebrates.

The first to reconstruct fossil vertebrates systematically, Cuvier aimed to demonstrate in his displays the relationship between skeletal structures, embryos, and the connections between species. An active proponent of the geological theory of catastrophism, Cuvier also aimed to show how the study of fossils revealed a history of the Earth's disasters that had led to extinctions. Following his lead, Robert E. Grant established the Museum of Zoology and Comparative Anatomy two years later in London. In 1860, the Swiss-born, American-based zoologist, Louis Agassiz, who had studied under Cuvier, opened America's first Museum of Comparative Anatomy at Harvard. Nonetheless, Paris remained the most active world center for comparative anatomy. So great was the impact of Cuvier's hall that it remained untouched until World War I and attracted hoards of artists, most notably in terms of Modernist history, Odilon Redon and Henri Rousseau.[16]

During this time, a huge array of human skulls was being measured and illustrated in the new discipline of craniometry, founded by Swedish scientist Anders Retzius. Civilization could, following Retzius, be analyzed according to the cephalic index, Stone Age people having relatively short brachycephalic skulls, progressive Bronze Age Aryan Europeans having large dolichocephalic ones. Skull shape became seminal to the pseudoscience of phrenology developed by Francis Joseph Gall. This fusion of craniometry and physiognomy functioned, according to Gould, "as a false version of the probably correct theory of multiple intelligences."[17] Intellectual, psychological, and moral faculties in phrenology were considered externalized by shapes of the skull. Scrutiny of each minute part could supposedly elicit such diverse aspects of persona as acquisitiveness, cautiousness, destructiveness, and even a sense of humor.[18] So significant was every cranial bump that machines were invented to read them, although invariably the bumps on Semitic and Negroid heads registered as retrograde.

Once skull size was correlated with brain volume by the foremost craniologist in France, Paul Broca, the most important task assigned his Anthropological Society and the French School of Anthropology was anthropometry and craniometry. Through skull measurements, Broca claimed to be able to rank races, generations, and gender by degrees of intelligence. After closely measuring and weighing thousands of different human and primate skulls to construct a table of racial difference, Broca deduced:

> In general, the brain is larger in mature adults than in the elderly, in men than in women, in eminent men than in men of mediocre talent, in superior races than in inferior races.[19]

The corollary of his thesis that women, non-white, and old people were intellectually inferior to illustrious European males seemed ratified by Charles Darwin's evolutionary theory that, although all species had descended from common ancestry, some races were favored through natural selection.

Despite the controversy that erupted when published in French, *The Origin of Species* gave new impetus to anthropometric research conducted at the French School of Anthropology. Broca and assistant director Paul Topinard showed how both skull size and body parts demonstrated the mutation of *homo sapiens* from their animal past through natural selection. Following Camper, Broca and Topinard measured facial angle, correlating it with such anthropological signifiers as skin color, hair texture, and cultural proximity to European civilization to rank races according to the term Darwin borrowed from Herbert Spencer, "survival of the fittest." Although Darwin stipulated that there was "no natural basis for the domination of the fit over the less fit, rich over poor, one race over another, civilized over

savage,"[20] Broca elaborated the term to justify white racial suprematism as demonstrated by his statement:

> A prognathous (forward-jutting) face, more or less black colour of the skin, woolly hair and intellectual and social inferiority are often associated, while more or less white skin, straight hair and an orthognathous (straight) face are the ordinary equipment of the highest groups in the human series.... A group with black skin, woolly hair and a prognathous face has never been able to raise itself spontaneously to civilization.[21]

Broca's conclusion seemed brought to life by "human zoos."

Launched in London and Paris in 1810 with public exhibitions of the Khoikhoi woman, Saartjie Baartman, *The Hottentot Venus*—whose genitals remained on display at the Musée de l'Homme until 1974—by 1877 these ethnological spectacles at the Jardin d'Acclimation consisted of a wide range of indigenous peoples captured in Africa who were displayed nude or seminude in cages, just like the animals, to millions of visitors. So popular did human zoos become that in Antwerp, Barcelona, London, Milan, Warsaw, and New York, living Samoans, Nubians, Eskimos, and other races classified as non-Western were exhibited as primitive phases in the forward march of human evolution and European civilization. By 1906, one of the most notorious of these manifestations was the four-foot eleven-inch Congolese pygmy, Ota Benga, who was encaged with chimpanzees and an orangutan at the Bronx Zoo as "The Missing Link." Not only were these human zoos corroborated by museums of comparative anatomy, but also the anthropometric methods devised to quantify racial difference. Yet no visual technology seemed more able to expose racial evolution than photography.

SNAPPING THE BODY: ANTHROPOMETRIC PHOTOGRAPHY, CHRONOPHOTOGRAPHY, AND THE FITNESS IMPERATIVE

As early as 1850, Agassiz commissioned a series of daguerreotypes of enslaved men and women in South Carolina to corroborate his theory of polygenesis: Different races were distinct species that were not necessarily human and could therefore be exploited for slavery. Once Thomas Henry Huxley, as president of the Ethnological Society of London, systematized photography, anthropometric displaced ethnological photography. To ensure photography functioned as "reliable comparative anthropometric data," Huxley prescribed the placement of a marked ruler called an anthropometer alongside the naked human body with the right arm outstretched against it.[22] To ensure uniformity of scale, each figure was to be photographed at a fixed distance from the camera. To acquire more precise data about racial anatomical proportions, John Lamprey of the Ethnological Society not only used an anthropometer but also a seven-by-three-foot stringed grid backdrop divided into two-inch squares. Against the vertical strings of this screen, he aligned nude Malayans, Madagascans, and other people of color holding anthropometers. Well into the twentieth century, this model continued to quantify biological differences as statistical proof that the most highly evolved were the races of Europe. While anthropometric photography and instruments were used to measure people of color, French criminologist Alphonse Bertillon developed an eleven-stage anthropometry known as Bertillonage and corroborated mug-shot photographs, to identify criminals. When correlated with anthropometric photography, it enabled Bertillon to calculate the dimensions of any body in space in order to reconstruct the scene of a crime. Once fitness was deemed essential to evolution of a nation and survival of a race, both anthropometric photography and chronophotography proved instrumental to monitoring the health of the body.

After French physiologist Etienne-Jules Marey invented the photographic gun, and American Eadweard Muybridge developed a multilens system, movement of the body could be monitored in less than 1/500 of a second. Through chronophotography, the energy and fatigue of soldiers, workers, and athletes could be gauged. Using chronophotography, French photographer Albert Londe and neurologist-artist Paul Richer mounted the first illustrated archive of "the normal man" walking, running, and exercising. Following the Olympic Games revival and their synchronization with the 1900 Universal Exposition, International Congress of Physical Education, and International Sporting Competition in Paris, "normal man" appeared increasingly athleticized. Despite Darwin's distinction of fittest from fitness, a misconstrual of Darwin's use of Spencer's term led to "survival of the fittest" being conflated with the imperative for "fitness." At the 1900 Olympic Games, Marey, Richer, and Londe took hundreds of photographs of Olympians. In being photographed nude against anthropometers, their bodies could be measured to provide calculations of a corporeal ideal. Already photography was being used for this purpose in gymnasiums and physical culture schools.

From the time Richer became anatomy professor at the École des Beaux-Arts in 1903, these photographs, together with their measurements, were presented to students as the "new artistic anatomy." In these photographs, athletes and bodybuilders were either posed as antique sculptures like the *Apollo Belvedere*

or compared to photographs of it (fig. 6.3). Following Camper's, Lavater's, and Broca's elevation of Europeans over people of color and those classified as "degenerate," these models of "new artistic anatomy" were white, not black, Occidental, not Oriental, healthy, athletic, and unstigmatized by either disability or disease. Through its relationship to symmetry and proportional muscularity, this transparent body was able to signify internal health, hygiene, discipline, ethics, intelligence, morality, and heredity. Not only was this body to be evolved through the practice of modern sports and physical culture, but also eugenics—the Greek word coined by British geographer and scientist Francis Galton, meaning "good in birth" or "noble in heredity."

Fig. 6.3 Edmond Desbonnet (attribution), *Le modèle athlete Adrian Deriaz*, 1906, *La Culture Physique*.

BREEDING THE BODY: FRANCIS GALTON'S EUGENICS AND COMPOSITE PHOTOGRAPHY

Rejoicing in his cousin Charles Darwin's theory of natural selection, Galton was determined to accelerate evolution by giving "the more suitable races or strains of blood a better chance of prevailing speedily over the less suitable."[23] For this avowed white supremacist, those races and bloodlines to be given "a better chance" were healthy Anglo-Saxons. From his experience of living in Africa—from which he contracted venereal disease—Galton mounted a biocultural theory to account for the supposed superiority of white races over people of color. Dividing races into nine biocultural types, Galton argued that because Africans and other people of color could never achieve the pinnacle of civilization, they should be prevented from reproducing among themselves and with white people to avoid any threat of racial degeneracy.

Among white races, Galton granted only the naturally gifted the right to breed. To implement "natural inheritance," he recommended that detailed pedigree data, accompanied by photographs and physical measurements, be compiled in every British region, which schoolmasters, ministers, and doctors could collect. After breeding for some generations, Galton predicted that "the number of families of really good breed" would increase and "the selected race will have become a power."[24] "Inferior non-gifted classes" were to remain celibate and to be treated with kindness for doing so. Yet should they endeavor to procreate, they were to be regarded as enemies of the state. "What Nature does blindly, slowly, and ruthlessly," Galton explained, "man may do providently, quickly, and kindly."[25] Following his recommendations, the British Association

for the Advancement of Science Racial Committee (BAAS) commissioned anthropometric photographs of all the main races in Britain in 1881 as means of "ethnographic policing." When the Anthropometric Committee took over in 1883, under the chairmanship of Galton, 53,000 anthropometric photographs framed these races into a hierarchy, the Anglo-Saxon and Teutonic types who settled in the southern counties being ranked as the most intellectually gifted, physically fit, beautiful, and virile, the lower, criminal, and diseased classes in the north being ranked as the least and the greatest threat to "national efficiency."

Natural Inheritance and Composite Photography

Following Lavater, Galton believed there was a direct relationship between inner being and outward appearance. Elaborating Lavater, he regarded physiognomy as a reflection of psychology and physiology inscribed upon the face and body. By no means was this misconception unusual in the twentieth century, as illustrated by Galton Professor of Eugenics at London University Karl Pearson's explanation in 1912: "The pathological state, the psychical temperament and the physique are correlated characteristics in man."[26] If a group of people shared a mental trait or persona, Galton considered this reflected in their physical appearance. Superimposing individual photographs of family members on one another supposedly enabled him to extract their common features. From these composite portraits, Galton claimed he was able to determine the hereditary transmission of physiological character and, in keeping with his "science of heredity," predict the incidence of physiological and psychological characteristics between generations. When published in his 1889 book, *Natural Inheritance,* these results were designed to prove how "natural inheritance" could replace "natural selection."

Once Galton used composite photography to capture "the central physiognomical type of any race or group," it became not just instrumental to classification of physiognomic types according to eugenic fitness, but proof that mental, moral, and physical difference among races were transmittable by inheritance. While the spread of "unfit" races could be arrested through nonbreeding, conversely Galton claimed that ability could be enhanced. Composite photography could illustrate the superior physical characteristics that ordinary citizens could aspire to through the practice of eugenics. Through his genetic investigation of distinguished jurists, statesmen, military commanders, scientists, poets, painters, and musicians across two centuries for his book, *Hereditary Genius,* Galton found that a disproportionately large fraction were blood relatives.[27] Deducing that distinguished families were much more prone to produce talented offspring than ordinary families, Galton concluded that heredity not only governed physiognomy, but also intelligence and a sense of aesthetics.[28] As a corollary, he claimed that through judicious marriages across several generations, it would be possible to produce a highly gifted race of males that would look like his composite portraits of, for example, "American Scientific Men" or "British Geologists." If the state was unable to regulate marriage for racial improvement, he maintained, it must then advocate eugenics as a secular religion. "Only through the action of selection," he wrote, "would the natural qualities of a race be permanently changed."[29]

Although Galton's mathematical analyses of familial hereditary relationships were, according to Daniel Kevles, not just "faulty" but "in

places wrong," and although he was never able to prove conclusively that talent was inherited, his model of heredity prevailed among Western sciences.[30] The biocultures of Galtonian eugenics formed the bases of eugenics education societies throughout Britain, America, Australia, New Zealand, and France, including the Galton Laboratory into Eugenic Research, the American Eugenics Record Office at Cold Spring Harbour, government commissions into the "feeble-minded," and legislation to deal with them.

Eugenics Education Societies

In 1905, Sir Francis Galton gave the University of London 1,500 pounds to establish a Eugenics Record Office and donated 500 pounds annually for eugenic research in a laboratory. For the next thirty years the Galton Laboratory of National Eugenics, under the direction of Galton's "statistical heir," Pearson, became a global center for Galtonian hereditarian eugenics with links to America, Australia, France, Germany, Italy, Russia, and New Zealand. From 1901 on, its records of thousands of noteworthy families, collection of thousands of skulls and photographs, plus research into the inheritance of ability, vision, alcoholism, deaf-mutism, tuberculosis, and insanity attracted scientists worldwide.[31] From 1906 on, it published illustrated articles on the body through the journal *Biometrika* and bound volumes of *The Treasury of Human Inheritance.* While Pearson, like Galton, was adamant that eugenics be treated as a science, Sybil Gotto, with the support of such notable academics as the Cambridge University physicist W.C.C. Whetham, Lucasian professor of mathematics at Cambridge Sir Joseph Larmor, Maynard Keynes, and Havelock Ellis, was equally adamant that eugenics be popularized

to ensure its practice as a secular religion.[32] This was the objective of the Eugenics Education Society founded in London in 1907 by Gotto with, by 1911, one thousand members in London alone and Darwin's third-born son, Leonard, as its president.

At the First International Eugenics Exhibition, images of the "feeble-minded" and physiologically "degenerate" were juxtaposed with those Galton defined as superior.[33] After World War I, this became a dominant strategy in stigmatizing racial and physiological difference, reinforced by such films produced by the British Eugenic Society as *Damaged Lives* and *The End of the Road,* and the American film, *The Black Stork,* that played to packed cinemas beginning in 1917. Following August Weismann's discovery of germ plasm transmission and rediscovery of Mendelian genetics, Race Hygiene associations had spread across Germany and Scandinavia, as well as America and Australia, while in France, Italy, and South America, Neo-Lamarckian eugenic leagues and euthenics associations grew.

BREEDING ARYAN NORDICS: RACIAL HYGIENE SOCIETIES AND INTERNATIONAL HYGIENE EXHIBITIONS

Drawing upon Weismann's germ plasm theory, published in 1883, the German physician and biologist Alfred Ploetz developed his theory of race hygiene, published in his 1895 book, *Race Hygiene Basics.* In 1904, he founded the *Journal for Racial and Social Biology.* The following year, he and Swiss psychiatrist Dr. Ernst Rüdin founded the Race Hygiene Society, restricted membership to the Nordic race, and subsequently founded a secret society within it called the Nordic Ring. It was joined by Hitler's future secretary of the

interior and others who became members of the Third Reich Expert Commission on Population and Ethnic Politics. This Ring vowed to strengthen the racial characteristics of the German people and save whatever Nordic elements existed in Western civilization through a eugenic campaign of racial hygiene. While the research conducted by Ploetz and other racial hygienists entailed photography, diagrams, and displays, it was complemented by racial hygiene exhibitions.

In 1903, at the Hygiene Exposition in Dresden, *The Fight against Diseases of the People,* curated by Karl August Lingner, photography of degenerate families was exhibited alongside microscopes to view bacteria. Eight years later, when the First International Hygiene Exhibition opened in Dresden, it had sections on bacteriology, hygiene, heredity, race hygiene, and the importance of eugenics for national health. The importance of modern sports and physical culture to national health was not only emphasized by the last two sections, *Gymnastics and Sport* and *Care of the Body,* but also by the huge male sculpture mounted on a plinth, *Der Mensch,* that greeted visitors in the entrance hall of the exhibition. Muscular, perfectly proportioned, Nordic featured, this eugenic ideal of the male body seemed to epitomize the modern *Apollo Belvedere.* Arms upraised, the *laudate* he made was to a new god, as indicated by the inscription clearly incised on the plinth: "No wealth equals you, O health." Attracting five million visitors and netting one million Deutschmarks, more Racial Hygiene exhibitions soon followed, culminating in the International Hygiene Exhibition at the German Hygiene Museum in Dresden in 1930 and the Wonder of Life Exhibition in Berlin in 1935. In both, *der Mensch* again greeted visitors, but as Transparent Man (*gläserner Mensch*).[34] (See fig. 6.4.)

Eugenics was integral to both exhibitions. Slick panels and posters produced by professional graphic artists charted population changes through birth and marriage rates, hereditary transmission, and the disproportion of unfit to fit Germans. Installed alongside photographs of muscular, Nordic bodies glowing with good health, these didactics stressed the need for sexual sterilization of the "unfit," sexual selection of the fit, and physical culture to strengthen both mind and body. The eugenic ideal was epitomized by Transparent Man, a clear cellon plastic version of *Der Mensch*. In this transparent sculpture, the suppliant gesture to health as the new god was repeated. Six feet tall, blond, with perfectly molded muscles and Nordic features, and internally lit, *Transparent Man* was a model of Nazi eugenic principles of "the fittest," both internally and externally. Through mediation of the American Public Health Association, fifty-one posters and charts from this exhibition, together with a copy of Transparent Man, traveled across six cities of America from 1934 until permanently housed at the Buffalo Museum of Science. Not until nearly two years after America had entered World War II was it finally dismantled.[35] By that time one hundred and fifty million people had been affected by eugenic sterilization legislation, and over six million identified with intellectual, psychological, or physical disabilities, or racial and Semitic difference, had been exterminated in Europe.[36]

Given the absence of any proven anagogic correlation between the internal and external body, these biocultures of evolution, eugenics, and race science that began with "the mismeasure of man" and ended with the Holocaust may be regarded as premised upon the fallacious circular argument of biodeterminism: that morality, ethics, persona, intelligence,

Fig. 6.4 Transparent Man, photographed at the opening ceremony of the *Wonder of Life* exhibition, Berlin, March 1935.

and cultivation were a reflection of the body and that the body was in turn a reflection of these qualities. As these abstract concepts and complex qualities were converted into unitary entities for visualization and quantification, they were also premised upon the fallacy of reification. Yet despite these fallacious premises, these biocultures of evolution succeeded in inscribing the identity of healthy white Christian Europeans—those racial hygienists called Aryans—as the most aesthetic, beautiful, intellectual, civilized, and progressively evolved of all races. Conversely, they inscribed the identity of Semitic persons, the disabled, and people of color as the opposite. Once fitness became an imperative and eugenics a transnational culture, they also inscribed the body that deviated from the Eurocentric Apollonic ideal as inferior and, in so doing, proved instrumental to its sterilization and incarceration. Hence, ultimately these biocultures of evolution, eugenics, and scientific racism wrought discrimination against any form of physiological, racial, and Semitic difference and endorsed legislation for its eradication—long before such campaigns became a reality in Nazi Germany.

NOTES

1. Michel Foucault, *The Order of Things: An Archaeology of the Human Sciences* (Éditions Gallimard, 1966; Tavistock Publications, 1970), 19.
2. Protagoras's famous dictum was often quoted by Renaissance scholars; see Leon Battista Alberti, *Della Pittura* (Florence, 1436); published in English as *On Painting*, trans. John Spencer (Yale University Press, 1966), 55.
3. Stephen Jay Gould, *The Mismeasure of Man* (W. W. Norton & Company; 1996 [1981]).
4. In the zoological nomenclature devised by Carl Linnaeus, humans were grouped with apes as "primates," and humans and orangutans were classified with the same genus, homo.
5. Georges Louis Leclerc Buffon, Comte de Buffon, *Histoire naturelle, générale et particulière*, vol. 14 (L'Imprimerie royale, 1749), 61.
6. Charles Bonnet, *Oeuvres d'histoire naturelle et de philosophie* (Fauche, 1779–1783). In *The Order of Things*, 151, Foucault points out that Bonnet conceived of evolution as a process of infinite perfection in which all species moved one step higher in the Great Chain of Being, as illustrated by his quote from Bonnet's *Palingénésie philosophique*, vol. 7, 149–50: "Man, once transported to an abode more suited to the eminence of his faculties, will leave to the monkey…that foremost place that he occupied amongst the animals."
7. Pieter Camper, *Oeuvres de P. Camper qui ont pour objet l'histoire naturelle, la physiologie, et l'anatomie comparée*, 3 vols. (H. J. Jansen, 1803). Ranked as secondary to man, woman was never the prime object of investigation.
8. Pieter Camper, *Works*, trans. Thomas Cogan (Hearne, 1821 [1770]), 42: "The two extremities of the facial line are from 70 to 80 degrees from the negro to the Grecian antique: make it under 70, and you describe an ourang or an ape."
9. Johann Caspar Lavater, *Essays on Physiognomy*, vol. 1 (John Murray, 1789), 19.
10. Lucy Hartley, *Physiognomy and the Meaning of Expression in Nineteenth-Century Culture* (Cambridge University Press, 2001), 34.
11. Lavater, *Essays*, vol. 2, 409.
12. David Bindman, *Ape to Apollo: Aesthetics and the Idea of Race* (Reaktion Books, 2002).
13. Johann Joachim Winckelmann, *Geschichte der Künst des Alterthums* [History of Art in Antiquity, 1764] (Getty Research Institute, 2006).
14. Winckelmann, *Geschichte der Künst des Alterthums*.
15. Lavater, *Essays*, vol. 2, 416.
16. Redon's biographer, André Mellerio, noted: "It was at the museum that he grasped Cuvier's great law regarding the correspondence of

being"; see Barbara Larson, *The Dark Side of Nature: Science, Society and the Fantastic in the Work of Redon* (Penn State University Press, 2005); Fae Brauer, "Wild Beasts and Tame Primates: Le 'douanier' Rousseau's Dream of Darwin's Evolution," in *The Art of Evolution: Darwin, Darwinisms and Visual Culture,* ed. Barbara Larson and Fae Brauer (University Press of New England, 2009).

17. Gould, *The Mismeasure of Man,* 22.

18. While texts on phrenology burgeoned from the 1830s on, and journals on phrenology circulated from the 1850s on, a popular text on the cephalic index and phrenology published as late as 1934 was recently brought to my attention by Mark and Linda Aronson, edited by Carl Richard Huson, *The Complete Book of Fortune: A Comprehensive Survey of the Occult Sciences and other Methods of Divination that have been employed by man throughout the centuries in his ceaseless efforts to reveal the secrets of the past, the present and the future* (Associated Newspapers Ltd., 1936).

19. Paul Broca, "Sur le volume et le forme du cerveau suivant les individus et suivant les races," *Bulletin Société d'anthropologie* (1861): 188.

20. Charles Darwin, *The Descent of Man, and Selection in Relation to Sex* (John Murray, 1871).

21. Paul Broca, "Anthropologie," *Dictionnaire encyclopédique des sciences médicales,* ed. A. Dechambre (Masson, 1866), 280; 295–96.

22. Frank Spencer, "Some Notes towards an Attempt to Apply Photography to Anthropometry during the Second Half of the Nineteenth Century," in *Anthropology and Photography 1860–1920,* ed. Elizabeth Edwards (Yale University Press, 1992), 99.

23. Francis Galton, *Inquiry into Human Faculty and Its Development* (Macmillan, 1883), 24–25.

24. Galton, *Inquiry into Human Faculty,* 24–25.

25. Francis Galton, *Essays in Eugenics* (The Eugenics Education Society, 1909), 42.

26. Karl Peterson, "Preface," in *Treasury of Human Inheritance,* ed. Karl Pearson (Dulau and Co., 1912), viii.

27. Francis Galton, *Hereditary Genius: An Enquiry into Its Laws and Consequences* (Macmillan, 1892 [1869]).

28. Francis Galton, "Kantsaywhere" (Unpublished manuscript, London, 1910; University College London (UCL), Galton Archives), 138/6.

29. Galton, *Inquiry into Human Faculty,* 15.

30. Daniel J. Kevles, *In the Name of Eugenics: Genetics and the Uses of Human Heredity* (Harvard University Press, 1995 [1985]), 17–18.

31. Karl Pearson, *Report on the Work of the Francis Galton Laboratory for National Eugenics,* February 1908–June 1909, University College London, 25.

32. Wellcome Institute, Contemporary Medical Archives Centre, SA/EUG/B.1.

33. Fay Brauer, "Eradicating Difference: The Bioethics of Imaging 'Degeneracy' and Exhibiting Eugenics," *Art and Ethics, Australian and New Zealand Journal of Art* 1 (2004), 139–66.

34. Christina Cogdell, *Eugenic Design: Streamlining America in the 1930s* (University of Pennsylvania Press, 2004).

35. Robert Rydell, Christina Cogdell, and Mark Largent, "The Nazi Eugenics Exhibit in the United States, 1934–43," in *Popular Eugenics: National Efficiency and American Mass Culture in the 1930s,* ed. Susan Currell and Christina Cogdell (University of Ohio Press, 2006), 361–66.

36. Fae Brauer, "Making Eugenic Bodies Delectable: Art, 'Biopower' and 'Scientia Sexualis,'" in *Art, Sex and Eugenics: Corpus Delecti,* ed. Fae Brauer and Anthea Callen (Ashgate, 2008), 1–34.

BIOLOGY AND CRIME: DEGENERACY AND THE VISUAL TRACE

Heather McPherson

In the civilized world there obviously prevails a twilight mood which finds expression, amongst other ways, in all sorts of odd aesthetic fashions. All these new tendencies, realism or naturalism, "decadentism," neo-mysticism, and their sub-varieties, are manifestations of degeneration and hysteria, and identical with the mental stigmata which the observations of clinicists have unquestionably established as belonging to these.

—Max Nordau, *Degeneration*

The criminologist re-creates the criminal from traces the latter leaves behind, just as the archaeologist reconstructs prehistoric beings from his finds.

—Dr. Edmond Locard

There are similar markings in the grain of woods, in the veining of leaves, and in the spots and stripes of flowers. The barks of some trees often display the very patterns that are so useful and interesting in finger prints.... Photography shows furrows exactly like those of finger prints in the overflowing lava of a volcano.

—Henry Faulds

THE MEDICALIZATION OF DEGENERACY

In *Degeneration* (1892), Max Nordau decried the pathological state of fin-de-siècle European civilization, particularly in France, which he diagnosed as suffering from degeneracy and hysteria.[1] He attributed the rise of hysteria and degeneration to far-reaching technological changes, urbanization, the wear and tear of modern living, and nervous fatigue, and identified modern art and literature as sources of contagion that exerted a disturbing and corrupting influence on the younger generation. For Nordau, the new aesthetic schools represented not youthful vigor or innovation, but the babbling of deranged minds and the convulsions and spasms of exhaustion indicative of degeneration.[2] Nordau, a physician turned journalist who had studied psychology under Jean-Martin Charcot, was an exponent

My research was supported by a Summer Study Grant from the National Endowment for the Humanities. I would like to thank the staff of the Bibliothèque Nationale, the Bibliothèque Interuniversitaire de Médecine and the Bibliothèque Charcot at the Salpêtrière in Paris. I also wish to thank Nina Kallmyer and Jane Kromm for their comments.

of the ordered progress of the natural sciences and the law of causality. Adopting a clinical approach, he applied the medico-psychiatric discourse of degeneration to artistic and literary movements such as Impressionism and Symbolism and to modern society more generally. Nordau's writings, which were disseminated throughout Europe and the United States, struck a responsive chord and resonated widely. In fin-de-siècle France, where medical knowledge was particularly esteemed, the biomedical model of degeneration laid the foundations for the intrusive medicalization of the modern welfare state and was instrumental in popularizing an ideology of deviance in which moral and medical judgments were increasingly conflated.[3]

This chapter reconsiders Nordau's trenchant critique of Modernism and the broader cultural ramifications of degeneration theory in late nineteenth-century France, focusing on its biological and medical genealogy and the heightened significance of the visual trace, or stigmata, as the visible manifestation of psychological as well as physical degeneracy, notably in the case of hysteria and criminality.[4] Writing in 1881, Emile Zola called on artists to adopt the scientific method—to study objective phenomena with the aim of analyzing man.[5] In his exhaustively researched *Rougon-Macquart* series, Zola examined French society during the Second Empire through the clinical lens of heredity and social degeneration.[6] Debates about the causes of criminality and the significance of heredity as opposed to milieu brought together doctors, lawyers, and social theorists and permeated the novels of naturalist writers, including Zola and the Goncourt brothers. Against the backdrop of rocketing crime rates and the ballooning problem of *récidivistes,* the need for a reliable scientific method for criminal identification took on heightened urgency,

especially in France.[7] Not coincidentally, the rise of criminal anthropology, spearheaded by Cesare Lombroso, coincided with the era of photographic identification. Photography became the embodiment of the objective scientific gaze, doubling as visual signifier and indexical record and rejuvenating the search for criminal physiognomy.[8]

In the late nineteenth century, anthropometric measurement, or "Bertillonage," and fingerprinting emerged as competing technologies for criminal identification and vied for ascendancy for several decades.[9] Likewise, the visual trace was a central preoccupation in the emerging field of forensic science and figured prominently in the exploits of fictional detectives like Sherlock Holmes. In his exchange principle, Edmond Locard postulated that at the scene of a crime every contact leaves a trace, underscoring the forensic and diagnostic significance of the visual trace in reconstructing a crime and revealing the criminal.[10] The concept of degeneration was similarly grounded in the direct correlation between visual trace and pathological state or condition, aligning it not only with forensics but also with the physiognomic tradition, Morellian connoisseurship, and semiotic theory.[11] By the end of the century, the biomedical model of degeneration, rooted in evolutionary naturalism and medical pathology, had amalgamated with widespread anxiety about irremediable social ills, such as prostitution, criminality, insanity, and alcoholism, exacerbated by historiography and the forces of nationalism. What particularly interests me here is the convergence of art, medicine, and evolutionary theory in the clinical and criminal arena, and the seminal role visual culture, particularly photography, assumed in codifying and representing degeneration from hysteria to anthropological criminology to fingerprinting.

Bénédict-Auguste Morel's influential *Traité des dégénérescences de l'espèce humaine* (1857) established the conceptual framework for the medico-psychiatric model of degeneration that permeated late nineteenth-century culture, particularly in France.[12] Morel, who was chief physician at the Maréville asylum and later director of the asylum at St. Yon, defined degeneracy as the outcome of deviation from a primal type, arguing that man was a product of the devolution of human nature acting either alone or in conjunction with external influences.[13] In his treatise he enumerated the principal causes of degeneration, including social milieu and toxic substances, but underscored the preponderance of heredity and the progression of degeneration across generations, culminating in idiocy and sterility. Morel's physiological theory of degeneracy and belief in the law of inheritance were reinforced by Charles Darwin's *The Origin of Species* (1859), which argued that the development of animal species was the result of evolution in which only the fittest survived.[14] Despite his rather pessimistic prognosis of the human species, Morel concluded his treatise with a clarion call for intellectual, physical, and moral regeneration.[15]

As the century advanced, the discourse on degeneration was buttressed by the Lamarckian concept of heredity and the outpouring of scientific writings on social evolution, morbidity, and perversion, and intensified concerns about political and cultural decline.[16] Art was analyzed by writers such as Nordau through the evolutionary model of progress and decline and came to occupy a prominent place within the discourse on degeneration.[17] Moreover, art, especially photography, served as the visual index and provided the aesthetic template for illustrating and contextualizing degeneration, notably in Charcot and Richer's *Les Démoniaques dans l'art.*

In the late nineteenth century, far-reaching changes engendered by technological progress and industrial expansion intensified anxieties about social and medical pathologies and cultural decline. Within the sociological discourse, which was dominated by the binary opposition between progress and decline and the social and the individual, the concept of degeneration became a corollary of social evolution that could not be ignored.[18] By the 1890s, degeneration had transmogrified from an individual debility into a collective disorder. From a narrowly defined medical concept, degeneration mutated into a self-reproducing, empirically demonstrable pathological specter that seemed to threaten the very fabric of society and the future of civilization.[19] Hippolyte Taine applied theories about degeneration and social evolution to the study of French history, producing a historiography infused with medico-psychiatric and evolutionary language in which the history of the French Revolution became a case study of degeneration.[20] Likewise, in *La psychologie des foules,* Gustave Le Bon appropriated the mantle of science and modern psychology in his paranoid assessment of the collective mindset, suggestibility, and atavism of crowds, echoing his fears of social disorder and profound mistrust of mass democracy.[21] As these examples suggest, the concept of degeneration became intertwined with positivism and the development of human thought, psychiatry, and the scientific method, and debates about the duality of madness and genius popularized by Lombroso.[22]

Nordau's writings are emblematic of the converging medical, sociohistorical, and cultural discourses on degeneracy and the dialectic of degeneration and regeneration that haunted the fin de siècle. *Conventional Lies of Our Civilization* (1883), which exposed the lies and hypocrisy poisoning modern existence

and extolled the logic of natural science as the road to regeneration, set the stage for Nordau's hyperbolic denunciation of modern art and civilization in *Degeneration*. He brazenly diagnosed fin-de-siècle society as degenerate and sterile, analyzing its pathological symptoms and etiology, and identified modern art and literature with the mental stigmata of hysteria. The fact that Nordau had studied psychology under Charcot helps explain his particular preoccupation with hysteria. In addition to the writings of Morel, Nordau was inspired by Lombroso, to whom he dedicated *Degeneration*.[23] Like Lombroso, Nordau believed that degeneration manifested itself in visually identifiable physical characteristics or stigmata, as well as in pathological mental traits such as unbounded egoism, impulsiveness, emotionalism, mental weakness, incapacity for action, and a predilection for reverie or mysticism.[24] Nordau's belief in ordered progress and the laws of causality and evolution narrowly circumscribed and colored his ideas about modern art. That is manifested in his resistance to the invention of new art forms and synaesthesia and his anathema for ambiguity and mysticism. Nordau's denunciation of artistic movements, such as Symbolism, was overdetermined by his pathological model of artistic creativity in which novel sensations, ambiguity, and subjectivity were construed as symptomatic of hysteria. In *On Art and Artists* (1907), Nordau critically examined the works of individual artists such as Rodin, whose art he stigmatized as embodying degeneracy.[25]

Art was further implicated in the degeneration discourse through the debates about the pathology of genius, in which genius was linked with madness. In *Genius and Insanity*, Lombroso considered the physiological characteristics and etiology of genius.[26] He argued that genius, like artistic creation, was involuntary and intermittent, and alleged that geniuses displayed the physical and psychological symptoms commonly associated with degeneration and conditions such as epilepsy. In particular, he investigated the analogies between the physiology of genius and the pathology of the insane. Citing historical examples such as Gérard de Nerval and Baudelaire as evidence, he concluded that there was a strong correlation between the physiology of geniuses and the pathology of the insane.[27] Although Lombroso's views were controversial and widely contested, they were endorsed and popularized by writers including Nordau and Charles Maudesley, and the pathological model of genius and the stereotype of the mad genius survived well into the twentieth century.[28]

PHOTOGRAPHY AND THE VISUAL TRACE: REPRESENTING AND DEMONIZING HYSTERIA

After midcentury the scientific and artistic applications of photography as an agent for observation and as a diagnostic tool developed rapidly.[29] Dr. Hugh Welch Diamond, who began photographing the inmates of Surrey County Asylum in the early 1850s, was among the first to advocate the use of photography in the diagnosis and treatment of mental illness.[30] The photographic depictions of hysterics in the *Iconographie photographique de la Salpêtrière* should also be situated within the broader context of physiognomic experimentation, in which the camera probed the mechanics of facial expression in the studio as well as the clinic. That preoccupation was shared by artists, such as Nadar and his brother Adrien Tournachon, who created a dazzling series of *têtes d'expression* depicting the celebrated mime, Charles Deburau, and

physiologists, like Duchenne de Boulogne, who used the camera to record clinical experiments that investigated the grammar of expression by applying localized electric shocks.[31] He sought to classify primordial and complex expressions and included an aesthetic section in which he attempted to represent ecstatic love and Lady Macbeth's terrifying gamut of emotions. Darwin's use of photographs by O. G. Rejlander and Duchenne de Boulogne to illustrate his treatise on *The Expression of the Emotions in Man and Animals* (1872) is a further demonstration of the scientific and diagnostic applications of photography. The expanding role of photography as a mode of surveillance and classification is exemplified by Bertillon's anthropometric identification system and the development of judicial photography (a point to which I shall return).[32]

Nowhere is the convergence of the clinical and the artistic and the significance of the visual trace more clearly manifested than in the diagnosis and representation of hysteria. Although recognized as a disorder primarily afflicting women since antiquity, hysteria gained unprecedented prominence and cultural resonance during the second half of the nineteenth century in conjunction with the professionalization of the psychiatric profession and anticlerical politics.[33] As a clinical syndrome, hysteria long proved recalcitrant because of its variable symptoms and its uncanny ability to mimic other diseases.[34] The heightened interest in hysteria and its treatment, which peaked in the 1880s and 1890s, was rooted in Pierre Briquet's groundbreaking treatise of 1859, which established the framework for hysteria's emergence as a medical and cultural metaphor, as both the symptom and the literal embodiment of degeneration.[35]

Charcot, chief physician at the Salpêtrière Hospital in Paris, is credited with introducing a new template for diagnosing and representing hysteria, characterized by clearly defined phases and symptoms (stigmata) that could be systematically analyzed and mapped.[36] In the early 1870s Charcot, a talented draftsman and collector, applied his visual acuity and artistic talents to the clinical diagnosis of hysteria.[37] He covered the walls of his office with art works related to hysteria; set up a casting and photographic studio; and established an anatomical-pathological museum at la Salpêtrière, using images to dramatize his demonstrations and document the phases of hysteria.[38] Charcot's riveting elaborately staged lecture-demonstrations, which attracted philosophers and social scientists including Henri Bergson and Emile Durkheim, dazzled Sigmund Freud on his Paris visit (1885–1886). Trained as a neurologist, Charcot focused his observation on the external signs of hysteria and codified hysterical attacks as a predictable series of successive phases, which were graphically illustrated in the *Iconographie photographique de la Salpêtrière*.[39]

With its dual prognostic and documentary role, the *Iconographie photographique* is emblematic of the scientific application of photography in recording and indexing pathological symptoms. Régnard's photographs functioned both as clinical evidence and as visual amplification of the case histories they illustrated. A typical case history begins with a "normal" portrait taken before the attack, followed by a series of close-up views that record the most dramatic phases of the epilepto-hysterical attack, creating a riveting psychodrama in which the various phases are isolated in still photographs. The most spectacular series forming the centerpiece of the *Iconographie photographique* represents Charcot's star patient, Augustine, who entered La Salpêtrière at the age of fifteen and a half. She is depicted in

a series of dramatic attitudes or tableaux, ranging from agony to amorous supplication to ecstasy to menace (figs. 7.1, 7.2). In a photograph depicting the beginning of the attack we see Augustine, tightly strapped, mouth wide open in a silent scream. The so-called *attitudes passionnelles,* which follow the violent contractures and "clownism" phase, portray Augustine in ecstatic attitudes steeped in sensuality reminiscent of Baroque saints. In one illustration suggestively titled "Amorous supplication," she is depicted with arms clasped, head tilted back, in an attitude of prayer (fig. 7.2). Although the photographs were intended as clinical documents, considerable artistry is displayed in the selection of poses and mise-en-scène. The close resemblance between the

Planche XXIII

ATTITUDES PASSIONNELLES

EXTASE (1878).

Fig. 7.1 Paul Régnard, photograph of Augustine, n.d.

documentary photographs in the *Iconographie photographique* and Paul Richer's line illustrations for *Les Démoniaques dans l'art* is symptomatic of the overlapping of the clinical and the artistic. Some of Régnard's photographs were reproduced as line engravings, serving as illustrations for Paul Richer's *Etudes cliniques.*

In *Les Démoniaques dans l'art* (1887), Charcot and Richer mined past art, compiling a sort of *"musée imaginaire"* that historicized hysteria and conflated the clinical with the aesthetic.[40] Tracing hysteria back to fifth-century Ravenna and proceeding chronologically, Charcot confidently diagnosed the works of earlier artists, including Rubens. The study concludes with a discussion of modern hysterics, the present-day *"démoniaques convulsionnaires."* Richer illustrated the stages of the attack with line drawings in which the patient's convulsive movements are sometimes indicated by dotted lines (fig. 7.3), literalizing the notion of the visible trace. The schematic illustration implies duration and movement, with the dotted lines creating a ghost image behind the figure, a physical trace of the grand attack in which two distinct moments are merged in a single cinematic image. In discussing the ecstatic phase of hysteria, Charcot conceded that it did not possess special characteristics that clearly distinguished it from other varieties of ecstasy but was rather a detached fragment from the third period of a grand attack.[41] Interestingly, he complained that artists depicting ecstasy tended to omit any appearance of convulsive violence, using the example *St. Catherine of Siena in Ecstasy* from the Church of Saint-Dominic in Siena as an illustration. Charcot concluded that rather than relying on conventions in depicting ecstatic states, artists searching for varied expressions might have done better to seek out hysterical models, as

Planche XX.

ATTITUDES PASSIONNELLES

SUPPLICATION AMOUREUSE

Fig. 7.2 Paul Régnard, photograph of Augustine, n.d.

PÉRIODE ÉPILEPTOIDE DE LA GRANDE ATTAQUE HYSTÉRIQUE

Représentation schématique des grands mouvements de la phase tonique.

Fig. 7.3 Paul Richer, *Epileptoid Period of the Grand Hysterical Attack.*

Charcot did at La Salpêtrière.[42] To detractors who complained that he had largely invented hysteria, he defended his project, insisting that he merely inscribed what he saw and was nothing more than a photographer.[43]

TRACING THE PHYSIOGNOMY OF CRIME: FROM ANTHROPOMETRY TO FINGERPRINTS

The other anthropological arena in which the visual trace played a central role in identifying and indexing pathological types or individuals was the emerging field of criminology and forensic science, to which I have already alluded. Cesare Lombroso, an army physician and professor of psychiatry at the University of Turin, was the founding father of criminal anthropology. Influenced by the work of Morel and Darwin, he sought to index the anatomical anomalies of the born criminal based on features such as skull size and shape, body proportions, and physiognomy, paralleling anthropologists' attempts to decipher and quantify the savage body.[44] In *Criminal Man*, Lombroso formulated an atavistic theory of criminality based on biological markers that were the stigmata of degeneration.[45] Using anthropometric and physiognomic data, he compared over eight hundred Italian delinquents with soldiers and developed a biologically based model of criminality. Although Lombroso's anthropometric focus and biological determinism were influential during the 1880s, by the 1889 Paris Congress his theories were under attack from French critics, such as Lacassagne and Gabriel Tarde, who insisted on the significance of social milieu.[46] In *La Criminialité comparée* (1886), Tarde assailed the anatomical method and the concept of the "born criminal," arguing for a more nuanced psychosociological explanation of crime. Durkheim,

who laid the foundations for modern sociology, likewise focused on sociological causation in his classic treatise on suicide, published in 1897.[47]

Bertillon developed the first modern system of criminal identification, based on the rigorous application and codification of the anthropometric method.[48] Although fingerprinting, which remains the cornerstone of legal and criminal identification, also made its debut in the nineteenth century, it was not widely adopted as a judicial identification technique until the twentieth century. The Bertillon method relied on eleven different measurements and a precise morphological vocabulary for accurately recording characteristic features such as the hair, eyes and ears (fig. 7.4), and other peculiar marks. For the ear he developed an elaborate taxonomic system of classification based on inclination, profile, reversion, and dimension, with separate entries for border, lobe, antitragus, and folds.[49] Bertillon was also instrumental in standardizing legal photography; each identification card included standard full-face and profile photographs of the type still used today for mug shots.[50] Implemented in France in 1883, the Bertillon system was widely disseminated and had spread to the United States and Canada by 1887. Despite its aura of scientific objectivity and quantitative precision, the accuracy and reliability of anthropometry depended on the skill of the operators and the rigor with which the method was applied. That inherent weakness became evident when Bertillonage was widely diffused and it proved impossible to create an internationally standardized system.[51] Meanwhile, the recognition of the uniqueness of the individual fingerprint suggested its potential as a mode of judicial and criminal identification.

Although fingerprints appear in prehistoric cave paintings and pottery and were embossed

Fig. 7.4 Alphonse Bertillon, Classification of the Ear.

on ancient Chinese seals, fingerprinting did not emerge as an identification technology until the late nineteenth century in British India. William Herschel, a colonial administrator stationed in Bengal, began using fingerprints for civil identification purposes in the late 1850s.[52] Even though the potential of fingerprinting for criminal identification was recognized as early as 1880, devising a workable classification system for indexing fingerprints presented formidable challenges. Henry Faulds, a British physician who was struck by the fingerprints on ancient Japanese ceramics while serving in Tokyo in the late 1870s, made the first stab at classification with a syllabic system.[53] In 1880 he wrote to Darwin about his fingerprint research. Darwin forwarded Faulds's letter to his nephew, Francis Galton. Best known for his eugenic fingerprint research, Galton developed a qualitative classification system, based on a tripartite scheme of arches, loops, and whorls, forming the basis for most subsequent classification schemes.[54] Edward Henry, a colonial police official, developed a more comprehensive system based on additional subclassifications. His treatise on *The Classification and Uses of Finger Prints* was published in 1900. Fingerprints, first introduced as forensic evidence in a murder trial in India, were officially endorsed as evidence in the Indian Evidence Act of 1899. Although the anthropometric system remained firmly ensconced, the tide was beginning to turn, and Bertillon added fingerprints to his identification cards.[55] With the advent of fingerprinting, it became evident that identity could be determined through the tactile traces of the body itself.[56]

Fingerprints, much like DNA today, were perceived both as a mode of individual identification and as hereditary markers—the visible trace of evolution.[57] That is where the morphological analysis of fingerprints intersected with the widespread preoccupation with degeneration and evolutionary theory that gripped the late nineteenth century and was echoed in modern aesthetics. In "Ornament and Crime" (1908), the Viennese architect Adolph Loos argued that excessive ornament was a sign of degeneracy and even criminality, paralleling the Wilder and Whipple theory of fingerprints, which associated less functional more ornamental fingerprint patterns with degeneration.[58] By the 1920s the morphological branch of fingerprint research focusing on the hereditary potential and patterns of fingerprints had given way to practical reliance upon fingerprinting as a scientifically objective identification technique associated primarily with law enforcement. Recent discussions about the reliability of identification techniques such as iris scans and the institution of fingerprinting as a means of tracking foreign visitors and tourists in the wake of rising fears about international terrorism have reinvigorated the debates about judicial and criminal identification techniques that raged in the late nineteenth century. The widespread use of video surveillance cameras and new medical technologies such as CT scanning have made the body visible and mappable to an unprecedented degree. It is not surprising that preoccupations about the medicalization of the body and the parameters and liminality of individual identity are reflected in the work of contemporary artists such as Mona Hatoum and Justine Cooper, in which issues about biological, genetic, and social identity and the universal portrait are played out.[59]

NOTES

Max Nordau, *Degeneration,* translated from the 2nd German ed., introduction by George L.

Mosse (Howard Fertig, 1968), 43. Edmond Locard, cited in W. Jerry Chisum and Brent E. Turvey, "Evidence Dynamics: Locard's Exchange Principle and Crime Reconstruction," *Journal of Behavior Profiling* 1, no. 1 (January 2000). Henry Faulds, cited in Simon A. Cole, *Suspect Identities: A History of Fingerprinting and Criminal Identification* (Harvard University Press, 2001), 98–99.

1. Nordau's *Degeneration,* originally published in German (1892), was widely translated and vociferously debated across Europe. See George L. Mosse, introduction to *Degeneration,* xv–xxxiv, 42–44.

2. Nordau, *Degeneration,* 43. On the preoccupation with language and symbolist art, see Natasha Staller, "Babel: Hermetic Languages, Universal Languages, and Anti-Languages in Fin de Siècle Parisian Culture," *Art Bulletin* 76, no. 2 (June 1994), 331–54.

3. See Robert Nye, *Crime, Madness, and Politics in Modern France: The Medical Concept of National Decline* (Princeton University Press, 1984), xi–xii, 45.

4. See Daniel Pick, *Faces of Degeneration: A European Disorder, c. 1848–c. 1918* (Cambridge University Press, 1989); J. Edward Chamberlin and Sander Gilman, eds., *Degeneration: The Dark Side of Progress* (Columbia University Press, 1985); Nye, *Crime, Madness, and Politics.*

5. Cited in Rhona Justice-Malloy, "Charcot and the Theatre of Hysteria," *Journal of Popular Culture* 28 (Spring 1995), 133–34.

6. Emile Zola, *Les Rougon-Macquart, histoire naturelle et sociale d'une famille sous le Second Empire,* 5 vols. (Gallimard, 1960–67).

7. Cole, *Suspect Identities,* 33.

8. See Nye, *Crime, Madness, and Politics,* 97–131; Cole, *Suspect Identities,* 22–23.

9. Cole, *Suspect Identities,* 32.

10. On Locard's exchange principle, see John K. Thornton, "The General Assumptions and Rationale of Forensic Identification," in *Modern Scientific Evidence: The Law of Science and Expert Testimony,* ed. David L. Faigman, David H. Kaye, Michael J. Saks, and Joseph Sanders (West Publishing, 1997).

11. See Richard Wollheim, "Giovanni Morelli and the Origins of Scientific Connoisseurship," in *On Art and the Mind* (Harvard University Press, 1974), 177–201.

12. Bénédict-Auguste Morel, *Traité des dégénérescences physiques, intellectuelles et morales de l'espèce humaine* (Baillière, 1857). See also Georges-Paul-Henri Genil-Perrin, *Histoire des origines et de l'évolution de l'idée de dégénérescence en médecine mentale* (Leclerc, 1913), who discusses Morel and the influence of degeneration on nineteenth-century psychology; Ruth Friedlander, "B-A Morel and the Development of the Theory of *Dégénérescence*" (Ph.D. diss., University of California, San Francisco, 1973).

13. Morel, *Traité des dégénérescences,* 1–5; Friedlander, "B.-A. Morel," 282. Morel viewed degeneration as a pathological form of deviance and underscored the progression of mental illness, hysteria, and rising crime and suicide rates. See also Nordau's discussion of Morel, *Dégénération,* especially 16–20.

14. See Shearer West, *Fin de siècle: Art and Society in an Age of Uncertainty* (Overlook Press, 1994), 17.

15. Morel, *Traité des dégénérescences,* 693.

16. See Pick, *Faces of Degeneration,* especially 20–27; Eugen Weber, *France, Fin de Siècle* (Belknap, 1986), 11–14; Robert Nye, "Sociology and Degeneration: The Irony of Progress," in Chamberlin and Gilman, *Degeneration: The Dark Side of Progress,* 49–71.

17. West, *Fin de siècle,* 17. Despite art's prominent position in degeneration theory, it has received little scholarly attention.

18. Nye, "Sociology and Degeneration," 49.

19. Pick, *Faces of Degeneration,* 20–21. Degeneration encompassed racial anthropology as well as internal dangers, such as crime, alcoholism,

and prostitution, which threatened the hegemony of European society.

20. See Hippolyte Taine, *Les Origines de la France contemporaine: La Révolution,* 3 vols. (Hachette, 1878–1885); Pick, *Faces of Degeneration,* 67–73. According to Taine, the French Revolution bequeathed a legacy of degeneration to the nineteenth century that culminated in the Paris Commune. Taine and other writers also utilized syphilis as a metaphor for the decline of French society.

21. See Gustave Le Bon, *The Crowd, a Study of the Popular Mind* (1895), trans. into English (T. Fisher Unwin, 1896); Susanna Barrows, *Distorting Mirrors: Visions of the Crowd in Late Nineteenth-Century France* (Yale University Press, 1981); Robert A. Nye, *The Origins of Crowd Psychology: Gustave Le Bon and the Crisis of Mass Democracy in the Third Republic* (Sage, 1975).

22. See Genil-Perrin, *Histoire des origines,* especially 9–15, 183–205; Cesare Lombroso, *L'homme de génie* (*Genio e Follia,* 1863), trans. Colonna D'Istria (Félix Alcan, 1889).

23. See Nordau, *Degeneration,* v–vii. Nordau was influenced by Lombroso's *Genius and Insanity.*

24. Nordau, *Degeneration,* especially 18–22.

25. Max Nordau, *On Art and Artists,* trans. W. F. Harvey (T. Fisher Unwin, 1907), 275–93.

26. See Lombroso, *L'homme de génie,* especially 6–51.

27. Lombroso, *L'homme de génie,* 490.

28. See George Becker, *The Mad Genius Controversy* (Sage, 1978), 28–34. Becker asserts that the pathological view of genius predominated until the twentieth century. The links between genius and mental illness have been explored in several recent studies. See Arnold Ludwig, *The Price of Greatness: Resolving the Creativity and Madness Controversy* (Guildford Press, 1995); Daniel Nettle, *Strong Imagination: Madness, Creativity and Human Nature* (Oxford University Press, 2001), 137–60; and Andrew Steptoe, ed., *Genius and the Mind: Studies in Creativity and Temperament* (Oxford University Press, 1998).

29. On photography as an indexical system of representation and surveillance, see Alan Sekula, "The Body and the Archive," *October* 39 (Winter 1986): 3–64.

30. See Carolyn Bloore, *Hugh Welch Diamond, 1808–1886: Doctor, Antiquarian, Photographer* (Orleans House Gallery, 1980); Sander L. Gilman, ed., *The Face of Madness: Hugh W. Diamond and the Origin of Psychiatric Photography* (Citadel Press, 1977). In a paper read at the Royal Society, May 22, 1856, Diamond outlined the value of photography to psychiatry. He concluded, "Photography gives permanence to these remarkable cases,…and makes them observable, not only now but forever, and it presents also a perfect and faithful record, free altogether from the painful caricaturing which so disfigures almost all published portraits of the Insane" (cited in Gilman, *The Face of Madness,* 24).

31. See G.-B. Duchenne de Boulogne, *Mécanisme de la physionomie humaine ou analyse électro-physiologique de l'expression des passions* (Ve Jules Renouard, 1862); André Jammes, "Duchenne de Boulogne, la grimace provoquée et Nadar," *Gazette des Beaux-Arts* 92 (December 1978): 215–20.

32. On photography as surveillance, see John Tagg, *The Burden of Representation: Essays on Photographies and Histories* (University of Massachusetts Press, 1988), 66–102. Bertillon devised the anthropometric system still used by police departments. See Alphonse Bertillon, *La photographie judiciare* (Gauthier-Villars, 1890).

33. Jan Goldstein, *Console and Classify: The French Psychiatric Profession in the Nineteenth Century* (Cambridge University Press, 1987), 361–69. The 1838 asylum law formalized the asylum's role as a training institute.

34. Mark S Micale, *Approaching Hysteria: Disease and Its Interpretations* (Princeton University Press, 1995), 111. Micale argues that hysteria was in large part socially and culturally constructed.

35. See Pierre Briquet, *Traité clinique et thérapeutique de l'hystérie* (J.-B. Baillière, 1859).

36. On Charcot, see Georges Guillain, *J.-M. Charcot, 1825–1893, sa vie, son oeuvre* (Masson, 1955); Goldstein, *Console and Classify*, 322–77; Etienne Trillat, *Histoire de l'hystérie* (Seghers, 1986), 127–55.

37. See Henry Meige, *Charcot Artiste* (Masson, 1925), who discusses Charcot's artistic proclivities.

38. Charcot left his library and the museum to the hospital, but the museum was dispersed after his death.

39. See D.-M. Bourneville and P. Régnard, *Iconographie photographique de la Salpêtrière*, 3 vols. (Delahaye, 1877–1880); Georges Didi-Huberman, *Invention of Hysteria: Charcot and the Photographic Iconography of the Salpêtrière*, trans. Alisa Hartz (MIT Press, 2003).

40. See Jean-Martin Charcot and Paul Richer, *Les Démoniaques dans l'art* (Macula, 1984 [1887]).

41. Charcot and Richer, *Les Démoniaques dans l'art*, 107.

42. Charcot and Richer, *Les Démoniaques dans l'art*, 109, Richer's line illustration of Saint Catherine of Siena is implicitly linked with the earlier illustrations of a hysterical attack.

43. Didi-Huberman, *Invention of Hysteria*, 29.

44. Cole, *Suspect Identities*, 23–24.

45. See Cesare Lombroso, *Criminal Man*, ed. Gina Lombroso-Ferrero (Patterson Smith, 1972 [1911]). The book in Italian, *L'uomo delinquente*, was originally published in 1876 and reedited in 1878. *La donna delinquente* [Criminal Woman], coauthored with Guglielmo Ferrereo (Torino, 1893), translated into English as *The Female Offender* (Fisher Unwin, 1895), had a lasting impact on the study of female crime.

46. Nye, *Crime, Madness, and Politics*, 104–10.

47. Nye, *Crime, Madness, and Politics*, 144–45. Yet as Nye notes, Durkheim remained dependent on the medical model.

48. See Cole, *Suspect Identities*, 32–39. My account of Bertillon and fingerprinting is based on Cole's illuminating discussion and Sekula, "The Body and the Archive," 25–37. As Sekula points out, the merging of photographic evidence and statistical methods was essential to the development of criminology and systems of criminal identification (18). In contrast to Bertillon's biographical approach, Francis Galton attempted to create statistically defined composite portraits of "criminal types."

49. See Cole, *Suspect Identities*, 40–42, who reproduces the morphological classifications for the ear. It is noteworthy that the ear was of particular significance for Morelli's scientific method of connoisseurship. See Wollheim, "Giovanni Morelli," 182, who reproduces Morelli's illustration of typical forms of ears.

50. Cole, *Suspect Identities*, 43; Sekula, "The Body and the Archive," 30. Bertillon called for an aesthetically neutral standardized representation based on a standard focal length and consistent lighting. Although the frontal view was more recognizable, the profile view remained consistent over time and avoided the contingency of expression.

51. Cole, *Suspect Identities*, 52–53.

52. Cole, *Suspect Identities*, 64–65.

53. Cole, *Suspect Identities*, 73–74.

54. Cole, *Suspect Identities*, 79.

55. Cole, *Suspect Identities*, 91.

56. Sekula, "The Body and the Archive," 34.

57. Cole, *Suspect Identities*, 98.

58. Cole, *Suspect Identities*, 109.

59. Amber Henson, "Science, Technology, and Portraiture: Justine Cooper's *Rapt* and *Transformers*" MA thesis, University of Alabama at Birmingham, 2008.

VISUAL MODELS AND SCIENTIFIC BREAKTHROUGHS: THE VIRUS AND THE GEODESIC DOME: PATTERN, PRODUCTION, ABSTRACTION, AND THE READY-MADE MODEL

Nancy Anderson

> One of the most interesting aspects of the world is that it can be considered to be made up of *patterns*.
>
> —Norbert Weiner, *The Human Use of Human Beings*

PATTERN

In 1945, three years before he published *Cybernetics*, Norbert Wiener cowrote an essay with Arturo Rosenbleuth on the role of models in science. "No substantial part of the universe is so simple," the authors premised, "that it can be grasped and controlled without abstraction. Abstraction consists in replacing the part of the universe under consideration by a model of similar but simpler structure. Models, formal or intellectual on the one hand, or material on the other, are thus a central necessity of scientific procedure."[1] Presuming that readers understood the more obvious central role of the formal mathematical model, the authors turned to an analysis of the material model, a surrogate embodying select variables of the original, more complex system. Physical models can include objects out in the actual world, constructed objects, or other biological life, that is, "model" organisms.

Three years after *Cybernetics* appeared, one of Wiener's colleagues at the Massachusetts Institute of Technology (MIT), the social and political scientist Karl Deutsch, revisited the topic of scientific models, noting that: "[M]en think in terms of models. Their sense organs abstract the events which touch them; their memories store traces of these events as coded symbols; and they may recall them according to patterns which they learned earlier, or recombine them in patterns that are new." For Deutsch, "pattern" could be summed up as the sensing body's recognition of "some 'laws' of operation," and initially when he speaks of pattern he means a formal correspondence to the outside world, not a material one. Yet Deutsch claims, "in one sense all models are physical and knowledge is a physical process. Knowledge in general relies on physical structure. What interacts has structure. And what has structure can be known." And, as was pointed out by Wiener and Rosenbleuth as well, the discovery of patterns and models have a real-world use: "If this pattern and these laws

resemble, to any relevant extent, any particular situation or class of situations in the outside world, then, to that extent, these outside situations can be 'understood'…and perhaps even controlled—with the aid of this model."[2] So, models are a means for foreseeing. Or, as philosopher of science Georges Canguilhem so succinctly stated, "the model, one might say, predicts."[3]

Another MIT faculty member, the Hungarian artist and designer Gyorgy Kepes, was at this same moment actively pursuing the role of "pattern" in art, architecture, and science. Kepes, who had immigrated to the United States in 1937 to teach at the New Bauhaus in Chicago, had joined MIT in 1946, where eventually he would be the founding director of the Center for Advanced Visual Studies. Throughout the 1950s and 1960s he put considerable energy into building intellectual links between art and science, including a series of published anthologies, which brought together artists, biologists, physicists, technologists, architects, psychologists, and others to consider themes of common interest, such as structure, scale, and, most certainly, pattern. The first of these publications, *The New Landscape of Art and of Science* (1956), grew out of an exhibition Kepes mounted in 1951 and included contributions by artists (Naum Gabo, Jean Arp), an engineer (Paul Weidlinger), a biological crystallographer (Kathleen Lonsdale), architects (Richard Neutra, Walter Gropius), as well as a short piece by Norbert Wiener on "Pure Patterns in the Natural World."

Kepes filled this 1956 volume with hundreds of images, arranging them in order to connect visual patterns and play with scale; for example, a photograph of magnified raindrops is paired with that of sea urchin eggs, an aerial view of a cloverleaf intersection with a Kandinsky painting, and Buckminster Fuller's geodesic dome with a drawing of radiolaria by Ernst Haeckel. Maintaining that "vision is itself a mode of thinking," Kepes also called for a turn to "pattern-seeing" (as opposed to "thing-seeing") as a way to "trace the interplay of processes in the world." And it was the artist, he believed, who could help the scientist discover these patterns and processes:

> Contemporary scientists recognize that visual models of their new concepts cannot be provided by a portrayal of things; it is a model of relatedness that is called for. Artistic expressions which convey a sense of relatedness can provide science with new resources for visualization. In a closer communion between artists and scientists, it may be possible to work out new visual idioms.[4]

Finally, there is Buckminster Fuller, visionary architect, inventor, and cartographer, who studied the laws of Universe (he himself would avoid the definite article here) with the intention of applying nature's patterns to designs that could address crucial human needs. Fuller, whose geodesic dome is the "ready-made model" of the virus in this paper's title, wrote and spoke frequently about "pattern integrity," believing:

> When we speak of pattern integrities, we refer to generalizing patterns of conceptuality gleaned sensorially from a plurality of special-case pattern experiences…In a comprehensive view of nature, the physical world is seen as a pattern of patternings.[5]

The geodesic dome, then, was a special-case pattern experience, a design initially intended to solve a global housing problem. And like Kepes, he believed the artist was essential to the work of gleaning the patterns and forces of the universe's dynamic systems. "Man has been flying blindly into his future on scientific

instruments and formulas," he told a group of Bennington College alumni in 1960. Then he added:

> The great news on the artist-scientist intellectual frontier is that as the fog-and-black shadow of ignorance and misconception recedes, there looms a sublimely comprehensible conceptual patterning, which characterizes all the mathematical principles heretofore only formulatively employed by the scientists, yet intuitively pursued by the artist as potentially modelable.[6]

In the following pages I will explore the scientific model in the period following World War II, taking a particular instance when two scientists found inspiration for understanding virus structure in a well-known architectural design. Aaron Klug of Birkbeck College and Donald Caspar at Yale University discovered in Buckminster Fuller's geodesic dome, a building that could span hundreds of feet and had been reproduced around the globe, a pattern analogous to that of a virus, a biological entity measuring perhaps two hundred nanometers. The geodesic dome as model would eventually lead Klug and Caspar to a theory offering an explanation of how viruses constructed their shells. Key structural features of this architectural work offered, in essence, an idea, a pattern, for the protective casing that the virus assembled around its bare genetic matter.

Architecture, of course, has a long history of serving as metaphor in the life sciences, and by the time the twentieth century opened one read of the "architecture" of the cell or of the organ frequently enough, with descriptions at times confusing the two. "The central spaces, even though occupied by marrow," wrote one researcher in 1919, "give the bone some of the architectural advantage of a tube over a solid rod, i.e., greater rigidity or resistance to bending strain than is possessed by a solid structure

of the same length and weight of material."[7] What is so striking about the adoption of the geodesic dome as scientific model, though, is that it is a specific architectural design, and one of iconic status by the end of the 1950s, not least of all because it embodied a future of advanced technologies and mass production.

PRODUCTION

So how might a geodesic dome enter the virologist's laboratory—as a mental image, a series of images, a group of smaller-scale models, if not the building itself? To begin, there is the career of Buckminster Fuller. After a childhood in Milton, Massachusetts, Fuller would attempt a college education at Harvard, but he was expelled from the school twice. Between expulsions, he worked at a Canadian cotton mill, where he first learned the economics of manufacturing, and in 1917 he joined the navy and married this same year. It was while he was in the navy that Fuller began developing ideas that would lead to his study of synergetics, which he defined as the science of addressing the whole system with the understanding that the system's behaviors cannot be predicted by its individual parts. Two major misfortunes befell him, then, in 1922: A young daughter died of spinal meningitis, and his father-in-law, for whom Fuller worked, lost his building materials business. From here Fuller would decide to commit himself professionally to the study of "nature's own geometry" and, specifically, to use what he learned to tackle the problem of economical, durable housing. The geodesic dome would be the culmination of his efforts.

Fuller built his first successful geodesic dome in 1949 at Black Mountain College in North Carolina. Its shape was a tetrahedron and it spanned fourteen feet. The design relied

on emphasizing discontinuous tension of parts over discontinuous compression, an idea he and sculptor Kenneth Snelson had discussed the previous summer in North Carolina. Snelson's own sculptural pieces, often rigid cables balanced with flexible ones, were based on tensional relationships, that is, their stability came from an arrangement of parts that distributed stress across the whole system. (In contrast, compression relations, such as post and lintel structures, absorb pressure only locally.) Fuller was intrigued by the practical possibilities of exploiting the structural flexibility of tensional behaviors, believing that architects had failed to see this potential for creating more secure, efficient buildings. At some time later Fuller coined the term *tenesgrity* (tension + integrity) to describe structures that incorporated tensional relationships.

According to Fuller, the triangle was the most stable geometric form, and out of triangles came three Platonic solids: the tetrahedron, the octahedron, and the icosahedron. Because the icosahedron (twenty triangular surfaces = 60) covered the most volume with the least amount of material, he chose that form for subsequent dome designs. As a writer for *Architectural Forum* described it, Fuller "exploded the icosahedron onto the surface of a sphere" and then divided that surface "into a number of spherical triangles, or triangles with bowed legs."[8] All together, this system—triangles, icosahedron, sphere—exerted the least effort and provided maximum resistance to pressures and forces.

Aaron Klug was the first scientist to apply the geodesic dome to virus research after he began working at Birkbeck College. In 1953 he had received his doctorate in physics from Cambridge and soon after decided to direct his interest in X-ray analysis to examining biomolecules. Klug found himself applying

X-ray diffraction to the study of viruses, and by 1955 was focusing on the polio virus. His work clearly had implications for public health, but research on viruses could also offer knowledge about all life at the molecular level. Molecular biology had emerged out of World War II poised to become a leading discipline of the life sciences, and key questions of the discipline concerned how genetic matter coded for and controlled the production of proteins, the content of life. As loose bits of DNA or RNA, which self-assembled protective protein casings, viruses were, perhaps, not "life," but they offered a simple system for studying life's molecular elements. In this way, these quasi-living beings took on the role of "model" organisms.[9]

By the mid-1950s preliminary theories regarding just how viruses assembled their protective protein coats had begun to emerge. Most notably, in 1956 Francis Crick and James Watson, the scientists who had introduced the double helix of DNA in 1953, published their hypothesis. Because a virus had, or was, such a tiny amount of genetic matter, Crick and Watson pointed out that it could not possibly code for a wide variety of proteins. Thus, the shell must be constructed from identical protein molecules (subunits), which they surmised were attached to each other by identical bonds. Additionally, since life invariably organizes to the lowest energy state, this would dictate the final shapes of the shells, ones of cubic symmetry to be precise. These were the Platonic solids: tetrahedron, octahedron, and icosahedron. Crick and Watson refrained, however, from stating which of these shapes the virus would prefer.[10] This assertion was left to Klug and John Finch, a graduate student, who pored over photographs of their X-ray diffraction research as well as the visual data produced by other researchers, including that

of Cambridge postdoctoral fellow and colleague Donald Caspar, and concluded that the so-called spherical viruses definitely preferred the icosahedron.[11]

Klug and Finch published their observations in June 1959 in the scientific journal *Nature,* and because it involved the polio virus (one virus of certain widespread interest), their research captured the attention of the public press.[12] The *Manchester Guardian,* interestingly enough—and perhaps a bit prescient, as well—gave the story the headline, "The Architecture of Viruses." Another newspaper, the *London Observer,* provided readers with a diagram and an image of a ping-pong ball model to illustrate the capsid's geometry. Coincidentally, the artist, John McHale, member of the British Independent Group and acquaintance of Buckminster Fuller, saw the picture in the *Observer* and recognized a connection with Fuller's domes. Before the end of the summer McHale had brokered a meeting between Klug and Fuller.[13]

As Gregory Morgan, in his excellent research on the scientific route of the geodesic dome–virus connection, has reported in detail, a major problem persisted. If the virus really did organize into an icosahedron, then identical units must total sixty or a multiple of that. However, data emerging from various laboratories in the late 1950s refused to cooperate with that geometric fact. Klug and Caspar, who was back in the United States but now Klug's collaborator, were in frequent contact by then. At that time Klug was busy trying to build evidence to show how identical triangular units could bond to create a virus's shell. He wrote Caspar of this and cited Fuller. By then Caspar had discovered the book *The Dymaxion World of Buckminster Fuller,* by Robert Marks and, with these images of domes before him, the idea occurred to him

that—as in Fuller's designs—the contacts or angles between virus subunits (triangular faces on the domes) might vary slightly. He wrote of this to Klug, and remarked, "[I]n retrospect, I expect you will find it surprising that you did not recognize how well Fuller's geodesic structure does, in fact, represent virus structure."[14] Out of this they developed their hypothesis that the contacts between molecules were not absolutely equivalent and called it the "quasi-equivalence" theory.

Klug, too, found Marks's book and, as Morgan has noted, the scientist found one of the author's anecdotes particularly intriguing. In 1956 the U.S. government had commissioned a geodesic dome for an international trade fair in Kabul, Afghanistan. The building was sent in packages of color-coded parts and assembled, it was reported, quickly and competently by "unskilled" Afghan workers. In considering this, Morgan wrote that it struck Klug that "viruses also might assemble by following simple building rules," and certainly with minimal oversight.[15] In fact, years later Caspar would reiterate this connection between geodesic dome and virus, noting that, "[B]iologically relevant aspects of the Kabul Dome are: the economy of its construction from identical copies of a few types of subunits that are coded to fit together in a predetermined way; and the efficiency of its assembly that required only minimal supervision to avoid or correct mistakes."[16]

Underlying this connection between Afghan workers and viruses was an interest in linking virus capsid design to factory-like subassembly work. In fact, this idea of the factory as a model for molecular production had been made as early as 1950. "The modern art of the mass production of automobiles, houses, and radios, and other articles by the technique of subassemblies," Richard Crane, a physicist,

had written, "may seem at first sight to be quite far removed from the questions of the assembly of protein particles, but I believe it can be shown that some features are as applicable to one field as to the other."[17] The correlation wasn't perfect, however. According to Klug and Caspar, the virus constructed its capsid in an act of self-assembly (not subassembly), although it quite possibly was programmed to accept or reject components piece by piece, or molecule by molecule, and thus had an internal check that might very broadly be thought of as a variation on oversight.

As for Caspar, while studying the domes and talking with Fuller when they both had appointments at Harvard in 1962, he began to be see virus capsids as tenesgrity constructions.[18] Klug, however, remained cautious about making too much of the connection, agreeing on a possible geometric correlation between virus and dome, but rejecting that they shared any "engineering principle."[19] But Caspar's interest in the connection drove him to create a series of small "geodesic dome" models, using in some cases Fuller's own Geodestix modeling materials of rigid sticks and flexible plastic connectors as components, but also creating small dome-like objects from ping-pong balls or poppit beads. It was at this time that he came across an article showing how flat mosaics folded into cubic shapes could be used to determine which configuration of shapes fit on, for example, an icosahedron. Here, according to the author, Cambridge crystallographer Stuart Pawley, was a working model for the structure of viruses, assuming that the shell could be seen as a "plane group on a polyhedron."[20] Caspar began experimenting with two-dimensional sheets of mosaic patterns, cutting and folding them to consider bonding patterns in space. Working with these sheets, he could try out his and Klug's

theory—manually, intellectually, and visually. And here was the geodesic dome as abstracted "mechanical" drawing that could be manipulated into a three-dimensional paper shell. The plane nets became a tool that allowed Caspar to lift the idea of quasi-equivalence taken from Fuller's own constructions and test it by taking a drawing in his hand and shifting it from two-dimensional (surface) representation to three-dimensional (spatial positioning) model.

ABSTRACTION (BUILDING MODELS VERSUS THE READY-MADE)

After World War II molecular biologists and virologists found themselves with two especially powerful imaging technologies: electron microscopy and X-ray diffraction or crystallography. Klug and Caspar would rely most heavily on, and were experts in, the latter. In fact, Klug has made it clear that he specifically chose his career to advance the use of X-ray diffraction in molecular biology, and he received the Nobel Prize in Chemistry in 1982 for his creative work, which brought X-ray diffraction methods to electron microscopy so that researchers could build three-dimensional images of their molecular specimens with electron micrographs. Although both methods produce flat photographic pictures, from the beginning X-ray crystallography specifically gave information that was more conducive to recreating the three-dimensional spatial conformation of the specimen. With X-ray crystallography, a crystallized specimen is bombarded with a beam of X-rays. These rays scatter, and the diffracted light is captured on a photographic plate. After repeatedly rotating the specimen and shooting it with X-rays from various positions, the final image reveals an abstract pattern of light spots of different densities. This pattern represents

the distances of the molecule's atoms in three dimensions, and with the aid of a computer the researcher calculates the coordinate relationships between the spots, creating a blueprint of sorts, that can be used to construct a physical model.

Most visual modeling now occurs in a computer, but in the 1950s and 1960s scientists constructed their models from assorted real-world materials, including metal, wood, plaster, cork, paper, wire, plastic, glass—even commonplace objects like paper clips, beads, and ping-pong balls. The visual and tactile world of building models of molecules or viruses with such materials was, in practice, a performance.[21] These models were sculptural objects around which researchers might walk or through which they could peer. The physical model bridged the microworld with the macroworld, allowing the researcher to interact with the model so he or she might figure out how molecular entities organize and fit their components in space and how these components are constrained by space. This is geometry. As it has been suggested, "knowledge is produced in the contact between models and the world."[22]

Arguably, the most well-known scientific model of the second half of the twentieth century is Crick's and Watson's double helix of DNA. Publicity photographs show the researchers, Crick and Watson, peering through and pondering a six-foot-tall "sculpture" (fig. 8.1), but the initial model was only a single helical turn. Building this first model was a hands-on project, moving from drawings on paper to metal pieces arranged in space, and rearranged in space again. Speaking to historian Soraya de Chadarevian, Crick recalled building a series of models, the first, of course, being "hopeless incorrect."[23] And James Watson's memoir, *The Double Helix,* gives over significant space

to the hectic, heady days of model building that culminated in what we now know as the double helix. According to Watson, after recognizing a pattern in the crystallograph, rough sketches were followed by frantically rush-ordering metal pieces to act the parts of organic bases in the construction of the model. As soon as these arrived, he began stringing them together to get at the spatial arrangement of DNA.

As disappointing as the initial creations were, fortunately, the three-dimensional work-in-progress did raise the right questions: backbone-centered or backbone-out? and what should the angle of rotation be? Once the scientists settled on a reasonable configuration, there was the problem of the nucleobases. Watson returned to doodling on paper, only to return to three-dimensional hands-on thinking with the metal pieces. How did these bases, adenine (A), thymine (T), guanine (G), and cytosine (C), fit spatially in this tight braid without overlapping and still provide the maximum combinations to code for thousands of proteins? Watson explained that sometime late one afternoon he arrived in his office and "cleared any paper from my desk top so I would have a large flat surface on which to form pairs of bases held together by hydrogen bonds." This was when and where he discovered the base pairings we now know to be the formation of DNA: A-T and G-C. Playing further with the model, Watson and Crick would see in their theoretical sculpture how the two chains could intertwine and that they ran in opposite directions: the double helix. As they would tell it, they had discovered the secret of life.[24]

So the double helix ended up as one of the key scientific icons of the twentieth century, but what about the role of this other post–World War II icon, the geodesic dome, in scientific modeling? This architectural model was

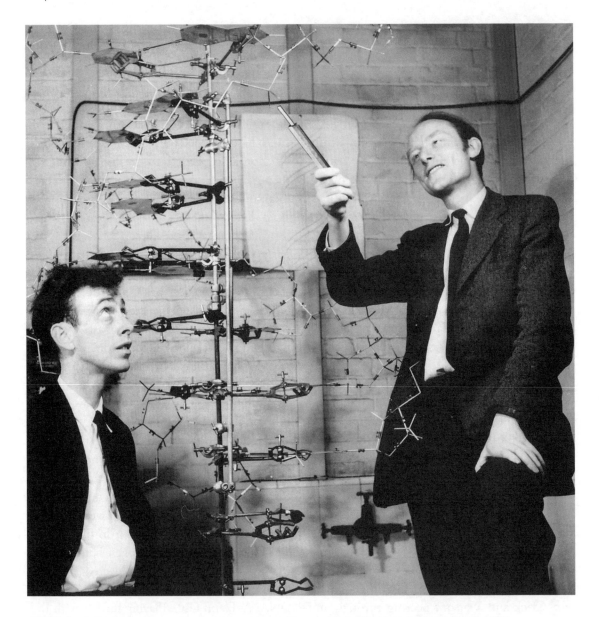

Fig. 8.1 A. Barrington Brown, *Francis Crick and James Watson with the Double Helix Model of DNA*, 1953.

not handmade by the researchers but came initially as a "ready-made." Without pushing the Duchampian connection too far, we can remember that Marcel Duchamp's ready-mades (the urinal, snow shovel, etc.) challenged the category of "art" through their unambiguous connections to the world of mass production and the jettisoning of the individual maker.

But as Molly Nesbit has explained, the ready-made is not necessarily a simple send-up of the artwork as the artist's unique production, but investigates the modernist trope of the "mass-produced model of repetition." Nesbit posits that Duchamp brought his schoolboy memories of mandatory mechanical drawing classes to his art practice, creating paintings

of a coffee mill, for example, and eventually, with the introduction of the ready-made, "producing the object from the drawing."[25] I am intrigued by Nesbit's attention to the transformations from mechanical drawing to mass-produced object, two dimensions to three, and its crossing of categories or social domains (commerce/industry and art in Duchamp's case). Here I would like to consider the relationship between mechanical drawing and object, and the crossing of these domains—architecture and science—in the case of Caspar's and Klug's use of Fuller's geodesic dome as a model for viruses.

By 1962 Klug and Caspar felt some pressure to publicize their "quasi-equivalence" theory before rival researchers were able to figure it out for themselves. The occasion that arose was the annual Cold Spring Harbor Symposium on Quantitative Biology, which that year took up the topic of mechanisms in animal viruses. Klug and Caspar introduced their theory at this meeting and acknowledged Buckminster Fuller and his dome as inspiration and model. In the published proceedings the two scientists included a photograph of a geodesic dome (fig. 8.2) and emphasized that Fuller's "physically orientated geometry" and "principles of efficient design" had suggested a solution to the problem of how viruses formed their icosahedral shells: the "quasi-equivalence" theory.[26]

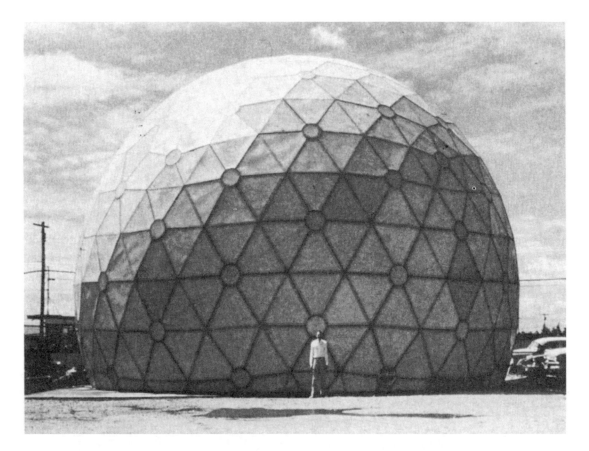

Fig. 8.2 W. H. Wainwright, *Fuller Geodesic Dome.*

To provide a demonstration of the theory, they showed the plane net experiments. Directly beneath the photograph of the dome the authors placed an image of the mosaic pattern showing the contact sites and the variants of quasi-equivalence, indicated by the letters A, B, C, D and E (fig. 8.3). In the text, and with additional illustrations, Caspar and Klug led their colleagues through an exercise showing how the patterns, or "plane nets," standing in for molecules or subunits, were able to reproduce how an icosahedral shell could be constructed with a variety of contacts (fig. 8.4). They do this by exhibiting the transition from flat sheet to curved surface, and then to an enclosed shape. The photographs documenting the folding of the patterned "plane nets" into three-dimensional forms include the hands of the researcher himself, reminding the viewer of the scientist-modeler's active—visual and tactile—role as the sheet of paper is transformed from two-dimensional drawing to three-dimensional model. In the end, though, the image, as pattern, remains on the surface, maintaining what we might call a "logic of surface perception," a term borrowed from architectural historian K. Michael Hays.

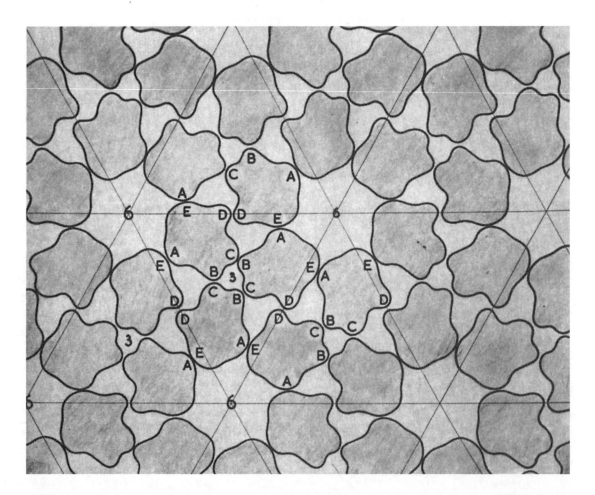

Fig. 8.3 *Asymmetrical Units Arrayed in an Equilateral-Triangular Plant Net.*

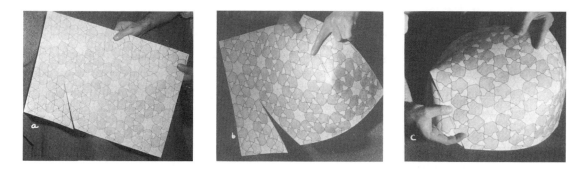

Fig. 8.4 *The Folding of the Plan Net into a Closed Surface.*

Hays has introduced the concept of the "logic of surface perception" as a way to discuss another particularly important icon of late modern architecture, the "curtain wall," best exemplified by Mies van der Rohe's Seagram Building of 1957. Hays describes the experience of stepping away from Mies's work and finding that "the modulations of the surface—the reticulated grid of wielded mullions and panels—as technically thick as they are, can not be read deeply … they can only be scanned for textural information." Interestingly, Hays also refers to the curtain wall as embracing the "optics of mechanical reproduction," in that the repetitive components—panels and mullions—are reminiscent of the assembly line even as they produce an experience of an abstract field that is accessible only to the eye. More to the point, perhaps, is that Hays saw Mies's surface design as presenting a grid of "found forms" of the mass-produced sort, which to Hays comes off as a visual display of the ready-made.[27] Recently architectural historian Reinhold Martin also analyzed the "curtain wall" of the 1950s and suggested that its aesthetic intentionally confronted viewers with the "collapse of the architectural object into a field of modulated patterns."[28] The Seagram Building's grid of windows does nothing if not force attention to the flat surface of a wall, offering an imposing, if perhaps overly rigid, surface pattern, not unlike the intention of the planet nets, or mosaics.

One has to be cautious about linking Mies to Fuller, however, as Fuller was highly critical of what he saw as the "technology as symbol" in International Style architecture and was especially disparaging of what he saw as these architects' ignorance or superficial interest in effective engineering and industrial design. But it was effective geometric patterns and shapes, and not engineering laws, that Klug, in particular, felt linked Fuller's design to spherical viruses. Additionally, Klug and Caspar had only two-dimensional images, not objects, as primary data, that is, crystallographs (and electron micrographs). What these images offered, the only possible view of a virus, was a pattern on a flat surface. It is from this that scientists conjectured the virus's geometric figuring in space. Caspar's folding of the plane nets into three-dimensional space can be seen as shifting from flat crystallograph (mechanical drawing-image) to an object—in this case, a paper copy of their ready-made model, that is, what in their minds was the geodesic dome.

As suggested at the beginning of this chapter, founded in cybernetics and its wide influence as a metadiscipline of sorts, the search for patterns framed key activities within the

work of post–World War II science and art. At just this same moment theoretical biologist C. H. Waddington, presenting his work on "New Patterns in Genetic Development" as the 1961 Jesup lecturer at Columbia University, claimed the recognition of dynamic patterns in the structures of developing cells and tissues as "one of the most striking and at the same time enigmatic phenomena with which the biologist is confronted."[29] "Much of science," one cybernetician suggested, "is man's search for basic patterns which will simplify his concepts of the universe."[30] This now can bring us back to Gyorgy Kepes and his call for "pattern-seeing," as opposed to "thing-seeing," in order to "trace the processes in the world."

The scientific models discussed in this chapter visualize Kepes's point. Crick and Watson show a brilliant understanding of pattern as tracing process when, at the conclusion of the article in *Nature* in which they introduced their pattern or model, the double helix, they state: "[I]t has not escaped our notice that the specific pairing we have postulated immediately suggests a possible copying mechanism for the genetic material."[31] A good model like the double helix, of course, *predicts*. Indeed, it did. That we are in the age of biotechnology is proof of its success. In the case of the virus and the geodesic dome, it was a matter of Fuller's own technological design, his dome as a special-case pattern experience culled from the patterns of the physical universe and brought back to nature as an abstraction, a model, for the study of viruses. The connection of a pattern between human-scale building and nanoscale virus suggested ideas of how the virus produced its shell. As Caspar noted, "[A]nalogies with human technology and behavior have provided essential keys for understanding the *operation* [my emphasis] of biological systems."[32]

I will end by returning to the artist/architect-scientist relationship that marks the example of the geodesic dome as a model for the virus. Kepes, I have mentioned, devoted decades to advocating these connections, and Fuller specifically claimed that "the artist frequently conceives of a unique pattern in his imagination before the scientist finds it objectively in nature."[33] Donald Caspar supported Fuller's claim, it seems, when he called the geodesic dome the "anticipatory key" to virus structure.[34] The exchange, however, is mutual, and Fuller's own research culminating in the geodesic dome is a case in point. As Reinhold Martin observed in his analysis of Kepes's project:

> It is exactly a new, aesthetically advanced biomechanical, sociotechnical "organism" that Kepes is attempting to build with his stunning compilation of patterns, an organism whose unity is enforced by the patterns themselves. These "patterns in a natural world," as Wiener puts it, are revealed to art by science, only to be fed back into science by art, with architecture acting as one of many media enabling the exchange.[35]

NOTES

Norbert Weiner, *The Human Use of Human Beings* (Houghton Mifflin, 1954 [1950]), 3.

1. Arturo Rosenbleuth and Norbert Wiener, "The Role of Models in Science," *Philosophy of Science* 12, no. 4 (1945): 316.

2. Karl Deutsch, "Mechanism, Organism, and Society: Some Models in Natural and Social Science," *Philosophy of Science* 18, no. 3 (1951): 230, 232.

3. Georges Canguilhem, "The Role of Analogies and Models in Biological Discovery," in *Scientific Change: Historical Studies in Intellectual, Social, and Technical Discovery and Technical Invention, from Antiquity to the Present,* ed. A. C. Crombie (Basic Books, 1963), 517.

4. Gyorgy Kepes, *The New Landscape in Art and Science* (Theobald, 1956) 18, 26, 205.

5. R. Buckminster Fuller, *Synergetics* (Macmillan, 1975), 221–26, sections 505.01–4.

6. R. Buckminster Fuller, "Prime Design," in *The Buckminster Fuller Reader,* ed. James Meller (Cape, 1972), 341.

7. R. M. Strong, "Adaptation in Bone Architecture," *The Scientific Monthly* 8, no. 1 (1919): 71.

8. Walter McQuade, "Geodesic Dome," *The Architectural Forum* 102 (1951): 148.

9. See Angela N. H. Creager, *The Life of a Virus: Tobacco Mosaic Virus as an Experimental Model, 1930–1965* (University of Chicago Press, 2002).

10. Francis Crick and James D. Watson, "Structure of Small Viruses," *Nature* 177 (1956): 473–75.

11. Viruses have two basic shapes: helical or rod-shaped and spherical or round. Spherical viruses are then found to be more accurately called "icosahedral" by the research considered in this chapter.

12. John Finch and Aaron Klug, "Structure of Poliomyelitis Virus," *Nature* 183 (1959): 1709–14.

13. Philosopher and historian of science Gregory J. Morgan has done a superb job piecing together the events and meetings that led to the connection of spherical viruses to the geodesic dome, and my synopsis is possible because of his meticulous work. Morgan, *The Beauty of Symmetrical Design: The Alleged Epistemic Role of Aesthetic Values in Theoretical Science,* Ph.D. dissertation, Johns Hopkins University, 2004; Morgan, "Early Theories of Virus Structure," in *Conformational Proteomics of Macromolecular Architectures,* ed. H. Cheng and L. Hammar (World Scientific Publishing, 2004), 1–38; Morgan, "Historical Review: Viruses, Crystals and Geodesic Domes," *Trends in Biochemical Sciences* 28, no. 2 (2003): 86–91.

14. Morgan, *The Beauty of Symmetrical Design,* 104. The letter quoted here is dated November 18, 1960 and is in the Jeremy Norman Archive (Novato, CA).

15. Morgan, *The Beauty of Symmetrical Design,* 105.

16. D.L.D. Caspar, "Movement and Self Control in Protein Assemblies," *Biophysical Journal* 32 (1980): 105.

17. H. R. Crane, "Principles and Problems of Biological Growth," *The Scientific Monthly* 70, no. 6 (1950): 388.

18. In 1962, Donald Caspar was affiliated with Children's Hospital Medical Center and Children's Cancer Research Foundation, and Fuller held the Charles Eliot Norton Visiting Professorship in Poetry at Harvard.

19. In a letter to Caspar, Klug wrote, "I have always thought of the application of tenesgrity to virus structure as more a geometrical principle rather than of an engineering principle....I think it would be unwise to carry the analogy further." Morgan, *The Beauty of Symmetrical Design,* 116. The letter is dated January 9, 1962 and is found in the Jeremy Norman Archive (Novato, CA).

20. G. S. Pawley, "Plane Groups on Polyhedra," *Acta Crystallographica* 15 (1962): 49–53.

21. See Natasha Myers, "Animating Mechanism: Animations and the Propagation of Affect in the Lively Arts of Protein Modeling," *Science Studies* 19, no. 2 (2006): 6–30.

22. James Greisemer, "Three-Dimensional Models in Philosophical Perspective," in *Models: The Third Dimension of Science,* ed. S. de Chadarevian and N. Hopwood (Stanford University Press, 2004), 433.

23. Soraya de Chadarevian, "Portrait of a Discovery: Watson, Crick and the Double Helix," *Isis* 94 (2003): 90–105.

24. James D. Watson, *The Double Helix* (Atheneum, 1968), 99–115.

25. Molly Nesbit, "Ready-Made Originals: The Duchamp Model," *October* 37 (1986): 53–61.

26. D.L.D. Caspar and A. Klug, "Physical Principles in the Construction of Regular Viruses," *Cold Spring Harbor Symposium on Quantitative Biology* 27 (1962): 1–24.

27. K. Michael Hays, "Abstraction's Appearance, (Seagram Building)," in *Autonomy and Ideology: Positioning in Avant-Garde America,* ed. R. E. Somol (Monacceli Press, 1997), 283–89.

28. Reinhold Martin, *The Organizational Complex: Architecture, Media and Corporate Space* (MIT Press, 2003), 6.

29. C. H. Waddington, *New Patterns in Genetics and Development* (Columbia University Press, 1962), 1.

30. J. F. Young, *Cybernetics* (Iliffe, 1969), 41.

31. J. D. Watson and F.H.C. Crick, "A Structure for Deoxyribose Nucleic Acid," *Nature* 171 (1953): 738.

32. Caspar, "Movement and Self-Control," 110.

33. Fuller, *Synergetics,* 505.06.

34. Casper, "Movement and Self Control," 104.

35. Reinhold Martin, "The Organizational Complex: Cybernetics, Space, Discourse," *Assemblage* 37 (1998): 123.

PART THREE

GAZE AND SPECTACLE

INTRODUCTION

Jane Kromm

The sense of being an object under observation, and the sight lines that induced this awareness, elevated visuality to a significant role in the new public spaces of the urban milieu. The idea of the gaze as defining a certain kind or kinds of looking associated with power and the desire to control others is characteristic of social visual politics in the modern era. Dominant or oppositional or voyeuristic gazes operated in certain settings to produce sight lines that might begin in non-committal acts of observation but that soon could lead to more surveillant or subversive or even predatory opportunities. Such a gazer's complete independence, occupying the top position in this visual hierarchy, is exemplified by the figure of the *flâneur* in nineteenth-century Paris. The *flâneur*'s itinerary included outposts for observation created through urban redevelopments, in which more opportunities for circulation and more sites for leisure pursuits permitted new mixtures of urban constituencies and classes. By blurring the traditional demarcations between the public and private spheres, these novel means of access created opportunities for injecting visual intimacy into what were still primarily public venues. The increased proximity to bodies that such sites accommodated in turn implied that a freer access to sexuality might be within reach. The necessity for new rituals of self-preservation—either to encourage or to rebuke the gaze–object exchange—enabled the development of new techniques of self-fashioning, of imprinting, or of otherwise marking the body under review.

GAZE, BODY, AND SEXUALITY: MODERN RITUALS OF LOOKING AND BEING LOOKED AT (1830–1880)

The redesigned urban landscape of nineteenth-century Europe increased and altered opportunities for looking at others in the city. This development created new configurations that emphasized contiguity rather than distance between the public and the private, drastically altering the distinctiveness of these two supposedly separate realms. Spatial adjustments, with their novel vantages and juxtapositions, affected in turn the social parameters of seeing and being seen for both sexes. The result was a "logic of the gaze" that developed around the circumstances in which the body might become an object of focus, but also of sexual interest and control. From the high visibility of the promenades, with their limitless vistas promising a freedom of unconstrained mobility, to the furtive setting of the cul-de-sac, with its implicit danger and illicit potential, modern rituals of looking across the urban setting imprinted visual culture with lines of sight that proved resistant to being exposed as anything more than the natural practices of focalization.

Temma Balducci's chapter, "Gaze, Body, and Sexuality: Modern Rituals of Looking and Being Looked At," examines the popular sites for various kinds of public viewing that proliferated in nineteenth-century Paris. At these locations, including the annual salons and the newly formed galleries, the many outdoor and indoor performance venues, the cafes and the boulevards, men and women of different classes were observers of whatever spectacle was on offer. But they also, and sometimes even more importantly, were looking at each other and were well aware of the mutual scrutiny. While many studies of this phenomenon tend to concentrate on circumstances in which male viewers focus on passive female objects, this chapter turns to conditions of looking in which men and women participated as both objects and subjects in the visual field. These more diversified conditions of looking can be found in the mixed crowds of the salons as well as in the ubiquity of the male nude in exhibition halls and studio settings. An interest in male objects of the gaze was reinforced outside the fine art setting by the rise in body-focused masculine sports and entertainments such as wrestling, and in the poses struck by bodybuilders and strongmen. Women were active spectators at these events, and they were also engaged in the new visual and kinetic opportunities made possible by the widened boulevards and their appurtenances. Even familiar representations of the well-studied venues of cafes, café-concerts, and theaters, such as Edouard Manet's *Bar at the Folies-Bergère,* can be usefully revisited to query that image's patterns of looking. By employing a more diverse template of possible gazes, scholars like Balducci are able to unravel the complex visual dynamics of gaze and body that flourished in nineteenth-century Paris.

THE *FLÂNEUR/FLÂNEUSE* PHENOMENON (1830–1900)

Much urban modernism was cast from the vantage of the *flâneur,* a detached observer who searched for novelty and inspiration in public city spaces, and whose inclinations represent a new kind of visual experience. While flânerie was an essentially Parisian phenomenon, Paris often also stood for modernity in general, a generality that allowed the extension of the *flâneur*'s purview to other urban centers, especially London and Vienna. Charles Baudelaire, who refined the *flâneur*'s profile, likened the figure to that of modern painters, establishing for the group a visual preoccupation that was investigative and exploratory, but also insatiable and invasive. Among the *flâneur*'s many qualities, the most outstanding is his disengaged status—his incognito remains intact as he perambulates the milieu, observing, without any moral obligation, the disrupted lives of those displaced by urban renovation. Experiences gleaned from these noncommittal explorations he regards as vastly superior to his own private, domestic contacts. In his orientation and preferences, the *flâneur*'s biases are clear, as the objects of his gaze always occupy a status inferior to his own. Whether there can be a *flâneuse,* a female *flâneur,* is thus a debatable possibility, just as a lower-class figure would be similarly problematic. The *flâneur*'s visual field can thus be regarded as open and egalitarian only from his position, for his visual practices define an optical freedom for modernism that is implicitly asymmetrical and imbalanced. In "The *Flâneur/Flâneuse* Phenomenon," Jane Kromm examines the rise and fall of this intriguing figure, both a cipher and an essential motif of modernity cast in significantly gendered terms. From a desultory and derogatory character of the post-revolutionary era, to his transformation into a gentleman with literary and artistic inclinations, the *flâneur*'s visual style altered conceptions of vantage and outlook across the cityscape of the modern era.

SPECTACLE AND THE VISUAL CALIBRATION OF CLASS
AND GENDER (1880–1920)

The new urban spaces of the modern era offered city dwellers unprecedented opportunities for inter-
mingling both on and off the sidewalks and boulevards. A proliferation of novel destinations became
the catalyst for urban explorations of unfamiliar venues, where standards for rank and propriety were
stretched or overruled. Whether cafes, café-concerts, music halls, theaters, or street entertainments,
these locales increased the proximity between audience members, and this spatial intimacy allowed
traditional divisions between previously distinct members of society to be questioned. The destabilizing
effect of this process was an essentially visual one, not only in terms of the mutual regard now acces-
sible for a range of participants, but also because visual experimentation in clothing and behavior added
a further element of novelty and confusion to experiences at such spectacular sites. The status of tradi-
tional dress codes was slowly eroded at such venues. Here those desiring to appear as something other
than their ordinary selves could move up or down the social ladder aided in part by the burgeoning field
of secondhand clothing and by adapting the edge of a masquerade ethos to the real dramas of quotidian
street life. Scenes of spectacle in art, literature, and drama exploited this new visual calculus of propriety
and impropriety as they revealed or concealed underlying truths of class, gender, and human behavior.

Elana Shapira's chapter, "Gaze and Spectacle in the Calibration of Class and Gender: Visual Culture
in Vienna," studies the social and psychological dynamics invested in and unleashed by the dressed
and undressed male and female bodies that inspired four members of the Austrian Expressionist
movement—Otto Wagner, Adolf Loos, Oskar Kokoschka, and Egon Schiele. Appropriate dress tradition-
ally correlated with propriety along with acceptable behavior and social conformism. Judged against
this standard, anomalies of both dress and ornamentation were objects of increased psychological and
moral theorizing, from Loos's attacks against the decorative to Sigmund Freud's linking of ornament
with the instinctual and the uncultured. A number of projects around 1900 investigate practices of
dress, of covering—as well as their opposites of undressing and uncovering—in male and female fig-
ures, and examine the significant ramifications these practices had for both male and female viewers.
From bathroom designs that enriched opportunities for voyeurism and physical pleasure to bedrooms
conceived as "dress-collages" redolent of a kind of ritual disrobement, Wagner and Loos attempted to
reposition male and female bodies in relation to dress or undress as central to the goal of modern de-
sign. Loos also brought these concerns to his design of private residences, whose exteriors the public
and the media alike correlated with clothed or bare female bodies. In tortured representations, many
of them self-referential, Kokoschka and Schiele portrayed male bodies as exposed, as awkwardly dis-
played, offering images in which the conflicts and dilemmas of masculine identity are painfully uncov-
ered. All these works variously calibrate and forcefully articulate the visible anxieties and insecurities
about gender and sexuality that were the core preoccupations of avant-garde Vienna.

INSCRIBING THE BODY: FROM HYSTERICAL MARKS TO TATTOOS
AND PIERCINGS (1870–2000)

A handling of costume and dress that was socially calibrated and spectacle-sensitive brought into
focus issues relating to the underlying physical presence of the body itself. Its wholeness, surfaces,

and contours, as well as the body's capacity for gestural novelty, were important variables that could be brought into spectacularizing play. Fashion slogans that treated the body as a dress and vice versa encouraged interchangeability between what had been a core and its superficial, temporary covering. The dynamics of exposure and revelation that this reversal exercised proved to be highly adaptable in medical and anthropological contexts. In the service of clinical instruction, physicians' demonstrations that extracted diagnoses from the signs inscribed on the bodies of model patients galvanized the attention of professional men. The extravagant and outrageous body positions adopted by these, usually female, hysterics, were treated with solemnity and high seriousness, and the photographs of their posing in gowns while in bed were collated and published in learned journals, extending their exposure from the clinics of Paris to the medical centers of Germany, England, and the United States. Clinical demonstrations typically centered on skin sensitivity or its absence, often while the patient was hypnotized, a concentration that revived procedures infamously familiar from witchcraft proceedings. Anthropological explorations introduced to Western observers a different range of skin insensitivity in the form of tattoos and piercings, which, while originally considered strange and exotic, have since become increasingly universal forms of self-expression among the independent or disaffected across Europe and the United States. Contemporary translations of these practices juxtapose pattern with pallor, and in the public airing of decorated, embossed, or invaded skin, sensitivity collides with insensitivity at increasingly spectacular and uncanny levels.

Fae Brauer, in "The Stigmata of Abjection: Degenerate Limbs, Hysterical Skin, and the Tattooed Body," examines physical changes to the body's extensions and surfaces, especially imperfections of contour, skin, and symmetry, as signs antithetical to the Western tradition that had corroborated wholeness and intactness with perfectly smooth, white skin. As Morel's and others' theories of degeneracy gained ground, the involuntary markings of skin associated with conditions like rickets and hysteria, as well as voluntary markings such as tattoos, were both invoked as evidence of the dangers of heredity and inherited ailments. Hysterical skin conditions were a particular concern, as these were invisible, fleeting, and evanescent, occurring in a variety of forms from complete numbness to hypersensitivity. Charcot's clinical demonstrations of patients suffering from hysterical skin phenomena became the subject of photographs and other representations, offering spectators glimpses of exposed skin that required probing or pricking. Such images could readily be inappropriately aligned or associated with other contexts, and this was especially the case in England, when newspapers paired clinical pictures of hysteria with photographs of protesting suffragists. Voluntary markings like tattoos were similarly implicated in arguments about degeneracy, and they were variously seen as indexes of the criminal, the savage, and the exotic other. In certain protest movements of the twentieth century, tattoos gradually came to be regarded as evidence of freedom from oppressive forms of normality. Resisting privileged arguments touting the white and the immaculate, custom tattoos, along with various temporary forms of skin markings, presented a strong, aggressively visible alternative to the unblemished skin that had long been central to concepts of the natural and the normal.

GAZE, BODY, AND SEXUALITY: MODERN RITUALS OF LOOKING AND BEING LOOKED AT

Temma Balducci

Jean-Louis Comolli's oft-quoted phrase that the "second half of the nineteenth century lives in a sort of frenzy of the visible" seems an appropriate opening for this chapter.[1] Comolli refers to the proliferation of images and technologies through which Western society was continually re-presented to/for itself, images that were fashioned within a complex cultural matrix and, simultaneously, constitutive of it. I would argue, however, that a description that highlights the crucial importance of vision/spectacle to cultural identities and social practices is also applicable to the first half of the nineteenth century. Throughout the century in Paris, a focus on looking was pervasive in a wide variety of forms; for example, the explosion of print media in the July Monarchy, the popularity of the stereoscope and the *carte-de-visite,* the continued improvement of binocular technology, fashionable accessories such as the veil and the fan that shielded women's eyes but that also provided clandestine viewing opportunities, and the growing popularity of the salon and the rise of a private gallery system that put art on display for an ever-expanding public.[2] Much of this attention to spectacle was rooted in the rise of capitalism and the modernization of western Europe. The new forms of leisure that developed concomitantly with such cultural and political shifts more often than not provided visual pleasure of some sort and/or necessitated the use of viewing aids. An abbreviated list of such popular amusements would include the circus, the race track, the café-concert, photography, and window-shopping.[3]

It is tantamount to scripture that women during this century, especially in Paris, provided the greater part of the spectacle. Women are conventionally understood in scholarship as the passive recipients of a specifically male gaze, their bodies inscribed as objects and sexualized commodities.[4] Although I disagree strongly with such a blanket characterization, it is certainly true that women's bodies were frequently on display, often in contexts that were sexual. Such scholarly territory is well trod. Thus, while this chapter will review some of this literature, it will also investigate largely overlooked ways in which men and male bodies were constructed as spectacle, subject to the gaze of both men and women in contexts that were also sometimes sexual. Attending to significant cultural institutions as well as popular Parisian pastimes in the period from 1830 to 1880, this chapter focuses on how the bodies of both men and women were subject to various gazes, rendering them both as sexual and as commodities in a century defined by a "frenzy of the visible."

THE SALON AND ACADEMIC CULTURE

The desired male body was a shared public form.

—Darcy Grimaldo Grigsby,
Extremities (2002)

The fact that both male and female bodies were often on display is nowhere more evident than in Salon exhibits (of the Académie des Beaux-Arts in Paris), which became annual affairs in 1833. The French Royal Academy of Painting and Sculpture and the Salon were arbiters of visual culture from the mid-seventeenth century throughout the greater part of the nineteenth century.[5] Although the Salon lost stature in certain circles toward the latter part of the century, at least as early as the July Monarchy, it was a highly anticipated and well-attended social event.[6] It was precisely this popularity that caused consternation with some critics and academicians because of the market-like atmosphere generated by the large crowds who came to ogle works of art like so many trinkets on display.[7] In addition to the countless reviews in various journals that attest to the cultural significance of the Salon, there are images that confirm its popularity for both men and women. In Francois-Auguste Biard's (1811–1892), *Four O'clock at the Salon* (1847), for example, the viewer notes the crowded gallery space as well as the fact that the Salon-goers pictured are of both genders and various classes. Two decades later, Honoré Daumier (1808–1879) published several prints in which he imagines the reactions of Salon-goers to the works of art on display. In one of these, two women remark on the many depictions of Venus: "More Venusses this year…always Venusses!…as if there were any women who look like that!" As

both works underscore, the Salon was a well-respected venue that provided opportunities for both men and women not only to critique works of art, but also to exercise their gazes.

While the women whom Daumier depicts lament the many idealized female bodies on display, there were also nude male bodies on view. Women took note of these as well. Caroline Wuiet had this to say about François Gerard's (1770–1837) *Cupid and Psyche* when it was exhibited in 1798: "How the eye skims over his rounded forms! How it is brought back to the juicy contours of his delicate members!"[8] Wuiet's comments reveal that the male bodies on display at the Salon could appeal erotically to female viewers.[9] Indeed, there were countless images of nude male figures put on display in the Salon, not only in the July Monarchy but also throughout the century. While the nude figures in Eugène Delacroix's (1798–1863) *Massacre at Chios* (1824), for example, were part of a colonialist discourse in which foreign male bodies were sexualized,[10] the majority of the male nudes were found in works whose subject matter was drawn from Western literature or from classical history. For example, Jean Bernard Duseigneur's (1808–1866) *Roland Furieux,* shown at the Salon of 1831, was a theme taken from Ludovico Ariosto's (1474–1533) Renaissance poem of the same title. The work depicts Roland with a taut, muscular body as he struggles, writhing just below the viewer's line of vision, to loosen the ropes that bind his hands and feet. The figure is nude except for a strategically placed fig leaf. His body is shown as sinuous and helpless—very much on display for the perusal and delectation of Salon viewers. Fifteen years later, Eugène Guillaume (1802–1905) won the Prix de Rome for *Theseus Discovering his Father's Sword beneath a Rock* (1845; fig. 9.1). The work depicts a youthful male body whose

Fig. 9.1 Eugène Guillaume, *Theseus Discovering His Father's Sword beneath a Rock,* 1845.

the male nude was repeatedly assigned for the Prix de Rome, the fiercely competitive award offered to students at the Ecole des Beaux-Arts that was coveted throughout the century as a guarantor of success. Thus, while certain paintings of female nudes have become infamous in the art-historical canon, it was in fact the nude male body that received the most attention both in the studio and in the Salon.

In the majority of these works, the male body was displayed with unashamed inclusion of pubic hair and/or penis that affirmed and celebrated their masculinity.[14] Such representations of the nude male body symbolized not only art, heroism, and beauty, but also the height of academic excellence. Considering the importance of developing skills in rendering the male nude and its status as a symbol of the ideal, the paintings and sculptures in the Salon and in other venues served to put the nude male body on display in an increasingly specularized and commodified context.

BRAWN AND BEEFCAKE

He will display for you during his performance his perfect manly beauty.

—Edmond de Goncourt, *The Zemganno Brothers* (1879)

complete nudity is framed by an artfully arranged cloak. Guillaume shows the figure turned toward the viewer—presenting both the recovered sword and the carefully considered pose that showcases Guillaume's skill in rendering the male nude.

Bearing in mind the importance given to representations of the female nude by art historians,[11] the plethora of male nudes at the Salon throughout the century is staggering.[12] Indeed, despite the decline in innovative history paintings throughout the century, the importance of the male nude in academic culture continued. Honing the ability to draw the male nude formed the crux of academic practice and education until well into the twentieth century.[13] In both painting and sculpture, subject matter requiring the representation of

Susan Waller has shown that the men employed as models in the studios of the Ecole often did not receive a living wage.[15] Many of them were beggars or had second jobs peddling their bodies in other locales. After midcentury, the confluence of an increasing interest in physical fitness and the mushrooming number of venues devoted to entertainment meant that it was common to see men displaying their muscular physiques as strongmen, wrestlers, and acrobats at circuses and café-concerts.[16] These men performed their masculinity for

a paying audience, and images of them were available as early as the 1860s in the form of *cartes-de-visite,* postcards, and advertisements, and in paintings and drawings by artists such as Daumier and Gustave Courbet (1819–1877).[17] These depictions, along with descriptions found in literature, reveal how male bodies were presented to viewers at performances. The bodies of weight lifters, for example, were often clothed in little more than fig leaves that hid genitalia, or in form-fitting clothing—paralleling the way male bodies were represented in works of art on display at the Salon. Indeed, strongman Eugen Sandow (1867–1925) worked as an artist's model in Paris before becoming famous for his physique and physical prowess.[18] It was part of his performing repertoire to cover his body in white powder to imitate the poses found in statuary from the ancient world, such as the *Dying Gladiator.* In so doing, he reenacted— probably for many of the same viewers—the types of poses that he assumed for the artists at the Ecole and that were on view each year at the Salon.

While Sandow was best known in Great Britain, the popularity of weight lifting in France increased after the Franco-Prussian conflict (1870–1871). Numerous gymnasiums for the purpose were opened in Paris— the earliest in the late 1840s by Hippolyte Triat (1813–1881) on the Avenue Montaigne.[19] One of the most famous French weightlifters, Louis Uni (1862–1928), performed under the stage name Apollon in the 1880s and 1890s at the Folies-Bergère (where he made his debut), the Hippodrome, the Grand Orient, and the Cirque d'Hiver.[20] In *La Lutte at les Lutteurs,* Léon Ville describes how male wrestlers flaunted their bodies before performances:

In front of the tent, the wrestlers pace, some unpretentiously with their hands behind their

backs; they are the rare ones. The others cross their arms over their chests with their hands placed between their pectorals and their upper arms in such a way as to exaggerate the size of their biceps, as if to say, "Aren't we well built?"[21]

Ville also describes reactions to famous wrestlers such as Arpin: "He is an idol to his fans at the Montesquieu arena; they are in ecstasy over his splendid torso!"[22] According to Ville, it took practice for the wrestlers to get used to the noise and attention of the crowd: "One must wrestle in public several times before becoming accustomed to the stares and exclamations of the audience."[23] Spectators, both male and female, attended such performances precisely to gawk at the muscular, fit male bodies and to admire their extraordinary abilities.

Some of this subject matter found its way to the Salon. Courbet exhibited a painting of two male wrestlers at the Salon of 1853 (fig. 9.2). While *Wrestlers* depicts the type of muscular male body often on display in history paintings and sculpture, Courbet's rendering is determinedly contemporary and realistic. Its large format put near life-size, barely clothed, working-class male bodies before Salon-goers, continuing Courbet's ongoing challenges to the academic system and its hierarchies. It was in part for these reasons that the painting was not favorably received.[24]

The section of the Arc de Triomphe just visible in the background situates the wrestlers in the Hippodrome as sweaty, dirty performers in a competition put on for the purposes of a paying audience in Second Empire Paris rather than in the context of a heroic ancient battle. Courbet has taken some artistic license in his representation of the Hippodrome, which is made to look insignificant, although it could in fact accommodate around ten thousand people. Those men and women who have paid to

Fig. 9.2 Gustave Courbet, *Wrestlers*, 1853.

men, in the opening pages of *Bel-Ami* (1885), Guy de Maupassant (1850–1893) describes the attention Georges Duroy attracts from female diners as he exits a Parisian restaurant: "Women turned their heads to look at him including three slender working-class girls, a middle-aged music teacher, disheveled and slovenly, wearing a dirty hat and an ill-fitting dress, and two bourgeois women with their husbands who were regulars at the cheap restaurant."[26] Maupassant's description of Duroy focuses on the impression Duroy makes on others; he carries himself in such a way as to draw attention: "He walked as he did when he wore the uniform of the hussars, with his chest thrown out and his legs a bit bowed as if he had just finished riding; he pushed his way through the crowd almost brutally, colliding with passersby...."[27] In theorizations of public space, the Haussmannized Parisian boulevards are tied closely with modernity and the notion of spectacle, because they encouraged looking by pedestrians. The Impressionists and their contemporaries in the early Third Republic are known for depictions that celebrate precisely the gaiety and jouissance associated with the boulevards.[28] Jean Béraud's (1849–1935) oeuvre, for example, focuses almost exclusively on the urban outdoors. In an image such as *Morris Column* (c. 1879–80; fig. 9.3), he fashions men and women as equal participants in boulevard culture—both as observers and as spectacles.[29]

The center of Béraud's composition is occupied not by the Morris column of the title, but by the elegantly dressed woman who peruses it. Still holding up her skirts, she has just crossed the street—much like the woman on her left who navigates her way across the intersection. The Grand Café in the background locates the setting of the painting on the corner of the Boulevard Capucines and

watch men wrestle are shown in the distant background, partially encircling the fighters, while those viewers presumed to be directly in front of the wrestlers (both within the narrative of the painting and at the Salon) are provided with an intimate view of the struggling men.[25] The male body is again on display and becomes spectacle for viewers at the Salon and at the Hippodrome.

THE GAZE AND THE BOULEVARD

> Please remember when you get inside the gates you are part of the show.
>
> —From pamphlet, "A Short Sermon to Sightseers"

While it is often assumed that Parisian public space was dominated by gaze-wielding

Fig. 9.3 Jean Béraud, *Morris Column,* about 1879–1880.

the rue Scribe—one of the most fashionable intersections in the city.[30] Several things about this image are notable: the busy street life, the number of lone women of indeterminate class who participate in boulevard culture, and the people who watch all of this from the balcony that is visible to the right of the column. The intermingling of public and private, indeed, the lack of any distinction between masculine and feminine spaces, is striking in this work.

In the foreground, the aforementioned woman and a man read the advertisements on a Morris column.[31] The man and the woman pictured, both involved in the same activity, take no notice of each other. The gentleman leans back on his umbrella as he tries to read something above his head; the fashionably dressed woman on the opposite side looks at something further down. Both appear to have

stopped purposefully, either attracted by the colorful display or to plan an evening out by studying the available possibilities. The columns were not only considered informative, but were also seen as hubs for socializing and gossip: "The Morris columns are always surrounded. People consult the theatre posters, exchange impressions, inquire about the time, slander the authors, and swap backstage gossip."[32] As a focal point for congregation, the columns were an integral part of boulevard culture and were thus associated with the modernity of the city. Béraud here posits the boulevard as a space shared by men and women, where both genders enjoy the spectacle of Paris as well as help constitute it.

THE FOLIES-BERGÈRE

> Our masculine gaze, which at first seems to penetrate the depths of the establishment's interior space…is actually rebuffed by the mirror and thrown back on itself.
>
> —Bradford R. Collins,
> *12 Views of Manet's Bar,* 1996

Manet's fascination with looking spans his entire career, from notorious early paintings such as *Le Déjeuner sur l'herbe* (1863) to his last large-scale work, *Un Bar aux Folies-Bergère* (1881–1882; fig. 9.4). It should not be surprising then that, as a summation of the artist's lifelong interests, the latter painting represents a barmaid who returns the gaze of the viewer. Indeed, it is hard to ignore the painting's focus on looking and spectacle, which is evident throughout the canvas. As others have noted, there is at least one other conspicuous viewer in Manet's *Bar.*[33] This woman, to the left of the barmaid's shoulder, uses her lorgnette to view the various goings-on—perhaps including a performance by Apollon—in the popular

Fig. 9.4 Edouard Manet, *A Bar at the Folies-Bergère,* 1881–1882.

café-concert. In addition, the mirror, with its reflections that double and confuse, underscores Manet's interest in looking by allowing the viewer both to see the barmaid and to see what she observes.[34] The barmaid herself is reflected at an odd angle. While she takes note rather indifferently of the crowded scene before her, in her reflection she seems solicitous as she bends toward a male customer who is only visible in the reflection and who may be a stand-in for the viewer.

In its representation of an urban female worker in a popular place of consumption, Manet's painting is both unusual and not. As Linda Nochlin has argued, the majority of representations of women during this period depict them providing services and pleasure for others (most often bourgeois men), including dancers, singers, prostitutes and servers.[35] On the other hand, the women depicted, while seeming bored and indifferent, are nevertheless active lookers. Much of the secondary literature on Manet's painting overlooks this aspect of the work and is thus in keeping with how women are often theorized in art-historical literature on the nineteenth century. Most notable in this regard is T. J. Clark's discussion of the work in *The Painting of Modern Life: Paris in the Art of Manet and His Followers* (1984).[36] As with the other paintings he discusses, Clark sees *Bar* as exemplary of modern life: the commercialization of leisure,

the specularity emphasized by the mirror and the crowd, the alienation in the barmaid's expression, and especially the uncertainty of class. Clark's originality is found precisely in his focus on the latter, particularly the creation of a new, more complex class structure in late nineteenth-century Paris in response to urbanization, industrialization, and new forms of leisure. Tying in closely with the class background of the barmaid is her presumed sexual availability for the top-hatted gentleman who faces her across the bar. While it is true that prostitution was a problematic issue during the period, Clark's assumptions about the woman's availability are the extent of his attention to gender.[37]

That the person working behind the bar is a *female* who is actively looking does not register as part of what Clark sees as the painting's modernity. It is important only insofar as it makes her of a different class than the man across the bar and, therefore, a possible sex object. It seems, however, that a woman's gainful employment in an urban context is a more significant marker of modernity than any potential sexual availability on her part—prostitution being, reputedly, the world's oldest profession. In fact, women servers were a relatively new sight in the city, that spoke to the growing number of women employed outside the home and, thus, to their increased participation in public life.[38] Manet himself cannot seem to decide if the barmaid is interested in pleasing her male customer or not. The top-hatted gentleman is visible, and acknowledged by the barmaid only in the reflection.

What should scholars make of the fact that Manet posits this working-class woman as an active looker?[39] In a painting so obviously about looking, it is significant that the top-hatted gentleman, so conflated in scholarship with the gaze, is confined to the small, delimited space on the right side of the painting—sandwiched between the barmaid in the mirror and the edge of the canvas. Manet allows him just enough space to verify his existence, to make overt that which is typically assumed by art historians, that is, that works of art posit male viewers.[40] In reifying this assumption, Manet also turns it back on itself. He makes clear that part of what has attracted the gaze of the barmaid is her male customer. So, while the barmaid, standing amidst the displayed and consumable objects on the bar—bottles of champagne, oranges, various liqueurs—is irreducibly part of the spectacle of the Folies-Bergère, the gentleman, reflected as he is with the crowd and the boots of the performing acrobat, is also part of the spectacle, the object of the barmaid's gaze as well as that of the viewer.[41]

Paris, throughout the nineteenth century, was defined by its focus on spectacle across the cultural spectrum—from high to low. Conventional scholarly understandings of spectacle posit an active male subject/viewer juxtaposed with a passive and sexualized female object. As this chapter has shown, however, this reading is belied by the numerous images and social practices that highlight men and the male body as part of the commodified spectacle, underscoring the incredible ubiquity of the gaze across class and gender divides in the period from 1830 to 1880—from the hallowed halls of the Ecole des Beaux-Arts to the performances at the Hippodrome and the Folies-Bergère.

NOTES

1. Jean-Louis Comolli, "Machines of the Visible," in *The Cinematic Apparatus,* ed. Teresa de Lauretis and Stephen Heath (St. Martin's Press, 1980), 122.

2. Petra Chu and Gabriel Weisberg, eds., *The Popularization of Images: Visual Culture under*

the July Monarchy (Princeton University Press, 1994); Beatrice Farwell, *The Cult of Images: Baudelaire and the Nineteenth-Century Media Explosion* (University of California Santa Barbara Art Museum, 1977); Tony Bennett, *The Birth of the Museum: History, Theory, Politics* (Routledge, 1995); Marni Kessler, *Sheer Presence: The Veil in Manet's Paris* (University of Minnesota Press, 2006); Elizabeth McCauley, *Industrial Madness: Commercial Photography in Paris, 1848–1871* (Yale University Press, 1994); Patricia Mainardi, *Art and Politics of the Second Empire: The Universal Expositions of 1855 and 1867* (Yale University Press, 1987).

3. On the pervasiveness of spectacle in Parisian life, see Vanessa Schwartz, *Spectacular Realities: Early Mass Culture in Fin-de-Siecle Paris* (University of California Press, 1998). On spectacle and capitalism, see Guy Debord, *Society of the Spectacle* (Black and Red, 1973); Jean Baudrillard, *The Consumer Society: Myths and Structures* (Sage, 1998); and Jean Baudrillard, *Simulations,* trans. Paul Foss (Semiotext(e), 1983).

4. Laura Mulvey, "Visual Pleasure and Narrative Cinema," *Screen* 16, no. 3 (Autumn 1975): 6–18; Abigail Solomon-Godeau, "The Other Side of Venus: The Visual Economy of Feminine Display," in *The Sex of Things: Gender and Consumption in Historical Perspective* (University of California Press, 1996); and Griselda Pollock, "The Gaze and the Look: Women with Binoculars—A Question of Difference," in *Dealing with Degas: Representations of Women and the Politics of Vision,* ed. Richard Kendall and Griselda Pollock (Pandora, 1992), 106–30.

5. On the convoluted history of these institutions, see Albert Boime, *The Academy and French Painting in the Nineteenth Century* (Phaidon, 1971).

6. Jann Matlock refers to its prominence in the social calendar in "Seeing Women in the July Monarchy Salon: Rhetorics of Visibility and the Women's Press," *Art Journal* 55, no. 2

(Summer 1996): 73. There were more than a million visitors to the Salon during the July Monarchy, according to W. Hauptman, "Juries, Protests, and Counter-Exhibitions before 1850," *Art Bulletin* 67, no. 1 (March 1985): 95–96. On the problematic academic tradition, see Patricia Mainardi, "The Death of History Painting in France, 1867," *Gazette des Beaux-Arts* 100 (December 1982): 219–26.

7. Patricia Mainardi, "The Eviction of the Salon from the Louvre," *Gazette des Beaux-Arts* 6, no. 112 (July–August 1988): 31–40.

8. Quoted in Gen Doy, "What Do You Say When You're Looking?" *Women's Art Magazine* 70 (June/July 1996): 12. On women as art critics in France, see also Jann Matlock and Heather Belnap Jensen, "*The Journal des Dames et des Modes:* Fashioning Women in the Arts, c. 1800–1815," *Nineteenth-Century Art Worldwide* 5, no. 1 (Spring 2006).

9. Jensen discusses other women who had similar reactions to Salon works in "Portraitistes à la Plume: Women Art Critics in Revolutionary and Napoleonic France," Ph.D. dissertation, University of Kansas, 2007, 31–99.

10. See Grigsby, *Extremities,* and Elisabeth Fraser, *Delacroix, Art and Patrimony in Post-Revolutionary France* (Cambridge University Press, 2004).

11. For example, Heather Dawkins, *The Nude in French Art and Culture, 1870–1910* (Cambridge University Press, 2002) and Jennifer L. Shaw, "The Figure of Venus: Rhetoric of the Ideal and the Salon of 1863," *Art History* 14, no. 4 (December 1991): 540–70.

12. Abigail Solomon-Godeau's *Male Trouble: A Crisis in Representation* (Thames and Hudson, 1997) focuses on male nudes from earlier in the century, as do Darcy Grigsby, "Nudity à la Greque in 1799," *Art Bulletin* 80, no. 2 (June 1998): 311–35, and Carol Ockman, "Profiling Homoeroticism: Ingres's Achilles Receiving the Ambassadors of Agamemnon," *Art Bulletin* 75, no. 2 (June 1993): 259–74.

13. See Boime, *The Academy and French Painting,* for discussion of this as well as for examples of such drawings.

14. While penises are sometimes partially hidden, pubic hair is typically visible. I discuss the implications of this in the unpublished "Napoleon's Empire, Nude Male Bodies, and Masculine Identity," presented at the 2008 Nineteenth-Century French Studies colloquium, Nashville, TN.

15. Susan Waller, *The Invention of the Model: Artists and Models in Paris, 1830–1870* (Ashgate, 2006), 16–18.

16. On the growing interest in physical fitness, see Eugen Weber, "Gymnastics and Sports in Fin-de-Siecle France: Opium of the Classes," *American Historical Review* 76, no. 1 (February 1971): 70–98.

17. I discuss some of these images in my manuscript in progress, *Beyond the Flâneur: Masculinity in the Paris of Manet and His Followers.*

18. Tamar Garb discusses weightlifters in the early twentieth century in "Modelling the Male Body: Physical Culture, Photography, and the Classical Ideal," in *Bodies of Modernity: Figure and Flesh in Fin-de-Siècle France* (Thames and Hudson, 1998), 54–79. On Eugen Sandow, see David Chapman, *Sandow the Magnificent: Eugen Sandow and the Beginnings of Bodybuilding* (University of Illinois Press, 1994).

19. Michael Anton Budd, *The Sculpture Machine: Physical Culture and Body Politics in the Age of Empire* (New York University Press, 1997), 34.

20. Edmond Desbonnet includes a chapter on Apollon in *Les Rois de la Force* (Librairie Berger-Levrault, 1911). The chapter is reprinted in *Iron Game History* 4, nos. 5–6 (August 1997): 23–47.

21. Léon Ville, *La Lutte et les Lutteurs* (J. Rothschild, 1891), 59.

22. Ville, *La Lutte et les Lutteurs,* 32.

23. Ville, *La Lutte et les Lutteurs,* 42.

24. Klaus Herding discusses the complexities of class and form disturbing to viewers in 1853 in "'Les Lutteurs Détestables': Critique of Style and Society in Courbet's *Wrestlers,*" in his *Courbet: To Venture Independence* (Yale University Press, 1991), 11–43.

25. Bennett remarks that such venues emphasized the spectacle of both the performers and the spectators. Tony Bennett, "The Exhibitionary Complex," in *The Nineteenth-Century Visual Culture Reader,* ed. Vanessa Schwartz and Jeannene Przyblyski (Routledge, 2004), 117–30.

26. Guy de Maupassant, *Bel-Ami* (Garnier Frères, 1959), 3. The notion that men dominated the boulevard is derived in large part from Charles Baudelaire's description of the *flâneur* in "The Painter of Modern Life." In *Beyond the Flâneur,* I critique the dominance of the *flâneur* paradigm in understandings of masculinity.

27. Maupassant, *Bel-Ami,* 4.

28. Robert Herbert, *Impressionism: Art, Leisure, and Parisian Society* (Yale University Press, 1988).

29. My dissertation looks in detail at the works of this artist. Temma Balducci, "Jean Béraud: Revisioning the Boulevard in the Early Third Republic," Ph.D. dissertation, University of Kansas, 2005.

30. Patrick Offenstadt and Nicole Castais, *Jean Béraud, 1849–1935: The Belle Époque: A Dream of Times Gone By* (Taschen, 1999), 121.

31. Morris Columns were erected in 1868 for playbills and other advertisements. Marie de Thezy, "Histoire du Mobilier Urbain Parisien du Second Empire à Nos Jours," in *Paris, la Rue: Le Mobilier Urbain du Second Empire à Nos Jours,* exhibit catalog (Société des Amis de la Bibliothèque Historique, 1976), 37–40.

32. A. Press. de Lannoy, *Les Plaisirs et la Vie de Paris: Guide du Flâneur* (Librairie L. Borrel, 1900), 27.

33. Carol Armstrong, "Counter, Mirror, Maid: Some Infra-Thin Notes on *A Bar at the Folies-Bergère,*" in *12 Views of Manet's Bar,* ed. Bradford R. Collins (Princeton University Press, 1996), 38; and Ruth Iskin, *Modern Women*

and Parisian Consumer Culture (Cambridge University Press, 2007), 46.

34. Nicolas Green discusses how windows and mirrors created spectacles in "Circuits of Production, Circuits of Consumption: The Case of Mid-Nineteenth-Century French Art Dealing," *Art Journal* 48, no. 1 (Spring 1989): 31. Susan Buck-Morss argues that Paris was a city of mirrors where the crowd became the spectacle. Buck-Morss, "Dream World of Mass Culture: Walter Benjamin's Theory of Modernity and the Dialectics of Seeing," in *Modernity and the Hegemony of Vision,* ed. David Levin (University of California Press,1993), 310–11.

35. Linda Nochlin, "Morisot's *Wet Nurse:* The Construction of Work and Leisure in Impressionist Painting," in *Perspectives on Morisot,* ed. T. J. Edelstein, exhibit catalog (Hudson Hills Press,1990), 94.

36. T. J. Clark, *The Painting of Modern Life: Paris in the Art of Manet and his Followers* (Thames and Hudson, 1984), 205–58.

37. Others have criticized Clark for this oversight. See Pollock, "Modernity and the Spaces of Femininity," in his *Vision and Difference* (Routledge, 1988), 51–54. On prostitution in the period, see Alain Corbin, *Women for Hire: Prostitution and Sexuality in France after 1850* (Harvard University Press, 1990); Vern and Bonnie Bullough, *Women and Prostitution: A Social History* (Prometheus, 1987); and Jill Harsin, *Policing Prostitution in Nineteenth-Century Paris* (Princeton University Press, 1985).

38. Theresa Gronberg, "Les Femmes de Brasserie," *Art History* 7, no. 3 (September 1984): 329–44. Also see Herbert, *Impressionism,* 79.

39. Albert Boime acknowledges the import of her gaze in "Manet's *Un Bar aux Folies-Bergère* as an Allegory of Nostalgia," *Zeitschrift für Kunstgeschichte* 57[56], no. 2 (1993): 234–48. Reprinted in Collins, *12 Views,* 47–70.

40. I question the notion that the gaze is always male in *Beyond the Flâneur.* See also Edward Snow, "Theorizing the Male Gaze: Some Problems," *Representations* 25 (Winter 1989): 30–41.

41. Tag Gronberg discusses the relation between the *flâneur* and the acrobat in "Dumbshows: A Carefully Staged Indifference," in Collins, *12 Views,* 189–213.

THE *FLÂNEUR/FLÂNEUSE* PHENOMENON

Jane Kromm

Among the many pedestrians in the nineteenth-century city, one of the preeminent, and certainly the most notorious, was the type of strolling onlooker known as the *flâneur*.[1] In the midst of the crowd—on the boulevards, in the arcades, or in the cafés, restaurants, and theaters—the *flâneur* yet remained aloof, detached, observing and being observed without commitments or responsibilities. Identifiable by his independent status and his purposeless sauntering, the *flâneur* was associated first and primarily with Paris. This was where his "type" originated, but the figure soon became a token of modernity in cities from London to Vienna. This chapter will trace the rise and fall of the *flâneur* across the nineteenth century and consider whether the role ever truly broadened to include women or workers or anyone other than that of the dominant model—the well-to-do bourgeois man of leisure.

Appearing first in the wake of the revolutionary decade, the *flâneur* debuted as a somewhat vague and derogatory character linked to laziness and idleness, and not too distant from the "*clochards*," those layabout drunks with vague but distinctly radical political connotations.[2] Within the next few years, however, the *flâneur*'s aimless wandering moved up the social and intellectual scale, becoming very quickly the strolling of a gentleman who possessed a thoughtful, inward-turning orientation toward his perambulations that was connected with some kind of literary ambition.[3] Scholars see in this authorial desire an influence from new forms of journalistic writing, the short takes and episodes characterized by brevity, currency, and visual pungency.[4]

The *flâneur*'s route across the city of Paris was associated with the newer spaces that seemed to usher in the modern era with their inventive restructuring of traditional urban uses. An early association with the arcades or passages, the recent hybrid combinations of street and shop, and then later with cafés, restaurants, and *terrasses,* the *flâneur* haunted sites identified with the urban crowd. Here he could mingle with people from all levels and ranks of society in places that enticingly mixed the private with the public.[5] The *flâneur* could thus indulge in the proximate, but without explicit social relatedness, and experience the intimate, but without the risk of any personal commitment. And in greatest contrast to an idler or loafer figure, the *flâneur* did not gawp with open mouth; he looked about him with an avid glance and an analytical kind of observation.

The earliest extended treatment of the *flâneur* is an anonymous pamphlet of 1806, *Le flâneur au salon, ou M. Bonhomme; Examen joyeux des Tableaux, mêlé de Vaudevilles.*[6] Presented as a familiar character, M. Bonhomme is a Parisian

flâneur who spends his time frequenting a number of the new urban sites, including the salon, stores, cafés, and restaurants, where he carefully observes details and notes anything novel in his diary. He is thus a kind of cultural writer, and his preferred haunts are also those to which journalists, painters, and writers similarly flocked. And although M. Bonhomme's movements are somewhat routine and unvarying, his behavior is that of the classic *flâneur* who repeatedly sought out the company of the crowd, while remaining aloof and detached, a clear-eyed observer of the urban mêlée around him.

In fact *Le flâneur au salon* is a kind of guidebook to the city's sights and is one among several types of publications with this purpose and orientation. These new series reported happenings in an anecdotal manner, much like the journalistic feuilleton literature. One example of the type is the literary guidebook; these appeared in serial format and typically have a consistent figure serving as escort. In one series, this figure is a hermit whose position is mundane and grounded, yet clearly regarded as a loner and marginal type. In another, he is the devil who conducts his tour from an airborne and supernatural vantage.[7]

An especially popular addition to the guidebook genre, and one that flourished from around 1820 through the 1840s, is the type known as "physiologies."[8] These added a degree of scientific precision to the observational stance of the earlier models, projecting with confidence an ability to explain the healthy functioning of a species. This approach was then extended to a myriad of social types and phenomena. The methods followed by the physiologies were derived from late eighteenth-century physiognomical studies, especially those of Johann Caspar Lavater and Franz Gall. Their treatises assumed—often with more confidence than

was scientifically warranted—that inner character, class, and occupation could be assessed from the physical features of face and figure.[9] In their wake, popular handbooks soon appeared that encouraged the useful application of such ideas as a way to judge the character of new acquaintances. They were also recommended as an aid in hiring reliable, trustworthy servants and employees, or, conversely, as a way of avoiding contact with the suspicious and the degenerate. The physiologies updated these procedures of visual analysis, often with the aim of revealing something about the approach's satirical potential in contemporary moral terms.

Some years before the *flâneur* was given a physiological treatment of his own, he appeared as a character in Honoré de Balzac's *Physiologie du marriage* of 1826.[10] Here Balzac's formulation is notable for positioning the *flâneur* as an artist who finds opportunities for creativity in every perambulation, because while "to stroll is to vegetate, to flâner is to live."[11] This type of *flâneur* identifies creative opportunity with his random excursions, and his aim is to discover and explore novel experiences that might be set in motion by a furtive glance or a chance encounter. He is thus no longer a guide leading a tour of sites fully known to him, but a kind of investigator-explorer of the unexpected or uncharted from a protected position of disengaged anonymity. This random aspect, with its modern flavor of the fragmentary, noncommittal, and inconsistent is also characteristic of J. B. Auguste Aldeguier's *Le flâneur* of 1825, which was popular enough to warrant a second edition in the following year.[12]

Then by 1841, with the publication of Louis Huart's *Physiologie du flâneur,* the artistic credentials of the *flâneur* figure were reinforced with such claims that "[a]rtists are above all *flâneurs,* since for them the promenade is a

veritable necessity."[13] The type is identified with the new hybrid site for strolling and observing—the arcades—which seem necessary for his continuation, for "without the arcades, the *flâneur* would be unhappy."[14] Huart reports that the *flâneur* can produce an entire novel solely from a moment's encounter in these new urban spaces, and his incognito is thus a necessary aspect of his artistic enterprise. Honoré Daumier's frontispiece for Huart (fig. 10.1) condenses these characteristics into vignette form. In a spacious walkway, implied rather than delineated by the positions of the three figures, Daumier has depicted the *flâneur* as a leisurely and respectable gentleman who

follows, all the while maintaining a decent interval, the advancing figures of two well-dressed women. He looks intently at their retreating forms, while his momentary pause accentuates his focused gaze. The women continue on their course, without any recognition of their status as observed or followed characters, an indication that they are not aware that the *flâneur* has them in his sights, and so his incognito is thus preserved as well.

As the midcentury approached, the *flâneur*'s unimpeded pleasure in his perambulations is gradually inflected by the negative consequences of urban modernization. The pace of these changes increases, with subsequent losses

Fig. 10.1 Honoré Daumier, title page, Louis Huart, *Physiologie du flâneur*, 1841.

of neighborhoods and accommodations, and with the enforced relocation of certain sections and contingencies.[15] Through these developments, displacement and alienation enter the *flâneur*'s purview, putting an edge to his earlier confidence in his freedom and autonomy. Consequently the *flâneur* character in literary and visual representations also darkens. This is first evident in Edgar Allan Poe's short story, "The Man of the Crowd" (1840/1845).[16] There are two principal characters in this tale, the pursuer, who is also the narrator of events, and the man whose movements fascinate him. The pursuer, a recent convalescent comfortably installed by a bow window inside a London hotel's coffeehouse, whiles away the afternoon and early evening in observing the sights and passersby on the adjacent street:

> With a cigar in my mouth and a newspaper in my lap, I had been amusing myself for the greater part of the afternoon, now in poring over advertise-ments, now in observing the promiscuous company in the room, and now in peering through the smoky panes into the street. (285)

From this vantage, he is able to take full account of the physical and physiological range of humanity before him as he "regarded with minute interest the innumerable varieties of figure, dress, air, gait, visage, and expression of countenance" (285). The range of types he observes moves down the social scale just as the evening draws on, and the gaslight prevents more than an intriguing glimpse of the passing subjects. At this point the pursuer's attention focuses on a shabby elderly man, and, with his curiosity aroused, the convalescent begins his pursuit, which lasts all night and into a second day before exhaustion brings the adventure to a close. Throughout the duration of this expedition, the old man leads his follower through such public sites as bazaar, shop, theater precinct, and gin palace, a trajectory of descending social status, and ends back at the original hotel before beginning the sequence anew. The old man's movements, his *flânerie,* seem desperate rather than leisurely, and once the crowd begins to disperse, he quickly moves on with a panicky haste to another location. This prompts the pursuer's observation: "He refuses to be alone. *He is the man of the crowd"* (289).

An early drawing by Georges Seurat from 1877–1878 articulates some of the same critical spatial elements that Poe used to establish the mise-en-scène for his pursuer, and by extension also for the man of the crowd or *flâneur* himself (fig. 10.2).[17] The drawing is

Fig. 10.2 Georges Seurat, *Sketchbook I,* 1877–1878.

part of a sketchbook that Seurat used to record quick notations of views on the street or in cafés, and the notations seem to have been done on the spot, before the motif. This more experimental practice contrasted with the academic orientation of the artist's training, and it aligns the sketches with an experiential, daily-life modus operandi to which Seurat also brought a keenness for popular art and journalistic illustration.[18] This image is one of two in the sketchbook that represent the street viewed from within the interior spaces of a café. The composition records the vantage of *flânerie* and its practices of looking through and beyond, of observing from a protected position, and thus preserving the spatial coordinates of the *flâneur*'s initial point of observation. A careful, incremental sequencing of spaces is presented: from the counter with its papers to the coatrack and rear view of a top-hatted figure, beyond to the interior wall and past the reinforced window, to the metal supports and inside view of the awning, and thence to the street and the gaslight lamp. But unlike Poe's story, and at variance with many accounts of the *flâneur*'s haunts and preferred milieu, the café or coffeehouse setting is nearly deserted; there are no crowds, no intriguing customers or passersby, just the single occupant establishing the position of the lone person's outlook. This essential isolation brings Seurat's sketch closer to a significant aspect of the *flâneur*'s experience—his resolute loneliness, his aloofness, his alienation—which is never ameliorated despite his perambulations and immersion in the crowd. It is this paradox within the plot line of *flânerie* that Seurat has articulated, and it is an integral element in Poe's story as well as in subsequent accounts of the *flâneur*'s pursuits.

The best-known as well as most influential treatment of the *flâneur*'s character and itinerary was formulated by Charles Baudelaire. Published in 1863 in installments in the newspaper, *Le Figaro,* "The Painter of Modern Life" showcased the *flâneur*'s creative credentials: "he is a poet; more often he comes closer to the novelist or moralist; he is the painter of the passing moment."[19] Many of these qualities Baudelaire identified with the minor artist Constantin Guys, who is presented as a "passionate lover of crowds and incognitos," and whose preferred subjects in art are those that depict "the outward show of life."[20] Guys's curiosity leads Baudelaire to invoke Poe's earlier story and to see aspects of the pursuer-convalescent in this artist's creative nature.[21] The figure of Guys thus crystallizes Baudelaire's notion of the artist-*flâneur* in the modern city, whose element is the crowd and who "set[s] up house in the heart of the multitude…in the midst of the fugitive and the infinite."[22] The *flâneur*'s pursuit is identified in part with a quest for modernity, and by modernity Baudelaire means "the ephemeral, the fugitive, and the contingent."[23] In his observations of the "passing moment," the *flâneur* is often setting his sights on women, ranging from those of "elegant families" to those belonging "to the lower world" as he longs for a chance encounter that might become the catalyst for great art.[24] When Walter Benjamin revisited Baudelaire's *flâneur* in the early twentieth century, he clarified that the figure's terrain was imprinted with the effects of capitalism, its urban displacements and disarray.[25] Benjamin also reinforced the visual nature of the *flâneur*'s obsessions, the longing for the chance encounter and the scrutinizing of the faces in the crowd, a veritable "botanizing on the asphalt," which thus continued the objective of nineteenth-century physiologies to read truth from visage.[26]

Images of pedestrians in the city among whom a *flâneur* or two might be identified

proliferated after midcentury. Such views were celebrated topics in official art circles as well as in commercial art and in the new movements associated with the modern era.[27] Clearly this was a theme whose popularity overturned traditional hierarchical distinctions in the literary and visual representational field. Contemporary critics tended to view some painters, especially those affiliated with the impressionist group, as perfect realizations of the *flâneur*'s type. Edouard Manet, for example, seemed to be a good match for the model of the aloof, detached kind of *flâneur* whose perambulations were presumed to be the source for his depictions of people in the city. Along the same lines, Edgar Degas's personal motto— "*ambulare, postea laborae*"—similarly underscored the role of walking and looking as a first stage in his creative method.[28] The results of this roaming and creative looking were as various as were the artists' particular inclinations, but many clearly favored a range of pedestrian vistas in their work. Images of urban walkers seemingly enmeshed within a network of purposeful movements and gazes became the particular contribution of Gustave Caillebotte. Such compositions increased just as the younger Seurat was recording an observer's vantage from inside the café looking out. Over the next decade, he would return to the *flâneur* theme in a series of independent drawings representing walkers in the city.

For those familiar with Seurat's paintings, it may come as some surprise to see the comparatively darker mood that characterizes his drawings. Most often produced as independent works with no definite connection to larger painterly projects, Seurat's drawings offer elusive rather than precise images that take full advantage of pictorial effects, suggesting absence, silence, and isolation.[29] Individuals are portrayed through an economy of silhouette-like contours that Seurat derived from Daumier, and anchored simply in space by the earlier artist's device of "pedestal shadows"—a further streamlining effect in itself.[30] Forms are created by the massing of darks and lights, and the resultant contrasts frequently suggest something unsettling yet imprecise, perhaps even a "double meaning" in which images of several people or couples are concerned.[31] As the darks and lights interface around a figure's edges, an effect of "irradiation" is produced, which in the street scenes helps to evoke a sense of gaslight and mystery.[32] Many compositions favor lonely, often indeterminate urban sites with an iconic, centrally placed figure seemingly self-contained and absorbed.

A group of images by Seurat invokes the idea of the *flâneur,* not so much as a person losing himself within a large crowd, but as a solitary walker attentively absorbed in gazing at another, usually female, passerby. In *Man Waiting on a Sidewalk,* of 1884–1886, an indeterminate but relatively broad walking area serves as the viewing position for a male pedestrian seen from the rear.[33] His hands in his pockets and his umbrella slanted by his side, he is firmly rooted to a dominant, observational vantage. Having just shifted his upper body in her direction, he is alert to the vague profile of a woman walking rather briskly across the drawing's middle ground. She obviously has a destination and a purpose, but his journey is paused and possibly has yet to be ascertained or decided. While there is no clear pursuit, the contrast in visual resolution and position of the two figures conveys a strong asymmetry. This suggestive difference recalls the *flâneur*'s attachment to investigation and intrigue, and his socially dominant position is here pictorially conveyed to a predatory degree by the looming, confident stance.

The positions of the two figures—the gazer and the gaze's object—are exchanged in *Woman Raising her Parasol* (fig. 10.3).[34] A well-dressed Parisienne, hatted and veiled, is seen in profile in the act of opening her umbrella. The railing behind her suggests a similarly indeterminate urban site, perhaps a terrace or some other tiered arrangement, on the other side of which are the heads of several figures, but particularly at left a top-hatted man who seems to turn in the women's direction. She is absorbed and self-contained or otherwise preoccupied, just as the woman in the previous work was self-sufficiently engaged. He is alert to the visual opportunities of urban perambulation, and in this he resembles the man in the other drawing. With both images, the viewer of the work is positioned to experience the same focus on the female figure as that of the male figure or figures within the image. The dyad of the male viewer and the female object is of course the familiar gender economy of the *flâneur's* situation, particularly along the lines emphasized by Baudelaire. Commentators on this theme have in fact mentioned the poet in relation to Seurat's work.[35] They see a connection to "To a Passerby" from Baudelaire's *Les fleurs du mal*, which described the impact of a chance encounter on the observant *flâneur*. Intrigued by her costume of deep mourning and solitary status, the *flâneur* muses on this unknown woman's appearance:

Graceful, noble, with a statue's form.
And I drank, trembling as a madman thrills,
From her eyes, ashen sky where brooded storm,
The softness that fascinates, the pleasure
 that kills.
A flash...then night!—Oh lovely fugitive,
I am suddenly reborn from your swift glance;
Shall I never see you till eternity? [36]

Here the *flâneur's* object is a mysterious, statue-like woman who attracts but endangers the male viewer, providing a thrill akin to madness.[37] She is, paradoxically, a fugitive presence whose sudden flash of a returned gaze both captivates and captures the *flâneur* with its evanescent power. He sadly acknowledges her unattainable status, retains his incognito and independence, and continues on his wandering course. The chance encounter motif perfectly summarizes the critical aspects of the *flâneur's* existence.

Because none of Seurat's drawings portray the *flâneur* as part of a larger crowd, some critics have queried whether any connection can be made between the artist's street scenes and the *flâneur* phenomenon.[38] It is true that if immersion within the crowd is the sole defining visual paradigm for *flânerie*, than Seurat's drawings hardly qualify. However, there are significant elements in his work that do address the *flâneur's* role and convey his pursuits extremely well. The literary accounts of the *flâneur's* existence emphasize his limbo status, his loneliness and isolation. While his ultimate goal may be immersion in the crowd, he often is seen failing to achieve this. There are many solitary movements within the *flânerie* experience, and these are portrayed as thoughtful episodes of absorption and reverie. Or, alternatively, he is paused in pursuit of a solitary female passerby. For such moments, a depiction of two principal characters within a much larger crowd would fail to convey the angst and the impossible-to-satisfy conditions that propel the *flâneur's* movement and supply his momentum. In Poe's story, the convalescent pursuer is arguably as much a *flâneur* as is the man of the crowd, who is himself often represented in limbo, between one kind of crowd and another. Such absorptive, existential moments are embedded in the very idea of the

Fig. 10.3 Georges Seurat, *Woman Raising Her Parasol (Une Promeneuse)*, about 1884–1886.

flâneur's quest, and astutely conceptualized in Seurat's drawings.

The notion of *flânerie* as the defining experience of modern life in the city began to decline toward the end of the nineteenth century. Having evolved from the disreputable to the artistic, bohemian, and intellectual, the *flâneur* eventually lost some of his distinction with the rise of the department store, along with a sales-based egalitarianism that then permeated the streets and boulevards.[39] The model of vicarious experience that was central to the *flâneur*'s endeavor was transmitted to others through the medium of literary guidebooks and visual tourism. These further eroded the figure's carefree mobility and incognito status. But the mobile and transitory forms of observation characteristic of the *flâneur* at his most creative left behind their marks of visual discernment and scrutiny. Whether derived from immersion in the crowd or from isolated moments of revelatory clarity, the *flâneur*'s visual inclinations remained singular enough to retain their power wherever the modernity of outlook and purview is the critical frame for debate and discussion.

NOTES

1. For the figure of the *flâneur,* see Charles Baudelaire, *The Painter of Modern Life and Other Essays* (Phaidon, 1964); Walter Benjamin, *Charles Baudelaire: A Lyric Poet in the Era of High Capitalism,* trans. Harry Zohn (NLB, 1973); Keith Tester, ed. *The Flâneur* (Routledge, 1994); Elizabeth Wilson, "The Invisible Flâneur," *New Left Review* 191 (January–February 1992): 90–110; Kathleen Adler, "The Suburban, the Modern and 'Une Dame de Passy,'" *Oxford Art Journal* 12, no. 1 (1989): 3–13; Priscilla Parkhurst Ferguson, *Paris as Revolution* (University of California, 1994), chap. 3, "The Flâneur: the City and its Discontents," 80–114, 240–43; Ferguson, "The Flâneur on–off the Streets of Paris," in Tester, 22–42; Nancy Forgione, "Everyday Life in Motion: The Art of *Walking* in Late Nineteenth-Century Paris" *Art Bulletin* 87, no. 4 (December 2005): 664–87; Susan Buck-Morss, "The Flâneur, the Sandwichman and the Whore: The Politics of Loitering," *New German Critique* 39 (Autumn 1986): 99–140; Aruna D'Souza and Tom McDonough, eds., *The Invisible Flâneuse?* (Manchester University Press, 2006); Tom McDonough, "The Crimes of the Flâneur" *October* 102 (Fall 2002): 101–22.

2. Ferguson, *Paris as Revolution,* 82; Wilson, "The Invisible Flâneur," 95.

3. Ferguson, *Paris as Revolution,* 88.

4. Wilson, "The Invisible Flâneur," 96; Ferguson, *Paris as Revolution,* 82.

5. For a theoretical discussion of the *flâneur* in relation to the masculine and the feminine, the public and the private sphere, see D'Souza and McDonough, *The Invisible Flâneuse?*

6. Ferguson, *Paris as Revolution,* 83; Wilson, "The Invisible Flâneur," 94.

7. Ferguson, *Paris as Revolution,* 83–85.

8. Ferguson, "The Flâneur on–off the Streets of Paris," 29; Ferguson, *Paris as Revolution,* 81–93; McDonough, "The Crimes of the Flâneur," 103; Benjamin, *Charles Baudelaire,* 36–39.

9. See chapter 6 of this volume.

10. Ferguson, *Paris as Revolution,* 81–93.

11. Cited in Ferguson, *Paris as Revolution,* 90.

12. Ferguson, *Paris as Revolution,* 25.

13. Cited in Adler, "The Suburban, the Modern and 'Une Dame de Passy,'" 11, n. 5.

14. Cited in Ferguson, *Paris as Revolution,* 88.

15. This is often referred to as the "Haussmannization" of Paris, after Baron Haussmann, who was responsible for redesigning the city. See Donald J. Olson, *The City as a Work of Art: London, Paris, Vienna* (Yale University Press, 1986).

16. Stuart Levine and Susan Levine, eds., *The Short Fiction of Edgar Allan Poe* (Bobbs Merrill, 1976), 283–93. The story was published

in a magazine in 1840 and then appeared in a collection of Poe's stories in 1845 (292, n. 1).

17. Sketchbook I, Yale University Art Gallery. For Seurat's drawings, see Erich Franz and Bernd Growe, *Georges Seurat: Drawings* (Little Brown, 1984); Robert L. Herbert, *Seurat's Drawings* (Shorewood, 1962); Herbert, *Georges Seurat 1859–1891* (Abrams, 1991); Michael F. Zimmermann, *Les mondes de Seurat* (Albin Michel, 1991); Jodi Hauptman, *Georges Seurat, The Drawings,* exhibition catalog (Museum of Modern Art, 2007), introduction and "Medium and Miasma: Seurat's Drawings on the Margins of Paris," 107–17. The preference for scenes of daily life as emblematic of the modern era was characteristic of many artists in the realist and Impressionist movements. Among many sources, see T. J. Clark, *The Painting of Modern Life* (Princeton University Press, 1986).

18. Herbert, *Seurat's Drawings,* 65.

19. Charles Baudelaire, *The Painter of Modern Life and Other Essays* (Phaidon, 1964), 5.

20. Baudelaire, *The Painter of Modern Life,* 5, 24.

21. Baudelaire, *The Painter of Modern Life,* 7, 8.

22. Baudelaire, *The Painter of Modern Life,* 9.

23. Baudelaire, *The Painter of Modern Life,* 12.

24. Baudelaire, *The Painter of Modern Life,* 35.

25. Walter Benjamin, *Illuminations,* ed. and trans. Hannah Arendt (Harcourt Brace World, 1968), "Some Motifs in Baudelaire," 155–200; Tester, *The Flâneur,* 13; Ferguson, *Paris as Revolution,* 112.

26. Wilson, "The Invisible Flâneur," 97. For a broader model for walking that incorporates its physical and introspective aspects, see Forgione, "Everyday Life in Motion."

27. Forgione, "Everyday Life in Motion," 664.

28. Forgione, "Everyday Life in Motion," 670.

29. Hauptman, *Georges Seurat, The Drawing,* 13, 112; Herbert, *Georges Seurat,* 34.

30. Herbert, *Seurat's Drawings,* 56.

31. Zimmermann, *Les mondes de Seurat,* 133.

32. *Irradiation* is Seurat's term. See Herbert, *Seurat's Drawings,* 56.

33. Hauptman, catalog number 57. The drawing is also entitled *Perplexité* and dated 1882 (Zimmermann, *Les mondes de Seurat,* 128).

34. Hauptman, catalog 56.

35. Zimmermann, *Les mondes de Seurat,* 130; Herbert relates the poet to another drawing, *The High Collar* (*Georges Seurat,* 58).

36. Translation by C. F. MacIntyre; cited in Benjamin, *Charles Baudelaire,* 45.

37. Poe also refers to a statue-like woman, but in a clearly more ominous way: She is "in the prime of her womanhood, putting one in mind of the statue in Lucian, with the surface of Parian marble, and the interior filled with filth." Levine and Levine, *The Short Fiction of Edgar Allen Poe,* 286.

38. Hauptman notes the absence of the crowd in Seurat's drawings and sees a greater connection to the *flâneur* in Victor Hugo's *Les misérables,* whose haunt is the zone or *banlieue* area on the outskirts of Paris (*Georges Seurat,* 107–110).

39. Ferguson, "The Flâneur on–off the Streets of Paris," 23, 31; Forgione, "Everyday Life in Motion," 674–75. Forgione emphasizes that street scenes in paintings of the 1890s show equal numbers of men and women among pedestrians.

GAZE AND SPECTACLE IN THE CALIBRATION OF CLASS AND GENDER: VISUAL CULTURE IN VIENNA

Elana Shapira

To be properly dressed has long been established as a way of claiming social authority. Yet in the Viennese art scene, male architects and artists claimed creative license by choosing to design special dresses or to project dresses onto spaces, as well as to remove their own clothes and those of others (female relatives, models, and companions). Viennese modernism is typically identified with Jugendstil architecture and design and with Expressionist art. Famous architects and artists such as Otto Wagner, Adolf Loos, Oskar Kokoschka, and Egon Schiele exposed, through their dress designs and their literal removal of clothes, masochistic and romantic male sexual fantasies crucial for the understanding of the visual culture in Vienna in 1900.

In his article "Ornament and Crime" from 1908, the architect, interior designer, and essayist Adolf Loos (1870–1933) argued that modern man uses his clothes as a mask and therefore should not restrict his individuality to external signs.[1] Loos identified in his essay those who have ornamental cravings with primitive people and criminals who tattoo their bodies. The art historian Peter Haiko compared Loos's demand to remove all ornaments from objects to Sigmund Freud's argument that the progression of culture is based on the suppression of instincts.[2] The father of psychoanalysis, Freud (1856–1939) documented in his groundbreaking book *The Interpretation of Dreams* (1900) the important role of dress and the threat of physical exposure in Viennese society. Freud presented a private dream expressing the importance of a "correct dress." He was trying one day to find out the meaning of being inhibited—"of being glued to the spot"—which often occurs in dreams handling anxiety. In his dream that night,

> I was very incompletely dressed and was going upstairs from a flat on the ground floor to a higher storey. I was going up three steps at a time and was delighted at my agility. Suddenly I saw a maid-servant coming down the stairs— coming towards me, that is. I felt ashamed and tried to hurry, and at this point the feeling of being inhibited set in: I was glued to the steps and unable to budge from the spot.[3]

Freud explains the notion of "incomplete dress" by referring to the evening before in which he had made the same journey "in rather disordered dress—that is to say, I had taken off my collar and tie and cuffs. In the dream this had been turned into a higher degree of undress, but, as usual, an indeterminate one."[4] Freud makes evident the relationship

between "disordered dress," "incompletely dressed" (beginning with taking off the collar), and eventually "higher degree of undress" and the emergence of anxiety. In other words, "orderly" dress and "complete" dress are expressions of self-control and "guarantee" anxiety-free journeys. It is interesting to note that the "undressed" Jewish man Freud is caught by the gaze of a socially lower-ranked gentile woman, making him fear the possibility of her questioning his authority.

In 1908, the Jewish playwright Arthur Schnitzler (1862–1931) published his novel *The Road to the Open*. Schnitzler presented sad confrontations between a liberal Christian aristocrat, a dogmatic Zionist, and a confused assimilated Jewish author. In an atmosphere of growing anti-Semitism, Schnitzler's assimilated protagonist, Heinrich Bermann, described the feeling of embarrassment while noticing another Jew making a fool out of himself by comparing it to the experience of a brother watching his sister undressing herself.[5] Realizing Schnitzler's fear of "incest" and proving that shame is not exclusively a "Jewish trait," the controversial young artist Egon Schiele (1890–1918) claimed his creative authority, by showing a portrait of his sister Gerti naked in the International Hunting Exhibition in 1910. His client was the architect Otto Wagner.[6]

The stimulus for the desire to reclaim the male body—the discovery of the male naked body—was first observed in an interior design exhibit. The first time the Viennese public confronted a private bath exhibited publicly was in Otto Wagner's (1841–1918) exhibit of his own bathroom in the Kaiser's grand Trade-Anniversary Exhibition in June, 1898. Wagner exhibited a glass bath as a modern revelation in contrast to the normative ceramic or metal baths of those days (fig. 11.1). While Peter

Haiko analyzes Wagner's avant-garde claim as rendering the naked body available on display, he also notes that the body is exhibited in a bath in the form of a sarcophagus, which insures the purity of the body and which could be understood as an echo to the Zeitgeist tendency to desexualize the "newly discovered" body.[7] Still, Haiko points out, Wagner transformed the rigid sterile bathroom setting into a place of narcissistic and voyeuristic gratification of bodily delights.[8]

The architect Loos certainly identified with the transformation of the sterile bath scene into one of luxury, as he admired both the hygienic norms and the sports imported from American and British culture.[9] In his first effort to make a grand tribute to the "Bath cult" in *Villa Karma* in Montreux (Switzerland), he designed a black marble bathroom containing black marble baths for the owner Theodor Beer in 1904–1906. Beer was a renowned Viennese natural scientist and essayist.[10] Here Loos connects bathing with sports and hedonistic delight: "The culmination [of the extravagant interior] is the bathroom that breathes an atmosphere of Roman hedonism. From a higher situated room for gymnastics, lighted from above and provided with an open fireplace, one descends, surrounded by marble columns, into the bathroom where two bathtubs are sunk into a black marble floor."[11] In contrast to Wagner's bathroom, which appears, as Haiko suggests, as the boudoir of an elegant "lady,"[12] Loos's bath designed with black marble for Beer suggested a sensual transformation of the classical gentleman's black frock-coat.[13]

In 1903, Loos designed his apartment in Vienna. Inspired by the occasion of his own marriage, Loos expressed a romantic male fantasy in his design for his and his wife Lina's bedroom.[14] The newlyweds' bedroom was publicized with a photo entitled "My Wife's

Fig. 11.1 Otto Wagner, Bathroom, 1898.

Bedroom" in the poet Peter Altenberg's journal *Die Kunst* (The Art).[15] Loos dressed the walls with long white batiste curtains and covered the floor with white rabbit fur.[16] Loos combined a daring mixture of an enticing petticoat fabric with the luxurious flair of an expensive fur overcoat laid down on the floor as a "dress-collage."

This white virginal fantasy dress may have been created contrary to the seductive image of the woman wrapped in black fur in Leopold von Sacher-Masoch's scandalous book *Venus in Furs* (possibly inspired by Peter Paul Rubens's portrait of his young lover Helene Fourment, seen partly naked, wrapped only with black fur,

at Vienna's Kunsthistorisches Museum).[17] Yet, an immediate inspiration for Loos's "virginal" yet sensual dress setting may have been the series of Gustav Klimt's (1862–1918) portraits of society ladies dressed in white in front of white or light blue amorphous backgrounds. Klimt's portrait of a prominent Jewish patron, *Portrait of Serena Lederer,* 1899 (Metropolitan Museum of Art, New York), presented at the tenth Secession exhibition in early 1901, depicts Klimt's attempt to disclaim the female body by allowing it to disappear in a white nocturne.

A well-known portrait by James Abbott McNeil Whistler of his lover Joanna Heffernan, titled *Symphony in White No. 1,* also called *The White Girl,* 1862 (National Gallery of Art, Washington) may have served as an inspiration for both Klimt's portraits and Loos's bedroom design.[18] Joanna appears in a white dress standing on a bear-fur rug, and the wall behind her is draped with white fabric. In her interpretation of Loos's bedroom, the art historian Irene Nierhaus identifies his bride's dress as a nonfigurative white dress. Further, Nierhaus suggests that Loos's choice of the white dress and eventually his choice to reveal the (female) body underneath it, as in the case of the upper "naked" façade of the Goldman & Salatsch House across from the Imperial court at the center of Vienna (1911), as an abstract interpretation of the traditional female dress, led eventually to the connotation of its absence.[19] By "removing" the white dress from his wife and projecting it on the walls and floor, Loos may have suggested, in contrast to Klimt, that he would like to join his wife underneath her dress, wrapping them both in their bedroom's "bridal dress." Loos represented in this setting his expectation that his wife and he will walk, sit, rest, and sleep nude in this room. The art critic Ludwig Hevesi complimented the lyrical

tone of Loos's "snow white bedroom" design.[20] In his children's book titled *The Dreaming Boys* from 1908, recording seven erotic dreams, the young Oskar Kokoschka further developed the metaphor, transforming a white room into a white dress in his pursuit to grasp the body of his girlfriend Li.[21]

In real life, the girl Li referred to Lilith Lang, who came from a well-situated bourgeois family—in contrast to Kokoschka (1886–1980), who was raised in a petit-bourgeois family.[22] The difference in social class between Kokoschka and his self-assured girl Li is documented in the description of the youth in his children's book's last lithograph, *The Girl Li and I* (fig. 11.2). Two visual references can identify him as the admirer of the Girl Li: the strange scar, which resembles a stitched wound, on his chest near his left wrist, hinting at his love wound, and the figure of a small man dressed in blue, who appears above the closed form of the youth. The small man is

Fig. 11.2 Oskar Kokoschka, *The Girl Li and I,* 1908, lithograph.

tripled, and walking in the direction of the girl Li, possibly fulfilling the boy's wish to get closer to her. The idea of a wounded man (the "I") and a big woman (the "Girl Li" appears bigger than the boy) inspired Kokoschka's portrayal of the main heroes, "Man" and "Woman," in his scandalous drama *Murderer, Hope of Women* (1910): Man has a pale face, wears blue armor, and has a kerchief covering a (head) wound. Woman is big, with loose yellow hair, and wears red clothes.[23]

Only in the last lithograph of his children's book did Kokoschka allow himself to expose a portrait of himself as a naked young man. Austrian Expressionism documents the artistic recognition of the urgency to display also the male body in public. Inspired by avant-garde dance performances in Vienna, Kokoschka and Schiele expressed their wish to reclaim their bodies in a rather aggressive manner in their art at the end of the first decade of the twentieth century. A number of famous Viennese personalities recorded their impressions of Varieté dance performances during this period in their reviews of the performances of Isadora Duncan (Fremden-Blatt, 1902),[24] Mata Hari (Fremden-Blatt, 1906),[25] and Ruth St. Denis (Die Zeit, 1906).[26] Ludwig Hevesi and the author and playwright Hugo von Hofmannsthal, in their reception of these dance performances, identified the dancers as exotic both racially and nationally, which only served to thrill and to stimulate further curiosity.[27] Critics also pointed out the tension accompanying the erotic dance performance by referring to its physical effects on both the audience and themselves.[28] Further, they regarded the experience of viewing as an act of adoration of both *her* and her art. The "religious" projection could be interpreted as the act of "Othering," meaning distancing through an act of worship.[29] The art historian Patrick Werkner

described how first Kokoschka, and later on, Schiele were both inspired in their early works by avant-garde dance performances in Vienna.[30] Both artists used dramatic choreography in order to express their physical and psychological inquiries. Yet Kokoschka and Schiele challenged the elevated position of these dancers through focusing on the discomfort and dangers involved in the exposure of the female and male body.

Kokoschka's ambivalence, consisting of mixed emotions of admiration and fear, toward the dancer's emancipated physical display resulted in the development of a disharmonious body language. In early 1908, in his letter to his friend Erwin Lang reporting his delight in watching the dancer Grete Wiesenthal at Cabaret Fledermaus, he admitted: "Those passages [in Wiesenthal's dance] get to me with a dark warmth that comes from my sensitivity's terrifying capacity for reaction. I have always had to take care to direct my entire inner self only at such things [that] couldn't answer back and restored my equilibrium."[31]

The poor girls who worked as models for Kokoschka were usually picked up off the streets, available for very low prices.[32] Kokoschka expressed his awareness of the Viennese social prejudice against girls from the lower class through drawing adolescent girls with unkempt hair and unclean bodies in his drawing class in 1907–1908. In Kokoschka's *Nude Girl Leaning Forward, Supporting Herself with Her Hands on the Ground* (Collection Serge Sabarsky, Neue Galerie, New York),[33] he exploited the girl's state of physical humiliation. In order to emphasize her physical degradation, caught in an uncomfortable pose, Kokoschka smeared with light color the parts of the body sticking out from the torso: the lower part of her legs, her hands, and her face. Even though she is turning her head to the place where

the viewer is situated, she cannot lift her eyes from an unseen point on the ground. A comparison between her provocative pose with a possible visual source, the image of the fleshy sensual woman in Gustav Klimt's *Goldfish* from 1901–1902 (Kunstmuseum Solothurn, Dübi-Müller Foundation), reveals how the young artist's awareness of her discomfort resulted in a disturbing caricature of Klimt's sensual source. In contrast to Klimt's sensual play with his woman's long red hair and expecting smile, the messy hair and slanting eyes of Kokoschka's girl evoke a wild impression. Her hair is a sign of self-neglect or defiance of a respectable orderly look, hinting at her low social background. The slanting eyes suggest an allusion to a cat's eyes, an "animalistic" association, stressed by her long fingernails.[34] Kokoschka also portrayed his young model's aggressive potential in action, as a frightening image of an ugly girl, in *The Juggler's Daughter* from 1908 (private collection).[35]

The social prejudice relating physical exposure to animalistic metamorphosis was not exclusive to the representation of poor girls alone. In 1911, the young Schiele was at the height of his creative work, but, still fighting for public recognition and searching for financial support, he drew *Eros* (fig. 11.3). Schiele borrowed the decorative robe of his predecessor Klimt's androgynous female models, to introduce himself as a sensational new subject matter to the Viennese public. Disclosing his own naked body, emerging out of a decorative robe, in *Self-portrait I*, 1909 (private collection), Schiele claimed authority by offering himself as a new "authentic" sex object. During the years 1909 to 1911, Schiele went through a painful process in which he reclaimed his body: he undressed, exhibited, projected his double, and turned his own body into an artistic manifestation.[36]

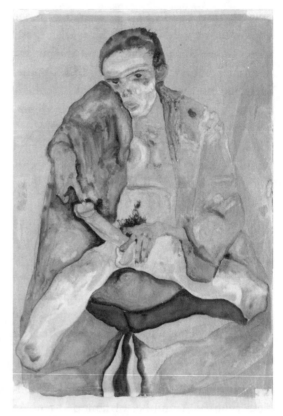

Fig. 11.3 Egon Schiele, *Eros*, 1911.

In a series of tormented "self-body-portraits," Schiele revealed, through agonized facial expressions, mutilated torsos, and dirty coloring, feelings of physical discomfort and disgust. In two drawings, *Self-Portrait Masturbating* (Albertina, Vienna) and *Eros* (Private Collection), of 1911, Schiele describes his estranged relationship to his masculine sexuality. While in *Self-Portrait Masturbating* Schiele introduced himself as a forlorn social outcast, confronting the at-this-time taboo subject of masturbation,[37] in *Eros,* he rewrites the same subject, introducing it as part of Western cultural mythologies. Therefore, in *Eros,* Schiele promoted his own body reclamation as a revolutionary cultural statement. On the right upper side of Schiele's drawing of 1911, the title appears

in capital Latin letters in a square frame: *Eros*. The lower part of the last letter *S* ends with a spiral, a reference to a popular ornamental motif decorating Klimt's erotic paintings. Did Schiele present the mythological figure *Eros* as an old-new young man's role model?[38]

In *Eros*, 1911, Egon Schiele exhibited himself to the public, dressed with a rugged dirty gray open robe, exposing part of his chest and lower body. Schiele uses the original light brown color of the paper as a background color. He is sitting frontally with legs apart, forming an open triangle. His head is tilted to the right, leaning on his right shoulder. Looking at his brutish facial characteristics, the dumb eyes and the open mouth with swollen lips, Schiele appears to have gone through a monkey-like metamorphosis. The main attraction and possibly the first sign of life, marked with a bright color in this dirty gray, black-and-white color composition, is the light red-orange oversized penis rising alert, directed to the right. Schiele holds down with his left hand's first and second fingers, circling the bottom part of his penis, the prepuce, exposing the glans penis. At the same time, the other three left-hand fingers touch/stroke his testicle. With his right hand's second finger, Schiele points at the glans penis. There are scattered red spots marking sensitive (aroused) parts in his body, like the swollen lips and part of the exposed right nipple. Sitting alone facing a mirror or an anonymous viewer, it is possible to assume that he is either in a "premasturbation" stage or he wishes to seduce his viewer. Yet, there is no expression of excitement or enjoyment on his face or in the color of his hands. In contrary, Schiele appears as a dog-slave to his awakening sexual organ. The tensed grayish (ashlike color) body is not enjoying the erotic awakening itself. Moreover, the existential fears and guilt feelings, relating to his masturbating wishes,

result in a self-imposed punishment: an animalistic metamorphosis. Since he is forced to distance himself from the penis, he reclaims it artistically, elevating it as an illuminated (mythological) fetish object.[39]

By introducing himself as a potent uncanny love object, pointing at his exposed, oversized manly organ, Schiele presents himself as a diabolical messenger of love. The uncanny is identified in *Eros* as a reversal of a warm sense of intimacy into a cold sense of fear: Schiele describes how the awakening of his erotic feeling led to his animalistic degradation. Still, he holds on to his role as a messenger of love. An expression of physical liberation surfaces in the lower part of the drawing as a creative revelation. Schiele's own sexual degradation gives birth to a new recognition, which transforms the lower part of his grayish gown to abstract amorphous forms, colored in soft tones of gray and black.[40] The amorphous forms, describing a kind of a symbolic earthquake, fill the triangle shape between his cut-off legs. Schiele's physical humiliation is transformed into a new poetic apotheosis of himself as a *traveling* (departing from earth) Eros.

The same year Schiele drew *Eros*, Adolf Loos's sensational "naked" building, the Goldman & Salatsch House on the Michaelerplatz (fig. 11.4), was at the center of a public debate. The idea of marketing the work of art or in this case work of architecture as a sex object through the play of dressing and undressing, as suggested earlier, is crucial for the understanding of Viennese avant-garde before World War I. The geometric elegance of Loos's façades reflected an enlightened way of life identified with the charisma of Loos as a well-dressed European gentleman. Yet, the painful process of dressing the Goldman & Salatsch House—the architect waited for weeks for the arrival of the Cipollino marble (while the city

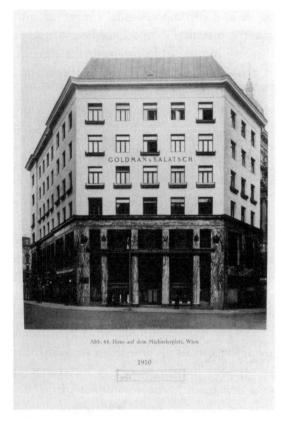

Abb. 44. Haus auf dem Michaelerplatz, Wien

1910

Fig. 11.4 Adolf Loos.

officials, the public, and the media questioned the legitimacy of the naked façade), in order to determine the fitting color and possible décor of the upper parts—proved that Loos enjoyed the public attention given to the happening of "dressing up" a building in public.[41] Moreover, the novel match of plain stucco above and the watery pattern of green Cipollino marble below caused a moral provocation in the Viennese media that could be compared to the scandal accompanying Klimt's presentation of androgynous female exotica, for example, the half-naked young female in his painting *Water Serpents,* of 1904–1907 (Belvedere, Vienna).

Loos may have indeed been inspired by Klimt when he matched naked stucco with luxurious marble, which was interpreted by a

number of critics as producing an erotic effect. In February 1911, Paul Engelmann, a future student of Loos, in his attempt to defend the façade in Karl Kraus's journal *Die Fackel* (The Torch), compared the two parts of the Goldman & Salatsch House to two types of women, one soft and virginal (so that you would like to kiss it) in the upper part, and the other naive and lustful like a lascivious woman in the lower, marble part.[42] Yet the flat-chested upper part was identified with the androgynous body shape of a girl. In his article "Women's Fashion," Loos stated: "The child-woman came into fashion. One yearned for immaturity." Loos mentioned in this article in connection with the phenomenon of admiring young girls the name of his friend, the poet Altenberg (1859–1919). Possibly influenced by Altenberg's admiration of the Secessionist painter Klimt, and in contrast to his friend Kraus, who dismissed Klimt's paintings as an expression of "Jewish taste,"[43] Loos toyed with the idea of calling his Kärntnerstrasse Bar in 1908 the "Klimt Bar."[44] It was later named *American Bar* and the portrait of Altenberg adorned the compact space.

With his androgynous, seemingly naked façade, Loos attempted to prove to the public that he was a better Secessionist than Klimt. Hoping to launch a new avant-garde movement in Vienna, Loos, with the support of his tailor and loyal client Leopold Goldman, fulfilled the very promises made by the founding members of the Secession: to display a new type of image of physical youth, to refuse to yield to public demands, and to demonstrate, in the name of "true art," an indifference to immediate profit. Further, if we compare the Secessionist buildings of Otto Wagner (for example, Majolica House, built in 1898–1899, at Linke Wienzeile 40, possibly inspired by a flowery pattern of female

dress, as in the shirt seen on the back of the journal *Wiener Mode* on July 1, 1898) to Loos's Goldman & Salatsch House (1911), we recognize Loos's victorious moment in the chronicles of Viennese modernism. Loos took over the leading role of the Viennese avant-garde by showing through the plain-colored upper façade a progression from a decorative dress façade toward a geometric abstraction in architecture.

Four prominent architects and artists staged themselves in new settings or without settings that forced viewers to focus on their exposed male bodies. The male gaze is dominant in the works of Wagner, Loos, Kokoschka, and Schiele. Yet in all cases they document conflicts within the representation of masculine identity, such as in Kokoschka's reversal of the violent dimension, projected through his masculine power onto the poor girls, and in the self-violation principle possibly triggered by the self-directed gaze in Schiele's self-portraits. Moreover, the admission of a potential threat, as in the case of Kokoschka watching the girl "turning violent" against her viewer, as well as the challenge to viewers' morals and sense of security in their own clothes when they look at Wagner's glass bath, Schiele's *Eros* or the "naked" façade of the Goldman & Salatsch House, is a calculated risk specifically intended to claim artistic authority as pioneers of modern painting and architecture.

NOTES

1. "Primitive men had to differentiate themselves by various colours, modern man needs his clothes as a mask. His individuality is so strong that it can no longer be expressed in terms of items of clothing" (Adolf Loos, "Ornament and Crime" [1908], translated in: Yehuda Safran and Wilfried Wang, assisted by Mildred

Budny, eds. *The Architecture of Adolf Loos* (Art Council of Great Britain, 1985), 103.

2. Peter Haiko, "The 'Obscene' in Viennese Architecture of the Early Twentieth Century," in *Schiele, Art, Sexuality, and Viennese Modernism,* ed. Patrick Werkner (Society for the Promotion of Science and Scholarship, 1994), 90.

3. Sigmund Freud, *The Interpretation of Dreams* (New York: Avon Books, 1965), 272.

4. Sigmund Freud, *The Interpretation of Dreams,* 272.

5. Arthur Schnitzler, *Der Weg ins Freie* (Verlag der Nation, 1990), 156.

6. Robert Jensen, "A Matter of Professionalism, Marketing Identity in Fin-de-Siècle Vienna," in *Rethinking Vienna 1900,* ed. Steven Beller (Berghahn Books, 2001), 195.

7. Peter Haiko, "Otto Wagners Interieurs: Vom Glanz der französischen Könige zur Ostentation der 'modernen Zweckmäßigkeit,'" in *Otto Wagner Möbel und Innenräume,* ed. Paul Asenbaum, Peter Haiko, Herbert Lachmayer, and Reiner Zettl (Residenz, 1984), 30f.

8. Haiko, "Otto Wagners Interieur," 31. Haiko further pointed out that Wagner wanted to present to the public a small city apartment of a bachelor rather than an apartment of a family man. Photos of the interior were published in *Ver Sacrum* 2 (1900): 295.

9. Adolf Loos, "Die Plumber," *Neue Freie Presse,* 1898, republished in Loos, *Sämtliche Schriften* (Herold, 1962), 75.

10. Theodor Beer lost his professorship at the Vienna University following a trial in which he was accused of homosexuality and pedophilia in 1905 (See Florian Mildenberger, "'…als Conträrsexual und als Päderast verleumdet …'—Der Prozess um den Naturforscher Theodor Beer [1866–1919] im Jahre 1905," *Zeitschrift für Sexualforschung* 18, no. 4 (2005), 332–51.

11. Paul Groenendijk and Piet Vollaard, *Adolf Loos House for Josephine Baker* (Uitgeverij 010, 1985), 18. See also Benedetto Gravagnulo,

Adolf Loos: Theory and Works (Rizzoli, 1995), 112.

12. Haiko, "Otto Wagners Interieurs," 31. Haiko points out the toilette uniform and the use of *frottée* fabric for covering wall, floor, chair, and even oven.

13. The critic Ludwig Hevesi recorded in his review of Loos's Viennese interiors that Loos explained to him that his interiors can be regarded as different variations of a frock-coat (Ludwig Hevesi, "Adolf Loos," in his *Altkunst-Neukunst* (Konegen, 1909); reprint: (Ritter Verlag, 1986), 285.

14. On July 21, 1902, Loos, age thirty-one, married Lina Obertimpfler, age nineteen. In 1903, they moved to a small apartment bought by her father and redesigned by Loos.

15. The photo was published in the first issue of Peter Altenberg's *Die Kunst, Halbmonatsschrift für Kunst und alles Andere* 12 (1903).

16. I thank Burkhardt Rukschcio, former curator at the Albertina in Vienna, and Loos expert, for identifying the type of fur. In the literature it is identified as white angora sheepskin.

17. Leopold von Sacher-Masoch, *Venus im Pelz* (Insel Verlag, 1997 [1869]), 44. Sacher-Masoch describes the electrical physical excitement stimulated by the fur.

18. Manu von Miller, "Embracing Modernism, Gustav Klimt and Sonja Knips," in exhibit catalog *Gustav Klimt, the Ronald S. Lauder and Serge Sabarsky Collections,* ed. Renée Price (Neue Galerie, 2007), 197. Whistler's works appeared in two Secession exhibitions in Vienna (the first opening in March 1898 and the sixteenth in January 1903).

19. Irene Nierhaus, *Arch6, Raum, Geschlecht, Architektur* (Sonderzahl, 1999), 128f. I return to the analysis of Loos's Goldman and Salatsch House toward the end of this chapter.

20. Hevesi, *Altkunst-Neukunst,* 287.

21. Oskar Kokoschka, *Die Träumenden Knaben* (Jugend und Volk, 1968 [1908]), 8.

22. Lilith Lang's mother was the famous Austrian feminist Marie Lang. In a letter to her brother, Erwin Lang, Kokoschka complained that he hardly sees Lilith because he still does not have a dinner-jacket (Oskar Kokoschka, *Oskar Kokoschka Letters 1905–1976* (Thames and Hudson, 1992), 15.

23. Oskar Kokoschka, "Mörder, Hoffnung der Frauen," *Der Sturm* (1910): 155. See Kokoschka, *Vier Dramen* (Cassirer, 1919). The play concerns a power struggle between a virile man and a seductive woman.

24. Ludwig Hevesi, "Miß Duncan in der Sezession," in *Acht Jahre Sezession, Kritik—Polemik—Chronik* (Ritter, 1984 [1906], 24).

25. Ludwig Hevesi, "Mata Hari, die indische Tänzerin (Sezession)," *Fremden-Blatt,* December 16, 1906, 15.

26. Hofmannsthal reported on Ruth St. Denis's performance in Berlin in "Die Unvergleichliche Tänzerin," *Die Zeit,* 1906. See Hugo von Hofmannsthal, *Gesammelte Werke,* 15 vols., ed. Bernd Schoeller and Herbert Steiner, vol. 8, *Reden und Aufsätze 1, 1891–1913* (Fischer-Taschenbuch, 1979), 496–501.

27. Hevesi, "Mata Hari, die indische Tänzerin [Sezession]," 15.

28. Hofmannsthal, "Die Unvergleichliche Tänzerin," 497.

29. Hevesi, "Miß Duncan in der Sezession," 24.

30. Patrick Werkner, "Kokoschkas frühe Gebärdensprache und ihre Verwurzelung im Tanz," in *Oskar Kokoschka, Symposion, abgehalten von der Hochschule für angewandte Kunst in Wien,* ed. Erika Patka (Residenz, 1986) 93–99.

31. Kokoschka, *Oskar Kokoschka Letters 1905–1976,* 17.

32. Alfred Weidinger, *Oskar Kokoschka, Dreaming Boy, Enfant Terrible, Oskar Kokoschka at the Vienna School of Applied Arts* (Graphische Sammlung Albertina, 1996), 43. For further discussion of the portrayal of poor children in Austrian art, see Elana Shapira, "An Early Expressionist Masterpiece, Oskar Kokoschka's Children Playing from 1909," *Zeitschrift für Kunstgeschichte* 64, no. 4 (2001), 519f.

33. Reproduced in Shapira, "An Early Expressionist Masterpiece," 521.

34. Another portrayal of the girl-model by Kokoschka evokes the impression of an"animalistic metamorphosis": In *Nude Girl Running toward the Left,* 1907 (private collection; reproduced in Weidinger, *Oskar Kokoschka,* cat. no. 31) the lines of her loose hair reappear scattered on her stomach and back area, hinting at a hairy catlike transformation. The sharpened nails of her spread left hand fingers express an aggressive potential. The idea of identifying the frightening natural element in women with the image of a cat was presented already in Friedrich Nietzsche's writings; see his *Werke in drei Bänden,* vol. 3, *Jenseits von Gut und Böse, und Andere Schriften* (Könemann, 1994), 171.

35. Reproduced in: Shapira, "An Early Expressionist Masterpiece," 521.

36. "Wenn ich mich ganz sehe, werde ich mich selbst sehen müssen, selbst auch wissen, was ich will, was nicht nur vorgeht in mir, sondern wie weit ich die Fähigkeit habe, zu schauen, welche Mittel mein sind, aus welchen rätselhaften Substanzen ich zusammengesetzt bin, aus wie viel von dem mehr, was ich erkenne, was ich an mir selbst erkannt habe bis jetzt" cited from Egon Schiele's letter to Dr. Oskar Reichel (Neulengbach, September 1911) in *Briefe und Prosa von Egon Schiele,* ed. Arthur Roessler (Lányi, 1921), 146.

37. During the second half of the nineteenth century, medical publications, promoting religious dogmas, described masturbation as a sexual perversion leading to self-destruction. Masturbation was identified as a cause for physical and mental degeneration that leads to self-castration, blindness, and madness: Ludger Lütkehaus, "*O Wollust, O Hölle,*" *Die Onanie, Stationen einer Inquisition* (Fischer-Taschenbuch, 1992), 9–53. Schiele's courage to confront the issue of masturbation in his work was inspired by his colleague Kokoschka. Frightened arms and thin fingers hold an unseen object and move blindly in an exotic uncanny place in the opening of Kokoschka's *The Dreaming Boys,* 1908 (Kokoschka, *Die träumenden Knaben,* 3).

38. The mythological figure Eros went through a metamorphosis in the history of ancient Greek mythology; from a respectable old god, deity of the loveliness of young men and boys, he turned into a pretty little messenger, a capricious and mischievous winged child, part of a divine machinery for making people fall in love. H. J. Rose, *A Handbook of Greek Mythology* (Dutton, 1959 [London, 1928]), 123. It is not clear if Schiele is referring to the old deity or to the winged child.

39. In a provocative watercolor drawing called *Die Rote Hostie* (The Red Host), 1911 (private collection); reproduced in Wolfgang Georg Fischer, *Egon Schiele, Desire and Decay* (Benedikt Taschen, 1995), 69, Schiele presents himself like a marionette, seated leaning back with open legs, his head tilted to the right with a lifeless expression on his face, and his raised red over-sized penis held from underneath by the hands of a naked woman. She rises between his open legs, her red hair stroking his penis. Her raised left elbow echoes his bent raised left leg. The identification of his red penis with the holy bread (the *red* flesh of Christ?) is a clear provocation and at the same time expresses a wish to elevate his male organ as a religious fetish. Similarly and in contrast to Schiele, the Austrian Expressionist Richard Gerstl (1883–1908) claimed his artistic license by identifying with the figure of the "unattainable" Christ. Gemma Blackshaw argued in her article on Gerstl that his self-portraits, showing his identification with Christ, were meant to express "his rejection and persecution by an intolerant society and culture, whilst simultaneously claiming his (undisputed) place within it"; Gemma Blackshaw, "The Jewish Christ: Problems of

Self-Presentation and Socio-Cultural Assimilation in Richard Gerstl's Self-Portraiture," *Oxford Art Journal* 29, no. 1 (2006), 30.

40. The abstract amorphous forms could remind us of Georgia O'Keeffe's abstractions based on enlargements of flower forms.

41. I am grateful to Burkhardt Rukschcio for this observation.

42. Engelmann's poem appeared in *Die Fackel,* February 21, 1911; see also Haiko, "The 'obscene' in Viennese Architecture," 93.

43. Karl Kraus, *Die Fackel,* no. 41, Vienna, May 1900, 22, and in *Die Fackel,* no. 73, April 1901, 9.

44. Sketch A.L.A. 260 ([Adolf] Loos-Archiv, Albertina).

THE STIGMATA OF ABJECTION: DEGENERATE LIMBS, HYSTERICAL SKIN, AND THE TATTOOED BODY

Fae Brauer

Scabs, scratches, cuts, bruises, warts, moles, smallpox scars, fractures, amputations, and other deformities all marked the body in the eighteenth century. Neoclassical sculptures of the immaculate body bound by smooth, clear surfaces conjured paranoiac disavowal of these daily inflictions, according to Barbara Maria Stafford, along with the constant confrontation with rotting corpses and squamous flesh.[1] In the face of rampant syphilis, smallpox, rickets, tuberculosis, and other forms of incipient contagion in the nineteenth and twentieth centuries, the Western obsession with the immaculately healthy, hygienic body conjured the horror of abjection in terms of degeneration, devolution, and extinction. Only the immaculate clean-and-proper body could, following Julia Kristeva, act as a bulwark against the abjection of degeneration and its constant threat to erode the inner and outer boundaries through which the wholesome speaking subject is constituted and subjectivity civilized.[2]

So overwhelming did degeneration seem by mid-nineteenth century that Bénédict Morel likened it to a plague that was capable of invading the borders of the body, contorting limbs, skewing spines, twisting legs, webbing feet, and producing harelips. Not only was it portrayed by such visible disfigurations, but also

betrayed, according to Morel, by their asymmetrical configurations that marked the body like stigmata. Twenty years later, when Jean Martin Charcot was exploring both female and male hysteria, while Alfred Fournier was diagnosing congenital syphilis, both reached the frightening realization that the stigmata of degeneracy could also be invisible and untraceable. This was why those stigmatized by degeneration began to be treated as sources of contagion that needed to be extirpated from Western cultures, as did those who self-marked their bodies with scars and tattoos.

By focusing upon these biomedical cultures of degeneracy during the nineteenth and twentieth centuries, this chapter is divided into three parts, to unravel the curious constellation of conditions in which such differing involuntary self-marking conditions as rickets and hysteria, and such voluntary markings as tattoos, were all construed as forms of abject stigmata able to invoke fear, dread, and loathing. After assessing the impact of Morel's theory, the first part will investigate how anthropometric photography proved instrumental to stigmatizing corporeal asymmetry with, at times, disastrous inhumane ramifications. After sketching the shift in diagnosing the stigmata of degeneracy generated by Charcot, the second part will

examine the roles played by visual cultures at Salpêtrière Hospital in the detection of hysteria, particularly body maps, drawings, and photographs, before revealing their repercussions upon feminism and suffragism. The criminological discourses in which tattoos were perceived as defacing the immaculate surface of the body will be scrutinized in the third part in order to understand why tattoos stigmatized their bearers as both degenerate and criminal. While these three studies are designed to expose the destructive roles that can be played by visual cultures in inscribing the body, this chapter will end by questioning the possibility of counter-inscriptions able to invert and subvert the stigmata of abjection.

THE STIGMATA OF ASYMMETRY: DEGENERATE LIMBS AND ANTHROPOMETRIC PHOTOGRAPHY

Nails seemingly driven through the hands or feet of Christians like other wounds inflicted upon Jesus during the crucifixion were called "stigmata."[3] That this marking of the body may be bioculturally psychogenic is testified by the absence of reported cases of stigmata until the crucified Jesus became an icon hung above the altar in almost every Catholic church and until St. Francis of Assisi was painted by Giotto with rays piercing his body from the wounds of Jesus. At a time when numerous sightings of stigmata were reported by religious orders in the rapidly modernizing French Second Empire, this was the very term that the head of medicine at the Saint-Yon Asylum, Bénédict Morel, chose in his highly influential 1857 treatise to describe the manifestation of degeneration.[4]

Degeneration, according to Morel, took the form of a "morbid deviation from a normal type of humanity."[5] Rather than being concealed, Morel considered that this "morbid deviation" left an indelible stain on the body. Like tattoos, it could not be washed off. No matter how hard a degenerate may try to conceal or erase their condition, Morel found their "stigmata" betrayed them. While disclosed by markings of the skin, it was inescapably revealed by:

> Such asymmetries as the unequal development of the two halves of the face and cranium; the imperfection in the development of the external ear, which is conspicuous for its enormous size, or protrudes from the head, like a handle, and the lobe of which is either lacking or adhering to the head, and the helix of which is not involuted; further, squint-eyes, hare lips, irregularities in the form and position of the teeth; pointed or flat palates, webbed or supernumerary fingers (syn- and poly-dactylia), etc.[6]

Published two years before Charles Darwin's *On the Origin of Species,* the human "types" in Morel's treatise were developed from Jean-Baptiste Lamarck's model of evolution: The hereditary transmission of accumulated characteristics that had arisen from the gradual process of adaptation to environment. From his research into the overpopulated and unsanitary areas of Edinburgh, Manchester, and Paris, Morel had deduced that the modern industrial city posed "new causes of decline and consequently of degeneration."[7] In these environments, he found parents became far more easily "tainted" by the abuses of alcohol, syphilis, malnutrition, tuberculosis, and other scourges, which they transmitted to their children. When the "stigmata" of alcoholism passed from one generation to the next, Morel considered it led to neurosis, psychosis, idiocy, infertility, and ultimately extinction of an entire family. One of its most potent

illustrations was the self-extinguishing family bearing signs of Morelian "stigmata" in Emile Zola's Rougon-Macquart novel cycle. And not only did Morel's theory permeate literature but also degenerate body photography.

To demonstrate how degenerate stigmata were manifested by anatomical asymmetry, Morel commissioned thirty-five photographs from Dr. Baillarger at Salpêtrière Hospital to illustrate his treatise. They included photographs of physically disabled and mentally retarded children. At that time such photographs were rare. Forty years later, the opposite was true.[8] Between 1880 and 1914, as Allan Sekula writes in his seminal essay on this subject, "the archive became the dominant institutional basis for photographic meaning."[9] Extensively used for anthropometry, biometry, and criminology, degenerate body photography proved the most instrumental in inscribing the bodies of alcoholics, syphilitics, arthritics, dwarfs, and the disabled as abjectly stigmatized. Pictured throughout the widely disseminated encyclopedia of degeneration published by Charcot and his colleagues from 1888 to 1922, *Nouvelle Iconographie de la Salpêtrière*, degenerate body photography also featured in such lesser-known publications as *Biometrika* and the *Treasury of Human Inheritance* assembled by the Biometric Laboratory and the Francis Galton Laboratory of National Eugenics at University College London under the direction of Karl Pearson.[10]

A close friend and colleague of Francis Galton, Pearson had become director of the Eugenics Record Office in 1906, the central storehouse of eugenic records in Britain that included photographs of both degenerate and noteworthy families.[11] On Galton's death in 1911, Pearson had not only been appointed inaugural director of the Francis Galton Eugenics Laboratory for National Eugenics at University College, but also its first Galton Professor of Eugenics.[12] A Neo-Darwinist who vigorously endorsed reproduction of "the perfect race," since the Boer War Pearson had consistently demanded an increase in national efficiency through encouraging better stock to produce larger families and, conversely, preventing degenerate stock from multiplying. Dividing the human species into superior Western races and inferior non-Western ones, Pearson did not hesitate to proselytize apartheid and genocide to extinguish the latter.[13] Invited to deliver the prestigious Cavendish Lecture to Britain's top physicians, hot on the heels of the First International Eugenics Congress and Exhibition in London, Pearson did not hesitate to endorse his mission through misappropriating degenerate body photography.

By suspending the action of natural selection and enhancing the survival rate of the unfit, medical progress and Darwinism had, Pearson argued, become antithetical forces.[14] Because medico-scientific intervention had, according to Pearson's statistics, led to the greater survival and propagation of those he called "weaklings," he deduced that the progress of medical science was militating against "the upward progress of man" and "race efficiency."[15] Projecting photographs of a brother and sister severely crippled with rickets (figs. 12.1 and 12.2), Pearson rhetorically asked, "do you think that the reproduction of such deformities generates racial efficiency? Should not such families at least stop at one child?"[16] The answer to his question lay in the shock impact of these photographs, in which signs of "healthy normality" appeared jarringly intertwined with "degeneracy" in a singular body.

Without cropping, exaggeration, distortion, overt manipulation, or conspicuous retouching, these photographs were presented by Pearson

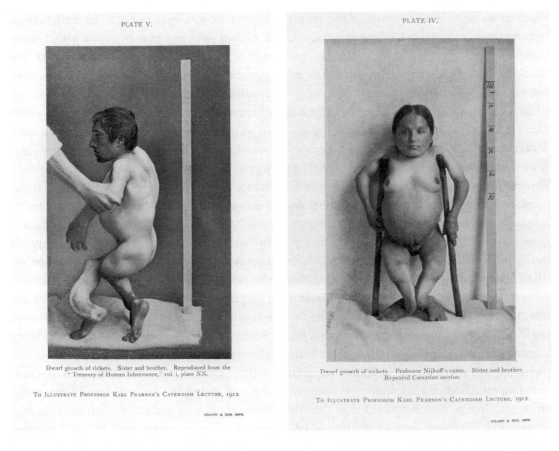

PLATE V.

Dwarf growth of rickets. Sister and brother. Reproduced from the "Treasury of Human Inheritance," vol. i, plate NN.

To Illustrate Professor Karl Pearson's Cavendish Lecture, 1912.

ADLARD & SON, IMPR.

PLATE IV.

Dwarf growth of rickets. Professor Nijhoff's cases. Sister and brother. Repeated Cæsarian section.

To Illustrate Professor Karl Pearson's Cavendish Lecture, 1912.

ADLARD & SON, IMPR.

Fig. 12.1 Dwarf growth of rickets, brother, photograph.

Fig. 12.2 Dwarf growth of rickets, sister, photograph.

as objective witnesses to degeneration. Framed by an ordered sanitary context, with no sign of blood, sweat, tears, pus, urine, feces, or other such abject excretion, they did not necessarily signify either impurity or putrefaction. Portraying what Bruno Latour calls an optical consistency as coldly measurable as hard facts, they could be treated as equivalent to anthropometrical diagrams and biometrical statistics.[17] Nevertheless, the incorporation of anthropometrical apparatus within these photographic frames transmuted these forms of corporeal anomaly into Morelian stigmata.[18]

Although the photograph in figure 12.1 records the brother's handsome head, it also reveals his disfigured limbs and skin. Although

his sister's symmetrically aligned face and evenly developed breasts are captured by the lens in figure 12.2, so are her stunted bowed legs and discolored webbed feet. This disjunction was resoundingly reinforced by juxtaposition of their asymmetrical bare bodies with upright anthropometers. While these metric scales made it possible to calculate the dwarfing of these mature siblings and their degree of deviation from anatomical symmetry, the very perpendicularity of these rods accentuated their disfiguration, from the humped back of the brother's scoliosis to his mangled knees and twisted legs. Invoking the trope of abjection, it made them seem unclean, uncivilized, and a threat to evolution. This threat

was intensified by the scar running from just below the sister's navel to her vulvic region.

While curiously paralleling the perpendicular anthropometer, this scar was far removed from healthy symmetry. Pertaining to repeated Caesarean section, as Pearson's caption explains, it demonstrated that this dwarfed sister was not only sexually active but also capable of reproduction. To prove that she was far from an isolated example, Pearson followed this image with photographs of two achondroplasic daughters of an achondroplasic father, both of whom had undergone repeated Caesarean section and given birth to dwarfs. The prospect of their perpetuating the stigmata of abjection was highlighted by the deceptive caption Pearson imposed upon his next photograph of five siblings, misappropriated from *Nouvelle Iconographie de la Salpêtrière,* misnamed the "Rickets Family": "To illustrate how the birth of a first rickety child does not deter persons from parentage at present."[19] Having shown how they could weaken the Western race, Pearson urged the medical fraternity to subscribe to compulsory sterilization and the "better dead" doctrine:

> I feel sure that many of you who have, by your skill, helped into the world the cripple, or the child of deformed or diseased parents, must have said to yourselves…better it had not been born. Many of you…hold with me the "better-not-born" doctrine ….[20]

The first step he advocated was implementation of a national register. Comparable to the one established two decades later for the Third Reich Eugenics Sterilization and Euthanasia Programmes, it was designed to document all those with hereditary-based illnesses, as well as those "diseases, non-hereditary in character, where an active condition is injurious to offspring."[21] "Only a very thorough eugenic

policy," he concluded, "can save our race from the evils, which must flow from the antagonism between natural selection and medical progress."[22] For Pearson and other euthanasia eugenicists, these evils included hysteria. Because its stigmata were not visible on the body, hysteria appeared even more pernicious.

THE STIGMATA OF HYSTERIA: SKIN, SEIZURES, AND THE "SHRIEKING SISTERHOOD"

Long identified with the wandering womb and Satanic possession, the only cure for *hysteria stigmata diaboli* seemed exorcism by a celebrant. Committed to an empirically scientific and anticlerical French Republic, Jean Martin Charcot and his "charcoterie" of neurologists at Salpêtrière aimed to show that hysteria was an illness afflicting men as much as women, requiring treatment by a physician, not a priest. Following Morel's concept of degeneration, Charcot considered that its invisible sensory stigmata in the form of "nervous taints" emanated not from the devil but a latent hereditary flaw activated by traumatic incident. To illustrate how hysteria was disclosed through paralysis and seizures, beginning in 1875 Charcot commissioned physiology professor Paul Régnard to photograph his women patients. In 1882, not only did he appoint artist-neurologist Paul Richer to head a clinical laboratory of nervous illnesses with its own art studio, but also 24-year-old Albert Londe to direct Salpêtrière's photographic service—the first professional photographer, as Sander Gilman points out, to be given a full-time appointment in any European hospital.[23] Subscribing to the spurious premise of the immanent truth of vision and appearances outlined in chapter 6, photographs, pen-and-ink drawings, plaster casts, wax models,

tableaux, and maps of hystericized skin were mobilized at Salpêtrière to demonstrate how epileptic and traumatic hysteria was manifest by the male and female body.[24] Not only were these visual biocultures devoted to recording how hysterical attacks and symptoms afflicted arms, legs, hands, feet, limbs, and face but also to revealing how hysteria insidiously permeated the hypersensitive surface of the body. "The sensitive skin of the hysteric becomes," Charles Féré explained, "a tabula rasa upon which the disease can be inscribed."[25] Yet, disseminated at a time when hysteria became permeated with political significance, these images furnished a pathological model that could be mapped onto feminists and suffragists.

The opposite of judicial or penal branding, hysterical skin involuntarily emitted signs in a psychic imprinting of rashes, flushes, ulcers, blisters, or pruritis, just as in stigmata. This was why every morning Charcot would silently probe every mark on his patient's body for these tell-tale "nervous taints" ("tare nerveuse"). To discover whether these "nervous taints" betrayed the invisible but infallible sign of hysterical stigmata in zones of anaesthesia and hyperaesthesia (fig. 12.3), Charcot would then squeeze, pinch, and prick every part of the body with a needle. Despite the comparability between these procedures and those deployed by clerical witch-finders and tattoo artists, they were justified as essential to locate the invisible stigmata of anaesthesia and hyperaesthesia on the body and to define its expanse and configuration on body maps devised for every patient. While the body map in figure 12.3 illustrates how anaesthetic stigmata were clustered in pockets or in hysterogenic zones wrapped around the male body, it also shows how hyperaesthesic excitation points the size of a coin were concentrated around

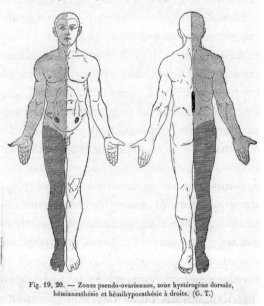

Parmi les zones cutanées, nous en trouvons deux chez l'homme, qui sont également très fréquentes.

Fig. 19, 20. — Zones pseudo-ovariennes, zone hystérogène dorsale, hémianesthésie et hémihypoesthésie à droite. (G. T.)

Fig. 12.3 Georges Gilles de la Tourette, Hysteria Body-maps: pseudo-ovarian and hysterogenic zones (left); hemi-anaesthetic and hemihyperaesthesic zones (right).

the genitalia. These points even appeared on hysterical men, as Charcot pointed out, in the same position as woman's ovaries.

When the loss of sensation led to parts of the body becoming utterly numb, Gilles de la Tourette recalls that no matter how deeply he penetrated these anaesthesic pockets or zones with a needle, it caused neither pain nor bleeding nor any reflex reaction. By contrast, sensitivity in hyperaesthetic places was often so acute that merely stroking or breathing on them was sufficient to elicit an attack.[26] That Charcot was aware that these attacks could also be suspended by manipulating hysterogenic zones is demonstrated by unpublished medical notes describing his use of ovarian compressors, batons, and even his fist plunged into the vagina.[27] No less averse to genital manipulation in hysterical men as in women,

Charcot found that "testicular hysteria" could be provoked merely by exerting pressure on hyperaesthesic points around the groin, on the penis, or even just by brushing the scrotal skin.[28] With the help of hypnosis or amyl nitrate, these attacks could be carefully staged for Charcot's Tuesday lectures to the public, as André Bouillet illustrated in his painting, *Clinical Lesson at Salpêtrière,* in which "Queen of Hysterics" Blanche Wittmann was shown swooning in a wanton state of décolletage in front of seventeen mesmerized male interns. With such images of women far surpassing those of men, the so-called "frail gender" was deemed far more susceptible to hysterical attacks. Nevertheless, Charcot's case studies, Londe's photographs, and Richer's drawings (fig. 12.4) reveal that the four main phases of the grand attack were equally common among hysterical men, only much more violent.[29] Far from being effete intellectuals and effeminate homosexuals, these visual cultures also reveal that hysterical men were robust workers with clearly striated muscles as embodied by Charcot's term, "virile hysteria."[30]

After losing consciousness, the first epileptoid phase of "virile hysteria" was described by Charcot as marked by hallucination and rigidification manifested by trembling hands, straightened arms, clenched, twisted fists, extended limbs, and eyes convulsed upward. In the following phase of hallucinations and convulsions, hysterical men became increasingly violent until, Charcot observed, "the patient breaks or tears everything he can lay his hands on."[31] After adopting bizarre postures in keeping with Charcot's definition of "clownism," these contortions gave way, according to Charcot, "to the distinct position of the arc de cercle...in which the loins are separated from the plane of the bed by a distance of more then fifty centimetres with the body resting on the

head and heels." As Charcot observed and as Richer illustrated, "at other times, the arching is made in front, the arms crossed over the chest, legs in the air, and the trunk and head lifted upwards, with the back and buttocks alone resting on the bed"[32] (fig. 12.4).

While Charcot published more than sixty cases of "virile hysteria," and while Richer's drawings and Londe's photographs of hysterical men circulated globally through *Nouvelle Iconographie de la Salpêtrière,* it was Régnard's photographs of hysterical women that were popularized by the press to demonstrate that hysteria was the quintessential female condition. Despite Charcot's, Pierre Janet's, and Sigmund Freud's theories that both male and female hysteria was an acting out of cultural oppression and sexual repression, these visual cultures seemed to confirm its sexual etiology, particularly Régnard's photographs of eighteen-year-old Augustine (figs 7.1 and 7.2, in chapter 7 of this volume).[33] These photographs proved irresistible to hygiene leagues intent on lobbying the government for lifelong institutional incarceration of hysterics. Yet during this time of vigorous suffragism, when Régnard's photographs of the iconography of hysteria appeared to map women's multiple orgasms, they also proved irresistible to the antifeminist press intent on framing feminists and suffragists as the sexually deviant "Shrieking Sisterhood."[34] With fin-de-siècle artworks of woman as vulvic vampires preying upon men and as nymphomaniacs with insatiable sexual appetites, these photographs played a potent role in the politics of antisuffragism.

By 1890 in Paris, Hubertine Auclert's feminist journal *La Citoyenne* was established, and by 1897, the feminist newspaper *Le Fronde,* inaugurated by Marguerite Durand, was run entirely by women. When French feminism and British suffragism were rapidly gaining

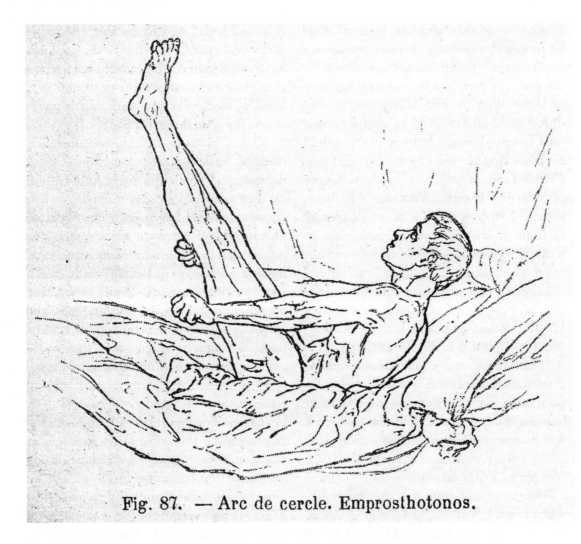

Fig. 87. — Arc de cercle. Emprosthotonos.

Fig. 12.4 Hysterical man during a grand attack: arc de cercle, emprosthotonos position.

ground and destabilizing gender relations, these photographs of women shrieking, panting, swooning, and convulsing as if simulating childbirth and orgasm simultaneously[35] compounded long-established tropes of woman as emotional, uncontrollable, labile, and sexually capricious—both *femme fragile* and *femme fatale*.[36] "The new woman" *(la femme nouvelle),* who campaigned for access to universities, professions, and parliament was accused of destabilizing gender demarcations and portrayed as mentally and sexually disturbed. During

rallies for women's emancipation, as Lisa Tickner has shown, newspaper photographs taken of suffragists were framed by those of hysterical women, particularly Régnard's shots of Augustine (figs. 7.1 and 7.2).[37] Pictured shouting or swooning, these suffragists were readily lampooned as "the shrieking sisterhood."[38] As Tickner succinctly surmises:

For half a century and more, feminism and hysteria were readily mapped on to each other as forms of irregularity, disorder, and excess, and

the claim that the women's movement was made up of hysterical females was one of the principal means by which it was popularly discredited.[39]

Hence, as "the new woman" made the first inroads into the public and professional sphere in France, America, and Britain, she was pictured as stigmatized with hysteria. Not only was she blamed for the declining birth-rate and inclining degeneracy, but also the breakdown of the family and destabilization of the nation-state. Although hysteria was perceived by many feminists to be a mode of resistance to the place assigned to women by men, "woman's protest against confinement in the home-sweet-home of bourgeois industrial capitalism,"[40] the visual cultures of hysteria demonstrated to others why "the new woman" could be dangerous to the medico-scientific regulation of the nation-state and should be resolutely confined to the private sphere. Not surprisingly suffragists were imprisoned, deprived of emancipation, and denied the franchise on the same terms as men until 1928 in England and 1945 in France. With the hyper-regulation of sexual surveillance, feminists and other opponents of inequality endeavored to seize control of their bodies and subvert the oppressive order through the visual cultures of tattoos and piercings.

INSCRIBING AND INVERTING STIGMATA: PAPUANS, CRIMINALS, AND THE TATTOOED BODY

At a time when only slaves, deserters, and convicts suffered the penal or judicial marking of the skin to signify their degradation, the imprint of tattoos, like the scars of flogging, was a badge of shame, as illustrated by two engravings appropriated by Caesar Lombroso of a tattooed French thief expelled from France who wandered aimlessly throughout Africa and Australia and a French sailor who deserted his ship and committed a crime (fig. 12.5). So inextricably imbricated within criminality did they become that tattoos were even believed to lead to crime, as demonstrated by the soldier who told Lombroso he was not tattooed "because these are the things that lead to the galleys."[41] Until the mid-nineteenth century, deserters from the British army were branded with the letter "D" on the forehead. Convict ships were thought to breed epidemics of body-marking, self-mutilations being a signifier of entropic, malingering, infantile self-attention. Yet it was their association with those Charles Darwin called "barbarous races" that led to tattoos being stigmatized as abject and the tattooed body becoming identified not just with criminality and other forms of degeneration, but with atavism and savagery.

First brought to the West by such eighteenth-century British explorers of the Pacific as Captain James Cook, tattooing presented a dramatic inversion of the aesthetic of immaculateness.[42] During his *Beagle* voyages, Darwin was struck by the urge for tattoos among indigenous peoples: "That (savages) have a passion for ornament is notorious," he wrote. "They deck themselves with plumes, necklaces, armlets, ear-rings…painting themselves in the most notorious manner."[43] Implicit within his commentary, particularly his comparison of the marking on a gorilla head with indigenous bodily ornamentation, was that tattoos were a sign of evolutionary regression. "One of the most singular characteristics of primitive men and those who still live in a state of nature," explained Lombroso, "is the frequency with which they undergo tattooing."[44] While German Darwinist Ernst Haeckel linked "primitive" body ornamentation with atavism, in *L'Uomo Delinquente,* Lombroso deduced

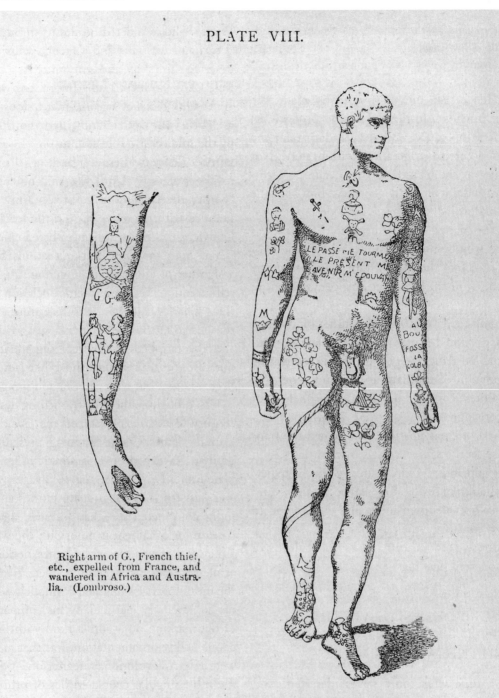

PLATE VIII.

Right arm of G., French thief, etc., expelled from France, and wandered in Africa and Australia. (Lombroso.)

M. J., French sailor and deserter; the nature of his crime is unknown. (Lombroso.)

Fig. 12.5 Tattoos on the right arm of a French thief expelled from France (left) and tattoos on the body of a French sailor and deserter (right).

that because the criminal's urge to tattoo was equivalent to that of the "primitive," they too were atavistic. That tattoos inscribed the body as an atavistic criminal was supposedly corroborated by the two engravings Lombroso appropriated showing the tattooed arm of the French thief and the tattooed body of the French sailor (fig. 12.5), as well as the tattoo on the penis of a Neapolitan criminal soldier saying "it enters everywhere."[45] "There are prisons in which eight percent of the criminals are tattooed," explained Austrian architect Adolf Loos in 1908. "If someone who is tattooed dies in freedom," Loos claimed, "then he does so a few years before he would have committed murder."[46] Whenever modern man tattooed himself, Loos deduced that he was then acting like a criminal. "The modern person who tattoos himself is either a criminal or a degenerate," he explained, and "people with tattoos not in prison are either latent criminals or degenerate aristocrats."[47] Tattoos also inculpated Papuans.

Germany's colonization from 1884 of what is now called Papua New Guinea, when ethnographic images of Papuans were published, is no doubt why Loos singled them out from other indigenous peoples. Misappropriating ethnographic photographs of Papuans with tattoos covering their faces and bodies, Loos explained that "the Papuans tattoo themselves, decorate their boats, their oars, everything they can get their hands on."[48] Due to the act of tattooing, Loos, following Lombroso, not only aligned "Papuan savages" with criminals but also cannibals, supposedly slaughtering their enemies and devouring them. Like Lombroso, he considered tattoos an unequivocal sign of the evolutionary development of a nation or race. "One can measure the cultural development of a country by the amount of graffiti on bathroom walls," he wrote. However, what

was understandable in the child and "natural in the Papuan," was "a sign of degeneration in modern man."[49] So repulsed was he by tattoos that Loos condemned all ornamentation in functional realms of art and pronounced "the evolution of culture synonymous with the elimination of ornamentation."[50] Nevertheless, tattoos also held the allure of exoticism.

After being tattooed with animals and plants by Polynesians beginning in 1784, Cook's crewmen took this culture of body ornamentation to Britain, along with tattooed Polynesians as live exhibits. So popular did the Polynesian practice of tattooing become that sailors bore them on their bodies as a mark of their voyages, while powerful women were drawn to them. Not only did they draw attention to the flesh, but they also flouted conventions of feminine modesty and decorum. By the Great Exhibition of 1851, not just Englishmen but Englishwomen were being secretly tattooed. In 1873, when the most successful promoter of tattoos, P. T. Barnum of Barnum & Bailey circus, brought Prince Constantine with 388 tattoos to the United States, this ignited greater popularization. In 1880, *The New York Times* announced that at least 7.5% of "fashionable London ladies were tattooed in accessible localities." Six years later a London tattooist boasted of having tattooed 900 women. In the 1890s, the railroad heiress Aimée Crocker, known as the "Queen of Bohemia," had a red-and-blue tattooed wristlet. In 1901, to commemorate the coronation of King Edward VII, and the ban against facial makeup, even Winston Churchill's mother was tattooed with patriotic images and proudly bore the Greek symbol of eternity, Uborus, on her wrist like a bracelet. So popular did tattoos become that in the very year that Emmeline Pankhurst and her daughters formed the Women's Social and Political Union, which became known as the

Suffragettes, the London-based socialite magazine *The Tatler* announced "The Fashionable Craze of Today" (fig. 12.6). In 1903 alone, it estimated that around fifteen thousand women had been tattooed. In eight photographs, it illustrated the antelope, dove, dragon, duck, mermaid, and lion motifs popularly chosen, six of which were photographed on women's arms, as illustrated by figure 12.6.

During the period of suffragism and the ensuing waves of feminism when women interrogated ownership and control of their bodies, the tattooing of women grew from five percent of the market to sixty percent. During the sexual revolution, when gender roles were being challenged, this form of visual culture written on the living skin provided a countercultural sign of resistance to the white aesthetic of immaculateness, as well as a means of expressing difference and reclaiming the body. While such body artists as Carolee Schneeman, Hannah Wilke, Eleanor Antin, and Gina Pane were using their bodies as art, Wilke and Pane scarifying themselves in performances, such women tattooists as Julie Moon were exploring tattoos as an art form, covering themselves with tattoos as body art. Indelible images on a woman's body were designed to subvert the male gaze and act as badges of self-empowerment. The stress on individuality of the tattoo, especially when a "custom," not a "flash," requiring a tattooist with artistic skills, was perceived as a means of transforming the self. This is illustrated by the boldly colored tattoos of flowers, insects, animals, and stars designed by California artist Rob Nunez in collaboration with Roberta Soll Hunt, covering her head, arms, shoulders, back, and legs. Far from inscribing the body of Soll Hunt as a criminal, degenerate, or devolved human being, they do the opposite. "Tattoos make unique the surface of one's self," explained Diane Ackerman, "embody one's secret dreams, adorn with magic emblems the Altamira of the flesh."[51] As its design reflects some aspect of the self that is publicly repressed, it generates the feeling of

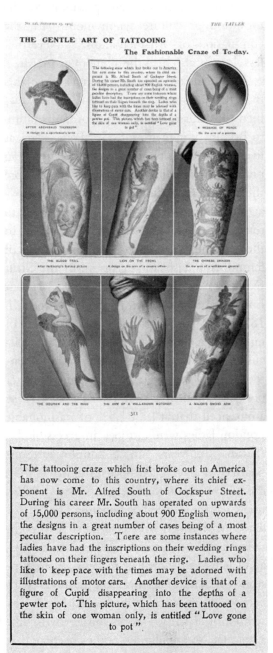

Fig. 12.6 Six female arms showing different tattoo designs and two circular views of bird tattoos.

a distinctive identity, as illustrated by Margot Mifflin's quote of a woman with an Art Deco painting tattooed on her back: "Being tattooed separates me from anybody else. No one else has anything like what I have.... I guess inside it makes me feel special." This includes the choice of the uterus tattoo as a sign of female power—not hysteria.

In decoding how such diverse visual cultures were deployed to inscribe the stigmata of abjection upon the so-called degenerate body, this chapter has endeavored to reveal the destructive roles that photographs, prints, and drawings can play. While corporeal asymmetry was defined as stigmata long before the advent of anthropometric photography, this form of visual culture became instrumental to not just inscribing but stigmatizing the degenerate body as putrescent. This stigmatization was capable of provoking, in the hands of hard-line eugenicists, fear, dread, and loathing. Since the attainment of "healthy," "civilized" subjectivity is, according to Kristeva, conditional upon expulsion of the abject and disorderly, this was why so many insisted that those bearing this stigmata be expunged from Western civilization. While the hysterical body was rarely subjected to such dire inhumane demands, those visual cultures capturing its seizures and invisible stigmata, especially of hysterical women, provided ammunition for hygiene leaguists to demand their lifelong incarceration, while granting the mass media a model for framing feminists and suffragists as pathological. Following criminologists' deployment of visual cultures to stigmatize tattoos, the bearers of tattoos, no matter how ethical, cultivated, or harmless, were automatically inscribed as criminals or savages, while ornamentation and graffiti were recoded as signifiers of racial and national decline. Nevertheless, inherent in the very activity of pricking the skin lay the possibility of counter-inscription.

In denaturalizing and denormalizing the body, counter-inscription offered a new topology of resistance. By individualizing the body with tattoos and by constructing distinctive narratives around them, it seemed possible to dislodge abject inscriptions and to disrupt pernicious misappropriations. As an act of defiance against the aesthetic of immaculateness and as a strategy of refusal of the wholesome clean-and-proper body, the contemporary tattooed body reveals how it may be possible to invert and subvert the stigmatization of abjection.

NOTES

1. Barbara Maria Stafford, *Body Criticism: Imaging the Unseen in Enlightenment Art and Medicine* (MIT Press, 1991).
2. Julia Kristeva, *Powers of Horror: An Essay on Abjection* (Columbia University Press, 1982).
3. Its etymology can be traced to the Latin Vulgate in Saint Paul's letter to the Galatians: "I bear on my body the marks (stigmata) of Jesus."
4. From 1868, Louise Lateau bled from her hands, feet, and side weekly until her death in 1883. In *The Book of Skin* (Cornell University Press, 2004), 122–23, Steven Connor points out that many Salpêtrière patients identified strongly with Lateau.
5. "Dégénérescence et déviation maladive du type normal de l'humanité...." B. A. Morel, *Traité des Dégénérescences: Physiques, intellectuelles et morales de l'espèce humaine et des causes qui produisent ces variétés maladives* (Librairie de l'Académie impériale de médecine, 1857), 5.
6. Morel, *Traité des Dégénérescences,* 17.
7. Morel, *Traité des Dégénérescences,* 50.
8. Fae Brauer, "Le duo dangereux: 'L'homme normal' et le corps dégénéré au temps de eugénisme," in *Représentations du corps: normes et normalité; le biologique et le vécu* (Presses Universitaires de Nancy, 2006), 76–80.
9. Allan Sekula, "The Body and the Archive," *October,* 39 (1986): 56.

10. From 1901, *Biometrika* was published by Karl Pearson and W.F.R. Weldon in consultation with Francis Galton until his death in 1911, while *Treasury of Human Inheritance* was published from 1909 until 1958.

11. By 1911, the Eugenics Record Office held a collection of around 7,000 skulls.

12. Pearson remained inaugural director of the Eugenics Record office until 1933, on condition that it adopted research projects and methods comparable to his Biometrics Laboratory.

13. Karl Pearson, *National Life from the Standpoint of Science* (London, 1901), 20; reprint 1919, 302: "If you bring the white man into contact with the black, you get superior and inferior races living on the same soil, and the co-existence is demoralizing for both. They naturally sink into the position of master and servant... if not of slave-owner and slave."

14. Karl Pearson, "Darwinism, Medical Progress and Eugenics," *Cavendish Lecture* (Allard & Son, 1912), 1–29.

15. Pearson, "Darwinism, Medical Progress and Eugenics," 16, 26.

16. Pearson, "Darwinism, Medical Progress and Eugenics," 23.

17. Bruno Latour, "Visualization and Cognition: Thinking with Eyes and Hands," *Knowledge and Society: Studies in the Sociology of Culture Past and Present* 6, (1986): 1–40.

18. Fae Brauer, "Les doubles dangereux: La photographie du corps dégénéré et du corps régénéré," in *Image et Imagination,* ed. Martha Langford (Queen's-McGill Press, 2005), 91–102.

19. Pearson, "Darwinism, Medical Progress and Eugenics," 16; refer figure 2, Fay Brauer, "Eradicating Difference: The Bioethics of Imaging 'Degeneracy' and Exhibiting Eugenics," *Australian and New Zealand Journal of Art* 1 (2004): 139–66.

20. Pearson, "Darwinism, Medical Progress and Eugenics," 16.

21. Pearson, "Darwinism, Medical Progress and Eugenics," 28.

22. Pearson, "Darwinism, Medical Progress and Eugenics."

23. Gilman, "The Image of the Hysteric," in *Hysteria beyond Freud,* ed. Roy Porter (University of California Press, 1993), 282.

24. Gilman, "The Image of the Hysteric." Gilman points out that Charcot's clinic was organized primarily around the visual, the photographic, the theatrical, and the spectacular.

25. Charles Féré, "Note sur un case de l'épileptique apathique," *La Nouvelle Iconographie de la Salpêtrière* 10 (1889), 339.

26. These hysterogenic zones were, Charcot explained, "circumscribed regions of the body on which pressure or simple rubbing rapidly produces the phenomenon of the aura and which, if you persist, may be followed by the hysterical attack."

27. Michel Foucault, *The History of Sexuality,* vol. 1, *An Introduction,* trans. Robert Hurley (Penguin Books, 1984), 56.

28. Jean Martin Charcot, *Leçons du mardi,* vol. 1, lesson 4 (1887–1888), 63.

29. Charcot, *Leçons du mardi:* "grande crise hystérique."

30. Jean Martin Charcot, *Leçons sur l'hystérie virile* (S.F.I.E.D., 1984).

31. Jean Martin Charcot, "A propos de six cas d'hystérie chez l'homme (1)," *Leçons du mardi,* vol. 2, lesson 18, 276–78.

32. Charcot, "A propos de six cas d'hystérie."

33. Most of the girls and women Charcot treated for hysteria were victims of poverty, sexual exploitation, and ignorance, as illuminated by Augustine. Raped at thirteen by her mother's lover, who had threatened to slash her with a razor, she experienced seizures thereafter and hallucinations of her rapist chasing her with a knife or of being hounded and bitten by wild dogs.

34. Elaine Showalter, "Hysteria, Feminism, and Gender," in Porter, *Hysteria beyond Freud:*

"The hysterical seizure, grande hystérie, was regarded as an acting out of female sexual experience."

35. Among many potent examples illustrated in Lisa Tickner, *The Spectacle of Women: Imagery of the Suffrage Campaign, 1907–1914* (University of Chicago Press, 1988), the one that most clearly embraces childbirth and orgasm is "The Suffragette Face: New Type Evolved by Militancy": "Derby Day," *The Daily Mirror,* May 25, 1914, 5.

36. Roy Porter, "The Body and the Mind, The Doctor and the Patient: Negotiating Hysteria," in Porter, *Hysteria Beyond Freud,* 248.

37. Tickner, *The Spectacle of Women.*

38. This term was coined by antifeminist writer Eliza Lynn Linton, who wrote in 1883 that "one of our quarrels with the Advanced Women of our generation is the hysterical parade they make about their wants and their intentions.... For every hysterical advocate 'the cause' loses a rational adherent and gains a disgusted opponent"; see Linton, *The Girl of the Period and Other Essays* (Macmillan, 1883).

39. Tickner, *The Spectacle of Women,* 194.

40. Juliet Mitchell, *Women: The Longest Revolution* (Virago, 1984), 117.

41. Cesare Lombroso, *L'uomo delinquente,* 1876; as translated by Havelock Ellis, *The Criminal* (Walter Scott, Limited, 1895), 105.

42. Marbo DeMello, *Bodies of Inscription: A Cultural History of the Modern Tattoo Community* (Duke University Press, 2000), 44–70. Although the Celts were known to tattoo their bodies before the Roman invasion of Britain, and pilgrims tattooed images of their faith on their bodies, tattoos did not become a culture in the West until colonization of the Pacific. After discovering Tahiti, Cook was the first Westerner to use their term, *tatau.*

43. Charles Darwin, *The Descent of Man and Selection in Relation to Sex* (John Amherst, 1998 [Murray, 1871]), 557.

44. Cesare Lombroso, *Criminal Man,* trans. Mary Gibson and Nicole Hahn Rafter (Duke University Press, 2006), 58.

45. Lombroso, *Criminal Man,* 60.

46. Lombroso, *Criminal Man,* 169.

47. Adolf Loos, *Ornament and Crime: Selected Essays* (Ariadne Press, 1998), 167.

48. Loos, *Ornament and Crime,* 168.

49. Loos, *Ornament and Crime,* 170.

50. Loos, *Ornament and Crime,* 80.

51. Margot Mifflin, *Bodies of Subversion* (Juno Books, 1997).

PART FOUR

ACQUISITION, DISPLAY, AND DESIRE

INTRODUCTION

Jane Kromm

This section traces the development in the modern era of those practices in which visuality was elevated, from a primarily practical basis on which transactions might be conducted, to much more complex modes of visual negotiation. This development was assisted considerably by spatial and architectural changes, as small shops with limited footage and hence a relative disinterest in the visual display of goods were replaced by arcades and eventually department stores that could lavish ambient space and light on a multitude of objects. Elaborate installations of this sort mobilized viewing processes among customers and attached acquisitiveness to the visual enticements of the many commodities on offer. The harnessing of display to acquisition proved to be highly adaptable to other circumstances. Similar processes underlie both the large-scale expositions that were temporary exercises, demonstrating the appeal and brilliance of the world's or a nation's goods, and the museum exhibitions that nurtured imaginary fantasies of ownership and possession, offering an elevated status for onlookers. As the display of marketable objects and high-status masterpieces became increasingly similar and even interchangeable, the notion of "researched design" became the basis for a kind of store that marketed a serious alternative to visual contradiction and confusion and highlighted the seductiveness of the minimal over the lavish and elaborate.

TO THE ARCADE: THE WORLD OF THE SHOP AND THE STORE (1800–1890)

Making objects and services more visually alluring was central to the evolution of the arcade and the department store, those communal areas for shopping in which spatial, commercial, and social elements were brought into newly complicit combinations and relationships. The exploitation of ambient space and light created large halls capable of accommodating crowds and of maximizing the airy, outdoor sensations of what was really still an indoor experience and a highly controlled environment. Transparencies of glass and mirrors, along with novel arrangements for access and circulation, all promised a degree of freedom and empowerment that was totally illusory. They were also beside the point, since such establishments concentrated all their clever acts of presentation on heightening the consumerist leanings of their clientele. Under these auspices, "just looking" did not measure up to the *flâneur* experience, and stores exploited this discrepancy by making their precincts into a kind of urban safety zone for bourgeois women, even as opportunities for class intrigue and social mobility proliferated there. An elaborate alternative hierarchy of management and floor staff was well situated to offer "service" in all its potentially mixed meanings and was able to take advantage of customers enthralled by these visually compelling sites of competitive consumption.

In "To the Arcade: The World of the Shop and the Store," Jane Kromm examines the brief flowering of the Parisian arcade before it was overtaken by the grand department stores and expansive boulevards of the second half of the nineteenth century. Arcades drew crowds of promenaders, pickpockets, prostitutes, book buyers, and shoppers at various times of day as they came to examine each other, all the while ogling the goods on display. These were to be seen in increasingly seductive arrangements that tantalized the eyes and enticingly attenuated the browsing experience.

EPHEMERAL EXHIBITIONS, EXPOSITIONS, FAIRS (1850–1960)

A kind of gigantism of the display ethos characterized the international expositions and national fairs that flourished in the wake of the department store's innovations, from the Great Exhibition of 1851 in London and the World's Columbian Exposition of 1893 in Chicago, to the Exposition Internationale des Arts Décoratifs et Industriels Modernes of 1925 in Paris. Instructing through visual revelation and sometimes even more fantastic optical effects, these large, temporary exhibitions combined national identity and commerce with a carnival atmosphere of novelty and transgressiveness. Sited in one or more huge temporary structures that were purpose-designed and themselves often spectacles in their own right, these exhibitions included individual displays ranging from patented inventions to natural wonders and fine art. This mixture of values and objects looked back to the early modern *wunderkammer* while mimicking the shopping spaces of the modern emporia. Visitors might find valuable gems alongside objects in papier mâché, taxidermy with statuary, and mechanical equipment close by exotic textiles. By confounding normative visual expectations and the sight-based premises upon which traditional values were typically set, these ephemeral exhibitions offered large-scale opportunities for the dramatic transvaluation of objects, for the promotion of novelty, and for the exploitation of transitory and opportunistic display strategies. A small number of biennial exhibitions survives today, notably the Whitney Biennial in New York and the Venice Biennale, which still offer this special combination of occasional occurrence and uncommon hype.

Amy Ogata's chapter, "'To See Is to Know': Visual Knowledge at the International Expositions," examines the modern mercantile model of the world's fair from its beginnings in the 1850s through the twentieth century. These international fairs exploited the premise that information and knowledge were grounded in visual experience by providing attractive exhibition spaces filled with sample goods, materials, and machines, and supplementing these displays with illustrated maps, guidebooks, and catalogs. Large structures, often temporary and glass-covered, contained an orderly arrangement of objects in the manner of a nineteenth-century covered arcade. Subsequent fairs by the 1870s enhanced this connection to the world of shopping by imitating the appearance and practices of department stores. From the Great Exhibition of 1851 in London with its glass and iron Crystal Palace to the Exposition Universelle of 1889 in Paris with its Eiffel Tower, fairs introduced large, often experimental structures that were visually alluring as well as being marvels of modern engineering and construction. As the international fairs evolved, they relied on a footprint based increasingly on models for an ideal city. In the twentieth century, multiple pavilions in a carefully conceived layout became the rule, offering the experience of a city within a city that satisfied viewers' desires for visual excitement and information while surreptitiously reinforcing nationalist goals.

CHANGING MUSEUM SPACES: FROM THE PRADO TO THE GUGGENHEIM, BILBAO (1800–2000)

The earliest museums were rarely independent spaces in their own right, but places enfolded within the larger boundaries of a palace or stately home. They were open only occasionally for visits from suitable guests, and these typically were genteel middle-class tourists respectably curious about the taste and inherited valuables of the nobility. Class distinctions, along with a tradition of noblesse oblige, were thus embedded in the accessing of museum-like spaces, and these characteristics persisted long after more independent cultural sitings of these institutions were attained. In fact many purpose-built museums proceeded along palatial lines, recapitulating the mythos of noble ownership, controlled access, and lower-order visitors, and often adding to this mix the political agenda of city or state government aspirations. As museum design itself became more of an object of exploration in its own right, the palatial paradigm was moderated into something more like a shed or terminal with envelope walls. This model was then itself surpassed by more sculptural, irregularly shaped structures. While still relying on what might be called an "acquisitional imaginary"—instilling in visitors a sense of vicarious ownership and its privileges—some of the more unusual museum designs attempt the uncommon pairing of an exhibitionistic exterior with an exhibition-sensitive interior. These critical issues are brought into focus when the stately spaces of the Prado in Madrid are compared with the pioneering brashness of the American-backed Guggenheim in Bilbao.

Susan Bakewell's chapter, "Changing Museum Spaces: From the Prado to the Guggenheim Bilbao," examines the museum's evolution from an enlightenment-era, palatial container exemplified by the Prado in Madrid to a contemporary, extroverted, and exterior-focused model represented by Frank Gehry's Guggenheim Bilbao. The venerable Prado, now doubled in size and incorporating architectural elements from the seventeenth through the twentieth centuries, maintains a traditional emphasis on displaying its originally royal but now national collections in rational, fairly reticent interior spaces. The Guggenheim Bilbao, by contrast, has a more complex and ironic relationship to its host location, even as its site and idiosyncratic presence define the essential contours of its appeal. Formulated around the concept of the "museum-as-spectacle," the Guggenheim remains a major tourist attraction, while the ambiance of its interior spaces and their suitability as exhibition settings continue to be debated. Both institutions are recognizable outgrowths from a common core that valued making collections of all kinds of objects and art works more visible to a wider public for a greater good.

DESIGN FOR A DISPLAY CULTURE: DESIGN RESEARCH TO IKEA (1930–2000)

There are compelling arguments suggesting that, from Renaissance Florence to prewar Berlin and contemporary Europe, there developed what has been called a display culture—a culture in which fashion and domestic designs were self-consciously adopted to demonstrate and then maintain personal and social status through visual means. While originally the standards for such displays were established through individual acts of taste and discernment, by the modern era, designing for a display culture became a commercial goal in its own right. Palatial in-store installations were discarded in favor of more domestic-looking arrangements, as store space became more like household space in a bid to market a philosophy and total view of life as a kind of *gesamtkunstwerk* or total work of art for the home. Eschewing the carnival atmosphere of the great expositions and fairs, these efforts achieved a

status of high seriousness through the adaptation of methods grounded in study and experimentation, establishing a new type of approach known by such rubrics as "design research," and pioneered in the store by that name in Cambridge, Massachusetts. From the high modernism of the Bauhaus, to more contemporary purveyors like the Scandinavian companies of Marimekko and IKEA, these researches produced a clear, clean, uncluttered look that boldly advanced increasingly refined design standards that appealed to consumers across Europe and North America. These standards were redolent of freedom and independence and gave a nearly illusory degree of self-reliance to the achievement of both self- and home-improvement.

Michael Golec's chapter, "Design for a Display Culture: Domestic Engineering to Design Research," investigates the household engineering movement that originated in the United States at the beginning of the twentieth century and subsequently influenced residential interior design and retail display all over America and Europe. Such scientific studies fostered designs that were drawn from studies of efficiency and movement patterns in household activities. These designs entered the retail sector in the form of model rooms with their furnishings organized for domestic use. Comparative displays could be found at fairs, where an example of Victorian clutter would be set beside a model room of modern simplicity and efficiency. In the 1920s, department stores followed suit, with model rooms set up in gallery-like spaces in Macy's and Wanamaker's in New York City, encouraging shoppers to imagine how such displays might be integrated into their own residences. By the 1920s, European designers were beginning to incorporate the domestic engineering outlook, and avant-garde exhibitions like those organized by the Bauhaus showcased designs in the model room format. These spare geometric prototypes influenced domestic design on an international scale, and Scandinavian contributions that added more color and lighter furniture forms facilitated the wider adoption of these functional interior spaces. By the 1950s and 1960s, a store like Design Research would invoke the "studious" aura of the domestic engineering movement by its very name, with its premises completely structured along model-room lines as inducements to customers for whom such displays suggested new furnishings as well as lifestyle renovations.

TO THE ARCADE: THE WORLD OF THE SHOP AND THE STORE

Jane Kromm

One seemed to be transported into some kind of fairy country on entering them of an evening, so brilliantly illuminated were they by light reflected endlessly off window panes and mirrors.

—Philip G. Nord

Such was the experience of entering an arcade, a structure identified by many architectural and social historians as one of the essential forms of modernity.[1] Most were located in Paris, but once they became synonymous with luxury and urban innovation, they spread to other major cities in Europe, England, and the United States. Arcades flourished from 1820 to 1840, but the earliest examples date from 1791 and 1798, and some of the last were created around 1850. An arcade is a covered passage or walkway with a skylight or glass roof, and shops along with other businesses on both sides, the whole resembling a kind of ministreet in suspended isolation. The French word for an arcade is *passage,* a term that underscores its function as a conduit and as a site for movement and connection. It might be a shortcut to the next street, a place to wait out a storm, or a principal destination, a place to stroll, browse, and observe others even late into the evening once gaslight was introduced. Arcades proved irresistible for *flâneurs* as well as for other promenaders drawn to the crowds, the bright objects of merchandise enticingly displayed, and the dazzling effects of glass and light that enhanced the visual excitement of the location. A photograph of the Passage Montesquieu Cloître St. Honoré, by Eugène Atget, from 1906 (long after this arcade's heyday was well over) clearly shows the bare bones of its structure (fig. 13.1). Built in 1811, the Passage Montesquieu has dark wood interior walls modestly articulated in the classical idiom. The glass of the shop windows dominates the side elevations, and the whole is covered by a saddleback roof from which large glass lanterns are suspended. There is a carnival-like effect of reflections glancing off roof and window, complicating the views into the individual shops with a mix of objects for sale and ethereal replications of the sloping glass above.

HISTORY AND TYPOLOGY OF THE ARCADE

An arcade's basic template consists of a gateway entrance typically marked with the passage's name, and an interior that extends into a longitudinal space, ending with an exit gateway or a connection to another building. Architectural precursors of a generic sort for this template include the arcaded streets of classical and medieval cities and the exchanges

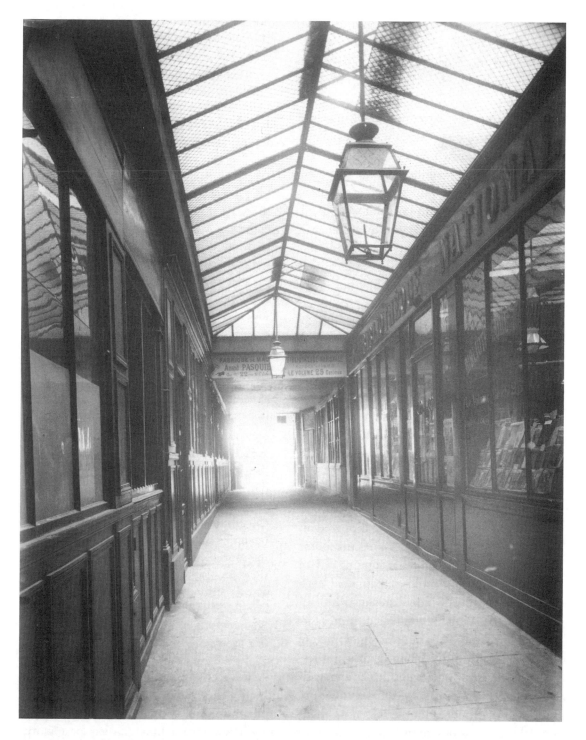

Fig. 13.1 Eugène Atget, *Passage Montesquieu Cloître St. Honoré, 1906.*

or bourses of the sixteenth and seventeenth centuries.[2] In both interior form and to some extent function, the arcade relates to the gallery, a long room or connecting passageway between buildings that provided a protected promenade space in palaces and upper-class residences from the sixteenth century onward. In nineteenth-century Paris, the arcade offered pedestrians a similar protection, creating opportunities for safe walking at a time when the city's streets were still close to medieval conditions, often flooded with rain and waste, and without sidewalks. Encouraged by a dramatic increase in a broader range of luxury goods, the arcade is associated with such commercial innovations as the fixed price, the high turnover, and the visible lure of merchandise on display. In its marketing functions, there is some resemblance between the arcade and the bazaar, although there appears to be no direct structural relation, since the bazaar is a marketplace with open stands or booths that is an integral part of a town's public street system. More like a grouping of shops, the arcade benefited from advances in the use of glass: glass panes were introduced into storefronts around the late seventeenth century, with pane size increasing steadily throughout the next century, and eventually reaching a standard that offered an expanse of uninterrupted glass.[3] At this point the shop window became a marketing device whose transparency could be exploited with artful displays and "window dressing."

While luxury trades dominated, from fashion and millinery to furniture and picture galleries, arcades also contained cafés and restaurants, theaters and cabarets, clubs and reading rooms, panoramas, wax museums, and brothels. All clamored for the passerby's attention through various means. Straightforward signage and posters were common, as were signs that mixed words with pictorial elements:

in the *Galerie Véro-Dodat,* there is a grocery store; above its door, one reads the inscription: "*Gastronomie Cosmopolite."* The individual characters of the sign are formed, in comic fashion, from snipes, pheasants, hares, antlers, lobsters, fish, birds, kidneys....[4]

Often objects functioned as signs, such as cascades of fabric or arrangements of opened umbrellas:

The shoemaker has painted different-colored shoes, ranged in rows like battalions, across the entire façade of his building. The locksmith's is a six-foot high gold-plated key; the giant gates of heaven could require no larger. On the hosier's shop are painted white stockings four yards high, and they will startle you in the dark when they loom like ghosts....[5]

All kinds of display boxes, cases, and cabinets completed the effect, whose full impact the ingenious proprietors expected to be enthralling:

there is hardly a building without a shop. It only takes a minute, only a step, for the force of attraction to gather; a minute later, a shop further on, and the passerby is standing before a different shop....One's attention is spirited away as though by violence, and one has no choice but to stand there and remain looking up until it returns. The name of the shopkeeper, the name of his merchandise, inscribed a dozen times on placards that hang on the doors and above the windows, beckon from all sides; the exterior of the archway resembles the exercise book of a schoolboy who writes the few words of a paradigm over and over.[6]

A number of these arcades remain today, although they are all now altered, with different businesses and contemporary signage. Only a few give a hint of their past glory, which is now obtained primarily through depictions, photographs, and from the many

literary descriptions found in nineteenth-century travelogues and guidebooks, as well as in the writings of Honoré de Balzac, Emile Zola, and others. The earliest true arcade of the modern period was the Passage Feydeau (1791), which was soon followed by the Passage du Caire (1799), the Passage des Panoramas (1800), the Galerie Vivienne and Passage Choiseul (1825), and the Galerie Véro-Dodat (1826), to give just a sample. A critical model for these *passages* was the Palais Royal, which received its own arcade, the Galerie de Bois, in 1781–1786.

THE GALERIE DE BOIS

Sited close by the Louvre, the Palais Royal was built in 1624–1629 as the residence of Cardinal Richelieu. He bequeathed it to the royal family, and it eventually became the property of the king's brother, the Duc d'Orléans. To supplement his income, the Duc expanded the public space of and access to his property through the creation of gardens, galleries, shops, apartments, and brothels.[7] In 1781, the Duc commissioned the architect Victor Louis to add a new structure, which was completed a few years later (1786). The wooden building held rows of shops, its supports and beams holding up a roof of canvas; here were

> two parallel lanes covered by canvas and planks, with a few glass panes to let the daylight in. Here we walked quite simply on the packed earth which downpours sometimes transformed into mud. Yet people came from all over to crowd into his space, which was nothing short of magnificent, and stroll between the rows of shops that would seem like mere booths compared to those who have come after them.[8]

There were reading rooms and bookstores, shops offering jewelry and perfume, furniture and pottery, and apartments for five grades of prostitutes, with a descriptive catalog available to aid in the selection process. Besides the shops and the promenade, the Galerie de Bois was also a politicized space associated with speechmaking, agitation, and transgressive publications, which attracted an edgy, socially diverse crowd.

In *Lost Illusions* (1837), Balzac offered an extended account of this arcade, and much of it is critical, for he viewed it as a "squalid bazaar" consisting of "small, wooden huts, far from weather-proof and badly lit through small apertures overlooking the court and the garden" with the whole pervaded by a "foul atmosphere."[9] Positioned opposite the stock exchange, the site necessarily attracted men of banking, business, or political clout, and the majority of the shops catered to them and to their interests: "Booksellers dealing in poetry, politics, and prose, and the clothing trade, enjoyed a monopoly of the place, except for the prostitutes, who arrived only towards evening."[10] There were often so many of the latter that "in the evenings, such large crowds [were drawn] to the Wooden Galleries that one had to walk in step, as if in a procession or at a masked ball. This slow motion nobody minded, for it gave time for examination."[11] Even the milliners' salesgirls were part of this scrutinizing process, "with bold looks and free comments on the passersby."[12] For Balzac, the sum effect was piquant and ambiguous:

> It was horrible and gay. The dazzling skin of necks and shoulders glistened among the darker vesture of the men, producing magnificent contrasts.[13]

The Galerie de Bois lasted until 1828, when it was replaced by a more permanent and stately structure, the Galerie d'Orléans, the first arcade to have a glass-vaulted roof. Along with

the Galerie de Bois's demolition came a concomitant moderation of its more boisterous and provocative attractions.

THE PASSAGE DES PANORAMAS

But much of the gaiety, commerce, and sexual allure could be found at other arcade locations. More architecturally imposing than the Galerie de Bois and offering a mixture of luxury items and entertainments was the Passage des Panoramas (1800). With a wooden saddle roof interrupted by cut-out skylights, this passage introduced visual effects enhanced by glass and light, and here the first experiments with artificial illumination were concentrated.[14] The passage took its name from the two cylindrical-shaped panorama buildings that flanked its entrance, one of which was built in 1799 along the Boulevard Montmartre.[15] Here viewers were absorbed by the continuous murals, usually of battlefields and cityscapes, and these were enhanced by a host of trompe l'oeil effects. Equally absorptive and dazzling was the range of shops, which included stationery, pastry, confectionery, haberdashery, millinery, bootmakers, hosiers, a reading room, and a bookstore. The resident theater, the Théâtre des Variétés, offered further delights, and in 1827 this included a one-act play in which disagreements between an umbrella-maker, a hatter, and a clogmaker among others ends in reconciliation followed by dramatic illumination effects and a ballet of streets and arcades.[16]

Contemporary descriptions of the shops and their stock are detailed and discerning. They are hearty endorsements of the rewards of browsing: in the stationery shop

> one finds everything; not only any kind of paper, pens, lamp shades, but also porcelain,

fine woodwork, bronze figures, articles for oil painting and watercolors, small frames for miniatures and even sketches or paintings which in some cases can even be rented.[17]

Caricatures by the sculptor Dantan were also available at this shop. A virtual tour of the arcade was undertaken by Louis Montigny in *Le provincial à Paris* (2d ed. 1825), and he lingered over certain establishments, savoring the tastes and charms on offer. At the Duchesse de Courlande confectionery store, Montigny was impressed:

> Astonished, one looks under the glass bells and sees red currants, peaches, cherries, grapes. Sugar takes all forms here. It is Protean. Even prettier are all the truly natural colors. I should say to the customers who would make all of their "sweet" purchases here that the salesladies are especially attractive, and it is the custom to tell them so.[18]

Montigny was equally smitten with the milliners' hats and clerks, encouraging customers to "glance at Mme Laposton's charming straw hats and a longer glance at the equally charming persons who sell them." Within the arcade but outside the shops themselves, the experience was visually rich and visually cacophonous. Zola's account of this arcade in *Nana* (1880) emphasizes the nearly chaotic impact experienced within:

> Under the glass panes, white with reflected light, the passage was brilliantly illuminated. A stream of light emanated from white globes, red lanterns, blue transparencies, lines of gas-jets, and gigantic watches and fans outlined in flame, all burning in the open; and the motley window displays, the gold ornaments of the jewelers, the crystal jars of the confectioners, the light-coloured silks of the milliners, glittered in the glare of the reflectors behind the clear plate-glass

windows; while among the brightly coloured array of shop signs a huge crimson glove in the distance looked like a bleeding hand which had been severed from an arm and fastened to a yellow cuff.[19]

A certain anxiety has entered into the arcade experience in Zola's description, which singles out the potential danger of the artificial lighting when it is pushed to marketing extremes within a confined space, and he is especially disconcerted by the repetition of disembodied elements and their unsettling effect.

An 1807 gouache by Philibert Louis Debucourt of the Passage des Panoramas offers an early glimpse into the kinds of looking exploited there, including a lively and confusing visual field that can reinforce the spirit of public commerce on several levels (fig. 13.2).[20] In this image, the architectural structure of the arcade is clearly delineated, with the sloping roof interrupted by skylights in a repeated pattern, and with small-paned windows separated by pilasters. A hanging lantern is suspended from the ceiling, and there are gas jets interspersed along the walls. The view begins at the arcade's juncture with the Théâtre des Variétés, and ends with an iron bridge connecting the two panoramas. There is a sequence of receding signs announcing various proprietors and their wares by name, sometimes accompanied with an illustrative depiction, and sometimes with the goods themselves—drapes, umbrellas, animal carcasses, and pyramids of fruit. In the distinctive clothing of the Directoire period, salesclerks, customers and strollers commingle, and Debucourt discreetly, perhaps a bit secretively, suggests the practice of inquiring or surreptitious looks by the strollers at the goods, and among the strolling couples themselves in the image's foreground.

THE DECLINE OF THE ARCADE

Some arcades continued successfully for most of the century, surviving the social and commercial pressures introduced by the new boulevards and the rise of the department store. Others deteriorated as they ceased to be competitive once shoppers and strollers had moved on to other venues. Arcades in neighborhoods that went into decline were similarly affected, while those in areas that continued to thrive had the best survival rates. Complaints that the narrow passages and some of their less savory clientele created a public health concern, with conditions heightened by the fetid air and crowds in confined spaces, become commonplace from the 1860s onward. A sense of sickliness begins to pervade the descriptions of some arcades. In *Thérèse Raquin* (1867), Zola's account of the Passage du Pont Neuf is a good example of this type:

> [in summer] a whitish light does fall through the dingy glass roofing and hang dismally about this arcade, but on nasty winter ones, on foggy mornings, the panes send down nothing but gloom on to the greasy pavement below, and dirty, evil gloom at that.

Zola describes the interactive effects of light, glass, and merchandise as somewhat less than dazzling:

> the small window-panes cast strange greenish mottlings on the goods for sale. The murky shops behind are just like so many black holes in which weird shapes move and have their being.[21]

Louis-Ferdinand Céline, who grew up in the Passage Choiseul where his family had a shop, describes the premises in less than enticing fairyland terms: "we always had two showcases, but only one of them was lit up because there was nothing in the other."[22]

Fig. 13.2 Philibert Louis Debucourt, *Le Passage des Panoramas à Paris*, 1907.

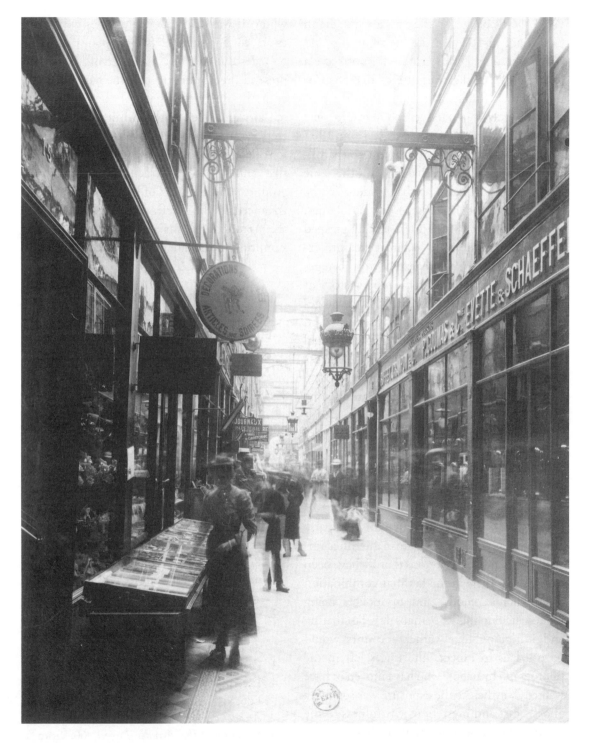

Fig. 13.3 Eugène Atget, *Passage du Grand Cerf,* 1907.

An example of the kind of arcade that survived these changes is the Passage du Grand Cerf, built in 1824 on the site of an inn and coach terminus.[23] This arcade did not serve a luxury goods market, but catered to craftspeople and their studios, with a focus on the production and sale of handcrafted items. Eugène Atget's photograph of the arcade from 1907 (fig. 13.3) suggests that shopping and strolling continued here, but hardly with the same gaiety and enthusiasm as that evident in the earlier images of the Passage des Panoramas. The Grand Cerf's structure is readily grasped in Atget's image, with its great height, expanses of glass, and repeated iron bridges connecting both sides of the upper story at regular intervals. This architectural arrangement, which some scholars have likened to Piranesi's *Carceri* for its potential for spatial intrigue, is thought to be what drew the director Louis Malle to film a scene here for *Zazi dans le Métro* (1960).[24] Within the arcade, one can see the elaborate pendant lanterns, a multiplicity of signs, and to the left a range of very sedate glass display cases that has replaced the teeming arrangements of goods that jockeyed for attention in the Passage des Panoramas.

Atget's photograph shows both customers and strollers, but it is a comparatively sparse crowd when considered against the other images and literary descriptions that we have been canvassing. There is the familiar combination of looking at goods, and of lookers being looked at, but this is perhaps less fascinating and intriguing than earlier accounts would have led us to expect. The traces left in the photograph by people who have moved or have walked away before the exposure was set give a ghostly cast and mysterious wistfulness to the arcade. The most prominent of these ghostly figures, the man at right with his hands in his pockets and his gaze fixed in the direction of

the shoppers, brings to mind the *flâneur*, of whom it was said that the arcades were necessary for his survival (see chapter 10). Here he fades out to a vestigial trace of his former presence, reminding us that the flâneur, along with the delimited space of the arcade and its fairyland-like, world-in-miniature parameters, eventually gave way to the preference for the open visibility of more spatially expansive venues. The department stores, exhibition grounds, and network of broad boulevards all advanced to the forefront of sites devoted to the more active forms of visual access and consumption in the late nineteenth century.

NOTES

Philip G. Nord, *Paris Shopkeepers and the Politics of Resentment* (Princeton University Press, 1986), 90.

1. Walter Benjamin, *The Arcades Project*, trans. Howard Eiland and Kevin McLaughlin (Belknap Press of Harvard University Press, 1999); Johann Friedrich Geist, *Arcades: The History of a Building Type*, trans. Jane O. Newman and John H. Smith (MIT Press, 1983; first edition 1979); Bertrand Lemoine, *Les passages couverts en France* (Alençonnaise, 1989); Margaret MacKeith, *The History of Shopping Arcades* (Mansell, 1986); Nikolaus Pevsner, *A History of Building Types* (Thames & Hudson, 1976); Robert Proctor, "A Cubist History: The Department Store in Late Nineteenth-Century Paris," *Transactions of the RHS* 13 (2003): 227–35.

2. Geist, *Arcades*, 4, 5, 10; Pevsner, *A History of Building Types*, 261–62; MacKeith, *The History of Shopping Arcades*, 1.

3. Pevsner, *A History of Building Types*, 258.

4. Excerpted from a travel account of 1839 by Eduard Kroloff and cited in Benjamin, *The Arcades Project*, 32.

5. Benjamin, *The Arcades Project*, 60, from a travel account by Ludwig Börne of a visit to Paris in 1822 and 1823.

6. Benjamin, *The Arcades Project,* 60.

7. Geist, *Arcades,* 64, 448–58; Pevsner, *A History of Building Types,* 263.

8. Benjamin, *The Arcades Project,* 39, citing Théodore Muret.

9. Honoré de Balzac, *Lost Illusions,* trans. Kathleen Raine (Modern Library, 1967), 272.

10. Balzac, *Lost Illusions,* 274.

11. Balzac, *Lost Illusions,* 277.

12. Balzac, *Lost Illusions,* 276.

13. Balzac, *Lost Illusions,* 278.

14. Pevsner, *A History of Building Types,* 263; Geist, *Arcades,* 68; 464–67.

15. Geist, *Arcades,* 466; Nord, *Paris Shopkeepers,* 123. The panorama was the invention of Robert Barker in 1787. Robert Fulton obtained the patent to introduce the panorama into France, but he sold this to the proprietor of these panoramas.

16. Benjamin, *The Arcades Project,* 56.

17. Cited in Geist, *Arcades,* 471.

18. Cited in Geist, *Arcades,* 471.

19. Emile Zola, *Nana,* trans. George Holden (Penguin, 1988), 209.

20. Musée de la Ville de Paris; Musée Carnavalet, Paris.

21. Quoted in Geist, *Arcades,* 486.

22. Quoted in Nord, *Paris Shopkeepers,* 185.

23. Lemoine, *Les passages couverts en France,* 114, 116; Geist, *Arcades,* 486, 489.

24. Lemoine, *Les passages couverts en France,* 116; Geist, *Arcades,* 489.

"TO SEE IS TO KNOW": VISUAL KNOWLEDGE AT THE INTERNATIONAL EXPOSITIONS

Amy F. Ogata

The world's fair is a unique aspect of the age of modern industrial capitalism. As fabricated environments staged to sell impressions and manipulate desire, world's fairs encompassed grand schemes of urban planning, and thousands of individual buildings, in addition to extensive displays of objects, commodities, and even people. Years of advance planning and vast sums of money were invested in these extravaganzas, which usually lasted only six months. These ephemeral public spectacles attracted millions of visitors who traveled long distances to attend in order to see for themselves.[1]

World's fairs were invented to catch the eye and keep it occupied. As the crowds made their way to the fairgrounds, entered the exhibition buildings that contained endless displays of manufactured goods and working machines, wandered through carefully staged vignettes of exotic cultures, perhaps mounted special viewing platforms, and eventually consulted a commemorative book or souvenir, their visual sense was the primary source of information. Tony Bennett has identified the world's fair as a key embodiment of the "exhibitionary complex," a series of institutions and techniques that ordered visual knowledge, thereby also "ordering the public that inspected."[2] The visual sense was so fundamental to the inculcation of knowledge that in 1889, G. Brown Goode, a

scientist and assistant secretary of the Smithsonian Institution who was an instrumental figure in planning several American fairs, observed that "to see is to know."[3] By positing the empirical specimen as self-evident truth, the international exhibitions offered viewers a coherent visual system that reinforced the power structure of the bourgeois state. Just as knowledge was codified and classified to impose order on the chaotic assemblage of goods and materials, the spatial character of exhibition buildings reinforced social dynamics, and national self-representation was given a solidly physical form that was offered up to the observer as transparent fact.

Although national fairs were held in France in the earliest years of the nineteenth century, and a spate of popular mechanics' institutes in Britain in the 1830s were similar spectacles, the world's fair—a particular genre of public entertainment that encompassed international participation—began in the mid-nineteenth century. It was amidst the context of rapid industrialization, enhanced competition, popular uprising, and growing international tensions that the first world's fair was devised. The Great Exhibition of the Works of Industry of All Nations, which was held in Hyde Park in Central London in 1851, was the brainchild of bureaucrats who envisioned an international exhibition as a means of stimulating the British

economy.[4] The benefits of competition, they suggested, could improve the qualities of manufactures and open up new markets under the then-controversial notion of international free trade. Largely organized by Henry Cole, a designer and civil servant, along with the patronage of Prince Albert, the Great Exhibition was planned, erected, and opened in two years.

The exhibition was housed in a temporary building designed and constructed for the fair. Joseph Paxton, a gardener and engineer, created a large structure of iron, wood, and a huge amount of glass (fig. 14.1). Conceived and built according to modern industrial methods, Paxton's building depended upon prefabricated parts that were manufactured and delivered to Hyde Park for rapid assembly on site.[5] The open, transparent qualities of the long rectangular structure, which was bisected by a barrel-vaulted transept, allowed for the preservation of several fully grown elm trees as well as a second floor with balconies from which visitors gazed down upon the spectacle of exhibits, special events, and other people attending the fair. The exposed girders and trusses of the roof were painted according to the designer Owen Jones's chromatic theory to give visual definition to the colorless walls. The ethereal qualities of the shimmering panes of glass enclosing a seemingly enchanted world inspired the British magazine *Punch* to call it a "Crystal Palace," a name that has become so thoroughly associated with this exhibition that its official title is often forgotten.

The Crystal Palace was packed with 100,000 objects from 14,000 different manufacturers and arranged according to a system of classification that comprised four broad categories and thirty individual classes. Parsing the processes of manufacture from beginning to end, the classification system implied values of industriousness and workmanship that could transform stone, metal, wood, or fiber into a finished product. Working machines and demonstrations drew large crowds that watched goods undergoing manufacture. Partially enclosed courts near the entrance held displays of important highly finished objects. A.W.N. Pugin's Medieval Court showed art manufactures, from ecclesiastical fittings to small objects for the home, in the Neo-Gothic style that he championed as the "true" and properly moralistic style that would redeem the materialism of the industrial age.

Viewing merchandise was the chief attraction of the early world's fairs, and many commented on the mesmerizing effect of seeing all those goods. Following Karl Marx, Walter Benjamin famously noted, "the world exhibitions glorify the exchange value of the commodity. They create a framework in which its

Fig. 14.1 North transept of the Crystal Palace, the Great Exhibition, London, 1851.

use value recedes into the background. They open a phantasmagoria which a person enters in order to be distracted."[6] In the enchanted space of the iron-and-glass building, often likened to a "fairyland," commodities themselves performed for viewers. A German taxidermist sent a series of stuffed frogs and cats arranged in scenes of human activities, such as dining, playing music, or shaving, in 1851. At several Paris exhibitions, the glass manufacturer Baccarat showed glass tables, glass hats, and even an elaborate glass *tempietto* in 1878. The alchemical transformation of base matter into visual delight was achieved through clever conceit, ambition, and workmanship, and the proximity to so many other things. Thomas Richards has argued that the Great Exhibition taught Victorian consumers their first lessons in understanding commodities as "a sensual feast for the eye of the spectator."[7]

The goods on display in the Crystal Palace had no prices on them (this changed with the second international fair in Paris in 1855), allowing the vast displays to resemble a princely tradition of rarified collections. The difference between the *Kunstkammer*, or museum, and the world's fair was public access to the things on view. For a few shillings, any paying visitor could take in the wonders of the world's fair. As visual entertainment, the Great Exhibition was tethered to a longer tradition of both elite and popular amusements.[8] The Crystal Palace resembled the early nineteenth-century arcades, covered streets lined with individual shops. By the 1870s, the resemblance between fairs and department stores was deliberate and mutually reinforcing.[9] In 1925, at the Exposition des arts décoratifs in Paris, shopping was the motif of the fair, and the Pont Alexandre III was transformed into a street of luxury boutiques.[10]

The Great Exhibition created the idea and format for nearly all of the fairs that succeeded

it. The erection of special temporary buildings and the participation of international manufacturers provided a template for later, much larger, and more ambitious exhibitions. The fairs held in the mid-nineteenth century retained the model of creating a single exhibition building. For the 1867 Exposition Universelle in Paris, officials erected a circular building of iron and glass to embody the image of the globe itself. This structure, designed by Commissioner Frédéric Le Play, gave form to the classification system, imposing spatial order on the things it contained. Divided into concentric circles and bisecting walkways, the plan allowed the visitor to explore an entire country's output, or select specific materials to peruse.

The French fairs of the nineteenth century were organized by the state (in contrast to the British and American fairs that depended on heavily private funding) and were held in central Paris on the Champs de Mars. In 1889, for the Exposition Universelle that commemorated the centennial of the French Revolution, Victor Contamin and Ferdinand Dutert designed a vast exhibition building that demonstrated the potential of industrial materials and announced France as a nation of technological knowledge.[11] The Galerie des Machines, built of iron girders and glass walls, created the largest open span yet achieved, and a suitable frame for the working machines that were put on view inside. Another monument of engineering erected for the fair in 1889 was an iron tower, 300 meters high, which was built as the gateway to the exhibition (fig. 14.2) Designed by Gustave Eiffel, the openwork tower of iron beams and trusses divided late nineteenth-century French intellectuals, who argued for and against its aesthetic merits. Charles Garnier, architect of the Paris Opéra, led a campaign to stop Eiffel's project, comparing it to

Fig. 14.2 Alphonse Liébert, view of Eiffel Tower and fair grounds from a balloon, Exposition Universelle, Paris, 1889.

"a gigantic black factory chimney."[12] The tower was not only a gateway, it was also a viewing station. Ascending in five elevators, spectators climbed to the top of the tower to gaze upon the exhibition and the city.

The concentration of attractions in the middle of the city meant that the city itself was on display. And the temporary exhibitions left behind traces on the urban fabric. Buildings such as the Eiffel Tower, Trocadéro (1878, remodeled for 1937), the Grand and Petit Palais (1900), the Pont Alexandre III (1900), and the Musée des Colonies in the Bois de Vincennes (1931), as well as the Métropolitain stations by Hector Guimard (1900) were permanent contributions to the city of Paris.[13] In other

fairs, utopian cities in miniature were imposed onto existing areas, transforming parklands or industrial areas into temporary wonderlands. The competition to outdo the previous fair encouraged increasingly bigger and more ambitious grounds and attractions. The model of the Crystal Palace, in which the exhibits were housed in a single structure, persisted until the end of the nineteenth century. In 1876, for the Centennial Exhibition in Philadelphia, Pennsylvania, Hermann Schwartzmann pioneered the use of individual pavilions. Sited in Fairmount Park, a pleasure park on the edge of the Schuylkill River, the Philadelphia Centennial included a large main building, horticultural hall, art gallery, and seventeen

state pavilions, as well as other structures. The campus-like scheme accommodated the large crowds, yet the symbolic placement of the Corliss Engine, the largest working steam engine at the center of Machinery Hall gave the exhibition a gravitational center for appreciating American industrial power.

The plan for the 1893 World's Columbian Exposition in Chicago was among the most ambitious of its time. The site and design of the grounds were the choices of Daniel Burnham and Elihu Root, with Frederick Law Olmstead. Set on 600 acres in Jackson Park, south of the Loop, the designers created a romantic landscape of watery courts, lagoons, and canals, enhanced with statuary and electrically illuminated fountains. The symmetrical, white, neoclassical beaux-arts buildings of the Chicago fair were the collaboration of the New York firms McKim, Mead, and White and Richard Morris Hunt, along with Chicago firms Adler and Sullivan and William L. Jenney. Housed in the symbolic visual codes of European aesthetics, the exhibition offered a pristine "white city" in deliberate contrast with the gritty image of industrial Chicago. Louis Sullivan, whose transportation building departed from the beaux-arts designs of the fair, criticized the scheme, and his objections fueled a modernist disdain for the plaster-covered historicist fair buildings that lasted through most of the twentieth century.[14]

The vision of an orderly city within a city was taken up with zeal in successive fairs and enhanced through special visual effects employing electricity and applied color. At one of the largest fairs, held in Buffalo, New York, in 1901, electricity was both the central theme and primary visual entertainment as crowds gathered to watch the illumination at dusk.[15] At the Louisiana Purchase Exhibition in St. Louis in 1904, a vast city park was transformed with beaux-arts planning, basins and fountains spraying colored light. The relationship between fair planning and color was heightened in the fairs of the 1930s. For the Century of Progress exhibition, opened in Chicago in 1933 during the depths of the Great Depression, a desire to keep down costs and embrace Modernist aesthetics contributed to the planar forms of the fair buildings and a complex color scheme developed by Austrian designer Josef Urban, adapting techniques from theatrical set design. Similarly, the New York World's Fair of 1939, under the direction of Robert Moses and fair director Grover Whalen, turned a former ash dump in Queens into a magical realm of prismatic geometrical shapes that were color-coded from the center of the fair outward. Pale tones were used as an organizing device to orient visitors to the fair's center and signature motif, the Trylon and Perisphere, an attenuated pyramidal form next to a gigantic sphere.

From Democracity, a model town exhibited within the Perisphere, to the utopian image of a city of automobiles in GM's Futurama, viewing cities was a key attraction in 1939. The urban ambitions of Robert Moses extended well beyond temporary fairs, and he used the exhibitions to make major urban changes. Moreover, he made the tradition of city-as-spectacle into its own attraction.[16] The nineteenth-century exhibitions with their balloon rides (1867), hydraulic lifts (1889), the Eiffel Tower (1889), the Ferris Wheel (1893), or the Atomium of the Brussels Worlds Fair (1958) gave visitors a view of the exhibition and the host city that was impossible from the ground. For the New York World's Fair of 1964–1965, Moses commissioned a massive model, called the "Panorama." An accurately scaled replica of the entire five-borough city of New York, the Panorama showed fair viewers

who walked around and over on glass balconies, or took the simulated "helicopter" ride that swooped down on the model, a sprawling vision of the city in miniature.

World fairs were competitive events in which manufacturers vied for medals and awards, and countries competed for prestige. Benedict Burton has compared the international exhibitions to ritual potlatches in which goods are offered and then destroyed, and reciprocation requires an even greater show of material wealth.[17] The tensions that accompanied the nineteenth-century world's fairs were disguised in the diplomatic language of international peace and free-market competition, but nationalist sentiment heightened the tenuousness of these claims.

Over the course of the nineteenth century, visual references increasingly denoted national identity. In 1878, at the Exposition Universelle in Paris, a mock Street of Nations was set up within the Palace of Industry. Each façade, designed to suggest specific national architectural traditions, functioned as a gateway to the exhibits of that country and therefore acted as a visual representation of the country. Spain, for example, exhibited itself in a splendid Moorish palace and Russia in a house from the time of Peter the Great. The use of facades gave way to iconic freestanding structures at the Paris Exposition Universelle in 1900. Lined up in two rows along the banks of the Seine, the buildings that comprised the Quai des Nations embodied the virulent nationalism and rising political tensions at the end of the nineteenth century.[18] The freestanding pavilions revealed how carefully each country used architecture to convey its image. The United States pavilion was modeled on the Roman Pantheon. The British pavilion was built of stone and took the form of a seventeenth-century manor house. The Belgian pavilion evoked the fifteenth-century Brussels

Town Hall. The second row included smaller nations, such as the Grand Duchy of Finland, which was then ruled by the Russian tsar. In its resistance to Russian control, the Finnish pavilion, designed by Eliel Saarinen, Herman Gesellius, and Armas Lindgren, bore pointed visual references to its political campaign for independence. Akseli Gallen-Kallela's interior fresco paintings, for example, portrayed scenes from the epic national myths. Russia, which had one of the largest displays at the fair, but not on the Quai des nations, promoted its folk crafts and rural architecture in a *teremok* made of hewn logs.[19] This image of the timeless peasant working according to tradition rather than new technology contrasted with the exhibition as a showcase for modern manufacture. Yet the presentation of the past reinforced the positivist narrative of progress that underscored every world's fair.

Retrospective exhibitions not only suggested that the material past was available to present-day artists and designers, but they also showed how patrimony might be used to build up national identity. The History of Work exhibition at the Paris Exposition Universelle in 1867 charted the history of manufactures from antiquity to the present, showing an international array of applied art from public and private collections, with emphasis on excellence in craftsmanship and taste.[20] In 1876 at the Philadelphia Centennial, national heritage was demonstrated in the Colonial Kitchen, a three-dimensional display showing material specimens from the prerevolutionary past, explained by costumed guides. Bruxelles-Kermesse recreated a historical Flemish fair for the International Exhibition of 1897, and in 1900 a simulated quarter of medieval Paris by Albert Robida was designed as a picturesque image fitted out with people dressed in "medieval" costume.[21]

Retrospective exhibitions were not just sentimental evocations of the past but were taken as literal and authentic. The History of Habitation, mounted in 1889 and designed by Charles Garnier along with Auguste Amman, purported to demonstrate visually the history of human existence. The exhibition comprised thirty-three life-sized dwellings arranged according to a schema of progress that divided history into three periods. The exhibit included reconstructions of well-researched examples of domestic architecture from Egypt and Persia, but it also covered civilizations, such as the Phoenicians, about which little was known, and for whom Garnier invented a highly romanticized dwelling. The historical promenade of the history of habitation provided a visual teleology that privileged European culture. During the fair, the Roman House, with its mythic associations of Roman Gaul, was put at the disposal of the president of the Third Republic.[22]

The representation of extraterritorial lands, people, and goods were continually displayed to polish the national image and to create social cohesion, especially in places where little actually existed. In 1851, Britain showed its wealth and power in the form of manufactures, machines, and raw goods, and its imperialist displays gave material form to their political ambitions. The extensive Indian selection included a special court near the entrance of the Crystal Palace with the glistening ivory throne of the Raja of Travancore set amid fine carpets, shawls, and the royal dress of the Raja of Bundi, as well as a stuffed elephant and *howdah*, the Kohl-i-noor diamond, and coal, oil, and spices. Scholars have suggested how these political gifts were displayed as trophies, emphasizing an image of exotic splendor and availability.[23] The Canadian exhibits featured timber, a bark canoe, piles of pelts and skins, and carved furniture. The implication of plentiful raw materials and abundant skilled labor made the colonial project appeal visually, and it was designed to create popular support and to obscure critique.

The spectacle of the colonial staged for the international exhibitions was constructed around perceptions of exoticism and material wealth. While the designers of the Great Exhibition put the emphasis on goods, in later international exhibitions and at colonial fairs, organizers created more extensive simulations.[24] At the Exposition Universelle in Paris in 1889, the colonial territories were grouped together along the Esplanade des Invalides, laid out for inspection by French citizens. Newly acquired Southeast Asian territories were displayed in lavish pavilions that evoked the architecture, decoration, and material culture of Cochin, Tonkin, and Annam, which had been taken in the Sino-French War of 1884–1885. Outfitting of these environments with people who lived in the exhibits created what some have called "human showcases," in which the colonized performed their daily life for the visual delectation of viewers.[25] The highly asymmetrical frame of viewing was built around racist ideas but cloaked in the guise of benevolence and education.

The commodification of the exotic was a resounding theme at the international exhibition, and the line between amusement and education was blurred. In the pavilion of Asiatic Russia in 1900, organized with Wagon-Lits Cook, visitors could take a simulated journey on the Trans-Siberian Railroad, watching through the windows the changing scenery of exotic attractions as they unfolded from a rolling canvas.[26] The optical tricks of the amusements were also three-dimensional. The "Street in Cairo," a popular amusement at the world's fairs of 1889 and 1893, simulated a quarter of

the old city, and offered food and beverages, as well as donkey rides, dancing women, and souvenirs for sale (fig. 14.3). Like the colonial exhibits, indigenous men and women were brought in to enhance the illusion. Timothy Mitchell has shown how the Orientalist vision of the "Street in Cairo" bewildered a delegation of Egyptians who visited the Paris fair in 1889, for the simulated "street" paired realism with disorienting fakeness.[27]

At the World's Columbian Exposition in Chicago in 1893, the midway entertainments made bona fide educational exhibits into popular attractions, including Street in Cairo camel rides, Algerian belly dancers, Dahomean drummers, a German beer hall, Irish Blarney Castle, and the 240-foot Ferris wheel. Frederick Ward Putnam, director and curator of the Peabody Museum at Harvard, along with Franz Boas,

Fig. 14.3 Street in Cairo, World's Columbian Exposition, Chicago, 1893.

organized a living exhibition of Native American tribes whom they viewed as object lessons in the forces of history and an opportunity to popularize anthropology.[28] Putnam and Boas's attempt at public science was subsumed in the mile-long street of entertainment. As scientific and commercial interests collided in the midway spectacle, the passive observer was also an active consumer of ideologies.[29]

Visual contrasts designed to inculcate messages of superiority and control helped to demonstrate progress at world's fairs, but visions of the future were also sold as reassurances of what remained ahead. Images of a self-conscious modernity prevailed in the buildings, machines, and processes exhibited in the nineteenth-century fairs, yet familiar historical references were firmly part of the visual culture of world's fairs. At the Paris Exposition des Arts Décoratifs in 1925, the image of modernity reigned supreme in angular facades, a garden of concrete trees, and pavilions such as Constantin Melnikov's USSR building and LeCorbusier's Esprit Nouveau pavilion. Yet throughout the exposition, sumptuous interiors updating eighteenth-century traditions of fine workmanship, such as Emile-Jacques Ruhlmann's Collector's Pavilion, complicated and enriched the idea of modernity.[30] The future-oriented themes of the Depression-era exhibitions in the United States were also tied to the past. For the Century of Progress Exhibition held in Chicago in 1933 to mark the one-hundredth anniversary of the founding of the city, a whirling planet was the signature motif. The New York World's Fair of 1939, whose motto was "A World of Tomorrow," was also designed to commemorate the 150th anniversary of Washington's inauguration as president in New York.

There were futuristic attractions in the nineteenth century—at the 1900 Exposition

Universelle in Paris the Celestial Globe offered a journey into space—but it was in the Depression-era fairs in the United States that futuristic worlds of tomorrow came to life. Like Democracity, an idealized town of the future housed in the iconic Perisphere of 1939, Futurama in the GM (General Motors) pavilion offered a visit to tomorrow. Norman Bel Geddes's Futurama was a full-scale phantasmagoria designed to give an alluring form to GM's vision of the future. From the hushed dark entryway showing an illuminated map of highway routes, a cushioned seat carried the visitor along on an invisible conveyor belt with a reassuring voice narrating GM's vision for America in 1960. The spectator was shown cities of wide superhighways with teardrop-shaped cars and busses, tall buildings, and countryside. Bel Geddes's image of 1960 offered stunning realism and ended with a surprise exit, dropping viewers into a life-size scale model of the "future."[31]

Umberto Eco, writing after the Montreal Expo 67, noted how the world's fair had shifted away from its origins as a means of displaying produce and toward making an abstract impression.[32] The Cold War fairs mounted in Brussels in 1958, Seattle in 1962, New York in 1964–1965, and Montreal in 1967 traded in heightened representations of nationality and used commercial goods to make political impressions. Although key attractions, such as the Seattle Space Needle (1962) and Atomium (1958), or the IBM pavilion (1964) and the Circarama in the American pavilion (1958), were updated versions of nineteenth-century viewing attractions, such as the Eiffel tower or panorama; the visual character of fairs changed as demonstrations of individual manufactures and processes gave way to entertainment organized by powerful corporate entities. Countries distanced themselves from the material

specifics in favor of a broader impression. A fashion show that meandered through the American Pavilion at the Exposition Universelle et Internationale de Bruxelles in 1958 was not designed to sell individual garments but rather the "American way of life."[33] In this sense, visual knowledge had more power than ever.

The emphasis on visual knowledge persisted in the ways that the exhibitions were remembered. Thousands of guides, catalogs, maps, and commemorative albums were produced and sold to visitors, along with domestic objects, such as plates, writing blotters, papier-mâché boxes, fans, and scarves bearing the image of the signature buildings. Long after these structures were emptied and dismantled, they and their contents were preserved in the lavish lithographed and photographic commemorative albums, and stereo views. The visual knowledge that accrued around these images has created a lasting image of the grandiose schemes erected, the growth of international commerce, and the popular culture of the past.

The international world's fairs were part of a long tradition of spectacular knowledge that reached a high point as popular entertainment in the nineteenth century. International expositions are still mounted today under the aegis of the Bureau International des Expositions in Paris; however, the world's fair has none of the relevance that it had before television, the Internet, and shopping malls, not to mention Disneyland, Disney World, or the Epcot Center. The closest corollary to the international prominence of the exposition is the modern Olympics, which was also an invention of the nineteenth century, held in conjunction with several international fairs, and mounted even today with some of the familiar promises of promoting world peace and knowledge through competition. Eco's critique of world's

fairs, that they were most accessible to elites, had become blandly corporate, and did not fulfill a sufficiently educational role because they did not travel were aspects that have led to their increasing irrelevance. Yet, historically, the world's fair, or international exposition, was a monumental achievement. World fairs gave form and shape to prevailing attitudes and values, and the study of world's fairs continues to show how cultural knowledge is fundamentally visual.

NOTES

1. John E. Findling and Kimberley D. Pelle, *Historical Dictionary of World's Fairs and Expositions* (Greenwood Press, 1990); Paul Greenhalgh, *Ephemeral Vistas: The Expositions Universelles, Great Exhibitions, and World's Fairs, 1851–1939* (Manchester University Press, 1988); *The Book of the Fairs: Materials about Worlds Fairs 1834–1916 in the Smithsonian Institution Libraries* (American Library Association, 1992); and John Allwood, *The Great Exhibitions* (Studio Vista, 1977).

2. Tony Bennett, "The Exhibitionary Complex," in his *The Birth of the Museum: History, Theory, Politics* (Routledge, 1995), 61.

3. Robert W. Rydell, *All the World's A Fair* (University of Chicago Press, 1984), 44. Good is speaking about the "Museum of the Future."

4. Jeffrey Auerbach, *The Great Exhibition of 1851: A Nation on Display* (Yale University Press, 1999), 14.

5. John McKean, *The Crystal Palace: Joseph Paxton and Charles Fox* (Phaidon, 1994).

6. Walter Benjamin, *The Arcades Project,* trans. Howard Eiland and Kevin McLaughlin (The Belknap Press of Harvard University Press, 1999), 7.

7. Thomas Richards, *The Commodity Culture of Victorian England: Advertising and Spectacle, 1851–1914* (Stanford University Press, 1990), 21.

8. Richard D. Altick, *The Shows of London* (The Belknap Press of Harvard University Press, 1978).

9. Shane Adler Davis, "'Fine Cloths on the Altar': The Commodification of Late-Nineteenth-Century France," *Art Journal* (Spring 1989): 85–89.

10. Tag Gronberg, *Designs on Modernity: Exhibiting the City in 1920s Paris* (Manchester University Press, 1998).

11. Debora L. Silverman, "The 1889 Exhibition and the Crisis of Bourgeois Individualism," *Oppositions* 8 (Spring 1977): 71–91; and *1889: La Tour Eiffel et l'exposition universelle* (Réunion des Musées, 1989).

12. "Protestation contre la tour de M. Eiffel," *Le Temps,* February 14, 1887.

13. Other buildings that were once part of fairgrounds include the St. Louis Art Museum (1904), the Palace of Fine Arts in San Francisco (1915), and the Museum of Science and Industry in Chicago (1893).

14. Louis Sullivan, *Autobiography of an Idea* (Dover, 1956 [1924]). See also Sigfried Giedion, *Time, Space and Architecture: The Growth of a New Tradition* (Harvard University Press, 1941); Neil Harris, "Memory and the White City" in *Grand Illusions: The Chicago World's Fair of 1893* (Chicago Historical Society, 1993).

15. David E. Nye, "Electrifying Expositions, 1880–1939," in *Fair Representations: World's Fairs and the Modern World,* ed. Robert W. Rydell and Nancy Gwinn (Vrie University Press, 1994), 148.

16. *Remembering the Future: The New York World's Fair from 1939 to 1964* (The Queens Museum and Rizzoli, 1989).

17. Burton Benedict, *The Anthropology of World's Fairs: San Francisco's Panama Pacific Exposition of 1915* (Lowie Museum of Anthropology, 1983).

18. Richard D. Mandell, *Paris 1900: The Great World's Fair* (Toronto University Press, 1967), 56.

19. Lou Taylor, "Displays of European Peasant Dress and Textiles in the Paris International Exhibitions 1862–1900," in *The Lost Arts of Europe: The Haslemere Museum Collection of European Peasant Art* (Haslemere Educational Museum, 2000), 30–43; Debora L. Silverman, *Art Nouveau in Fin-de-Siècle France: Politics, Psychology and Style* (University of California Press, 1989).

20. Michel Chevalier, ed., *Exposition universelle de 1867 à Paris, Rapports du Jury International,* vol. 1 (Imprimerie administrative de Paul Dupont, 1868).

21. Jean-Christophe Mabire, ed., *L'Exposition universelle de 1900* (L'Harmattan, 2000), 91–104.

22. Alexandre Labat, "Charles Garnier et l'exposition de 1889," *La Tour Eiffel et l'exposition universelle,* 130–147.

23. Tim Barringer, "The South Kensington Museum and the Colonial Project," in *Colonialism and the Object: Empire, Material Culture and the Museum,* ed. Tim Barringer and Tom Flynn (Routledge, 1998), 12; Carol Breckenridge, "The Aesthetics and Politics of Colonial Collecting: India at World's Fairs," *Comparative Studies in Society and History* 31, no. 2 (1989): 195–216.

24. Patricia A. Morton, *Hybrid Modernities: Architecture and Representation at the 1931 Colonial Exposition in Paris* (MIT Press, 2000).

25. Raymond Corbey, "Ethnographic Showcases 1870–1930," *Cultural Anthropology* 8, no. 3 (1993): 338–69.

26. Mandell, *Paris 1900,* 79.

27. Timothy Mitchell, "Orientalism and the Exhibitionary Order," in *Colonialism and Culture,* ed. Nicholas B. Dirks (University of Michigan Press, 1992).

28. Rydell, *All the World's a Fair,* 60–68. See Curtis M. Hinsley, "The World as Marketplace: Commodification of the Exotic at the World's Columbian Exposition, Chicago, 1893," in *Exhibiting Cultures: The Poetics and Politics of Museum Display,* ed. Ivan Karp and Steven D. Lavine (Smithsonian Press, 1991), 347.

29. Hinsley, "The World as Marketplace," 344–65.

30. Nancy J. Troy, *Modernism and the Decorative Arts in France: Art Nouveau to Le Corbusier* (Yale University Press, 1991).

31. Roland Marchand, "The Designers Go to the Fair, II: Norman Bel Geddes, The General Motors 'Futurama' and the Visit to the Factory Transformed," in *Design History, An Anthology,* ed. Dennis P. Doordan (MIT Press, 1995), 103–21.

32. Umberto Eco, "A Theory of Exhibitions," in his *Travels in Hyperreality* (Harcourt Brace Jovanovich, 1983), 291–307.

33. Robert H. Haddow, *Pavilions of Plenty: Exhibiting American Culture Abroad in the 1950s* (Smithsonian Institution Press, 1997), 111.

CHANGING MUSEUM SPACES: FROM THE PRADO TO THE GUGGENHEIM BILBAO

Susan Benforado Bakewell

Spain boasts two world-class art museums, the Prado in Madrid, and the Guggenheim Bilbao, in the Basque country. The Prado, venerable and traditional, is renowned for its Old Master holdings. The youthful Guggenheim Bilbao is famed for innovative design and credited with reviving its urban site. Together, the Prado and the Guggenheim Bilbao embody the public museum's evolution over the past two hundred years. An examination of each museum's history and reception, both critical and popular, suggests what a key role that quintessentially Enlightenment institution, the museum, plays in cultural, economic, political and social spheres.[1]

Often seen as the start and finish of a natural development, the Prado and the Guggenheim Bilbao also embody a significant shift in the art museum's function and significance. Whereas the Prado typifies the museum-as-container, widely regarded as an outmoded model for display, the Guggenheim Bilbao has become a byword for innovation, its spectacular exterior considered by many to represent a new kind of preserve for art. The twenty-first century's verdict on this debate will be decades in the making. What can be said now is that for all the Guggenheim Bilbao's novelty and popularity, the Prado has not been consigned to history's dustbin.

The Prado opened in 1819, Spain's first public art museum. A late eighteenth-century building, neoclassical in style and almost domestic in appearance, the Prado was intended by its architect, Juan de Villanueva, and his patron, Charles III, as a natural-science museum.[2] The façade organizes columns, elongated windows, and blind panels into a rigid, yet reticent design that offers no obvious access. Visitors enter, not from the street side, on the urban and upscale Paseo del Prado, but at the ends, one facing the Ritz Hotel, the other a royal botanical garden (fig. 15.1).

Although the Paseo del Prado's namesake fields have vanished and carriages have ceded to cars, the leafy street with broad walkways remains a lively social space where citizens and tourists mingle. In a former empire governed since the later sixteenth century from a capital deliberately constructed in the country's geographical middle, the Prado can be figured at the very heart of Spain. Visitors come for rich collections ranging from the fifteenth through the nineteenth centuries, with Venetian, Flemish, and Spanish paintings of the sixteenth and seventeenth centuries predominant, a reflection of imperial tastes[3] (fig. 15.2). Until recently, mid- to late nineteenth-century and later work was neither acquired nor displayed, a prohibition broken only in 2007 by

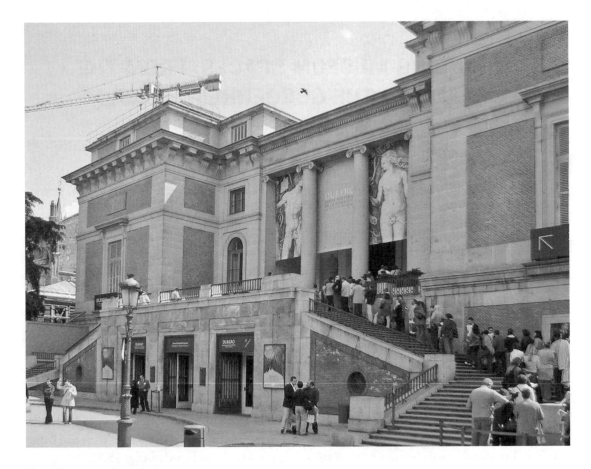

Fig. 15.1 The Prado, Madrid.

a polemical Picasso exhibition.[4] And until recently, the Prado remained as it had been upon its inauguration, apparently as impermeable to time and tradition as its holdings.

However, two new and nearby museums, both dating to 1992, both in renovated eighteenth- and nineteenth-century buildings, and both popular with locals and visitors alike, prodded the Prado to ponder its future. The range and depth of the Thyssen-Bornemisza's holdings, a baronial collection bought for the nation and installed across the Paseo del Prado, spurred the Prado to seek loan exhibitions, some of the "blockbuster" variety, to contextualize and showcase its holdings. The presence at the Paseo's terminus of Picasso's *Guernica,* and a changing array of global modern and contemporary art in the Reina Sofía, caused the Prado to reconsider its identity and its reach. The explosive arrival on the museum scene of Bilbao's Guggenheim in 1997 speeded this process and culminated, in 2007, with the opening of an expanded and updated, yet still traditional, Prado.[5]

From its inception, the Guggenheim Bilbao achieved iconic status. Critics rhapsodized, "Have you seen the Bilbao.... Have you seen the future?"[6] Millions who have never visited Bilbao recognize the museum's billowing curves and luminous surfaces, so idiosyncratic

Fig. 15.2 The Prado, Madrid, interior view.

that a slice of the building can represent the whole (fig. 15.3). The Guggenheim Bilbao served as a backdrop for the opening scenes of the 1999 James Bond film, *The World Is Not Enough,* one among many instances of the museum's engagement with popular culture.

Gehry's Guggenheim is credited with an urban renaissance so complete as to constitute a phenomenon, purportedly replicable. This is the "Guggenheim Bilbao effect," whereby a novel structure by a famous architect rehabilitates faded industrial cities.[7] Certainly the "effect" is visible in Bilbao. The Nervión River that bisects the city once gleamed with chemical effluent; it now reflects the museum's titanium-clad surfaces. Once partnered by metropolitan decay, the Guggenheim Bilbao now consorts with high-concept hotels and is linked to a refreshed nineteenth-century core and historic quarter (*casco viejo*) by walkways, bike paths, and a sleek subway, all thronged by tourists and residents.[8]

The Guggenheim Bilbao's small permanent collection includes contemporary art from Europe and North America; it also shares the vast modern holdings of its parent, the original Guggenheim in New York. The Guggenheim Bilbao's signature piece, Jeff Koons's *Puppy* (fig. 15.4), sits outside like a mascot, a reminder that visitors see the building as a destination in its own right, not, as at the Prado, a shell valued for its contents.[9]

Fig. 15.3 The Guggenheim, Bilbao.

In many ways, Spain is an unlikely laboratory for the study of the Western art museum's evolution. Although collecting had flourished in Spain from the Renaissance on, most notably in the centuries of Spain's imperial dominance, it existed largely within royal and aristocratic contexts. The public museum arrived late, like most Enlightenment-related projects.[10] A divine-right monarchy where the Inquisition held sway constituted an inhospitable environment for advanced ideas, however much the occasional monarch espoused them. The Peninsular (Napoleonic) Wars convulsed Spain as the Prado was being planned, followed, after midcentury, by the Carlist conflicts.

The twentieth century opened to loss of empire, then civil war and Franco's forty-year dictatorship, entailing virtual closure to the world. After Franco's death in 1976, Spain effected a fraught transition to a constitutional monarchy. Shucking the constraints of the recent past, Spain began to invoke a distant and glorious heritage by investing in cultural institutions, most notably the Prado. National identity, a concern since the mid-nineteenth century at least, attached itself easily to such efforts, and it was a short step to the appropriation of transnational and international cultural identities.[11] A corollary in the later twentieth century has been to market Spain as a brand and to seek culturally significant representatives of this brand. The Prado's collections served this need; advertised, they soon figured in tourists' decisions to visit Madrid. With the advent of the Guggenheim Bilbao, the notion of what constituted a culturally relevant experience changed for Spain, as did tourists' itineraries.[12]

Fig. 15.4 The Guggenheim, Bilbao, with Jeff Koons's *Puppy*.

The practice of visiting museums was not, of course, a twentieth-century invention. When the Prado became public property early in the nineteenth century, after the Peninsular War, bonneted and top-hatted visitors rushed to engage in the peculiarly Western custom of looking at framed paintings hung on walls. The collection's wealth was available for spectators' scrutiny, although displays constituted a scant sample of what lay in the vaults. All displays attested to royal taste, patronage, and collecting practices established in the sixteenth century.[13] Spectators would have been aware that their looking took place in a purpose-built structure rather than in the palaces where art would have been displayed originally. Their interest in what one commentator has called the "as-if

merchandise" of museums, its possessions, may have elicited feelings of simulated ownership, just as the appearance of the Prado's rooms recapitulated the pictures' first placement within princely contexts.[14] Pride in nation and heritage mixed with pleasure at access to the riches of what was now a people's palace.

Today's Prado entices viewers with the same luxuriant array of pictures, installed in an early nineteenth-century building characterized without and within by a classical, yet opulent, restraint. Orderly queues at the entrance suggest that today's audiences share cultural aspirations and assumptions with early nineteenth-century visitors, despite casual dress and demeanor (fig. 15.2). The art historian Michael Baxandall has argued that most modern museum viewers know what to expect; imbued with the norms and expectations of their developed societies, they possess the "museum set...a sense of the museum as treasure house, educational instrument, secular temple"[15] Like their nineteenth-century fellows, the prospective Prado visitors seen here feel kinship with the works on display and seek to capture that sense of connection, not, as well-heeled nineteenth-century visitors might, with a handpainted copy, but via the modern equivalent, a museum-shop postcard or a photograph.

The banner over the entrance announces a major loan exhibition. Few tourists would be aware of the "blockbuster" exhibition's role in contemporary museum financing: Spanish government policy now requires national museums, even the flagship Prado, to fund increasingly large parts of their budgets by charging attendance fees.[16] Visitors shown in this 2005 photograph may have observed during their wait ample ambient activity: the crane overhead announces an expansion in progress, the first since the Prado's inception, completed late

in 2007. That this project virtually doubles the Prado's size, incorporates a historic building, provides space for nineteenth-, twentieth- and twenty-first-century art to be shown, and is, moreover, the work of an internationally known Spanish modernist architect, Rafael Moneo, suggests how great Bilbao's impact has been, even at home.[17]

As noted, the Guggenheim Bilbao is among the most instantly recognizable structures in any country. It typifies the "museum effect," a phenomenon (codified by the art historian Svetlana Alpers) whereby any object, produced with "visible craft" and meant for "attentive looking" becomes art.[18] The Guggenheim Bilbao demonstrates that a museum building can undergo the "museum effect," becoming a gaze-worthy object of the sort traditionally reserved for interior displays; it is captured now, acquired, virtually, by visitors' cameras. They use the latest version of a world-changing nineteenth-century technology to take the international-museum-changing Guggenheim Bilbao home with them.

Although the Guggenheim Bilbao's interior has hosted many exhibitions, it is the outside of the Guggenheim and its connection to its site that continue to fascinate (fig. 15.3). Communities worldwide have sought to emulate the "Bilbao effect," whereby a cult structure banishes blight and conjures prosperity. Skeptics doubt the transferability of the Bilbao experience; proponents, purveying quasi-Enlightenment certainty in the powers of culture, insist it can be replicated.

Architectural exuberance like the Guggenheim Bilbao's masks a connection to long-established notions about art, culture and society. That the public museum and its displays reflect cultural, historical, and ideological determinants is generally accepted today. As one art historian puts it, "The extraordinary global success of museums in the past two centuries together with an equally remarkable consistency in museum design and values has managed to naturalize a set of ideals and practices that were invented and institutionalized at the dawn of the museum age in the eighteenth century."[19]

Private collecting, initially royal, aristocratic, or ecclesiastical, formed the Prado's and other public museums', bedrock in Spain, as elsewhere.[20] Spain's shift from private to public patronage of the arts constitutes an ideal subject for the investigation of modern museum practices and their antecedents. Ultimately, a concern for aesthetics and their relation to social position and power replaced a concentration on objects. Collectors' identities become bound up with a collection's components and their ability to dazzle and impress. Writers and critics across Europe, including Spain, began in the eighteenth and nineteenth centuries to urge public access for private museums.[21]

The Bourbon Restoration provided the Spanish public with a grand, if tardy, museum, the Prado, in progress since the late eighteenth century, a reflective moment even in retrograde Spain. By 1808, just before the Napoleonic invasion, the building was essentially completed with the exception of the domed entry and the roof.[22] Revolutionary for Spain and reflecting the cultural aspirations of Charles III, the Prado was, ironically, birthed by one of the country's least enlightened monarchs, Ferdinand VII, Charles's grandson. The nineteenth-century Prado has been characterized as a profoundly rational structure for which few claim architectural eminence.[23] Even the art-historical expert lauding the buildings as a masterwork of Spanish neoclassicism concedes that, "[This] museum is, above all, its collection."[24]

What the reworked Prado retains of its beginnings besides the Villanueva structure is

the impulse, generous or self-aggrandizing, to display private purchases and commissions to the citizenry, to whom such objects now belong, and a didactic agenda, at once late-eighteenth-century and wholly up-to-date.[25] The 2007 Prado attends fully to its original imperative to educate. Its director, Miguel Zugaza, indirectly invoking the Guggenheim Bilbao experiment, accepts that the art world is a marketplace, while claiming the intellectual high ground: "That the Prado has arrived rather late can be considered a competitive advantage because we were able to learn from the success of others and not repeat their mistakes." He makes the comparison with Bilbao explicit and insists on the Prado's primacy: "we have not fallen victim to the trend of creating signature buildings which compete with the institution itself."[26] With delicate irony, Zugaza, by birth a Basque, sums up the old-fashioned Prado's new institutional identity thus: "The real extension of the Prado is in the old building."[27] The collection, in other words, still matters more than the container.

Today, visitors to the original Prado building see what early visitors saw: generic neoclassical spaces. Although modifications were made to the interior over time, in part to accommodate ever-larger crowds and to take account, in a modest way, of new modes of lighting and display, the basic disposition of the galleries remained constant.[28] A photograph from 2005 (fig. 15.2) reinforces the museum-as-palace analogy: an otherwise mundane link between floors functions as display space while attesting to Spanish royal predilections and prevailing early nineteenth-century taste. In the foreground, a neoclassical urn adorns an otherwise severe array of marble stairs. A scalloped niche shelters a classical nude, while a blank wall is dominated by a dark oil, Spanish artist José de Ribera's *Ixion,* of 1632, depicting

with Baroque exuberance the Olympian punishment accorded Greek mythology's Cain.[29] Contemporary museum behavior is also modeled, as a pair of visitors pauses to study the sculpture while others, blurred in the camera's capture, seem intent on an unseen goal beyond the stairs. These Prado tourers exude informality in their dress, unlike the museum's earliest spectators. Children are present, as they would not have been in 1819. Yet the modern visitors' behavior seems knowing—the "museum set" in evidence—and their devotion to the cause of culture clear, not least in their haste to consume the museum's displays.

This photograph of the original Prado's interior in the twenty-first century includes a single painting, possibly one of the three hundred shown in 1819.[30] To the pre-1819 royal holdings the Prado added over time material from the former Trinity convent, where works dispersed during the 1835 disestablishment of the Roman Catholic church were stored, and much later, from 1971 on, the holdings of the Museo de Arte Moderno, a gathering of nineteenth- and twentieth-century works, mostly Spanish in origin and, until the 2007 expansion, seldom shown. Along the way, the Prado gained the Casón del Buen Retiro, a small nineteenth-century structure near the original building, used initially to show the modern collections and, temporarily, as a home for Picasso's *Guernica* between its return to Spain and the permanent move to the Reina Sofía Museum. In the estimation of a former director, Fernando Checa, the Prado, despite the size and brilliance of its pan-European collections, never aimed to be "encyclopedic...a complete history of art comprising all ages, cultures and countries." Rather, the Prado represents a nationalizing collection, in the sense that its origins and expansion are tied to Spain's history and identity.[31] The many paintings from other

European countries reflect the history of collecting in Spain, and not the history of art.

As of October 2007, another Prado stands next to the old. Besides space to display later nineteenth- and twentieth-century acquisitions, the Moneo Prado joins the modern museum age in its attention to visitor needs, with public gathering areas, restaurants, and gift shops. The expanded Prado distributes key museum functions—display, conservation, security, and research, as well as the non-art-historical tasks of public welcome and administrative work—among five buildings. In this dispersal and unification, Checa thinks, lies the innovation of the revamped royal collection turned public museum.[32] Controversy accompanied the expansion because it threatened Madrid's historic urban fabric. The "new" Prado expropriated part of the former Palacio del Buen Retiro, then occupied by the Army Museum (Museo del Ejército) and gutted the Convent of the Jerónimas, one of central Madrid's few remaining sixteenth- and seventeenth-century structures, conserving only its exterior walls.

In some minds, Moneo collaborated in an act of desecration, plundering the "Madrid of the Austrias," as seventeenth-century portions of the city are known, for political reasons. Checa denies this, characterizing the Moneo plan as one in which "the external architectonic sign of the actualization and amplification of the museum and the *barrio* (urban area)" of the Jerónimas becomes the "museistic area" of the Prado. The new Prado's buildings, linked by walkways and gardens, constitute a historical–architectural *"recorrido"* (journey), representative, and deeply respectful, of the past, with buildings of the seventeenth, eighteenth, nineteenth, twentieth, and twenty-first centuries conjoined.[33] Delayed for years, like the 1819 original, by acts of violence (the

Madrid train bombings of 2005), changes of government, shifting government priorities in an age of anxiety and citizen unrest, and prospect of alterations to the city's historic core, the "new" Prado has recast and revived itself, while retaining primary focus on the collections.

From an urban vantage, Bilbao represents Madrid's antithesis. Frank Gehry's 1997 Guggenheim Bilbao Museum exemplifies the ultimate in museum design since the Prado's inauguration. Madrid is a created capital city, built near the geographical center of late Renaissance Spain, in Castile, the country's most characteristically Spanish—and royal—province. (The Spanish language, *español* to those outside Spain, is invariably referred to within as *castellano,* Castilian.) Bilbao is a Basque city, and a center for industry, with all that that implies about marginality, difference, and an identity that rejects Hispanism. As Madrid was created by the Hapsburgs in Spain's midsection, actually and figuratively central to the state, so Bilbao represents the periphery and "ex-centricity." At its most expansive, greater Bilbao offers the pleasures of *tapas* and well-preserved Renaissance, Baroque, and early-modern buildings, the comfort of vintage seaside resorts, and the open wound of Guérnica (site of atrocities against a civilian population, seared into public memory by Picasso's painting). Yet Bilbao's key monument is neither very Basque nor very Spanish, but a museum created for a U.S. foundation (which insisted on local funding) by a Canadian architect and famous for its looks, with an international exhibition program.[34]

The building's quilted-titanium-clad surfaces curl, swoop, stretch, and turn in upon themselves, seeming, at times, to be on the verge of explosion. Gehry's task, as he saw it, was two-fold. First, he had to produce a response to a particular place, a decayed industrial city at the

margins of a dead empire. From Thomas Krens, the Guggenheim complex's director and in a sense the Guggenheim Bilbao's patron and godfather, Gehry also knew he was being asked to extend the Guggenheim "brand" with a building "able," in the words of a critic, "to broadcast its presence and establish a wide sphere of influence."[35]

The irony of a North American, quasi-corporate venture receiving credit for lifting Basque Bilbao out of postindustrial penury has not escaped notice. ETA (Euskadi ta Askatasuna, or Basque Fatherland and Liberty), the violent Basque liberation movement, targeted the museum, attempting to blow up Koons's thirteen-meter-high steel, earth, and flower sculpture, *Puppy* (fig. 15.4). Like the museum for which it serves as mascot, *Puppy* has achieved iconic status, "collected" by visitors via photographs and the innumerable simulacra of it for sale in the museum gift shop. Cuddly, despite its size and rigid armature, *Puppy* stands for a revived, knowing art derived from popular culture crossed with high (in this case, literally) art. ETA's attack made the sculpture synonymous with the museum, from the Basque vantage, an outsider in a region seeking a distinct identity that is at once anti-Spanish and antiglobal. It is appropriate that this massive modern incarnation of a guardian figure (akin to those from sacred spaces of old despite its playful spirit and partially ephemeral materials), should have functioned to protect its tutelary temple: An internal watering system installed to ensure longevity for *Puppy's* 70,000-odd bedding plants set into twenty-five tons of earth dampened and defused the ETA bomb.[36]

Puppy's welcoming presence at the Guggenheim Bilbao's portal reinforces the site's popularity while constituting, in its fictive bounciness and tactility, a foil to Gehry's sleek designs. The sculpture lends the museum a homey feel and may enhance any "museum set" that visitors bring to the site. (The means by which visitors access the museum begins a deliberate actual and figurative break with custom: One descends to the principal entrance, rather than ascending, as at the Prado.) That a key object resides outside the building reinforces the notion that the Guggenheim Bilbao's interest and impact resides in its architectural profile, rather than in its interior displays. Despite Gehry's attention to the development of appropriate interiors, the building's tradition-shattering, shape-shifting exterior, and its riverine, industrial site are inescapable for viewers within and overshadow the art.[37]

Once museum-goers have negotiated the ticket counters, gift shop, and café, they enter an enormous atrium. As in New York's Guggenheim, an organic array of smaller galleries opens out from here. Although Gehry resists comparisons with the Frank Lloyd Wright building in New York, it is an inescapable influence. Krens articulated this by challenging Gehry, in Gehry's words, to "Do better than Wright," a task Gehry says he completed with the anti-Wright Guggenheim in Bilbao, an "improvement on the anti-art Guggenheim in New York."[38]

One critic characterized the effect of looking through the Guggenheim Bilbao's interlocked spaces, distinctive in shape and scale, as producing "views…Piranesian in their complexity and beauty."[39] Not all critics have reached for such exalted, eighteenth-century, scenographic comparisons. A recent critique praises Gehry's shell as having earned its legendary status, while decrying the "fragmented arrangement of gallery spaces and the overwhelming presence of the architecture," as curatorially deadening.[40] In truth, vistas of the Nervión and of twisted titanium exterior

surfaces are as evanescent and transfixing as anything on view in the galleries; paradoxically, the rooms devoted to display look traditional and feel almost clinical when compared with the often-derided neoclassical galleries at the Prado.[41] For ordinary visitors, the relationship of interior to exterior and site may be the most collectible visual experience of all.

There are individual art objects to see, as in most conventional museums. Holdings reflect political necessity, acknowledging the museum's Basqueness and Spanishness, while attending to the larger European community and the unbreakable connection to the New York Guggenheim. Directorial and curatorial awareness relates to the museum's origins, location, and mission as does the Prado's, a conservative aspect to a rule-breaking institution's persona.

The Guggenheim Bilbao is regarded as both a benchmark and a stimulus for massive urban civic projects; its followers are many. As the "Guggenheim effect" is endlessly cited, so Gehry's iconic building is everywhere to be seen in the common culture. Working toward an understanding of the museum at the end of twentieth century, an architectural historian has described the Guggenheim Bilbao as a site-specific, environmentally aware success, giving "the impression . . . of always having dominated this urban landscape." In fact, Thomas Krens, director of the Guggenheim Museum in New York and its satellites, disrupted an early plan to make a museum from an existing building, insisting that the Basque government accept and fund a signature structure that would come to stand for Bilbao as the Sydney Opera House does for its home city.[42]

The Guggenheim's physical presence has made of it a spectacle, enticing the curious and the cultured to Bilbao. Mere spectacle is what critics of Gehry's building rate it or simply an advertising brand. One of the best-known critics of contemporary art and architecture, Hal Foster, dismissed Gehry, the Guggenheim Bilbao, and the "Guggenheim effect" in a review essay entitled "Why all the hoopla?" He compares Bilbao with the original Guggenheim in New York, designed in 1959 by Frank Lloyd Wright. Both, he notes, can be considered as sculptural objects, and both impose themselves on their sites, rather than accommodating to them. For Foster, there is an inherent "formal logic" and contextual appropriateness about the Wright building that the Gehry structure lacks. The Guggenheim Bilbao he characterizes as "perverse and self-indulgent," denying that its industrial materials, its wild forms, or its shifting colors relate in any meaningful fashion to the industrial, over-the-water site or even to the Nervión's iridescent, effluent-derived, hues.[43]

Foster is not alone. A Bilbao-based architect, Eduardo Arroyo, has complained that Bilbao's "reinvention" rides on the reputations of famous, outsider architects, questioning whether there is a "Guggenheim effect," since to have a Guggenheim effect, one must have a Bilbao, a port city with medieval-to-nineteenth-century infrastructure in place, significant regional funding, and excellent placement. Concerns about cultural identity and globalization's strengths accompany his skepticism about a single structure's potency. For Arroyo, "[this supposed revival] is not architectural, but a social act, to reinvent a city thanks to foreign support of an art collection and all the media power that goes with it. . . . For now, there isn't more than one [Guggenheim effect]." This argument insists that single buildings seldom save moribund cities unless there is already something there worth saving and seeing.[44]

The contrary view is that the Guggenheim Bilbao has earned its halo. It has proved, by

the ever-increasing numbers of visitors and an impressive infusion of visitor cash into the regional economy, that architecture equals power and that a spectacular museum can become a commodity. The Guggenheim Bilbao's addition to the city's cultural landscape, effected with an eye to the built environment's history and the ramifications it continues to have on the visibility and the economy of Bilbao, now frame any discussion of how new architecture can benefit cities.

The Guggenheim Bilbao represents a key shift in the museum's appearance and its function. At the Prado, two centuries ago, royal Titians and Velázquezes animated anonymous interiors. The collections became the museum, the building a means to an end for viewers. The nature of this discourse changes with Moneo's expansion, a complex and visually alluring design in which the restrained lines of the Villanueva building are linked by a glass gallery and walkway to the sky-piercing elevation of the Jerónimas convent.[45] Here is the "old" Prado framed by its prehistory (the convent) and its future (the Moneo extension). Crowds still line up for the privilege of seeing the fabled collections. The Guggenheim Bilbao's interiors, of secondary interest, showcase art that, however intriguing, seldom competes with the fabulous and famous profile to which spectators flock.

Spain today attracts more tourists than any other European country except England. Most visitors begin in Madrid; millions—five in 2005 and nine in 2007—journey to Bilbao; many come for the museums. As cultural attractions, the Prado and the Guggenheim Bilbao couldn't be more distinctive in inception, appearance, collecting history, or function. Yet their similarities resonate, as does their mutual awareness. Could anyone have predicted the extent to which a building like Gehry's Guggenheim Bilbao would rehabilitate a rust-belt port

in a little-visited part of Spain, extend Spain's "brand" as a nation—and spawn a continuing series of hopeful imitators? Could anyone have envisaged an enlarged, modernized Prado dedicated to showing the full range of art history, including the contemporary, referencing its home city's royal and ecclesiastical history, and serving visitors, rather than awing them? Much of consumer culture is replicable, available globally. In the enlarged Prado and the gleaming Guggenheim Bilbao, Spain possesses two valuable commodities that cannot be confused with anything else, or reproduced. They are fixed in place, requiring of would-be visual consumers a journey, one might even say a pilgrimage, focused on loftier goals than mere commerce, however significant fiscal issues have become to cultural institutions.

The overriding aims of the staid Prado and the showy Guggenheim Bilbao are identical: to establish identity, regional, national, and international, to attest to Spain's cultural significance, and to entice viewers for their own, and the greater, good, goals familiar in intellectual circles since the late eighteenth century, to which one must add the modern imperative of financial self-sufficiency. The Prado has recast itself as a user-friendly repository (the last of the great old-style European museums to do so) whose treasures' magnetic allure endures. The Guggenheim Bilbao's attractions have yet to fade any more than has its signature titanium cladding.

NOTES

1. See Krzysztof Pomain, "De la collection particulière au musée d'art," in *The Genesis of the Art Museum in the 18th Century,* ed. Per Bjurstrom, 9–27 (Nationalmuseum (Stockholm), 1993). Spain is addressed in Ana Ávila, *El arte y sus museos* (Ediciones de Serbal, 2003), 42–47.

2. For this aspect of the Prado's history, see Santiago Alcolea Blanch, *The Prado Museum* (Ediciones Polígrafa, 2002), 17–22.

3. Alcolea Blanch, *The Prado Museum,* 9–13. Also see Javier Portús, "Las colleciones del museo del Prado," in *El Nuevo Museo del Prado* (Museo Nacional del Prado, 2000), 45–62.

4. Cristina Carrillo de Albornoz, "The Prado Will Never Cater to the Masses," *The Art Newspaper,* October 23, 2007.

5. José Luis Sancho, "El museo como paseo arquitectónico," in Portús, *El Nuevo Museo del Prado,* 65–88, and "Proyecto para la ampliación del Prado," 92–94, with unpaginated plans for the expansion. On the Thyssen and Reína Sofía Museums, see Ávila, *El arte y sus museos,* 144–45.

6. The Muschamp quote appeared on the cover of the *New York Times Magazine,* September 7, 1997, and is cited in Anna Maria Guasch and Joseba Zulaika, *Learning from the Guggenheim Bilbao* (Center for Basque Studies, University of Nevada, Reno, 2005), 8. For less critical views, see *The Guggenheim Magazine* 11 (Fall 1997), and *Connaissance des Arts* 134 (2000).

7. On the "Bilbao effect," see Kim Bradley, "Basque Report: Regional Renaissance," *Art in America* (November 2005): 83, and Guasch and Zulaika, *Learning from the Guggenheim Bilbao,* 7.

8. For pre-Guggenheim Bilbao, see Jesús Torbado, *Ciudades de Espana* (Tribuna, 1995), 97–112.

9. Ávila, *El arte y sus museos,* 37–38, and Keith Moxey, "Gehry's Bilbao: Visits and Visions," in Guasch and Zulaika, *Learning from the Guggenheim Bilbao,* 173. On museistic aspects of the Guggenheim Bilbao, see Ascensión Hernández Martínez, "Museos para no dormir: la postmodernidad y sus efetos sobre el museo como institución cultural," in *Museología Crítica y Art Contemporáneo,* ed. Jesús Pedro Lorente and David Almazan (Prensas Universitarias de Zaragoza, 2003), 125–44.

10. Alcolea Blanch, *The Prado Museum,* 13–21 on the Prado as public museum.

11. Oscar Vásquez, *Inventing the Art Collection: Patrons, Markets, and the State in Nineteenth-Century Spain* (Pennsylvania University Press, 2001), 69–96 and 97–121.

12. On "selling" the museum, see Jon Azua, "Guggenheim Bilbao: Coopetitive (*sic*) Strategies for the New Culture-Economy," in Guasch and Zulaika, *Learning from the Guggenheim Bilbao,* 73–95 and Appendices H, I, and J.

13. Alcolea Blanch, *The Prado Museum,* 17–22, and Fernando Checa, "El Nuevo Museo del Prado," in *El Nuevo Museo del Prado,* 12–43. Page 12 shows the Prado's main gallery and rotunda, about 1830.

14. James A. Boon, "Why Museums Make Me Sad," in *Exhibiting Cultures: The Poetics and Politics of Museum Display,* ed. Ivan Karp and Steven D. Lavine (Smithsonian Institution Press, 1991), 255–77.

15. Michael Baxandall, "Exhibiting Intention: Some Preconditions of the Visual Display of Culturally Purposeful Objects," in Karp and Levine, *Exhibiting Cultures,* 33.

16. According to Daniel Henninger, "Still More Masterpieces: The Prado Expands," *Wall Street Journal,* November 1, 2007, p.D7, 30% of the Prado's budget derives from admissions.

17. *El Nuevo Museo del Prado.*

18. Svetlana Alpers, "The Museum as a Way of Seeing," in Karp and Levine, *Exhibiting Cultures,* 25–27.

19. Andrew McClellan, "The Museum and Its Public in Eighteenth-Century France," in Bjurstrom, *The Genesis of the Art Museum in the 18th Century,* 61–80.

20. On European collecting and the Prado, see Germain Bazin, *The Museum Age* (Universe Books, 1967), 98. For the Prado specifically, see Alcolea Blanch, *The Prado Museum.*

21. Vásquez, *Inventing the Art Collection,* 7–17.

22. Checa, "El Nuevo Museo del Prado," 82.

23. Checa, "El Nuevo Museo del Prado," p.27.

24. Sancho, "El museo como paseo arquitectónico," 65.

25. Checa, "El Nuevo Museo del Prado," and Alcolea Blanch, *The Prado Museum.*

26. Henninger, "Still More Masterpieces," D7.

27. Michael Kimmelman, "The Prado Makes Room to Show Off More Jewels," *New York Times,* October 31, 2007, B5.

28. Checa, "El Nuevo Museo del Prado."

29. Illustrated in Alcolea Blanch, *The Prado Museum,* 135.

30. Bazin, *The Museum Age,* 185.

31. Checa, "El Nuevo Museo del Prado," 13.

32. Checa, "El Nuevo Museo del Prado,"16; and Kimmelman, "The Prado Makes Room," B5.

33. Checa, "El Nuevo Museo del Prado," 91–94.

34. Bradley, "Basque Report."

35. Joseph Giovannini, "Art into Architecture," *The Guggenheim Magazine* 11 (Fall 1997): 18–23.

36. Bradley, "Basque Report," 89, note 5, provides a full account of the incident.

37. Victoria Newhouse, *Towards a New Museum* (Monacelli Press, 1998), 248.

38. Statement by Frank Gehry in *Gehry Talks: Architecture and Process,* ed. Mildred Friedman, rev. ed.(Universe Publications, for Rizzoli Press, 2005), 140. Gehry speaks in Sydney Pollack's film, *Sketches of Frank Gehry.*

39. Newhouse, *Towards a New Museum,* 252.

40. Mark Irving, "Mind over Matter: Richard Serra's Bilbao Guggenheim Sculptures Both Respond to and Challenge Their Context," *The Architectural Review* (August 1, 2005), 1, http://www.thefreelibrary.com/Mind over_matter:Richard Serra's Bilbao Guggenheim sculptures both...-a0141803508.

41. I am indebted to Jane Kromm for this observation; Gehry's Bilbao exhibition spaces receive lesser coverage in official publications, perhaps because, compared with the exterior, they seem conventional.

42. Newhouse, *Towards a New Museum,* 245 and 247.

43. Hal Foster, "Why All the Hoopla," *London Review of Books,* no. 16 (August 23, 2001), http://www.lrb.co.uk/v23/n16/fost01_.html.

44. Interview with Eduardo Arroyo, *El País,* March 19, 2006.

45. Checa, "El Nuevo Museo del Prado," unpaginated inserts; also photographs in Henninger, "Still More Masterpieces," and Kimmelman, "The Prado Makes Room."

DESIGN FOR DISPLAY CULTURE: DOMESTIC ENGINEERING TO DESIGN RESEARCH

Michael J. Golec

MODERN WAYS OF LIVING

In 1953, the American architect Benjamin Thompson opened the doors of Design Research (D|R) on Brattle Street in Cambridge, Massachusetts. The retail home furnishings shop—originally occupying several rooms and floors of a clapboard row house and then expanding in 1969 in a building designed by Thompson—sold furniture, lamps, rugs, dishware, kitchenware, fabrics, and, most importantly, a lifestyle that accompanied a modern environment.[1] Whether in the more homey atmosphere of the row house or the prismlike complex of Thompson's concrete and glass building, D|R created displays that were scaled to the domestic sphere in its "homelike arrangement."[2] A quirky but elegant mix of materials and objects characterized the displays: Aalto birch furniture arranged next to unglazed pottery set on teak tables and framed by Marimekko fabrics. The visual and tactile appeal of D|R's innovative array of items— vibrant colors and rustic surfaces—for everyday life resulted in a unique retail experience, one that legitimated "modern" design in the United States and that suggested new "ways of living"[3] (fig. 16.1).

Yet for all of its ostensible originality, D|R was neither the first instance of the validation of modern design in the United States nor the first instance of a retail display to suggest new ways of living. There is little doubt that Thompson and D|R intended to challenge the conventions of home furnishings and their marketability. Nevertheless, when observing Thompson and his staff's artfully arranged design objects within a homelike environment, one could see in them a history of past visualizations and displays of modern ways of living. In other words, D|R was but the culmination of a near century-long commitment to the visualization of the spatial logic of domestic engineering, as it was first introduced in the United States by Christine Frederick's *The New Housekeeping* (1912) and *Household Engineering* (1915) and spread throughout Europe in the 1920s and 1930s. The domestic engineering movement provided a template for the rational organization of the home. The model that was defined as "a shelter devoted primarily to the function of reproduction, nutrition, and recreation" has since been obscured by stylized approaches to the presentation and marketing of home furnishings within both the exhibition hall and the retail environment.[4] While D|R represented modern retail at its zenith, Thompson and his store were not alone in the development of this manner of visual display in the postwar era. Other instances include Habitat in Britain, Crate & Barrel in the United States, and IKEA worldwide.

Fig. 16.1 Design Research, Cambridge, MA.

Understood from this perspective, visual displays of home furnishings are blueprints for imagined or real lifestyles. (Perhaps it is not by chance then that Martha Stewart Omnimedia's latest publication is entitled *Blueprint,* and the subheading of the magazine is "Design Your Life.") As such, the organization of the home as it reflects and responds to the many exemplifications of ideal domestic arrangements circulating through the marketplace reveals multiple life options available to consumers. What you see is what you get (at many different price points). Yet, at the same time, the visual display of home furnishing conceals the normative and universalizing tendencies of the modern rationalization of the home and its occupants. What you do not see or only partially see is what you get (across just as many price points).

VISUAL DISPLAY

A recent study on visual display proposes that it is "the other side of the spectacle: the side of production rather than consumption or reception, the designer rather than the viewer, the agent rather than the patient."[5] Here the emphasis is on the active construction of displays

and their participation in the coercive force of spectacle, or as "the stuff of which consciousness is forged."[6] Yet, if there is anything to the idea that visual display constructs consciousness, then its successes are based on its persuasive character and in the way it simultaneously reveals and conceals patterns of everyday existence into new forms of life. Indeed, visual display is a form of concealment best understood "when its flow is arrested," revealing it as a symptom.[7] What we see in display when we look past or through the image (or look at it "awry") is its hidden yet apparent structure or "truth." Thus, as one scholar concludes, "Each historic period has its own rhetorical mode of display, because each has different truths to conceal."[8] Understood according to these terms, the visual display of modern furnishing within the retail environment is a symptom of the rationalization of the domestic sphere.

The psychoanalytic approach that this argument offers—in which shopping is a pathology—situates a passive consumer who is at the mercy of organizing powers beyond her control. Material culture studies has provided a means to study shopping, not as a thing disconnected from culture, but rather as a means to study the social relations and "lived experiences" of consumers.[9] In this sense, shopping is understood as an active venture or performative gesture in an ongoing construction of identity within a capitalist–consumer culture. Material culture examines cultural systems of belief embedded in material artifacts and, by extension, their exchange. The fundamental concern of the discipline is, however, "with the artifact as the embodiment of mental structures, or patterns of belief."[10] While not overtly or overly committed to psychoanalytic methods of cultural analysis, material culture studies still presumes a psychological event in its search for intentionality. Such a focus on

material objects and their consumption—for example, objects attract consumers because both are produced within a culture—too often ignores the crucial role of the retailer in the production of cultural meaning or the social construction of identity.

Urban studies focuses on the role that consumption has played in the delimiting of gender-specific spaces. Innovations in retail produced the "first instances of female-oriented space."[11] While much has been made of the impact of retail on urban spaces in terms of consumption and gender, actual forms of innovation have rarely been discussed. For example, the observation that shopping is largely an activity for women suggests that this gendered activity entails the accrual of knowledge and the cultivation of taste. From an urban studies perspective, gender, epistemology and aesthetics are significant in the production of urban spaces. Yet, what innovative forms provided for the establishment of urban spaces as spaces of consumption? Theorists of retail geography have paid close attention to both retailing and consumption, suggesting that the "point of purchase" and the visual display of products in retail sites greatly contribute to both the meaning of commodities and to the construction of consumer identities.

A recent study of the spatial organization of consumption argues, "The relationship between retailing and consumption is not only complex but mutually reinforcing."[12] Crucial to this study is how retail geography has pushed beyond the psychology of consumption to investigate the cultural significance of the interrelatedness of retailing and shopping. Understood in this way, we can also look to how it is that the social construction of the consumer along economic, political, and cultural lines produces historically specific visual displays within the retail environment. The

study explains, "[C]onsumption is a cultivated and conscious process wherein normative judgments are made about the value of the different physical spaces and social environments within which the act of consuming occurs."[13] This emphasis on retail and its spatial logic of visual display avails a more thorough account of the complexities of consumption and identity construction. Retailers have exploited the fact that the home represents its occupants, playing to their desires and anxieties.[14] The visual display of the home and the organization of home furnishings into a coherent and recognizable representation of domestic order are of paramount importance for the retailer.

Visual display establishes the normative judgments that inform the "mutually reinforcing" dynamics of both retailing and consumption. Design for display in the retail environment attempts to visualize "normalcy" as a mode of social assimilation and social ascendancy. It is assumed that the consumer can fully integrate the display in the store into her mental picture of her perfected home. Just as are advertising and marketing, so too retail is invested in the study of the visual field, spatially conceived to establish eidetic images and apperceptions that are crucial to, on the one hand, psychical motivations for consumption, and, on the other hand, a drive for acceptance and integration in the social sphere. Home furnishings were transformed into a mass business that relied on consumers to construct interiors that were representations of themselves as individuals.[15] The household engineering movement in the United States set these norms, which have since been replicated throughout the twentieth century and embedded in the visual display of modern home furnishings. These norms have since been codified across a range of retail environments and are now the norm of lifestyle retailing in the form of "branded" interiors like those marketed by IKEA.

RATIONALIZATION AND THE PATTERNS OF EVERYDAY LIFE

Household engineering impacted the visual display of the domestic sphere. The notion of a rational and efficient domestic space as it was considered by household engineering in the United States influenced modern design. Histories of science and technology have accounted for the rationalization of the domestic sphere.[16] By rationalization, I mean an impulse to organize aspects of experience according to logical and observable principles. The impetus of the domestic engineering movement in the United States was toward the attainment of a "modernist fantasy," in which control paradoxically equals freedom.[17] The home as a site of personal perfection was also a site of conflict between the pursuit of self-improvement and the regiment of social conformity.[18] Modeled after the radical productivity of industrial capitalism, domestic advisor Christine Frederick's methods of streamlining the activities of the home transformed the homemaker into one of many ready-made elements inserted into a system of production. Frederick restructured the home along the lines of scientific management. She eliminated all idiosyncratic tendencies and self-serving specialties, so that all home functions would become mechanized. Certainly, it was argued, an efficient household resulted in less labor for the homemaker, which in turn amounted to more leisure time and more time for shopping.

Diagrams and photographs of optimal work patterns were reproduced in Frederick's books and articles, in domestic advice magazines like *Better Homes and Gardens,* and they were codified into a design methodology in

Lillian Gilbreth's "Efficiency Methods Applied to Kitchen Design" in *The Architectural Record*.[19] Mapping the reduction of effort for homemakers, the domestic engineer took up Frederick Winslow Taylor's scientific management and Henry Ford's principle of "flow" as spatial organizations of work and production to organize the home into efficient routes that included, but were not exclusive to, bedroom to kitchen to stove to sink to dining room to table to kitchen to sink to bedroom to bed.[20] Domestic advisors represented these modifications as modes of empowerment and self-satisfaction in the pages of magazines and books dedicated to the self-improvement of the homemaker. As Frederick commented in the introduction of her book, "the deadening point about the whole situation was that I never seemed to finish my work, never seemed to "get anywhere," and that I almost never had any leisure time to myself."[21] The domestic advisor's new organization of housework and the physical design of the home promised a break from the "deadening" and ceaseless repetition of cooking, housecleaning, clothes washing, and childrearing. While the rhetoric of household engineering emphasized freedom from toil, the design of the home represented the concentration of homemaking activities into a series of replicating, and ever narrowing, movements.

The transition from the organization of the home to the organization of the store was rather nonmomentous and an obvious outcome of the trend in domestic advice. Here the overlapping of interiors—domestic space over retail space and retail space over domestic space—resulted from a remaking of a place of splendor into a familiar place. The richness of the store overcomes the poverties of the home. The success of such an overcoming was predicated on a comparative event in which one could observe the potential remaking of the home into an image of efficiency. As early as 1902, a gallery at the Mechanic's Fair Exhibition in Boston staged such a comparative event. Here visitors to the fair were presented with two examples of "typical living rooms"— one traditional and the other "modern." Domestic advisors hoped that the modern example would change the way Americans lived in their homes.[22] The visual rhetoric of before and after and of old and new argued for the less complex visual display of the "modern" and the trend toward efficiency in the home.

Soon retail spaces incorporated the lessons learned from comparison into the display of home furnishings. In the late 1920s, the American department stores John Wanamaker's and Macy's (both in New York City) opened "model room" exhibitions.[23] There was nothing modest about these displays. While emulating the glamour of movie set designs, the Wanamaker and Macy's rooms took up the "machine" like aesthetic of the "modern." In this case, efficiency and technological innovation signified the life worlds of the rich and famous. Machine aesthetics, efficiency, and technological innovation were also matters of taste. The "modern" had to be cultivated; thus, the strategies of the art museum informed the visual ordering of style and period in retail displays for the home. No doubt, the high-mindedness of the model rooms at Wanamaker and Macy's alienated some consumers who were not of the cultivated class or not predisposed to the modern style. No less efficient or modern, the "gallery store" originated with the Ethan Allen chain in the United States. Beginning in 1936, the Baumritter Corporation expanded its hardware business into the manufacture and sales of furniture under the Ethan Allen brand. Much of the success of the chain can be attributed to its introduction of the gallery

store, which included room settings.[24] The traditional styles on display at Ethan Allen were a far cry from the "modern" model rooms of the New York department stores. Nevertheless, both instances of retail innovation of home furnishings were in keeping with the models set by domestic engineering in their visualizations of ideal spaces. Whether purchasing modern furniture for a Park Avenue penthouse in Manhattan or buying traditional furniture for a bungalow in Oskaloosa, Iowa, each instance had to contend with the ongoing rationalization of the domestic sphere. The issue of design for display, then, was less a matter of style and more a matter of organizational techniques.

In the 1920s, Europe had accepted scientific management as an American phenomenon and had sought to integrate this "characteristic feature of American civilization" into all aspects of labor, production, and efficiency.[25] The rationalization of the home reinforced the "social possibilities of mechanization."[26] Indeed, these "social possibilities" were predicated on the pursuit of efficiency in all aspects of life, from the laboratory to the home. In the German context, "patterns of living" in the postwar years were drawn from American techniques of scientific management as they were applied to the home.[27] Within the German *neue Wohnkultur*, American style rationalization of the domestic space took on a cultish following.[28] Influenced by American domestic advisors, progressive German designers conceived of the model of the "New Dwelling" along the lines of American household engineering. This was despite the fact that there existed entirely different conditions in Germany in the early 1920s.[29]

While the rhetoric of American household engineering focused on the construction of an efficient kitchen (the *Kochküche* in Germany),

German designers expanded the role of scientific management in the home to include all areas of and activities in the domestic sphere. Modernist architects like J.J.P. Oud, Adolf Meyer, and Bruno Taut were all sympathetic to the prescriptions of American domestic advisors. Such was their influence that Erna Meyer illustrated her book *Der neue Haushalt* (1926) with the work of *Neues Bauen* architects, and Taut used Christine Frederick's books as models for his *New Architecture*.[30] The culmination of the American influence took two important forms of visual display. The first was Georg Muche and Adolf Meyer's experimental house project at the 1923 Weimar Bauhaus exhibition. The second, and farther ranging, was the 1927 Weissenhof exhibition in Stuttgart. The latter was "the product of the enthusiasm" for American scientific management.[31]

Like the comparative events offered to visitors to the Boston exhibition, a comparison of traditional and modern was the case at the Weissenhof exhibitions. The event was first staged with the distribution of images that announced the exhibition and that marketed its newness through the visual rhetoric of comparison. Willi Baumeister designed a series of three posters for the Werkbund exhibition, which oversaw the case studies exhibited at Weissenhof. Two of Baumeister's posters featured photographs of cluttered Victorian interiors. In each of these posters, a red hand-drawn "X" crossed out the obsolete interiors of the past. The third poster featured a photomontage of the Weissenhof interiors.[32] The exhibition itself performed the work of Baumeister's third poster. Nowhere was an interior from the past to be found on the grounds of the exhibition. Instead, visitors found twenty-one structures designed by seventeen architects from Germany and abroad. It took a total of fifty-five

designers to organize and fit the interiors of these many structures. For example, in the case of Ludwig Mies van der Rohe's "House 1," Walter Schneider designed the living room of Apartment 1 and Richard Lisker designed the bedroom of Apartment 2. In each instance, the designer fulfilled the exhibition criteria for rationalization and standardization.[33] In addition to the model homes and housing units presented at Weissenhof, there was an indoor exhibition of furnishings, fittings, and other items, including Bauhaus furnishing fabrics, Deutsche Linoleum Werks, and IG Farben curtains.[34] Overall, the exhibition was a resounding success, especially for the designers associated with the Bauhaus. Their furniture designs were associated with Weimar "radical chic" and were unofficially reproduced soon after the exhibition.[35] The German furniture industry dominated Europe in the 1920s, in part due to its adaptation of American-style mass production.[36]

The Germans were not alone in their passion for the rational approach to the patterns of everyday life in the home. The Swiss architect Le Corbusier took up the challenges of scientific management. Scientific management was crucial to Le Corbusier's design and theory of the interior. The tenets of Taylorism became pervasive in "*l'esprit nouveau*" after the war.[37] As he wrote in *Towards a New Architecture* (1928, trans. 1928), "The Engineer, inspired by the law of Economy and governed by mathematical calculation, puts us in accord with universal law. He achieves harmony."[38] Indeed, his conception of the house as a "machine for living in"[39] struck some critics as hostile to family life.[40] While it may have been the case that Le Corbusier understood the radical implications of scientific management, much like American domestic advisors, he approached its application to the design of the domestic space as a

means to reorganize the family unit. He was not so progressive in his attitudes as to ditch the family *tout court;* rather he was progressive enough to understand that housing and the reorganization of the domestic sphere were means to redistribute its social dynamics. The potential of household efficiency resulted in Le Corbusier's redesign of the modern interior as a way to remodel society. Not only did scientific management influence his conception of architecture, but it also led to a full-on analysis of the interior space, including its furnishings.[41] This resulted in his design for the "*casiers standard*" modular storage group, his rationalization of furniture into basic units, and his design of the "Domino" system for the mass production of housing.[42]

Both the modular storage units and tubular steel-framed tables were key components in the interior of the Esprit Nouveau Pavilion at the International Exposition in 1925. Le Corbusier designed his pavilion in opposition to the Exposition's celebration of elaborately decorated luxury goods. While French designers had been impressed by the systematic and unified work of Munich furniture design, as it was exhibited in 1910 in Paris, the traditions of the highly aestheticized decorative work of the past still reigned. It was not until 1925 that Le Corbusier's style incorporated the machine into French design traditions.[43] Indeed, the "purified" geometry of industrial objects and the rationalization of their production had influenced Le Corbusier's interior of the Pavilion. Where he could not have furniture made to his specifications, he incorporated Thonet bentwood chairs, because of their geometrical integrity and their mass producibility. He wanted to mass-produce homes just as Ford had mass-produced automobiles.[44] Le Corbusier was successful in this pursuit when he produced a variation on the Pavilion for the

Weissenhof exhibition in 1927. Here visitors experienced the same modular organization of the interior—Baumeister 's geometric abstract paintings, Thonet bentwood chairs, and tubular steel tables.

DISPLAY

The experiments and exhibitions of the European modernists produced two lines of advice on the decoration of the home. The first was one that promoted tradition, nationalism. and continuity with the past. No doubt this conservative move in interior decoration was a response to the traumas of World War II. The second was along the lines of the development of Modernist rationalism. Regardless of which line designers and retailers pursued, there existed an underlying rational for the composition of interior spaces. Whether traditional or modern, the two lines of thought on interior design and retail furnishing were not necessarily mutually exclusive. Indeed, the rationalization of the domestic space had little to do with the representation of a modern style and more to do with the organizing tendencies of modernity.

Where in the United States the organization of the home came to represent freedom from drudgery and in Europe similar ideas came to connote a new social order, in Britain the organization of the home signified freedom from postwar depression, as exemplified by the Heals bedroom suite and other displays at the Britain Can Make It exhibition in 1946.[45] The realization of the goal set by the 1946 exhibition happened in the early 1960s. The rise of "swinging England" beginning in 1963 and the influence of Carnaby Street affirmed that indeed Britain had made it.[46] Founded in 1964, Terence Conran's Habitat innovated the organization of retail space and developed

"coordinated setting displays" of home furnishings. Habitat presented shoppers with "carefully arranged room sets that suggested how furniture could be used."[47] Importantly, the store leveraged this retail innovation into the establishment of a vital brand.[48] And yet, Conran believes that retailers are not educators. In his view, "[I]t is not our responsibility to increase design awareness or put on design exhibitions."[49] But if awareness and education are synonymous with "lifestyle" and all three are the unintended results of retail display, then all the better. Perhaps Conran's resistance to the idea that Habitat and other stores like it were in the business of educating the public is due to a perceived resistance to the utopian projects of European modernism.[50]

An end run around the resistance to European modernism came in the form of the importation of Scandinavian design. The light molded forms exported from Sweden, Denmark, Finland, Norway, and Iceland were seen as the antithesis of the functional furniture of the prewar years. Scandinavian design connoted a more humanistic approach to the organization of the domestic space.[51] Beginning in the 1950s, exhibitions of Scandinavian design in England and the United States contributed to its mass appeal and its retail presence in both countries. And its international circulations contributed greatly to a heightened awareness of "good" design.[52] For this reason, Scandinavian interior design became popular between 1940 and 1960. Indeed, Habitat was one instance of the influence that Scandinavian design had on retail furnishing and housewares. During those years, Scandinavian furniture established a significant hold on the international market to such an extent that it is regarded as the first "mass furniture style" of the twentieth century.[53] One of the hallmarks of the Scandinavian design craze in the two

decades after the war was "its association with craftsmanship and quality."[54]

The Boston based D|R was one of the first retailers in the United States to capitalize on the "branding" of Scandinavian Design. In 1959, Benjamin Thompson invited Armi Ratia, the founder of the Finnish design company Marimekko, to install a display of Finnish design in his Brattle Street store. The boldness of Ratia's installation of brightly patterned fabrics among an assortment of products from Europe was a success. The arrangement resulted in D|R becoming the sole retailer of the Finnish line of clothing and fabric in the United States. (The Chicago-based Crate & Barrel would soon become another distributor.) Chair of the Department of Architecture at Harvard and partner, along with Walter Gropius, in TAC (The Architect's Collaborative), Thompson committed himself to making "good" design available to all.[55] The emphasis on the domestic and the everyday was the guiding design ethic of display at D|R. Objects were organized within a "modern family home setting."[56] Shoppers could browse the items on display in actual living room, bedroom, and kitchen settings. Thompson chose products based on the perceived needs of the consumer, bucking the traditional retail system of purchasing according to already established buying patterns.[57] The organization of these products—from all over the world—was based on a philosophy of multicultural mixture. The juxtaposition of Marimekko prints, Italian plastic kitchenware, and Palumbo molded chairs, hand-blown glassware from Wirkkala and Aalto birch furniture, and Thompson's own designs created an image of worldly goods and a kaleidoscope of "good" design.[58] The arrangement of disparate objects into a unified display further enhanced the crucial success of the domestic scale of the store. Even when the

D|R was relocated across the street to Thompson's concrete and glass building and expanded to include stores in New York City and San Francisco, the image of domesticity remained as the character of quality.

One might characterize the permissive approach to goods on display at D|R as the retail version of "critical regionalism" in support of domestic engineering. The term denotes "recent 'regional' schools whose aim has been to represent and serve, in a critical sense, the limited constituencies in which they are grounded."[59] The regional status of Marimekko was best exemplified in a story on the design company in *Life* magazine.[60] The photographs taken by Tony Vaccaro are at great pains to locate the designs within their regional context. The outcome, however, is an exoticism that frames the designer-clad models as glamorous others liberated by the expressiveness of their fashionable attire and surroundings. A photograph of a naked blond woman in a four-poster bed and wrapped in Marimekko linens reveals the schema of domesticity and its social reproduction. The caption reads: "Finnish Bridgitte snuggles into black-and-white printed cotton sheets (two sheets and two pillow cases, $49)." The model's pose suggesting that she waits for her male counterpart to join her in heterosexual domestic bliss underscores its complicity in the maintenance of social norms. Very similar connotations are mapped onto the visual display of Marimekko goods in the D|R stores. The apparent transparency of display belies the underlying rationalizing tendencies of retail sales as they were informed by scientific management and circulated through modern principles of interior design and architecture. As one critic observes, "Despite an apparent freedom of expression, such a level of liberative regionalism is difficult to sustain today."[61] This state of affairs has to do with the

too easy co-option of authentic regional expression for marketing purposes. Informed by the studies in the psychology of advertising, such forms of co-option are turned coercive in their production of schemas of desire. Indeed, the association of domestic bliss with modern design is integral to the biological functions of the home. This aestheticization of modern rationalism transformed into consumer desire performs an integral role in the social reproduction of normative activities in the home.

MARKETING TO DISPLAY CULTURE

Display culture, as I argue above, began with domestic advisors mapping efficient movements in the home. These maps were spatialized or made "spatial," first, in the performance of domestic work, and, second, in the production of retail displays and exhibitions of home furnishings. Beginning with Christine Frederick's "domestication" of scientific management, its spread across Europe, and its eventual efflorescence with D|R, the spatial logic of the visual display of the home in a retail setting has transformed into display culture. The visual display of ideal home decoration and furnishing now offers consumers an experiential form of mapping in three dimensions and in "real" spaces. The domestic scale that D|R innovated is now standard retail practice. Such is the case that all manner of retailers from Anthropologie to Ralph Lauren display their goods in a homelike setting. There are multiple registers of viewing and experiencing domesticity in design culture. The pursuit of lifestyles becomes more fluid in a culture where retail environments are designed to give the consumer the sense of already inhabiting the world of his or her dreams. Mass-market retail organizations like the Swedish IKEA capitalize on this aspect of visual display so as to fix an image of

upward mobility in the minds of its consumers. Here the "message" of design *is* desire. As Penny Sparke observes, "Partly as a result of its appropriation by large mass-market retail organizations such as IKEA, the message of design had been diluted, and there was a sense of that consumer "desire" needed to be reinvigorated in new ways."[62] Yet, IKEA has reinvigorated consumer desire by constructing displays that consumers can easily retrofit into the patterns of their everyday lives. In this, the international IKEA Group has realized the aspirations of early twentieth-century domestic engineering in its conception of the furniture retail store as a place that is responsive to the desires of its customers. Affordability, ease of distribution, and the do-it-yourself ethic all contribute to IKEA's marketing of attainable perfections for the home and for the self—what their Vision Statement describes as "A better everyday life."[63]

NOTES

1. "Bright Glass Prism on Brattle Street," *Architectural Record* 147 (May 1970): 105.
2. "The 'Design Research' Prophesy," *Process: Architecture* 89 (June 1990): 14.
3. "Bright Glass Prism on Brattle Street," 111.
4. Quoted in Catherine Bauer, *Modern Housing* (Houghton Mifflin Company, 1934), 141.
5. Peter Wollen, "Introduction," in *Visual Display: Culture beyond Appearances,* ed. Lynne Cooke and Peter Wollen (Bay Press, 1995), 4.
6. David Harvey, *The Condition of Postmodernity: An Enquiry into the Origins of Cultural Change* (Blackwell, 1989), 54.
7. Harvey, *The Condition of Postmodernity,* 10.
8. Harvey, *The Condition of Postmodernity,* 10.
9. Daniel Miller, *A Theory of Shopping* (Cornell University Press, 1998), 9.
10. Jules David Prown, "Mind in Matter: An Introduction to Material Culture Theories," *Winterthur Portfolio* 17, no. 1 (Spring 1982): 1.

11. Chuihua Judy Chung, "Ms. Consumer," in *Harvard Design School Guide to Shopping,* ed. Chuihua Judy Chung (Taschen, 2002), 507.

12. Sallie A. Marston and Ali Modarres Marston, "Flexible Retailing: Gap Inc. and the Multiple Spaces of Shopping in the United States," *Tijschrift voor Economische en Sociale Georgrafie* 93, no. 1 (2002): 84.

13. Marston and Marston, "Flexible Retailing," 87.

14. Clive Edwards, *Turning Houses into Homes: A History of the Retailing and Consumption of Domestic Furnishings,* History of Retailing and Consumption (Ashgate, 2005), 219.

15. Edwards, *Turning Houses into Homes,* 225.

16. The defining texts are Christine Frederick, *The New Housekeeping: Efficiency Studies in Home Management* (Doubleday, Page & Company, 1913); and Mary Pattison, *Domestic Engineering: Or the What, Why, and How of a Home* (Trow Press, 1915). For an early and somewhat problematic account of the history of the rationalization of the domestic sphere, see Sigfried Giedion, *Mechanization Takes Command: A Contribution to Anonymous History* (Oxford University Press, 1948). The history of the scientization of the home is covered in Gwendolyn Wright, *Building a Dream: A Social History of Housing in America* (Pantheon Books, 1981); Glenna Matthews, *"Just a Housewife": The Rise and Fall of Domesticity in America* (Oxford University Press, 1987); and Kathleen Anne McHugh, *American Domesticity: From How-To-Manual to Hollywood Melodrama* (Oxford University Press, 1999).

17. Sarah Abigail Leavitt, *From Catharine Beecher to Martha Stewart: A Cultural History of Domestic Advice* (University of North Carolina Press, 2002).

18. Michael J. Golec, "Martha Stewart Living and the Marketing of Emersonian Perfectionism," *Home Cultures* 3, no. 1 (March 2006): 5–20.

19. Lillian Gilbreth, "Efficiency Methods Applied to Kitchen Design," *Architectural Record* (March 1930): 291.

20. On "Fordism" and "flow" see Terry Smith, *Making the Modern: Industry, Art, and Design in America* (University of Chicago Press, 1993).

21. Frederick, *The New Housekeeping,* vii.

22. Leavitt, *From Catharine Beecher to Martha Stewart,* 98.

23. Marilyn F. Friedman, *Selling Good Design: Promoting the Early Modern Interior* (Rizzoli, 2003), 31.

24. Edwards, *Turning Houses into Homes,* 202. By the 1960s, the firm had expanded such that, by 1968, it operated some one hundred franchise stores across the United States.

25. Charles S. Maier, "Between Taylorism and Technocracy: European Ideologies and the Vision of Industrial Productivity in the 1920s," *Journal of Contemporary History* 5, no. 2 (1970): 27.

26. Maier, "Between Taylorism and Technocracy," p. 28.

27. Nicholas Bullock, "First the Kitchen: Then the Facade," *Journal of Design History* 1, nos. 3/4 (1988): 177.

28. Bullock, "First the Kitchen," 178.

29. Bullock, "First the Kitchen," 180–81.

30. Bullock, "First the Kitchen," 184–85.

31. Bullock, "First the Kitchen," 185.

32. See Karin Kirsch, Gerhard Kirsch, and Deutscher Werkbund, *The Weissenhofsiedlung: Experimental Housing Built for the Deutscher Werkbund, Stuttgart, 1927* (Rizzoli, 1989), 19–20.

33. Kirsch, Kirsch, and Werkbund, *The Weissenhofsiedlung,* 55.

34. Kirsch, Kirsch, and Werkbund, *The Weissenhofsiedlung,* 24–30.

35. Frederic J. Schwartz, "Utopia for Sale: The Bauhaus and Weimar Germany's Consumer Culture," in *Bauhaus Culture: From Weimar to the Cold War,* ed. Kathleen James-Chakraborty (University of Minnesota Press, 2006), 132.

36. Penny Sparke, *Furniture.* Twentieth Century Design. (Bell & Hyman, 1986), 29.

37. M. McLeod, "'Architecture or Revolution:' Taylorism, Technocracy, and Social Change," *Art Journal* 43, no. 2 (1983): 133.

38. Le Corbusier, *Towards a New Architecture* (Brewer and Warren, 1927), 1.

39. Le Corbusier, *Towards a New Architecture,* 95.

40. McLeod, "'Architecture or Revolution,'" 140.

41. Charlotte Benton, "Le Corbusier: Furniture and the Interior," *Journal of Design History* 3, nos. 2/3 (1990): 111.

42. See McLeod, "'Architecture or Revolution,'" 135, and Benton, "Le Corbusier," 111–12.

43. Nancy Troy, "Toward a Redefinition of Tradition in French Design, 1895–1914," *Design Issues* 1, no. 2 (Autumn 1984): 169.

44. Tag Gronberg, "Making up the Modern City: Modernity on Display at the International Exposition," in *L'esprit Nouveau: Purism in Paris, 1918–1925,* ed. Carol S. Eliel (Los Angeles County Museum of Art in association with Harry N. Abrams, 2001), 111.

45. Sparke, *Furniture,* 76. For an account of the impact of the exhibition on design in Britain, see Nigel Whiteley, "Pop, Consumerism, and the Design Shift," *Design Issues* 2, no. 2 (Autumn 1985): 32.

46. Whiteley, "Pop, Consumerism, and the Design Shift," 42.

47. Elizabeth Wilhide and Terence Conran, *Terence Conran: Design and the Quality of Life* (Watson-Guptill Publications, 1999), 12.

48. Edwards, *Turning Houses into Homes,* 203.

49. Quoted in Edwards, *Turning Houses into Homes,* 182.

50. The British reception of scientific management was not as enthusiastic as it was on the Continent. See Maier, "Between Taylorism and Technocracy," 30. While not necessarily related to retail and the design of housewares and furniture, Robin Kinross accounts for the historical and cultural context of the British reception of European Modernism. See Robin Kinross, "Émigré Graphic Designers in Britain: Around the Second World War and Afterwards," *Journal of Design History* 3, no. 1 (1990).

51. Sparke, *Furniture,* 60.

52. Penny Sparke, *An Introduction to Design and Culture: 1900 to the Present,* 2nd ed. (Routledge, 2004), 200.

53. Sparke, *Furniture,* 65.

54. Sparke, *Furniture,* 65.

55. Marianne Aav and Bard Graduate Center for Studies in the Decorative Arts Design and Culture, *Marimekko: Fabrics, Fashion, Architecture* (Yale University Press, 2003), 154.

56. Aav et al., 154.

57. "The 'Design Research' Prophesy," 14.

58. "The 'Design Research' Prophesy," 14.

59. Kenneth Frampton, "Prospects for a Critical Regionalism," *Perspecta* 20 (1983): 148.

60. "Bright Spirit of Marimekko," *Life,* June 24, 1966.

61. Frampton, "Prospects for a Critical Regionalism," 155.

62. Sparke, *An Introduction to Design and Culture,* 180.

63. Quoted in Youngme Moon, "Ikea Invades America," *Harvard Business School Bulletin* (2004): 5.

CONQUEST, COLONIALISM, AND GLOBALIZATION

INTRODUCTION

Jane Kromm

The imperialistic and "civilizing" correctives pursued by dominant societies through conquest and civilization were supported by distinctive forms of representation that belied the true nature of the colonial order. Some invasive impulses might be channeled into strategies of exploration and exploitation, and they too were also established and then maintained by a pervasive visual apparatus. These and other efforts grounded in unequal transactions of control and exchange were the subjects of a visual apologetics ranging across an ever-expanding racial and geographical field. Whatever precise form these apologias assumed, a standard relation predominated, which saw European modernism in the superior position, and colonial cultures, often with the imputation of primitivism and savage behavior, positioned well below. In fact, the colonial experience was conceived in European cognitive terms as well, from such high-end phenomena as academic painting on exotic subjects, world expos, and expeditions documented by artists and writers, to a lower end of models, maps, dioramas, fashion, and tourism.

The Western obsession with exotic Eastern countries that was known as Orientalism transformed the culture of the Near East and North Africa into a style exemplified by a small number of motifs such as the harem, the bazaar, or the hunt, whose fascinating contours filled salon canvases and travel accounts. Slave trading within and beyond this geographical area flourished, and the conflict between philanthropic assistance and economic expediency activated by these transactions created a preoccupation with images about the marketing of human beings. Historical artifacts and the indigenous cultures of overtaken lands, as in the tradition of the spoils of war, presented opportunities for gains in status and riches through the wholesale acquisition of another nation's artistic heritage. In an era of globalization, transferrals of property across territorial boundaries and the complex problems these actions create are complicated further by a world public with a supraterritorial mindset who query whether things are too familiar or too foreign, with ownership as well as boundary issues becoming newly critical distinctions for our understanding of visual culture.

ORIENTALISM AND ITS VISUAL REGIMES (1830–1880)

The Western preoccupation with the lands and cultures around the eastern Mediterranean and North Africa, the "Orient," was a romanticizing and emotional one. Travelers, merchants, military operatives, and explorers produced or commissioned depictions of people and scenery that helped to establish the colonizers' visual control over the colonized for consumption by Western spectators. This imagery in its cumulative effect comprised a style and formal system that was able to pass for a kind of political reality, identified with a visual regime as oppressive as any other type of rule. The main components of this style or regime were the antithesis of Modernism in the West, repeatedly underscoring

the passive and inchoate, the damagingly emotional, the nonrational, and the barbaric. These qualities reinforced the truth claims of European colonizing efforts as they presented isolated, exotic cultural phenomenon as exemplary for entire cultures and countries. Such vignettes depict the harem, the bazaar, or the hunt, and revel in a visual tactics of Orientalism by their sharp focus on intrigues of concealment and confinement, of entrapment and exposure. Pretending to document where they invent and to describe where they embellish, the visual regimes of Orientalism adjust the unfamiliar sights of racial and cultural differences to an "exhibitionary order" for Western consumption. It is this order's false truth claims that current postcolonial thinking has endeavored to expose.

Mathew Potter's chapter, "Orientalism and Its Visual Regimes: Lovis Corinth and Imperialism in the Art of the Kaiserreich," examines the visual preoccupations of German artists, including Emil Nolde and Wilhelm Liebl and concentrates on the work of Lovis Corinth in particular. Most studies of orientalism have focused on this topic—the Western construction of the exotic "other"—as it played out in France and England. Recent studies suggest that forms of Orientalism in Germany were significant too, and distinguished by colonial efforts that while on a relatively small scale, were notable for engaging the urban middle class on more personal levels of profit and acquisition. German colonialism was intimately linked to issues of German national and domestic identity, with artists like Nolde including Eastern objects in his still-life paintings. Positioned alongside familiar items, these exotic elements created a tension explored by numerous modern artists attracted to the "primitive" in contrast to the civilized as a means of questioning assumptions about identity. Even images of German primitivism, such as the depictions of peasants by Liebl, were drawn into explorations of contemporary life launched by colonial opportunities. Corinth's work bears the closest resemblance to the Orientalist history paintings popularized by French academic painters, with depictions of the harem and femme fatale figures in scenes that cast eroticism and voyeurism as the visual core of non-Western cultures. But unlike these "normative" French orientalizing canvases, Corinth's images show German middle-class types unconvincingly acting various parts in costume dramas of greed and promiscuity, offering in effect a parody of modern urban life rather than a glimpse into an imaginary non-Western world.

MARKETING THE SLAVE TRADE (1830–1880)

Slave trading continued to flourish in the modern era, and images recording numerous aspects of the enterprise proliferated—sometimes to divert attention from and sometimes to bring attention to—slavery's more problematic features. Such images demand close scrutiny, so that the implicit standards and values they convey can be identified. This is especially critical when slaves are presented as the most natural and willing of elements in a market economy or an open, free society. In many depictions that circulated throughout Europe, England, and North America (and the latter in particular), commercial realities often were effaced and subordinated to the higher-profile motivations of philanthropy and charitable assistance that some saw as acceptable justifications for their enterprise. A confidence in productive activity for its own sake contributed to the popularity of scenes depicting slaves working the land together in a communal spirit that seemed to mimic the values of Western society, even as the same images showcased the solid ownership vantages of property, stock, and breeding. By contrast, auction notices, conditions of capture and transport, and depictions of punishments argued for the tragic aspects and undeniable cruelty that accompanied the slave trade and were perpetrated

by its sponsors. But it was the images of daily life and especially representations of the newly freed with a seemingly positive edge—with former slaves participating fully in society as both subjects and objects—that stretched the limits of visual pretension by attempting to cast emancipation in purportedly natural and Westernized terms.

Marcus Wood's chapter, "Marketing the Slave Trade: Slavery, Photography and Emancipation: Time and Freedom in 'The Life of the Picture,'" examines the new forms of photography, including daguerreotypes and *cartes-de-visite,* that purported to report the acts and effects of emancipation for the new markets of freed slaves, for abolitionist societies, and for consumers of magazines and newspapers. These photographs articulated the contrast between slavery and freedom in new ways in images complicated by their medium's problematic relationship to the elements of time and to conceptions of reality. Works representing emancipated blacks from an album of photographs taken by the war artist James Taylor reveal an indeterminate, still somewhat displaced status for those recently freed by the Union army. Even though grounded in the traditions of group portraiture, such images convey, through the variables of stasis or movement, focus or diffusion, the existential indeterminacy of the slave body. The *cartes-de-visite* used for professional and social situations of exchange also were adapted to the emancipation scenario with examples that rely on a visually common "before–after" sequence. These photographs supposedly document the liberating joy experienced by grateful figures, and in fact, most of the visual records of emancipation take a similarly propagandistic view in which passive slaves receive their freedom with suitable expressions and demeanor. Photographs commissioned and distributed by antislavery societies to celebrate successful escapes of slaves, by contrast, invoked the drama and exotic daring of a foreign expedition. But the majority of photographs that document official ceremonies of emancipation legislation tend to be organized instead around those figures and forces granting freedom rather than to the recipients of this new freedom themselves.

CULTURES OF CONFISCATION (1880–2001)

The traditional rights of conquest entitled victors to the cultural artifacts and valuables of the conquered. This cultural form of imperialism authorized the appropriation of objects, transporting them to other sites for private display and public exhibition as symbols of superiority, domination, and usurpation. Modern variations of this acquisitive practice occur within countries as well as between them and concentrate on the confiscation of cultural property for political reasons. Widely held standards of ownership, property rights, and inheritance were in this way temporarily suspended in the interests of the usurping rights of governing bodies or invading forces. Many of these actions were rationalized through various arguments grounded in the politics and poetics of cultural precedence. Common justifications might include a superior ability to care for certain artifacts or a better appreciation of their value. And often patterns of conquest and acquisition were presented as an advanced society's natural rights, requiring little in the way of justification. Yet there are outstanding examples of acquisition, like the Elgin marbles, whose questionable ethics persist in public debate and continue to be the center of controversy. Investigations are ongoing into the dispossession of works from museums, galleries, and private owners before and during World War II, with objects being returned and repatriated as a result. More recently, the demonization and destruction of the Bamiyan Buddha figures in Afghanistan have raised the practice of cross-cultural confiscation to a new and ominous level.

Kim Masteller's chapter, "Cultures of Confiscation: The Collection, Appropriation, and Destruction of South Asian Art," examines local, national, and international issues of ownership and cultural property in relation to several art sites and objects, including the Bamiyan Buddhas of Afghanistan, *Tipu's Tiger,* the Ashokan Lion Capital from Sarnath, and the Nehru family home museum. Destroyed by the Taliban in 2001, the Bamiyan Buddhas had been created when Indian image-based religious practices prevailed in this area. At that time, the figures were revered in rituals that united visual experience with the divine, and they had since become objects of local pride and veneration before ideological forces hostile to all representation insisted on their annihilation. *Tipu's Tiger,* a life-sized wood sculpture now in the Victoria and Albert Museum, was acquired by the British East India Company in the late nineteenth century as a spoil of war following the defeat and death of the work's owner and namesake, Tipu Sultan, the "Tiger of Mysore." Wrested from its cultural context, the sculpture is now a kind of trophy in a public museum, a museum housing a world art collection with other objects whose ownership rights are being increasingly debated. The Ashokan Lion Capital excavated from a Buddhist monastery in Sarnath, India, was later considered as a potential emblem for that country's national flag, an act that would erase the object's origins and historical meanings. These and many other objects of world art have been variously collected, appropriated, and even destroyed by the political and ideological conflicts surrounding ownership and representation, a situation that has recently reached a new extreme of strident intolerance and disrespect for cultural difference.

TRADING CULTURES: THE BOUNDARY ISSUES OF GLOBALIZATION (1960–2000)

The late modern phenomenon of globalization, with its worldwide publics extending over unprecedentedly large areas, has turned the familiarity or strangeness of visual culture into newly controversial subjects for debate. Supraterritoriality and deterritorization are the spatial concepts that globalization enhances, making border issues with their hyperconscious sense of space and place some of the most critical and challenging aspects of the postmodern world. Conjuring up the harmonious nature of experience that globalization might produce and maintain through the mechanisms of consumerism and advertising could be refreshingly unifying or chillingly imperialistic. From another vantage, the visual world culture of globalization could offer a desirable diversity enlivened by local variations on broader themes. These might represent the optimal effects of the hybrid over the homogeneous, even if the result was sometimes a difficult-to-comprehend picture of fragmentation. Opportunities for intercultural collaboration in the arts created by globalization's model of a transworld spatial reach have mobilized reactions steeped in transborder sensibilities. An acute awareness of limits, margins, perimeters, or enframements characterizes much of the significant visual thinking about the new global status of visual culture.

Nada Shabout's chapter, "Trading Cultures: the Boundary Issues of Globalization," examines the contradictory elements unleashed by the forces of globalization. Despite its promises of mediating, unifying, and empowering across traditional boundaries, globalization often continues to foster the familiar, frequently exploitative networks of capitalism and imperialism. Recent developments in the art world are investigated in this chapter in relation to these contradictory dynamics of globalization in an attempt to understand whether and to what extent they constitute exemplary developments of inclusiveness and acceptance. One example of these new developments is the inclusion of some women

artists with Islamic or Arabic backgrounds in group exhibitions beginning in the 1990s. Shabout finds in this practice more evidence for the shortcomings rather than the benefits of globalizing operations. The critical reception of works by Shirin Neshat, Shazia Sikandar, Ghada Amer, and Mona Hatoum tends to associate them with a largely imaginary, simplified notion of their very different backgrounds. Some of the familiar Orientalist biases resurface alongside presumptive accounts of the art produced by this disparate group, particularly in relation to issues of identity, religion, and ethnicity, and often in contrast to the artists' own comments. This blinkered outlook tends to flatten the individual character of the art works considered, revealing that the positive outcomes anticipated by globalization are often in practice handicapped by the persistence of the very boundaries that globalizing inclusiveness was supposed to overcome.

ORIENTALISM AND ITS VISUAL REGIMES: LOVIS CORINTH AND IMPERIALISM IN THE ART OF THE KAISERREICH

Matthew Potter

In the history of cultural exchange between East and West, the phenomenon of Orientalism has commanded great attention. In their cataloging and cognitive functions, Orientalist discourses encompass both objective and subjective perspectives that have controlled perceptions of Eastern cultures through the mixing of real and fantastic elements. Much Orientalist scholarship has focused on "normative" French and British experiences to the neglect of other examples, such as Germany. While historians have recently exorcised the "peculiarities" of German history, most notably the specter of the *Sonderweg* (special path) as an explanation for twentieth-century geopolitical traumas, domestic constitutional and political issues have tended to be privileged.[1] Was there a *Sonderweg* for Germany in terms of its imperial ambitions and Orientalist visual culture, or did it conform to standards set by its Franco-British rivals? Can familiar "hegemonic" controls be detected in its art? Did the nationalist anxieties of this fledgling state in combination with a desire to flex industrial and military muscles result in an Orientalist art that represented an even greater fantasy of dominion? Using postcolonial theory alongside an empirical account of German imperialism, this chapter pushes the discussion of art

and Orientalism in Germany beyond current chronological limits back to the end of the nineteenth century.

The distinctive nature of Germany's imperial experience is deeply enshrined in the foundation of modern Orientalist discourse. In his seminal text on *Orientalism,* Edward Said set out what has become the standard definition of this cultural enterprise, as a more perfect reflection of the subjective ideologies and identities of its Western authors rather than an objective or authentic representation of the "real" East. This cultural exchange between East and West took on a hegemonic character, for, according to Said, Orientalism "*is,* rather than expresses, a certain *will* or *intention* to understand, in some cases to control, manipulate, even to incorporate, what is a manifestly different (or alternative and novel) world."[2] Said was careful to distinguish Germany from its imperialist neighbors, establishing that the German term *Orientalismus* had a narrower ideological meaning due to the lack of a nation-state or coherent national interests in that country for much of the nineteenth century.[3] However, such assumptions of difference have since been challenged because, despite its informal nature, Germany's imperialist activities "nevertheless display structural and functional similarities

to the Orientalist representations generated by the culture of colonial powers."[4]

Given the opportunist *Realpolitik* nature of post-Unification Germany, questions of power inevitably infused domestic as well as foreign affairs. Artists shared the belief systems of their Western compatriots and even played active affirmative roles in broadcasting Orientalist ideologies through their practice. They reassembled Eastern objects using their Western hands, minds, and eyes in various erotic, exotic, and explicatory modes spreading "knowledge" and influencing imperial destinies. Art historians like Griselda Pollock have described how male Western artists used Orientalism to exert power over women and indigenous peoples, with "imperialising claims" that perpetuated "fantasies of a universal human nature, an ideology of sameness which is only possible because of an uncritical acceptance of the authority of masculinity, whiteness and Europeanness."[5] Yet these descriptions of dominant ideologies and alternatives of "otherness" have tended to oversimplify Orientalist cultural exchanges. With his concept of "hybridity," Homi Bhabha has fractured previously homogenous groupings of "them" and "us,"[6] and this paradigm shift can be helpfully carried through into investigations of Orientalism in art.[7]

It is no accident that francocentric Modernist and postcolonialist discourses have conspired to privilege accounts of French Orientalism in art, with their examples of politically programmed history painting, exotic fantasy, documentary realism, allegorical allusion, and indulgent aesthetic pleasures. However, in the 1870s, when France's colonial confidence was waning and Britain was overstretched, Germany's imperialism took place under vastly different circumstances. Its industrial and political appetites were paired with inexperience in colonial governance. What did imperialism mean during the *Gründerzeit* (the period following Unification)? Its nineteenth-century intellectual culture was couched in the neo-Platonism of Kantian philosophy, which represented the very "fantasies of a universal human nature" and the "ideology of sameness" of Western idealism that Pollock identifies as problematic. Additionally Germany shared a crucial constitutional characteristic with France; like the Napoleonic "Empires" before it, the term *Reich* inextricably linked state and empire, and implied the necessity of colonization.

While territorial ambitions were based initially in the creation of a unified state in Europe, certain interest groups saw European and global empire as indistinguishable due to Britain's precedent.[8] While individual German adventurers, merchants, and scientists had been involved in the imperial enterprises of other nations in previous centuries, it was only under Otto von Bismarck that state-sponsored imperialism began, with *Schutzgebiete* (protectorates) declared in response to the opportunist acquisitions of men like Carl Peters in Africa. In 1884–1885 the state sanctioned a series of colonies in Africa (Southwest Africa, Togo, Cameroon, and German East Africa) and the Pacific (northeastern New Guinea, part of Samoa, the Bismarck, Marshall, Caroline, and Mariana Islands, and Kiaochow in China, which would form the extent of Germany's imperialism until the end of World War I, when they would be forfeit as part of the Versailles settlement. The German empire was a small-scale and unstructured expedient for the personal profit and political gain of its champions, and ultimately none of the colonies provided substantial returns as economic, migratory, or strategic opportunities.[9]

A historical consensus on the nature of German imperialism is conspicuously lacking.

Writing the visual history of German imperialism is made difficult when "even historians in Germany have traditionally accorded little attention to Germany's colonial past."[10] Multiple forms of popular, economic, and bureaucratic imperialism have been identified, with each interest group rendered ineffective as much by infighting as by external opposition.[11] Nevertheless, there is agreement that the key stakeholders in state and empire were the middle classes, who, as historian Wolfgang Mommsen puts it, "yearned to belong to a large and powerful state and thus have a share…in the great processes of political decision-making that the semi-democratic nature of the constitutional system debarred them from influencing directly."[12] The assumed link between the saber-rattling conservative *Junker* (Prussian military aristocracy) and imperialism has been thus dismissed as part of the *Sonderweg* myth. It is instead clear that German colonialism of the 1880s was "anti-conservative" and the product of an alliance between power politicians and an ambitious modernizing urban bourgeoisie.[13] The experience of empire had a deep psychological impact upon the Germans. While fantasies of domination and superiority were rehearsed by the power-hungry middle class in what some saw as the "safety" of the colonial theater, there were nevertheless domestic repercussions as "German colonial fantasies affected notions of Germanness and of German cultural and national identity."[14]

A similar mindset informed the race for empire as did constructions of national and middle-class identities, with the *Bildungsburgertüm* (educated middle classes) using universalizing systems to define nation *and* empire. Before 1884 the peculiar status of Germans as Europeans without colonial possessions allowed them to assume the identity of enlightened arbitrators, "objective onlookers,"

siding with natives as victims of atrocities,[15] but despite their rhetorical subscription to liberal ideals, eventually the values that had freed the eighteenth-century citizens of the West now allowed for the enslavement of Oriental populations in the nineteenth century.[16] An example of this occurs in Karl May's *Orientzyklus* novels (1881–1888), in which his "hero" starts out as an objective scientist, only to lapse into a stereotypical violent colonizer, brandishing a whip, which he uses ever more frequently against the indigenous peoples he encounters, as a symbol of colonization, empowerment, and subversion.[17] In seeking to understand the values of the imperial past it is, however, dangerous to replace Enlightenment assumptions with postcolonial ones, for to do so is simply to exchange ideological paradigms. Conceptual hybridization offers a richer heterogeneous alternative whereby Orientalism and Enlightenment may be seen as opposite *and* equivalent perspectives. Postcolonial methods can thus be used to identify, analyze, and record, not dispel episteme or expunge past ideologies.[18]

Recent historical studies of German imperialism have largely omitted artists. Engagements with Oriental subjects were more common in the multicultural centers of the Hapsburg Empire, where artists like Ludwig Deutsch (1855–1935) and Rudolph Ernst (1854–1932) adopted francophone academic accents in their depiction of Oriental genre scenes. By contrast, a much more subtle engagement with Oriental subjects took place within Germany, which reflected the unstable relationship of nationalism, imperialism, and artistic identities. The frequent synonymy of state and empire often filtered through into the attempts of artists to create iconographic representations of the new *Reich*. While the realist art of Adolph von Menzel (1815–1905)

seemingly avoided any direct engagement with colonial affairs and artifacts, Orientalism informed his depictions of Zulu and Japanese displays at international exhibitions.[19] Even his historicist paintings of the life of Frederick the Great contain oblique reference to the Enlightenment foundations and military arrogance of the new *Reich*.

NOLDE, CORINTH, AND LEIBL: GERMAN PRIMITIVISM AT HOME AND IN THE COLONIES

Primitivism presents itself as the most obvious starting point when searching for the impact of empire on German art. Artists such as Emil Nolde (1867–1956) and Max Pechstein (1881–1955), who were connected with *Die Brücke* movement, decorated their studios with primitive artifacts—Oriental and European[20]—while theorists like Wilhelm Worringer began to examine the nonfigurative empathetic potential of such objects in *Abstraktion und Einfühlung* (1907).[21] Nolde's 1911–1912 ethnographic still-life work (fig. 17.1) provides a good case study of Western misrepresentations of Oriental visual culture using Orientalist sources for modernist and primitivist ends.[22] Despite finding autonomous artistic value in these artifacts,[23] Nolde used his Orientalist vision of the East to promote a new national identity for Germany in the West.[24] This manipulation was consistent with his Nietzschean view of imperialism, in which colonies were disposable props for a European rebirth, and the artist himself painted with revolver in hand like the fictional hero of the *Orientzyklus*.[25] The combination of progressive and regressive values meant that Nolde "fell between the stools of conservative and modernist values, relating to aspects of both but identifying fully with neither."[26]

Fig. 17.1 Emil Nolde, *Masks*, 1911.

and this fractured identity was carried through into his simultaneous appreciation for home-grown German "primitive" art.

That Wilhelm Leibl (1844–1900) inspired Nolde's *Fishermen* (1902) suggests that there was an equal enthusiasm for *völkisch* and Orientalist primitivisms in Nolde's "spiritual counter-images to the modern world."[27] These constructs can only be understood in terms of peasant ideology and the "Blood and Earth" motivation for imperialism and *Lebensraum* (living space) policies, with their territorial perspectives.[28] Leibl trained in Munich but for nine months in 1870 worked with Gustave Courbet in Paris. His studies of unidealized peasants appealed to a public seeking the visual manifestation of a "true" *völkisch* German spirit (see fig. 17.2).[29] While painters of rural Germany were guilty of romantic artifice, transforming their subject matter "in the manner of ethnographers" and Orientalists, Leibl's works by contrast offered "blunt realism," representing peasants as they "were" in all their contradictions and ambiguities.[30]

Fig. 17.2 Wilhelm Liebl, *Peasants in Conversation/The Village Politicians*, 1877.

A second axis of affinity may be extended to another artist, Lovis Corinth (1858–1925), in this ideological triad of primitivism, imperialism, and Orientalism in German art. In his autobiography, Corinth noted the importance of the Leibl circle in the formation of a modern national school of art, rejecting "franco-slavic international art," and claimed that "Leibl, Feuerbach [and] Victor Müller...showed us the way to achieve such a German art."[31] Like Nolde, Leibl's work was thus inspirational to Corinth.[32] After Leibl's death in 1900, Corinth wrote an appreciation of the artist, recounting the spiritual impact of seeing *Die Wilderer* (The Poachers, 1884) on exhibition in Paris, for "It was as if *furor teutonicus* led it by the hand."[33] Corinth designated the work as a masterpiece and found special value in Leibl's painstaking labor, concordant with Corinth's own "primitive" upbringing in East Prussia. Corinth's autobiography records how the *Plattdeutsch* (Low German) environment he grew up in culminated in a *"primitivsten Schulbildung"* (a primitive school education) and a singular absence of *"Weltbildung"* (worldly learning).[34] The peasantry had a special character and value to him[35] and was very much part of his

identity as an outsider figure and a "hands-on" artist, who displayed practical energy typical of the "old principle of the East Prussian."[36]

THE ORIENTALISM OF LOVIS CORINTH'S *SALOME*

Jill Lloyd's assertion of "the reluctance of German nineteenth-century artists to leave the shores of Europe," partly due to the lateness of colonial acquisitions, plays an important role in tying the innovations of German primitivism to the first decade of the twentieth century.[37] However, the chronological watershed this implies is misleading. The assumption that *Orientalismus* did not influence the work of artists before Nolde, simply because they did not visit the colonies in person, is potentially dangerous, for as Menzel's example shows, colonial objects could nevertheless come to Germany. Bismarck's alternative *Gross-* and *Kleindeutschland* (Large and small Germany) strategies for Unification demonstrated that the racial constitution of the new state was open to debate, and the incorporation of non-European dominions was only a minor complication in an already complex formula. Corinth internalized the awkwardness of these identity debates in his self-promotion as a boorish East Prussian peasant, conspicuous in the sophisticated art centers of Germany, ever the outsider.[38] There is ample evidence that imperial concerns informed Corinth's worldview. Returning to Königsberg, he recalled the berth of the steamer, with its advertisement for "William Bauer, colonial business and steamer expeditions," demonstrating the pervasive nature of imperial business in the domestic sphere.[39] It was also embedded in the peculiarly colonial mindset of his relatives, who had developed over generations a "stubbornness and craze after acquisition," with his

farmer grandfather moving to the Pregel valley in East Prussia "in order to colonize new land."[40]

Corinth's work has always defied comfortable categorization by historians, symptomatic as it is of fin-de-siècle fractures in the German art world.[41] In a similar way to Nolde, Corinth stood awkwardly between the camps of the progressives and the Wilhelmine "philistines." His admiration for modern French artists like Gauguin, Cézanne, and Manet was based on their personal visions and not on the schools and imitators they inspired in Germany.[42] While 1909 found Corinth lamenting the narrow-mindedness of German art, by 1914 the war saw him patriotically attacking foreign styles.[43] As in the literature of Paul de Lagarde and Julius Langbehn, Corinth's art sought sanctuary in an idealized realm, seeking to see off the challenges of modern life in a redeployment of traditional values and iconographies.

The effusive nudes of the age represented an ideological rallying point, linking the religious, spiritual, and erotic concerns of the imperial German art world and engendering "overlaps between salon painting and that most voyeuristic branch of nineteenth-century art, Orientalism."[44] As with the machinations of the *Bildungsbürgertum,* Corinth's use of the genre of history painting was cemented in its "universal" appeal to humanistic values.[45] Corinth was schooled in history painting at Königsberg and Munich and, despite developing a critical view of it in the 1880s, maintained an engagement with its principles in such works as *Pietà* (1889) or *The Temptation of Saint Anthony* (1897).[46] Instead of judging this engagement as merely conservative or reactionary, Corinth's history paintings can be seen as coded critiques of establishment values. The melodramatic exaggerations of emotion in their "un-idealised" figures "over-state...to the point

where they seemed to parody the subjects and narratives concerned."[47] Corinth's subtle adoption and subversion of conventional history-painting techniques allowed him to explore modern ambiguities as an outsider. By questioning but not condemning the imperial enterprise, Corinth's Orientalism engaged with a quintessentially modern subject, within a cultural frame that allowed it to be defused and talked away as history painting.

In his depiction of the Oriental, it is undeniably true that many charges of postcolonial discourse stick to Corinth's canvases. The black eunuch in *Harem* (fig. 17.3), 1904, seems to serve an aesthetic purpose that fits into French forms of Orientalist desire and sexual potency. Even his relatively straight-forward depiction of Black models, as in *Negro ("Un Othello"),* 1884, are made problematic by the insertion of a Shakespearean reference. In other works further Western constructs of the Orient appear, especially where figures are patently Orientalized Westerners playing at being primitive.

Nevertheless, Corinth was critical of Karl von Piloty's "hollow phrases" and "orgies of costumes," choosing to see Orientalism as an opportunity to broadcast a mindset predicated on a particular reading of the history of civilization, as he wrote in 1904: "the nude is the Latin language of painting."[48] While this statement could indicate an academic belief that the nude in art had the same universal foundational function as Latin grammar in language, the contemporary cultural contexts and Corinth's personal position suggest greater ideological significance. First, his relationship to classical education was not that of an insider. His backward East Prussian instruction distanced him from contemporary public school curricula in which civic humanist values of order were promoted. Fin-de-siècle classicism was also more closely

Fig. 17.3 Lovis Corinth, *Harem,* 1904.

associated with origin myths and Dionysian critiques, so for Corinth the magic of Homer's *Odyssey* was more appealing than the military history of the Roman Empire or the speeches of Cicero. In this reading the nude becomes a liminal figure, bridging the worlds of the urbane Roman and the "wild" Greek. Corinth further collapsed East/West divides with the hybridity of this construct, for the actual Easterner became lost in a complex matrix of

racial theory and *Urgeschichte* (primordial history) of Western civilization, replicating the assumptions of nineteenth-century anthropologists and their Aryan theories. The Bacchanalian excesses of Corinth's art similarly fit into an understanding of his work as describing a preternatural "otherness" for modern Germans to identify with, providing simultaneously satirical comment on and affirmation of the contemporary *Freikörperkultur* (cult of nudism).[49]

Corinth's *Salome* (fig. 17.4), 1900, was the climactic work of his Munich period. The aesthetic appeal of the fanciful nude is clear to see, as is the sensationalism of its passionate and violent abandon, in a mode recalling Delacroix. Most scholars read within this work Corinth's continuation of Gustave Flaubert and Gustave Moreau's critiques of the "irreconciliability of sexes,"[50] but it also reflects a gendered representation of hegemonic imperial relationships between the "colonizing" male and the "colonized" female. Arguably more interesting, though, is the "bare-breasted wanton form" of Salome, who art historian Bernhard Schwenk suggests is "an aristocratic whore in Oriental costume."[51] This judgment is, however, unleashed without any evident perception of its attendant complexities and oxymoronic content. Can a whore be aristocratic? Would not Oriental masquerade be problematic for Corinth given his own rejection of Piloty's "orgies of costumes"? These contradictions can perhaps be reconciled through a contextual reading of this Orientalist painting as a parody of its Berlin audience, critiquing their money-grubbing and land-grabbing ways. In its appearance on the Berlin art scene, *Salome* was exceptionally opportune, for it fitted perfectly into the frame provided by the contemporaneous reception of Mesopotamian visual culture.

Fig. 17.4 Lovis Corinth, *Salomé*, 1900.

Between 1899 and 1908, the imperial regime in Berlin attempted to harness the recent German triumphs in Babylonian archaeology for the glorification of the *Reich* as a direct challenge to British and French authority in matters archaeological and geopolitical. This archaeological enterprise fitted into the ideological and imperial ambitions of Wilhelm II, both militarily and racially, for: "To see figures on Assyrian reliefs as blonde-haired Aryans moves not only to colonize an entire artefactual field for a contemporary system of racial/national identity, but to appropriate the identity of an ancient empire renowned for its military might to that of a contemporary nation that sought to match it."[52] The kaiser's role was central as the head of the *Deutsche-Orient Gesellschaft* that funded the Babylonian excavations. The Assyriologist Friedrich Delitzsch's blasphemous identification of Babylonian origins for many Old Testament rituals threatened to alienate conservatives and Christians from this imperial project, but a timely state-sponsored performance of the more traditionalist play *Sardanapal* in 1908 defused the situation.[53] This episode amply

demonstrated the volatile and fractured nature of the imperial core that Corinth found on his 1900 arrival in Berlin. Compared to Munich, "cosmopolitan" Berlin was more receptive to titillating femmes fatales, which played to the carnal appetites of the capital's elite,[54] and, after all, the purchaser was a Rheinland industrialist who personified the modernity of the Berlin elite.[55]

Corinth portrayed himself as "swimming like a pike" through Berlin society, hinting at his cynical and predatory nature, while Julius Meier-Graefe described the artist as a "paunchy east Prussian on the make" and "like a polar bear with little red eyes he moved through the ballrooms of Berlin. He looked greedily at many a banker and many a banker's wife as she danced in his arms: a pig ripe for the slaughter!...At dinner he always had two jugs of wine by his plate."[56] Despite its accurate reflection of Corinth's commercial astuteness, the description of Berlin as cosmopolitan is potentially misleading. Munich's cosmopolitanism had seen Corinth's *Salome* languish, received as a relatively tired take on a Symbolist stock in trade. By contrast, Berlin's cosmopolitanism was of an innovative metropolitan type. At the center of the new nation and empire, *Salome* could be reborn as a parody of imperial and worldly excess through the medium of baroque realism.[57] In parading the dangers of overindulgence in Oriental excess, Corinth seduced and critiqued the new imperial and industrial elite using the selfsame carnal elements. Consistent with the antimaterialistic nature of many German Modernist dystopian visions, the equation of the East with matter and raw materials also fits with Said's Orientalist readings, for it enables the West to inhabit the role of the ideal creator that alone can make sense and significant forms out of the inchoate potentiality of the East.

This interpretation of *Salome* is strengthened by reference to two further examples of Corinth's reflection on imperial themes. While Lothar Brauner believes *The Trojan Horse* (1924) represents the artist's melancholic abandonment of history painting as parody,[58] it is in fact pregnant with continuities. If the horse is a metaphor for Corinth, then Berlin and Troy become synonymous. Rehearsing his personal conquest of the imperium in such a way represents a dark kind of humor, evidencing the way typologies of imperial dominion informed private and public spheres in the German art world. *Fair Imperia* (1925) continued the critique of corrupt authority represented by *Salome*. Taking Honoré de Balzac's *Contes Drolatiques* as its inspiration, this painting explored the moral bankruptcy of the Vatican in the fifteenth century.[59] This questioning of spiritual and secular power was relevant to Corinth, given his exposure to the reactionary Catholic policies of 1890s Bavaria and his own position of authority within the Berlin Secession; he was depicted as its pope and emperor by one satirical cartoonist of 1911.[60]

Ultimately for Corinth, primitivism and modernity were never fully resolved notions. The duality of domestic peasant and foreign exotic types of primitivism shared features but were not identical. It is perhaps unsurprising, given the impact of World War I, that Corinth developed a reactionary position as he reflected on the recent past. Complaining of the poverty of inspirations for the creative senses, he blamed it on the "punch in the face of naturalism" represented by "Tango, Cubist painting and the Hottentot naivety of art"—denigrating southern African tribesmen and the Parisian avant-garde in a seeming equivalence of values.[61] Even so, he continued to retain the belief in the need to regenerate

German art "by posing as and imitating an exotic savage Naïve-Man."[62] Such positioning helps us to understand better his anxieties over being labeled an expressionist and his own misgivings concerning the work of *Die Brücke* and associated developments.[63]

CONCLUSION

This discussion of Orientalism and art in Germany demonstrates that while certain aspects of German imperialism did constitute a *Sonderweg* of sorts (such as the short lifespan of its colonial possession from 1884 to 1919, and its lack of contiguous colonies or a significant diasporic literature), after the *Gründerzeit* the German colonial experience nevertheless conformed to Anglo-French "normative" standards, albeit at an accelerated rate for which it was arguably institutionally and psychologically insufficiently prepared. The inhumane excesses of Carl Peters and General Lothar von Trotha in Africa illustrate these failures most spectacularly.[64] The art of Corinth and Nolde represents fanciful responses to this environment and the modern culture generated by imperial control in Germany. Neither artist had focused political agendas for their work, but their paintings nevertheless represent "visual regimes" for normalizing Germany's imperial and Oriental experiences. The stereotypical division of "them and us" was not avoided in the German *Reich* or its Orientalist art, but such polarizing views were accommodated in the hybridized representations of German identity it led to at home. The importance of *völkisch* elements in art works of this period shows a crucial point of connection between domestic and overseas conceptions of the *Reich*. As artistic interventions they act as qualifiers to the enthusiasm for empire and modernity among the middle classes, constituting an ambiguous critique of modern life via primitivist explorations of the new national and imperial identities of Germany.

NOTES

1. David Blackbourn and Geoff Eley, *The Peculiarities of German History: Bourgeois Society and Politics in Nineteenth-Century Germany* (Oxford University Press, 1984).
2. Edward Said, *Orientalism* (Routledge & Kegan Paul, 1978), 12.
3. Said, *Orientalism,* 19.
4. Nina Berman, "Orientalism, Imperialism, and Nationalism: Karl May's *Orientzyklus,*" in *The Imperialist Imagination: German Colonialism and Its Legacy,* ed. Sara Friedrichsmeyer, Sara Lennox, and Susanne Zantop (University of Michigan Press, 1998), 52.
5. Griselda Pollock, "Beholding Art History: Vision, Place and Power," in *Vision and Textuality,* ed. Stephen Melville and Bill Readings (Macmillan, 1995), 39–40.
6. Homi K. Bhabha, *The Location of Culture* (Routledge, 1994), 5–6.
7. See for example Matthew Potter, "British Art and Empire: Holman Hunt's *The Light of the World* reflected in the Mirror of the Colonial Press," *Media History* 13, no. 1 (April 2007): 1–23.
8. Arne Perras, *Carl Peters and German Imperialism 1856–1918: A Political Biography* (Oxford University Press, 2004), 6; Arthur Knoll and Lewis H. Gunn, eds., *Germans in the Tropics: Essays in German Colonial History* (Greenwood, 1987), xiii.
9. Perras, *Carl Peters and German Imperialism,* 1, 8, 10, 257; Friedrichsmeyer, Lennox, and Zantop, "Introduction," 10.
10. Friedrichsmeyer, Lennox, and Zantop, "Introduction," 3.
11. Lewis H. Gunn, "Marginal Colonialism: The German Case," in Knoll and Gunn, *Germans in the Tropics,* 3; Wolfgang J. Mommsen, *Imperial Germany 1867–1918: Politics, Culture,*

and Society in an Authoritarian State (Arnold, 1995), 71–72, 75, 79, 92.

12. Mommsen, *Imperial Germany 1867–1918,* viii.

13. Mommsen, *Imperial Germany 1867–1918, 73.*

14. Friedrichsmeyer, Lennox, and Zantop, "Introduction," 6, 19.

15. Susanne Zantop, *Colonial Fantasies: Conquest, Family, and Nation in Precolonial Germany, 1770–1870* (Duke University Press, 1997), 20, 40.

16. Friedrichsmeyer, Lennox, and Zantop, "Introduction," 3.

17. Nina Berman, in Friedrichsmeyer, Lennox, and Zantop, *The Imperialist Imagination,* 56, 58, 60.

18. Russell A. Berman, *Enlightenment or Empire: Colonial Discourse in German Culture* (University of Nebraska Press, 1998), 6–8.

19. Claude Keisch and Marie Ursula Riemann-Reyher, *Adolph Menzel 1815–1905: Between Romanticism and Impressionism* (Yale University Press 1996), 313, 418–19: *Zulus* (c. 1863) and *Japanese Painter (At the Japanese Exhibition)* (1885).

20. Jill Lloyd, *German Expressionism: Primitivism and Modernity* (Yale University Press, 1991), 46, 54–57; Shearer West, *The Visual Arts in Germany: Utopia and Despair* (Manchester University Press, 2000), 49.

21. West, *The Visual Arts in Germany,* 68–69.

22. Jill Lloyd, "Emil Nolde's 'Ethnographic' Still Lifes: Primitivism, Tradition, and Modernity," in *The Myth of Primitivism: Perspectives on Art,* ed. Susan Hiller (Routledge, 1991), 90–91, 102.

23. Russell A Berman, *Enlightenment or Empire,* 227–228.

24. Berman, *Enlightenment or Empire,* 229.

25. Berman, *Enlightenment or Empire,* 229; Russell Berman, "German Primitivism/Primitive Germany: The Case of Emil Nolde," in *Cultural Studies of Modern Germany: History, Representation, and Nationhood,* ed. Russell A. Berman (University of Wisconsin Press, 1993), 117–18, 120.

26. Berman, "German Primitivism," 94–95.

27. Lloyd, "Emil Nolde's 'Ethnographic' Still Lifes," 93, 103.

28. Friedrichsmeyer, Lennox, and Zantop, "Introduction," 23–24.

29. West, *The Visual Arts in Germany,* 37.

30. Nina Lübbren, *Rural Artists' Colonies in Europe 1870–1910* (Manchester University Press, 2001), 40, 47–49.

31. Lovis Corinth, *Selbstbiographie* (S. Hirzel, 1926), 131.

32. Horst Uhr, *Lovis Corinth* (University of California Press, 1990), 70, 142, 295.

33. Lovis Corinth, "Wilhelm Leibls 'Wilderer,'" in *Lovis Corinth Gesammelte Schriften: Charlotte Berend-Corinth Mein Leben mit Lovis Corinth,* ed. Kerstin Englert (Gebr. Mann Verlag, 1995), 67.

34. Corinth, *Selbstbiographie,* 62.

35. Corinth, *Selbstbiographie,* 2: "Erst veil später reimte ich es mir zusammen, dass die Bauern und einfache Leute wichtige Ereignisse relativ miteinander bekennzeichen."

36. Corinth, *Selbstbiographie,* 100.

37. Lloyd, *German Expressionism,* 192: West, *The Visual Arts in Germany,* 67.

38. Peter-Klaus Schuster, Christoph Vitali, and Barbara Butts, eds., *Lovis Corinth* (Prestel, 1996), 8, 38.

39. Corinth, *Selbstbiographie,* 42.

40. Corinth, *Selbstbiographie,* 61.

41. Peter-Klaus Schuster, "The Birth of a Nation from the Spirit of Art: The Nationalgalerie in Berlin on its 125th Anniversary" in *Spirit of an Age: Nineteenth-Century Paintings from the Nationalgalerie, Berlin,* ed. Françoise Forster-Hahn, Claude Keisch, Peter-Klaus Schuster, and Angelika Weisberg (National Gallery, 2001), 14–16.

42. Schuster, Vitali, and Butts, *Lovis Corinth,* 16, 50.

43. *Lovis Corinth,* 19.

44. Robin Lenman, *Artists and Society in Germany 1850–1914* (Manchester University Press, 1997), 88.

45. Bernhard Schwenk, "'One Can Treat the Subject Matter in a Hundred Different Ways [...]': Corinth in Munich," in Schuster, Vitali and Butts, *Lovis Corinth,* 25.

46. Uhr, *Lovis Corinth,* 7, 9, 18, 26, 151.

47. Maria Makela, "Lovis Corinth's 'Themes': A Socio-Political Interpretation," in Schuster, Vitali and Butts, *Lovis Corinth,* 60.

48. Schwenk, "'One Can Treat the Subject Matter,'" 28–29.

49. Schwenk, "'One Can Treat the Subject Matter,'" 34; Jill Lloyd, *German Expressionism,* 107–10.

50. Uhr, *Lovis Corinth,* 119; Schwenk, "'One Can Treat the Subject Matter,'" 35.

51. Uhr, *Lovis Corinth,* 119; Schwenk, "'One Can Treat the Subject Matter,'" 35.

52. Schwenk, "One Can Treat the Subject Matter,'" 292.

53. Frederick N. Bohrer, *Orientalism and Visual Culture: Imagining Mesopotamia in Nineteenth-Century Europe* (Cambridge University Press, 2003), 280, 289.

54. Schwenk, "'One Can Treat the Subject Matter,'" 35.

55. Corinth, *Selbstbiographie,* 150.

56. Lenman, *Artists and Society in Germany 1850–1914,* 114.

57. Jill Lloyd, "Lovis Corinth: Intimations of Mortality," in Schuster, Vitali, and Butts, *Lovis Corinth,* 69–71.

58. Lothar Brauner, catalog entry, in Schuster, Vitali, and Butts, *Artists and Society in Germany 1850–1914,* 306.

59. Brauner, catalog entry, in Schuster, Vitali, and Butts, *Artists and Society in Germany 1850–1914,* 314–16.

60. Andrea Bärnreuther, "Biography," in Schuster, Vitali, and Butts, *Lovis Corinth,* 18.

61. Corinth, *Selbstbiographie,* 128.

62. Corinth, *Selbstbiographie,* 130; "sondern eine exotische wilde Männer-Naivität direkt zu imitieren und zu posieren."

63. West, *The Visual Arts in Germany,* 99.

64. Perras, *Carl Peters and German Imperialism,* 197–99, 215–30; Jan-Bart Gewald, *Herero Heroes: A Social-Political History of the Herero of Namibia 1890–1923* (James Currey, 1999), 142, 164–65, 191; Jeremy Sylvester and Jan-Bart Gewald, eds., *Words Cannot Be Found: German Colonial Rule in Namibia: An Annotated Reprint of the 1918 Blue Book* (Brill, 2003), vii.

MARKETING THE SLAVE TRADE: SLAVERY, PHOTOGRAPHY, AND EMANCIPATION: TIME AND FREEDOM IN "THE LIFE OF THE PICTURE"

Marcus Wood

Because of the comparatively recent dates of slavery abolition in the United States (1863) and Brazil (1888), many photographs recording the processes and experiences of emancipation were made. These daguerreotypes, glass negatives, albumen prints, tintypes, and *cartes-de-visite* constituted a wholly new and different emancipation archive from that which went before. It is the purpose of the following discussion to think about the interpretative, aesthetic, moral, and indeed temporal aspects of these works that might differentiate them from the preceding visual art that had claimed to represent the experience of slave freedom. Early photographs of slave emancipation, because of the fraught relation of the medium with time and reality, were capable of empowering the black subject and even of expressing slavery and freedom, as human conditions, in new ways. The discussion is centered on set-piece analyses of four very different images that represent slave emancipation, three of them North American and one Brazilian.

TIME ON HIS HANDS: JAMES TAYLOR AND THE SLOW EXPOSURE OF FREEDOM

I have one favourite photograph...my hand is half raised, not to pat Shade on the shoulder as seems to be the intention, but to reach my sunglasses which, however, it never reached in *that* life, the life of the picture.[1]

Some of the most extraordinary images to track the lives, and the fight for survival, among the thousands upon thousands of newly emancipated blacks, as the Union army moved through the South, are contained in the albums of James Taylor.[2] Taylor was a celebrated war artist, and collector of war memorabilia, who produced vivid sketches mainly for *Leslie's* magazine, throughout the war. He moved with Sherman's army as it cut a swath through the deep South. As he traveled he took photographs and amassed images from other nomadic war photographers, in order to use them as primary source material to work into the drawings that would eventually appear as wood engravings in *Leslie's*. The most powerful thing about these images is that they have an unguarded and spontaneous documentary veracity that is very rare in the formally posed photographs of this time. Made using the wet plate, or wet collodion process, and printed from glass negatives, the images could be made in under ten, and in good conditions as little as three, seconds. These images consequently exist in a hinterland between the instantaneous effects we now associate with

the snapshot, and the frozen formality of the daguerreotype, with its vastly extended exposures, which necessitated formal posing and prolonged stasis.[3]

All the blacks Taylor photographed have just been liberated by the Union army, yet they exist in a social and military state of indeterminacy. The vast majority of Civil War photographs featuring blacks show them not as spectators of war, or even as soldiers, but as "contraband of war." This now odd-sounding term, suggesting that the slaves are illegal, illicit, extrajudicial, but still property, was the accepted contemporary label for black slaves who passed into the Union lines, and it is often repeated in the captions to the photographs in Taylor's albums, and in the commentary to Mathew Brady's celebrated Civil War albums. As far as the photographers who made the images are concerned, the blacks in these pictures are part of the shifting flotsam and jetsam of property cut loose, and turned up, by the processes of war. I want to focus on one image of Taylor's that shows with a particular force the unstable and destabilizing effects of the slave body, here the infant slave body, when placed within a setting of white liberating patriarchal military power.

FACELESS SIGNIFICANCE AND STATIC IRRELEVANCE— OBLITERATION AND EMANCIPATION THROUGH MOTION

The photograph Taylor made bearing the manuscript title "Camp Stoneman, Cavalry Regiment" (fig. 18.1) shows Colonel Gamble and his officers amassed for a group portrait.[4] The senior officers sit splendidly turned out, with polished boots and shining buttons, the junior officers standing behind them. But there are also three freed blacks and two domestic animals in this portrait, and each of these beings operates in a very different interpretative space from the rest of the inhabitants of the image. The carefully staged portrait of Colonel Gamble, Major Sawyer, and their officers suggests the bizarre tensions that existed between black and white under the temporal forces of early photography. This image is at one level all about stasis, the refusal of stasis, and what this refusal might do to authority and memory. It is also about the glorious unpredictability and temporal subversiveness of the glass albumen technique. Two out of the three black figures are adult males who stand right at the back, directly above the heads of the two seated senior officers. The third is a little black boy in a soft white hat, trousers, and shirt, who sits between the polished boots of the two senior officers, in the center of the foreground. In terms of the space of portraiture these black figures define the limits of the picture plane. The standing blacks define the point at which space loses its principal narrative authority, when the focus of middle ground moves off into something distant and less important. The little boy defines the point at which the foreground becomes too close, too intimate, the point at which the foreground abases itself and falls beneath both the feet and the interest of the main protagonists, and by implication the photographer and the viewers.

The blacks mark out special boundaries; they have been ordered quite precisely into the pictorial margins of portraiture, and yet they challenge the legitimacy of those margins. The two distant blacks, with faces one-quarter, maybe one-fifth the size of those of the white officers, have been ordered to retreat two or three paces behind the rump of the major's horse, which has also been sent to the back of the picture plane, but not as far back

Fig. 18.1 James Taylor, *Camp Stoneman, Calvary Regiment.*

as the blacks. And yet the time of exposure and the deep focus lens ensure that of all the faces in the picture, those of the distant blacks are the most perfectly in focus. Their formal, glassy, fierce stares are set off against their conspicuous lack of uniform, the informal dress that casts them as extras, outside the military drama. The figure on the right is almost ironically celebratory in his lack of uniform. He is wrapped in loose fabric fantastically decorated with polka dots, or possibly flowers; he is wearing a silk dressing gown or possibly a woman's shawl. As he hugs himself, swathed in the feminine fabric, his informality and domesticity somehow make an ironic comment

on these stiff soldiers, and his slackness also links him with the little boy at the front.

The little boy with his bare feet, loose white suit, and vast white Panama hat, quaintly parodic of traditional planter dress, rests in a recumbent zigzagging parody of Hogarth's serpentine line of beauty. The little black hands tenderly embrace an ambiguous plaything. It may be a doll, but the animated intensity with which he holds it suggests a pet, probably a puppy or a kitten. The black face is lost, a dark smudged patch floating within the frame of collar and blurred hat—a face without feature, a face lost in space, a face lost in a certain pitch-blackness that may or may not be its own

pigmentation. This black boy exists in a narrow furrow, a special spatial gutter that lies explicitly between the feet and the knees of the leading officers. Gamble and Sawyer, the authority figures in their broad cavalry hats, have both flung their right legs over their left knees. The left legs swing out below the knees and the toes of their gleaming boots and hang in the space where the black infant sits, caging him within an empowered white military world of swords and brilliant boot leather. He has moved dramatically, and so shares with the horse the distinction of being conspicuously out of focus, yet alive. He is a trace, a map of movement which challenges in its vivacity what now appears the forced, the phony, stasis of the other figures.

This print asks what it means to have focus and to lose focus, in a world where people pretend that time has stood still and that they can control their own image. Maybe what we see here is a definition of black freedom and white aesthetic servitude. The stiff and ineffectual theatricality of the posed white soldiers appears superficial, its fragile authority obliterated by the black hole of the boy's lost face. This is the fact of blackness; the child's face is a black hole we are challenged to dare to enter. In aesthetic terms what this face displays is not the mere prick, or puncture of the Barthesian *punctum,* but a *vulnus,* a rent.[5] The boy's arbitrary effacement weirdly indicates the internalized racism of the soldiers, who cannot see him as an individual and an equal, and who placed him as a pet, and in so doing unconsciously mimicked the gesture of so many English and American eighteenth-century portraits of slaves and masters. And yet the picture also contains a new element of empowerment for the black subject. In his anonymity, in his intimate emotionalism as he grips his pet in a loving gesture, in his casual clothes, and most of all in his insistence on moving, in real time,

this infant is a perpetual mystery and an energized challenge to the absolute control these white soldiers assume. Here the formal group portrait is unexpectedly invaded by documentary realism. No drawing, painting, or wood engraving could mimic this effect, cause such a collision, and bring the slave into freedom and back to life. What this image finally tells us about slavery and freedom, about emancipation and empowerment, is remarkably complicated, but maybe one way of looking at it is as a definition of marginality.[6]

"BEFORE AND AFTER": SLAVERY, PHOTOGRAPHY, FREEDOM, AND THE FUTURE

In order to understand how important that faceless little black boy who smeared himself across Taylor's image is, it is useful to consider the photographic archive he exists in relation to, and in tension with. So what did photography lead to when it was being commandeered to describe the official record of emancipation? In the formal narrative espoused by popular propaganda, and developed out of the tried and trusted narrative mechanisms used by British abolition, emancipation might be described as illustrating a moral Big Bang theory. Slaves move from nonbeing into being; they move from the moral chaos of slavery into the refulgent light of an ordered Christian liberation. The moral life of the slave begins with the passage of a bill, the reading of a law, but how do you make that graphically exhilarating, and what advantages might photography have when it comes to the representation of such a blinding narrative flash? By 1865 photography had reached the technical position where it could claim to record action. Action photography as we know it, with shutter speeds of a thousandth of a second or less, was of course

years ahead. But two- or three-second exposures were capable of recording some action; if a subject held an expression, then images could be made that caught something close to a "fleeting expression." This quality came in most useful when describing the finality of abolition in terms of an instantaneous emotional transformation.

One popular photographic solution to the challenge of articulating the explosive transformative impact of the gift of freedom was the "before and after" diptych. There were many variations on this model, which was in fact well tried out in the context of erotic art of the Baroque (the passage of a couple from sexual innocence to experience). The device was to become a staple of product advertising in the twentieth century. Andy Warhol, who so loved to explode high and low art distinctions took cosmetic surgery "before and after" photography in order to create some hilarious early paintings satirizing American consumerism.[7] Yet Warhol was not the first to move the "before and after" formula from the popular domain into somewhere ideologically and aesthetically more serious (fig. 18.2).

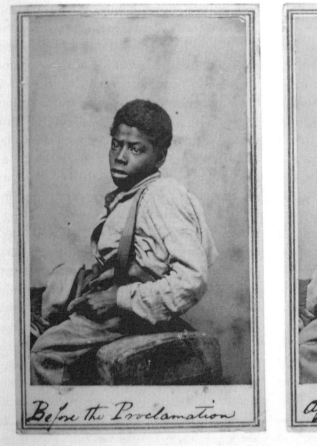 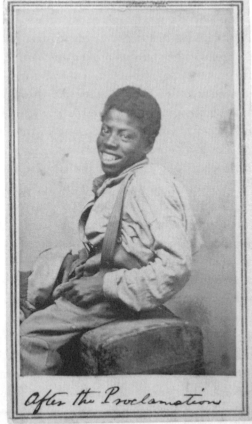

Fig. 18.2 Morse and Peaslee, *Before and After the Proclamation*, 1863.

In 1863 Morse and Peaslee produced a narrative diptych in the form of two high-quality mass-produced *cartes-de-visite* entitled "Before and After the Proclamation."[8] Here the new fast exposure times are used to dramatic effect to express the joy injected into a black countenance by the formerly indescribable gift of freedom.

A black teenager is shown in three-quarter profile sitting on what seems to be a packing trunk, indicative of his unstable position. His pose works around a strong diagonal composition, which invites the eye to move from top right to bottom left. In the left panel his face expresses sadness and longing; the eyes look askance away from the camera lens, as if frightened to look at us as an equal. In the right-hand panel a frank and joyful gaze stares straight at the camera and at us, while the face has broken into a huge grin. The force of this transformation of countenance is cleverly achieved through isolation. It is essential that the rest of the body remains completely unchanged, that it provides a monumentally static base for the moving face. Not only the hand and leg, but the loose braces, and the folds in the shirt, remain frozen; the slave body remains consistent in its corporeality, while the eyes and mouth, those infinitely expressive orifices, tell the whole truth. This image has tremendous force in that it puts a completely human face to that rather crabbily phrased and short legal document, the Emancipation Proclamation.[9] The Manichean construction of the emancipation moment could hardly be articulated with more extremity. What the frozen states of this black boy's face are supposed to tell us is that under slavery there is eternal sadness frozen onto the countenance of all slaves, and in a state of freedom this changes immediately to a perpetual living joy. Because of the assumption that the snapshot is supposed to tell the truth about human appearance, and to tell the truth most emphatically when reality is caught at its most unstable, this image claims to put on display the real experience of freedom. To come at it another way, one could say that the lie embodied in this picture grows out of a single truism, namely the popular superstition that "the camera never lies."

TOURIST LIBERATION: NIAGARA FALLS AND THE RUNAWAY

There has been a vast amount of work produced regarding the possibility or impossibility of representing mass trauma in art. There has been far less thought about what is, in aesthetic terms, an equally problematic and compromised area, the representation of freedom and the emotions of ecstatic joy that emancipation is expected to engender. There are in point of fact very few representations of emancipation as a phenomenon produced by the slaves themselves. Where slave narratives do talk about liberation and incorporate the visual arts to do so they frequently do so in ways that question and subvert the celebratory rhetorics produced by the dominant white culture. Frederick Douglass, Henry "Box" Brown, Henry Bibb all used the visual inheritance of British emancipation propagandas in order to question the validity of the tradition. Box Brown was particularly pioneering and imaginative in terms of the way he ironized and satirized the celebratory tropes of Christianity that underpinned English and North American emancipation propaganda.[10] Acknowledging these important exceptions, there is in reality a pitifully small surviving archive of visual art made by contemporary blacks to celebrate their experience of freedom. Representations in visual art by blacks describing the process of slaves taking

back their freedom are rare; indeed, contemporary representations seem not to exist. It is, however, equally significant that representations of slaves gaining or taking freedom made by whites are equally rare. The images in Taylor's albums slipped through by chance, but they were not made intentionally as records of the experience of black freedom. Virtually all of the visual propaganda produced in Europe and the Americas to celebrate successive emancipation legislation is not about black agency, but black passivity and receptivity. Slaves are shown being given freedom, not taking it.

The one representational area in which whites were prepared to show slaves involved in liberating themselves, or at least trying to do so, was the scenario of running away. I have dealt with this subject fairly exhaustively elsewhere, and the core of my argument was that built into prints and paintings showing runaways was an assumption of black disempowerment. The very phrase *run away* is hugely significant; the slaves do not run to freedom, they run away from slavery, and the act of running away has almost universally negative connotations. The abolition imagery dedicated to the running or fugitive slave shows hounded, hunted, cornered, captured, tortured, and dead figures. In other words these works again privilege black passivity, suffering, and victimhood, rather than black strength, violence, or imagination. And again, frequently the attainment of liberation only happens once the slave has passed into the protective custody of the free North, or of Canada. In this sense the runaway is not properly liberated until freedom is bestowed upon him or her by white philanthropic benefactors in the North.[11]

What I would like to consider in the context of this visual archive are the commemorative photographs of successful escapees commissioned and circulated by the antislavery societies, and

to think about how one of these photographs subverts the extant visual archive of the runaway (fig. 18.3). The photograph "Abolitionists at Niagara Falls" operates within a different set of visual registers from the paintings and prints describing successful escape, and the reasons for these differences come out of the new visual markets created by photography, and the new expectations of the consumer.[12] There are four separate photographic traditions that give this image meaning—portrait photography, landscape photography, tourist photography, and the official commemorative photograph relating to exploration. This image shows two white abolitionists who frame a liberated slave, who stands in the middle. They stand on the shore of Lake Erie, on Canadian soil, with Niagara Falls in the background.

When this image was made in the early 1860s, landscape was becoming one of the most powerful and aesthetically fully realized areas of early American photography. Robert Vance, J. Wesley Jones, James Wallace Black, Samuel Masary, C. H. Gay, Thomas Easterly, and a host of now forgotten or anonymous photographers had, in the 1840s and 1850s, begun to explore the expressive possibilities of landscape photography. By the 1860s landscape had become firmly established as a popular area of the photographic market, and most young photographers included views of essentially American subjects in their catalogs. Niagara soon became an absolute stock favorite, expressing the sublime extremes of the American landscape experience. So popular had the subject become that there were several photographic workshops set up around the falls by the 1870s in order to feed the public's unquenchable thirst for depictions of the mighty waters.[13] In this sense the Niagara Falls as a photographic subject stood somewhere between tourism (every visitor liked to pose with

Fig. 18.3 Anonymous, *Abolitionists at Niagara Falls.*

the falls in the distance) and pure aesthetic landscape photography. George Barker, based near Niagara, organized a whole stage of his career around the production of "mammoth plate" views of Niagara, which were shipped all over the states. These photographs adopted the conventions of mid-nineteenth-century sublime landscape painting and presented the falls void of human subjects, as an expression of sheer natural power.

The escaped slave photograph cleverly, or is it inevitably, locates itself in relation to the viewer's established symbolic associations for the landscape setting. The noble, strong, and rough-hewn countenance of the liberated slave, who stands between a rustic bench and a dry stone wall, complements the subject of the falls, which stretch away behind him. He appears not merely as a tourist, but as some sort of force of nature himself. One of the separate cascades of the falls flows right onto his head; the composition is so arranged that the cascade expands outward, following the lines of the black man's head and body, as if he is subsumed into the falls itself and has become part of its great untamable rush. The lasting strength of this part of the image comes out of the man's complete stasis, set against the movement of the great waters. The idea of black freedom is melded with a sense of power, natural grandeur, and sheer unstopablility, by the seamless conjunction of human and natural subject.

The photograph also takes up a different set of associations to do with endurance and extreme courage. Unlike the customary tourist shots of people in fashionable suits and dresses, the free slave, and the two abolitionists who flank him, are dressed in cagoules, a type of clothing developed by the Inuit and by several indigenous Canadian peoples in the far north and originally made out of seal intestine. The clothing was later adopted by arctic explorers. The image consequently carries strong echoes of the official expeditionary photographs that marked the key points of discovery and arrival of white European and American explorers. Although it is obviously a later image, it is effective to compare the photograph of Ernest Shackleton's Arctic expedition, as the composition is strongly analogous (fig. 18.4). Three men in cagoules stand before their sledge, and Shackleton the leader is flanked by his trusty companions. The three men stare steadfastly at the camera, and consequently at us, while the Arctic wastes stretch away in the background. What we get from the Niagara photograph is the idea that these men have also been on an intrepid voyage of discovery, a voyage from slavery to freedom, a voyage into the unknown that has finally achieved it goal.

It would be anachronistic to apply the conventions of the outdoor fashion shoot to this photograph, but one could surely further argue that this photograph preempts a certain school of male fashion photography. The three men look beautiful in a stern and rugged way. The hoods of the cagoules wonderfully frame their faces, each visage hanging in its own little

Fig. 18.4 Anonymous, *Shackleton Polar Expedition*.

cave of darkness and refulgence. This hooded effect has many sophisticated ways of shaping how we read this group. In terms of the portrait tradition of Europe, the hooded male in long robes is associated with monasticism. The Spanish seventeenth-century painters, and Francisco Zurburán in particular, developed a whole genre of spectacularly hooded monks shown in high-contrast lighting against stark backgrounds, involved in extreme religious activities, including the contemplation of human skulls, or flagellation. There is a sense in which this hooded black man and his companions can be seen as some sort of holy brotherhood dedicated to the religion of freedom. The monastic associations also carry through to ideas of purity, abstinence, and high seriousness in devotion to God. But there are also less elevated advantages to be found in this early and inspired use of the "hoody."

The effectiveness of hoods in bringing out the beauty of the human face have been consistently exploited in fashion photography, and many stars, from Olivia de Haviland and Katherine Hepburn to Grace Jones, Kylie Minogue, and Isabelle Adjani have benefited from the canny exploitation of this device, on and off screen. Within the realm of male portrait photography, boxing is especially associated with hooded portraiture, boxers frequently entering the ring with their faces majestically swathed. In the Niagara photograph it is also the fact that these men are clearly wearing elegant clothing beneath their outdoor garments; the man on the right wears a bow tie, and the man on the left has on elegant city shoes, and this adds to the effect. All three men look, quite frankly, drop-dead gorgeous. In this sense the photograph makes escape seem glamorous and sophisticated. The imagery of degradation, terror, and victimhood that had encased the runaway in Anglo-American art up to this point

was not easily dislodged or overwritten. In creating one of the first great early images of black "cool," this photograph began to challenge the monolithic and negative traditions that had enclosed the runaway. As an image of freedom, this photograph offers a powerful set of alternatives to the normal stereotypes that abolition graphic cultures had established. The black man is not patronized but incorporated into the essential visual democracy of the image.

TOO MUCH PLEASURE: PHOTOGRAPHING JOY IN RIO AND A NASTY TASTE IN THE MOUTH

Of all the great slave cultures of the African diaspora, it was only in Brazil that the camera recorded images of the climactic "gift of freedom," when virtually the entire population of a great modern urban center celebrated the fantasy of the emancipation moment. It is, however, no easy thing to decide what these photographs finally mean. In Rio de Janeiro, on May 13, 1888, Princess Isabel sat before the government ministers of Brazil and a crowd of distinguished onlookers, took up a jewel- and pearl-encrusted feather quill pen, and signed the Lei Áurea.[14] She then made a climactic appearance on the balcony of the Paço de Cidade. The photographer Luis Ferreira (about whom almost nothing is now known) set his equipment up on the balcony of a building across the square and photographed the appearance of the princess and other notables, clustered in groups on the balcony of the building, as the massed crowd stood before them. This first photograph is a scene familiar to monarchical cultures of nineteenth-century Europe. What we have here is royalty appearing to the people as they do for royal birthdays, royal weddings, and in this sense emancipation is sanctioned, unexceptional, another special date in

a crowded commemorative calendar for white kings, queens, and princesses. There is no exotic Afro-Brazilian costume on display and absolutely no flesh, and there is no singing or dancing. What impresses about this crowd is the stasis and the dark, almost funereal, garb.

After taking the first picture, Ferreira, it seems, turned his camera to take a picture at eye level, looking along the balcony of the adjoining building on his side of the square where Isabel held her public audience (fig. 18.5). The building he was now photographing was the headquarters of one of the biggest Rio newspapers, *O Paiz*. This photograph takes us into another world, a world where darker emotions, racial division, and a certain skepticism enter the picture. A group of journalists and their friends, all white, stand on the flower- and flag-bedecked balcony of the middle floor. Flags of Brazil, Italy, and England hang down, limply unfurled. The figures are all male, and there is one boy, who looks to be in his early teens, who stares directly at the camera, while the adults stare out over the square.

What gives this picture its peculiar charge is a single tiny detail. Above the central group, high up but right in the center of the windows on the top floor, standing on his own in a white suit, is the isolated figure of a black man. He stares out in his isolation across the square from his window ledge, at those bustling groups of royal figures and dignitaries opposite, and at the massed crowd, some of whom indecipherably teem right below him. In his separateness, his singularity, his elevation, he seems to embody so many doubts and questions relating to the future of the liberated slave population. Has anything really changed, why won't the whites stand with him, invite him down? Did he choose to spend this deeply strange time on his own, and what is he supposed to do with this celebration that tells him his basic human status has altered forever; has the whole fanfaronade deliberately excluded him? He is so very far away, but elevation is not always power, as servants and slaves often inhabited attics. In this sense to be very high up can be the same as to be very low down; they are both marginal positions, and it is only the metaphorics of Christian ascension that privilege the top story. What this photograph intimates is the loneliness, the separateness, the sudden desolation of the liberated slave, nominally free in a society that has fundamentally changed very little. This image stands in a stark photographic space quite distinct from the triumphalist visual rhetoric with which the official graphic propagandas of Brazil trumpeted the emancipation moment.

NOTES

1. Vladimir Nabokov, *Pale Fire* (Penguin, 2000), 24.

Fig. 18.5 Luis Ferreira, *O Paiz Building, Rio*, 1888.

2. James Taylor, *Photographic Scrapbooks of the Civil War,* PhotCl. 300, vols. 1–3. Huntington Library, Art Collections, San Marino California.

3. Scholarship on early photographs of slaves, and of nineteenth-century America and Brazil in general, is remarkably lax about precisely which technical processes are being used at which time. The technical advances that occurred in photographic methods and particularly in printing technologies, from Nicéphore Niépce's first heliograph of 1826 to the glass albumen prints that recorded the passage of the 1888 Lei Áurea, the so-called Golden Law emancipating all slaves in Brazil, were huge. Techniques and processes came and went with remarkable speed; the revolutions in photographic technology in this period were not dissimilar to the speed at which things are developing in the world of digital photography now. How long it took to make a photograph, and how capable equipment was of freezing action or catching spontaneity, were elements that, to a large extent, controlled how pictures were set up, and what emerged when they were finished. By far the best account of the full range of processes remains Oliver Mathews, *Early Photographs and Early Photographers: A Survey in Dictionary Form* (Reedminster Publications, 1973); the most careful account of developments in nineteenth-century America is Martha A. Sandweiss, ed., *Photography in Nineteenth Century America* (Harry N. Abrams, for the Amon Carter Museum, 1991); and for Brazil, Gilberto Ferrez, *Photography in Brazil 1840–1900* (University of New Mexico Press, 1984).

4. Taylor, *Scrapbook,* vol. 1, 25.

5. For Barthes and the *punctum* see Roland Barthes, *Camera Lucida* (Vintage, 2000 [1980]), 25–27, 94.

6. I am using *marginality* here specifically in the sense in which it was developed by Orlando Patterson, who so forcefully developed the transhistorical thesis that the slave is physically alive, but socially dead. See his *Slavery and Social Death* (Harvard University Press, 1982); see also T.E.J. Wiedemann, *Slavery: Greece and Rome, New Surveys in the Classics, No. 19* (Oxford University Press and the Classical Association, 1997), 3–5.

7. The most famous erotic examples within the English tradition were Hogarth's two series entitled "Before and After," produced in 1731; see Mary Webster, *Hogarth* (Studio Vista, 1978), 44–47; but even the cheeky grandeur of Goya's *Clothed Maja* and *Unclothed Maja* grows out of the tradition. For Warhol's *Before and After* pictures, see Kynaston McShine, ed., *Andy Warhol, a Retrospective* (Museum of Modern Art, 1989).

8. See Daniel Cowin, *African American Vernacular Photography Selections from the Daniel Cowin Collection* (Steidl, 2005), 27, 115. The image, produced in Tennessee, is read in this volume as being parodic.

9. The peculiar legal rhetoric employed in the Proclamation was brilliantly commented upon by Karl Marx. See David Brion Davis, "The Emancipation Moment," 22nd Annual Robert Fortenbaugh Lecture (Gettysburg College, 1983), 19–21.

10. See Marcus Wood, *Blind Memory: Visual Representations of Slavery in England and America 1780–1865* (Routledge, 2000), 103–15.

11. See Wood, *Blind Memory,* 94–99.

12. Sophie Spencer-Wood, ed. *Freedom: A Photographic History of the African American Struggle* (Phaidon, 2002), 25.

13. See Peter Hales, "American Views and the Romance of Modernization," in Sandweiss, *Photography in Nineteenth Century America,* 222–25.

14. The pen remains on display in the Imperial Museum in Petropolis. It is reproduced in Osvaldo Orico, *O Tigre da Abolição* (Grafica Olimpica, 1953), opposite page 113. For the Golden Law, photography, and cults of personality around Nabucco and the royal family see Pedro Karp Vasquez, *A fotografia no Império* (Jorge Zahar, 2002) and *Iconografia de Joaquim Nabuco* (Convenio IJNPS–MEC–DAC, 1975).

CULTURES OF CONFISCATION: THE COLLECTION, APPROPRIATION, AND DESTRUCTION OF SOUTH ASIAN ART

Kimberly Masteller

In early March 2001, the world awoke to explosive images of the destruction of fifteen-hundred-year-old sculptures filling their newspapers and television screens. The Taliban was in the process of destroying the colossal sculptures cut into the powdery cliff face that overlooks the Bamiyan Valley in Afghanistan. It would have been difficult for the Taliban to find a more potent local symbol than the Bamiyan Buddhas (fig. 19.1). Renowned for centuries in travelers' accounts, the colossal sculptures were a grand achievement of engineering. The "small" Buddha stood at a height of 120 feet, while the towering 175-foot sculpture was the largest Buddhist icon in the world. The Taliban documented their acts on film and video, clearly intending the jolting imagery to communicate their ideology and their control over the Bamiyan region. The message to the rest of the world was chilling and clear: the Taliban leadership envisioned a strict Islamic society in which other faiths, histories, and images could not coexist.

Although the Bamiyan Buddhas were defaced by Mahmud of Ghazni in the twelfth century and the Mongols in the thirteenth, they survived primarily intact in Muslim-controlled lands for over a millennium. Yet no one could have foreseen the turmoil that was to come, which began in 1979, when the Soviet Russians invaded Afghanistan, which led to a civil war ten years later and culminated with the Taliban's rise to power in 1996. The Taliban asserted their power through the visual culture, in this case, a complete restriction of images. They promoted a strict interpretation of the Qur'an and the Hadith literature that forbade all graven images regardless of their context and use. This ban was applied both to iconic sculptures and secular imagery. The rich visual culture of modern Kabul, which was replete with figural imagery in popular print media, from posters of political leaders and martyrs to advertisements for music and movies, was immediately transformed. Figural posters were replaced by textual decrees, and movie houses, video shops, and music shops were shut down.[1] Seemingly overnight, images were transformed into texts and stifled from view.

Although the Taliban had, at first, promised to protect Afghanistan's ancient monuments, their language turned increasingly hostile by the end of 2000. On February 26, 2001, Mullah Omar issued an edict calling for the destruction of the ancient images at Bamiyan and at other Afghan sites and museums. The Taliban announcement was met with an international outcry. The British Museum, the Metropolitan Museum of Art, and the National Palace

Fig. 19.1 Edward Grazda, *Freemont, CA,* 1988. Photograph of Afghan youth holding his father's picture of the large Bami-
yan Buddha taken in the 1970s, silver gelatin print.

Museum, Taipei volunteered their services to remove and house the reliefs in their respective institutions.[2] These offers went unheeded. The sheer amount of resources and firepower expended upon the destruction of the images was startling, as explosive charges and heavy artillery were employed on the sculptures for days, beginning on March 9.

For many, this violent chain of events was one of their most recent and powerful encounters with South Asian art. These actions also clearly demonstrated the compelling local and ideological forces that impact our engagement with global art and issues of cultural heritage. This chapter will explore the ways in which individual works of art, like the Bamiyan Buddhas, have been transformed into icons through a variety of cultural–political frames. It is my intention here to use iconic works from South Asia as points of entry into larger discourses of ownership, cultural property, and the creation of categories of national and global heritage. Framed by the recent and ancient histories of Bamiyan, this chapter will also explore colonial collecting and display with Tipu's Tiger, the rise of Indian nationalism and its iconization with the Sarnath Lion Capital, and the use of Western models to create new national institutions and memories as documented in Dayanita Singh's photography inside the Nehru family home, Anand Bhavan.

Increasingly, museums with collections of world art are struggling to balance their presentations to focus upon both aesthetic concerns

and cultural meaning while they renegotiate their commitment to collecting within wider issues of cultural heritage and ownership. In this tense landscape, many major museums have repatriated works from their collections associated with living traditions or that appear to have left their owners or countries of origin under dubious and unlawful circumstances. Museum advocates argue that works in these collections, though severed from their original context, take on new roles as symbols of a shared humanity that justify their continued displacement. These sentiments were articulated in 2002, in the "Declaration on the Importance and Value of Universal Museums," signed by the directors of eighteen major museums with important holdings of world art.[3]

Museums, however, are often the last participants in a long history of agents that have collected and co-opted art objects and monuments for their own ends. During the last two centuries, in the age of empire and nation building, many art works have been confiscated and used for overtly political purposes. This is certainly the case in South Asia, where key works of art have been recast in different terms by new agents, including curators, educators, politicians, and patriots.

While several of the objects explored in this chapter have ancient or premodern origins, it is the past two centuries of their lives that are of interest to this discussion. This was a critical era for South Asian art in the discourse of art history. It is during this period that the idea of a universal, public museum became manifest in Europe, providing a new context for presenting objects from around the globe deemed to embody cultural or aesthetic importance. South Asian art also had a direct impact upon European art and aesthetics. In the second half of the nineteenth century, Britain, in particular, directed her eyes outward, looking to the

achievements of world art and design to inform students and influence popular aesthetic taste. The colonial government in India established museums, art schools, and archaeological offices mirroring contemporary institutions in Britain. These efforts inspired a brief, vital period of shared practices and aesthetic vision, although dictated by the colonial center. Educators and Indian art advocates, such as Lockwood Kipling and George Birdwood, championed indigenous art forms while encouraging Indian students and artisans to study basic Western principles of art production, including design and figure drawing.[4] The use of reproductive methods, including plaster casts and photography, also fueled arts education and supported the emerging fields of archaeology and art history in South Asia. This nexus of artwork, art history, and institutional bodies provided the material and means for the modern iconization of South Asian art, as key objects were transformed into embodiments of "India," by a variety of constituents in Asia and in Europe.

COLLECTING, CONTROLLING, AND TEACHING INDIA

The South Kensington Museum, later known as the Victoria and Albert Museum, was founded at the height of this moment of aesthetic exchange between South Asia and Europe. Planned as a state repository of good design, the institution would serve a critical role as a training center for British artists and architects. The museum had a global outlook from its birth, as the foundation of the collection consisted of objects purchased for the British government from the Great Exhibition of 1851. This exhibition also gave rise to a second Victoria and Albert Museum in Bombay (Mumbai), which was based upon a

collection of locally produced industrial arts, begun in 1857 and renamed the "V and A" in 1873. Now known as the Dr. Bhau Daji Lad Museum, this institution housed examples of design, plaster casts, and copies of the Indian objects sent to international exhibitions. Thus the two sister museums shared similar collections and a common purpose from their inception.

The South Asian holdings of the British Victoria and Albert Museum expanded exponentially after the dissolution of the British East India Company in the wake of the Uprising of 1857, also known as the Mutiny, when India sepoy soldiers rose up against their British officers. Afterward, the Indian Museum collections held in the Company office were divided between the Victoria and Albert Museum, the British Museum, and Kew Gardens. The South Asian holdings designated for the Victoria and Albert resided in their own galleries in a wing of the Imperial College, adjoining the Victoria and Albert galleries, where they formed a treasure house of Indian art.

Many of these objects had already been displayed in the East India Company Office in the East India House on Leadenhall Street. In this venue, the experience of the objects would constantly be mediated by the facts of their curation, as works possessed and presented by the Company, and therefore, as Britain by proxy. The wondrous objects displayed there served as trophies, symbols of the greatness and foreignness of Britain's colonial possessions. The dynamics of power underlying this display were made clear by the ceiling mural that spread over Revenue Committee Room at East India House. Here, a potent allegory of colonial power is cloaked in genteel classically-inspired forms. Against the backdrop of a glowing sky, the East,

represented by a dark-skinned Indian maiden and a Chinese woman kneeling over a large blue-and-white porcelain pot, an object of export, hand over their wealth to Britannia, who peruses their offerings. The allegorical presentation of this scene underscores the reality of the Company project. Clive, Wellesley, and their Company armies are replaced with nonmilitant putti, and the transaction between East and West is transposed into mythic time, as if Asia had bowed to Europe from time immemorial.

THE TIGER OF MYSORE

In the British Victoria and Albert Museum, one Indian object truly stands alone in form, function, and history, the famed sculpture known as Tipu's Tiger (fig. 19.2). This striking object was commissioned sometime in the last decade of the eighteenth century by Tipu Sultan, known as the Tiger of Mysore. While Tipu's Tiger makes an undeniable impression on the viewer, it is difficult to classify. It is a life-size sculpture in the round made of polychromed wood, depicting a red-coated British man being mauled by a ferocious tiger. Its classification as sculpture does not clearly encompass all of the features of Tipu's Tiger. A hinged panel on one side reveals a row of fourteen metal pipes that formed an internal pipe organ. This organ was played by turning a crank inserted at the side of the tiger. Tipu's Tiger was a musical automaton that issued a chorus of roars and screams, while the air compression in the organ also powered the flailing arm of the victim.

The manufacture of the tiger was a fascinating product of the colonial encounter. While the wooden sculpture itself is boldly painted in a somewhat folky style, suggesting that the body may have been crafted by local Indian

Fig. 19.2 *Tipu's Tiger,* about 1790, Mysore, India. Emblematic organ carved and lacquered wood.

artists, the pipe organ and its mechanical components are European, and likely a product of French design.[5] Tipu Sultan had a very close relationship with France, which in the late eighteenth century was still vying with Britain for control over India. Tipu aligned himself and his vast kingdom with France, and correspondence between Tipu and Napoleon in 1798 reveals a grand scheme.[6] Tipu had requested a contingent of French troops to be sent to join forces with his army against the East India Company's expansionist campaigns in the south. Had events gone as planned, the kingdom of Mysore would

have become a new front in the growing war between the European rivals, and its ruler, Tipu, would have been propelled into the position of the paramount ruler of South India. However, the Battle of the Nile in 1798 got in the way. Without French reinforcements, the end of the Fourth Mysore War became Tipu's Waterloo.

On May 4, 1799, British troops under the command of Colonel Arthur Wellesley overwhelmed Tipu's fortified capital, Sri Ranganapattana (Serangapatam). Tipu was killed in the battle, and his wealth and possessions became spoils of war. As ownership of this property

ultimately rested with the British Crown, the Tiger was eventually taken to London. Wellesley suggested that the Tiger should be housed inside the royal prison for political dissidents, the Tower of London.[7] However, the Company kept the Tiger in their offices, and it became a centerpiece of their new Leadenhall Street gallery. Here, the Tiger could be seen and heard, as visitors would take turns manning the crank to activate the screaming pipe organ. John Keats saw the Tiger here, which inspired his Orientalist poem "The Pipe and Bells," about a despotic Asian prince and his "Man-Tiger-Organ." Indeed, the horrific image of a wild beast attacking a helpless fellow Britain must have stirred strong reactions in the British audience so few years after the brutal Mysore campaigns. Contained within one wondrous work of art was an illustration of the intensity of resentment toward European imperialism, the ferocious power of the enemy prince, and a moral justification for colonization.

In its final move to the Victoria and Albert Museum, Tipu's Tiger holds pride of place. It remains one of the best-known works in the collections, an icon of the institution. The Tiger's iconicity within the museum is reinforced through reproduction and marketing. Tipu's Tiger has been replicated in a variety of media in the museum gift shop, including post cards, paper model kits, and plush stuffed tigers. The Tiger's continuing popularity is also fostered through educational practices. When local schoolchildren visit the museum, Tipu's Tiger is one of the highlights of the trip. It is a powerful image that children can interpret and react to without mediation. For many Londoners, the image of Tipu's Tiger has remained ingrained upon their memory since childhood, even if its history has long since been forgotten.

THE IMAGE OF A NEW NATION: THE ASHOKAN LION CAPITAL FROM SARNATH

The century after the fall of Tipu Sultan saw the consolidation of most of India under British rule. After the quelling of the Uprising of 1857, India became a full-fledged territory of the British Empire. Britain took a state interest in India's ancient archaeological sites, which were now part of her own patrimony. In 1871, the government founded the Archaeological Survey of India. This institution trained generations of British and Indian archaeologists and restorers, and over the past 150 years, it has made some of the most significant discoveries in world archaeology.

In 1905, excavations at the third-century B.C.E. Buddhist monastic complex of Sarnath revealed what would become the face of a new nation, a striking column and its colossal sandstone capital.[8] Archaeologists had documented similar columns throughout north and central India in the nineteenth century, and there was no doubt that this was another *dharma stambha* (Sanskrit for "Pillar of Law"), associated with the third Mauryan ruler, Ashoka (271–231 B.C.E.).[9] The pillar was inscribed with edicts issued by Ashoka, intended to propagate his *dharma,* or "duty," meaning law or a code of appropriate or moral conduct.

The Sarnath Lion Capital, however, was the recipient of the greatest interest (fig. 19.3). Removed from the broken column, the lion capital is a grand monument in itself. The capital stands seven feet in height. Carved from a monolithic block of tan Chunar sandstone, the sculptural capital is crowned by four western Asiatic lions set facing back to back at ninety-degree angles. The lions sit atop a circular abacus, which contains a naturalistic freeze of four animals: a bull, a lion, a horse,

Fig. 19.3 Lion Capital, Sarnath, India, about third century B.C.E., Chunar sandstone.

and an elephant, alternating between circular spoked wheels, known as *chakra*s. The base of the column takes the form of an inverted bell-shaped flower with curved petals. The surface of the capital was burnished, creating a smooth, glossy patina, a treatment known to art historians as "Mauryan Polish." Originally, the capital was capped by another large stone *chakra,* supported on the backs of the lions.

The *chakra* was invested with specific meanings in ancient India, as a symbol of the multivalent *dharma,*[10] invoking both political law and Buddhist teachings, beginning with Shakyamuni Buddha's first sermon at Sarnath, where he set "the Wheel of Law into motion." In a more profane interpretation, the *dharma* symbolizes Ashoka's authority and ethics within his expansive empire.[11] It is this latter, secular interpretation of these concepts that would appeal to Indian nationalists over two thousand years later.

The year of the column's discovery, 1905, was also a pivotal year in India's struggle for independence. In an attempt to quell sectarian violence in eastern India, the British viceroy, Lord Curzon, partitioned Bengal into two separate provinces. For many Indians, this divisive act fueled a rising tempest of anger against the colonial government, and it provided a flood of support for the Indian National Congress. Founded in 1885, the Congress was established to work within the colonial system to assure rights and opportunities for Indian citizens. However, in the early years of the twentieth century, the Congress joined the independence movement. Some of India's greatest moral and political leaders rose up through the Congress party, including Mohandas K. Gandhi (known as the Mahatma), and Jawaharlal Nehru, who would become the first prime minister of independent India.

Many of these young leaders had grown up and been educated in a world shaped by contemporary British ideals and institutions, either traveling abroad or studying at British-run colleges in India. Thus the educated elite were fortified with an appreciation of art and aesthetics, both European and Indian. Public interest in Indian art was also informed by museums, beginning with the Indian Museum in Calcutta (Kolkata), founded by the Asiatic Society in 1814. Museums became repositories for archaeological material that could not be safely remain *in situ.* The combination of arts education and a growing museum culture

fostered a strong appreciation among Indians for their cultural heritage.

It is in this educated and politicized context that the Sarnath Lion Capital emerged. It was recognized immediately as a masterpiece of Indian art and as the grandest monument associated with India's greatest indigenous ruler, Emperor Ashoka. Its significance was attested to in various art publications, and it was proclaimed to be "one of the most magnificent specimens of art that have yet been discovered in the country."[12] The sculpture's fame was also increased through its reproduction. Although housed at the museum in Sarnath, plaster reproductions of the capital were created and distributed to regional museums throughout India, including the Victoria and Albert Museum in Bombay, which was the recipient of this life-size cast (fig. 19.3).

The cultural importance of the Capital and its sudden familiarity guided Jawaharlal Nehru when he proposed that the Lion Capital serve as the emblem of India. The historical link with the Mauryan Empire, the only Indian empire to unite much of the subcontinent, was a powerful factor in this decision. It was important to find a national symbol that was not strongly associated with either Hinduism or Islam. The Sarnath Capital's connections to Buddhism were less volatile, as the religion was primarily a fixture of India's remote past. Moreover, Ashoka's edicts promoted religious tolerance, a message at the heart of Nehru's secular ideals. The form of the *chakra,* a nonfigural disk, easily lent itself to a variety of new, secular interpretations.[13] As independence approached, members of the ad hoc committee appointed to determine the design of the national flag advocated for the tricolor Congress flag to be redesigned to incorporate the *chakra* from the Sarnath Capital in its center, a plan endorsed by the Constituent Assembly on July 22, 1947.

Like Nehru, Gandhi also had Utopian visions for a new India. However, while Nehru embraced modernism and technology, Gandhi saw the answers to the country's ills in its thousands of villages. His *swaraj* (self-rule) movement promoted national development through *swadeshi,* or personal self-sufficiency. Gandhi advocated growing one's own crops, tending one's own livestock, and spinning one's own cloth as a method to break Britain's economic hold on India. The original tricolor Congress flag, which Gandhi designed in 1921, bore in its center a potent symbol of Gandhi's message of independence and self-sufficiency, the home spinning wheel. Gandhi, then, did not approve of the selection of the politically expedient Sarnath Capital as symbol of modern India. He saw the Capital as a symbol of violence and conquest, linking it to Ashoka's early militancy while he was expanding his kingdom. Although he eventually accepted the *chakra,* when Gandhi was first informed that the Congress had approved the new flag design with the Ashokan *chakra* replacing his spinning wheel, he is said to have pronounced, "however artistic the design may be, I shall refuse to salute a flag that carries such a message."[14]

BAMIYAN

Returning to Bamiyan, the dust has settled and the Taliban army has been replaced by Afghan and International security forces. The human tragedy was great, as graves containing the bodies of local Hazara men were discovered in the fields near the excavated cliff face. The violence and intolerance shown toward history and humanity at Bamiyan, which preceded the September 11, 2001 attacks by just seven months, is communicated in the acts of destruction carried out upon the

Buddhist rock-cut sculptures. The Taliban's attack on Afghan history and culture is certainly not a new phenomenon. From the Chinese Emperor Qin Shih Huang Di's burning of libraries in the third century B.C.E. to the destruction of European cities and monuments in World War II, the world has witnessed numerous governments that have asserted their legitimacy through the purposeful destruction of the peoples and histories that preceded them. The world has also witnessed periods of artistic iconoclasm. What makes the Taliban's acts at Bamiyan so particularly poignant to us has much to do with their timing and their implementation of a powerful symbolic visual language.

By timing, I mean the "age of information" created by electronic media and the Internet at the turn of the twenty-first century. Through modern modes of travel and postmodern forms of communication: digital imagery, streaming video, "breaking news" scrolling across television broadcasts and Web sites, the world seems closer to Afghanistan than it was previously. While few outsiders could imagine the landscape and inhabitants of the Khyber Pass while British soldiers struggled and failed to secure Afghanistan for the Empire in the nineteenth century, a global audience could be on hand for battles at Tora Bora. This pixilated surrogate enables viewers to feel as if they can experience a siege, know the local population, and share in a common history. While impossibly limited, these shadowy digital experiences have created virtual "imagined communities."[15]

Regarding the Taliban's use of symbolic language, I refer to both their choice of subject, Buddhist images in Afghanistan, and to the manner in which they transformed them through their total destruction. While one kind of symbolic act is committed by the

confiscation and appropriation of historic images, the willful destruction of an object is a very different kind of act. In semiological terms, the signifier is no longer present; it is irretrievably eliminated. It is difficult to imagine a more potent and imperative form of symbolic communication.

The Buddhist sculpture of Afghanistan developed in a very different worldview. Rooted in Indian religious practices, the civilization that created Bamiyan was image-based. In South Asia, religious imagery, sculpture, and painting were used as a focus for worship and as a receptacle of divinity. Key to the functionality of these images is the concept of *darshan*. *Darshan*, from the root "to see," refers to a dynamic system in which a worshipper sees but is also seen by the divine through the medium of the icon.[16] For example, Hindu images are considered lifeless and must be ritually consecrated in order to host the divine in them. In order to invite the deity into an image, a priest may trace the eyes of the image with a brush or needle, or apply eyes to an image as a last act in the *pranpratishtha* consecration ceremony.[17] Buddhist images appear to have been created and consecrated in a similar manner. In Buddhist theology, Buddha images were classified as a "reminder relic" and intended for veneration. Like the Hindu icon, the Buddhist image contains spiritual power that can be accessed in its presence through worship, including prayer, offerings, and actual sight. The importance of *darshan* is illustrated by the extraordinary lengths taken to provide visual contact with the main image of the early twelfth-century Ananda Temple at Pagan, Burma (Myanmar) (fig. 19.4). Due to structural damage sustained during a major earthquake, there is no longer any public access to the main shrine on the upper floor. To remedy this, the

Fig. 19.4 Buddha icon of the main shrine at Thatbyinnyu Temple, twelfth century, on closed circuit televisions, Pagan, Myanmar, January 2007.

government has installed a closed circuit television, making the main shrine icon available to Buddhist practitioners for *darshan* and worship near an entrance and shrine on the ground level of the monument. As this example illustrates, just the knowledge that the Buddha image is present in its shrine will not suffice; the worshipper needs to see it.

Created in the South Asian tradition of invoked images and *darshan,* the Bamiyan Buddhas were on a collision course with the iconoclastic worldview of the Taliban.[18] However, at Bamiyan, the strict teachings of the Taliban came into conflict with local history and identity. The Hazara tribals of the valley lived with the sculptures for generations. Known affectionately by the local population as the "husband" and the "wife,"[19] the Buddhas were talismans, guardians of place, and beloved members of their community. On the national level, the Bamiyan figures were a source of wonder, pride, and a highly visible link to Afghanistan's interconnectedness with the rest of the world. It is not surprising that Mullah Omar's orders to destroy the sculptures were met with resistance from the local Taliban. The setting of explosive charges and artillery had to be carried out by senior Taliban members, who arrived on March 8, after the road from Kabul was

cleared of snow. They did not share the personal identification with the images that the local Afghans did.[20]

The iconic power of the Bamiyan Buddhas was felt particularly strongly among the Afghan diaspora community. For Afghan immigrants in the United States, reaffirmation of one's own identity occurs through engagement with the symbols and traditions of Afghanistan. In his documentary work on Afghan communities in New York and California, Edward Grazda found that strong ties to the distant homeland were forged through engagement with the symbols and traditions of shared cultural experiences such as prayer, music, food, and imagery. For Grazda, the power of Bamiyan as a cultural icon was exemplified during a 1998 meeting with a young Afghan man in Freemont, California. The youth showed Grazda an old family photograph that served as important link to his heritage, cultural and lineal (fig. 19.1). The young man's father had worked in the Afghan tourism industry in the 1970s, and the photograph was taken with his father's camera.[21] The black-and-white image depicts a stripe-shirted man, possibly his father, standing in front of the largest Bamiyan sculpture. As a tangible relic of a moment, photography has been employed in South Asia to create memorializing images that honor one's family and ancestors.[22] Grazda's own photograph of the young Afghan holding up his father's framed image thus suggests an especially poignant reading: connecting the displaced youth with his homeland and his father. The sense of cultural memory expressed in this photograph is shared by many Afghans that Grazda has encountered in the United States. According to Grazda, every Afghan he asked personally identifies with Bamiyan, and for many, "Bamiyan is Afghanistan."[23]

CONCLUSION

These case studies attempt to trace an evolution of the appropriation and politicization of key works of South Asian art. Although created at different times for varied purposes, these works are enmeshed within the historicity of the past two centuries. Their confiscation and iconic repurposing—as trophy, as museum object, as national symbol—are a response to historical circumstances in South Asia: British colonization and resulting indigenous nationalism. The destruction of ancient figural art in Afghanistan also arose from international and cultural encounters, in this case, the rise of foreign Islamist fundamentalism in the wake of the Russian invasion of Afghanistan. The European presence in South Asia and development of arts institutions also inspired both international appreciation of Indic art and a lasting interest in aesthetics and cultural heritage in the subcontinent. The effects of this more positive intervention can be seen in the burgeoning population of art and historical museums that have been established since independence. I will conclude this chapter with a visit to one of India's new museums, conceived in a climate of national introspection, Anand Bhavan. Located in the northern city of Allahabad, Anand Bhavan was the Nehru family estate and home to generations of this influential political dynasty, including the prime ministers Jawaharlal Nehru and his daughter Indira Gandhi. The home was converted into a house museum, which provides visitors with a rare glimpse at the private lives of India's most public family.

Photographer Dayanita Singh captured the cultural power of this Indian museum in a photograph titled "The Visitors, Anand Bhavan 2000" (fig. 19.5). While photographing inside Indira's bedroom, Singh turned her

Fig. 19.5 Dayanita Singh, *Visitors at Anand Bhavan, Allahabad*, 2000, gelatin silver print.

medium-format camera away from Mrs. Gandhi's personal effects and toward the display window that looks in upon the room. For an instant, a crowd of museum visitors pauses in front of the window, gazing at the room and the photographer. They are at once the viewers of the scene, yet framed in the window, they also become the objectified subject of the photograph. That Anand Bhavan draws a large and diverse visitorship is a testament to India's successful promotion of its own culture and history. Many museums and monuments are free to Indians, while others are subsidized. Indian museums and archaeological sites create a space in which Indians can self-identify with their nation and over two thousand years of its diverse human history. While at Anand Bhavan, the nostalgic Indian visitor is, in fact, performing Indian culture.[24]

In the twentieth century, scholars and policymakers have also moved beyond national boundaries in favor of universalist notions of a shared global culture and heritage. These ideas have been reinforced by decades of framing through agencies like the United Nations Educational, Scientific, and Cultural Organization (UNESCO), and the World Monuments Fund, which have created imagined international communities of monuments, natural wonders, and cultural activities that may share little else in common other than their assignment to the same list. Even with its altruistic intentions, UNESCO's categorization and support of World Heritage monuments are deeply politicized, as national governments must propose monuments to the list.[25] Bamiyan was not nominated to World Heritage status until 2002, a year after its demolition.

In the end, Bamiyan suffered because it had achieved international iconic status. Renowned throughout history since the seventh century, Bamiyan had become synonymous with Afghanistan and its ancient, image-based culture. The loss of such powerful images resonated internationally, as the world mourned with the Afghans. Through the imagined global communities created through print media and cybertechnology, the Buddhas, it seems, belonged to the entire world. The Taliban, perhaps, did not realize the appropriateness of their choice of icon. Through the destruction of Bamiyan they succeeded in uniting the global community against them. Colossal in life and even larger in their afterlife, there are some symbols that are just too powerful to control.

NOTES

In this chapter, Indian words will be italicized and transliterated phonetically without diacritical marks.

1. For discussions of the transformation of Afghan visual culture, see Juliette Van Krieken-Peters, "The Buddhas of Bamiyan: The Quest for an Effective Protection of Cultural

Property," in *Bamiyan: Challenge to World Heritage,* ed. K. Warikoo (Bhavana Books, 2002); Edward Grazda, "Searching for Mullah Omar," *Vanity Fair,* February, 2003; and Grazda, personal interview, August 8, 2007. Grazda intends to address this issue in greater detail in an upcoming book.

2. Metropolitan Museum director, Phillippe de Montebello, presented his offer to pay for the removal of the sculptures directly to the United Nations secretary general, Kofi Annan. See "U.N. Pleads with Taliban Not to Destroy Buddha Statues," *The New York Times,* March 3, 2001.

3. For the full text of the "Declaration on the Importance and Value of Universal Museums," see http://www.clevelandart.org/museum/info/CMA206_Mar7_03.pdf.

4. See Partha Mitter, *Art and Nationalism in Colonial India: 1850–1922, Occidental Orientations* (Cambridge University Press, 1994), 27–62.

5. Richard Davis, *Lives of Indian Images* (Princeton University Press, 1997), 149, and Mildred Archer, *Tippoo's Tiger,* Victoria and Albert Monograph no. 10 (Her Majesty's Stationery Office, 1959), p. 10.

6. Archer, *Tippoo's Tiger,* 10.

7. Davis, *Lives of Indian Images,* 157.

8. Daya Ram Sahni, *Guide to the Buddhist Ruins of Sarnath, with Seven Plates* (Archaeological Survey of India, 1933).

9. John Irwin convincingly argues that several of the "Ashokan" pillars were likely created before Ashoka's reign and were later reinscribed with his edicts. See John Irwin, "Asokan Pillars: A Reassessment of the Evidence," *The Burlington Magazine* 115, no. 848 (1973): 706–20.

10. *Dharma* translates as: "that which is established or firm, steadfast decree, statute, ordinance, law; usage, practice, customary observance or prescribed conduct, duty;" and also as "the law or doctrine of Buddhism." See M. Monier-Williams, *A Sanskrit English Dictionary* (Motilal Banarsidass Publishers, 1899 [1872]), 501.

11. See Romala Thapar, "As'oka and Buddhism as Reflected in the As'okan Edicts." *Cultural Pasts: Essays in Early Indian History* (Oxford University Press, India, 2000), 422–38.

12. Daya Ram Sahni, *Catalogue of the Museum of Archaeology at Sarnath* (Museum of Archaeology at Sarnath, 1914), 29.

13. In 1931, Dr. S. K. Chatterji proposed that "The wheel can be made to represent our India as a Federal Union." Cited in P. Nair and P. Thankappan, *Indian National Songs and Symbols* (Firma KLM Private Ltd., 1987), 116.

14. Cited in Larry Collins and Dominique Lapierre, *Freedom at Midnight* (Simon and Schuster, 1975), 202.

15. I use the term *imagined communities* in reference to the proposition that communities, identities, and nations have been manufactured through mythologies of singular histories, as proposed in Benedict Anderson, *Imagined Communities: Reflections on the Origin and Spread of Nationalism* (Verso, 1983).

16. For an excellent introduction to the concept and practice of Darshan, see Diana Eck, *Darshan: Seeing the Divine in India* (Anima Books, 1981).

17. For descriptions of image consecration, see Paul B. Courtright, "On This Holy Day in My Humble Way: Aspects of *Puja*," in *Gods of Flesh, Gods of Stone: The Embodiment of Divinity in India,* ed. Joanne Punzo Waghorne and Norman Cutler (Columbia University Press, 1996), 31–50; and Christopher Pinney, *Camera Indica: The Social Life of Indian Photographs* (University of Chicago Press, 1997), 109.

18. For a thorough exploration of the history of Islamic iconoclasm and the complex issues raised at Bamiyan, see Barry Finbarr, "Between Cult and Culture: Bamiyan, Islamic Iconoclasm, and the Museum," *The Art Bulletin* 84, no. 4 (December 2002): 641–59.

19. For example, when interviewed about the destruction of the images, Taliban officer Abdul Haidi stated that they first blew up the woman, then her husband. CNN 3/26/2001 at CNN.org, cited in M. Darrol Bryant, "The Tragedy of Bamiyan: Necessity and Limits of the Dialogue of Religions and Cultures," in Warikoo, *Bamiyan: Challenge to World Heritage,* 192.

20. Christian Manhart, "UNESCO's Response to the Destruction of the Sculptures at Bamiyan," in Warikoo, *Bamiyan: Challenge to World Heritage,* 152.

21. Edward Grazda, *Afghanistan Diary: 1992–2000* (Powerhouse Books, 2000), 45.

22. For a case study of contemporary studio practices in Central India, including the production of memorializing photographs, see Pinney, *Camera Indica,* 1997.

23. Personal interview with Edward Grazda, August 8, 2007.

24. For a detailed exploration of the museum as a space of ritual performance, see Carol Duncan, *Civilizing Rituals: Inside Public Art Museums,* from the series ReVisions: Critical Studies in the History and Theory of Art (Routledge Press, 1995).

25. Although Bamiyan was on Afghanistan's own "Tentative List" of important sites provided to the UNESCO in 1980s, the government never responded to requests for further information; thus, none of Afghanistan's cultural monuments made it onto the World Heritage list. See Christian Manhart, "UNESCO's Response to the Destruction of the Statues in Bamiyan," in Warikoo, *Bamiyan: Challenge to World Heritage,* 154.

TRADING CULTURES:
THE BOUNDARY ISSUES OF GLOBALIZATION

Nada Shabout

A recent exhibition entitled "Beyond East and West: Seven Transnational Artists" characterizes the participants, of various nationalities, as displaced beings, living between cultures. They have trespassed cultural, political, and religious borders and disrupted norms of thought and behavior; in more than one sense, they can be considered borderline artists.[1] At the same time, the work produced by these artists is seen as offering a chance for better intercultural understanding. Painters, photographers, multimedia, and installation artists like those included in this exhibition define the new ideal of a global(ized) artist, a hybrid.[2]

Globalization is at once a contemporary buzz term and a loaded concept. Hailed for its universalism and transcendence of territory, it is also hated for its links to a notional West assumed to be monocultural and to Western histories of imperialism. Arguably, both features are correct. From the vantage point of visual culture, globalization can make the strange seem familiar, overlap identities in such a way as to create an apparent commonality, collapse hierarchies and borders, and enable artists to function in what has been called a "liminal third space," beyond and between traditional boundaries.[3] Such a new global visual culture can be conceived of as inclusive, allowing a voice and agency to those whose identities transgress borders as

well as to those historically marginalized by the West.

Nevertheless, the notion of globalization that is inevitably tied to the West's history of imperialism and colonialism elicits negative perceptions. In real terms, globalization intensifies the gap between developed and the underdeveloped areas of the world by enforcing unconditional surrender to the dominance of Western-style capitalism. This in itself is not new: Ours is by no means the first age of globalization. Rome, Baghdad, Cairo, and Istanbul were all once centers of globalization. Imperial Rome ordained a kind of a globalization in its colonizations, imposing and replicating Roman ideals, forms of government, and urban planning. Recognized today as part of the Roman imperium, these were, in fact, in many ways products of hybridization, given Rome's embrace of aspects of its conquered territories' identities. Islam, also a culture of conquest, for several centuries acted as a synthesizing center within and beyond its territorial holdings, tolerating, even encouraging difference.

One of the most obvious elements that distinguishes today's globalization from the previous incarnations is the speed and ease of communication. A prime example is the Internet. Cyberspace, a vehicle for the transmission of visual culture and its ideas, among many

other things, has been celebrated by scholars, artists, and advocates of marginalized peoples for its potential of equity and equality. However, global interconnectivity tends to exalt the modern, an assumption at variance with systems of ideas and practices prevailing in myriad cultures around the world.

Furthermore, wealth and power remain the determining factors for accessibility and availability. Despite the spread of Internet cafes in urban areas, many developing nations in the so-called Third World lack widespread Internet access, particularly outside cities; in some cases, Internet access has been restricted deliberately for political reasons. In the aggregate, large sections of the world are isolated from the information highway. Even when access is available, the conditions of use vary widely. Thus, the view of globalization from cyberspace, which can be considered a Western construct, depends very much on one's geopolitical and economical position in the world.

A case in point if the problematic role cyberspace has played with respect to global understanding of cultures outside the West, most notably Islam. While one would expect a global medium to demystify Islam and explain it on its own terms, this has not invariably been the case. The late Palestinian writer and literary critic Edward Said, best known for defining long-standing and entrenched attitudes toward the Middle East, which he termed Orientalism, has argued that "one aspect of the electronic, postmodern world is that there has been a reinforcement of the stereotype by which the Orient is viewed."[4] Instead of presenting or allowing for an articulation of the considerable differences within Islam, there has been instead a standardization of the "Orient" through media; this uniform image is further perpetuated through rhetoric about terrorism and the Middle East's political upheavals.

Globalization must be investigated within the context of its historiography and its development as a concept, from the premodern era, though the modern age, to our postmodern present. In the views of many scholars, history remains essentially Western in focus, with a presumption of Western superiority, despite the fact that areas outside the West comprise a far greater proportion of the globe than do Europe and the West.[5] Conflicting historiographic discourses aim to create historical meanings from distinct points of view. There is the postmodern view, looking at societies in their postcolonial and postnational (and in some cases, transnational) phases. There is also the premodern view, which studies societies from the vantages of their states before colonialism and before nationhood.[6] The former celebrates displacement and transcendence of origins, while the latter seeks meaning through the return to precolonial and prenationalist traditions. Yet postmodernism, linked to globalization, asks the marginalized to abandon identity, while clinging to notions of nationalism also championed by the premodernists, largely antiglobalization. Many have argued that the homogenizing forces of globalization have pushed the underdeveloped parts of the world into a stronger, more chauvinist nationalism as a way of battling for their existence.

Of interest is that indigenous traditions, which are said to hold in backwardness today's (post)colonized countries, were invented, reinvented, or supported by colonizers as a form of legitimization and then later used to demonstrate illegitimacy. A good example is how most of what Iraqis consider iconically Iraqi in the way of traditions came into being in the twentieth century, based on archaeological discoveries by the British and the rhetoric of amateur ethnologists like Gertrude Bell; these were developed after Iraq's creation as a state in

the 1920s as part of the national project and carried on until very recently. Today, this history and these traditions are deconstructed—dismissed and deprived of legitimacy—in an effort to demonstrate Iraq's incoherence as a state. Ironically, nationalism in Iraq is defunct even as it is highlighted in the United States to drum up support for an invasion of the country, purportedly rooted in national values and patriotism.

Modernism and postmodernism and critiques of both are articulated and debated in the West. The postmodern world of globalization is still explained through a Western prism. Equality between West and non-West, between center and periphery, is achieved through hybridity, which still tends to favor the West in its effect. The West makes token allowance for difference, for the "Other," without truly acknowledging or accepting such difference. Eurocentrism has not been displaced by globalization.

Art history's efforts to atone for Eurocentrism in textbooks has been relegated too often to the addition of chapters on, for example, Islamic art, placed in such a way that there is no possibility of understanding contemporary developments elsewhere in the world. Students are thus left with the impression that Islamic culture and Islamic art came into being in a different universe. (Some texts have begun to adopt more sophisticated approaches, dealing with early Islamic art in the context of early Christian and Jewish art, rather than dedicating a chapter to each belief system and its parent culture.) Departments of art history frequently design a non-Western art history survey course in their curriculum and hire a designated non-Western faculty member to teach that and upper-division courses in a specific field, such as Islamic art. Cross- and intercultural connections are rare; the discipline

of art history remains to some extent territorial, as does its scholarship, save for occasional art-historical exhibitions that have explored interactions between the West and another culture.

Contemporary exhibitions and the art market display greater breadth, although their practices are still restrained enough to constitute a kind of globalized tokenism. A specific "token inclusion" moment is the acceptance of a representative number of generally female artists with Islamic or Arabic backgrounds and hybridized identities. These artists will be discussed in ways that focus mainly on their reception in the West and not on their work itself.

REPRESENTING THE POSTMODERN "OTHER"

As noted earlier in this chapter, hybridity and hyphenated identities have been explained as the result of negotiations taking place in "third spaces." Four women artists exemplify the globalized hybrid: the "Iranian-American" Shirin Neshat (fig. 20.1), the "Egyptian-American" Ghada Amer (fig. 20.2), the "Pakistani-American" Shahzia Sikander (fig. 20.3), and the "British-Lebanese-Palestinian" Mona Hatoum (fig. 20.4). Neshat, Amer, Sikander, and Hatoum, all with hyphenated, hybrid identities, practice in the West and are considered to embody the successful negotiation of both hybridity and globalization.

Of this small group of "hybrid" women artists, Shirin Neshat is probably the best known in the West. For some commentators, Western art's enduring interest in the "other," and specifically in the supposedly exotic East, common since the nineteenth century and revived in the later twentieth century, is central to Neshat's characterization as an honorary

Fig. 20.1 Shirin Neshat, *Women of Allah* (4), 1995, ink on photograph.

Western artist.[7] Ample examples from Delacroix, Ingres, and Matisse, to name only a few nineteenth- and twentieth-century European producers of art that is characterized as Orientalist in varying degrees attest to the power of this interest. Whether the West's willingness to accept Neshat's form of "Otherness" stems from global postmodern discourse or a revived fascination with the exotic is unclear, even before one considers the background against which such qualified acceptance is set, the current political situation with respect to the West and Iran. Although Neshat has been lauded "as a symbol of resistance to Iranian repression," a closer examination of her

photographs and videos complicates matters. Western viewers bent on viewing her work as critical of contemporary Iran, and in particular of attitudes toward women, may fail to see layers of intent and ambivalence.[8]

Writing about Neshat's acceptance into the American art scene in the early 1990s, a period notable for an expansion of interest in globalization and the manifestations of cultural similarities and differences, one contemporary critic recalls nineteenth-century Orientalism with her choices of words and phrases, reinforcing an old-fashioned and arbitrary dualism that pits West against non-West, and free versus oppressed women, with scene setting to match, "for Western observers Neshat's work *pulled back* [my italics] a curtain on a hidden world." In one sentence, images of Delacroix's, Ingres's, and other European artists' harem odalisques are equated to Neshat's "veiled" women and Neshat's presumed visual "critique of female oppression in Iran," interpreted as emphasizing "Western values of freedom, autonomy, and individuality."[9]

Admittedly, many of Neshat's earlier works seem to reinforce this dualism through their strong contrasting of black and white, women and men. Few critics realize that the words Neshat used in a number of her provocatively titled *Women of Allah* series (fig. 20.1) were not sacred texts from the Qu'ran, but in fact those of the feminist poet Forugh Farrokhzad, a reality that fundamentally changes the reception of the images, although only for those informed enough to understand. An image of a woman clad in a chador carrying a Kalashnikov rifle, with an overlay of Arabic calligraphy is, not surprisingly, seen by most viewers as a personification of the stereotypical anti-Western aggression of Islam, an up-to-date form of "Oriental despotism." Complex visual issues pertaining to composition, juxtapositions of

Fig. 20.2 Ghada Amer, *Red Diagonales*, 2000.

private and public spaces, and the pairing of text and image, all positioned by Neshat to empower this powerfully gendered representation of culture, are sadly missed.

Though Neshat is quoted as saying "I don't want to be an ethnographic artist," she later clarified her position, stating, "I see my work as a visual discourse on the subjects of feminism and contemporary Islam—a discourse that puts certain myths and realities to the test, claiming that they are far more complex than most of us have imagined."[10] Her unqualified use of the phrase "contemporary Islam," nevertheless, reminds Westerners of Neshat's difference and allows for the persistence of the old formula of Orientalism's homogenized "Other."

One wonders if, identified as an Iranian-American artist, Neshat would be able to sustain her popularity through focusing on issues outside of her home country of Iran. Moreover, having lived in exile, outside of Iran, since 1975, Neshat missed the whole of the Islamic revolution. With only a few trips back to Iran in the 1990s, one could argue against accepting her artistic voice as "authentic" Iranian. While it is true that Neshat does not claim to represent more than her own negotiation of the experience of diaspora and her adaptation of a hybrid persona, the Western audience for her work tends to simplify it, regarding it only as representing all the ills of the Islamic revolution of Iran and nothing of her evolution and Westernization. This results in her being perceived, inevitably, as more Iranian than American. In fact, Neshat's work, closely read, comments forcefully on Iranian and Islamic issues and realities, reflecting not only the artist's past, but her relocation to New York. It is the "complicated geographies" of Neshat's, and her birth nation's, as well as her Western-home-in-exile, that inform her examinations of identity.[11] The apparent directness and reliably exotic content of Neshat's work are in no small measure responsible for her acclaim as an artist in the West, but one must ask whether such subject matter can survive its boundary crossing intact or whether it is inevitably liable to misunderstanding and misrepresentation.

Whatever cultural confusions attend Neshat's reception as an artist, her entrance into the American world of art immediately created a new category of art in the West: that of women artists from Muslim backgrounds. Ghada Amer and Shahzia Sikander are two other Muslim women artists who have become known to the art scene in the United States. One might well decide that the coincidence of gender allied to a shared Islamic background does not suffice to forge a type; if one considers the versatility and nuance likely to have informed the different contexts from which Amer, Sikander, and Neshat came, then making of their commonalities a category is problematic. The three have been so categorized, however, and from a Western perspective are linked in the public eye.

Ghada Amer is known for controversial erotic work that explores the subject of female sexuality by integrating the traditionally masculine medium of painting with embroidery, a traditional female domain. A self-declared feminist artist, Amer's work does not deal with Muslim female sexuality exclusively. Some of her earlier work did, however, qualifying her as a member of the new category of female Muslim artist. Ghada Amer herself is aware of her work's reception, acknowledging that "everyone loves to see me as a Muslim, but they don't see it's not about Islam.... It just happens that I'm Muslim and a woman."[12] Nevertheless, Amer is not given the luxury simply to be an artist. Her work (as with that of Neshat and Sikander) is seldom appreciated for its aesthetic value, or even for its globalizing tendencies, but rather solely, and in rather simplistic fashion, for its presumed ethnic and political background. In *Red Diagonales,* of 2000 (fig. 20.2), Amer's women act with almost complete disregard to their audience, except in rare cases in which they might look out at the viewers from behind a screen. Their acts, in the main merely suggestive and only occasionally graphic enough to quality as pornographic, are largely undecipherable behind the abstract-expressionist overlay that conceals the activities depicted from the viewer. The two-dimensional surface Amer creates through painted and threaded lines conceals a three-dimensional social space.

Her eroticized women can certainly be taken as signifiers; in their repetition, they create a visual pattern with connections to Islamic aesthetics. These women could symbolize women's sexuality hidden behind a social façade that creates firm boundaries. The screen can be taken as a "wall" in the political sense of a separation between peoples, or as a "veil" in the personal sense of exclusion. Islam may be referenced, but Amer's point in making these images is that what she chooses to depict as a Muslim woman is not necessarily about Islam.

Among the three internationally recognized and acclaimed women artists thus far discussed, Neshat seems to generate the most publicity in the United States. Perhaps her veiled women are the reason. Neshat's actual chadors are easier to recognize and to equate with Muslim oppression than are Amer's symbolic representations of veiling. Shahzia Sikander's work is made somewhat difficult to access because of her techniques and aesthetics. She is one of the very few artists of today to use the format and scale of traditional Islamic miniatures. For the most part, however, that is the extent of her direct reference to tradition. Within this format, Sikander negotiates contemporary issues freely, often through a juxtaposition of mythology and current concepts. The hybridity of her images is akin to that of the Indian Basholi and Kangra styles (manifestations of hybridizations of local and Mughal styles). Sikander's work reinvents a technique and reevaluates tradition in an alliance with modernism, rather than in opposition to it.[13]

In her 2001 watercolor, *Pleasure Pillars* (fig. 20.3), Sikander presents an amalgamation of globally recognizable iconography within a typical Persian miniature format, tiny, ornate, and detailed. A manuscript frontispiece framed by a geometrical ornamentation and flanked by two centralized women

Fig. 20.3 Shahzia Sikander, *Pleasure Pillars*, 2001, watercolor, dry pigment, vegetable color, tea and ink on wash paper.

(in reference to the seventeenth-century artist Riza Abbasi's single-leaf portraits), the "pleasure pillars," is juxtaposed in the manner of a collage with natural and figurative imagery reminiscent of elaborate manuscript illuminations. The work is further enriched by symbols from Western, Islamic, and other traditions. The richness and complexity of Sikander's visual images and their obvious reference to the Persian miniature, well-known in the West for centuries, with the additions of contemporary representations, confronts viewers with their need for further knowledge and thus defies the images' reduction into the simplistic monolithic statements such work might invite.

The American experience of women artists from a Muslim background is quite distinct from that of Muslim women in Europe, specifically

Fig. 20.4 Mona Hatoum, *Homebound,* 2000. Kitchen utensils, furniture, electric wire, light bulbs, computerized dimmer switch, amplifier, speakers.

in Britain. Mona Hatoum, the "British-Lebanese-Palestinian" artist, has achieved much acclaim in the United Kingdom through work that addresses political issues more directly than have her counterparts in the United States. Hatoum explains that her interest in feminism was "like a jumping-board towards investigating power structures on a wider level as in the relationship between the Third World and the West and the issue of race; and of course I very quickly realized that the issues and directions within Western feminism were not necessarily relevant to women from less privileged parts of the world."[14]

Hatoum's work, exemplified here by an installation from 2000, *Homebound* (fig. 20.4), is grounded in daily realities and steeped in the politics of deconstruction. She overtly questions notions of authenticity and interrogates the role of the hybrid artist as representative of a milieu, whether that of a nation, an ethnicity, or a religion. Hatoum introduces a "third space" of tensions and contradictions that blurs differences between the familiar and the strange; in *Homebound,* her materials, taken from ordinary life—kitchen implements, tables, chairs, and lamps, are altered and subtly recontextualized by the use of a computerized dimmer switch, an amplifier, and speakers. The industrial feel of the installation's individual elements proves a distancing element: These are recognizable, known objects made alien. It is not difficult to move from the experience of viewing the installation to the experience of processing it as metaphor. As Edward Said has argued, "An abiding locale is no longer possible in the world of Mona Hatoum's art which, like the strangely awry rooms she introduces us into, articulates so fundamental a dislocation as to assault not only one's memory of what once was, but how logical and possible, how close and yet so distant from the original

abode, this new elaboration of familiar space and objects really are."[15]

Said's argument applies equally well to the work of Neshat, Sikander, and Amer. Looking beyond superficial signs of the "Other," one is confronted by a space of both negotiations and contestations of the self and the other, within these artists' cultures of origin and within the cultures to which they have migrated. Not surprisingly, given the size, depth, and nature of the spaces to be traversed and understood, what Neshat, Sikander, Amer, and Hatoum produce are tracts of difficult and profound questions, with very few answers.

CONCLUSION

The reception of work by displaced women artists from Muslim backgrounds living in the West, like Neshat, Amer, Sikander, and Hatoum, demonstrates that globalization does not always effect understanding and may, in fact, produce the opposite. Believing that works like those illustrated mirror Western notions of gender issues and political outlooks works against the works' visual complexities and layered meanings. As so often, globalization promises universality and a sort of generally accepted modernism in which particularity and nuance are too often casualties.

The veil has endured as a fetish in Western Orientalism, connoting repression and exciting desire. As works by the artists discussed in this essay attest, such symbols, and other, related ones, however apparently obvious, tend to be far less literal than imagined and indeed harbor a multiplicity of meanings and, often, complicated rationales. Yet the veil remains the focus of Western viewers, curious about it, dogmatic in their assumptions about it, and avid to look beneath it. It is a commonplace of the discourse about hybrid artists who are women and who

come from Muslim backgrounds that the veil is what distinguishes East from West. In the West, the very notion of the veil fuels almost prurient interest and tends to bespeak prejudice. After the events of September 11, 2001, the veil as an image was taken to represent Muslim difference from, even hatred for, the West, reifying received opinion and hardening attitudes. Critiques of work by women artists from Muslim backgrounds like those considered in this chapter has, to date, merely updated itself from Romantic reveries, constituting still a simplistic and monolithic misreading of complicated realities; such essentialization is permitted by the supposedly similar histories of these women artists and is encouraged by the universalizing assumptions of globalization. Globalization may unite the world in significant ways, and yet boundary issues of the kind considered in this chapter constitute a perennial reply to, and dissent from, it.

NOTES

1. The phrase is Homi Bhabha's.
2. David O'Brien and David Prochaska, eds., *Beyond East and West: Seven Transnational Artists* (University of Illinois Press, for the Krannert Art Museum, 2004), 11.
3. Homi Bhabha, *The Location of Culture* (Routledge, 1994), 4.
4. Edward W. Said, *Orientalism* (Vintage Books, 1979), 26.
5. Peter Gran, *Beyond Eurocentrism: A New Face of Modern World History* (Syracuse University Press, 1996), 1.
6. R. Radkhakrishnan, "Postmodernism and the Rest of the World," in *The Pre-Occupation of Postcolonial Studies,* ed. Fawzia Afzal-Khan and Kalpana Seshadri-Crooks (Duke University Press, 2000), 37.
7. Eleanor Hartley, "Shirin Neshat: Living between Cultures," in *After the Revolution: Women Who Transformed Contemporary Art,* ed. Eleanor Heartney, Helaine Posner, Nancy Princenthal, Sue Scott, and Linda Nochlin (Prestel Verlag, 2007), 230.
8. Hartley, "Shirin Neshat," 230, 233.
9. Hartley, "Shirin Neshat," 233.
10. Bill Horrigan, "Double Tour," in his *Shirin Neshat: Two Installations* (Ohio State University Press, for the Wexner Center for the Arts, 2000), 8, 10.
11. See Siva Balughi, "Exile Art," in *The Invisible Diaspora: Between the Middle East and the Americas,* ed. Ella Shohat and Evelyn Alsultany (University of Michigan Press, 2008).
12. Sonia Kolesnikov-Jessop, "Ghada Amer: Defining the Power of Erotic Images," *International Herald Tribune,* March 12, 2007. (See http://www.iht.com/articles/2007/03/12/features/jessop.php).
13. Homi Bhabha, "Chillava Klatch: Shahzia Sikander interviewed by Homi Bhabha," in *Shahzia Sikander,* ed. Shahzia Sikander, Homi K. Bhabha, and Faisal Devji (University of Chicago Press, 2000), 16.
14. O'Brien and Prochaska, *Beyond East and West,* 44.
15. Edward W. Said, "The Art of Displacement: Mona Hatoum's Logic of Irreconcilables," in *Mona Hatoum: The Entire World as a Foreign Land,* ed. Edward W. Said and Sheena Wagstaff (Tate Britain, 2000), 15.

PART SIX

IMAGE AND REALITY

INTRODUCTION

Jane Kromm

The nature of reproductive image making and the competing models for representing the real that these techniques put forward are the central concerns of this section. Traditional standards and expectations for the truth claims of depictions were dramatically called into question by the proliferation of new reproductive technologies. These inventions affected the rhetorical standards for discerning the value of images themselves, and they also influenced the development of different attitudes toward vision itself. The exact degree of accuracy or deception, of appearance or apparition, of mimesis or illusion, required for convincing representation came in for serious debate even as reproductive techniques seemed to settle such polarizing claims in the simple direction of a naive, descriptive realism. Trends toward abstraction also have to be understood in relation to the notion of realism as it was reconfigured in prints, photographs, and films, and by such visual mechanisms as magic lanterns and stereoscopy. Advances in the production and dissemination of images produced a new competitiveness for control of the visual field, one that unsettled established systems for the provision and consumption of images. Valuing multiples and copies over singularity and uniqueness redefined the audience for visual culture and offered new models for social control through the large-scale dissemination of visual material. The very nature of new reproductive media focused on presumptions about the nature of realism and the paradoxical values inherent in the ways visual experience might be reconfigured. A certain detachment from context encouraged by reproductive media affected production in numerous ways. In silent film especially, the practice of fabricating settings, of manipulating the mise-en-scène as opposed to on-site production, created opportunities for dissembling in what was apparently one of the most realistic of representational modes. The unreal nature and phantom-like qualities accentuated by such techniques had a fitting parallel in theories about abstraction in art, particularly those proposing an incorporeal or spiritist core inhering in the simple forms and spaces of nonobjective art. All of these phenomena offered dramatic reconfigurations of reality in the imagery made possible by modernity's new representational formats.

MULTIPLES AND REPRODUCTIONS: THE SOCIAL ECONOMY OF PRINTS AND PHOTOGRAPHS (1850–1900)

New reproductive practices not only increased the range of available media, they also initiated a major shift in our understanding of the nature of images themselves. The multiple formats introduced first by printmaking techniques and continued more radically by photographic processes dramatically altered traditional notions about reproduction, its essential characteristics as well as its potential capabilities.

A concentration on the nonmimetic or nonimitative aspects of reproductive media, including quantity, mechanistic attributes, and the implications of detachment, were the natural accompaniments of procedures that relied upon repetition, sameness, and consistency in appearance. The phenomenon of multiplicity also had a profound effect on reception, greatly extending the public sphere for reproductive images and increasing opportunities to have access to them. What had been the relatively narrow enclave of artists, patrons, and collectors now became a much wider social cohort through readily available illustrations, posters, albums, and newspapers. A new politics of image circulation developed in the wake of the new reproductive mediums and outlets for their distribution, which can be usefully tracked as global as well as local phenomena in centers like New York or Paris or London. The dissemination of visual material soon became an opportunity for acquiring power at unprecedented levels through the extension of knowledge, but also through the social manipulation over markets, tastes, and opinions. Ownership of such means of control over a wide visual field had profound implications for society, and above all it compromised the independent nature of visual reality.

ANTIREALISM AND PHOTOGRAPHY (1850–1920)

Presumptions about the nature of realism and confidence in its role as the defining standard for all reproductive media, especially photography, have proved to be ingrained and persistent. One major consequence of faith in these unexamined beliefs is that elements foreign or antagonistic to realism in such works have been easy to overlook or misunderstand. But visual elements that chafe against the limits of realism or that even contradict the necessity of these limits are the significant features through which much reproductive work queried assumptions about exactness and verisimilitude. On the rare occasions when the less veristic qualities of photography have been discussed, the usual focus has typically been on the idealizing penchant in so-called "fine art" photography. Here the medium was often handled in ways that mimicked high-art strategies of stylization, abstraction, and composition. Some popular photographic practices, such as the tableaux vivants in which participants posed for the camera, seemed to promise a high degree of a certain kind of realism, yet these results were full of hyperartificial and uncanny effects. Even when unacknowledged by critics and viewers, it was nevertheless well-known among practitioners that the technical processes of photographic development and printing actively encouraged a degree of manipulation that interfered with the presupposed mirroring functions many associated with the medium. This interference might take the form of excisions and additions, of rearrangements and piecings, of cropping and enframing. A fascinating outcome of these manipulations is the way they toyed with the dynamics of exposure and manifestation, leading to a scientific extreme in the form of experimentation with chemical processes, and to a nonscientific, occult extreme, in the form of spirit, ectoplasmic, and fairy photography that flourished in England and the United States.

Joy Sperling's chapter, "Prints and Photographs in Nineteenth-Century England: Visual Communities, Cultures, and Class," addresses critical issues in both areas of multiple reproduction and the photographic manipulation of reality. Sperling investigates the ways in which print and photographic culture provided a visual continuum for different kinds of communities in nineteenth-century England while also enhancing hierarchical distinctions within and among them. Prints and photographs themselves

were produced in the context of overlapping visual cultures, shared market suppliers, and a common taste for devices, spectacle, and chemical experimentation. New formats and outlets proliferated after 1800, as artists and image producers became increasingly entrepreneurial, organizing private viewings, selling replicas along with exhibition and engraving rights, and becoming involved in a range of public events such as fairs and panoramas. These activities and venues offered significant opportunities for social exchange and engagement, and their commercial potential was an inducement to ever greater degrees of participation at all class levels. By purchasing *cartes-de-visite,* stereoscopic viewers and images, fair guidebooks and postcards, consumers whetted their appetite for the new visual forms of the day. They also influenced the direction taken by such inventions in print and photographic culture through endorsing their social transactional possibilities even more than their novel visual effects.

INVENTING THE MISE-EN-SCÈNE: GERMAN EXPRESSIONISM AND THE SILENT FILM SET (1900–1930)

The visual habits of dramatic presentation familiar from theater and other public, live forms of entertainment were major influences in the development of silent film formats and practices. Stagecraft customs in particular, when adapted to the new film medium, promised novel opportunities for deploying and manipulating the mise-en-scène concepts and templates that had evolved within theatrical tradition and had been most recently influenced by the stylistic innovations of German expressionism. Some of these stage-based customs influenced the expository element in film, taking the form of segments interspersed with written clarifications, while others affected the degree of emotional display and melodrama made desirable by the absence of sound. A further critical area, especially with regard to the reality effects of film production, was the handling of the setting, and in particular the ways in which stage-derived formulas came to be used as backdrops for the characters' filmed movements. Artificial sets of the Expressionist type might enframe and clarify uncomfortable degrees of the fragmentary, the static, and the distorted. When the artificial stage set was used as the principal mise-en-scène device, it created an atmosphere of pretense and dissembling that, poised in opposition to authenticity, seemed to encourage misdirection and sleight-of-hand operations. These inauthentic contextualizations had political ramifications, but they also might be the object of political manipulation by directors, producers, or government officials. For in silent film, the static settings of the mise-en-scène became the contested territory of authority and ideology, the place where manipulation and delusion were focused, in which backdrops were capable of substantiating the insubstantial and thereby misdirecting the unwary spectator.

In "Inventing the Mise-en-Scène: German Expressionism and the Silent Film Set," Jane Kromm examines the primarily German practice of preferring carefully structured sets and decors to location shooting, and how this preference played out in the film classic, *The Cabinet of Dr. Caligari.* Approaching photography more in the creative, composite spirit of animation and so less inclined to a straightforward objective, realistic orientation, the film has been decried by some for its emulation of stagecraft and penchant for histrionic expressionistic effects. But the film's integrative approach and psychological objectives mesh in intriguing ways, communicating an ambiguity and suggestiveness that continue to fascinate viewers today.

THE REALITY OF THE ABSTRACT IMAGE: MATERIALITY AND TRANSCENDENCE (1900–2000)

As nonrepresentational imagery approached what promised to be a dominant position in modern art, explanatory systems supporting the significance of radically abstract images proliferated. Many of these theories argued for a substantial, symbolic role for abstract notations that was superior to and would in fact displace and even render obsolete the previous static focus on forms as direct reproductions of reality. Certain explanations drew parallels between abstracting tactics and psychological processes, characterizing the new art's shifting views and multiple options as examples of freedom and opportunity in the visual field. Other theories took a less sanguine view, seeing in abstraction a system of fissures, breakdowns, and disintegration that signaled dissolution and danger. A further option saw in abstract forms an impressive degree of referentiality that operated much like the dynamics of empathy, with shapes and colors participating in a system of communication as purveyors of moods and feelings. Arguments like these supported claims made by modern artists that abstract configurations were meaningful in significant, if unfamiliar ways. Surpassing the model of empathetic communication, but benefiting from its strategies, were more extreme propositions presenting abstract compositions as both materially dense and ethereally transcendent. A "new reality" could thus be claimed for nonrepresentational images in which an unveiling of novel levels of meaning might be accomplished through operations associated with spiritualism and clairvoyance. By positing nonmaterial, spiritual forces within abstract forms as their true reality, these and similar propositions promised to bring a utopian end to an outmoded materialist view of art. While this was a worldwide artistic movement, it had a forceful presence in the United States, when new museums, such as the Guggenheim in New York, were founded on the basis of promoting these new antimaterialist ideals.

Sarah Warren's "The Reality of the Abstract Image: Rethinking Spirituality in Abstraction" studies the revival of interest in spirituality as it accompanied the rise of abstraction in the early twentieth century. Most studies of this phenomenon assume a fairly undifferentiated kind of spiritual interest, usually identified with the work and writings of Wassily Kandinsky and such popular movements as theosophy. In Warren's study, it becomes apparent that even among other Russian artists, spiritual inclinations were more diverse and were often squarely in the service of rethinking the very basis of representation.

MULTIPLES AND REPRODUCTIONS: PRINTS AND PHOTOGRAPHS IN NINETEENTH-CENTURY ENGLAND—VISUAL COMMUNITIES, CULTURES, AND CLASS

Joy Sperling

The history of nineteenth-century print and photographic culture is anchored by a list of firsts: the first lithograph, the first steel engraving, the first photograph, and the first wet-plate photograph. A standard assumption is that an expanding appetite for prints and photographs emerged in response to a series of inventions.[1] But print culture performed a more critical and transformative function. It helped to create and consolidate a multitude of precise and complexly ranked visual markers of class, ethnicity, and nationality that not only facilitated and demarcated a subtle taxonomy of class and social order, but also provided a broad visual continuum for comparisons among nations. In short, print culture forged visual communities that concretized and reified underlying class (and racial) hierarchies as well as national communities for those who could not (or did not) read. While Benedict Anderson[2] argues that the dissemination of the printed word created national communities, and the printed word may have functioned as the fulcrum balancing the interests of attentive elites in the nineteenth century, it was the printed image that functioned as the pivot around which almost everything and everyone else revolved.

Prints and photographs crossed almost seamlessly between overlapping visual cultures as independent works of art, as surrogates for paintings and for each other, and as illustrations and other visual ephemera. Print and photographic cultures were symbiotically interconnected; ideas, themes, and materials were exchanged and recycled continuously. Joseph Nicéphore Niépce's photographic experiments (1820s), for instance, were circumscribed both intellectually and practically by his printmaking experience; Louis-Jacques-Mandé Daguerre's (1820s and 1830s) by the visual and commercial demands of producing dioramas; and Henry Fox Talbot's (1830s) by his reliance on the camera lucida. Printers and photographers used the same standard-sized metal and glass plates. They patronized the same glazers, framers, and chemical suppliers. And many early photographs were retouched by artists or printmakers, were often sold in print shops, and functioned frequently as proxies for portrait paintings. The products offered by both printmakers and photographers were relatively inexpensive pictures of people and places. Some were proudly displayed on the wall, others sat on sideboards, and some were stored privately in cases or folios. But both

kinds of print culture were integral to how the nineteenth-century middle classes enacted status and class within nationally circumscribed visual communities.

PRINTS AND DISPLAY IN 1800

The production and consumption of art objects, in unique (paintings) and multiple (printmaking) forms, changed profoundly in the nineteenth century when artists, who had bridled under the power held by private patrons, increasingly broke free to produce art independently "on speculation" (without a commission) for sale to the highest bidder. This new art economy won some autonomy for artists in London by 1800, but it also brought both increased financial risk and the imperative to diversify markets, exhibitions, and sales outlets.

London was a city of visual displays, spectacles, and entertainments by this time, although its formal art world was dominated by the Royal Academy (founded in 1768). The Academy's annual exhibitions at Somerset House included private receptions that extended forty academicians preferential patronage opportunities. British artists were so severely disadvantaged by this closed system that many, academicians included, began to adopt alternative marketing strategies. John Singleton Copley, for example, earned £5,000 by privately exhibiting *The Death of the Earl of Chatham* in Spring Gardens (1781); netted £3,000 by exhibiting *The Siege of Gibraltar* in a tent in St. James Park (1791) and selling several small-scale replicas to private patrons; exhibited *The Death of Nelson* to 30,000 visitors (1806) earning £1,200 from sales of its engraving; and then sold *The Death of the Earl of Chatham* by lottery (1806) for an additional £2,100.[3]

Public exhibitions of art could generate a vast secondary market in sales of reproductive prints of noncommissioned art. They expanded the number of people involved in the production and consumption of visual art in England and precipitated a significant reevaluation of consumer preferences and the art business. After 1800, the British art market increasingly attracted the attention and patronage of the emerging middle classes, who often used engravings as surrogates for more expensive paintings. Artists and dealers marketed prints for the middle classes, providing easy, accessible styles and subjects, such as local landscapes, genre scenes, fancy pictures, portraits of the famous, and reproductions of very popular or widely exhibited works of art. The middle classes wanted to build their collections quickly, efficiently, and relatively inexpensively. Prints were bought and sold in such numbers and at all price levels in the nineteenth century that artists increasingly assumed high levels of personal financial risk in the hope of producing a painting that would translate into a best-selling print. Print shops, such as William Holland's Caricature Rooms, frequently displayed topical prints for sale in their large shop windows and interior exhibition rooms, in addition to selling costly copper engravings of famous works of art, such as Benjamin West's *Christ Healing the Sick* (1811), or plates from James Stuart and Nicholas Revett's *The Antiquities of Athens* (1762).[4]

As the print market developed in London, the print shop transformed from a small operation staffed by one or two employees using hand-operated equipment in 1800, into a specialized, integrated system of businesses involving engravers, printers, publishers, and sellers by 1850.[5] John Boydell is often credited with consolidating British engraving's reputation as

the best in Europe. In 1786, Britain exported £200,000 in prints, mostly from Boydell's vast inventory of 4,432 plates, finally outstripping the French print trade.[6] Boydell's best-selling engraving, West's *The Death of General Wolfe* (1771), painted in four versions by popular demand, earned the artist as much as £15,000 over fifteen years.[7] Boydell, however, is most remembered for his Shakespeare Gallery, an ambitious plan to exhibit sixty-seven paintings, to produce a folio of 170 large prints illustrating Shakespeare's plays, and to publish an illustrated edition of his collected works, all to be sold by subscription. War with France in 1793 ruined many of Boydell's subscribers, while his costs escalated to over £100,000. He declared bankruptcy in 1804 and abandoned the project unfinished, but many of his prints circulated in Britain for years.[8] Other speculators tried to emulate Boydell's plan. Thomas Macklin proposed both a Poet's Gallery (1788–1799) and an Illustrated Bible (1791–1800); Robert Bowyer invested £30,000 in an illustrated *Hume's History of England* (1792); and Henry Fuseli, who first worked with Boydell, took over John Johnson's project for an illustrated *Paradise Lost* (1799). All of these projects failed.[9]

By contrast, contemporary popular spectacles around 1800 that charged an admission fee were more successful. Magic lantern slide shows, for example, in which painted images on glass slides were projected by a lantern onto walls, screens, or diaphanous floating fabrics to imitate ghosts were particularly well received.[10] Although the magic lantern slide was not a new technology in 1800, the popularity of the magic lantern show was, and it spread rapidly with improved lantern technology and a rising passion for the macabre and the Gothic.[11] In performances of Étienne Gaspard Robertson's *Phantasmagoria* (1802), magic lantern slides projected ghostly apparitions on screens from behind (fig. 21.1). Robertson told spectacular tales of murder, mayhem, and destruction involving dramatic lighting, smoke from burning phosphorus, projections on gauzy screens that swooped around on pulleys, mirrors, and terrifying sound effects. Robertson's illusions mimicked reality without ever threatening to become real, and as exquisite simulacra they thrilled and entertained. In 1837, Henry Langdon Childe developed a "dissolving view," a technique to dissolve one magic lantern slide into the next as it changed, further enhancing both the slide's illusionistic power and its marketability.[12] By 1851, glass magic lantern slides also found a vast new market both as supports for wet-plate photographs and as photographic slides for projection.

THE DISSEMINATION OF THE PRINTED IMAGE AROUND 1850

The growing appetite for and pleasure taken in display, spectacle, and the consumption of manufactured material objects in England around 1850 led to middle classes for whom the constant and changing display of material possessions such as prints and photographs demarcated distinctions in class and taste. In London, public exhibitions and entertainments such as the Great Exhibition of 1851 also functioned as highly structured environments where different social classes could mingle, evaluate themselves comparatively, and compare British culture with that of other nations. The Crystal Palace Exhibition was ostensibly intended to compare "The Industry of All Nations" on the basis of trade, manufacturing, communications, and design, but it in fact reified British convictions about order and power: It both claimed British cultural

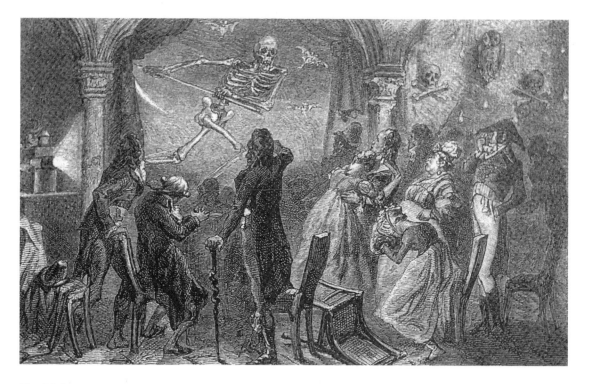

Fig. 21.1 Gaspard-Etienne Robertson, *Fantasmagorie de Robertson, Cour des Capucines, près la place Vendôme, tous les jours à sept heures,* about 1800.

superiority and made explicit British class distinctions.[13]

In 1851, London was a metropolitan center of culture and display, known for its elegant terraces and arcades designed for the elegant promenade. These spaces combined leisure, pleasure, observing, being observed, and visual (at the very least) consumption. Shop windows along the major thoroughfares increased in size long before the repeal of the window tax in 1851. Shopkeepers vied for the attention of patrons with elaborate window displays that were part fantasy, part illusion, and part vanity (many included mirrors), extending visual access to their wares into the evening hours by directing gaslight onto their window displays, and by producing brightly printed advertising.[14] Visitors to the Crystal Palace Exhibition were bombarded with this kind of display at the fair, in its advertising, on souvenirs, and in printed memorabilia over the entire spectrum of quality and price.[15]

Royal Academy exhibitions were popular in the nineteenth century: In 1822, David Wilkie's *Chelsea Pensioners* had to be roped off to protect it from crowds of visitors, as did William Frith's *Derby Day* in 1858.[16] But public art exhibitions drew much larger crowds: For example, 95,000 people visited Benjamin West's memorial exhibition in 1851.[17] Both art exhibitions and popular spectacles like the Panorama drew crowds at well-trod entertainment spots such as Vauxhall Gardens, Egyptian Hall, Madame Tussauds, and the Colosseum.[18] Indeed, the distinction between high and low exhibitions, locations, and art forms seems to have been very fluid at that time. Henry Courtney Selous, for instance,

painted canvases prolifically for exhibition but also created prints for the Art Union of London and painted most of the twelve Panoramas on display in London in 1844.[19]

The English print trade gained additional momentum in the 1830s as steel plates (versus copper), the ruling machine, and the steam press mechanized printmaking. Steel engraving (intaglio) was expensive and time-consuming, because steel is harder than copper. A plate could take two years to engrave, yet a single plate could yield several thousand prints, reduce production costs per print, and increase profits. But quality was inevitably jeopardized. In the 1840s, Art Union prints were widely criticized for their slow production, poor production values, pandering to broad and thus mediocre taste in their choice of images, and ultimately because each edition was too large and therefore the print was "too common."[20]

While steel engravings were frequently disparaged by the art elite as mechanical copies or counterfeits, or as evidence of uninspired production or mediocre taste, their mass production by 1850 represented an irrevocable change in relations between artists, print producers, and audiences. William P. Frith exemplifies this change. In 1854, Frith sold *Ramsgate Sands: Life at the Seaside* to the dealer Lloyd after its highly successful exhibition at the Royal Academy. Lloyd resold it at cost to Queen Victoria but retained the exhibition and engraving rights. The Art Union of London purchased the engraving rights from Lloyd for £3,000 and published 12,000 prints in 1859.[21] In 1856, Frith sold *Derby Day* to Jacob Bell for £1,500 but retained the exhibition and engraving rights, which he sold to Ernest Gambart for £750 and £1,500, respectively. And in 1862, Louis Victor Flatou paid Frith £5,250 in advance for the sale,

exhibition, and engraving rights to *The Railway Station*. Flatou charged eighty thousand people to see the painting at his Haymarket Gallery, and Frith later complained that Flatou's gross from the exhibition and engraving of *The Railway Station* amounted to £30,000.[22]

Wood engraving (relief) emerged over steel as the favored print technology for magazine illustration in the 1850s because, while the hardwood block was small and hard, the engraver could cut a sharp detailed image into the wood grain that was durable enough to yield thousands of prints and possessed the advantage of being able to be set in the printing press with type to be printed on the same page with text. When blocks were reproduced using stereotype or mezzotint processes, wood engraving editions were extended to tens of thousands, making the wood engraving the most durable and adaptable printing process for popular illustration. Charles Knight's *The Penny Magazine* (1832) was one of the first widely read English magazines illustrated with wood engravings. By the 1840s, *The London Journal* (1845), *Reynold's Miscellany* (1846), and *Cassells' Illustrated Family Papers* (1853) were all illustrated with wood engravings and enjoyed circulations in the hundreds of thousands, while by 1849, the *Art Union* (later *Art Journal*) boasted that its pages contained eight hundred illustrations annually. Photographic reproduction of engraving blocks further extended their use in the 1870s; the *Illustrated London News* was able to print 25,000 copies of a single issue for the 1882 Christmas edition.[23]

Lithography, although flexible, fast, very inexpensive, and able to sustain large editions by the 1830s, was not widely accepted in England, probably because its drawn appearance may have appeared hasty and slightly cheap.

It was more popular in France for magazine illustration and for political imagery.[24] Lithography was most prized in England when it was hand-tinted to make it look more precious and used to illustrate lavishly produced publications such as David Robert's *The Holy Land, Syria, Idumea, Arabia, and Nubia* (London, 1842–1849), published in five volumes, sold by subscription and so successful that it received a royal imprimatur. Chromolithography, on the other hand, developed in the 1830s, often appeared flat and oily. It was used to illustrate Owen Jones and Jules Goury's *Plans, Elevation, and Details of Alhambra* (London 1838–1845); Thomas Shotter Boys's *Picturesque Architecture in Paris, Ghent, Antwerp* (London, 1839); and the flat decorative schemes in Owen Jones's best-selling *The Grammar of Ornament* (London, 1856). But chromolithography was more often used to illustrate children's books; it was also the preferred medium of very inexpensive prints for mass markets: nostalgic, sentimental, moralizing, or pious images as well as their inverse, barroom prints of gambling and carousing, and prints for the burgeoning advertising markets of the 1870s and 1880s.

THE DISSEMINATION OF THE PHOTOGRAPHIC IMAGE

Photography emerged in 1839 from the arenas of printmaking, public entertainment, industry, and natural science. It brought together several strands of interest in reproductive images, optical illusions, and devices, visual theatrics, "fixing" the image, and chemical experimentation. But the synergy between the hardware of printmaking and popular entertainment—the plates and glass slides of magic lanterns—the optical trickery of the kaleidoscope and stereoscope, and the alchemy of the smoke and mirrors of the phantasmagoria produced in photography a new visual delight with real commercial potential; it was not merely a fast, accurate process for reproducing images, but was widely regarded as a glamorous new spectacle in an age already abundant with spectacles.

In France, Niépce first employed the infant process to duplicate an engraving (1822) and then to "fix" a view from his window (1827); Daguerre's theatrical demonstration of the daguerreotype process, in which he made the "latent image" appear (1839), must have seemed like a veritable magic trick; while Talbot described his calotype process as *The Pencil of Nature* (1844). Also, in 1839, Daguerre and Talbot competed for the right to claim priority over the invention of photography and the fame that went with it. Both patented their processes in England, were transfixed by photography's commercial and historical potential, and wanted and needed to assert a propriety claim over its future assets.

Daguerreotypes were direct-positive images of exquisite delicacy. They were highly prized because they were fragile, unique (nonreproducible) and so precise (literally composed of chemical amalgam) that they mimicked tiny labor-intensive miniature paintings. They were often encased in elegant pressed-leather cases and had to be held at an angle to reveal their image, giving them a magical, intimate, private aura. Daguerreotypes were luxury items for an exclusive audience: A good daguerreotypist charged as much for a portrait as a mediocre painter. In London, Richard Beard took the first daguerreotypes in 1841, but within five years Antoine Claudet's photographs were so highly regarded that the Duke of Wellington was among his patrons, and the post of photographer-in-ordinary to Queen Victoria was created for him.

The Crystal Palace Exhibition (1851), held in an immense glass exhibition hall surrounded by nineteen acres of park in London, attempted to maintain a shaky peace and order in Britain after the 1848 revolutions on the European continent.[25] Within the orderly confines and controlled space of the Crystal Palace, the exhibition underscored British industrial supremacy internationally and British social hierarchies internally by reifying visually for the various strata of British society the belief that everything and everyone had its place at the exhibition and in the world (fig. 21.2). Additionally, the exhibition appealed to the growing British appetite for tourism (especially the armchair variety), and for public displays of piety or family. Armchair tourists and families bought books, prints, photographs, stereographs, and magic lantern slides about the fair for later enjoyment, while the newly pious avoided the sins of the city by enjoying the healthy entertainments of the fair. The illustrated press covered the Crystal Palace Exhibition exhaustively: Many

Fig. 21.2 *Wot Is to Be* (1851), printed handkerchief souvenir from the Great Exhibition, Crystal Palace, London.

magazines produced their own checklist of exhibits, and the official catalog was actually printed on site at the exhibition.[26]

The Crystal Palace was also the first international exhibition to be documented photographically. In 1851, Talbot released his patent on the calotype, thereby allowing others to commercially exploit his negative–positive photographic process. Frederick Scott Archer announced his wet-plate (collodion) photographic process in 1851 and the ambrotype in 1852.[27] The wet-plate process, which produced chemically stable, clear, high-quality, relatively inexpensive multiple photographs that could be printed on paper, was favored by two important figures, P. H. Delamotte and Joseph Cundall. Delamotte, appointed official photographer of the Crystal Palace Exhibition, recorded the royal family at the fair for an eager nation in *Opening Ceremony by Queen Victoria of the Rebuilt Crystal Palace, Sydenham, 10 June 1854* (London, 1854), while Cundall, an independent photographer, published the equally successful *Photographic Views of the Progress of the Crystal Palace, Sydenham* (London, 1855) with 160 wet-plate photographs.[28] The popularity of these publications did much to establish the wet-plate process's dominance in England.

Archer's equally successful ambrotype process (1852) harnessed the inexpensive wet-plate technology to imitate expensive and much higher-quality portrait daguerreotypes, suggesting that the daguerreotype's material quality as a marker of social status or class was often valued over its veristic representation. The premium placed on the display of material possession was also exploited in Andre Disdéri's *cartes-de-visite* (1861), which he made by taking eight small visiting-card-sized photographs of a sitter on a single plate. The fact that each *carte* was a small, ill-defined

photograph explains its paradoxical attraction for some middle-class clients: It displayed the fine clothes and public persona of the sitter but did not betray the possible absence of true breeding. *Cartes* were so inexpensive to (re)produce that celebrity cards were collected widely. J. E. Mayall's *Royal Album* (1861), which presented *cartes* of Queen Victoria, is credited with starting an international craze dubbed "cartomania" (fig. 21.3). Millions of *cartes* were collected in England; one *carte,* William Downey's *Princess of Wales with Baby Louise* (1867), reputedly sold 300,000 copies.[29]

Fig. 21.3 John Jabez Edwin Mayall, *Queen Victoria and Family with Bust of Prince Albert,* about 1860, carte de visite.

The stereoscope, which exploited binocular vision to mimic the perception of depth by forcing a viewer to look at two slightly different images separately, was invented by Charles Wheatstone in 1832. When photography was announced, Wheatstone recognized immediately its potential for the stereoscope and commissioned the London daguerreotypists Claudet and Beard to make stereoscopic photographs as soon as the technology permitted. Wheatstone's stereoscope was large, cumbersome, and expensive, but that changed in 1849, when Sir David Brewster (who developed the kaleidoscope in 1817) marketed a small, inexpensive home version. He sold 250,000 stereoscopes in three months. In 1851, Louis-Jules Dubosq also produced a luxury version with a set of stereograph cards of the Crystal Palace Exhibition for Queen Victoria, firmly establishing another craze. George Swan Nottage, founder of the London Stereoscope Company, sold 500,000 additional stereoscopes between 1852 and 1854, and he boasted an inventory of 100,000 stereographs.[30] With so many and such varied stereoscopes on the market, they inevitably marked class: Stereoscopes ranged from expensive pieces of parlor furniture to cheap wooden hand-held viewers, and as a home entertainment, stereocards ranged from quasi-educational sets of scientific, geographical, artistic, and moralistic cards to humorous, sentimental, supernatural, or titillating scenes that were purely entertaining. Some stereographs of famous paintings, such as Frith's *Derby Day* (1856) or Henry Wallis's *Death of Chatterton* (1856), became best sellers in a kind of "edutainment" category, and some were simply odd: Charles P. Smyth's *Teneriffe: An Astronomer's Experiment* (1858) was a stereographically illustrated book. The enthusiasm for stereographs waned in the 1870s, probably owing to competition from postcards, but waxed again in the 1890s.

THE PAPER EXPLOSION IN 1900

The numerous European and American international exhibitions organized between 1851 and 1900 were pivotal in reframing public and private visual spectacle. These fairs promoted a number of public entertainments that had been reconceptualized as domestic or family entertainments.[31] The phantasmagoria was transformed into a family entertainment as a magic lantern projector and slides; the panorama was reduced to a panoramic print, photograph, or book for personal use; the photographic studio was replaced by the snapshot photograph; and the print shop was replaced by the stereograph and the postcard. At the fairs themselves, the disorder of the public realm was also reframed within the limited, controlled space of the fairground and re-presented in an orderly manner that attempted to reaffirm systems of cultural power and superiority.

The published prints and photographs that described the fairs, like the fairs themselves, functioned as an interface between self and other (private and public). They presented "natives" of other, "barbarous" nations, as consumable. It has been argued that international exhibitions actually functioned as proxy department stores, displaying exotic peoples in a jumble of fancifully decorated booths that at first impression seemed a chaotic muddle of ethnicities, but that were in fact well organized into strict racial, social, and class hierarchies.[32] By 1900, the international exhibition had firmly supplanted the midcentury belief in social advancement with the conviction that social status, taste, and even level of civilization were birthrights. At the World's Columbian Exposition in Chicago (1893),

a Euro-American civilizational hegemony was openly promoted in the rational, ordered grid of the "White City," while non-European nations and the lower classes were exoticized and commodified as the "Other" in the disorder of the "midway."[33] Likewise, at the Universal Exposition in Paris (1900), the Trocadero Palace functioned as a living panorama of fantasy architecture and visual delights designed to amuse the tourist and, like the earlier phantasmagoria, never threatened by becoming real.[34] Fifty million visitors attended the Paris Exposition, most consuming the hegemonic narrative along with souvenirs, books, pamphlets, prints, photographs, lantern slides, and much more.

By 1900, working people who attended fairs were also active consumers of inexpensive prints and photographs. While large, individually commissioned portrait photographs might still have been a financial stretch for them, ambrotypes, tintypes, stereocards, *cartes,* and postcards were cheap and readily available; photographs in books and magazines reproduced using the fast new inexpensive half-tone process (1880s) were widespread; and in 1888, George Eastman had launched the inexpensive Kodak Camera for U.S.$25, placing cameras in the hands of thousands of ordinary people (fig. 21.4). The Kodak was a simple box camera with both a fixed aperture and focal length that came fully loaded with a roll of Eastman's paper-backed film (the Eastman business was founded on pre-prepared dry plates and cheap, easy-to-use, storable roll film).[35] Kodak film was advanced by turning a key; when the roll of film was finished the entire camera was returned to Eastman for processing and reloading, then returned to the owner. Owners had to do little more than the advertising guaranteed: "You Press the Button and We Do the Rest." The Kodak demystified photography. Eastman

marketed increasingly to women, created an ancillary market for Kodak photo albums, published a *Kodakery* magazine with tips on how to take "snapshots," and even established Kodak Clubs. Thus, in ten years the company sold 1.5 million cameras, and by 1900, they introduced the Brownie Camera, which was marketed to children for the incredibly low price of U.S.$5.00 but which sold to all ages and survived in various forms until 1980.

Working people also purchased postcards at fairs. Postcards, first marketed in the 1870s,[36] recorded one's presence at the fair and could be posted to family members or collected in albums alongside personal snapshots. They cost pennies each and could be purchased even by those unable to afford the cheapest camera. By 1910, British postcard sales averaged 800 million annually; the partnership of Valentine and Wilson dominated the trade, publishing postcards of international and national fairs, seaside resorts, and local beauty spots, and joke cards, cards of ships, trains, storms and floods, and political and military events as well as advertising and trade cards.[37]

The thousands of paper images created for fin-de-siècle international fairs represents only a small segment of the print and photographic market, but they stand for a range of products that was inexpensive enough to tempt the average working person, was attractive to the middle classes, and formed a visual community. The print culture produced high-quality prints and photographs for framing, large advertising images, smaller images for books, magazines, and pamphlets, custom-made photographs, Kodak snapshots, and inexpensive postcards. By 1900, society was fully infused with printed and photographic images that did not merely represent, but created, a visual community. In 1806, printed images still had the ability to enthrall audiences with their relative rarity.

Fig. 21.4 *All Out-Doors Invites Your Kodak,* about 1914.

In 1899, British society was wholly dependent on them.

CONCLUSION

At century's end, however, ever sharper distinctions were drawn between the kinds of images appropriate for different classes, cultures, nations, and communities. Clear demarcations were established between good or bad (high or low) print culture using the language of quality, production value, and cost. Prints and photographs were adjudged as high art according to the intellectual difficulty and relative scarcity of the images, or were devalued as low culture for being too easily understood, mass produced, or widely marketed to those with neither class nor money. The quality and quantity of a print or photograph varied in a fixed relationship between the quality of the print and the size of the edition; the higher (lower) its quality, the smaller (larger) the edition. By 1900, the most highly valued image was thus a unique image—a monotype print or a *cliché-verre* photograph—proving that all communities find a way of describing an elite and guarding its prerogatives. If the nineteenth century was the age of the mechanical reproduction, then print-based visual communities were its agents of social intermediation. Print and photographic technologies were subject to latent demands in society, forming visual communities, but they did so in complex transactional ways.

NOTES

1. K. Flint, *The Victorians and the Visual Imagination* (Cambridge University Press, 2000); R. Hirsch, *Seizing the Light* (McGraw Hill, 2007); W. Ivins, *Prints and Visual Communication* (Da Capo Press, 1969).

2. B. Anderson, *Imagined Communities: Reflections on the Origin and Spread of Nationalism* (Verso, 1991), 46.

3. G. Reitlinger, *The Economics of Taste: The Rise and Fall of the Picture Market 1760–1960* (Holt, Rinehart and Winston, 1961), 68.

4. Reitlinger, *The Economics of Taste,* 70.

5. Ivins, *Prints and Visual Communication,* 1969.

6. R. Altick, *The Shows of London* (Belknap Press, 1978), 106.

7. Reitlinger, *The Economics of Taste,* 68.

8. Altick, *The Shows of London,* 107.

9. Altick, *The Shows of London,* 109.

10. K. B. Stauberman, "Making Stars: Projection Culture in Nineteenth Century German Astronomy," *British Journal for the History of Science* 34 (2001): 441.

11. C. J. Wright, "The 'Spectre' of Science: The Study of Optical Phenomena and the Romantic Imagination," *Journal of the Warburg and Courtauld Institutes* 43 (1980): 188.

12. T. Castle, "Phantasmagoria: Spectral Technology and the Metaphorics of Modern Reverie," *Critical Inquiry* 15 (1988): 35; K. Vermier, "The Magic of the Magic Lantern (1660–1770): On Analogical Demonstration and the Visualization of the Invisible," *British Society for the History of Science* 38 (2005): 158.

13. P. Greenhalgh, *Ephemeral Vistas: The Expositions Universelles, Great Exhibitions and World's Fairs, 1851–1939* (Manchester University Press, 1988), 53.

14. R. Thorne, "Inventing a New Design Technology: Building and Engineering," in *The Victorian Vision: Inventing New Britain,* ed. J. M. MacKenzie (Victoria and Albert Publications, 2001), 176.

15. P. Anderson, *The Printed Image and the Transformation of Popular Culture 1790–1860* (Oxford University Press, 1991.

16. W. P. Frith, *My Autobiography and Reminiscences* (Richard Bentley, 1887).

17. Reitlinger, *The Economics of Taste,* 70.

18. G. Waterford, ed. *Palaces of Art: Art Galleries in Britain 1790–1990* (The Dulwich Picture

Gallery and the National Gallery of Scotland, 1991).

19. Altick, *The Shows of London,* 138.

20. J. Sperling, "'Art Cheap and Good:' The Art Union in England and the United States 1840–60," *Nineteenth Century Art Worldwide* 1, no. 1 (2002): 8.

21. Sperling, "'Art Cheap and Good,'" 12.

22. Reitlinger, *The Economics of Taste,* 150, 238.

23. J. R. Ryan, "Images and Impressions: Printing, Reproductions and Photography," in *The Victorian Vision: Inventing New Britain,* ed. J. M. MacKenzie (London: Victoria and Albert Publications, 2001).

24. B. Farwell, *The Cult of Images: Baudelaire and the Nineteenth Century Media Explosion* (University of California, Santa Barbara Museum of Art, 1977).

25. Greenhalgh, *Ephemeral Vistas,* 18.

26. *Official Descriptive and Illustrated Catalogue of the Great Exhibition of the Works of Industry of All Nations* (W. Clownes and Sons, Printers; Contractors to the Royal Commission, 1851).

27. Archer's wet-plate process bound light-sensitive silver salts to a glass plate with collodion when wet and exposed it to light when tacky. The ambrotype, a wet-plate negative image on glass that appeared positive when backed by a dark lacquer or card, met the market need for an inexpensive daguerreotype surrogate when framed to mimic a daguerreotype. The tintype functioned similarly, by substituting a thin piece of tin for the glass mount and costing only pennies to produce.

28. Ryan, "Images and Impressions," 232.

29. Ryan, "Images and Impressions," 228.

30. Ryan, "Images and Impressions," 226.

31. T. Richards, *The Commodity Culture of Victorian England: Advertising and Spectacle, 1851–1914* (Verso Press, 1990.

32. Greenhalgh, *Ephemeral Vistas,* 23; J. R. Ryan, *Picturing Empire: Photography and the Visualization of the British Empire* (University of Chicago Press, 1997), 191.

33. M. Armstrong, "'A Jumble of Foreignness': The Sublime Musayums of Nineteenth-Century Fairs and Expositions," *Cultural Critique* 23 (1992–1993): 199–250.

34. R. Rydell, "Gateway to the 'American Century': The American Representation at the Paris Universal Exposition of 1900," in *Paris 1900: The American School at the Universal Exposition,* ed. D. P. Fischer (Rutgers University Press, 2000), 128.

35. N.M. West, *Kodak and the Lens of Nostalgia* (University of Virginia Press, 2000).

36. C. Harding, "The Smudger's Art: the Popular Perception and Representation of Itinerant Photographers in the 19th Century," in *Visual Delights: Essays on the Popular and Projected Image in the Nineteenth Century,* ed. S. Popple and V. Toulmin (Flick Books, 2000), 143.

37. R. Vaule, *As We Were: American Photographic Postcards, 1905–1930* (Godine Press, 2004).

INVENTING THE MISE-EN-SCÈNE: GERMAN EXPRESSIONISM AND THE SILENT FILM SET

Jane Kromm

Many of the early practitioners drawn to the movie industry as it developed in the early twentieth century wanted to explore cinema's unique capabilities. Others, however, preferred to exploit effects indebted to the visual orientation and persuasiveness of other mediums. These borrowed sources or habits ranged from older art forms as traditionally practiced to their more recent adaptation for the scenic requirements of contemporary theater. German cinema in particular gravitated toward adopting the mise-en-scène practice common to current stagecraft, which resulted in a preference for studio rather than location shooting.[1] Appropriating the popular modernist style of German expressionism as a commercial advantage, directors and designers accepted that movement's idiom of the fragmented and the distorted. By downplaying the photographic approaches of a relatively nonmanipulative, camera-based kind in favor of an obviously manipulated, hermetic, and slanted style, these professionals forcibly contrasted the identifiable and familiar with the disorienting and the dissimilar and so forged a hauntingly new visual hybrid. This chapter will discuss the visual nuances and intellectual implications of this composite, hybrid approach as it unfolded in the German silent film classic, *The Cabinet of Dr. Caligari*.

Filmed in the winter of 1919–1920, *Caligari* was produced at the beginning of the Weimar Republic, just as Germany was coping with a multiplicity of destabilizing developments, including the recent defeat in the war, a failed revolution, and rampant inflation. For the duration of World War I (1914–1919), Germany was cut off from most film imports except for those from Scandinavian countries. In the face of these limitations, the pace of German cinematic production began to pick up. World events, as well as a continuing fascination with certain themes drawn from German Romanticism, led to the dominance of older motifs cast with the moodiness and gloom of ballads and tales from a hundred years earlier. A further distinctive feature of the cinema as it developed in Germany was its connection to lower, more unsavory forms of entertainments such as carnivals and nickelodeons.

Inspired by postwar malaise, the personal experience of a bizarre murder, and the recent viewing of a hypnotized strongman in a Berlin amusement park, the scriptwriters, Hans Janowitz and Carl Mayer, collaborated on the Caligari story in late 1918 and presented it to Erich Pommer, the head of Decla studio, in April 1919. A contract was signed immediately, and Pommer agreed to produce this tale of Caligari, a carnival showman, and his somnambulist Cesare, who are part of a traveling fair newly arrived in the town of Holstenwall. Two students, Alan and Francis,

and their friend Jane, with whom both men are in love, are attracted to the carnival's entertainments. These are dramatically interrupted by a series of mysterious murders, and when Alan becomes one of the victims, Francis resolves to search for proof that Caligari and Cesare are behind these events. Francis tracks Caligari to the local asylum where, in a surprising twist, he apparently serves as director. Francis also discovers that the doctor has an obsession with an eighteenth-century hypnotist, the original Dr. Caligari, who was responsible for a series of murders committed by a somnambulist he had hypnotized for this purpose. When confronted with this evidence and also shown the dead body of Cesare—who had collapsed while attempting to abduct Jane—Caligari becomes insane, attacking one of the doctors until they restrain him with a straitjacket and remove him to a cell. A framing device in the script indicates that this is a "story within a story," and the filmed version adjusts the frame to suggest that Francis, the narrator, is not reliable and is in fact mad himself, with the tale thus a madman's deluded interpretation of perfectly normal events.[2] However, the film's final shot, a slow iris-in on the face of Caligari/asylum director, hardly reassures the spectator of the character's benevolence, despite the absence of the Caligari makeup, and so the ending is ambiguous and strangely without closure.

The film went into production in late 1919 and was completed early in the next year. It was shot entirely in a glass studio, the Lixie-Atelier, under the direction of Robert Wiene. The sets were largely painted flats and backdrops and were the work of designers Hermann Warm, Walter Reimann, and Walter Röhrig, and the photographer was Willy Hameister. While there has been some controversy regarding whose decision it was to use sets inspired by German Expressionism, it is generally now accepted that this was Wiene's idea. Nothing in the script gives any indication of a preference for this style, although it does include specific notations for such devices as fade-ins and fade-outs for transitions. Barnet Braverman recalled in 1926 that Wiene "saw an opportunity for getting away from the customary by giving the scenes in *Caligari* settings and forms which intensified the thoughts and emotions of the characters and established a very positive relation between them and mimetic action."[3] Pommer, along with Rudolph Meinert, who succeeded him as producer, approved of this innovation largely on financial grounds, and both hoped also that it would reinforce the film's notoriety.[4]

CALIGARI AND GERMAN EXPRESSIONISM

By 1919, German expressionism had become a familiar, even fashionable, style, with its emphasis on interiority and subjective feeling as these existed within the individual and as they might be externalized in surroundings and material objects.[5] Continuing in many ways the themes of German Romanticism, the Expressionist movement had by war's end differentiated into two generations. While prewar German Expressionism had focused on spiritual and social ideals, the postwar group was markedly less hopeful, disillusioned by the impact of the war's destructiveness. A number of visual constructions or preferences remained intact through this transformation within the movement (although the second group is associated with a turn toward a more objective approach). One of the continuing threads was the conviction, grounded in German etymology, that objects were animate, active, and gendered, resulting in a tendency to

anthropomorphize them and their surroundings. In *Caligari*, this is evident in the dynamic distortion of shapes, of rooms and their contents, of windows and houses, which all seem to suggest a quality or a "physiognomy" germane to the mood of the scene.[6] Whenever possible, the actors, and this is particularly true of Werner Krauss's Caligari and Conrad Veidt's Cesare, move in ways that communicate an uncanny affinity with the surroundings. Cesare slinks along walls as if he were some kind of emanation, and in his final moments, he dramatically mimics the silhouetted dying trees around him (fig. 22.1).

Before *Caligari*, a few films attempted to adapt an Expressionistic outlook and style, such as *Thais* (1916) by A.G. Bragalia, who was associated with the Italian Futurist movement, or Maurice Tourneur's *The Blue Bird* (1918) and Ernst Lubitsch's *The Doll* (1919).[7] But these films tended to use Expressionist motifs in a limited way, for certain segments designed to convey something like an alternative world. By contrast, Abel Gance's *The Madness of Dr. Tube* (1915) was shot with the assistance of convex and concave mirrors borrowed from an amusement park, so as to suggest that the distortions of madness were primarily visual, as in a hallucinatory experience, rather than misperceptions or misinterpretations of a shared, recognizable visual field. More readily available influences for the association of the Expressionist style with film came in the widely disseminated forms of graphic design, such as magazine illustrations, advertisements, propaganda posters, and theatrical promotional paraphernalia. From the realm of live entertainment, the redesign of Berlin's amusement grounds, Luna Park, in the Expressionist mode, was an important reinforcement of the style's association with the popular and especially the slightly transgressive or sinister fairground setting. But it was in the theater that the most influential Expressionist practices took hold in Berlin around 1919, and these had a major impact on the subsequent production of *Caligari*.[8]

GERMAN EXPRESSIONIST THEATER

A number of productions at this time used sets gauged to match the demands of Expressionist drama, with the emphasis on externalizing inner emotions in visible ways that were extensive and unifying, pervading backdrops, curtains, décor, and even costume. This practice, with its emphasis on the mise-en-scène, the context or milieu that would integrate the dramatic motives of the play, the sets, and the acting, was a notable feature of the German Expressionist theater. A number of stagings in Berlin in 1919 are significant instances of this practice. For example, the sets by Robert Neppach for Ernst Toller's *Die Wandlung* (The Transformation) were minimal but distinctly Expressionist in their preference for jagged forms and angular accents. Photographs documenting the production indicate a curtain

Fig. 22.1 Cesare dying after his attempt to kidnap Jane. *The Cabinet of Dr. Caligari*, 1919. Film still.

backdrop decorated only in its central portion with agitated forms, consistent with the angst and trials of the principal character. Centered in front of this curtain and flanked by several supporting, chorus-like figures, the central character, along with the supporting players, wear costumes embellished with the same complement of violent, nonrepresentational, dynamic forms. This intermingling of principals and decor was quite different from French and British practice; here, in sets for the Russian ballet, to cite one instance, artists were commissioned to produce backcloths that left the stage open for the full use of the dancers.[9]

While the German mise-en-scène approach to setting or décor was much admired in the context of the country's experimental, Expressionist theater, its use in *Caligari* was somewhat controversial. Numerous critics complained about this aspect, sensing in it a kind of demotion, with cinematic form being treated as little more than the static filming of a theatrical production. Jean Cocteau was particularly critical of this practice, seeing in it a denigration of film's inherent formal qualities, with *Caligari* "the first step towards a grave error which consists of flat photography of eccentric decors, instead of obtaining surprise by means of the camera."[10] Other reviewers noted this practice as somewhat unusual and eccentric but observed that the spectator eventually becomes used to it and appreciates what had seemed at first to be strangeness and incongruity, as now well-suited to the film's narrative.[11] A common barb leveled in the negative reviews is that there is a conflict or breach between the painted décor, the actual objects, and the more naturalistic acting style of the cast members (with the exception of the more explicitly Expressionist acting of Krauss and Veidt).

But there are many scenes in the film that demonstrate the care taken in the relationship between the décor and the mentality or status of the characters. Alan's attic room, where he tries to study but is drawn to the window and the outside world where the carnival is being set up, conveys the precarious existence of the impoverished, struggling student (fig. 22.2). The repetition of forms in the chair backs, for example, suggestive of humble furniture types but also of the edgy, iterative tendencies of contemporary avant-garde design, are played off at careful angles against the more ominous shadows and highlights of the walls and floors, as Alan makes his way to the out-of-plumb window, beyond which tilting chimneys can be seen. This room, along with Francis's room and Caligari's asylum office, are fascinating variations on a similar theme, the different, potentially uncanny nature of the studious milieu, redolent of the absorption in books and the learned secrets of the past. The setting of Jane's room is quite different, with a fabric-draped, cocoon-like arrangement for her bedroom, where she is shown asleep in bed in the famous pose of the *Sleeping Ariadne*.[12] In her scenes in the

Fig. 22.2 Unable to study, Alan is drawn to the sounds of the carnival. *The Cabinet of Dr. Caligari*, 1919. Film still.

Fig. 22.3 Jane in her family's sitting room. *The Cabinet of Dr. Caligari*, 1919. Film still.

home, the angularity of many previous scenes is avoided in favor of curved silhouettes and repeated forms (fig. 22.3). This is an obvious attempt at developing the difference gender could contribute to an Expressionistic dramatic scheme, as the pure oval of Jane's face is picked up in all the surrounding features. While this effort might be traced to an impulse that is already rather stereotypical, it is played out in a highly effective manner that melds décor with character and dramatic purpose in effectively composed frames. Both scenes suggest that the charge that *Caligari* is merely a static filming of a staged play is not entirely convincing but is perhaps only a partial assessment of the film's mise-en-scène construction.

CALIGARI AND THE CINEMATIC PROCESS

An analysis of the work's design procedure as well as its cinematic qualities contradicts the charge that the film lacks any of the features of the new medium. The three professional designers, Warm, Reimann, and Röhrig, worked in collaboration to achieve the sets' particularly consistent look. In contrast to the procedures adopted for cinematic production in other countries, in Germany it was customary for designers, cameramen, and technicians to reach a collaborative consensus before filming commenced, thus assuring a more seamless approach to the film as a whole. Surviving documentary evidence suggests that Warm was probably the source for the more architectonic elements and Reimann for the intriguing moodiness of the ensemble, encouraging an approach more akin to that of animation.[13] The formal tendencies of several prominent German Expressionist artists have been cited by scholars who have studied the film, including painters associated with the movement who were particularly inclined toward adapting Cubist-inspired crystalline forms, such as Lionel Feininger and Conrad Felixmüller. But it was Warm's insistence that "the cinema image must become an engraving" or become "drawings brought to life" that helped free the designs from a purely derivative or static orientation.[14]

Painted light and shadow combine with townscape and interior setting for the backdrops, flats, and floors of the limited space available in the Lixie studio. A wide range of cinematic techniques enlivens the scenes as filmed. Although Hameister's camera is relatively static, the film has around 370 cuts, which suggests a fairly high degree of technical intervention.[15] Other filmic practices in evidence range from cross-cutting and split screens to high- and low-angled shots and lighting, as well as the much used tactic of reducing and expanding the image field with circular iris-ins and -outs.[16] In addition to the latter, there are also shots reduced by a diamond-shaped configuration, which seem to be used for scenes in which there is a pursuit or search or abduction

Fig. 22.4 Cesare about to enter Jane's bedroom. *The Cabinet of Dr. Caligari*, 1919. Film still.

involved, as characters close in on their objectives. Cesare's entrance into Jane's home through her bedroom window is dramatized by such a shot; the configuration increases the sense of impending threat as the interplay of jagged edges thereby put into play is intensified (fig. 22.4). This graphic emphasis extends from the lozenge-shaped frame through the two-dimensional pointed spiral shapes on the window embrasure, to Cesare's knife and outstretched arm, and beyond to the painted slanting rooftops and window patterns behind him. Although the poet and critic Blaise Cendrars famously chastised the film for adopting "deformations [that] are not optical," there are many scenes like this one in which the integrative effort expanded across the film's several visual levels is especially effective.

CALIGARI AND INTERPRETATION; GERMAN EXPRESSIONISM AND MADNESS

With only a few exceptions, the contemporary reception of *Caligari* was positive and enthusiastic. A number of reviewers found that the atmosphere and mystery of the film reminded them of the work of Edgar Allan Poe. The *Motion Picture News* declared that "it was like a page from Poe," while the reviewer for *The New York Times* found it "a fantastic story of murder and madness such as Edgar Allan Poe might have written."[17] No reviews refer to underlying political messages within the film, reserving their focus for *Caligari's* novel visual effects. It was only after Siegfried Kracauer published *From Caligari to Hitler: A Psychological History of the German Film* in 1947 that film scholars were inclined to follow the book's thesis that *Caligari* is the first in a long line of German cultural artifacts in which tyrannical authoritarian characters prefigure Hitler and the rise of Nazi socialism. The cornerstone of Kracauer's thesis is Janowitz's recollection of the film's genesis. This account we now know to be flawed, especially in its claim that the frame for the tale was forced on the writers by the studio (see note 2).

However, the frame as filmed does inflect the story differently: Instead of the script's frame, in which Francis and Jane are a successful and happy middle-aged couple, the film's frame complicates the narrator's position, suggesting that he and not Caligari is truly mad, and thus indicating that the entire narrative might be the delusion of an insane student. A careful reading of the final shot seems to even undermine this certainty, as the iris-in closes on the face of Caligari—denuded of his Expressionist makeup—but looking inscrutable and shiftless to the very end. This indeterminacy further complicates the view, found in many of the film's early reviews, that the German Expressionist mise-en-scène can be rationalized as the visual evidence and externalization of Francis's madness. This of course is an oversimplification of the relationships between external reality and inner tension that were at the core of German Expressionist aesthetics, in which

there was never, except in satire or caricature, a simple equivalency between feeling bad and looking jagged. It was concern about suppositions of this kind that fueled Cendrars's criticism that the film "casts discredit on modern art because the discipline of modern painters (cubist) is not the hypersensitivity of madmen but equilibrium, intensity, and mental geometry."[18] Yet Cendrars's position also flattens the principal distinctions between modern styles, since Expressionism is always concerned with the communication of significant feeling, usually very strong, while Cubism typically involves a more cerebral approach to the analysis of form. And, of course, in practice, the two tendencies were often combined. But more importantly, the film itself does not strictly conform to any clear distinctions between the vantages of sanity or insanity and blurs their distinctiveness both within the film and for its spectators. This is especially clear in the existence of Expressionist décor, both within the story as well as within the frame segments themselves.

A closer look at the film's scenes associated with the asylum and its precincts will clarify the multiple viewpoints and references within the work that confound a simple sane–insane perceptual vantage. These scenes have consistent features, both in the narrative as well as in the framing story. In the scenes of the asylum courtyard, populated by patients, all are shown "enacting" their delusions or obsessions. Like other depictions of this subject from the eighteenth century onward, the scene articulates the notion that the madhouse is a microcosm exposing the foibles and traits of the world at large.[19] When Francis confronts the asylum director/Caligari in his office, the viewer is reminded of the other "study" interiors in the film with their sparse furnishings and plenitude of books (fig. 22.5). The

humble student study is quite different from this office, despite the prominent position of the same ladder-back chair. Here the space suggests both cave and cathedral, invoking the mysteries of the past, of the secret pursuit of knowledge that the presence of so many very old tomes similarly accentuates. Only the skeleton—a demonstration-type arrangement of the sort used in medical teaching—identifies the professional context of the room and injects a note of potential terror. The film's contemporaries would have recognized this feature as the kind of marker for inhumanity shown in many scathing antiwar images depicting doctors, but especially those of George Grosz. This medical reference, the essential display culture of Caligari's carnival act and its star, the somnambulist Cesare whom the doctor routinely controls through hypnotism, are features linked to the quasi-acceptable yet mysterious world of the alienist or psychiatrist. Numerous scholars have investigated the parallels between the film and the work as well as public reputations of Jean-Martin Charcot and Sigmund Freud.[20] Recognizing these parallels and similarities, both within the film and between the film and its cultural context, tends also to reduce the effectiveness of any simplistic mad–sane dichotomy as the crucial interpretative framework for *Caligari*.

In fact, the most consistent aspect of the film in this regard is its highly orchestrated advertising campaign, which is invoked in the film when the doctor's obsession with the eighteenth-century hypnotist Caligari is unmasked. He is shown outside, surrounded by lurching buildings and trees, seeing writing on the walls and in the sky and all around him, but these words evade him and disappear as he approaches (fig. 22.6). The phantom writing, "Du must Caligari werden," or "You must become Caligari," is the haunting obsessive

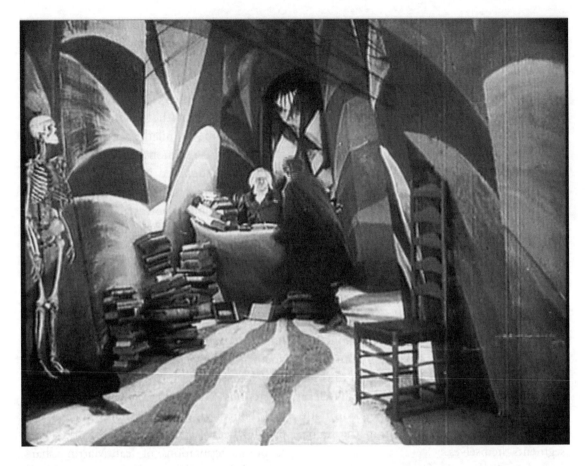

Fig. 22.5 Francis confronts Caligari in the asylum director's office. *The Cabinet of Dr. Caligari,* 1919. Film still.

Fig. 22.6 Caligari, unmasked and unhinged, cannot escape the phantom writing. *The Cabinet of Dr. Caligari,* 1919. Film still.

message from which the doctor can find no release. This same phrase inexplicably filled posters and kiosk displays before the film's release, ratcheting up the excitement, calculated to instigate a widespread compulsive drive among the public to view the film as soon as it premiered. This message urged everyone to share in the obsession of a contemporary alienist, a Faustian figure, who himself has been compelled to merge his personality with one who practiced the "dark arts" of hypnotism. These hallucinatory scenes in the film consist of Caligari alone with his fleeting obsessional visions, and they are perhaps the sole moments

in the film when an imputation of madness is both clear and delimited. Using the phrase in the film's advertisement underscores the significance of this episode and its psychological implications to the work as a whole, as Caligari's madness is revealed and confided to the spectator. Viewers will recollect the memory of this episode, along with the overtly malevolent gestures and expressions of Caligari the showman, as the slow iris-in on the doctor's face brings the film to its ambiguous end.

NOTES

1. Among the many sources dedicated to this film, see especially Mike Budd, "Introduction," 1–5, and "The Moments of Caligari," 7–119, in *The Cabinet of Dr. Caligari: Texts, Contexts, Histories,* ed. Mike Budd (Rutgers, 1990); David A. Cook, *A History of Narrative Film* (Norton, 1996 [1981]); Lotte Eisner, *The Haunted Screen,* trans. Roger Greaves (University of California, 1973 [1952]); Lotte Eisner, "L'Influence de l'art expressioniste sur les décors des films allemands des années vingt," in *Paris, Berlin: rapports et contrastes france-allemagne, 1900–1933* (Centre Pompidou, 1978), 264–73; Thomas Elsaesser, "Social Mobility and the Fantastic: German Silent Cinema," in Budd, *The Cabinet of Dr. Caligari,* 171–89; S. S. Prawer, *Caligari's Children* (Oxford University Press, 1980); Ian Roberts, "Caligari Revisited: Circles, Cycles and Counter-Revolution in Robert Wiene's *Das Cabinet Des Dr. Caligari,*" *German Life and Letters* 57, no. 2 (April 2004): 175–87; David Robinson, *Das Cabinet Des Dr. Caligari* (British Film Institute, 1997); Kristin Thompson, "Dr. Caligari at the Folies-Bergère, or, The Successes of an Early Avantgarde Film," in Budd, *The Cabinet of Dr. Caligari,* 121–69; John Willett, *Expressionism* (McGraw-Hill, 1970); John Willett, *The Theatre of the Weimar Republic* (Holmes & Meier, 1988). The term mise-en-scène is used to emphasize the importance of the context or milieu in the work's imaginative conceptualization.

2. In Janowitz's version of the film's genesis, he claimed that the frame had been forced on the writers by the director with damaging results, turning the truth-seeking Francis into a delusional madman and the mad Caligari into a benevolent and sane psychiatrist. Other recollections of the film, along with the publication of Werner Krauss's script in late 1995, do not conform to Janowitz's version and prove instead that a frame was always part of the script from its inception. However, the frame in the script is more conventional, setting the story twenty years in the past, and told now from the vantage of an older, successful Francis now happily married to Jane. For details about this controversy, see Robinson, *Das Cabinet Des Dr. Caligari,* chap. 1.

3. Cited in Robinson, *Das Cabinet Des Dr. Caligari,* 21.

4. Eisner, *The Haunted Screen,* 19; Robinson, *Das Cabinet Des Dr. Caligari,* 22.

5. Among numerous sources, see Willett, *Expressionism*; Jill Lloyd, *German Expressionsim: Primitivism and Modernity* (Yale University Press, 1991); Stephanie Barron, ed., *German Expressionism 1915–25: The Second Generation,* (Los Angeles County Museum of Art, 1988).

6. Eisner, *The Haunted Screen,* 11.

7. Cook, *A History of Narrative Film,* 111.

8. Willett, *The Theatre of the Weimar Republic,* and *Expressionism,* 152–59.

9. Willett, *The Theatre of the Weimar Republic,* 167; Thompson, "Dr. Caligari at the Folies-Bergère," 153.

10. Cited in Robinson, *Das Cabinet Des Dr. Caligari,* 53.

11. Many reviewers are canvassed in Robinson, *Das Cabinet Des Dr. Caligari,* 53–59.

12. The sculpture dates from about 240 B.C.E. and is in the Vatican Museum.

13. Eisner, *The Haunted Screen*, 36–37, 78; "L'Influence de l'art expressioniste," 266.

14. Warm's phrase has been variously translated: Eisner, *The Haunted Screen*, 25; Prawer, *Caligari's Children*, 32.

15. Prawer, *Caligari's Children*, 32.

16. Prawer, *Caligari's Children*, 168.

17. Robinson, *Das Cabinet Des Dr. Caligari*, 50.

18. Robinson, *Das Cabinet Des Dr. Caligari*, 52.

19. On these depictions, see Kromm, *The Art of Frenzy: Public Madness in the Visual Culture of Europe 1500–1850* (Continuum, 2002).

20. See for example, Catherine B. Clément, "Charlatans and Hysterics," in Budd, *The Cabinet of Dr. Caligari*, 191–204.

THE REALITY OF THE ABSTRACT IMAGE: RETHINKING SPIRITUALITY IN ABSTRACTION

Sarah Warren

In the period immediately before World War I, Europeans witnessed enormous political and cultural tumult. There were challenges to every kind of orthodoxy. From the revolutionary and nationalist threats to the Austrian, Ottoman, and Russian Empires, to the discrediting of Euclidian geometry and Newtonian physics, whatever had formed the basis of everyday life and reality was now under siege. The development of abstract painting was one of these challenges, as artists began to quarrel with the idea of representation and reality itself. In their Cubist paintings of 1908–1909, Picasso and Braque mounted a powerful critique of representation, and by 1912–1913, a number of artists throughout Europe had begun to create paintings that were almost entirely nonrepresentational.

Perhaps the most famous of these was the Russian-born artist Vassily Kandinsky, who saw abstraction as related to a spiritual revival. Because of Kandinsky's prominence, this connection between abstraction and spirituality has long been a subject of debate in histories of modernism. Kandinsky's spiritual abstraction is often contrasted with the more materialist approaches of French Cubism and Italian Futurism. While these contrasts are important, the fact that Kandinsky's position alone has stood for the relationship between spirituality and abstraction is a sin of omission. There

were, in fact, a number of other European artists who saw a connection between spirituality and abstraction but were often quite different from Kandinsky. The Russian painters Mikhail Larionov and Natalia Goncharova also started painting abstractly in 1912–1913. Although they shared with Kandinsky both an abstract painterly practice and an overriding interest in Russian folk culture with its spiritual elements, their understanding of the primitive, spirituality, and abstraction deviated sharply from Kandinsky's.

In 1912, Kandinsky published his book-length essay, *On the Spiritual in Art,* in which he called for an art that would counter "the whole nightmare of the materialistic attitude, which has turned the life of the universe into an evil, purposeless game."[1] The current state of art, with its superficial focus on the technically "correct" representation of nature (in portraiture and landscape, for example), reflected this materialistic nightmare. Kandinsky argued that the inherently spiritual qualities of art should be further developed through an emphasis on the emotional qualities of purely painterly forms, unmediated by resemblance to actual objects. Therefore, such basic building blocks of painting as color and line should not be used to depict the external forms of nature but should be marshaled for their direct emotive effect on the viewer. As Kandinsky

said, "In this way, the abstract element in art gradually has come increasingly to the fore, [that same striving] which only yesterday concealed itself shyly, hardly visible behind purely materialistic strivings."[2]

In addition to the pure emotive effects of form, Kandinsky saw primitive culture as pointing the way toward a more spiritual art practice. Indeed, before the lyrical abstraction he developed in the 1910s, much of Kandinsky's work depicted old Russian folk themes—Slavic princesses, medieval market fairs, and folklore heroes. Even in the later abstract paintings, such as *Painting with White Border* (fig. 23.1, 1913), we see the visual remnants of motley peasant crowds, onion-domed churches, and mounted warriors.

The mounted figures that inhabit so many of Kandinsky's paintings (in this case with a large white lance) were a manifestation of the artist's identification with the heroic figure of Saint George. This "Blue Rider," as Kandinsky called him, was his personal emblem, and the artist named the famous *Blue Rider Almanac* after him.[3] For Kandinsky, the Blue Rider symbolized his role as a shamanic warrior and healer in the fight against toxic materialism. Kandinsky's fascination with folk culture went back to his early years as a law student in Moscow, during which time he went on an ethnographic expedition to western Siberia. The impact of this experience on his later artistic development cannot be overestimated, and in his *Reminiscences* Kandinsky

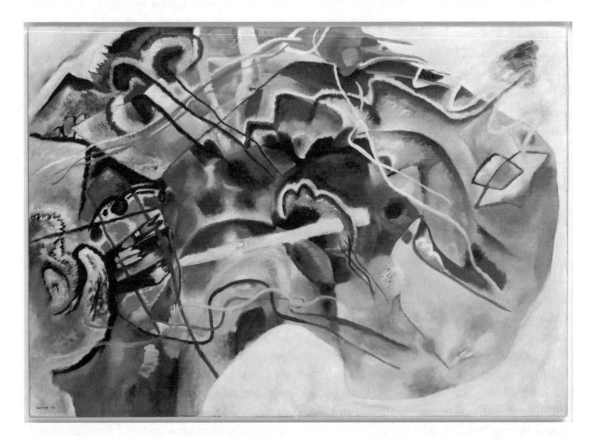

Fig. 23.1 Vassily Kandinsky, *Painting with White Border*, 1913.

recalled the revelation of color and emotion he found in the decoration of peasant homes.[4] Although his interest in the spiritual effects of color and form prompted Kandinsky toward abstraction, he often preserved a visual reference to archaic Russian culture, as a way to invoke the spiritual bonds of an earlier, more authentic culture.

Although he lived and worked in Germany, Kandinsky did maintain some professional relationships in Russia, and it was because of these connections that a version of *On the Spiritual in Art* was read at the December 1911 All-Russian Congress of Artists in Saint Petersburg. At a session on aesthetics and the history of art, several chapters of *On the Spiritual in Art* were read aloud by Nikolai Kul'bin, a former military doctor and avant-garde impresario. At the same session of the Congress (in fact, just before it), a young poet named Sergei Bobrov presented a paper entitled "Foundations of the New Russian Painting," in which he extolled the virtues of a group of artists he dubbed "Russian Purists," whose foremost examples were Mikhail Larionov and Natalia Goncharova. Bobrov's "Purism," which echoed many of Kandinsky's ideas, found its sources in

Our amazing icons—those world-class culminations of Christian religious art, our old folk prints [*lubki*], Northern embroideries, stone women, bas-reliefs on communion bread and crosses, and our old shop signs. There is so much here that is new, touched by no one. . . . Russian purists, having seen all this value, became one with it, penetrated into the very soul of it. Henceforth our native antiquities, our archaism lead us towards unknown prospects.[5]

Bobrov clearly shared Kandinsky's interest in folk and archaic art, and his list of sources looks much like those Kandinsky included in *The Blue Rider Almanac*. Like Kandinsky, Mikhail Larionov and Natalia Goncharova endowed Russian folk culture with a special significance. But while Larionov's and Goncharova's approach to the primitive may have resembled Kandinsky's on the surface, it operated under fundamentally different conditions. Despite the importance Kandinsky placed on Russian folk culture, he had left Russia in 1896 to begin his artistic career and returned only for periodic visits. With Kandinsky spending almost his entire professional career in Germany, he was able to compartmentalize his homeland as "Old Russia," the Russia of saints, shamans, heroes, and medieval lore. Larionov, Goncharova, and their cohort, on the other hand, were living and working in Russia and therefore were forced, at least in part, to reconcile their vision of "Old Russia" with the reality of Russian modernity.

LARIONOV AND GONCHAROVA

Larionov and Goncharova first rose to leadership roles as founding members of the Jack of Diamonds, a group that became notorious in the press for its extreme avant-gardism. Although the members of the Jack of Diamonds shared an interest in popular and folk art—Ilya Mashkov, Petr Konchalovskii, and David Burliuk, among others, filled their paintings with images of *lubki* (folk broadsheet prints), shop signs, icons, and other examples of Russian folk design—they were probably better known to the public as followers of French Modernist painting and were often dubbed "cézannistes."[6] It was this second aspect of the Jack of Diamonds reputation that apparently prompted Larionov and Goncharova to break from the group in late 1911, less than two years after they had helped to establish it. After a flamboyant split enacted at a public debate introducing

the second Jack of Diamonds Exhibition in February 1912 (Goncharova interrupted and denounced a lecture by Burliuk on Cubism), Goncharova wrote an open letter to a number of newspapers, explaining her objections:

> Cubism is a positive phenomenon, but it is not altogether a new one. The Scythians' stone images, the painted wooden dolls sold at fairs are cubist works. True, they are sculpture and not painting, but in France, too, in the home of cubism, it was sculpture—Gothic sculpture—which served as the point of departure for the movement.[7]

While Goncharova's understanding of French Cubism was clearly limited, this did not stop her from using it for her own purposes. Instead of rejecting Cubism outright, Goncharova reframed it as a Russian tradition rather than a French innovation. By establishing a parallel between her own use of native "primitive" objects and French Cubists' use of Gothic sculpture, Goncharova positioned her work as an organically Russian modernism, rather than the derivative use of French Modernism she associated with the Jack of Diamonds.[8] Her comments should remind us of Bobrov's at the All-Russian Congress of Artists. Bobrov was, in fact, speaking as a representative of Larionov's and Goncharova's new group, the Donkey's Tail, and he underlined the originality of the Russian artists by claiming that they had surpassed their debt to French Modernist painting: "having overcome Cézanne, Gauguin, and Matisse, [the purists] returned to their Russian roots, to Russian archaism."[9]

At this point, it may seem that Larionov and Goncharova were casting off modernity (under the guise of Western Modernism) and wholeheartedly embracing a simpler, more "authentic" primitive Russian culture. But the truth was not nearly so simple. While the "Old Russia" of folk art, religious painting, fairy tales, and picturesque peasant cottages, as envisioned by Kandinsky and others, was the domain of popular taste in prerevolutionary Russia, the Donkey's Tail works were unrecognizable as such to the Russian public. It would be difficult for us to imagine how, for example, Goncharova's beautiful, almond-eyed *Mother of God* (fig. 23.2, 1911) could pose a problem for a public accustomed to romanticized visions of "Old Russian" paintings—and yet the censor confiscated Goncharova's religious paintings from the opening of the Donkey's Tail Exhibition.[10] Even sympathetic critics claimed to find "demonic temptation" in her works.[11]

In the case of Larionov the story is slightly different. Larionov was equally invested in the concept of "Old Russia" and its authenticity, but in his paintings he showed a side of Russian folk life many did not want to see. At the Donkey's Tail he exhibited a series of paintings of soldiers (he had just recently served his mandatory term in the army). The vulgarity of his subjects, combined with his rough technique, made the pictures particularly difficult for critics and public alike. The critic Maksimiliam Voloshin, in his review of the Donkey's Tail Exhibition, described a very visceral negative reaction to the works:

> Among all the participants in the Donkey's Tail there appears a particular passion for depicting soldier life, military camps, hairdressers, prostitutes, and pedicurists.
>
> They clearly try to borrow their paints from the objects they represent: they paint a hairdresser [using] pink lipstick, fixative, brilliantine, and hair-growth liquid, a soldier with tar, dirt, leather, etc. With this they succeed in transmitting the aroma of the represented objects and arouse nausea and disgust in the viewer.[12]

As was evident in countless works of popular theater, illustration, and applied design,

Fig. 23.2 Natalya Goncharova, *Mother and Child,* 1911.

folk culture was romanticized and sacralized in prerevolutionary Russia. The Donkey's Tail artists, however, insisted on the vulgar and profane nature of the folk.[13] In this, already, we can see that the Russian artists did not follow Kandinsky's model of primitive cultures offering access to a purer spirituality.

Both Kandinsky and his Russian counterparts emphasized the value of folk culture (Russian in particular) in their publications

and at the same time moved toward painterly abstraction in their own artistic practice. Kandinsky clearly related these two elements of his work—the superior spirituality of the primitive could be approximated through a focus on the pure painterly elements of color and line. Like primitive art, this form of abstraction would appeal directly to a viewer's emotional and spiritual life, rather than through the proxy of narrative that was found in traditional representational painting. But since Larionov and Goncharova did not approach Russian folk culture in the sacralized way that Kandinsky did, how do we understand the relationship between folk culture, abstraction, and spirituality in their work?

Larionov and Goncharova began their new rayist paintings in late 1912, several months after the Donkey's Tail Exhibition. As we can see from Larionov's *Rayist Landscape* of 1912 (fig. 23.3), rayism also differed substantially in style from Kandinsky's lyrical abstractions. They called the new style of painting rayism because the assertively applied lines of bright colors depicted "the sum of rays reflected from an object" instead of the object itself.[14] In describing rayism, Larionov sounds very close to Kandinsky in his focus on painterly form: "In accordance with purely painterly laws, rayism is concerned with introducing painting into the sphere of those problems peculiar to painting itself."[15] But, unlike Kandinsky, Larionov and Goncharova's turn to abstraction was not accomplished by a gradual shift in style. In fact, as late as October 1912 Larionov claimed to be still working on his primitivist *Venus* series.[16]

Fig. 23.3 Mikhail Larionov, *Rayonist Landscape,* 1912–1913.

How do we explain this sudden change? There are any number of European artists who may have influenced Larionov and Goncharova to turn so abruptly toward abstraction in late 1912, and the influence of Italian futurist painting and Cubism on Larionov and Goncharova has been addressed by scholars over the last two decades.[17] The abruptness of the shift in painting styles, and the stark difference between the vehement rejection of the past found in Italian Futurism and the "Russian archaism" described by Bobrov might lead one to assume that the Donkey's Tail artists were again performing an about-face, rejecting the primitive for a fierce acceptance of modernity.[18] But the painters' dedication to the primitive continued full force. If we look closely at what Larionov and Goncharova were doing during the period in which they developed rayism, we see that, indeed, their Russian archaism was leading them toward unknown prospects—in this case, abstraction.

EXHIBITION OF ICON PATTERNS AND LUBKI

Two projects that engaged Larionov and Goncharova during this period are particularly significant for the development of rayism and point to the ways in which their use of primitive spirituality differed from Kandinsky's. In March 1913, Larionov organized two exhibitions that opened simultaneously and in the same gallery—one consisted of icon patterns and *lubki,* while the other, entitled The Target, constituted the second exhibition of the Donkey's Tail artists. The Target was also the exhibition where Larionov and Goncharova first revealed their rayist paintings to the Moscow public. With these exhibitions, Larionov forwarded a strong relationship between the archaic and primitive (icons and *lubki*) and

his own modern practice. At the same time that he was putting these exhibitions together, Larionov and Goncharova were collaborating with the Futurist poets Aleksei Kruchenykh and Velimir Khlebnikov on a number of cheaply printed books of experimental poetry. While the two painters first began to experiment with the sharp abstract linearity of rayism in their illustrations, the poets Kruchenykh and Khlebnikov used the books to develop their *zaum* or "beyonsense" language, which also looked to archaic Russian forms in order to transform the conventions of poetry.

Larionov clearly invested in the importance of icons, but the relationship between those and his own work was unclear. While Goncharova, Kazimir Malevich, and Vladimir Tatlin (two other artists who exhibited with the Donkey's Tail) had clear ways in which icons affected their work, rayism is still seen as having no relationship with icons. This is strange, considering the coincidence of Larionov's interest in icons and his development of rayism. Looking at the futurist books give us an alternative model for understanding the possible relationship between archaic religious forms and modernist artistic practice.

One of the earliest indications we have of Larionov's interest in icons came during the same All-Russian Congress of Artists where Bobrov had promoted the archaism of the "Russian purists" and Kandinsky's *On the Spiritual in Art* was read. Larionov was interviewed by a Moscow paper about his participation in the Congress. His response was that the Congress was vital for one and only one "infinitely necessary" goal—the preservation of church antiquities and "Byzantine" painting.[19]

A little over a year later, Larionov paired his own work (and that of his fellow contemporary artists at The Target) with the icon

patterns and *lubki,* a good deal of which were from Larionov's own collection.[20] The *lubki,* with their often bawdy depictions of popular folklore, were clearly connected to the previous work of the Donkey's Tail artists, especially Larionov's.[21] But the inclusion of icon patterns was a more complicated matter. Icons were the most sacralized objects of traditional Russian culture, and the disjuncture between the perceived profanity of the Donkey's Tail artists and the sacredness of icons goes some way toward explaining the reception of works like Goncharova's *Mother of God.*

Two other artists who exhibited with the Donkey's Tail also claimed a connection between icons and their creative process (although somewhat later than the development of rayism). Kazimir Malevich used religious themes in his early work, but an even clearer reference to icons is found later in the *Black Square.* When it was first exhibited in the 1915 0.10—Last Futurist Exhibition, the *Black Square* was hung in the upper right corner of the room, just as an icon would be displayed in a traditional Russian home. Vladimir Tatlin received training as an icon painter in workshops in Yaroslavl' and Moscow.[22] Many of his early primitivist paintings take fundamental aspects of their style (palette, regularized highlights of drapery) from the conventions of icon painting. Tatlin later attributed his radical foray into sculpture to the inspiration of icon painting, claiming that "If it wasn't for the icons…I should have remained preoccupied with water-drips, sponges, rags, and aquarelles."[23] According to Tatlin, it was the direct use of materials in icon painting that allowed him to reject the technical preoccupations of European easel painting.

We know that Larionov collected icon patterns, that he advocated for icon preservation, and that he presented them in an exhibition next to his own rayist paintings. And yet the importance icons had for Larionov's work is not clear. Moreover, neither Larionov nor Goncharova map any relationship between the development of rayism and their interest in icons. Nevertheless, in his pairing of the Exhibitions of Icon Patterns and Lubki with The Target, Larionov insisted on the link between the two kinds of painting.

Of course, Modernist art historiography provides us with a very basic way of understanding this relationship—"primitive" forms, like icons and old Russian religious painting, offered an alternative to the perspectival mode of post-Renaissance painting. But icons were not incidental items, whose visual features could simply be appropriated at will. They were important ritual objects that were embedded in the fabric of everyday life. While no satisfactory explanation of the relationship between rayism and icons can be found among visual artists at the time, the collaboration with the Futurist poets Aleksei Kruchenykh and Velimir Khlebnikov does offer an intriguing model.

LARIONOV, GONCHAROVA, AND THE FUTURIST BOOKS

The first of the Futurist book collaborations was *A Game in Hell,* published in the summer of 1912. For Velimir Khlebnikov's and Aleksei Kruchenykh's poems, Goncharova created primitivist images that resembled both *lubki* and manuscript illumination. This collaboration was successful enough that, over the course of the following year, Larionov and Goncharova contributed to or collaborated with Kruchenykh and Khlebnikov on a total of eight books. It was in these works that Kruchenykh and Khlebnikov were working out the mechanics of *zaum,* their "transrational"

or "beyonsense" language. Among the many interesting features of *zaum* were the ways in which the poets looked to archaic religious and spiritual forms of speech in order to delineate the importance and efficacy of *zaum*. In their use of religious and mystical forms of speech the poets hoped to disrupt the conventional signifying practices of language and replace them with a primal speech, in which a meaning was manifest in the very sound of the utterance. The collaboration of Larionov and Goncharova with the Futurist poets—and its corresponding intimacy with the antisignifying practice of *zaum*—took place at the same time the painters were developing rayism. It is through the frame of the *zaum* and its use of "speaking in tongues" that I suggest we look at Larionov's use of icons.

After *A Game in Hell*, the poets and painters collaborated on *Old-Fashioned Love*, but it was in the late 1912 book, *Worldbackwards*, that the first signs of transrational poetry show themselves in earnest. In this book, illustrated by both Larionov and Goncharova, Kruchenykh included poems made up of disconnected words, almost entirely lacking in structure.[24] The illustrations similarly lack unity, with Larionov including works that came from both his primitivist and rayist styles. The same could be said of Larionov's illustrations for Kruchenykh's *Pomade*, published in early 1913. While the cover and two other illustrations follow a cartoonish primitive style, the bulk of Larionov's illustrations seem to be experiments with intersecting lines—and therefore much closer to rayism. The most interesting of these is perhaps the drawing on the third page of *Pomade* (fig. 23.4), in which Larionov provided an unreadable image to go with a distinctly unreadable poem. On this page Kruchenykh composed the lines, "3 poems written in their own language, it differs from others! Its words

Fig. 23.4 Aleksei Kruchenykh and Mikhail Larionov, page from *Pomada*, 1913.

do not have fixed meanings." The first of these, included on the same page, was the following poem:

dyr bul shchyl
ubesh shchur
skum
vy so bu
r l ez

These verses are untranslatable because they are also meaningless in Russian. And it was precisely their lack of conventional signification that was meant to give them, and the *zaum* language they inaugurated, an amplified force. In their manifesto, "The Word as Such," the poets declared that this poem "provided

a model for another sort of sound and word combination." Kruchenykh later wrote of "Dyr bul shchyl" that, "in this five-line poem there is more of the Russian national spirit than in all of Pushkin."[25]

As prototypes for this reshaping of language, the two poets looked to forms of archaic speech that they believed already functioned directly through the sound of the utterance, without signification. Kruchenykh found his model in the practices of a number of fringe sects of the Russian Orthodox Church. In the Futurist manifesto "New Ways of the Word," Kruchenykh likened *zaum* speech to the glossolalia, or "speaking in tongues" practiced by worshippers in charismatic Orthodox sects.[26] The doctrinal origin of "speaking in tongues" is the Pentecost, when the Holy Spirit descended on the disciples and made them speak in strange languages unknown to man. Glossolalia, thus, relied on the manifestation of a spiritual presence, rather than the conventions of language, for its power and significance.

This is similar to the way icons function within a traditional Orthodox context. For Larionov, and anyone else raised within the Orthodox Church, an icon existed as a very particular kind of picture. It is a painting, but nevertheless a radically different kind of object than a secular painting. Hans Belting called the icon a "pictorial concept," in which the picture invokes the presence of its subject rather than representing it through resemblance.[27] As a type of image, the icon not only disrupts the mechanics of visual representation, but fundamentally rejects it, giving it a different ontological status than a "picture." What is important is that there is almost no substantive difference between the image and what it represents.[28] An icon exists in the unique ontological impasse of the "ancient antithesis between representing and being present, between holding the place of someone and being that someone."[29] Even in their myths of origin, Orthodox icons have traditionally been understood as a trace or manifestation of the divine presence—the picture itself should be translated to earth directly from a divine source (as in the case of shrouds), or else executed by a hand so holy as to be perfectly authentic (as in the example of the Saint Luke Madonnas).[30] In this sense, icons are a classic example of the form of sign that linguist Charles Peirce called "indexical," that is, registering a presence (or at least a trace of it) rather than representing through resemblance (a form of sign that Peirce, ironically, called "iconic").[31]

If we look at the Orthodox icon as an indexical sign, we are compelled to see the similarities between that and glossolalia, both articulations so authentic that they manifested a spiritual force in the world. In Kruchenykh's take on glossolalia, and Larionov's use of icons, the expectation that these archaic forms manifest a presence relied on the fact that the utterances or the images were nonsignifying and/or indecipherable, that is, abstract. Like these archaic forms of speech, Larionov's interest in icons indicated his desire for a more forceful visual language, one that did not rely on the mediation of iconic representation (or representation through resemblance). In addition, the rayist painters and the *zaum* poets shared the rhetorical appeal of using native forms (rather than appropriating French sources) in the development of their own modernist challenges to conventional signification.

In making this connection, it is highly significant that Larionov not only illustrated some of these books, but precisely *Pomade,* and precisely this page (fig. 23.4), in which Kruchenykh most decisively broke away from the conventions of language. Larionov, too, in his illustration, uses the sharp lines and cross-hatching

of his rayist style to forestall the possibility of representation through resemblance. Like glossolalia for Kruchenykh, icons may have presented to Larionov a model for how to break away from conventional modes of visual representation. Unlike Kandinsky, however, Larionov's and Goncharova's move toward abstraction did not try to preserve the outward signs of their religious and/or archaic origins. It was not the image, but rather the representational mode of the spiritual, that was important for Larionov's (and consequently Goncharova's) development of rayism.

Through abstraction, Larionov and Goncharova hoped to achieve a manifestation of power or force in their work that was not possible within the logical framework of representation, illusion, and conventional signification. But the way they went about this departs significantly from the model found in Kandinsky. In rayism, Larionov and Goncharova sought to collapse the "ancient antithesis of representing and being present," not in order to manifest a new spirituality, but in order to make the work of art more forceful. Unlike Kandinsky, the Russian painters did not aspire to usher in a new era of spirit, but rather saw spiritual forms as a way to rethink representation itself.

NOTES

1. Vassily Kandinsky, "On the Spiritual in Art," in *Kandinsky: Complete Writings on Art,* ed. Keith Lindsay and Peter Vergo (Da Capo Press, 1994), 128.

2. Kandinsky, "On the Spiritual in Art," 167–68.

3. See Peg Weiss, *Kandinsky and Old Russia: The Artist as Ethnographer and Shaman* (Yale University Press, 1995); and Carol McKay, "Modernist Primitivism? The Case of Kandinsky," *Oxford Art Journal* 16, no. 2, 1993.

4. Kandinsky, "Reminiscences," in Lindsey and Vergo, *Kandinsky,* 368–69.

5. Sergei Bobrov, "Foundations of the New Russian Painting," in *Proceedings of the All-Russian Congress of Artists in Petrograd, December 1911–January 1912* (R. Golike and A. Vilborg, 1914), 43.

6. See Gleb Pospelov, *Jack of Diamonds: The Primitive and Urban Folklore in Moscow Painting of the 1910s* (Soviet Artist Press, 1990).

7. Natalya Goncharova, as quoted in Benedikt Livshits, *The One and a Half-Eyed Archer,* trans. John Bowlt (Oriental Research Partners, 1977), 82.

8. For a full discussion of this topic, see Jane Sharp, *Russian Modernism between East and West: Natal'ia Goncharova and the Moscow Avant-Garde* (Cambridge University Press, 2006).

9. Sergei Bobrov, "Foundations of the New Russian Painting," 41.

10. The confiscation of the Donkey's Tail paintings was reported in "The Censor and the Donkey's Tail," *Voice of Moscow,* no. 59, March 11, 1912, 5.

11. Yakov Tugendkhol'd, "Contemporary Art and National Spirit," *Northern Notes* (November 1913): 157.

12. Voloshin, "Moscow: Artistic Life, the Donkey's Tail," *Apollon-Letopis,* no. 7 (April 1912): 105–6.

13. Sharp addresses this question in her *Russian Modernism,* and John E. Malmstad in "The Sacred Profaned: Image and Word in the Paintings of Mikhail Larionov," in *Laboratory of Dreams: The Russian Avant-Garde and Cultural Experiment,* ed. John Bowlt and Olga Matich (Stanford University Press, 1996), 153–73.

14. F. Mukhortov, "Rayists (in the Studio of Larionov and Goncharova)," *Moscow Gazette,* no. 231, January 7, 1913, 2.

15. Larionov, "Rayonist Painting," in *Russian Art of the Avant-Garde,* trans. John Bowlt (Thames and Hudson, 1988), 97.

16. *Capital-City Rumors,* no. 272, October 29, 1912, 5.

17. See especially Linda Henderson, *The Fourth Dimension and Non-Euclidean Geometry in Modern Art* (Princeton University Press, 1983); Anthony Parton, *Mikhail Larionov and the Russian Avant-Garde* (Princeton University Press, 1993); and Aleksandr In'shakov, "Rayism in Russian Painting and the Global Avant-Garde: The Mythology of Light in New Art," *Iskusstvoznanie,* no. 2 (1999): 354–71.

18. In their recent monograph on Larionov, Gleb Pospelov and Evgenia Ilyukhina are very explicit in their judgment that rayism does not come out of the primitivist work, but instead from landscape studies. M. Larionov, *Zhivopis'. Grafika. Teatr* (Galart, 2005), 140–41.

19. "Moscow [speaks] about the Congress," *Against the Grain,* no. 15, December 24, 1911, 2.

20. See Elena Ovsyannikova, "From the History of the First Exhibitions of the Lubok," *Soviet Art History* 20 (1986): 424.

21. John Bowlt, "Neo-Primitivism and Russian Painting," *Burlington Magazine,* no. 852 (March 1974): 133–40.

22. D. Danin, unpublished manuscript of a memoir on Tatlin (Private archive, Moscow), 4. Cited in Christina Lodder, *Russian Constructivism* (Yale University Press, 1983), 11.

23. Berthold Lubetkin, "The Origins of Constructivism," lecture, quoted in Lodder, *Russian Constructivism,* 12.

24. Gerald Janecek, *Zaum: The Transrational Poetry of Russian Futurism* (San Diego State University Press, 1996), 50.

25. Aleksei Kruchenykh and Velimir Khlebnikov, "The Word as Such" (1913), as translated and reprinted in *Russian Futurism through Its Manifestoes, 1912–1928,* trans. and ed. Anna Lawton and Herbert Eagle (Cornell University Press, 1988), 60.

26. Aleksei Kruchenykh, "New Ways of the Word," in Lawton and Eagle, *Russian Futurism,* 72.

27. Hans Belting, *Likeness and Presence: A History of the Image before the Era of Art,* trans. Edmund Jephcott (Chicago University Press, 1994), 29.

28. Leonid Ouspensky, *Theology of the Icon* (St. Vladimir's Seminary Press, 1992), 9–10.

29. Erhart Kästner, *Mount Athos: The Call from Sleep,* trans. Barry Sullivan (Faber and Faber, 1961), 91. The text is from a quotation in Belting, *Likeness and Presence,* 9.

30. Ouspensky, *Theology of the Icon,* 51–53.

31. Charles Sanders Peirce, "The Fixation of Belief," in *The Essential Peirce: Selected Philosophical Writings,* vol. 1, eds. Nathan Houser and Christian Kloesel (University of Indiana Press, 1992), 109–23.

PART SEVEN

MEDIA AND VISUAL TECHNOLOGIES

INTRODUCTION

Jane Kromm

Visual technologies capable of integrating movement with space and time have experienced a rapid and continuous development in the new media of television, video, Internet, and the World Wide Web. The ways in which these new technologies have overhauled former visual habits and consequently altered familiar strategies of presentation are the principal concerns of this final section. Commercial factors have a significant imprinting function here, since a majority of innovations flourished primarily because of their financial promise. Yet often these economic motivations are so masked and embedded within a medium's form or content that any explicit acknowledgement of them is not likely. Many new techniques also interact with cultural institutions and practices in a complex manner, seeming to be informed and knowledgeable, omnipresent and hegemonic, although the grounds on which these characteristics might be judged remain murky and unclear. Premises of the egalitarian exist alongside what are obviously elitist circumstances, and the absence of explicit affiliations seems to excuse most new media's relationships with increasingly oligarchic media conglomerates. Open access and intricacies of enticements strangely combine at the new technologies' points of entry and around their gatekeeping operations. The imagistic ramifications of these developments present formidable challenges to the observer as new techniques diversify and alter at bewildering rates, and as dissemination comes to equal diffusion in visual terms.

Mixed levels of representation stretch familiar standards of comfortable optical range, and speed and time considerations position viewers unwarily in front of previews, trailers, fillers, commercial breaks, and interrupted narrative sequences. The visual tactics of the screen format offer the virtual and the variable, giving the user an "as if" stance that is highly tentative. Divisions and subdivisions multiply, using jump-cuts, flickering signifiers, and the multiple hooks of "links" that, taken together, comprise the reality effect of the screen template. This effect induces displacement, along with other destabilizing opportunities, enhancing a viewer's own sense that human actuality is really only a virtual visual experience. These and other factors will be addressed as we focus variously on the trials of maintaining contact with systems of information technology, and on the expanding opportunities for self-portrayal by a new breed of digital auteurs. Of special interest here is the proliferation of paradoxical media formats in which real situations are purposefully fabricated. This phenomenon can be found in the virtual worlds of the video game, premised on a seamless union between simulation and human interaction, or when the Internet's constantly accessible information services amount to what is really a blitz of disinformation material, or where the universal language of music provides a sound-bite equivalent for the exceptionally hybridized, hermetically self-referential world of the music video.

I LOOKED IT UP ON THE INTERNET: DISORIENTATION AND DISINFORMATION (1990–2008)

The Internet has displaced many traditional research modes and sources that were formerly book-based, archival, or grounded in library procedures in which searching occurred within a rational, visible context of catalogued materials. Looking things up for school assignments or for personal enrichment is now more likely to take the form of information retrieval from virtual databases whose identities often come cleverly masked on the computer screen. While once the bulk of these virtual sources were variations on encyclopedias and traditional research compendia, now search engines (notably Yahoo and Google) retrieve a confusing mix of source types, giving them all equal weight in the accessing process. Jumbled search results whose truth claims can hardly be called forthcoming, combined with effortless accessibility, can easily fool unwary users into thinking that they have indeed obtained the best results for their queries when they really have done no such thing. Bringing a search to a successful conclusion can thus be fraught with glitches, and not the least of these are citation lists that are cryptic, unclear, and presented without benefit of context or origin. Many sites omit or abbreviate identifying material, and some manipulate their sources in ways that obscure their status or standards. Visually the search is imbued with notes of randomness and diffusion, consisting of lists with no visible endpoint, which make the selection process onerous if attempted with care. Marketing references are intermittent, with advertisements and testimonials intruding onto the retrieval screen. This bewildering profusion of information and infomercials demonstrates that the process favors searching over finding, since the user is positioned as an endless searcher or surfer whose need to make critical judgments has been rendered obsolete.

Brenda DeMartini-Squires's chapter, "Now You See It: Disinformation and Disorientation on the Internet," investigates the visual characteristics and intellectual validity of Internet research activities. In contrast to traditional, library-based research processes that were grounded in the geographies of a building and its collections through an organization that was both visual and manual, Internet searches take place in a cyberspace limbo amidst a series of lists, boxes, and moving advertisements. While universities continue to support and enhance the project of computer-based research for their students, it is becoming increasingly clear that judgments about the quality and reliability of sources have become a very problematic area for users. Internet searches turn up a bewildering range of results that mix ephemeral or fantasy references in equal measure with more serious sources. While the retrieval time is short, any repetitions of a search will invariably have differing outcomes. Even computerized reference collections can inadvertently distort their materials by eliminating their originals' layout and appearance. Some sites such as Wikipedia make a branding point about their collaborative but flawed and unreliable status as a source of information. In this way, disinformation and disorientation have assumed an apparently desirable inevitability on sites that flaunt their disinterest in the traditional goals of accuracy and excellence, formerly associated with research endeavors.

CARNIVAL MIRRORS: THE HERMETIC WORLD OF THE MUSIC VIDEO (1980–2008)

The three-minute music video began as a way of interpreting and promoting songs through a brief, filmed visual accompaniment. In the last few decades, this process has become more self-consciously

artistic, developing into something like a parallel visual world with the same dense atmosphere of associations suggested by the songs themselves. These increasingly filmic efforts attempt to mirror the complex, seductive, and fictive world proposed with evocative imprecision by lyric and melody. Both counterculture entertainment and marketing, the music video bridges the divide between commerce and art, between anarchy and the culture of celebrity. Videos' subversive visual characteristics have undermined traditional expectations carried over from drama, film, and TV, that a story will unfold and that characters will develop. The curtailment of these more time-intensive features has been credited with the wide-spread shortening of attention spans and the creation of a preference for images over texts. With a constant flow of novel visual effects, the music video dominates the position in which new technologies get interjected into artistic practice. Blending tactics, such as quick-cutting and solarization, absorbed from a range of typically antagonistic formats including experimental film, animation, and cinema verité, music videos reflect back to the viewer, like a carnival mirror, a constantly morphing, distorted world. These reflections meld familiarity—represented by music celebrities and a maze of referents to popular culture—with an unsettling, self-sufficient strangeness formatted by the provocative fast-frame handling of disconnected images and metaphors whose claims to real meaningfulness have been temporarily, perhaps permanently, suspended.

Kathryn Shields's chapter, "Carnival Mirrors: The Hermetic World of the Music Video," locates the strangeness and originality of this form in its oblique relation to lyrics, narrative, popular cultural references, and undercurrents of violence and sexuality. Mixing elements from these different modes or sources, music videos are often structured around connections between identity and the performing persona, using costumes and props in a spectacular, carnival-like manner calculated to have a transformative impact. The history of music videos can be traced back to the setting of pictures and cartoons to music in the 1920s and 1930s, to the role of music in film, and to the visual habits and experiments of musical acts. By the late twentieth century, it was customary for bands to publicize a new release by presenting a video of the group performing the song before an audience. MTV, a station dedicated entirely to showing music videos, debuted in the United States in 1981, and soon other stations followed with a similar format. Currently these stations have pursued other forms of programming, and now music videos are almost entirely encountered on the Internet. Shields traces the development of different types of music video through a close reading of four works of artists ranging from Madonna to Panic! At the Disco. Her analysis underscores the relationship between music video and qualities associated with the *commedia dell'arte,* the comedic tradition grounded in recognizable players or well-known types who engage in episodic improvisational performances.

THE DIGITAL AUTEUR: SITES, BLOGS, AND SELF-FASHIONING (1990–2008)

The Internet has developed an increasing number of sites for the exchange of ideas and opinions, and many of these new options have expanded opportunities for self-expression as well as self-promotion. With access to these sites open and assured, even the most experimental formats for self-presentation and portrayal have the capacity to communicate on a vast scale. While e-mail and chat rooms have established a pattern in which contact and exchange can be maintained and enhanced at the user's desire, these practices have now been enlarged to encompass more personal, even personality-based sites. Not unlike the childhood fantasies of anchoring one's own TV show, many sites offer a new kind of autobiographical enterprise to an extent never before imagined. Such venues have come to

be treated as postmodern occasions for self-fashioning—a concept first associated with Elizabethan courtiers and poets—in which persons actively shape their portrayal for presentation to the outside world. In self-fashioning exercises, there is room for definition, but also for deception, and a degree of self-aggrandizement that can breach the limits of common usage and approach exhibitionist extremes. Some of these sites are Web logs—the "blogs" that allow their authors to assume a significant critical voice in commentary regarding political affairs and current events, and to dwell especially on their own personal responsiveness. Or the sites might be connected to Web cameras, which act as the author's observing ego, or at the farthest extreme, as an exhibitionistic display resembling an endless film loop with little direction or focus. Voyeurism is openly courted from what would seem to be a safe distance, and the Webcam is used in ways that mimic the nonnarrative, decentered approaches of experimental films. These sites presuppose amateurism as a provocative and compelling creative position, as they take the telejournalistic premise of the close, personal view to unanticipated limits.

Matt Ferranto's chapter, "Digital Self-Fashioning in Cyberspace: The New Digital Self-Portrait," begins with the example of an elderly British widower who posted a series of videos on YouTube in which he appeared to be recounting stories from his life. His videos were very popular and elicited many viewer comments, making him an unusual celebrity in a format that most often focuses on the young. But cyberspace has created new opportunities for self-presentation and self-expression, and for experimenting with ideas about one's social identity. Digitizing and video processes, along with online distribution, have greatly enhanced the ability to communicate on a large scale, and numerous virtual spaces and electronic networks for presentation and exchange have been the result. The kind of self-presentation or self-fashioning made possible by digital media emphasizes the multiple and malleable approaches to identity, rather than any singular enduring sense of self. Video presentations are subject to editing, to being disassembled and rearranged, and these manipulations are often undertaken in the service of performance values. Many of those who post such videos are in effect adopting personae with running story lines that may have nothing to do with their own personal lives. They are rarely autobiographical in a traditional way but extend and redefine the self as a performer for a very wide audience, with multiple opportunities for interactive input, which itself then leads to further alterations of the original or previous portrayal.

FOOL THE EYE AND THE BODY: FEATS OF SIMULATION AND THE WORLD OF THE VIDEO GAME (1970–2008)

From arcade machines to the screens of computer monitors and handheld hybrids, video games have defined and monopolized the digital world of *homo ludens,* of human beings necessarily engaged with the dynamics of significant play. The basic design of most games presupposes an extensive, virtual world grounded in familiar narrative or cinematic characteristics. These virtual spaces then become the setting for one or more participants' journey through the game's strategies, whether quest, contest, or cosmic conflict. The digital rules of engagement are premised on interactivity, and some degree of immersion is expected of players as they manipulate screen information and respond to cues. Combative principles abound, and most games are sited in ways that make such aggression seem natural and appropriate, from Gothic labyrinths with lurking enemies, to interplanetary galactic engagements, and to the more earthbound terrains of war. In fact, the indebtedness of video games to military preoccupations and uses is a significant aspect of their history and development, and this

is especially true of formats that provide extensive, realistic virtual worlds as a basis for fine-tuning martial skills.

Such strategic simulations also pervade the visual appearance and space of the games. A confluence of visual tendencies drawn from a pilot or operator's vantage and the cinematic point of view have led to a preference for distant spatial vistas, such as the panoramic or the aerial view. Digital formats favored images grounded in graphs and grids, with the result that designers gravitated toward the measured practices of mechanical drawing and architectural drafting. To accommodate these extensive vistas, scrolling and other devices became necessary adjustments, given the visual constraints set by the monitor screens through which most games are accessed. The spaces circumscribed by video games present a complex aesthetic model that conflates representation with simulation and that accommodates interactive rather than merely passive practices of spectatorship. Such an engagement model extends more than it displaces traditional visual strategies of illusionism, especially those of the more extreme trompe l'oeil type, in which the image's capacity to provoke spectatorial immersion was a desirable quality. Many current game designers avoid the abstract-like or icon-derived features of earlier games that did not attempt virtuality or identification, turning instead to elaborate, photo-realistic perspectives combined with simplified, cartoon-like characters. Marketers of these games see this latter combination as the one that best enables the immersion experience, and so most video game innovations pivot around that familiar yet elusive goal—understanding the relation between visual illusion and human behavior.

Martin Danahay's chapter, "Video Games: Art, Cinema, and Interactivity," examines the history and development of video games, and particularly their relationship to the film industry and their increasing emphasis on extending opportunities for players' interaction. While the earliest games were text-based and grounded in novels of fantasy, subsequent designs incorporated themes from adventure tales, mythology, sports, horror and science fiction, combat, and the Gothic worlds of castles, chivalry, and mystery. In the 1980s, the most successful games were of the arcade type, like Pac Man, but this style was soon outmoded as side-scrolling became possible, a technique that allowed figures to move through extensively designed environments. This development placed a premium on visualizing extensive virtual settings that often relied on drafting and architectural paradigms to create enhanced perspectival vistas. The games comprising the Sim series revolve primarily around inventing simulated lives for their characters, with players creating virtual cities and imaginary locations that draw visually on a wide range of sources, from traditional fine arts to animation and film. In the 1990s, some games could involve multiple players on a global scale as the medium was launched on the Web as a multiplayer, role-playing dominant genre. The visual impact of digitization and the increased dissemination of media exploiting digital effects have created a distinct look for many video games that can also be found in movies, in television advertisements, and in contemporary art. While maintaining some connection to realism in representation, many games favor themes and motifs, such as cyborgs, that blur distinctions between the human and the technological, as players become increasingly immersed in their avatars and simulated settings.

In the second chapter on video games, Chris Kaczmarek's "What You See Is What You Get, or Reality Is What You Take from It" investigates the games' visual language and representational orientation and examines the various ways in which these have influenced contemporary artists. An analysis of the different perspectival preferences in gaming and how these are reflexively linked to the position of the engaged player leads Kaczmarek to consider the future of video game graphics in light of the industry's obvious preoccupation with mimicking the real world in scenographic ways.

NOW YOU SEE IT: DISINFORMATION AND DISORIENTATION ON THE INTERNET

Brenda DeMartini-Squires

During the 1980s, I took a graduate seminar in English, called Methods of Research, at the University of Missouri, which met in Ellis Library, a large research facility that represented the center of campus intellectual activity. The ultimate goal of the course was to prepare us for the first stage of our dissertations and master's theses, and the main written work was the production of an annotated bibliography on our potential thesis subject. Our class met weekly in one of the many seminar rooms located in the building. Our professor's field was biography, and she had done a great deal of work with special collections in libraries all over the United States, Great Britain, and India. Her decades of experience in negotiating these various settings were the anecdotal background of her lectures on what she called "the art of literary research." Much of our out-of-class work involved poking around the library, learning the layout of the large building, finding the books denoted on the tidy white cards in a huge card catalog, which were cross-referenced by author, title, and subject heading. We had to learn to use two different shelving systems, the older Dewey Decimal and the new Library of Congress system to which they were in the process of converting, a laborious physical transformation of the building that took years to complete. The rhetorical and internal logic represented by the two different systems were the sorts of subjects we discussed in class. We also had to learn to read and interpret the Humanities and Modern Language Association indexes. We became very familiar with the library's general English Department seminar room, where books were on reserve for the various other seminars being offered. Professors had culled out of the enormous collection the texts they thought would be in highest demand and put them on reserve so that there would not be fights between classmates over them. This meant that students had to spend many hours in that room, sitting around a table with as many as a dozen other people at a time, reading and taking notes, looking up all the articles published on our subjects since the dates of publication, hoisting the oversized indexes, one volume year at a time, between shelf and seminar room.

Over the course of that seminar, our intrepid professor taught us how to hunt down references to all types of publications; to determine what kind of sources we were looking for; to check abstracts when available to see if the articles or books were pertinent to our subjects; and then, to check our periodicals card catalog to find out if our library subscribed to the journal we were looking for and whether the periodical was in the reading room or whether it had already been casebound and shelved. (In many cases, the issue was at the bindery,

in which case we just had to wait, sometimes months, to lay hands on the material.) She also taught us how to order materials through interlibrary loan, a process that was at that time conducted from query to receipt through what we now call "snail mail." This, of course, made procrastination on any research assignment extremely costly. We also learned a great deal about what she called the "etiquette" of gaining permission to use the libraries of various universities, how to write a proper query to gain entry to their special collection rooms, and how to get permission to copy or publish the treasures we might find.

The Ellis Library also had various so-called private-space study carrels that could be rented out by graduate students. In actuality those spaces, which were located in the stacks, were metal cages with security gates that were padlocked from the outside, which made them look more like prison cells than conducive places for studying. I once watched a fellow graduate student try to fit his hands through the bars of one of those cells to get a book the student renting out the carrel had locked in without checking out, a tactic that made it useless to try to put in a call on the book. The idea that students might prefer the monastic setting of these carrels to the comforts of home seems almost as quaint and nostalgic in 2007 as the notion of fighting over library books.

My point is that all these activities included a significant amount of human interaction (contrary to the cultural idea of the isolated scholar), and engagement with a rationally organized visual landscape and visual rhetoric. The success of a search for information depended on the student's ability to engage in a set of manual exercises, including processing the visual system of organization in the library and interpreting a system of signs, including library maps, shelf tags, and the

material printed on the spines of books. In addition, a large part of a successful search was influenced by the physical spaces: the extent of the library's collections, the competency of special services, and the particular specialties of the institution within which the search was conducted. The different media—books, bound academic journals, monthly and weekly magazines, newspapers on microfilm or microfiche—were all visually differentiated in this physical and geographical space, and "links" to both information and learning had everything to do with pawing through cards in long wooden drawers, with clumping up the metal stairs in the stacks, with the look and feel of books, the texture of their covers, and the faintly damp mustiness of the paper that had been touched by sometimes many other hands, sometimes none.

Now let us cut to the scene of the college library in the year 2007. On an average day during the semester in the library at the school where I teach, there are still quite a few students clustered around long tables, but all of them are sitting in front of computer monitors. The only unused computer most of the time is the one with the sign that says, "For Library Catalog Only." Students are using the time between classes to check e-mail or the Internet phenomena of MySpace or Facebook, looking at pictures of themselves or people who have requested to be their "friends," many of whom they will never actually meet in real space or time. Others are engrossed in watching random personal videos or film and TV clips on YouTube. A few pained souls are there to "google" (a word that has become a computer slang verb) some wretched subject they have been assigned to "research." As they comb through disorganized and seemingly random lists of Web sites, the screens are filled with animated and flashy ads, hawking everything

from low-interest mortgages to cell phone plans to weight-loss programs. Of course when they click the print button, depending on a variety of variables that are not at all clear to those uninitiated into the mysteries of Internet posting, many of these ads that border the pages of text brought to them by commercial search engines will disappear into cyberspace, while the pop-up ads, which every Internet service claims in commercials to guard against, lurk behind, waiting for the user to close out of the Web site.

While this picture makes many pre-personal-computer-era academics feel nostalgic for the old ways of the library, most of them will support the idea that research can be much less time-consuming and potentially physically demanding than it was before the ubiquitous desktop computer became a staple of the academic landscape. A part of our curriculum for freshman writing classes involves a session in the library conducted by one of the college's research librarians, using a projection screen to explain and demonstrate how to use the large number of databases the college subscribes to, most with the option of full-text articles and chapters, on a dizzying array of subjects. Students do not even have to set foot in the library to use these sources. They can just log on to the library's Web catalog from personal computers or from a computer lab or café any where, and, with the magic of their student IDs, have a "virtual" library at their fingertips. Academics of my generation, who often assume that today's computer-savvy college students know more about the technology than we do, are continually surprised by and concerned about their students' difficulties in recognizing the (un)reliability and even the genre of sources they come up with online. The expectation that Internet research will be "easier" because it is so much more convenient than the old

archival searches is made problematic by the spotty results and confusion of students.

The problem with the "virtual" rather than actual library is explored in an article on one of these very databases, EBSCO Host. Originally published in the journal *College Teaching,* the article begins with an anecdote about the author's freshman composition student who e-mails her late in the semester asking her: "(1) Is *U.S. News and World Report* a magazine? And (2) Would the *Journal of the American Diabetes Association* be considered a scholarly journal?"[1] She relates another story of a student who complained about how short the articles are in the *Newspaper Abstract Index,* because he has no idea what the term *abstract* means in this context. Jenson notes that "differences between journals and popular magazine articles and abstracts, and annotations and advertisements have been lost on those whose education has been largely executed in the information age."[2] She identifies these problems with the fact that most students have no experience navigating actual libraries. In some sense, the problems of the so-called information age have to do with the implied audience of just such resources. For those already initiated into the visual culture of the library, the usefulness and/or supposed reliability of the publication is implied in its title, and we can place the former method of retrieval in the context of that physical space. Take, for instance, the way one would find a newspaper article in the library before the computer-culture revolution. Microfilm and microfiche are photographic negatives of the pages of newspapers—visual reproductions, which, in fact, are of far more historical interest than the separate reproductions of the paper's various parts. The layout of articles, the positioning and types of advertising, and the general visual plane of the page allows us

to experience one of the most popular sources of indoctrination into the historical period we are researching. Most students using databases or Internet postings pay little or no attention to dates of publication, and very little about a page of text on a screen can place the piece into the historical framework of a newspaper page.

We must, therefore, acknowledge the importance of distinguishing "information literacy" from "computer literacy." In an article from *American Libraries* with the tongue-in-cheek title, "Why Can't Johnny Search," author Joseph Janes describes the ETS (Educational Testing Service) "preliminary findings…on the firm's 'Information and Communication Technology' literacy assessment."[3] While he, like many academics, is somewhat leery of another standardized test, he suggests that "attention must be paid" to the inability of students to evaluate Internet sources.[4] According to the ETS Web site, in 2006 the test, which was created to measure "a student's ability to use critical thinking to define, access, manage, integrate, evaluate, create and communicate information in a technological environment," was administered to 6,300 students.

> Some of the most surprising preliminary research findings are that only 52% of test takers could correctly judge the objectivity of a Web site, and only 65% could correctly judge the site's authoritativeness. In a Web search task, only 40% entered multiple search terms to narrow the results. And when selecting a research statement for a class assignment, only 44% identified a statement that captured the demands of the assignment.[5]

While the contemporary academic in the Humanities might balk at concepts like objectivity and authoritativeness, the inability of students to narrow search terms and understand assignments is quite familiar and very alarming.

Ironically, many academics might also question the objectivity of this information on a screen with a sidebar advertisement for the test promising in-volume reduced prices, above which is a photograph of a pensive young man, one hand on his chin, the other on a computer mouse as he stares into the screen.

Another question for the twenty-first-century century academy is why students, despite constant exhortations from their teachers and library staff, often do not even take advantage of the materials available in their "virtual" college libraries, which have at least some guarantee of accountability if the student takes advantage of the option of searching peer-reviewed journals. Instead, a large number of students continue to rely on sites like Wikipedia or search engines like Google to conduct their research. Another more significant issue to address is the ways in which the use of the World Wide Web's visually disorienting and personally isolating technologies has changed the visual landscape and accountability of contemporary information retrieval and scholarship. Is the changing attitude toward research a result of the new technologies, or do the new media reflect the changing attitudes and anxieties about knowledge, "truth," and informational claims about objectivity?

Some of the appeal of using commercial search engines is easy enough to explain. One of the most important features of a service-oriented economy is the appearance of convenience, and the speed of the retrieval of materials by Google or Wikipedia seems to answer that call. The amazing numbers of "hits" that a typical Google or Yahoo! search can generate in less than a minute can be quite deceptive, however. To illustrate one of the main problems with these types of searches, I logged on to Google and typed in the name "Kandinsky." According to the first page of results, the

search engine gave me back 3,100,000 hits in 0.05 seconds. I then typed in "Wassily Kandinsky" and got back 1,120,000 hits in 0.08 seconds. Although the first ten hits on both pages referred specifically to the same person, for a reason not at all clear to the intended audience, the results on each page are listed in a different order. Even the "image results" are different. The search results on page after page are a confusing mix of online encyclopedias, university and gallery postings, personal interest pages, and commercial sites for purchasing reproductions/poster art. In my "Internet" research of the question of how Google and other sites are prioritized, I was unable to find a consistent factor identified.

While bloggers speculate on the topic, answering one another in cyberspace with numerous undocumented claims that advertisers pay for their positioning, or that Web sites are listed on the basis of number of hits or for their perceived aesthetic dimensions, the official search engine sites refer to algorithms based on the numbers of hyperlinks contained within the Web pages in relation to various other factors, none of which seem to the layperson to have anything to do with reliability of the content of the pages thus obtained. Because these "subject searches" are not organized by the traditional cataloging of author or date or any other apparent rational means, they bear little in common with the former geography of library research. Although I do not need to belabor the point by illustrating the next 20 to 1,000,000 hits, the list contains hundreds of repeated sources or sites that could not be found through the posted hyperlinks. While browsing in the visual context of the actual library meant locating a subject area and pulling books on the topic off the shelf and looking through tables of contents or indexes to determine the pertinence of the sources, Internet,

or virtual browsing, although seemingly lightening quick and convenient, can involve hour after hour of false starts, interruptions, and, quite frequently, questionable "information."

The one consistently prioritized source of (dis)information is Wikipedia, which bills itself as a multilingual, collaborative, free encyclopedia. The word *project,* used in all its official descriptions, suggests a work in progress, which is reinforced by the site's logo, a globe constructed of puzzle pieces, with several missing from the top of the Northern Hemisphere. This disruption of the globe is an image that expresses our anxieties about the unsettled and combative nature of international politics/economics, while the puzzle pieces remind us of the clichés about the ability of the World Wide Web to connect us to one another. Each puzzle piece contains a letter of various world alphabets. The open invitation to visitors to the site to contribute to this "sphere of knowledge" is contained in the image. One of Wikipedia's claims to fame is that "We speak Banyumasan...and about 250 other languages;[6] Banyumasan, they tell us, is spoken on the island of Java, although that may not be particularly important to the user who does not speak Banyumasan or even know where Java and its alphabet falls on the puzzle, since relatively few of their articles are available in translation. The various letters on the puzzle pieces suggest an international perspective and collaboration, and even a "solution" to the disruption of the puzzle. Ironically, "thing" number six on the list is the statement, "We do not expect you to trust us," which is used as a method to earn the trust of the viewer. As a matter of fact, this list is a barrage of contradictory and illogical statements of naked self-promotion, masked by the label "not for profit organization." Users are cautioned that none of the material is peer reviewed, that one

cannot change, but only add to, the material of questionable reliability, and that there is no guarantee provided that any of its content is based on actual confirmed sources. The editors also tell us that "We are not alone," but rather a part of "a growing movement for free knowledge that is beginning to permeate science and education."[7] All of these expressions of unity, however, are belied by the shattered image itself.[8]

This appeal to the idea of an academic community is Wikipedia's attempt to answer our cultural attitudes toward academia, as well as our ambivalence over the use of the computer, to exploit the tension between the notions that technology can bring together competing ideological camps and the fear that it tends to isolate us from direct personal contact rather than creating community. The idea of unity and connection is just another piece in the "virtual" information game.

The popularity of blatantly self-proclaimed sources of disinformation and distortion over more reliable Internet sources such as library history project/art gallery Web sites demonstrates the extent to which our popular cultural climate has distorted the aims of research. Endless and seemingly pointless searches mean an endless source of entertainment for the mass consumers of an equally endless supply of admittedly unreal "reality" television and tabloid journalism, of unsubstantiated celebrity gossip, of "fantasy" fiction and film, of the hypersubjectivity of blogging, and of video and computer games in which we are encouraged to lose ourselves in animated "action" while we sit in front of a machine. The extent to which we are conversant in the lingo of computer use is belied by the general inability to articulate the new media's inner workings. While these various powers of the Internet as expressed through visual images in existing and new media are shrouded in mystical and religious imagery, most especially in our various and pervasive forms of advertising, they are described in the kind of technical terms very few of the uninitiated can truly comprehend. Jackson Lears, in his cultural history of American advertising, *Fables of Abundance,* identifies the rise of the visual artistry of contemporary advertising over the more mundane campaigns featuring professional recommendations and explanations of products as way to "keep boredom at bay" and to appeal to the older, carnivalesque traditions of the early advertising of such commodities as tobacco products and patent medicines/snake oils.[9]

One might argue that visualizations of similarly misleading conveniences such as the Internet and "fiber optics" have taken on the image of mystical and religious faith, while their aural texts confuse and further alienate the consumer from the actual goods, because the product specifications are far too technical for the average user to comprehend. Take, for example, the Wikipedia "image" accompanying the articles on Internet technology labeled "Visualization of the Various Routes through a Portion of the Internet."[10] The article and caption contain the following description of the display:

> Each line is drawn between two nodes, representing two IP addresses. The length of the lines are indicative of the delay between those two nodes. This graph represents less than 30% of the Class C networks reachable by the data collection program in early 2005. Lines are color-coded according to their corresponding RFC 1918 allocation as follows:
>
> - Green: com, org
> - Red: mil, gov, edu
> - Yellow: jp, cn, tw, au, de
> - Magenta: uk, it, pl, fr
> - White: unknown

The image, captioned as "a featured picture" complete with the teacher's pet gold star of Wikipedia approval, could as verifiably be labeled as an enlarged photograph of the body's capillary system, a planetarium, an example of abstract expressionism, or a picture of the "religious light" Western society has lost to science but still longs for. The description, for the average reader of Wikipedia, remains shrouded in the abstractions of space and time, and the map remains a decentered visual analog of the World Wide Web.

A more self-deprecating and humorous example of this kind of visual mystification of the new media is demonstrated in the Verizon FIOS television commercial, in which a little boy is following around the Verizon FIOS "tech" as he is performing the apparent magic of installation. At the end of his litany of computer/scientific jargon, the tech says, "It's true quam," a statement of the uncanny aspects of the term "fiber optics." He then proceeds to mesmerize the adorable boy child with a burst of light from the back of his van, accompanied by the stereotypically chorused "aah" of a religious state of grace before the child replies, "Nice truck." In another commercial in the same campaign, the little boy, initiated into this new religion, gives a quick summary of "spectrums of light" to his father, who in the next shot stands transfixed as the same tech opens an electrical box on the side of the house that emits the same flash of light and celestial chorus. This time the little boy looks at his similarly transfixed father and says, "You should see his truck." In both examples, the juxtaposition of "seeing the light" with the acknowledgement of gross materialism is the source of the humor.

Compare these "visualizations" of the magic of computer technology to a typical front page of the only recently defunct *Weekly World News*, the last of the supermarket tabloids to continue the tradition of "news of the weird" so favored by the identity-fragmented public of the 1950s, in which the bland and typical images of conventional families were secretly eschewed by a consumer culture terrified of mundane day-to-day existence, which proclaims, "Heaven Photographed By Hubble Telescope: 'We found where God lives,' says scientist." Long after similar tabloids like the *National Enquirer* had given themselves over to celebrity gossip, the absurd humor and surreal images from their front pages began to dot the landscape of the Internet and the conversation of its users; from the discovery of "Batboy" to the alleged marriage of Saddam Hussein and Osama Bin Laden, and their eventual adoption of a "shaved ape baby," these have, like the similar popular cultural phenomena of television wrestling or reality television, been treated with a sense of irony that provides a kind of postmodern comic relief from the self-consciousness and cynicism of the twenty-first century. As the characters and headlines of *The Weekly World News* appear to upstage the online versions of such formerly favored sources of information as *The New York Times* and *The Washington Post,* in a case of metajournalistic complicity, we have the May 2000 AP photo of George W. Bush, widely circulated on the Internet, holding up a copy of *The Weekly World News* article entitled "Space Alien Backs Bush for President" (fig. 24.1). The picture within the picture shows the then-presidential candidate shaking hands with a Cold War-era depiction of a creature from outer space with oversized head and underdeveloped body, another image, like the Wikipedia symbol, which represents visually expressed fears in the guise of unity.

The proliferation of the trashy, tawdry talk show featuring a bizarre parade of socially and/or sexually transgressive adults, and celebrity

Fig. 24.1 George W. Bush holding up a copy of the now defunct *Weekly World News*.

"reality" shows, in which people pretend to live out their lives in front of an audience of jaded young people who claim not to believe any of it, but who sit as transfixed as they were by the big purple dinosaur of their childhood media indoctrination, belong in a similar category of visual culture. Other kinds of "entertainment" that are substituted for legitimate information-gathering include irresponsible conservative cable news network editorials thinly disguised as "objective journalism" and comedic late-night parodies of the same, a television pairing that leads to further confusion and disorientation.

Perhaps the certainties of courses like "Methods of Research" and the apparently rational search for information in the pre-Internet library belong to the same categories as nostalgic conservative arguments for an intellectual canon, a concept in direct opposition to the field of cultural studies. It is important to remember, however, that the appeal of such apparently collaborative materials as Wikipedia and other Internet and commercial media in comparison to the somber bound versions of the *Encyclopedia Britannica* (which contains within its name its claim to colonial-style pre-twentieth-century cultural authoritarianism), is a symptom of mystifications and manipulations that mark the dislocation of the idea of objective truths in favor of the endless and unfulfilled search for meaning in a world

over which we seem to be able to exert less and less control. In an era of information-gathering dominated by the technical "sound bite," when we have apparently given ourselves over to the worship of technology and the valuation of convenience of process over quality of results, when all the world's a text in the process of being written, the crisis in academic research is well represented by the metaphor of the "information superhighway" and its suggestion of an interstate, which connects place to place with a dislocating sense of sameness and the complete absence of local landmarks.

NOTES

1. Jill D. Jenson, "It's the Information Age, So Where's the Information? Why Our Students Can't Find It and What We Can Do to Help," *College Teaching* 52 (Summer 2004): 107.

2. Jenson, "It's the Information Age," 108.

3. Joseph Janes, "Why Can't Johnny Search," *American Libraries* 38 (January 2007): 38.

4. Janes, "Why Can't Johnny Search," 38.

5. Karen Bogan, "College Students Fall Short Demonstrating the ICT Literacy Skills Necessary for Success in College and the Workplace," Educational Testing Service. Online Posting, August 31, 2007, http://www.ets.org/portal/ site/ets/menuitem.c988ba0e5dd572bada20b c47c3921509/?vgnextoid=340051e5122ee01 0VgnVCM10000022f95190RCRD&vgnext channel=d89d1eed91059010VgnVCM1000 0022f95190RCRD.

6. "Wikipedia: 10 Things You May Not Know about Wikipedia," Wikipedia.org, August 31, 2007, online posting, http://en.wikipedia.org/ wiki/Wikipedia:Ten_things_you_may_not_ know_about_Wikipedia.

7. "Wikipedia: 10 Things."

8. Interestingly, when I attempted to get the permission from Wikipedia to use their logo as an illustration in this text, the person in charge of media relations wanted to know what I was going to say about them before he would consider allowing me to use it. When he finally agreed, the charge was so prohibitively high that I decided to leave it out. It is easy enough to find, though. One need only to "google" almost anything to find the Wikipedia logo at the top of the list, whether the search subject has an abundance of hyperlinks or not.

9. Jackson Lears, *Fables of Abundance: A Cultural History of Advertising in America* (Basic Books, 1994), 261.

10. "Wikipedia Image: Internet map 1024.jpg." Wikipedia.org. Online posting, August 25, 2007, http://en.wikipedia.org/wiki/Internet.

CARNIVAL MIRRORS: THE HERMETIC WORLD OF THE MUSIC VIDEO

M. Kathryn Shields

Music videos create their own unique world.[1] According to one scholar, they fashion "an alternative world where image is reality."[2] Music videos not only transform the familiar aspects of our world, they also bring celebrities into our lives and create a sense of familiarity with people who would otherwise be remote. Another scholar explains that "the relations of music, image, and lyrics raise questions of cause and effect, and the lack of clear causes may partly explain why music video's world seems strange."[3] Critical attention has been drawn to the music video's unique aesthetic elements, including nuances in relationships between either music and lyrics or television and cinema; specific styles of editing and their implications for meaning; larger societal issues addressed or ignored; and pervasive undercurrents of sexuality and violence. This chapter provides a brief history of the music video and examines its antecedents in art, film, television, and music performance that helped establish the primacy of clear and concise visual communication.

The Italian Renaissance *commedia dell'arte* provides a means for understanding how the music video came to emphasize appearance, the importance of identity for individual artists and their bands, and a concern, at times, for narrative. An explanation of the various types of music video offers an expanded framework for understanding selected videos, a topic discussed in depth later. The content of music videos is generally separate from the lyrics, and their length tends to be short. As a result, music videos, like the *commedia,* use shorthand to communicate succinctly and visually. An examination of three videos concludes the chapter. They are discussed in relation to aspects of *commedia* by considering the self-conscious formation of identity, the use of costuming and props to suggest a particular scenario, the encouragement of carnivalesque catharsis, and the emphasis on the transformative potential of imagery and entertainment to create the bizarre, otherworldly, and intriguing qualities that characterize music videos.

SYNAESTHESIA: HISTORICAL OVERVIEW OF SONGS AND IMAGES COMBINED

The history of music video[4] is marked by the presentation of music and pictures together. In the 1920s, German filmmaker Oskar Fischinger combined animated films with classical and jazz soundtracks to create visual music, notably in "Komposition in Blau" (1934) and in contributions to Disney's *Fantasia* (1940). In the 1930s and 1940s Max Fleischer designed cartoons to correspond to music by Cab Calloway and Louis Armstrong.

Scholars have made connections between visual images and popular music in forms similar to music video for some time. Many credit Eisenstein's film *Alexander Nevsky* (1938), with a score by Prokofiev, as the first music video. Recordings of Fats Waller (1930s) or Tony Bennett's clip "Stranger in Paradise" (1956) are significant because they were made to entertain audiences or promote a song rather than to document performances. Visual aspects of musical acts became important considerations for artists like Elvis Presley and the Beatles, who appeared on TV and starred in films.[5] Queen's *Bohemian Rhapsody* (1975) combines performance and special effects to create a new experience for an existing song, setting the stage for the current music-video format and its artistic potential. By the mid-1980s it was standard practice for bands to make a music video along with the release of a new song. These videos allowed a closer connection to the stars and simulated live performances, televised interviews, and film appearances.

The broadcast of videos has taken various forms. Until 1981, when MTV premiered as the first 24-hour music video channel, videos could only be seen using special equipment (1940s–1960s), on selected television programs like *American Bandstand* (1952–1989) and *Night Tracks* (1983–1992), or in clubs.[6] MTV revolutionized the way music was experienced, launching the channel with the Buggles' "Video Killed the Radio Star." By 1987, MTV had altered its format from all-videos-all-the-time to a more predictable schedule of videos with specific shows (120 Minutes, Headbanger's Ball, etc.), in keeping with the format of other channels. Also in the mid-1980s, alternative channels like VH-1, with an emphasis on pop instead of rock; Black Entertainment Television (BET), designed to compensate for the notorious absence of African-Americans in television; and numerous MTV affiliates were launched to appeal to markets outside of MTV's target audience.

Today MTV and VH-1 have virtually stopped showing videos. Focus has shifted to reality TV programs. The leading forum for music video today is the Internet, with select shows still available on cable, and DVD releases. The prominence of the Internet as an outlet for music videos has increased exposure and access at the same time it has lowered production budgets, due to the widespread availability of recording technology that can satisfy lower-resolution requirements for computer monitors, cell phones, and iPods. One major outcome of the new medium of music videos was to combine musical sound with image production in order to appeal to the public in unprecedented ways. Artists and viewers are more in control of what gets made and what gets seen than ever before in history, although the "quality" that was previously an integral part of the music video industry "may be lacking."[7]

Three general types of music video can be distinguished: performance, animation, and concept or narrative.[8] Performance videos, which show the band playing the song we hear, were the predominant mode in the 1950s and 1960s and also feature prominently in heavy metal videos of the 1980s and 1990s. These videos function in much the same way that live performance does, to give the viewer the sense of experiencing the band in person. Today, performances are featured in many, if not most videos, but they tend to be isolated cuts within a larger framework rather than the main event. Although they do not appear to be, even performance clips are staged and contrived to create a certain effect.[9] Soundtracks for most music videos are provided separately and, unless recorded live, feature lip-synching.

The most effective performance videos are those with a good stage presence, like Bruce Springsteen's or Madonna's, each with a different approach.

Animated videos, whether hand-drawn or computer-generated, offer an alternative to performance or narrative videos. Like live-action videos, animated videos may have a direct, tangential, or oblique relationship to a song's words. The 1982 video for Tom Tom Club's "Genius of Love,"[10] for example, creates a visual fantasy guided by the lyrics. The words of the lyrics sometimes appear with illustrations and relevant imagery, and the designs change with the beat during passages without lyrics. According to one of the video's directors, "with animation it's easier to make the visuals sort of abstract, and that is easier to make work with the music."[11] An increase in reliance on animation is likely a response to the often prohibitive budgets required to make live-action music videos. In 1991 the cost of producing a video for one song could be more than making an entire album.[12] In some ways these animated videos suggest a move away from the directly promotional nature of early music videos, because the band is often not even seen. Animated music videos can be very concept-oriented and often emphasize imagination, fun, and impossible scenarios.

The third category, narrative or concept videos, has the most similarities to the preexisting forms of cinema or television commercials. Although narrative and concept videos are being grouped together here, the terms are not necessarily interchangeable. Narrative videos tend to convey a story in a more or less coherent way. In some of the most elaborate cases, like Michael Jackson's "Thriller" (1983) and Pink Floyd's "Another Brick in the Wall" (ca. 1980), departures are even made from the song for the purpose of integrating dialogue and allowing

story development beyond the confines of the lyrics. Concept videos, on the other hand, progress in a less traditionally linear way, like Devo's "Whip It" (1980), based on the idea of a "whip tease," found in 1950s men's magazines, and TLC's "Waterfalls" (1994), with a socially conscious message about personal choices and safe sexual practices. Regardless of whether a video presents connections that are direct or indirect, "most videos that emphasize a story contain an enigmatic ending."[13] This open-endedness leaves parts of images and sounds to be accumulated through the video, creating a narrative ultimately completed by the viewer with a suggestiveness that recalls the early days of professional theater.

CONNECTIONS WITH *COMMEDIA DELL'ARTE*

There are some striking similarities in the operative devices of music videos and the methods of *commedia dell'arte*, because both forms communicate visually (fig. 25.1). A 1960s commentator used concepts of modern entertainment to introduce readers to *commedia*:

What the film, the comic strip, the TV situation comedy, and burlesque (in the American sense) have been to the twentieth century, the Commedia dell'Arte was to the Renaissance—entertainment for both high-brow and low-brow, compromising tried and true situations endlessly varied, always undemanding intellectually, and raunchy and vulgar, and, at its best, vigorous and spirited as only popular art can be. Like movie actors, the great performers in the Commedia troupes won international fame. Like comic strip characters, they seemed unreal and ageless, masks without souls or nerves. Like burlesque funnymen, they were both crude and subtle, slavering from an unquenchable appetite for life, enormously skilled after years of playing

Fig. 25.1 Jacques Callot, *Pulchinello, Balli de Sfessania* series, about 1621, etching.

before audiences of every sort, and so casually obscene that all standards of decorum were obliterated at one phallic stroke.[14]

Examining the construct of *commedia dell'arte* elucidates some of the basic elements that might initially be overlooked in music videos.

The *commedia* is centered on key characters that are readily identifiable by the masks that they wear. The performances followed a general script that set the stage with improvisation and digressions that became humorous due to the audience's familiarity with the character types. *Commedia* actors were professionals rather than amateurs. Similarly, in music videos the key characters are the stars, often the lead singer. Iconic performers like Madonna, Prince, Mick Jagger of the Rolling Stones, and U2's Bono become identifiable due to their stage presence. They seem to have a timeless, masklike quality that transcends the subtle changes in appearance that occur over the course of their careers. Some artists, for example David Bowie, have benefited

from video because it enhances or even helps create their performative identity.[15] Cultural icons and easily recognizable performers "all carry a trace of the self-referential with them. In whatever they do, we assume that they wear some sort of mask."[16]

Although music videos are usually carefully produced and do not use improvisation, the effect of quick edits and pacing often resembles the unexpected qualities of improvised performance. In addition, the reliance on text, which in the case of music videos is the lyrics, is usually the point of departure, rather than a confining mechanism. According to one director, "You find little spots where the sound makes you think of an image…if you're successful, you make a video that people can't separate from the music. In a way, it's a horrible thing to do to someone. Because they'll never listen to that music the same way again."[17] In these ways the video itself creates a multisensory experience that transports the viewer from the here and now to a different place altogether.

The content of the *commedia* and much of its allure derive from its transgressions. Colors were gaudy, scenarios lewd and suggestive, characterizations stereotypical and extreme. This same kind of immediate communication stands at the core of many music videos: "In a music video, you have three minutes. What you want to do is hold the attention of the viewer. The basic idea of the video is to hold the attention of the viewer so the music permeates your brain.…SEX, violence, color, fast-cutting, tricky effects, gimmicks. Sex being the biggest one. Violence is up there."[18]

The *commedia,* even as it was updated in the nineteenth century,[19] is more than just specific character types, storylines, and scenarios. It is a form of popular art, which, like language, is not static.[20] Viewers supply narrative that is not overtly presented, generalization is commonly used, and character types, known as "masks," are relied upon to convey information quickly and, perhaps more importantly, visually.

CREATING THE MASK: IDENTITY FORMATION IN MUSIC VIDEOS

Both the song and video for Madonna's "Vogue" are about display (fig. 25.2). The introductory images include a barrage of sculptures, paintings, connoisseurs, and performers in striking black and white. An aura of luxury is suggested as we see shadowy glimpses behind the scenes. This is clearly a realm where music, performance, and even entertainment are designed to help us, in Madonna's words, "escape the pain of life that you know" through the elaborate suggestion of proximity to the glamorous life. The rap section of the song lists famous personae, "Greta Garbo, and Monroe, Dietrich and Dimaggio," and recalls the ways we have come to know them "on the cover of a magazine" or as they "dance on air." Madonna has so successfully created her own image that the mask she portrays, or vogues, is that of her own iconic presence.

Fig. 25.2 Panic! At the Disco's "But It's Better if You Do," 2006.

Sprinkled throughout the video are re-creations from frozen moments in the fashion photography annals. One of these famous fashion shots is Edward Steichen's 1928 portrait of Greta Garbo with her arms framing her face, which might have presaged the whole phenomenon of voguing. According to a critic, "In New York gay subculture, 'voguing' is pretending to be a fashion model on a runway, dancing and striking exotic poses—a masquerade, and escape from everyday identity."[21] Throughout the video, the performers strike poses, indicating that "voguing" means preparing to be looked at, if not in a historic photo, then in a dance club or while hanging out with friends. Another iconic fashion photo referenced in the video is Man Ray's *Kiki with African Mask* (1926), in which the model rests her head on a table as she holds a stylized mask upright next to her face. The juxtaposition of the creamy white of her skin and the rich black of the mask reverberates throughout the video. The contrast of black and white appears in clothing, backdrops, bodies, ideas, and the monochromatic imagery itself. A third photographic reference occurs in a scene that virtually recreates Horst P. Horst's 1939 picture of a corseted model, called *Mainbocher's Pink Satin Corset*. The model's state of undress and the voyeuristic nature of the scene relate to the role of sexuality in the "Vogue" video, and by extension in all of Madonna's work.

In *commedia* and music videos, sexuality is spectacle, all potential rather than actuality. If it exists at all, it is in the mind of the viewer. There are definite innuendos of more and less overt nature in the lyrics ("Rita Haworth gave good face" or "let your body go with the flow") as well as erotic movements and choreography. Here the performance, both music and imagery, promotes escape; as the song says, "all you need is your own imagination, so use it, that's

what it's for…your dreams will open up the door." This video seems to offer a somewhat subversive message about breaking free from societal expectations. The way this video challenges "our idea of reality" recalls a distinctive characteristic of *commedia* connected by one writer to other contemporary products that "represent a recoil from our society's dominant respectable values, and attacks them by non-serious means."[22]

More overtly transgressive, the music of N.W.A. (Niggaz With Attitude) pioneered the genre of gangsta rap with its notoriously violent, aggressive, and misogynist themes. The particular "look" of gangsta rap—street clothes, droopy pants, baseball jerseys and hats, big chains, and tough attitude—is one that was cultivated by a group of guys from the economically depressed Compton district of Los Angeles.[23] The band's actual connections with the gang warfare they reference in their songs is not necessarily as autobiographical as it might at first seem. In a 2002 interview, MC Ren (Lorenzo James Patterson) said, "It's just an image….We got to do something that would distinguish ourselves. We was just trying to be different."[24] According to a historian,

That "hard" image—a staple of rap music since the 1980s—was indelibly linked to Compton by a group of African American youth who did not, themselves, always embody it. Easy-E (Eric Wright), despite his brief career as a drug dealer, was the product of a lower-middle-class home, the son of a U.S. postal worker; Ice Cube (O'Shea Jackson), the main voice of NWA, had to be lured back from Arizona—where he had gone to take advanced architecture courses—to record the album.[25]

While the reality presented by N.W.A. is not entirely fabricated, it is "selectively filtered…in

a way to deliver the most sensational and shocking impression to listeners."[26] This edited image is easier to convey visually in the three-minute song or video than the complexity of life in the "hood" would be otherwise. The members of N.W.A. do not have to pick up a gun to engage, and perhaps even satisfy, the desire to commit a violent act. The fact that they are presenting murder and rape in a virtually nonthreatening way, like commedia and carnival, makes people take notice. These social issues can be embraced when they are presented as entertainment, and this partial picture of transgression actually comprises the majority of its appeal in the commercial realm.

One of the points of N.W.A's graphic content is to suggest that there is a world out there that many people never experience.[27] The embrace of the N.W.A.'s extreme environment by listeners from an entirely different social milieu, however, suggests that their music can be an experience similar to the celebration of carnival. Like the rituals encountered during Mardi Gras, New Year's Eve, and Halloween, it allows people to step outside of their own societal expectations and become someone else for a while. This type of transgression is generally viewed as acceptable, even restorative, to keep people in line and retain social balance. The widespread appeal of gangsta rap for an audience outside the sphere of gangs and drug dealers, "primarily composed of suburban white males"[28]—suggests that it offers a release rather than a desirable model of reality. Catharsis is a crucial component of commedia, as seen in the vivid inclusion of "bloodshed, rape, robbery, torture, and famine." These themes exist in "ordinary life…in milder form."[29] The events played out in scenarios of commedia, like those on the streets of Compton, are appealing because they relate to the people's plight, often exaggerating it. Due to its extremity, gangsta rap provides a foil to the audience's own challenges, a mirror that reflects everything they are not, as well as an outlet.

Panic! At the Disco's (PATD) video for "But It's Better if You Do" foregrounds many of the defining characteristics of the commedia dell'arte (fig. 25.2). The band's emo appearance—with dark eyeliner, spiky hair-dos, ruffled tuxedos, and skin-tight pants—is as noticeable as that of Adam Ant, The Stray Cats, or The Cure. As they carve out their own personas, the band members[30] seem to parody the excess of 1980s styles that in themselves now look like costumes. In many ways a celebrity's public image is always a mask, but the fact that musicians like PATD wear costumes and masks highlights the fictive nature of their performances. Their songs often have cinematic or literary connections. The title of their song "But It's Better if You Do" is a quotation from Natalie Portman's character in the movie Closer.[31] The band's intertextual visual references range from Victorian clothing to vaudeville to the Cirque du Soleil and Moulin Rouge.[32] The use of the excess, masking, and theatricality to promote their first album, A Fever You Can't Sweat Out, recalls the "casino showroom-style spectacle"[33] of their hometown, Las Vegas.

Panic! At the Disco's video starts in black and white, with a couple arguing in a manner reminiscent of a scene from a 1950s TV sitcom like I Love Lucy. The man (played by lead singer Urie) is about to walk out the door and his wife pleads with him not to go to an "illegal strip club." Although he claims he has to "work to pay for this dump," he proceeds directly to "a cabaret." As he walks down the street the scene changes to color. When he reaches a door, a bird-masked face peers through the peephole (recalling a Prohibition-era speakeasy) before opening it to reveal a decadent interior. The bar is filled

with "burlesque queens" and men in suits, all wearing masks. It turns out the man is in a band that performs the song we are listening to. However, during the course of his performance, one of the red-masked cancan dancers catches his eye. They move to a chair, where he is undoubtedly "praying for love in a lap dance." When he removes his mask his identity is revealed and the woman recoils. As she runs away from him, cops are bursting in to raid the club. He chases her while the other dancers and the rest of the band continue performing. The final shot resumes in black and white, as the man and his wife smile at each other in the back seat of the police car, their identities revealed and their charade exposed.

In an interview with MTV, the band explained that the video was inspired by handmade masks they got from a shop in Venice. The masks transform the individuals into characters whose roles in the spectacle are easy to recognize. Part of the intrigue of the bordello is the release it offers from the confining domestic scenario presented in the opening scene. The masks that are worn there offer the protection of anonymity, suggesting that one's virtue is maintained as long as identity is undisclosed. Transgression takes on a ritual quality when it happens in a socially sanctioned environment, like the strip club in this video. As one writer notes:

> The burden of restraint normally imposed on the members of any given society is lifted momentarily, encouraging participants in that culture to indulge in typically forbidden patterns of interaction... *in excess* and within well defined parameters of *time* and *place*. Both qualifications are critical. Without them, the "carnival" would quickly descend into chaos.[34]

The lead character—and, as it turns out, his partner—seek an environment that will offer a release from the pressures and drudgery of daily life. The communal environment of the cabaret creates the impression that these characters are playing a social role beyond the fulfillment of a personal fantasy. The cathartic nature of music video is prominent here as "the viewer can indulge symbolically in behavior which he or [s]he might consciously condemn."[35] A person can here live out fantasies, at least for a moment. "But It's Better if You Do" brings together some of the overlapping ideas in the *commedia* and music video in its emphasis on image formation, release from societal expectations, and delving into an illicit world through the mask, popular music, and video.

CONCLUSION: TRANSFORMATION AND TEMPORARY RELEASE

Throughout its history, the genre of music videos has created an atmosphere of excess on the edge of social propriety. The fact that messages of sexuality, voyeurism, rebellion, violence, and decadence are made within the realm of art or entertainment presumably renders them "nonserious"[36] and therefore tolerable, even desirable. Madonna's video for "Vogue" not only reframes glamorous faces from the past, but also entrenches her own iconic image within that tradition and inspires the audience to adopt self-consciously alluring poses themselves. The lyrics and videos for N.W.A.'s songs suggest that the arena of release through creativity is not available to all segments of society. The popularity of their messages of aggression, misogyny, and drug culture to segments of the population that do not necessarily engage in those activities suggests that the image they have created can be cathartic. Finally, Panic At The Disco's "But It's Better if You Do" uses masks to disguise

identity and create a scenario of intrigue and unexpected reversal. All of these videos, like *commedia dell'arte,* highlight the visual communication possible through this form of expression. Music videos, like carnival, offer an escape, a temporary release through the world of the imagery and music. The identifiable characters and recognizable scenarios used in these videos create a shorthand way to convey identity and messages of imagination, individuality, and transgression that can be clearly conveyed in the short span of a music video.

NOTES

1. Prominent director Bob Giraldi states, "These things are another world altogether." Michael Shore, *The Rolling Stone Book of Rock Video* (Quill, 1984), 163.

2. Pat Aufderheide, "Music Videos: The Look of the Sound," *Journal of Communication* 36, no. 1 (March 1986): 57–58.

3. Carol Vernallis, *Experiencing Music Video: Aesthetics and Cultural Context* (Columbia University, 2004), xiv.

4. History derived from Marsha Kinder, "Music Video and the Spectator: Television, Ideology, and Dream," *Film Quarterly* 38, no. 1 (Autumn 1984); Shore, *The Rolling Stone Book of Rock Video;* Aufderheide "Music Videos"; Ann E. Kaplan, "Feminist Criticism and Television," in *Channels of Discourse: Television and Contemporary Criticism,* ed. Robert C. Allen (University of North Carolina Press, 1987); Andrew Goodwin, *Dancing in the Distraction Factory: Music Television and Popular Culture* (University of Minnesota Press, 1992); Vernallis, *Experiencing Music Video;* and Scott Mervis, "The 3 minute Director: Wood Street Galleries Spotlights Spike Jonze, Chris Cunningham and Other MTV 'Stars' with the Retrospective 'Music Video: 1982–2000,'" *Pittsburgh Post-Gazette,* April 22, 2005, Arts & Entertainment, W-22.

5. Presley first appeared on television in 1956 and made his first film, *Love Me Tender,* that same year. In 1964 the Beatles appeared on the *Ed Sullivan Show* and filmed *A Long Day's Night.*

6. One of these shows, *Soul Train,* like *American Bandstand,* often featured music video clips in addition to live performance. Other shows included *Top of the Pops* (BBC), *Midnight Special, America's Top 10,* and *Friday Night Videos* (NBC).

7. Tom Anderson, president of MySpace.com, quoted in Edna Gunderson, "Music Videos Changing Places," *USAToday,* August 26, 2005.

8. See further Kaplan, "Feminist Criticism and Television," 55; Vernallis, *Experiencing Music Video,* 24; and Dan Rubey, "Voguing at the Carnival: Desire and Pleasure on MTV," in *Present Tense: Rock and Roll Culture,* ed. Anthony DeCurtis (Duke University Press, 1992), 241.

9. Goodwin, *Dancing in the Distraction Factory,* 107.

10. This video was designed by James Rizzi and directed by Rocky Morton and Annabel Jankel of Cucumber studios.

11. Shore, *The Rolling Stone Book of Rock Video,* 130.

12. Jon Pareles, "As MTV Turns 10, Pop Goes the World," *New York Times,* July 7, 1991, section 2, page 1, column 1, Arts and Leisure Desk.

13. Vernallis, *Experiencing Music Video,* 8.

14. Evert Sprinchorn, "Introduction," in *The Commedia dell'Arte,* by Giacomo Oreglia, trans. Lovett F. Edwards (Hill and Wang, 1968; Italian edition, Sveriges Radio, 1961), xi.

15. Pat Aufderheide discusses Bowie's pioneering of the "disposable image" in Aufderheide, "Music Videos," 67. David Bowie's personas included Ziggy Stardust, Aladdin Sane, the Thin White Duke, and his "ordinary self" in the 1980s, discussed in Goodwin, *Dancing in the Distraction Factory,* 111.

16. Vernallis, *Experiencing Music Video,* 56.

17. Chris Cunningham, quoted in Kalefa Sanneh, "Music Videos That Show Everything but Performance," *New York Times,* August 17, 2003, Section 2, Column 1, Arts and Leisure Desk, 22.

18. Ed Steinburg quoted in Mervis, "The 3 minute Director," W-22.

19. See John Rudlin, *Commedia dell'Arte: An Actor's Handbook* (Routledge, 1994), 5.

20. The subjects used by pop artists are a case in point. Familiar in the 1960s pop era, Brillo box designs have changed and typewriter erasers no longer exist. Madonna would certainly be the object of Warhol's devotion in the 1990s as Marilyn Monroe was in the 1960s. Innuendo, imbedded references, and pastiche that are so pervasive as to be virtually invisible in music video and popular culture are also related to the postmodern aesthetic.

21. Rubey, 263.

22. Martin Burgess Green and John C. Swan, *The Triumph of Pierrot: The Commedia dell'Arte and the Modern Imagination* (Penn State University Press, 1993), xv. Green mentions myriad examples from Surrealism and later in art, theater, opera, and film. Although the examples cited may have profoundly impacted a person's conceptions and actions, the fact that these statements are made within the realm of art or entertainment seems to be what Green means by "nonserious."

23. The group was formed by Easy-E, Ice Cube, and Dr. Dre, with DJ Yella and Arabian Prince. The D.O.C. and MC-Ren were added later.

24. Terry McDermott, "Parental Advisory: Explicit Lyrics," *Los Angeles Times,* April 14, 2002, 1.

25. Josh Sides, "Straight into Compton: American Dreams, Urban Nightmares, and the Metamorphosis of a Black Suburb," *American Quarterly* 56, no. 3 (2004): 597.

26. Sides, "Straight into Compton."

27. "Express Yourself" is one of their most docile songs, virtually devoid of profanity, offensive statements against women, or prodrug references. The central theme of this song is to promote personal freedom in a creative way, even at the expense of breaching social expectations and laws.

28. David Samuels, "The Rap on Rap," *New Republic,* November 11, 1991, 25.

29. C. B. Wedgewood (17th century), quoted in Howard Daniel, *Commedia dell'Arte and Jacques Callot* (Wentworth Press, 1965), 15.

30. The band members are Brendon Urie, Ryan Ross, Spencer Smith, and Jon Walker, who replaced Brent Wilson in 2006.

31. The band's name itself comes from the lyrics of Name Taken's "Panic" and the Smiths's song "Panic."

32. Autumn de Wilde, "Panic Attack," *Spin,* October, 2006, 56–61; Jessica Herndon, "Panic! At the Disco Sounds Off," *People,* September 25, 2006, 15. Of late the band seems to be playing with the malleability of their personas by dropping the exclamation point from their name and considering a departure from the circus theme. See James Montgomery, "Panic At The Disco Know Punctuation Better Than They Think," *mtv.com,* January 15, 2008; and Montgomery (with reporting by Matt Elias), "Panic at the Disco Pledge to Drop Circus Theme, Underwear on Upcoming Tour," *mtv.com,* January 22, 2008, http://www.vh1.com/artists/news/1579620/20080114/hed_pe.jhtml.

33. Wilde, "Panic Attack," 9.

34. Lisa St. Clair Harvey, "Temporary Insanity: Fun, Games, and Transformational Ritual in American Music Videos," *Journal of Popular Culture* 24 (1990): 45.

35. Harvey, "Temporary Insanity," 56.

36. Green and Swan, xv.

DIGITAL SELF-FASHIONING IN CYBERSPACE: THE NEW DIGITAL SELF-PORTRAIT

Matt Ferranto

One of the biggest media sensations of 2006 was not a rapper or a video game but a seventy-nine-year-old reclusive widower from Britain's Peak District who wanted to "tell it all." Wearing a tan V-neck cardigan and sitting calmly in front of floral patterned wallpaper, Peter Oakley trained a video camera on himself and related stories of 1942 Luftwaffe bombing raids, his lifelong love of motorcycles, his halting experience with contemporary computing technology, and a variety of what he called "geriatric gripes and grumbles" (fig. 26.1). After posting his videos on the YouTube Web site under the moniker geriatric 1927, Oakley attracted more than half a million viewers in less than a month; his videos were among the site's most popular attractions, eliciting thousands of viewer comments and dozens of videos created in response. While fashioning himself into a "universal granddad,"[1] who openly confessed his addiction to YouTube videos on the Web, Oakley remained a painfully shy individual. When reporters and other individuals inevitably began seeking him out in person, he dissimilated, announcing via his videos that he lived in a town fifty miles away and rode a motorcycle.

Who was this geriatric1927? Along with ease of communication, the digital era promises new forms of self-expression and consequent strategies of self-fashioning. Digital

photography and video, coupled with online distribution, are expanding conceptions of both self and its depiction. Indeed, for the emerging "Generation @," virtual spaces and electronic networks have become social hubs, while digital images are crucial points of self-definition.[2] The advent of cyberspace has enabled an increasing number of sites for the exchange of ideas and opinions, and many of these new options expand opportunities for self-expression as well as self-promotion. It has provided a new forum for self-portraiture, but it has also facilitated an expanding visualization of identity. With access to these sites open and assured, even the most experimental formats for self-presentation and portrayal have the capacity to communicate on a vast scale.

The digital, networked self-portraiture of cyberspace inevitably calls for an investigation of the form throughout history. Scholars have traditionally situated the advent of visual self-portraiture with humanists' embrace of the sense of the self during the European Renaissance. Aside from surreptitious portraits, including marginalia of monks in medieval manuscripts, the first autonomous visual self-portraits in which the artist is the central figure are generally agreed to have emerged in the late fifteenth century. Some of these paintings seem to have functioned as advertisements for a painter's craft, such as Parmigianino's

Fig. 26.1 Peter Oakley, *YouTube,* 2006.

Self-portrait in a Convex Mirror, about 1524. But increasingly they also could be seen as statements of self; from Van Gogh to Picasso, the avant-garde took to self-representation as a chief expressive tool throughout the late nineteenth and the twentieth centuries. Although arguments may be made that some folk or outsider art encompasses self-portraits, self-portraiture largely remained the purview of professional artists throughout the early twentieth century.

While the growth of photography among nonidentified artists might point to a consequent growth of self-portraiture, digitization has led to the blossoming of the amateur self-portrait. A minor boom in photography took place in the twentieth century as middle classes with new-found leisure time took up photography in large numbers. But even then, nonprofessional photographers trained their lenses on friends, pets, families, events, or landscapes far more often than on themselves. *Americans in Kodachrome, 1945–65* (2002) includes snapshots culled from 500 American families; author Guy Stricherz reviewed more than 100,000 pictures over seventeen years in compiling the book but found fewer than 100 self-portraits.[3] According to Stricherz, "in 1960, a person just wouldn't take a Kodak Brownie picture of themselves. It would have

been considered too self-aggrandizing."[4] As recently as twenty years ago, photographs were generally used to document special occasions. Photographs cost money and time to develop, the prints and negatives took up space in boxes or drawers, and they were difficult to show to anyone beyond a close circle of friends. Today, not only are photographic images easy to manipulate and store, but digital self-portraits on home pages have become crucial to the idea of virtual community and an increasingly wider and more inclusive audience.

Digitization, as opposed to photography itself, led to the blossoming of the amateur self-portrait. Hailed as "folk art for the digital age,"[5] such images result from the advent of cheap, lightweight digital cameras coupled with digital storage and image manipulation; the truly democratizing effect of online distribution has made the visual self-portrait ubiquitous. New technologies in video and still photography do more than use binary data to capture and record images. There is an alchemy here that invites the amateur. In the 1970s, even cheap and simple prepackaged film cartridges that users were required to load into "point and shoot" cameras were generally still processed by professionals into slides or paper prints from negatives. Relatively bulky Polaroid models created unique paper photos in the space of five minutes or so. But such images were difficult to edit and distribute. Digital images, by contrast, are easily stored; unwanted pictures are merely deleted from the camera itself. Other images can be edited on a personal computer. Camera models are extremely small or portable, and photographic capabilities are frequently found embedded in cell phones or even key chains. Even digital cameras found in cell phones frequently come equipped with wide-angle lenses; pictures taken at arm's length can still remain in focus. Sophisticated editing and retouching techniques once available only to professionals or practiced amateurs with access to thousand-dollar darkrooms can now be accomplished with the click of a few buttons in computer programs like Photoshop. Moreover, with home computers growing faster and more powerful, screens once dedicated to text processing are increasingly used to view and process personal photos and movies. Foregoing the use of professional studios, and even the help of friends and family, individuals now fashion portraits as a solitary act.

But such portraiture is not necessarily isolating; the rapid development of the Internet has provided digital photographers with a ready audience. Previous generations were unable to distribute their photos, whereas digital self-portraits can be seen by millions on the Web. Sites like YouTube and Flickr enable Peter Oakley and millions of others to share their self-imagining with the world.

While such photo-sharing sites display a remarkable range of images and numerous distinct visual styles, the Internet was originally what one observer has called "a world of words, not images."[6] Developed in the late 1960s as a U.S. Department of Defense project, the Web was formulated as a global hypertext system, in which users could link to various text documents; HyperText Markup Language, or HTML, the coding language used to create hypertext documents for the World Wide Web, was not initially configured to display graphics. Even in the 1980s, when private companies, universities, and research labs combined to create the network of computer servers, switches, and routers that broadened the Internet and ended military dominance in computer networking, their transmissions were limited to text. Quickly, however, software engineers of various stripes introduced

new HTML tags that would control the look of a document, rather than specify the document's organization. Marc Andreessen and Eric Bina's Mosaic (1993), the first cross-platform browser to gain wide popularity, introduced support for sound, video clips, forms support, bookmarks, and history files, and quickly became the most popular noncommercial Web browser.[7] But, commentators note, such browsers allowed orations, manifestos, and diatribes, as well as soapboxes or salons, but not "posters, flyers, or newsreels."[8] The added element of the visual, along with the ease and freedom of electronic movement enabled by hypertext, pushed what was an obscure resource available to engineers and technocrats into the churning mainstream of popular culture and global commerce. Above all, the Web became a tool for presentation, opening up a range of possibilities for first thousands and then millions of people to fashion personae and identity.

When, in the early 1990s, Vice-President Al Gore helped popularize the notion of the digital revolution as "an information superhighway," he could hardly expect that it would also be a new route to fashioning identity.[9] Even before the Web transformed into a visual medium, however, individuals frequently created personae in online culture; in e-mail exchanges, chat rooms, or multiplayer games, text-based self-portraiture rapidly evolved. At their most complex, multiplayer dungeons, or MUDs, allowed players to create, maintain, and enhance these textual selves, using pseudonyms as descriptions of personae. This relatively early stage of Web technology established e-mail and chat rooms as sites in which contact and exchange could be maintained and enhanced at the user's desire, and almost immediately text-based portraits of self emerged, while subjectivity became a more fictional construction.[10]

Although the earlier Internet allowed limited textual self-fashioning, the confluence of digital imagery and a ready audience of the Web changed this situation in the mid-1990s. From the earliest days of the Web, personal home pages have provided some of the most prevalent forms of digital self-representation. One of the first of these was Howard Rheingold, who in 1995 had a page featuring a "pixel theatre" of his paintings, including one on his greenhouse door that he finished by only painting on his birthday each year for five years, a diary from his travels (with pictures and pointers to the home pages of interesting people he visits), and other things. Cobbled together by British research scientists in 1993 so that their dispersed group could keep abreast of the amount of coffee in their single pot, Webcams were quickly manufactured and marketed as the must-have tech toy. But the first Webcam quickly evolved into something more; the now famous Trojan Room Coffee Pot Web inadvertently echoed the bland disengagement of Andy Warhol's *Empire* and also achieved similar cult status, garnering more than two million page views and generating media coverage worldwide. Later, personal sites were often connected to Web cameras, which acted as the author's observing ego, or at the farthest extreme, as an exhibitionistic display. Many Webcam sites presuppose amateurism as a provocative and compelling creative position, as they take the telejournalistic premise of the close, personal view to unanticipated limits. One of the first and most popular personal Webcams was Jennifer Kaye Ringley's Jennicam (1996). After installing a Webcam in her Dickinson College dorm room, she eventually charged per view of her everyday life, which, as one media observer noted, could include "sitting in front of her PC topless, strolling across the room

wearing nothing but a towel on her head or even rolling around the sheets with her boyfriend."[11] Ringley later appeared as a television talk show guest and was featured in museum exhibitions.

Not unlike childhood fantasies of anchoring one's own TV show, many sites offer a new kind of autobiographical enterprise to an extent never before imagined. Perhaps the most vibrant arena of discourse, Web logs, or blogs, have come to be treated as postmodern occasions for self-fashioning. A frequent and chronological publication of comments and thoughts on the Web, blogs usually include links to stories, press releases, and (frequently) other blog entries to which the writer is responding; they are typically updated daily using software that allows individuals with little or no technical background to update and maintain the blog. Blogs offer expressive and narrative possibilities and increasingly use images of the blogger or links to images that visually enhance and organize the text. Emerging from lists of links to other Web sites—among the first widely recognized blogs were Justin Hall's "Justin's Links from Underground," which he started as a student at Swarthmore College in 1994, and Dave Winer's "Scripting News" of 1997—the sites now frequently combine texts and images with an interactive component; readers often post comments and portraits that become an important part of many blogs.[12] These sites tend to share a set of consistent visual elements, including a wide column of brief text entries introduced by short, colored headlines and smaller text noting the date and time of the posting, and a narrower column listing blogs and other sites that the blogger implicitly or explicitly recommends. Based on the same premise as text-based blogs are photo-sharing sites like Flickr, in which people can post, sort, search,

and archive digital photos. Such straightforward sites, however, facilitate more than communication; they have transformed the nature of self-presentation.

Commentators now note that "the art of the self portrait has never been so popular."[13] Digital self-portraits snapped with cameras and cell phones fuel such developments. But the transformation of the Internet into a visual medium, coupled with the flexibility of hypertext, has changed the nature of self-portraiture. Visual and self-elucidating, home pages, text-based blogs, Webcams, or photosets may all be considered extended self-portraits; representing new forms unimagined by self-portraitists in the Renaissance, digital self-portraits infiltrate the Web. Frequently found on user home pages, they complement and often supersede text profiles with bloglike entries detailing personal opinions, achievements, or events. Above all, digital self-portraits, both still and video, shape self-presentation.

Previously, what psychologists call "impression management" was dictated by dress, how one laughs or smiles, voice inflection, and the like.[14] Translated to cyberspace, users introduce themselves through alternative cues. Some may be textual, including diary-like entries or lines of poetry. But many incorporate self-portraits snapped on digital cameras or even homemade video clips, while others include more allusive imagery, constituting a composite self-portrait. Displaying the contents of a closet or purse, some can be more metaphoric; these images often serve as exercises in taste and discernment, somewhat akin to displaying a personal collection of books or artworks. Newer forms of Web-based self-portrayal include video diaries or memoirs like Oakley's reminiscences. Other sites are filled with photographs of user's meals, or images of locales visited by an author throughout the day.

In this context, then, digital self-portraiture does become a kind of folk art; but it is also a new kind of platform for self-fashioning.

In *Renaissance Self-Fashioning,* Steven Greenblatt argues that "the simplest observation we can make is that in the sixteenth century there appears to be an increased self-consciousness about the fashioning of human identity as a manipulable, artful process."[15] Tracing the phenomenon largely through the writings of figures like Thomas More and Shakespeare and other writers associated with Henry VIII's court, Greenblatt described self-fashioning as the creation of oneself according to a set of socially acceptable standards: "the achievement of...a distinctive personality, a characteristic address to the world, a consistent mode of perceiving and behaving."[16] Self-fashioning can take many forms—dress, voice, and so on; in the visual arts, self-fashioning commonly refers to the poses, postures, props, and other elements of portraits, including self-portraits. Greenblatt suggests that such public "portraits" promise autonomy and freedom but are also necessarily intertwined with responses to authority and control. As painters were attempting to elevate their social role from skilled craftsmen to visual poets, for instance, the self-portrait also served as a powerful promotional tool. Artists often painted themselves as classic heroes, as did Raphael in his *Disputa,* or as imperial knights, as in Velázquez's *Las Meninas.* Although he undertakes an extended reading of Holbein's *The Ambassadors,* most of Greenblatt's analysis is based on his writers' letters, personal narratives, early biographies, and literary works. That visual imagery, especially self-portraits, could be important in Renaissance society as a means for introducing cultural ideals and bolstering individuals' place in society is explored by another scholar,[17] as is the notion that self-fashioning can take place

in contemporary terms in the self-portraits of Cindy Sherman, Vito Acconci, and Chris Burden's early works.[18]

Allowing any user to present information to others, with few intermediaries or censors, the Web permits amateurs to fashion personae and provides an audience to both receive and respond to them. Such self-fashioning began before images were incorporated into the Web; e-mail, chat rooms, and MUDs introduced a performative element to digital self-presentation.[19] Now encompassing a visual dimension, the digital self-portraiture on view across today's Web may increase opportunities for self-fashioning, whether in video blogs or diary-like photo sets. But this isn't the self-fashioning of Sir Thomas More. Although the devices available to the Web's self-portraitists are technologically complex, the results are uneven; as one observer has suggested, cyberspace is not Disneyland. It's not a polished, perfect place built by professional designers for the public to obediently wait on line to passively experience. It's "more like a finger-painting party. Everyone is making things, there's paint everywhere, and most work only a parent would love."[20] Surveying home pages on the social networking site MySpace, another commentator proposes that this unrefined look "sends another message to users: We're like you. You're not a designer, and neither are we." The studied avoidance of "good design" in page templates and color schemes, coupled with users' ability to customize their pages with colors, fonts, music, images, and video clips, "resonates with the audience's desire for self-expression."[21]

The visual self as presented on the Web is consciously constructed and manipulated. Amateurism is inherent, given the relatively wide availability of computer software that replicates photographic studio processes

and effects. Typical MySpace self-portraits use high-contrast black-and-white or inverted color schemes; intense angles or close-ups add drama. Similarly, when Peter Oakley trained a camera on himself and became "geriatric 1927," viewers saw an elderly man wearing heavy earphones who stared at the ground as often as his audience when he talked; wittingly or not, he presented an amateurish persona, easily slipping into the character of a shy "universal granddad."

Reminiscences of old men like Oakley are familiar literary devices and their thoughts may be dismissed as mere nattering, but they can often be treated as sagelike and imposing. On the Web, the latter is increasingly common, as Oakley and other figures have become like archetypes. Moreover, thanks to social networking programs, that audience becomes part of the Web performance. Oakley's videos are accessible on his YouTube page, but his page also features his "friends," fans who submit comments and their own self-portraits to the site, "subscribers" who regularly view his videos, and "favorites," other sites on YouTube that Oakley recommends to viewers. Thus the Web portrait becomes more than a single image or video; sites like Oakley's comprise both images of the individual owner and a range of small thumbnail portraits submitted by individuals in his personal network. Peter Oakley, in his isolated cottage in northern England, is defined not only by his video diary but also by a visual network of friends and connections scattered around the globe.

In 1984, William Gibson identified cyberspace as a form of consensual hallucination;[22] more recently, Web critics argue that the "friendships" illustrated on these pages, often formed between people who have never actually met, are illusory. But such thinking is misleading. Rather than replicating the "real" world, they represent a new way of thinking and constructing social identity; as one observer notes, "different kinds of connections [form] between people than those made in physical space."[23] YouTube, Myspace, Flickr lay bare new patterns of connectedness; but their true power lies in their use of images, as work by the American artist Ethan Ham, who employs many distinct forms of media, including YouTube, demonstrates (see fig. 26.2).

At the end of the nineteenth century Vincent Van Gogh painted himself against a background of Japanese woodblock prints, suggesting his artistic sources and inspiration and making a complex statement about himself and his place in the artistic milieu of late nineteenth-century France. Self-portraits on social networking sites can suggest equally allusive, and complex, forms of self-imaging. Using a basic page template, social networking sites like MySpace enable, and even encourage, individuals to assemble and display an ever-changing collection of friends. With portions of each Web page dedicated to pictures submitted by members of the owner's network, the sites are image-heavy (with text subsidiary). Whereas social interaction in physical space is bounded by "social context cues," the Web presents a new arena of discovery and display; here images—especially digital self-portraits—are manipulated to replicate these cues. Nuances of spoken words, body language, and emotional tone are conveyed through color, composition, and pose. But personality, status, and connections are also conveyed through contacts. Like Pokemon cards or paper dolls, portraits of friends compose more than a collection. They deviate from van Gogh's self-conscious attempt to quote his artistic sources; instead, they form a group portrait of connectedness.

Fig. 26.2 Ethan Ham, *Self-Portrait: In Search of Myself, YouTube,* 2007.

But the networks on the Web are always mutable and changing; friends can be added, dropped, and shifted, and the composite portrait can change. Moreover, autonomous self-portraits taken with a cell phone or digital camera can be quickly uploaded, downloaded, and discarded, allowing users to change their self-presentation with flexible ease. What began as a series of short features outlining Oakley's complaints with the modern world deepened as he uploaded additional videos. Over time, his blog became more complex, emerging as a personal narrative that revealed his "lucky" selection for education beyond age fourteen, his wartime memories as a radar mechanic, years as a health department official, and his love of painting and motorcycles. Others simply change home page self-portraits as rapidly as

clothing; fanciful and entirely disposable, they add new images to show a change of haircut, just-purchased clothes, or new makeup.[24]

In Oscar Wilde's *The Picture of Dorian Gray,* the dissolute protagonist cheats, lies, and provokes suicides but remains untouched by the passage of time; instead his portrait constantly changes, growing more monstrous with each immoral act, aging as the years pass. Wilde's changing portrait becomes a metaphor for decadence. But the ever-changing self-portraits on the Web may be interpreted differently; postmodern theorists like Jacques Lacan cast doubt on the self as an inviolable whole, emphasizing instead instability and fragmentation. Moreover, the very idea of authorship, or portrayal, has been questioned by recent philosophers since Foucault linked "the question

of the author" to "a privileged moment of individualization."[25] Like the artist Cindy Sherman, whose photographic self-portraits shift and change the artist's identity from shopgirl to ingénue to femme fatale, we no longer approach the self as a single, indivisible essence.

Such concepts aptly describe the digital realm. Traditional self-portraits are fixed in paint, stone, or printed text. When Parmigianino painted his self-portrait in 1524 he proudly portrayed himself as an accomplished artist. Although he might alter the painting, traditional media like paint remains static. Ever-changeable electronic imagery, however, suggests a mutable, moldable, and postmodern self.[26] Hypertext, with its shifting narratives and potential for interactive collaboration, has captured the imaginations of more recent theorists.[27] Its ability to support multiple narratives, and the freedom of viewers to interact with or even change works of art, palpably demonstrates such theories. But it is the mutability of the digital, its ever-changing impermanence, that best echoes ideas of postmodern instability. Always shifting, the digital self is understood as a conglomeration of multiple identities.

While Oakley's attempt at self-portrayal was relatively straightforward, Little Loca, a YouTube contemporary, debuted in 2006 as a more equivocal figure. An eighteen-year-old Mexican American from East Los Angeles, Loca mesmerized audiences with tales of her overprotective brother, perfect grades, and stories about life in the ghetto. In the first six months she posted ninety-five videos and was viewed six million times.[28] But there was more than met the eye; Little Loca was soon outed as a struggling actress (and director, star, and camera operator). Stevie Ryan, the actress who conceived Loca, blended the fictional character with aspects of her off-screen self. While visiting her parents in Victorville, California, for instance, Ryan's car was broken into; she made herself up as Loca and turned on the camera. Filming the aftermath of the incident, she climbed into her front seat, trained the camera on disheveled CDs and papers, and announced to viewers, "This is real, you guys. I'm not trying to play no stupid YouTube joke or nothing...." After Ryan took her dog to the veterinarian, Loca devoted part of an episode to complaining about the expense of dog shots.[29] Where the lines of separation between Ryan and Loca blur on the Web, the medium also leaves room for multiple identities. At the same time that she crafted Loca, Ryan established another page introducing herself as "Jamie Lynn," a tough-talking parody of pop star Britney Spears. On yet another page, she created an alternate persona, "Brigitte," a French foreign exchange student prone to wearing berets and flirting soulfully with the camera.

Cyberspace has developed as a site for the exchange of ideas and opinions, but it also provides new opportunities for self-expression, self-promotion, and self-definition. Partial identities emerge, while others are hidden. To obscure his true identity (and throw curious reporters off the scent), Peter Oakley presented himself as a motorcycle-ridding octogenarian who lived in Leicester, a town removed from his isolated country cottage. Stevie Ryan fashioned herself as the feisty Chicana Loca, merging aspects of her real self with the character.

With the advent of cyberspace, the self can exist more in the digital realm than the real. An amateur guitarist eschews sleep to watch solos of himself on YouTube an average of 250 times an hour; he skews his rankings but does not have time to practice the guitar.[30] Not only does the performance grow in significance, but

the digital tools that enable it become obligatory. Cell phones with camera capabilities are carried not for calls, but to document life. When Stevie Ryan, a.k.a. Little Loca, discovers her car has been broken into, she goes on camera, announcing, "I feel like half of my life is gone right now. But hey at least I have my camera, right? They didn't take my video camera."[31]

NOTES

1. Jonathan Margolis, "'Geriatric' Peter, the Global Web Star," *Saga Magazine,* March 15, 2007, http://www.saga.co.uk/magazine/people/reallives/geriatric1927_160307.asp.
2. Jesse Hempel with Paula Lehman, "The MySpace Generation," *Business Week Online,* December 12, 2005, http://www.businessweek.com/magazine/content/05_50/b3963001.html.
3. Alex Williams, "Here I Am Taking My Own Picture," *The New York Times,* February 19, 2006, section 9, p. 1.
4. Williams, "Here I Am."
5. Williams, "Here I Am."
6. Michele H. Jackson and Darren Purcell, "Politics and Media Richness in World Wide Web Representations of the Former Yugoslavia," *Geographical Review* 87, no. 2 (April 1997): 219.
7. Bill Stewart, "Web Browser History: Mosaic," *Living Internet,* 1996–99, http://www.livinginternet.com/w/wi_browse.html.
8. Jackson and Purcell, "Politics and Media Richness," 219.
9. Albert Gore, "Remarks," The Superhighway Summit, UCLA Royce Hall, January 11, 1994, http://clinton1.nara.gov/White_House/EOP/OVP/other/superhig.html.
10. Angeliki Avgitidou, "Performances of the Self," *Digital Creativity* 14, no. 3, (2003): 135–36.
11. Todd Wallack, "Curtains in the Bedroom—JenniCam Switches Off," *San Francisco Chronicle,* December 12, 2003, B4.
12. Rebecca Blood, ed., *We've Got Blog* (Perseus Books Group, 2002), 12.
13. Amy Bruckman, "Cyberspace Is Not Disneyland: The Role of the Artist in a Networked World," *Getty Art History Information Program,* 1995, http://www.cc.gatech.edu/fac/Amy.Bruckman/papers/getty/disneyland.html.
14. For more information, see Daniel T. Gilbert, Susan T. Fiske, and Gardner Lindzey, *The Handbook of Social Psychology* (Oxford University Press, 1998).
15. Stephen Greenblatt, *Renaissance Self-Fashioning* (University of Chicago Press, 1980), 2.
16. Greenblatt, *Renaissance Self-Fashioning.*
17. For more on this, see Joanna Woods Marsden, *Renaissance Self-Portraiture: The Visual Construction of Identity and the Social Status of the Artist* (Yale University Press, 1998).
18. "Self-Styling after the 'End of Art': An Interview with Richard Shusterman," *Parachute* 105 (Spring 2002): 56–63.
19. For more information, see Sherry Turkle, *Life on the Screen: Identity in the Age of the Internet* (Simon & Schuster, 1995 [1985]).
20. Bruckman, "Cyberspace Is Not Disneyland," n. 13.
21. Jesse James Garrett, "MySpace: Design Anarchy That Works," *Business Week Online,* January 3, 2006, http://www.businessweek.com/innovate/content/dec2005/id20051230_570094.html.
22. William Gibson, *Neuromancer* (Ace Books, 1984), 51.
23. Stephen Heller, "The New Generation Gap: An Exploratory Conversation with John Carlin," *Voice: The AIGA Journal of Design,* May 22, 2007, http://www.aiga.org/content.cfm/the-new-generation-gap.
24. Williams, "Here I Am," 12.
25. Michel Foucault, "What Is an Author?" in *Language, Counter-Memory, Practice: Selected Essays and Interviews,* ed. Donald F. Bouchard (Cornell University Press, 1977), 51.

26. See Avgitidou, "Performances of the Self."

27. For more on this subject, see George Landow, *Hypertext 2.0* (Johns Hopkins University Press, 1997), and Michael Joyce, *Of Two Minds: Hypertext Pedagogy and Poetics* (University of Michigan Press, 1995).

28. Ben McGrath, "Online Chronicles: It Should Happen to You," *The New Yorker* 82, no. 33 (Oct 16, 2006): 86–88, 90–91.

29. McGrath, "Online Chronicles."

30. McGrath, "Online Chronicles."

31. McGrath, "Online Chronicles."

FEATS OF SIMULATION AND THE WORLD OF VIDEO GAMES: ART, CINEMA, AND INTERACTIVITY

Martin A. Danahay

Video games are distinguished from other visual media by their reliance on computer technology and the mediation of human movements through keyboards, game pads, or joysticks. Unlike other games, video games are impossible without computer technology and are thus completely embedded within the history of computer hardware, so that a history of video games is also a history of the increasing computing power of these machines and the visual capabilities of monitors used to display graphics; video games have developed ever-stronger connections with the visual arts as the color reproduction of monitors has improved. Video games as a genre are natural hybrids and draw upon a wide set of conventions, such as narratives of adventure (especially in text-based games), mythology (whether historical or imaginary, such as Greek mythology or Tolkien's Middle Earth), combat (both individual and on a mass scale), sports, and visual conventions such as perspective and color symbolism. With the capability of imitating movement in 3D, video games have become a mode of mass entertainment that rivals many other popular forms of leisure that involve the consumption of visual images.

The nearest, although perhaps deceptive, analogy for video games is now the film industry.[1] In the late twentieth and early twenty-first centuries, film and video games became increasingly intertwined. Films have been based on video games such as *Resident Evil* (2002), *Lara Croft: Tomb Raider* (2003), and *Silent Hill* (2006), for example, and video games employ film conventions in their introductions and in breakaway scenes in which characters talk to each other and to the player. In some series of video games, such as those based on *Star Trek* films, the same actor does the voice-over and plays the character in the game as in the film version; Patrick Stewart, who played Captain Picard in some of the *Star Trek* franchise films, for instance, has a had a lucrative career providing voice-overs in the games.

In the early 1980s the video game industry was dominated by arcade-style games like Pac-Man (1980) and Space Invaders (1978), and they are often cited as forerunners of today's video games. When the video capability of video games improved and home consoles became available, side-scrolling games (i.e., games that scrolled from left to right across the screen) usurped the arcade-style games. In side-scrolling games, players would guide cartoon-like figures such as Mario and Sonic the Hedgehog through various mazelike environments in which they would have to run, leap, and dodge their way past obstacles and other creatures that impeded them (these games involved a great deal of simulated jumping).

Visually these games could be likened to some of M. C. Escher's trompe l'oeil images such as *Relativity* (1953). These games, along with "first-person shooters" (i.e., games in which a single player controls a gun to shoot at a variety of targets) were the dominant genre in the 1980s. The Mario game made the transition into the film *Super Mario Brothers* in 1993, but this was not an influential movie, nor did the cartoon-like icons have much of an impact beyond the game industry itself.

Video games began to change in the 1990s with both the increased computational power of computers and the steadily improving graphics capability of monitors. Video games went from being primarily side-scrolling to being capable of rendering three-dimensional images and movement through virtual environments. While many games were simply first-person shooters with more complex graphics, new forms of games that relied on visual images to create their own atmosphere started to emerge. One early successful example was Myst (1993), in which a single player moved through different two-dimensional landscapes that gave the illusion of depth and extension while trying to solve the "mystery" implied in the game's title (fig. 27.1). The game was inspired by Jules Verne's story *The Mysterious Island* (1874). Solving the mystery of the island took the player through different "ages," each with its own graphics and atmosphere. The game relied upon visual images and narrative to hold the player's interest, and it engaged the intellect through puzzles and riddles that had to be solved in order to unlock the "mystery" of the island. The emphasis on "atmosphere" in the game meant that a great deal of attention was paid to making compelling visual environments as part of the pleasure of playing the game.

Another successful game was the Sim series. Starting with SimCity (1989), the games

Fig. 27.1 Screen shot from Myst III: Exile I.

allowed players to build fantasy virtual environments, eventually becoming a whole range of games such as SimLife, SimTower, and the like. Initially the games were a form of urban planning; the objective was to create a functioning, sustainable virtual city within a certain amount of time while battling against a series of disasters, like fires, floods, and earthquakes. This series eventually became the online game *The Sims* (2000), in which the player created a "simulated life" for one or more imaginary people in a virtual environment. This is now the best-selling game in video history, replacing Myst at the top of the industry. It is unusual in that it is a game that has no specific goal or objective. Its creator likens it to a virtual "doll's house," in which players can create and play out their fantasies and thus spin out their own narratives.

At this point the histories of video games and of the Internet converge, as what were initially games for individual players migrated onto the World Wide Web in the mid- to late 1990s. The development of Massively Multiplayer Online Roleplaying Games (MMORPGs) such as Ultima Online (1997) and EverQuest (1999) expanded the original Dungeons and Dragons games into virtual environments in which players from anywhere on the globe with an Internet connection could, either singly or in concert with others, move through a three-dimensional virtual environment fighting monsters, acquiring treasures and weapons, and progressing through a hierarchy of levels to mark their development. Such MMORPGs have made video games into an experience for a global audience in the millions.

The increasing availability and sophistication of video games have made them either a direct inspiration or a template for many mass-release films. Indeed, the increasing use of computer graphics effects in films has helped blur the line between the video game and the film industry. Also, no matter how simple-minded the game may be, it will always have some attempt at a plot to make it seem a little more than just elaborate ways to blow away an array of fictitious creatures.

The first release to unite computers and film was *Tron,* a very early example of the genre from 1982. The film *Tron* made extensive use of computer-generated graphics and was also made into a racing game in which users raced "light cycles." While it was not a big commercial success, *Tron* did point the way for future crossovers between films and games that have become standard in the early twentieth century.

When *Tron* was released, the movie was the prime creative vehicle, with the games as imitations (within the limitations of the technology and software) of its action sequences. By the early twenty-first century the balance has shifted, and video games as an industry are threatening to outstrip the movie industry in terms of profits. The line between video games and movies has also become increasingly blurred thanks to digitization. In movies themselves, it is becoming increasingly difficult to differentiate between materially based and digitized effects, leading to the convergence of the different media. As the sophistication of video games and monitors increases, the games use many of the same effects as movies, especially in "cut scenes," in which the game is interrupted by purely video sequences. Convergence of visual media has been characteristic of both video games and the Web, as digitization places different media on the same platform. In another example of this convergence, the American Museum of the Moving Image hosts "Hot Circuits: A Video Arcade," an ongoing exhibit of video games as an example of the art of the "moving image."[2]

The connections between video games and visual culture go beyond film, however. There have been numerous gallery exhibits devoted to art inspired by video games, although there is some lag time that makes the established art world adopt video game motifs a decade or so after their release. Thus, much of the art shown in these exhibits is inspired by arcade-style games rather than the more recent three-dimensional role-playing games. A recent exhibit in Los Angeles, "I am 8-bit," at Gallery Nineteen Eighty Eight, featured art inspired by such games as Super Mario Brothers, The Legend of Zelda, Frogger, Donkey Kong, and Tetris.[3] These were all arcade-style games, showing the roughly twenty-year lag between when the games are released and when they become part of the vocabulary of artistic appropriation. Similarly, an exhibit of video-game-inspired art in Toronto in 2006, "Artists Crack the Game Code," was based on games such as Mario and PacMan. *PacMondrian,* for instance, was a video game console adapted to play a game using Mondrian's abstract shapes.[4] There are also book-length treatments of the subject, with numerous examples, such as Kelman's *Video Game Art,* Bittanti's *Gamescenes: Art in the Age of Videogames,* or personal stories of conversion to the digital, such as Walker's *Painting the Digital River: How an Artist Learned to Love the Computer.*[5] Faure Walker's images, such as *Restless,* combine photography, drawing, and digital distortion in ways that recall games like The Suffering (2004), which themselves create surreal images that are aimed at destabilizing perception of everyday objects.

Video games' closest connections to mainstream visual art, however, are in the areas of the Gothic and fantasy.[6] Gothic fiction was one of the first mass-market genres and, in its dubious early status as an art form, shares much in common with video games. There are few direct counterparts in the visual arts for the Gothic novel, although paintings such as Henry Fuseli's *The Nightmare* (1781) would be one possible example. Fuseli creates a horrific image to inspire fear in the viewer in a way that seems to prefigure Freud and theories of the unconscious. Many video games seek also to tap into people's fears and create nightmarish landscapes. The video game genre combines elements of science fiction and horror associated with such classic Gothic tales as *Frankenstein* or *Dracula.* A painting like Munch's *Vampire* (1894) is part of the same tradition as many video games that also draw upon the figure of the vampire, which entered popular entertainment in the nineteenth century.

Like Gothic novels, video games rely on an explosive mixture of fear and desire, often combining violence and sexuality. Thus Lara Croft from the Tomb Raider series (later portrayed by the sultry actress Angelina Jolie in the movie based on the game) became a virtual sex symbol while wielding various weapons, and in Bloodrayne the female vampires are eroticized, keeping with the tradition of Bram Stoker's *Dracula* (1899), in which vampire biting is a displaced form of oral sex. The conventions of the Gothic can be adapted to a wide variety of media, from painting to video. A very good example of "Gothicization" of a traditional story is American McGee Alice (2000) (fig. 27.2). This video game took Lewis Carroll's *Alice's Adventures in Wonderland* and gave it the feeling of a horror movie. The difference can be seen in the contrast between the 1865 version of Lewis Carroll's book with illustrations by John Tenniel. Tenniel's illustrations, while certainly nightmarish, are not horrific, even in the scenes with the Queen of Hearts ordering heads to be chopped off. McGee makes the narrative more threatening

Fig. 27.2 The Cheshire Cat and Alice from American McGee's Alice.

and violent by having Alice be a former inmate from a mental asylum who wields a knife. Even the Cheshire Cat in McGee artwork becomes threatening, its mouth connoting biting rather than smiling.

Games such as Sid Meier's Pirates draw directly from the work of N. C. Wyeth, whose illustrations shaped the perception of such genres as westerns and pirate movies. This influence has been acknowledged by Meier himself.[7] Wyeth's illustrations for *Treasure Island* parallel almost exactly some of the scenes in the Pirates video game. Wyeth's melodramatic and stylized images are well-suited to the video game format, which exaggerates expressions and emphasizes easily grasped scenes over visual complexity and uncertainty.

Video games' strongest claim for the status of a radically new art form comes in the realm of online gaming. Online games are both a new form of representation and an example (within limits) of interactivity in digital art. Games such as Everquest (1999) and World of Warcraft (2004) create alternative realities in which players create new identities and interact in three-dimensional environments. These environments have to be imaginative and detailed, and much of the success of the games depends on their ability to create both an engaging story line and an aesthetically pleasing environment. To be sure, this is mass art and thus depends on the broadest appeal rather than any claim to high-culture status. Nonetheless, some video game artists do aspire to the status of art in their games and online sites; for example, IntothePixel (http://www.intothepixel.com/) have juried competitions and exhibits to showcase their best efforts.

The crossover between video games and contemporary art can be seen most strongly in the intersection between video games, science fiction, and the Gothic. The art work of Viktor Koen is a case in point. His "Damsels in Armor" series is conceived by the artist as "monuments testifying to war's truly brutal cost."[8] His images are essentially cyborg women who fuse the organic and technological and find their counterparts in numerous male and female protagonists in first-person shooters. They are striking figures of women who seem to combine heavy armaments with a surreal serenity as they glide through vaguely suggested postapocalyptic landscapes. While Koen conceives of the figures as a critique of war, his decision to use the faces of glamorous-looking women from 1940s and 1950s advertising inadvertently reinforces the appeal of such images. The armor and weaponry connote power in video games, and the monumental scale of these figures that tower over the sketched-in landscape reinforce this effect. In the world of video games, more armament means more power, and Koen's images seem to subscribe to this line of reasoning.

Karl Sims creates imaginary alien species through art that parallels the kind of creations

found in Starcraft. In his installation *Galapagos,* he allowed users to guide the "evolution" of three-dimensional virtual organisms.[9] Like games such as Simlife, his art and installations apply Darwinian theories (as acknowledged in the reference to the Galapagos Islands) to imaginary creatures (fig. 27.3). This is essentially the same thought process that video game designers use when they try to invent alien life forms. Of course, these creations very often embody our own fears of technology and bioengineering, since they are often created to inspire fear in the viewer. In the nineteenth century Elihu Vedder created similar hybrid creatures in his images such as *The Dead Medusa* (1875) and *Sphinx of the Sea Shore* (1879); Vedder drew upon classical myth when he created fusions of the human and animal in his nightmarish images. While the creation of "hybrid" life forms was the stuff of nightmares in the nineteenth century, Sims's images approach them more as imaginary aesthetic objects.

Kenneth Snelson's images, on the other hand, tap into more utopian and futuristic visions, similar in many respects to video games like Sierra Games' Homeworld. In Homeworld the player can build futuristic spacecraft and then do battle with intergalactic adversaries.

Fig. 27.3 Karl Sims, image from Panspermia.

Images like *Star Landing* suggest futuristic constructions that seem to stretch off into infinity (fig. 27.4). They are an amalgam of sculpture and digital art that are meant to appeal to the same futuristic visions as some video games and science fiction films. Of course, Snelson's images are much more peaceful than the average video game, which usually involves blowing up interesting-looking architecture with futuristic firepower. Snelson's images and sculptures invite reverie and contemplation.

It is difficult to say definitively whether video games represent a new form of art or simply a new combination of different forms of representation.[10] There is a "realist" bias in video games (no matter how imaginatively they mimic as far as they can the normal rules of perspective and physics), which allies them with realism in painting.[11] The use of video clips in games, and the increasing crossover between games and movies, suggests that they could be viewed as simply another form of movies or perhaps television, albeit one in which the user has a little more control over perspective but not over content. In first-person games, users can control where they look, but what they see is predetermined by the games creators The difference from this

Fig. 27.4 Kenneth Snelson, image from Landing.

perspective is one of degree, not kind, but depends of course on one's definition of art. If emotion is used as a category, for instance, then there is little difference between video games and art if they are simply meant to elicit an emotional response from a viewer.[12]

The main problem facing an attempt to define video games as art lies in the form's dependence on the entertainment industry. Like mass-market movies, mass-market video games aim to give their users a brief escape from their lives, but not to change their perceptions of their lives or environment. Any art produced currently by the video game industry is a byproduct of this profit motive, and it is not clear that the games can disrupt the conventions of their genre enough to make their appeal enduring beyond their brief shelf life as the latest release for the market. This aspect of the industry is captured nicely in the subtitle of the book *Smartbomb: The Quest for Art, Entertainment, and Big Bucks in the Videogame Revolution.*[13] There is some tension between the terms *art, entertainment,* and *big bucks* in the video game industry, which, while it may aspire to artistic status, is still dominated by the need to maintain profits through mass marketing.

NOTES

1. J. Wilson, "Screenplay: Cinema/Videogames/Interfaces," *Convergence: The International Journal of Research into New Media Technologies* 11 (2004): 116.

2. http://www.movingimage.us/exhibitions/cs98.

3. http://www.iam8bit.net/.

4. I saw this exhibit in person, although I have viewed exhibits such as "I am 8bit" only online; it must be said that the experience of viewing the artwork online for me was more compelling than seeing an actual exhibit, perhaps reinforcing Jean Baudrillard's contention that simulacra now dominate the "real." For more on the Toronto exhibit, see Terence Dick, "Controller: Artists Crack the Game Code," *Border Crossings* 25, no. 2 (2006): 113.

5. See Nick Kelman, *Video Game Art* (Assouline, 2005); Matteo Bittanti and Domenico Quaranta, eds., *Gamescenes: Art in the Age of Videogames* (Johan & Levi Editore, 2006); James Faure Walker, *Painting the Digital River: How an Artist Learned to Love the Computer* (Prentice-Hall, 2006). For a philosophical approach to video-game aesthetics, see Aaron Smuts, "Are Video Games Art?" *Contemporary Aesthetics* 6 (2005): 1–12. An interesting argument drawing upon the work of Theodor Adorno, applying "neo-Baroque" theory to the claims of artistic status for video games, can be found in Graeme Kirkpatrick, "Between Art and Gameness: Critical Theory and Computer Game Aesthetics," *Thesis Eleven* 89 (2007): 74–93.

6. I use the term *Gothic* here to refer especially to the literary genre inaugurated by Horace Walpole and *The Castle of Otranto* (1764). While the literary Gothic in its origins has much in common with Gothic Revival and Neo-Gothicism, I employ it here to denote narratives with a strong emphasis on horror, rather than as an architectural style that drew upon medieval models.

7. Kelman, *Video Game Art,* 125.

8. http://www.viktorkoen.com/exhibitions/d/F_d.html.

9. http://www.genarts.com/galapagos/index.html.

10. Another problem lies, of course, in defining the term *game* and ridding it of its pejorative connotations; see Thomas Malaby, "Beyond Play: A New Approach to Games," *Games and Culture* 2, no. 2: 95–113. For another concept of "performance" as overcoming the divide between games and art, see N. Wardrip-Fruin and P. Harrigan, eds., *First Person: New Media as Story, Performance and Game* (MIT Press, 2004).

11. For a thoughtful consideration of the dynamic between "realism" and fantasy in video games, see Jesper Juul, *Half-Real: Video Games between Real Rules and Fictional Worlds* (MIT Press, 2005).

12. See, for instance, the argument that "emotion" is the hallmark of an aesthetic experience, and thus there is no difference between painting, film, and video games if one uses "emotion" as a heuristic; in Jonathan Frome, "Representation, Reality and Emotions across Media, *Film Studies* 8 (2006): 12–25.

13. Heather Chaplin and Aaron Ruby, *Smartbomb: The Quest for Art, Entertainment, and Big Bucks in the Videogame Revolution* (Algonquin Books, 2005).

WHAT YOU SEE IS WHAT YOU GET, OR REALITY IS WHAT YOU TAKE FROM IT

Chris Kaczmarek

In the previous chapter, there was an overview of various landmark games and historical moments that helped to define the development of visual styles in the video game industry. This chapter will build on that base by focusing on the different visual modes of representation commonly used in video games, and on the various ways some contemporary artists have utilized this visual language in a range of different work.[1]

POINTS OF VIEW

The goal of a video game, which contextualizes the strategic concerns of the gamer, often dictates the visual perspective of the game. This perspective has the ability to influence the gamer's type and level of emotional involvement. When speaking of perspective in the context of video games, the reference is complex: it includes the traditional ideas of visual perspective but also extends to the perspective of the gamer within the game.

While early video games were restricted by the available technology to fixed backgrounds with a limited number of moving elements, modern gaming technology has allowed for an array of gaming perspectives, from the first-person shooter (FPS) to the galaxy-spanning overhead view of various space strategy games.[2] The many different currently available perspectives, or points of view, used in most popular games have expanded the visual experiences available to the gamer, and each creates a significantly different visual experience. A precedent for almost every point of view within the gamic space can be found in the history of images, and with each point of view comes its own culturally established meanings. Before one even begins to control the actions within a gamic space, the gamic space itself creates a controlled environment through visually imposed methods of interaction and game play.

As there are many examples of different variations and levels of available points of view, which could easily be subdivided into almost as many specific categories, this chapter will divide these points of view into three main perspectives: the overall view, the third person, and the first person. There are certainly cases in which the overall and third-person points of view may be blended, but it is useful to separate and define them for the purpose of attributing specific characteristics to each. The overall view might be considered the spectator's view of the gaming environment. This view allows for a comprehensive view of the gaming field. The overall view is distinctive from the third-person point of view, which consists of a perspective that is directly behind the gamer's avatar on the screen (whether this

avatar is a figure, vehicle, or other object intended to represent the gamer in the gamic space). Perhaps the most important defining characteristic separating the overall view and third person is that in overall view game play, the gamer is not directly represented in the game by a single avatar but rather is in command and control of multiple avatars in the gamic space.

The overall point of view is probably most often identified with the gaming genre that is labeled as real-time strategy (RTS). The RTS game is defined by a gaming experience that is not based upon an individual avatar for the gamer to control, but is a field of play in which the gamer controls whole teams or armies on different sides of a conflict. For this gamic experience the player is given an almost omniscient overhead view. This view reinforces the overarching powers of the gamer, as it allows the gamer to be aware of the entirety of the playing field all at once. While engaged in this perspective, the gamers are not involved in the minutiae of an individual firefight or the driving of a specific vehicle, they become the commander of armies. Perhaps the best example of this type is the Command and Conquer series of games, a military strategy game that has spawned many sequels and expansion packs. The vehicles (planes, tanks, boats, etc.), the people, and the landscape are guided by the gamer's will within the boundaries of the game, and the scope of the gamer's influence in the gamic space is reinforced by the scope of the available view.

In games that employ the overall point of view, a gamer does not "lose a life" as they do in most other perspectives. In these virtual battles many may die, but the gamer is not dead until all units have been exterminated from the battlefield. Important here is that the omniscient view from above molds the experience and the interaction of the gamer with the game. The action is not controlled, it is rather directed. In the scenarios presented, the gamic environment sanctifies the directed action that may result in the deaths of virtual thousands without any direct emotional engagement from the gamer as to the loss of units.

In the third-person perspective, the gamer is represented in the gamic space by a single avatar that is generally viewed from behind. Perhaps the most popular example of the over-the-shoulder third-person view is that of the Tomb Raider series of games, in which the gamer is represented by the Lara Croft avatar. While this literal third-person perspective is common, the idea can also be applied to many popular racing games and other combat games in which a vehicle (such as a tank or plane) is used. In this perspective the gamer is represented in the gamic space as a character, which, like the armies often used in the overhead view, is directed by the gamer. Or at this point, since there is individual representation, it might be said that the character is played rather than directed by the gamer. Since the gamer is represented as an individual in the third-person perspective, and not the master of a large faceless group, there is a higher level of emotional investment in the representation of the gamer in the space.

One distinct aspect that separates third-person games within the genre itself is that games that are third person and not multiplayer-orientated (such as Tomb Raider) often have fewer (or no) customizable aspects of the character for the player, while those that are designed for networked interaction often have extensive levels of customizable options for the gamer. Some massive multiplayer online role-playing games (MMORPG), such as World of Warcraft, a fantasy-based game that is played online by thousands, have specific

items that may be worn by the avatar only as they have progressed in levels of experience or have accumulated a certain level of what serves as currency in the gamic environment. These representations of stylistic distinction oddly reflect the real-world indicators of class and wealth typically denoted by clothing and material goods. Visual representations of status such as these are mostly only valued in games that involve other live players. The third-person viewpoint allows the gamer to inhabit a fantasy character and play the role of that character in a virtual space, while at the same time being both an exhibitionist and a voyeur of his or her own virtual existence.

Even though the third-person point of view allows for high levels of identification, perhaps the first-person perspective provides the most direct involvement with the gamic space. This perspective is best associated with the first-person shooter style of game, in which the gaming view actually directly represents the view of the gamic space from the eyes of the player as an individual inhabiting the space.[3] This point of view allows for a full 360-degree fluid exploration of the gamic space by the viewer without any forced visual direction or path to follow.[4] In this view the gamer is neither the director nor the player but actually inhabits the game on a personal (first-person) level. The FPS perspective actually puts you visually "in the game" as a participant and not a spectator, allowing for perhaps the most visceral level of engagement. The gamer is no longer a director of actions or a controller of a proxy figure within the gamic space but, through a specific perspective, actually an occupant of the space.

Perhaps the most popular current example of the use of this perspective would be the series of Halo games.[5] Halo is a fast-paced science-fiction-based story that allows the gamer to play the role of the Master Chief, an enhanced soldier with the capability to wield impressive firepower. The game is geared toward minimal strategy and maximum engagement. This extreme visceral/visual connection to the gamic space on the ground level differs greatly from the overhead perspective of an RTS, in which time is used to create strategy and direction, or the third-person view, in which the gamer is playing the character or customizing the character to reflect his or her virtual personality. In the FPS the focus is on the individual and the survival of the individual in the space, a narrow focus that is reinforced by the narrow field of view available through the virtual eyes of the gamer.

ART AND THE VIDEO GAME

There is still some discussion about the status of video games as art, a discussion that echoes those of earlier debates concerning photographs and film, while the main argument against video games as art is the commercial nature of the industry. Mark J. P. Wolf brings up the point that "video games also differed from interactive art because of their status as games, which meant that there was usually some motive or goal toward which the player's interaction was directed, whereas in art, the experience itself was the goal."[6] Even if the artistic status of video games themselves is still being debated, there is no denying that the ideas and visuals available through gaming environments have had a significant influence on the arts, an influence that is already evident.

Some defining works of the genre that might be labeled video game art are made far from the conceptual, financial, and artistic concerns of the gallery environment and are available for free online viewing. One such work, a video called *Launch Line* by TheGhost,

represents a form of personal expression that was acted and recorded from within a gaming environment.[7] This video, which can be found on the Web site YouTube and at the time of writing has been viewed almost 45,000 times, consists of a number of stupendous stunts performed within the gaming environment available through the FPS Halo. For this video, the game of Halo is used not as a realm for combat in the manner it was originally designed for, but as a virtual performance space, in which a player uses the game in a nongaming way to create and record an expressive action. The consumer has become creative producer, appropriating the gamic space to use as a tool for expression.

In *Launch Line,* TheGhost launches various military vehicles through the action of igniting stacks of grenades piled beneath them. While this may sound fairly ridiculous at face value, the resulting video can be appreciated by anyone who takes the time to watch it. The experience of witnessing an individual detonating a pile of grenades under a vehicle and watching that vehicle (miraculously unhurt by the explosion) hurtling and spinning through the air in an arc that carries it a virtual half-mile up and across a field to have it land within a hole that is almost exactly the size of the vehicle itself is stunning. It has been established that a work of art can be an event; this is now called performance art. In *Launch Line,* an action in the virtual gamic space becomes virtual performance art.

While *Launch Line* is able to captivate and amaze the viewer with a performance recorded in the plausible virtual world with incredible yet believable physics, many fine artists who are using video games in their work are actively trying to compromise and reveal the artificiality of the gamic space. Instead of an immersive experience that draws the viewer into the virtual world of the game, often the work of gallery artists using gaming as inspiration take the viewer out of the familiar gaming experience, whether in a jarring, disconcerting way like Tom Betts's *QQQ,* or in a calm and directly visual way like Corey Arcangel's *Super Mario Clouds.* Others, such as Jon Haddock, use the visual language of video games to create wholly original images that gain content and meaning through their references to the virtual world.

Corey Arcangel creates work involving digital media whose imagery and content often includes video games. In the work *Super Mario Clouds,* Arcangel has replaced the 6502 microprocessor in a super NES cartridge with one that has been custom-programmed by the artist so that the only visuals available on the screen are the blue background and the slowly scrolling iconic white clouds from a Super Mario Brothers video game (fig. 28.1).[8] In contrast to the appropriated virtual space used in *Launch Line,* for *Super Mario Clouds,* Arcangel hacked into the chip on the cartridge and modified it so that he was not only appropriating the images from a popularly recognized game, but also appropriating the gaming console and physically modifying the cartridge itself. It would have not been extremely challenging to simply create the image that is *Super Mario Clouds,* but the action of direct hacking as opposed to emulating or appropriating carries a different content. It is the action of hacking the chip and playing it on a console in the gallery that speaks.[9] The video is just secondary, evidence of this action. In *Super Mario Clouds,* Arcangel has removed all aspects of the game that might make it a game. Through his physical interference the game is no longer an interactive experience, it is purely a passive visual experience. This work emphasizes the abstract and iconic nature of video game visuals, but

Fig. 28.1 Cory Arcangel, *Super Mario Clouds V2K3,* handmade hacked Super Mario cartridge and game player, dimensions variable, edition of 5, 2002.

yet *Super Mario Clouds* is significantly hardware appropriation and modification, not direct visual appropriation.

Another artist who is pushing further into the realm of revealing the artificiality of the gamic space through visual abstraction is Tom Betts. In the work *QQQ,* Betts has created an environment in the gallery in which the viewer can see the point of view of different gamers from around the world who are playing the game Quake III on a server. In the projection available to the gallery viewer, the gamic space has been highly modified to become an almost completely abstract image of motion, color, and form:

> By manipulating Quake's graphics engine, Betts breaks open and dynamises the hermetically perceived surfaces of the game architecture, transforming them into free moving graphical elements and flowing patches of colour that are constantly joining together to create new abstract patterns.[10]

The view of the gamers actually playing the game on their computer is not modified, but the view available to the gallery visitors as they look through the virtual eyes of the live gamers is almost unrecognizable. The gallery viewer can switch between the various live gamers and can change the view between looking over the shoulder of the gamer and looking out from the front (as in an FPS perspective). While the gallery viewer has the ability to view the gamic space from multiple viewpoints, he or she is not able to actually have any direct influence in the gamic space itself. This juxtaposition of drastically different visual experiences and interaction with the gamic space between the gallery viewer and the remote player brings to the foreground the complex relationship that has evolved between viewership, interaction, and virtual spaces.

Jon Haddock takes a different track in the work *Screenshots,* in which instead of deconstructing the gamic environment the artist reconstructs it. In *Screenshots,* Haddock uses the isometric view that has been commonly used in many third-person omniscient video games such as the various *Sims* iterations.[11] Using what has become an iconic perspective and digital style, Haddock recreates images of climatic scenes from both fictional and historical events. These scenes cover a wide range of emotions and subjects, from the beating of Rodney King in Los Angeles or the abduction of Elian Gonzales by federal agents (fig. 28.2), to the picnic scene in the movie *The Sound of Music.* An interesting point of this work is that Haddock defines "the real pieces" as the ones available to the public on the Web site. If you go to a gallery to view this work the images will be printed and framed. But according to the artist, the "originals" were created in 880X600 at 72 dpi format with the intent to be viewed on the screen (thus the name: *Screenshots*).

Fig. 28.2 Jon Haddock, *The Screenshots (Elian),* 2000.

While in the images of *Screenshots* there is an obvious and direct reference to video games in terms of perspective, intended presentation, and image quality, it is notable that the images that make up this work are entirely created by the artist. Unlike *Launch Line,* in which the gamic space was appropriated for performance, *Super Mario Clouds,* in which the hardware was physically hacked, or *QQQ,* in which the software of the game engine was modified to abstraction, this work does not take any physical or digital root from an actual video game. The images created are purely referential. In this way *Screenshots* defines itself not as a work of art derived directly from video games, but as one influenced by and drawn from the historic visual culture of video games.

TO THE FUTURE: NATURALISM (OR IS IT ABSTRACTION?)

The chronicle of advancements in gaming technology has been a record of the rush toward an attempt at greater realism. Graphics capabilities have been the defining line between each generation of console gaming, and with higher graphics capabilities came a greater ability to create a visual space that mimicked the "real"

world. As we have reached the current generation of realism (which is still far from realism, and perhaps even more unsettling as it gets closer and closer to it[12]) some platform developers have been reconsidering the pursuit of realism and have begun reexamining what exactly makes good game play. In response to this consideration perhaps is the recent Wii gaming console from Nintendo, which goes strongly against the convention of platform evolution by offering comparatively reduced graphics capability and a drastically different physical interface for interaction. As we realize that the pursuit of "realism" brings us only farther and farther away from the real,[13] the mining of the abstract possibilities of representation as a choice for the gamic environment may likely open up higher levels of complexity and engagement in video game play.

NOTES

1. There is a growing literature on video games and technology. Some key works referenced during the writing of this chapter are: Mark J. P. Wolf, *The Medium of the Video Game* (University of Texas Press, 2001); Diane Carr, David Buckingham, Andrew Burn, and Gareth Schott, *Computer Games: Text, Narrative and Play* (Polity Press, 2006); Noah Wardrip-Fruin and Pat Harrigan, eds., *First Person: New Media as Story, Performance, and Game* (MIT Press, 2004).

2. There still are games being made with the earlier conventions that are generally defined as "arcade" style games. This name references their visual style, which mimics the early graphics of a time when games were mainly played in arcades, instead of on personal computers, consoles, or portable devices.

3. Alexander R. Galloway, *Gaming: Essays on Algorithmic Culture* (University of Minnesota Press, 2006), chap. 2.

4. This is made extremely odd by the fact that in most FPS games the gamer does not inhabit a body (there are no feet when you look down). From the perspective available to the gamer on the video screen, all that can be seen of them is the ubiquitous floating hand holding a weapon, even when looking directly down.

5. The first person perspective is used in *Halo* throughout the game, except when the player boards one of the available vehicles, at which point the perspective of the gamer pulls back to become third-person. Also, there are various cinematic cut scenes that further the plot and allow for transitions between environments where the gamer is represented in the third-person point of view.

6 Mark J. P. Wolf and Bernard Perron, eds., *The Video Game Theory Reader* (Routledge, 2003), 49.

7. TheGhost, *Launch Line* (YouTube, Date of authorship unknown), http://www.youtube.com/watch?v=QwR2EicxuAc. In addition to being available online, *Launch Line* was also part of the "youtube showreel" in the 2007 London exhibit *Zero Gamer;* the catalog can be downloaded from http://www.http.uk.net/zerogamer/zero_game_catalogue.pdf.

8. Corey Arcangel, *Super Mario Clouds—2005 Rewrite,* beigerecords.com, date of authorship unknown, http://beigerecords.com/cory/Things_I_Made_in_2003/mario_clouds_2005.html.

9. Interesting here is that Arcangel has posted exactly how you too can make a Super Mario Clouds cartridge with the modified code and step-by-step instructions available to all online. This amplifies the significance of the hacking action.

10. Katrin Mundt, *QQQ, Modified "Quake" Game and Video Installation,* netzspannung.org, 2004, http://netzspannung.org/cat/servlet/CatServlet?cmd=netzkollektor&subCommand=showEntry&lang=en&entryId=138669.

11. Jon Haddock, *The Screenshots,* 2000, http://whitelead.com/jrh/screenshots/.

12. Mathew Williamson observes: "the more human something appears, the more faults we find in

the depiction and therefore less empathetic we feel. When something is more stylized, however, our minds fill in the blanks, allowing the human qualities to shine through." See "Out of the Valley: Great Abstractions in Video Games" *Gamer's Quarter* 7 (2006): 16, http://www.gamersquarter.com/issues/The GamersQuarter7.zip.

13. "…these games aren't like wine; as they age they only become worse. Once they lose the power to awe us with their sheer muscle, we can see them for what they are.…Throw the original *Splinter Cell* into the Xbox, and what we see isn't Sam Fisher; it's a bunch of semi-organic polygons that we know are intended to be him. Then throw in the original Super Mario Brothers for the NES, and Mario is still Mario—not because he once looked realistic, but because he was always an abstract representation." See Williamson, "Out of the Valley."

LIST OF CONTRIBUTORS

Nancy Anderson is assistant professor of visual studies at the State University of New York Buffalo. Her research focuses on scientific visualizing technologies emerging out of World War II, and the imaging and imagining of atoms and molecules. She is completing a book on this topic, entitled *The Scale of the Event: Science-Art-Image, 1945–1970*.

Susan Benforado Bakewell is adjunct assistant professor of art history at Southern Methodist University in Dallas, Texas. She co-edited *Voices in New Mexico Art* (1996) for the New Mexico Museum in Santa Fe.

Temma Balducci teaches in the Department of Art at Arkansas State University. She has published on the nineteenth-century artist Mary Ellen Best and is a co-editor and contributor to the forthcoming volume, *Interior Portraiture and Masculine Identity in France, 1789–1914* (Ashgate).

Fae Brauer is research professor for visual art theory, University of East London, and senior lecturer, art history, the University of New South Wales. Her books are *Art, Sex and Eugenics, Corpus Delecti; The Art of Evolution: Darwin, Darwinisms and Visual Culture;* and *Modern Art's Centre: The Paris Salons and the French "Civilising Mission."*

Martin Danahay is professor of English and director of the Center for Digital Humanities at Brock University in Canada. He publishes at the intersection of visual and literary culture in two main areas, the Victorian period and the present.

Brenda DeMartini-Squires is a member of the English Department at Dutchess Community College. She is a contributing editor and book reviewer for *Southern Indiana Review*. Her work has appeared in journals such as *The Sun*, *Confrontation*, and *The Missouri Review*.

Matt Ferranto is assistant professor of visual arts at Westchester Community College in New York. He is also director of the college's Fine Arts Gallery and serves as managing editor of *Design and Culture* (Berg).

Michael J. Golec teaches in the Department of Art History, Theory & Criticism, School of the Art Institute of Chicago. He is the author of *Brillo Box Archive: Aesthetics, Design, and Art* (Dartmouth College Press, 2008).

Elizabeth Guffey is professor of art history at Purchase College, State University of New York. She is the author of *Retro: The Culture of Revival* (Reaktion, 2006) and founding editor and editor-in-chief of *Design and Culture.*

Chris Kaczmarek is an international multimedia artist based in New York and the recipient of several awards, including a grant from the New York State Council on the Arts, and a Westchester Arts Council Fellowship. He is director of faculty and student affairs and an adjunct lecturer in the School of Art + Design, Purchase College.

Jane Kromm is the Kempner Distinguished Professor of Art History at Purchase College, State University of New York. She is the author of *The Art of Frenzy: Public Madness in the Visual Culture of Europe, 1500–1850* (Continuum, 2002).

Kimberly Masteller is the Jeanne McCray Beals Curator of South and Southeast Asian Art at the Nelson-Atkins Museum in Kansas City, Missouri. She co-edited *From Mind, Heart and Hand: Persian, Turkish, and Indian Drawings from the Stuart Cary Welch Collection* (2005).

Heather McPherson teaches in the Department of Art and Art History, University of Alabama at Birmingham. She is the author of *The Modern Portrait in Nineteenth-Century France* (Cambridge, 2001).

Amy F. Ogata is associate professor at the Bard Graduate Center for Studies in the Decorative Arts, Design, and Culture. She is the author of *Art Nouveau and the Social Vision of Modern Living: Belgian Artists in a European Context* (Cambridge, 2001).

Matthew Potter is lecturer in art history at the University of Leicester. His research interests are in the fields of Anglo-German cultural exchange, and art and empire in the period between 1850 and 1945.

Nada Shabout is associate professor of art history and director of the Contemporary Arab and Muslim Cultural Studies Institute (CAMCSI) at the University of North Texas. She is the author of *Modern Arab Art: Formation of Arab Aesthetics* (University of Florida, 2007) and co-editor of *New Vision: Arab Art in the 21st Century* (Transglobe, 2009).

Elana Shapira is lecturer in the Art History Department at Vienna University and in the Design History and Theory Department at the University of Applied Arts, Vienna. Her recent essay is "Tailored Authorship: Adolf Loos and the Ethos of Men's Fashion," in *Leben-Mit-Loos* (2008).

M. Kathryn Shields teaches in the Department of Art at Guildford College. Her publications include "Stories These Masks Could Tell: Literary References in the Photographs of Ralph Eugene Meatyard," *Mosaic* (December 2004), and she is coauthor of an art appreciation textbook (Thames & Hudson, forthcoming).

Joy Sperling is associate professor at Denison University. She has published widely on art history and visual culture. Her most recent work is a book on Fred Harvey's Santa Fe Detours, a case study in identity, visual culture, and tourism.

Jelena Stojanović is an art historian who teaches and writes about postwar art and visual culture. Recent publications include *The Accursed Shore: Contemporary Art and the Museum* (Beograd, MSU, 2009) and "*Internationaleries*: Collectivism, the Grotesque and Cold War Functionalism 1948–1969," in *Collectivism after Modernism* (Minnesota, 2007).

Richard Taws is assistant professor in the Department of Art History and Communication Studies at McGill University. His recent publications include articles on French revolutionary visual culture in *Res: Anthropology and Aesthetics* and *Oxford Art Journal*.

Sarah Warren teaches art history at Purchase College, State University of New York. Her article, "Crafting Nation: The Challenge to Russian Folk Art in 1913," appears in the November 2009 issue of *Modernism/Modernity*.

Helen Weston is emeritus professor in the Art History Department, University College, London. She is co-editor of *David's "Death of Marat."* She works on art of the French Revolution, representations of slavery, and art of the magic lantern; a recent publication is "Failure of Imitation," in *Articulate Objects* (ed. A. Satz and J. Wood, 2009).

Marcus Wood is professor of English and American studies at the University of Sussex. He is the author of *Blind Memory: Visual Representations of Slavery in England and America, 1780–1865* (Manchester, 2000), *Slavery, Empathy, and Pornography* (Oxford, 2003), and *The Horrible Gift of Freedom* (forthcoming).

ILLUSTRATIONS

Fig. 3.1 Jules Grandjouan, *La révolution,* 1906. Art in the Public Domain. (42)

Fig. 3.2 János Tábor, *Vörös Katonák Elöre,* 1919. Hoover Institute, Stanford University. Art in the Public Domain. (48)

Fig. 3.3 Bogdan Nowakowski, *Patrzcie Do-kad Prowadza narod' Socjalisci!* Hoover Institute, Stanford University. Art in the Public Domain. (49)

Fig. 3.4 Anonymous, I.W.W. Is Coming! Labor Archives and Research Center, San Francisco State University. Art in the Public Domain. (50)

Fig. 4.1 Isidore Isou, *Traité de bave et d'éternité,* 1951. Film still. Courtesy Re-voir Video. (58)

Fig. 4.2 Marc-Gilbert Guillaumin (Marc'O), *Ion,* 1952. Magazine cover, recto. Courtesy of the artist. (60)

Fig. 4.3 Marc-Gilbert Guillaumin (Marc'O), *Ion,* 1952. Magazine cover, verso. Courtesy of the artist. (60)

Fig. 4.4 Guy Ernst Debord, *L'Anti concept,* 1952. Poster for Gil J. Wolman's film. Courtesy of Charlotte Wolman. (61)

Fig. 5.1 John Kay, *Dr. John Hope and His Gardener,* 1796. Collection: author. (75)

Fig. 5.2 Georg Ehret, *Linnaei Methodus Plantarum Sexualis,* 1736. Natural History Museum, London. Photo: Museum. (78)

Fig. 5.3 Georg Ehret, *Plantaes et Papiliones Rariores,* pl. VIII, 1748. The Botany Libraries, Harvard University. Photo: Library. (79)

Fig. 5.4 Peter Henderson, *Winged Passion Flower,* 1802; from Robert John Thornton, *A New Illustration of the Sexual System of Linnaeus,* 1797–1807. Beinecke Rare Book and Manuscript Library, Yale University. Photo: Library. (83)

Fig. 5.5 Giovanni Battista Piranesi, *Diverse Manners of Ornamenting Chimneys and All Other Parts of Houses…*pl. 2, 1769. © British Library (T44F7). All Rights Reserved. (85)

Fig. 6.1 Petrus Camper, *On the Points of Similarity between the Human Species,* 1778, pen and ink. Bibliothèque interuniversitaire de Médecine, Paris. Photo: Library. (90)

Fig. 6.2 Christian von Mechel, after Johann Caspar Lavater, *Twelve Stages in the Sequence from the Head of a "Primitive" Man Modeled on a Frog to the Head of Apollo Belvedere,* 1797, colored etching. Courtesy of the Wellcome Library. Photo: Library. (92, 93)

Fig. 6.3 Edmond Desbonnet (attribution), *Le modèle athlete Adrian Deriaz,* 1906, *La Culture Physique.* Courtesy of The Wellcome Library. Photo: Library. (97)

Fig 6.4 Transparent Man, photographed at the opening ceremony of the *Wonder of Life* exhibition, Berlin, March 1935. BG Papers. Courtesy of the Dittrick Medical History Center, Case Western Reserve University. Photo: Center. (101)

Fig. 7.1 Paul Régnard, photograph of Augustine, n.d., *Attitudes passionelles: Ecstasy, Iconographie photographique de la Salepêtrière,* v. 2. Bibliothèque nationale de France. Photo: BnF. (109)

Fig. 7.2 Paul Régnard, photograph of Augustine, n.d., *Attitudes passionelles: Amorous Supplication, Iconographe photographique de la Salepêtrière,* v. 2. Bibliothèque nationale de France. Photo: BnF. (110)

Fig. 7.3 Paul Richer, *Epileptoid Period of the Grand Hysterical Attack,* Jean-Martin Charcot

and Paul Régnard, *Les démoniaques dans l'art*, 1887, p. 92. (110)

Fig. 7.4 Alphonse Bertillon, Classification of the Ear, *Identification anthropométrique*, 1893, pl. 56. (112)

Fig. 8.1 A. Barrington Brown, *Francis Crick and James Watson with the Double Helix Model of DNA*, 1953. © A. Barrington Brown/ Photo Researchers, Inc. (124)

Fig. 8.2 W. H. Wainwright, *Fuller Geodesic Dome* (Radome designed by Geometrics, Inc., Cambridge, MA). In Caspar and Klug, "Physical Principles in the Construction of Regular Viruses," *Cold Spring Harbor Symposium on Quantitative Biology*, 27: 11 (1962), fig. 5. Courtesy W. H. Wainwright. (125)

Fig. 8.3 *Asymmetrical Units Arrayed in an Equilateral-Triangular Plant Net*. In Caspar and Klug, "Physcial Principles in the Construction of Regular Viruses," *Cold Spring Harbor Symposium on Quantitative Biology*, 27:11 (1962), figure 6. © Cold Spring Harbor Laboratory Press. (126)

Fig. 8.4 *The Folding of the Plan Net into a Closed Surface*. In Caspar and Klug, "Physical Principles in the Construction of Regular Viruses," *Cold Spring Harbor Symposium on Quantitative Biology* 27:12 (1962), figure 7 (a,b,c). © Cold Spring Harbor Laboratory Press. (127)

Fig. 9.1 Eugène Guillaume, *Theseus Discovering His Father's Sword beneath a Rock*, 1845. Photo: Bridgeman Art Library. (138)

Fig. 9.2 Gustave Courbet, *Wrestlers*, 1853. Széppmüvésti Muzeum, Budapest. Photo: Museum. (140)

Fig. 9.3 Jean Béraud, *Morris Column*, about 1879–1880. The Walters Art Museum, Baltimore. Photo: Museum. (141)

Fig. 9.4 Edouard Manet, *A Bar at the Folies-Bergère*, 1881–1882. The Samuel Courtauld Trust, Courtauld Gallery, London. Photo: Gallery. (142)

Fig. 10.1 Honoré Daumier, title page, Louis Huart, *Physiologie du flâneur*, 1841. Rare Book and Manuscript Library, Columbia University. Photo: Library. (149)

Fig. 10.2 Georges Seurat, *Sketchbook I*, 1877–1878. Yale University Art Gallery, Anonymous lender. Photo: Gallery, (150)

Fig. 10.3 Georges Seurat, *Woman Raising her Parasol (Une Promeneuse)*, about 1884–1886. Kupferstichkabinett, Kunstmuseum Basel. Photo: Kunstmuseum Basel, Martin P. Bühler. (154)

Fig. 11.1 Otto Wagner, Bathroom, 1898. Published in *Ver Sacrum* II, 1900, p. 295. (159)

Fig. 11.2 Oskar Kokoschka, *The Girl Li and I*, 1908, lithograph. © 2008 Fondation Oskar Kokoschka/Artists Rights Society (ARS), New York/Prolitteris, Zurich. (160)

Fig. 11.3 Egon Schiele, *Eros*, 1911. Galerie St. Etienne. Photo: Galerie. (162)

Fig. 11.4 Adolf Loos. Goldman and Salatsch House, Vienna, 1911. (164)

Fig. 12.1 Dwarf growth of rickets, brother, photograph, reproduced from *The Treasury of Human Inheritance*, v. 1, pl. NM, illustration from Karl Pearson's Cavendish Lecture, 1912. Courtesy of The Wellcome Library. (172)

Fig. 12.2 Dwarf growth of rickets, sister, photograph, reproduced from *The Treasury of Human Inheritance*, v. 1, pl. NN, illustration from Karl Pearson's Cavendish Lecture, 1912. Courtesy of The Wellcome Library. (172)

Fig. 12.3 Georges Gilles de la Tourette, Hysteria Bodymaps: pseudo-ovarian and hysterogenic

zones (left); hemianaesthetic and hemihyperaesthesic zones (right). From Gilles de la Tourette, *Traité clinique et thérapeutique de l'hystérie d'après l'enseignement de la Salpêtrière* (Librairie Plon, 1891), v. 1, p. 20, fig. 19. Courtesy of The Wellcome Library. (174)

Fig. 12.4 Hysterical man during a grand attack: arc de cercle, emprosthotonos position, Jean-Martin Charcot, *Leçons du Mardi à la Salpêtrière: Policliniques, 1888–89, notes de cours de MM. Blin, Charcot [fils] et Colin,* II, 1889, p. 427. Courtesy of The Wellcome Library. (176)

Fig. 12.5 Tattoos on the right arm of a French thief expelled from France (left) and tattoos on the body of a French sailor and deserter (right); Henry Havelock Ellis, *The Criminal* (Walter Scott Limited, 1895), pl. viii. Courtesy of The Wellcome Library. (178)

Fig. 12.6 Six female arms showing different tattoo designs and two circular views of bird tattoos. "The Gentle Art of Tattooing: The Fashionable Craze of Today," *The Tatler* (25 November 1903), p. 311. Courtesy of The Wellcome Library. (180)

Fig. 13.1 Eugène Atget, *Passage Montesquieu Cloître St. Honoré,* 1906. Courtesy of George Eastman House, International Museum of Photography and Film. Photo: Eastman House. (191)

Fig. 13.2 Philibert Louis Debucourt, *Le Passage des Panoramas à Paris,* 1907. Musée de la Ville de Paris, Musée Carnavalet, Paris. Photo: Erich Lessing/Art Resource, NY. (196)

Fig. 13.3 Eugène Atget, *Passage du Grand Cerf,* 1907. Bibliothèque nationale de France. Photo: BnF. (197)

Fig. 14.1 North Transept, Crystal Palace, the Great Exhibition, London, 1851, from

Dickinson's Comprehensive Pictures of the Great Exhibition of 1851 (London: Dickinson Brothers, 1854). Photo Courtesy of Smithsonian Institution Libraries. (201)

Fig. 14.2 Alphonse Liébert, view of the Eiffel Tower and fair grounds from a balloon, Exposition Universelle, Paris, 1889. Library of Congress, Prints & Photographs Division [LC-USZ62–94671]. (203)

Fig. 14.3 Street in Cairo, World's Columbian Exposition, Chicago, 1893; Hubert Howe Bancroft, *The Book of the Fair* (Chicago, 1893), p. 858. Bard Graduate Center Library. Photo: Library. (207)

Fig. 15.1 The Prado, Madrid. Photo: Owen F. Lipsett. (212)

Fig. 15.2 The Prado, Madrid, interior view. Photo: Owen F. Lipsett. (213)

Fig. 15.3 The Guggenheim, Bilbao. Photo: Owen F. Lipsett. (214)

Fig. 15.4 The Guggenheim, Bilbao, with Jeff Koons's *Puppy.* Photo: Owen F. Lipsett. (215)

Fig. 16.1 Design Research, Cambridge, MA. Photo: Ezra Stoller. © Esto. (225)

Fig. 17.1 Emil Nolde, *Masks,* 1911. The Nelson-Atkins Museum of Art, Kansas City, MO. Photo: Museum. (246)

Fig. 17.2 Wilhelm Liebl, *Peasants in Conversation/The Village Politicians,* 1877. Museum Oskar Reinhart am Stadtgarten, Winterthur, Switzerland. Photo: Museum. (247)

Fig. 17.3 Lovis Corinth, *Harem,* 1904. Hessisches Landesmuseum, Darmstadt. Photo: Museum. (249)

Fig. 17.4 Lovis Corinth, *Salomé,* 1900. Museum der bildenden Künste zu Leipzig. Photo: Bildarchiv Preussicher Kulturbesitz, Berlin. (250)

SELECTED BIBLIOGRAPHY

Alpers, S. *The Art of Describing*. Chicago: University of Chicago Press, 1983.

Anderson, P. *The Printed Image and the Transformation of Popular Culture 1790–1860*. Oxford: Oxford University Press, 1991.

Baker, K. *Inventing the French Revolution: Essays on French Political Culture in the Eighteenth Century*. Cambridge: Cambridge University Press, 1990.

Bamiyan: Challenge to World Culture. New Delhi: Bhavana Books, 2002.

Barrington, T., and T. Flynn, eds. *Colonialism and the Object: Empire, Material Culture and the Museum*. London: Routledge, 1998.

Baudelaire, C. *The Painter of Modern Life and Other Essays*. London: Phaidon, 1964.

Baxandall, M. *Painting and Experience in Fifteenth-Century Italy*. Oxford: Oxford University Press, 1972.

Benjamin, W. *The Arcades Project*, trans. H. Elland and K. McLaughlin. Cambridge, MA: Belknap Press of Harvard University Press, 1999.

Benjamin, W. *Charles Baudelaire: A Lyric Poet in the Era of High Capitalism*, trans. H. Zion. London: NLB (New Left Books), 1973.

Berman, R. *Enlightenment or Empire: Colonial Discourse in German Culture*. Lincoln: University of Nebraska Press, 1998.

Bhabha, H. *The Location of Culture*. London: Routledge, 1994.

Bindman, D. *Ape to Apollo: Aesthetics and the Idea of Race*. London: Reaktion, 2002.

Bittani, M., and D. Quaranta, eds. *Gamescenes: Art in the Age of Videogames*. Milan: Johann & Levi Editore, 2006.

Bowlt, J., and O. Matich, eds. *Laboratory of Dreams: The Russian Avant-Garde and Cultural Experiment*. Stanford, CA: Stanford University Press, 1996.

Budd, M., ed. *The Cabinet of Dr. Caligari: Texts, Contexts, Histories*. New Brunswick, NJ: Rutgers University Press, 1990.

Buerger, P. *Theory of the Avant-Garde*, trans. M. Shaw. Minneapolis: University of Minnesota Press, 1984.

Carr, D., D. Buckingham, A. Burn, and G. Scholt. *Computer Games: Text, Narrative and Play*. New York: Polity Press, 2006.

Cassell, J., and H. Jenkins. *From Barbie to Mortal Kombat: Gender and Computer Games*. Cambridge, MA: MIT Press, 1998.

Chadarevian, S. de, and N. Hopwood, eds. *Models: The Third Dimension of Science*. Stanford, CA: Stanford University Press, 2004.

Chamberlain, J., and S. Gilman, eds. *Degeneration: The Dark Side of Progress*. New York: Columbia University Press, 1985.

Chu, P., and G. Weisberg, eds. *The Popularization of Images: Visual Culture under the July Monarchy*. Princeton, NJ: Princeton University Press, 1994.

Clark, T. *The Painting of Modern Life: Paris in the Art of Manet and His Followers*. London: Thames & Hudson, 1984.

Cole, S. *Suspect Identities: A History of Fingerprinting and Criminal Identification*. Cambridge, MA: Harvard University Press, 2001.

Cooke, L., and P. Wollen. *Visual Display: Culture beyond Appearances*. Seattle, WA: Bay Press, 1995.

Crary, J. *Techniques of the Observer*. Cambridge, MA: MIT Press, 1990.

Crisp, C. *The Classic French Cinema, 1930–1960*. Bloomington: Indiana University Press, 1993.

Daston, L., and K. Park. *Wonders and the Order of Nature*. Cambridge, MA: MIT Press, 1998.

Davis, R. *Lives of Indian Images*. Princeton, NJ: Princeton University Press, 1997.

Dawkins, H. *The Nude in French Art and Culture 1870–1910.* Cambridge: Cambridge University Press, 2002.

DeMello, M. *Bodies of Inscription: A Cultural History of the Modern Tattoo Community.* Durham, NC: Duke University Press, 2000.

Dikovitskaya, M. *Visual Culture: The Study of the Visual after the Cultural Turn.* Cambridge, MA: MIT Press, 2005.

Edwards, C. *Turning Houses into Homes: A History of Retailing and Consumption of Domestic Furnishings.* Aldershot, UK: Ashgate, 2005.

Eisner, L. *The Haunted Screen,* trans. R. Greaves. Berkeley: University of California Press, 1973 [1952].

Ferguson, P. *Paris as Revolution.* Berkeley: University of California Press, 1994.

Flint, K. *The Victorians and the Visual Imagination.* Cambridge: Cambridge University Press, 2000.

Foucault, M. *The Order of Things.* New York: Pantheon, 1970.

Garb, T. *Bodies of Modernity: Figure and Flesh in Fin-de-Siècle France.* London: Thames & Hudson, 1998.

Geist, J. *Arcades: The History of a Building Type,* trans. J. Newman and J. Smith. Cambridge, MA: MIT Press, 1983.

Goodwin, A. *Dancing in the Distraction Factory: Music Television and Popular Culture.* Minneapolis: University of Minnesota Press, 1992.

Gran, P. *Beyond Eurocentrism: A New Face of Modern World History.* Syracuse, NY: Syracuse University Press, 1996.

Greenhalgh, P. *Ephemeral Vistas: The Expositions Universelles, Great Exhibitions, and World's Fairs, 1851–1939.* Manchester, UK: Manchester University Press, 1988.

Gronberg, T. *Designs on Modernity: Exhibiting the City in 1920s Paris.* Manchester, UK: Manchester University Press, 1998.

Hartley, L. *Physiognomy and the Meaning of Expression in Nineteenth-Century Culture.* Cambridge: Cambridge University Press, 2001.

Hayward, S. *French National Cinema.* London: Routledge, 2005.

Heartney, E., H. Posner, N. Princenthal, S. Scott, and L. Nochlin, eds. *After the Revolution: Women Who Transformed Contemporary Art.* Munich: Prestel, 2007.

Henderson, L. *The Fourth Dimension and Non-Euclidian Geometry in Modern Art.* Princeton, NJ: Princeton University Press, 1983.

Herbert, R. *Impressionism: Art, Leisure, and Parisian Society.* New Haven, CT: Yale University Press, 1988.

Hiller, S. *The Myth of Primitivism: Perspectives on Art.* London: Routledge, 1991.

Hunt, L. *Politics, Culture and Class in the French Revolution.* Berkeley: University of California Press, 1984.

James-Chakraborty, K. *Bauhaus Culture.* Minneapolis: University of Minnesota Press, 2006.

Jenkins, I., and K. Sloan. *Vases and Volcanoes: Sir William Hamilton and His Collection.* London: British Museum Press, 1996.

Joyce, M. *Of Two Minds: Hypertext Pedagogy and Poetics.* Ann Arbor: University of Michigan Press, 1995.

Juul, J. *Half-Real: Video Games between Real Rules and Fictional Worlds.* Cambridge, MA: MIT Press, 2005.

Karp, I., and S. Lavine, eds. *Exhibiting Cultures: The Poetics and Politics of Museum Display.* Washington, DC: Smithsonian Press, 1991.

Kepes, G. *The New Landscape in Art and Science.* Cambridge, MA: MIT Press, 1956.

Klonk, C. *Science and the Perception of Nature.* New Haven, CT: Yale University Press, 1996.

Lenman, R. *Artists and Society in Germany, 1850–1914.* Manchester, UK: Manchester University Press, 1997.

Lennox, S. and S. Zantop, eds. *The Imperialist Imagination: German Colonialism and Its Legacy.* Ann Arbor: University of Michigan Press, 1998.

Lloyd, J. *German Expressionism: Primitivism and Modernity.* New Haven, CT: Yale University Press, 1991.

Melville, S., and B. Readings, eds. *Vision and Textuality.* London: Macmillan, 1995.

Mirzoeff, N., ed. *The Visual Culture Reader.* 2nd ed. London: Routledge, 2002.

Mitchell, W. "What Is Visual Culture." In *Meaning in the Visual Arts: Views from the Outside,* ed. Irving Lavin, 207–17. Princeton, NJ: Princeton University Press, 1995.

Mitter, P. *Art and Nationalism in Colonial India, 1850–1922.* Cambridge: Cambridge University Press, 1994.

Newhouse, V. *Towards a New Museum.* New York: Monacelli, 1998.

Nye, R. *Crime, Madness, and Politics in Modern France: The Medical Concept of National Decline.* Princeton, NJ: Princeton University Press, 1984.

Ozouf, M. *La fête révolutionnaire.* Paris: Gallimard, 1976.

Patterson, O. *Slavery and Social Death.* Cambridge, MA: Harvard University Press, 1982.

Pick, D. *Faces of Degeneration: A European Disorder, c. 1848–c. 1918.* Cambridge: Cambridge University Press, 1989.

Pollock, G. *Vision and Difference.* London: Routledge, 1988.

Porter, R., ed. *Hysteria beyond Freud.* Berkeley: University of California Press, 1993.

Pospelov, G. *Jack of Diamonds: The Primitive and Urban Folklore in Moscow Painting of the 1910s.* Moscow: Soviet Artist, 1990.

Prawer, S. *Caligari's Children.* Oxford: Oxford University Press, 1980.

Puchner, M. *Poetry of Revolution, Marx, Manifestoes, and the Avant-Gardes.* Princeton, NJ: Princeton University Press, 2006.

Robinson, D. *Das Cabinet des Dr. Caligari.* London: British Film Institute, 2008.

Ryan, J. *Picturing Empire: Photography and the Visualization of the British Empire.* Chicago: University of Chicago Press, 2001.

Said, E. *Orientalism.* London: Routledge, 1978.

Sandweiss, M., ed. *Photography in Nineteenth-Century America.* New York: Abrams, 1991.

Schnapp, J. *Revolutionary Tides: The Art of the Political Poster 1914–1989.* Milan: Skira, 2005.

Schwartz, V. *Spectacular Realities: Early Mass Culture in Fin-de-Siècle Paris.* Berkeley: University of California Press, 1998.

Schwartz, V., and J. Przyblyski, eds. *The Nineteenth-Century Visual Culture Reader.* London: Routledge, 2004.

Sharp, J. *Russian Modernism between East and West: Natal'ia Goncharova and the Moscow Avant-Garde.* Cambridge: Cambridge University Press, 2002.

Shea, W. *Science and the Visual Image in the Enlightenment.* Canton, MA: Science History Publications, 2000.

Shohat, E., and E. Alsultany, eds. *The Invisible Diaspora: Between the Middle East and the Americas.* Ann Arbor: University of Michigan Press, 2008.

Sparke, P. *An Introduction to Design and Culture: 1900 to the Present.* 2nd ed. London: Routledge, 2004.

Spencer-Wood, S., ed. *Freedom: A Photographic History of the African American Struggle.* London: Phaidon, 2002.

Stafford, B. *Artful Science: Enlightenment, Entertainment and the Eclipse of Visual Education.* Cambridge, MA: MIT Press, 1994.

Stafford, B. *Body Criticism, Imagining the Unseen in Enlightenment Art and Criticism.* Cambridge, MA: MIT Press, 1991.

Sturken, M., and L. Cartwright. *Practices of Looking: An Introduction to Visual Culture.* Oxford: Oxford University Press, 2001.

Troy, N. *Modernism and the Decorative Arts in France.* New Haven, CT: Yale University Press, 1991.

Turkle, S. *Life on the Screen: Identity in the Age of the Internet.* 2nd ed. New York: Simon & Schuster, 1995.

Vásquez, O. *Inventing the Art Collection: Patrons, Markets and the State in Nineteenth-Century Spain.* University Park: Pennsylvania State University Press, 2001.

Vernallis, Carol. *Experiencing Music Video: Aesthetics and Cultural Context.* New York: Columbia University Press, 2004.

Wardrip-Fruin, N., and P. Harrigan, eds. *First Person: New Media as Story, Performance, and Game.* Cambridge, MA: MIT Press, 2004.

West, N. *Kodak and the Lens of Nostalgia.* Charlottesville: University of Virginia Press, 2000.

West, S. *The Visual Arts in Germany: Utopia and Despair.* Manchester, UK: Manchester University Press, 2000.

Williams, R. *Culture and Society, 1780–1950.* New York: Columbia University Press, 1958.

Wolf, M. *The Medium of the Video Game.* Austin: University of Texas Press, 2001.

Wolf, M., and B. Perron, eds. *The Video Game Theory Reader.* London: Routledge, 2003.

Wrigley, R. *The Politics of Appearances: Representations of Dress in Revolutionary France.* Oxford: Oxford University Press, 2002.

INDEX